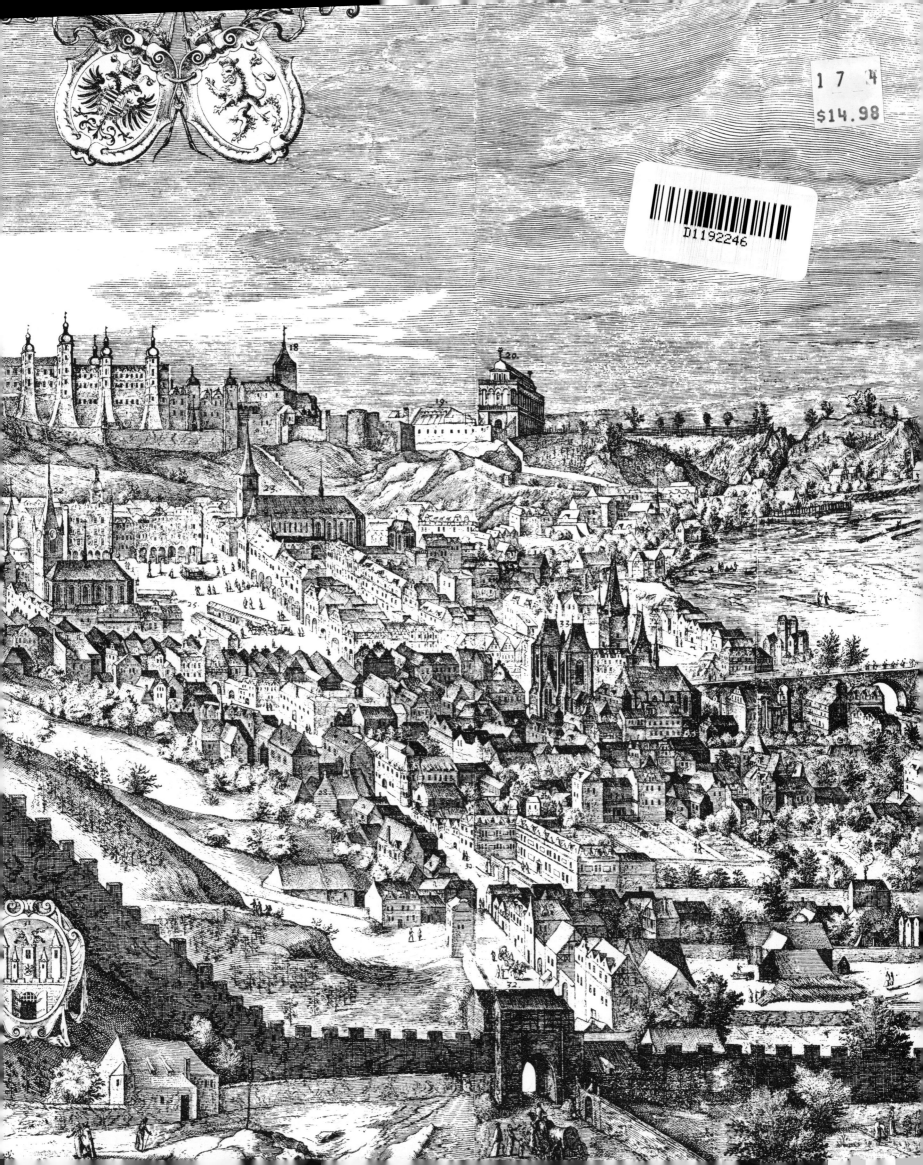

HAMLYN

RENAISSANCE
ART IN BOHEMIA

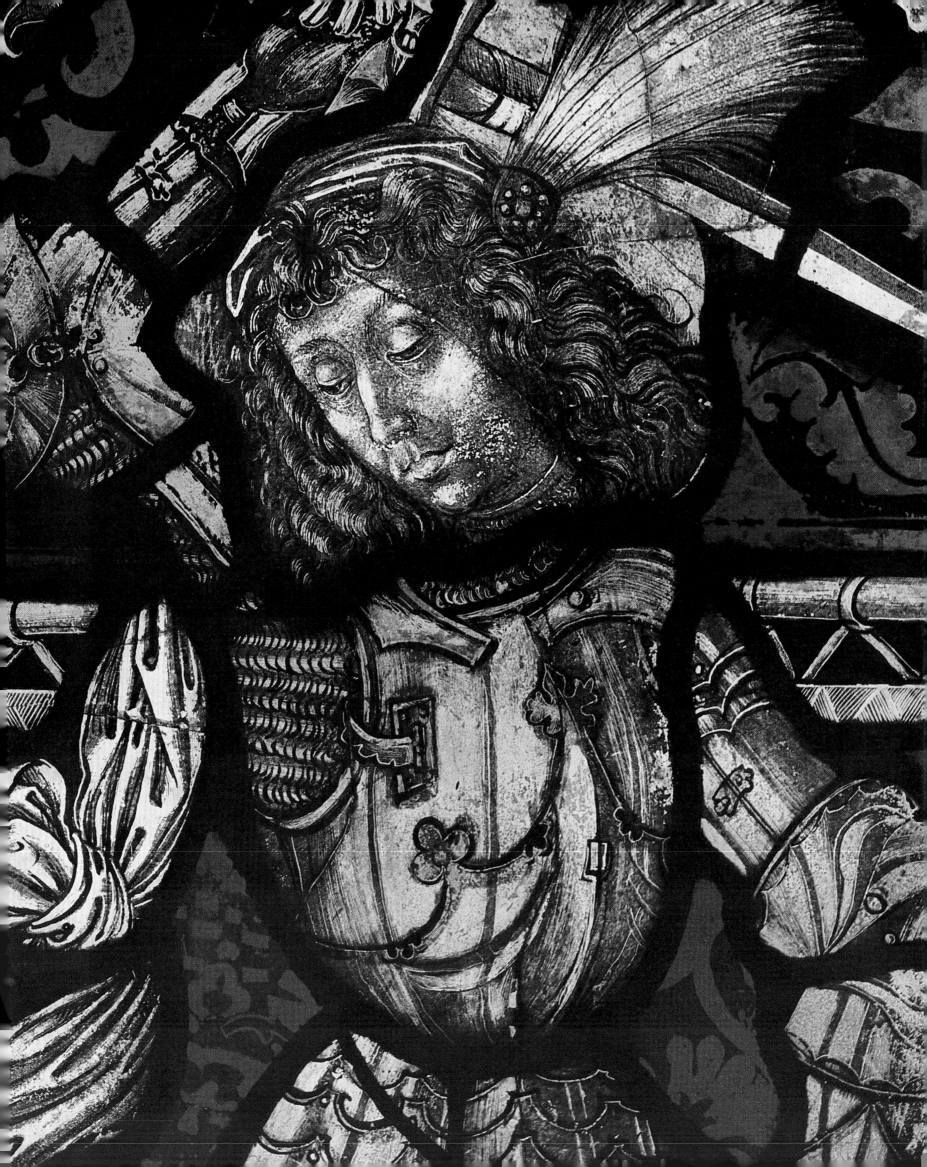

RENAISSANCE
ART IN BOHEMIA

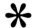

TEXT BY JIŘINA HOŘEJŠÍ, JARMILA KRČÁLOVÁ, JAROMÍR NEUMANN,
EMANUEL POCHE, JARMILA VACKOVÁ

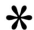

HAMLYN
London · New York · Sydney · Toronto

Frontispiece: Křivoklát Castle, glass-painting with St George, 1502—06
Front jacket: Bartholomeus Spranger, Glaucus and Scilla, about 1581, oil on canvas, 110×81 cm, Vienna, Kunsthistorisches Museum
Back jacket: Prague — Liboc, The Hvězda Summer Palace in the New Royal Game Reserve, detail of the vault in the central hall on the ground floor
Cover: The Kralice Bible, vol. VI, New Testament, Kralice, printing shop of the Unity of Moravian Brethren, 1594, the closing vignette, woodcut
Front flyleaf: Philip van den Bossche, Prospect of Prague, detail of a copper-plate, engraved by J. Wechter, ed. E. Sadeler, 1606
Back flyleaf: The ground-plan of Prague Castle and its gardens before 1757, colour pen-and-ink drawing, 147×212 cm, Prague, Archives of Prague Castle (the numbering and the commentary added for this book)

RENAISSANCE ART IN BOHEMIA

Translated by Pavla Dlouhá with revisions by Hugh Newbury
Graphic design by Jiří Blažek
Designed and produced by Artia for the Hamlyn Publishing Group Limited
London • New York • Sydney • Toronto
Astronaut House, Feltham, Middlesex, England
Copyright © 1979 Artia Prague
ISBN 600 37573 0
Printed in Czechoslovakia by TSNP Martin
2/01/03/51-01

Introduction

As a historical period, the sixteenth century in the Czech Lands, the time of the Renaissance and of Mannerism, is much less clear and more difficult to puzzle out than the preceding Gothic and the following Baroque periods, both of which were considerably longer. In the history of art, no adequate survey of all relevant facts has as yet been made of this century, so long neglected and even disregarded by scholars, so that the interpretations and assessments of this period are even more uncertain and hesitant. Scholars are facing difficult and insistent questions. What is the nature, the history, the artistic level and importance of the Renaissance in Czech history? What place is to be ascribed to Mannerism, a period that has been made so problematic by a plethora of contradictory interpretations, in the complicated process which started in Bohemia with the acceptance of the Renaissance and led in the seventeenth century to a creative adoption and an independent development of the Baroque style? Mannerism is both a sequel of the Renaissance and at the same time a forerunner of the Baroque, but what do these two inseparable aspects mean when compared with the art of contemporary Europe, in particular Central Europe? And how do they bear upon the shaping of the Czech tradition and, finally, upon the formation of Czech national art? Based on a long-term investigation, the present volume offers, or at least attempts to offer, concrete answers to these disquieting questions which begin outside the gates of the history of art, in general history.

The sixteenth century had long remained for modern Czech historians only a sort of overture to the fatal defeat of the uprising of the Estates on the White Mountain in 1620, an unsettled and restless period of religious conflicts between Protestants and Catholics, a time of increasing political tension which resulted in the terrible convulsion of the Thirty Years' War. The essential character of this period, its intellectual orientation, thoughts and ideals, as well as its lasting cultural contribution had long remained unveild and, with a few exceptions (Zikmund Winter), even underrated by national historians. But in 1913 Zdeněk Nejedlý, in connection with a dispute about the purport of Czech history, drew attention to the striking fact that, owing to the one-sided religious view of the preceding period as well as of the whole subsequent history, Czech historians had not completely understood the creative potency of the Renaissance and its influence on Czech culture. One of the traditional causes of this has been a tendency to look upon Czech history as an isolated process, without sufficiently considering world history. If we say that this conception prevented an adequate interpretation of the Czech medieval past and of its artistic culture, then we must admit an identical, if not greater, limitation in the interpretation of the sixteenth century, which practically closes the epoch of regional history and starts the era of world or European history. This is especially noticeable in the sphere of culture and art. Without consideration of the European development of art, without an understanding of the revolutionary significance of the Italian Renaissance and the consequences of its acceptance and transformation in the countries north of the Alps, it is quite impossible to reveal the nature and meaning of the restless but vital and fruitful artistic life in the Czech Lands. We shall not be able to perceive its problems, its erratic course, or its permanent results until we have become aware of the epoch-making impact of the intensive unprecedented exchange of ideas and creative impulses between the South and the North, between Italy on the one hand and Germany, the Netherlands, France and some advanced countries of Central Europe on the other.

True, sixteenth-century art in Europe was focussed, due to the whole preceding development, on marked regional styles. But these were not closed to one another: on the contrary, they were gradually losing their independence and local boundaries as the principles of the Italian Renaissance, of its culminating phase and above all of an internationally oriented Mannerism began to assert themselves as binding ideals in the development of individual areas. This Renaissance, and later Mannerist, integration of art was of a different nature from the spiritual universalism of the Middle Ages, which stood out so markedly in Gothic art, in its ideological programmes and the stylistic conception. It was not a religious universalism leaning upon the power of the Church as a decisive spiritual authority, but a secular universalism, based on a new concept of human personality (government, power) and on the products of perception. The process of the Renaissance artistic integration gradually broke down the local isolation of the individual European countries, and was parallelled by the degree to which Europe was becoming a complex of states, interdependent both economically and politically. It proceeded hand in hand with the dramatic discoveries in natural science and their rejection in the process of which revolutionary cosmic theories and oversea discoveries were shaping a new picture of the world and of the earth, and finally with the emergence of a new "cultural cosmos", which was reflected in new demands laid on the cognitive function of art and on its mission in society. A consequence of this new historical situation was the fact that it was no longer possible to develop art separately, with the existing local traditions predominating, and merely in dependence on the generally acknowledged spiritual principles of the Church. A radical change in art was now conditioned by contacts with the artistic production of the country where this swing had been initiated, as well as of those countries where the new ideas were adopted and further developed. The new Renaissance concept of art was dependent on the systematic development of specific artistic means, on the application of the theory of art; thus it could not gain ground without sufficient information about the achievements of the leading cultural centres, above all of Italy, because the idea of a gradual development towards perfection, the idea of progress, was the underlying principle of the Renaissance. In Bohemia it was equally impossible to advance without an understanding and acceptance of the

Italian Renaissance; thus the Czech Lands were confronted with a historic task in the sixteenth century: to adopt and finally transform the Italian Renaissance in accordance with native needs.

It is a well-known fact that nowadays the Renaissance is looked upon as existing in three conceptual specifications and on three levels — as a historical period, as an intellectual movement finding its expression in Humanism, and as a style. However, in spite of their interconnection, these three levels do not always overlap in time and geography (J. Białostocki). This is one of the reasons why the historians of general history and those of art often misunderstand one another and criticize one another's working methods and conclusions arrived at in the interpretations of the Renaissance, especially in the countries north of the Alps. The findings obtained in the study of one aspect of the Renaissance cannot be mechanically applied to another aspect; for the time being, it is, from the methodological viewpoint, extremely difficult to define a synthetic conception integrating all the aspects indicated above. It is therefore necessary to point out at the very beginning that we are mainly concerned with the Renaissance (and Mannerism) as a formally meaningful artistic system. True, we cannot leave out of consideration its historical bindings and conditions, but we do not attempt to solve any special questions connected with the other aspects of the Renaissance.

The end of the Middle Ages and the beginning of the new era showed themselves not only in a new ideological orientation but also in an increasing sophistication of the means of expression. In the countries north of the Alps the change involved the acceptance of a new artistic language based on Antiquity, which conflicted with the manner of expression of the Gothic period and could not strike roots until the new culture had been adopted in the course of a great cultural effort. Only then was it possible to accomplish a fruitful synthesis of the Italian Renaissance with the needs of the northern tradition as well as with the newly emerging specific cultural requirements of the countries and of the new "consumers" of art. Renaissance art was more exclusive than that of the preceding style, requiring higher education and greater knowledge. If medieval art was labelled, because it was used didactically to replace the written word, as biblia pauperum, *the bible of the poor, then Renaissance art was* biblia divitum, *the bible of the rich, i. e. of people well-read, acquainted with Humanism, educated, and eager for knowledge.*

While in Italy the Renaissance could successfully derive from native Antiquity, and simultaneously grow in a relatively organic manner out of the local medieval art permeated with Classical traditions, the acceptance of the Renaissance in transalpine countries represented a radical change of views. In the beginning, it involved a difficult departure from tradition and a gradual replacement of the Gothic view by a new concept, by a new artistic language with an unknown vocabulary, and an unfamiliar and very difficult Classical syntax. Late Gothic artists, preoccupied with the picturesque appeal of reality and placing individual elements in a great continuum of empirically conceived space, did not see the structure of reality in a rational way. They did not have that sense of logical order and typification, to which Italian artists had always been prompted by the presence of Antiquity and of its Classical works, which had never been completely forgotten. As the observation of reality in the Gothic style rested on examples and a firmly established pictorial tradition, it was mainly confined — even in the advanced late phase — to details whereas the Renaissance combined observation with a knowledge of the laws of nature. In architecture, the Renaissance expressed, by the order of its forms, the weight and function of mass; in painting, it expressed the "typical forms of the character and behaviour of live beings, especially of man" (Panofsky), according to the principles of symmetry and harmony typical of Classical art and in accordance with central perspective. From this point of view, perspective had a revolutionary impact on art: firstly, it accentuated a precisely measurable distance to the subject to be depicted, and thus proceeded from a clear distinction between the observer and the object to be rendered; secondly, it presupposed a painting as a section of reality viewed by a certain person at a certain moment. The interdependent factors of space and time had acquired an unprecedented significance in art. This weakened and gradually disrupted the direct relationship in medieval art between the size of the figure and its spiritual significance, and the principle of continuous narrative, in which successive and spatially remote actions were shown simultaneously on the surface of one single painting, was pushed out of art. Respect for the laws relating the subject to the object, and space to time, and application of the findings of mathematics and mechanics, anatomy and optics, led, together with the important aesthetic theory of proportions, to the search for an ideal image of the world, based on the laws of beauty as well as nature. To adopt this ideal "noble nature" (Goethe) of Antiquity and the Renaissance, differing so much from the limited, merely empirical "natural nature" of the Gothic, was a task made more difficult in transalpine countries by the fact that there the new view had long been linked to literature and the study of Antiquity, and had only slowly been finding support in the pictorial language of art: it was dependent on imports of works of art, on immigrant Italian artists, and finally on people travelling to Italy.

North of the Alps, as in Italy, the new artistic view was connected with the revision of the Hebrew-Christian concept of man as a mere clod, miraculously associated with the immortal soul, into a new concept, derived from Antiquity, of man as an "integral unity of body and soul". This view, originally Hellenistic and later also Roman, was in the Renaissance the basis of organic beauty and even of a revival of Antique forms, and made it possible to discover "man and world", to use the classical phrase. Man became not only the main object of representation and glorification, but also a binding standard and ideal which humanized and secularized the whole of art. True, the links with Antiquity were never completely broken even in medieval northern Europe; however, the themes drawn from Classical literature, from Ovid, Vergil and other authors, were treated — insofar as they were admitted in art — in a way quite remote from the Classical view, a way that accorded with contemporary customs, with Christian symbolism and morality, with the stylistic forms and the empirical realism of Gothic art. The Renaissance artist, striving to revive man as the Antique unity of body and spirit, sought to overcome also this artistic dichotomy of Classical themes and Classical motifs (ways, types and forms of representation). A reintegration of their former unity was, according to the revealing analysis by Panofsky, a "privilege of the Renaissance proper". At this point it is necessary to emphasize that this reintegration did not mean a return, but

that it was a move forwards as a search for new forms which were as different from the Antique forms (in the North also from the forms of the Italian Renaissance), as they were from the medieval ones; yet they were connected with both of them.

Another profound change was in the view of the position and function of art in society. This change, too, manifested itself more strikingly north of the Alps, because the break with the surviving tradition had necessarily to be more radical here. Art ceased to be subservient in the medieval sense, and was becoming an important form of human self-awareness, a weighty component of social consciousness, an independent and vital force in the search for knowledge, which was becoming divorced from theology; in close contact with literature and philosophy on the one hand, and with technical and natural disciplines on the other, artists were discovering, unhindered by dogmatism, the intricacies of reality as well as the real forces behind art. During the great transformation, art became a reflection of the deepest human feelings and, in the case of the greatest individuals, a universal philosophy of life and, simultaneously, a metaphysical interpretation of the world, as we can see in the work of Michelangelo and its penetrating influence. Art, ranked among the crafts in the Middle Ages (artes serviles), came to occupy now an important place among the liberal arts (artes liberales), and began to be truly respected like some new religion. Great artists were called divine (divus Raphael), for artistic activity was considered superior to mere learning — being compared, in terms of Neoplatonism, with divine creation. The artist, regarded as demiurge, was valued more than ever before or since, no less than the great earthly politicians and commanders. In theory, if not in practice, the privilege of talent and human values achieved by creative work was appreciated no less than the privilege of a noble origin or the ecclesiastically consecrated authority of magnates and monarchs. It was in this sense, too, that the Renaissance was the "greatest progressive revolution mankind had as yet experienced" (Engels).

The secularization of art, the drift to the earthly world, and the joyful liberalism, which is particularly characteristic of the Romance peoples, did not naturally result in artistic production lacking any relation to religion. Mature Renaissance art was neither Christian in the sense which was current until then, nor pagan in terms of Antiquity. "It is not lacking an approach to the sacral sphere; it showed itself, for example, in the Christian iconography; yet its function was secularized to a far-reaching extent. There is nothing earthlier than some of Raphael's Madonnas . . ." (G. Kaufmann). On the other hand, however, sacred ideas influenced the secular forms of art, for example Renaissance portraits, in which artists tried to render human physiognomy very much like that of Christ, whereas Christ's face was, in turn, given individual portrait features. The relationship between nature and religion, between learning and faith, was made problematic, and a tension arose between the two. Anyone who has noticed the inconspicuous but precisely rendered human embryo among the pebbles under the feet of the Virgin in Leonardo's Virgin and Child with St Anne *will never again regard this picture as just a humanized adoration of Christ's maternal ancestors; he will understand this sacred scene in the disquieting light of human knowledge. This so to speak biologically complicated idea of salvation tallied with the criticism of the accepted Christian concept, valid until then, of the universe as geocentric and with the emergence of a new concept that unsettled the current certainties of man's privileged position in the world. The sixteenth century saw the birth of a new age with its passion for discovery and with its uncertainties, with its belief in man and also with its deep crises. In Bohemia the best evidence of it is Rudolph II's reign with its epoch-making scientific discoveries and brilliant works of art, its bustling creativity and restless fervour, its triumphs and its tragedies. In both of the extremes we shall find a portent of the modern age.*

The difficult synthesis of the new with the old, which was to be the result of a creative coming to terms with the Renaissance and Mannerism, presupposed in a country remote from the direct artistic stimuli of Antiquity a relatively long process of acceptance. In comparison with the mature phases of the Czech Gothic and Baroque, this process resulted in a surprising lack of artistic continuity; in the isolation of individual, often remarkable, artistic accomplishments; frequently also in a disparity of their styles; in the great immigration of foreign artists, who produced the greatest individuality; in the great influx of artistic imports; and consequently in a reduced, even low, level of domestic production in branches which had been on a high level in Bohemia before and were to achieve it again later on. This is true, for example, of various branches of painting and sculpture. On the other hand, however, the fact that outstanding, and even brilliant, works were executed in Bohemia in the sixteenth century and that gifted artists of foreign origin had settled and taken root here, readily accepting impulses from the local environment and very soon adapting themselves to it in their art, especially in the second half of the sixteenth century, testifies to the high cultural and artistic needs as well as to the not insignificant intellectual and artistic maturity of the Czech milieu, which accepted the Renaissance as sensitively as the neighbouring countries, Austria and Germany, Hungary and Poland. Some artistic phenomena, for instance the classicizing trends of the Court art, drawing in Ferdinand I's time on Roman examples, and the anti-classical tendencies, i. e. Mannerism in Rudolph II's time, made themselves felt in an expressive form, often surpassing the neighbouring countries. Both these tendencies were connected, above all, with the Court and with the royal or Imperial commissioners; however, it is certain that owing to the local feelings there was in Bohemia a keen response to the architecture and sculpture of the Italian Renaissance. From time to time it was more clear-cut than in the neighbouring German lands, where the local "translation" of the Renaissance tended towards exuberant decorativeness, expressive exaggeration and the picturesque fancifulness of the differently oriented Late Gothic in Germany, which obliterated to a much greater extent the restraint and logic of the Italian Classical forms. The Czech Lands, too, had a sense of the beauty of a rich décor, but rather in terms of Northern Italy (see for example the extraordinary flourishing of sgraffito decoration, typical of Renaissance châteaux and burghers' houses); there was also an increased interest in dynamic forms (ovals and protracted centrals in ground-plans). All these tendencies, particularly the sense of movement, indicated that Bohemia would provide a milieu which would later understand and accept the spirit of the Baroque. By making a careful and unprejudiced analysis, comparing the way in which both the Renaissance and Mannerism were accepted and transformed in Bohemia with similar processes in the neighbouring, especially

9

German, lands, we find that this period already exhibited the first hints and indications of the tendencies that were much later to distinguish the Czech Baroque from that in southern Germany and the Danubian area. The specific character of the Renaissance and Mannerism in Bohemia laid the foundation of the significant Baroque period, which made the Czech Lands renowned as an inspiring, and for a time even trend-setting milieu which enriched the artistic culture of Europe, as the Gothic did in Charles IV's time.

The acceptance of the Renaissance was naturally easier in countries which had closer contacts with Italy, whether it was due to their being her neighbours (Alpine countries), or to their long-established trade and cultural relations with her. This is especially true of the Netherlands whose realistic painting influenced Italian art as early as the fifteenth century. In a certain sense the same can be said about Germany whose graphic art affected the Italian High Renaissance as well as Mannerism. If we mention in this connection Dürer's deep and long-lasting influence on Italian artists, we must point out as well that it was Dürer who, while being the greatest individual of the German Renaissance, began in Germany the appreciation of Classical monuments from the aesthetic viewpoint. Yet even he came to understand them not through his own studies, but only indirectly, through the eyes of the Italian quattrocento which was nearer to and more comprehensible for him for the very reason that it had been influenced by northern ideas. This well-known fact alone provides a telling proof that the Italian art of the fifteenth century was one of the important mediators between the aesthetic experience of the transalpine countries and the Antique world, a fact already recognized by Panofsky. If we regard, with Panofsky, all Italian Renaissance art as the balancing of two opposite tendencies — of Classical idealism of Antique coinage, on the one hand, and of empirical realism in the transalpine sense on the other — we can, from the viewpoint of place and time, better understand the response to the Italian Renaissance in the north. The convergence and crossing of the different tendencies was made possible by points of contacts between the Italian Early Renaissance and the transalpine Late Gothic, and the transference of mature Classical principles, of course, made itself felt later; the acceptance of them did not permit of any marked compromises with the traditional feelings of the Gothic.

A factor of a decisive importance for the acceptance of the Renaissance in Central Europe, Germany, Hungary, Poland and also in Bohemia, were the rulers' courts which invited either Italian artists or artists from elsewhere who were thoroughly conversant with Italian art (for instance Benedict Ried and his lodge, and later Boniface Wolmut in Prague Castle). A great number of Netherlandish artists journeyed to Rome in the sixteenth century and this accelerated the emergence of the German Renaissance (Dürer's journey to Venice during which he executed his famous Feast of the Rose Garlands *in 1506). Such travels were confined in the Czech Lands mostly to university studies of the humanists, while their effect on art was only indirect: they formed the aesthetic views and artistic requirements, especially in the sphere of architecture, of the aristocratic patrons who knew the Italian artistic atmosphere, its way of life and, last but not least, the theoretical treatises on art. A wider spread of the Renaissance influence extending over a broader social area among artists and consumers was made possible — apart from the general historical prerequisites — only by the combination of all available sources, ranging from Renaissance works made locally by experienced foreign masters and imported works to graphic pattern-books and theoretical literature as starting-points for the newly oriented artistic activity.*

The intention and will of the patron on the one hand, and the capacity of artists and others to grasp the new view on the other hand, were decisive and interdependent factors in the acceptance of the Renaissance in the Czech Lands. The fact that at this time the patron, ruler, magnate or rich burgher, had more influence on art and its expression and orientation than ever before, was partly due to the secularization of art and to the Renaissance emphasis on people. Hence the importance of the patrons' education. They were frequently not only well-read people who knew the theoretical treatises on art and, as a rule, passionate collectors with refined tastes, but sometimes also successful dilettanti and even noteworthy designers (for example Archduke Ferdinand of Tyrol and his design of the Hvězda Summer Palace at Liboc). Again, the patrons who built the most significant Renaissance châteaux in Bohemia and Moravia were the best educated individuals among the nobility, who had spent some time in Italy, had studied at universities there, and in some cases had family ties with the country: for instance, Lord Chancellor Vratislav of Pernštejn, who built the château of Litomyšl, William Trčka of Lípa, who had the château of Opočno built, Ladislas of Boskovice, who built the château at Moravská Třebová, John Šembera of Boskovice, to whom we are indebted for the outstanding quality of the Bučovice château and its decorations, the sons of Adam of Hradec — Joachim who, together with his son Adam II, built the château at Jindřichův Hradec, and Zacharias, who built the château at Telč. No less significant were of course the education, breadth of knowledge and taste of the patrons among the burghers; the more so, for without the enterprising spirit and humanist interests of the burghers the Renaissance would not have found acceptance in Bohemia to any large extent.

An important finding of the latest research is the fact that in the course of its acceptance in Central Europe (Bohemia, Hungary) and in central-eastern and eastern Europe (Poland, Russia), the Renaissance had first become art of the royal courts and of the highest nobility; as such it represented a symbolic form of the life conception of the social élite, and in particular a representative expression of the modern monarchical power (J. Białostocki). First when being accepted by rich burghers followed by other burghers' strata it gradually acquired a new social sense as well as a new artistic form; when the visual world of the Renaissance was being adopted from the Italians by local artists, it was losing (in J. Białostocki's words) in the long process of adaptation its original exclusive meaning and became completely popularized. This disintegration of the original Renaissance gave rise to a new order of forms (the so-called Czech Renaissance) whose characteristic was a marked but relatively moderate picturesqueness. An explanation of what the contents and life orientation of the adapted Renaissance had been in the Czech Lands, is only in its beginnings these days.

The Renaissance had already penetrated to Bohemia at the turn of the fifteenth and sixteenth centuries, at a time (1490) when Vladislav II

Jagiello was elected to the Hungarian throne and when the royal residence in Prague began to change its appearance under the influence of the mature Renaissance milieu of the Hungarian Court (the Renaissance of Matthias Corvinus), and, simultaneously, as a result of ambitious plans. The noble forms of the north windows of Vladislav Hall (1493), the structurally well thought-out and harmonious conception of the Louis Wing of Prague Castle (1502—08), and also the impressive solution of the southern portal of St George's Basilica (1508—09) are among the first marked achievements in the new style, which gradually began also to influence the building activity in the remainder of Prague. The first sculptural works influenced by the Italian Renaissance date from about the same time. The portrait medallions depicting Ladislas of Bosko-vice and his wife Magdalene of Dubá (1495) in the château of Moravská Třebová are apparently the work of a sculptor who was moulded by the artistic milieu of Florence and had earlier worked in Hungary. This conforms with the personality of the patron, Ladislas of Boskovice, who had studied at Italian universities and was in contact with the humanistic milieu of Matthias Corvinus's Court. In this case, too, as in Jagiello Court art, Hungary appears to be an important mediating link between the Czech Lands and Renaissance Italy. In painting, Renaissance principles permeated the magnificent decoration, so ambitious in its iconographic programme, of the Smíšek Chapel in the Church of St Barbara at Kutná Hora (1506—09), which links the motifs of the Imperial legend with a glorification of the patron (in this case an ennobled burgher, the rich mine-owner Michael Smíšek of Vrchoviště); Renaissance traits can also be discerned in the painted decoration of St Wenceslas's Chapel in St Vitus's Cathedral in Prague, in the legendary but contemporized "state" cycle from the saint's life (before 1509); we can find parallels to its advanced conception in the south German Augsburg school and in northern Italy, and some points of contacts can also be found with the "Maximilian" Renaissance. This cycle, a work by an anonymous artist, called the Master of Litoměřice, and his assistants, occupies as important a place in the beginnings of Renaissance wall-painting as do the preserved panels of the Litoměřice Altar-piece (from which the artist's name is derived) in panel-painting. Although the six panels, once parts of the Litoměřice Altar-piece which, according to a new hypothesis, appears to have originally been in Prague Castle, were executed at the very end of the Gothic period, the rendering of space and figures already shows some Renaissance traits. The mixture of the old, Late Gothic style with the elements of the new Italianizing conception was, of course, a characteristic feature of all works executed in this transient period. The new Renaissance forms of Vladislav's time represent only solitary brilliant islands in the sea of Late Gothic production which dominated the Czech milieu, particularly among the clergy and the burghers. It was not until after 1520 that the Renaissance style permeated the woodcarvings of the monogrammist I. P., who knew the work of Dürer and clearly of Mantegna too, and who introduced a new constructive conception into Bohemia from the Danubian school. It was characteristic of this first, preparatory phase of the Renaissance in Bohemia that art was still under the spell of traditional religious subject matter, and that the Antique themes, history, mythology and personal glorification, which can be seen in a remarkable way in Hungary and Poland, had not as yet found their way here. The "romantic" and historically oriented ideal of chivalry, which was represented for example by Emperor Maximilian I himself and which had its impact on the Jagiello milieu as well, seems to have been an obstacle in the understanding and acceptance of the Renaissance view of personality. Due to more general historical circumstances, the spiritual revolution at that time was not yet far enough advanced in Bohemia for the Renaissance conception of the world and life to acquire full validity here.

A radical change, representing a new, proper phase of the Renaissance, came in the year 1526, when Ferdinand I of Habsburg, younger brother of Emperor Charles V, mounted the Bohemian throne; in his view of life, as in his conception of rule in terms of an absolutist monarchy, Ferdinand I was already a sovereign of the new Renaissance period. He endeavoured to prove his legitimate claim to the Bohemian throne, confirmed by his marriage to Anne of Jagiello, by following the tradition of his great predecessors and, above all, by his modern cultural alignment, perceptible also in his orientation towards Renaissance Classicism. It was not only by court buildings and triumphal processions, so typical of Renaissance rulers and magnates, but also by monumental structures that Ferdinand emphasized his position as the King of Rome and, from 1556, also as the head of the Holy Roman Empire. A much travelled man, educated in Spain and particularly in the Netherlands, a keen collector of coins and antiquities, had various structures built at Prague Castle whose Renaissance forms, influenced by Roman examples, reflect his efforts to express the continuity with Roman emperors. The new Royal Garden (after 1534), crowned by the delicate, Classicizing Summer Palace of Queen Anne, usually called the Belvedere (ground floor built in 1538—52;, the upper storey added in 1556—63), a joint work by Francesco Terzio and Boniface Wolmut; the structurally ingenious loft in St Vitus's Cathedral (1556—61, again by Wolmut); the large Ball Court, built under Ferdinand's successor Maximilian II; all these are important stages which indicate the penetration and development of the Italian style in Bohemia. By this time, the advanced Prague Court had fully caught up with Italy. Simultaneously, the new principles of Mannerism began to be applied in the structures of Classical orientation, above all in the Ball Court. Along with the Classical Italian forms, Gothic forms continued to be used in Ferdinand's time (for example the Gothic-like vault over the noble Renaissance tribune in the Castle's Diet Hall); however, this intended co-existence differed considerably from the compromise mixture of the two styles in the Jagiello period.

The new works of architecture were based on knowledge of the advanced Renaissance theory, their designs being drawn from Palladio and Serlio. Their architects, such as the Prague Court architect Boniface Wolmut, were already educated Renaissance artists with broad humanistic interests, ranging from Neoplatonic philosophy and cosmological learning to the hermetic teaching of that time. The rapidly increasing knowledge of theoretical treatises, pattern-books and graphic folios made it possible to disseminate the new style beyond the court.

The full acceptance of the Renaissance was also reflected in the Classicizing themes in painting and sculpture. The mythological scenes from the lives of Hercules, Perseus and Cadmus in the sculptural decoration of the Belvedere Summer Palace were conceived as allegorical hero-worship of the representatives of the Habsburg dynasty who liked to identify themselves with characters from these myths. While the Jagiello iconographic

programmes were kept within the frame of traditional legends and connected with the Imperial ideas of the Middle Ages, the first building in purely Renaissance style in Central Europe displays a genuinely Renaissance programme proceeding from an Antique myth, from the idea of Antique virtues that the rulers of the new age boasted of (Charles V as Emperor Alexander, Ferdinand I as the hunter Meleager). Even mythological lovers from Ovid's Metamorphoses are here, foreshadowing the later cycles painted for Rudolph II by Bartholomeus Spranger. The stucco decoration of the Hvězda Summer Palace captivates the spectator with its Antique mythological and historical themes, as well as with its markedly Classicizing forms. This Rome-oriented décor of extraordinary workmanship, executed in 1556—60 by Italian pargeters (apparently including Antonio Brocco), is an accomplished reintegration of Antique themes and motifs (ways, types, and forms), so essential for purely Renaissance conceptions.

Works commissioned by Ferdinand I's Court officials also displayed Classicizing tendencies and traits, for instance the decoration and design of the château at Nelahozeves, (built from 1553 to the mid 1560s for the Tyrolian Florian Griesbeck of Griesbach). The châteaux and palaces of other courtiers, the Pernštejns, Rožmberks, Lobkovice, were stylistically influenced much more by northern Italy which was nearer to and more aesthetically acceptable to the Czech artistic atmosphere. We shall not unfold here the following phases of the acceptance and development of the Renaissance and Mannerism in the Czech Lands, which are described in detail in the following chapters of this book. We shall content ourselves with the remark that, along with Classicism, unclassical Mannerist tendencies were also becoming noticeable from the 1540s onwards, either in special, locally modified versions of the Renaissance conception, or as a contrast to Classical works and in accordance with Italian Mannerist examples. Mannerism characterized the majority of significant châteaux in the Bohemian and Moravian countryside (Bučovice, Litomyšl, Telč, Jindřichův Hradec) and was fully developed in Rudolph's time, when it became a pronouncedly Court style, consistently permeating all branches of art. The architecture of the numerous Czech and Moravian châteaux, clear-cut in disposition and refined in form, is at the same time the best evidence of the Late Renaissance of the Mannerist hue having struck firm roots in the Czech Lands an having enriched European art by new and original stylistic forms. In his book on the Renaissance in eastern (and Central) Europe (1976), J. Białostocki has in this connection arrived at the conclusion that so rich a group of Renaissance châteaux as that in the Czech Lands can hardly be found outside Italy in the sixteenth century; he has also pointed out that their characteristic feature, a three-storey arcaded court, is rather an exception even in Italy itself.

The Renaissance penetrated into subject towns where a full application of its stylistic principles was naturally hampered in many different ways: by social factors, such as the traditional system of guilds, by town-planning difficulties in the old medieval towns, and also by conservative attitudes towards life and religion. However, important factors in the development of artistic feeling in Bohemia was the ruralization and popularization of Renaissance motifs. True, the ground-plans, gables and decoration of Czech Renaissance houses, as a result of the surviving Gothic views, lacked the regularity and symmetry of those in Italy, but they brought to life characteristic, locally modified stylistic forms in a specific transformation of southern motifs and in picturesque forms connecting elements of various Italian origins. The characteristic forms of the so-called Czech Renaissance were distinct from the bizarre, fantastic forms of the German Renaissance, their sobriety pointing, in many respects, more to Italian Mannerism. This fact seems to have promoted the capacity of perception as well as the artistic distinctness that people in both the towns and rural areas displayed when they were faced with the powerful invasion of the Italian Baroque later on. If the Gothic had prepared the ground in Central Europe, and in the Czech Lands as well, for an inventive transformation of the Italian Baroque as well as for the development of its radical tendencies (Guarini's art), then it was the acceptance of the Renaissance and Mannerism that provided the basic prerequisite and the necessary stylistic starting-point for this creative independence. And the mature synthesis of northern and Italian feeling could be achieved in Bohemia only because the adoption of the stylistic forms of the Renaissance and Mannerism did not here remain on the surface, in spite of all the historical obstacles. While the Gothic and Renaissance more or less occurred together throughout the sixteenth century, whether in opposition or in co-existence, the Baroque succeeded, on the basis of the preceding development, in interweaving the transalpine conception, derived from the Gothic, and the Italian mode of expression, modelled on Antiquity (the protracted centrals of K. I. Dientzenhofer).

Mannerism, which in Bohemia dominated all the arts in Rudolph II's time (1576—1611), was in this connection of unperceived significance. Foreign artists, Italianized in training as well as in attitude, predominated in Court art; Netherlanders (B. Spranger, A. de Vries, E. Sadeler and R. Savery), Germans (H. von Aachen, J. Heintz), or Italians themselves (G. Arcimboldo, most of the architects and some of the craftsmen); but their production struck roots in Prague, drawing impetus from the local milieu. Even though Rudolphine Court art was able to develop unhampered for only three decades, i. e. during the lifetime of the ruler, who was its central personality and its ideological focus, it was this art that managed to restore in Bohemia, after a long period of disjointed starts and of passive receptivity, an internal, developing continuance of artistic production. The fundamental principles of the Renaissance did not fully take root until the period of Rudolphine Mannerism, for Imperial patronage led the visual arts — in the declaration of 1595, and mainly in Court practice — out of the narrow framework of medieval restrictions finding the crafts, establishing them among the liberal arts — artes liberales. It was not until then, even though only for a short time, that the native continuity of artistic endeavours was restored in the sense that important impulses no longer came just from abroad, from the advanced foreign environments; they originated also in Bohemia, in an atmosphere full of wide-ranging artistic activity — painting, sculpture, architecture and various branches of the rapidly developing artistic crafts, due to the close co-operation and mutual inspiration of the Court artists. Of great significance here were the advanced cultural conditions in Prague as well as the favourable situation at the Imperial Court, making possible a close co-existence of artists and scholars, representatives of both theory and practice, of people with skilful hands and restless, searching spirit. This is why the visual arts found impulses at home — from natural science and technical research, from philosophical thinking and the

newly revised cosmological theories (Kepler), and last but not least, from the hermetic learning and magic. A fruitful variety of ideas was characteristic of the atmosphere of Prague at that time and the city was opened, as had once been Hellenistic Alexandria or Hadrian's Rome, to the most diverse streams of contemporary European culture. This seat of the Emperor, the metropolis of the Empire, where men were seeking answers to the questions then disquieting the world, and looking for a way out of the steadily increasing spread of historical conflicts, had become a cradle of art which, with its complicated blend of speculative abstractness and realism, acquired European validity, also inspiring other significant traditional centres of art (the influence of Rudolphine art in the Netherlands).

Even though the immediate influence of Rudolphine art in Bohemia was impaired by ill-fated historical conditions — the success of the rigid recatholicization and the severe disturbance caused by the Thirty Years' War — the memory of it has remained as vivid as that of the glorious time of Charles IV. True, works executed in and for Prague have mostly been removed from Bohemia: for the magnificent collection brought together in Prague Castle by the educated and artistically sagacious sovereign we must search in a dozen places on different continents. But to this day we can distinctly hear the echo of the footsteps of mankind striving along the path to cultural aggrandizement.

Arts in Bohemia under the Jagiellos

The fifty years' rule of the Jagiello dynasty in Bohemia (1471—1526) is usually looked upon as a "transitional" period that need not be accorded any serious attention. In the monumental historical work of F. Palacký, who picked out the Hussite time in so high a relief, we can feel a certain reticence on the part of the author in his recounting the history of the Czech Lands under the "weak" king Vladislav and his son Louis, who met with a tragic death before he had a chance to show what he could achieve. Such assessments in the Jagiello period have become established conventions. Yet a very interesting phenomenon emerges in this context: it was during this time that a number of outstanding works of art were produced in Bohemia, a fact which contradicts the current view. We can even say that Jagiello Court art — a term that has only recently been introduced — persuades us to adopt a more appreciative attitude to that time (for Vladislav art itself represents a sort of authentic document); in some instances it will even enforce a more favourable interpretation of the written sources from that period. The meaning of this art in its individual layers reflects general factors as well as the innermost ideas of the patron. Jagiello art had indeed deeper roots and a broader effect than has hitherto been assumed. It advanced on purposeful lines, backed by a well-considered body of ideas. However, much of what speaks today of Vladislav's and Louis's mental make-up and their aspirations as sovereigns, had remained in the realms of kingly dreams and longings. In spite of the hard realities of life, pregnant with uncertainty and marked by a permanent crisis, there was room enough at the turbulent junction between two epochs, the Middle Ages and the modern times, for illusions, fiction and all possible ideas for reforming the world. Historians pay little attention to these escapist dreams that may operate as stimulants for a certain, sometimes long, span of time. As an example let us take the idea of restoring medieval knighthood, which will have seriously to be taken into account even within the context of the fifteenth century's fine arts. It is a well-known fact that this idea represented a motif: power for the "last knight" Maximilian I, who alternately favoured and betrayed the Jagiello king. At a time full of contrasts, when the capricious fate of the sovereigns might have been symbolized by the Wheel of Fortune, at a time of dramatic upheavals and changing ideas, it was only natural that contemporary man could not understand what the essence of such happenings was.

Even though no absolute boundary can be drawn between the Middle Ages and the modern times (the *annus mirabilis* 1492 is a great symbol only), it was at this time that problems arose whose common denominator has, after all, survived up to the present day. Perhaps no other turning-point in history has affected the consciousness of the modern man to such an extent as the time about 1500. The established "picture of the world" had been totally reversed. However, the people who had discovered new continents with their immense wealth had become masters of the maximum of human freedom for only a split second. For it was at the same moment that they were equally enslaved. The epoch-making oversea discoveries were immediately followed by a catastrophically uneven economic development, whose consequences were no longer local in their effects. Regional history came to an end, and

world history started. All this cannot indeed have been a matter of a moment. New seaways had been sought for even before 29th May, 1453, when Constantinople, the last corner of the Roman Empire, was seized by the Ottomans. And it was not until several decades later that this event affected Europe. Central Europe had long since lost its key position and, consequently, the Czech Lands found themselves on a sort of side-road which was to turn out to be a blind alley in a short time. At least two aspects played a determining role here: the dynamics of the development of the dawning modern age, making itself felt in full swing far away from the Czech Lands, and the special character of the Czech milieu. Bohemia, which had at the beginning of the fifteenth century so remarkably defended both social and religious ideas, had exhausted its strength and was forced to remain parched for some time. When a regeneration finally began to dawn, world events were irrepressibly proceeding in their own channels. If it is possible to speak about the Bohemia of about 1500 as experiencing a certain economic prosperity, it is necessary to add that it was a sort of ephemeral flourish. (It was at this time that the silver from the mines of Kutná Hora began to be devaluated by the overflow of precious metals brought by the Spanish galleys to the world markets from recently discovered continents.) However, at the threshold of the modern age Bohemia was still looking back to a time through which, elsewhere, history had already passed. But even so it was impossible for this country to avoid the conflicts typical of the modern age.

The elected King of the country that was such a crucial part of Europe was at this critical time Vladislav Jagiello, the eldest of the six sons of the Polish King Casimir IV. The election took place at the Diet at Kutná Hora on 27th May 1471. The Czech Estates unanimously preferred the fifteen-year-old Jagiello rather than the Saxon Duke Albrecht and the powerful and much feared Matthias, King of Hungary. The fact that the Jagiello won the election had a complicated background. The reason for the interest in the Czech throne was the idea of the Holy Roman Empire, of a restoration of the bygone glories of Ceasar, Augustus and later of Charlemagne, of the Hohenstaufen dynasty, and the Emperor Charles IV. The German humanist Martin Mayr had already suggested to George of Poděbrady that he should strive for the title of King of the Romans which George did not, however, succeed in achieving. In this context, it is necessary to point out his efforts to set up a centralized national monarchy. He was the first of the European sovereigns to set out to build up a state on a secular, not an ecclesiastical basis. And Casimir IV, whom the Czechs warring with Sigismund of Luxembourg had once wished to see on the Czech throne, showed a similar tendency. To oppose the expansionism of Germany, Casimir had the idea of creating a big union which would unite under the rule of a Slav dynasty not only Poland and Lithuania but also the Czech Lands and even Hungary, Austria and the territories of the Order of Teutonic Knights. This brave and persevering, but diplomatically not far-sighted enough, sovereign claimed, as a family inheritance, the crown of St Wenceslas for his son Vladislav (Casimir's wife Elizabeth was grand-daughter of Emperor Charles IV). It was typical of him that he wanted to achieve his aims simply and solely in a peaceful way. After many negotiations, in particular with

King George — who himself designated the Polish Prince as his successor — Casimir's clever manoeuvring was finally successful. His son became successor of the Kings and Emperors Charles and Sigismund, and was fully aware of the dignity of this position.

The role of the young Jagiello was extremely difficult and complicated from the very beginning. The rapid succession of the world events and the intricate and chaotic conditions of post-Hussite Bohemia would by themselves have been enough fundamentally to jeopardise the position of any sovereign, however strong he was. Even the shrewd George of Poděbrady had managed to achieve only a minimum of his original aims. Naturally the election of Vladislav at Kutná Hora did not put an end to the protracted struggle with Matthias Corvinus. This son of Hunyady, the arch-enemy of the Turks, who did not shrink from using any means whatever for achieving his aims, let himself, with the Pope's permission, be again confirmed in 1472 as King of Bohemia (the first time he had done so three years before, under George of Poděbrady). And it was not until 1478 that a bilateral treaty was concluded with much pomp in Olomouc, after which Moravia, Silesia and Lusatia passed to the Hungarian King. As far as Vladislav's personality is concerned, he was one of those rulers who were certainly not predetermined to exercise an authoritative rule. In this connection we must take into account the fact that Bohemia in the second half of the fifteenth century was, above all, characterized by the over-increasing power of the aristocratic oligarchy. Under these circumstances the King remained a foreigner in the country he was to rule. Evidence of this is, for example, the well-known uprising of Prague burghers (1483—84) directed against his person. It has hitherto been generally agreed that it was this rebellion that was the main impetus for Vladislav's building activity in Prague Castle, where the King moved from his Old Town residence immediately after the uprising mentioned. However, this was an outward circumstance only, which apparently accelerated the King's decision to make the Castle again a real residence of the sovereign. Vladislav possessed the necessary disposition for achievements of this kind owing to his having been educated in an environment where court culture was fostered. So it cannot be doubted that his intentions were grounded on higher ideological motifs. They were linked with the whole character of European politics at that period, thus consciously following a concrete model represented in Bohemia by Emperor Charles IV, one of Vladislav's ancestors. It was also significant that later on Vladislav was chosen for the Hungarian throne after the sudden death of Matthias, his powerful rival.

An introduction to the systematic works at the Castle can be provided by the entries in the account books of Kutná Hora. Here we can read that in 1477, for a period of twelve weeks, the mint of Kutná Hora sent to Prague four threescores of silver groschen a week, in the following year six threescores were sent regularly at the King's order. And it is not uninteresting that as early as 1476 John of Lobkovice recommends the *Werkemeister* (workshop master) of the town of Cheb (Eger), the stone-mason Erhardt Bauer, to royal service. Scarce as they may be, records like these indicate that Vladislav must have intended from the very beginning of his reign to turn Prague Castle into a dignified and representative seat, as it was under Charles IV. A sovereign who pursues so ambitious a project must have no doubt acted on the basis of a well-considered conception. This idea was certainly no insignificant link in the chain of great political and dynastic plans formulated by his father Casimir. It is necessary to say that Prague Castle, uninhabited for nearly a hundred years, was

naturally in a considerably dilapidated condition. Starting with Wenceslas IV, the Czech sovereigns had resided in the King's Court in the Old Town, near the present Powder Tower. (The foundation stone of this building whose construction was entrusted to Matthew Rejsek, Bachelor of the Church of Our Lady of Týn, was laid by King Vladislav himself in 1475.) If we consider the fact that during the uprising mentioned above the Praguers managed to conquer the Castle in three days, we can well understand that, for safety reasons alone, a modern system of defensible fortifications was the King's dominant concern. We can assume that Vladislav and his advisers were sufficiently informed about the building undertakings of his neighbours — the splendid *villa marmorea* of Matthias Corvinus in Buda, the residence of the Saxon Dukes at Albrechtsburg in Meissen, and finally the gigantic fortress of the Bavarian Duke George the Rich in Burghausen, which was to serve as a protection against the Turks.

The bold, and indeed kingly, plans for the reconstruction of the Castle in Prague could only be carried out if Vladislav managed to find an artist capable of realizing his ideas. We know that this man was *Benedict Ried*. There is one question to be asked; where could an architect of such genius have come from? When choosing his court master, Vladislav could not have asked King Matthias. Most probably the role of mediator was played by his near relations, namely the Saxon Duke, or George the Rich. A number of stone-masons did indeed immigrated from Meissen to Bohemia at that time. Nevertheless, Ried seems to have been sent by Vladislav's brother-in-law George the Rich. This occurred at a time when the construction of the Burghausen fortress on the river Salzach was drawing to its end. The work, lasting roughly eight years, was completed in 1489 with the consecration of the Chapel of St Hedwig (the Duke's wife Jadwiga was Vladislav's sister), built in the outer bailey. And it is from this year that the earliest record dates referring to Benedict Ried as working in Bohemia, a master who had already proved to be a distinguished builder of fortifications at Burghausen. His first undertaking in Prague — the modernization of the Castle's fortifications — was executed in about seven years, as is shown by the date 1496 and the King's crowned initial on the Daliborka Tower. However, before the fortification works had been started, a restoration was undertaken of the west wing of the Royal Palace (with the reception room on the ground floor and the living rooms upstairs), joined by a covered bridge with the splendid oratory in the southern part of the ambulatory of St Vitus's Cathedral.

Let us recall some more details in this connection. The beginnings of the reconstruction of the Castle, whose date is *post quem* given by the year 1484, are connected with another name apart from Ried. It is the stone-mason *Hans Spiess* of Frankfurt, who had held an important position before Ried. It is this artist who is generally credited with the adaptation of the palace chambers and, in particular, with the construction of the oratory in St Vitus's Cathedral (about 1493) with its sophisticated stone décor in the form of dry, lopped-off twigs. The masterly construction of the oratory, however, points to the participation of Ried. The situation may have been like this. Benedict Ried's coming to Prague brought about a radical change in the orientation of the court lodge. Some of the masons, among whom conservative masters and workers of the Saxon school apparently predominated, were sent to work on a prominent building out of Prague — Křivoklát Castle. (Work on this castle proceeded from the 1490s up to 1522 when the northern wing was completed and the chapel consecrated.) The whole complex of this traditional royal hunting castle — we know

that Vladislav, too, was a keen hunter — was fundamentally reconstructed in an ostentatious and costly way. Supervising the works until 1511 was Spiess (his group worked simultaneously at the adaptation of the nearby Karlštejn Castle). In the first place, a big Knights' Hall was built; its high wall surfaces were covered with a programmatic painting decoration. (What is still visible under the later plaster permits us to assume that it may have been a cycle from the life of the sovereign.) In the oriel in the façade above the early Gothic gateway leading into the inner castle was set an official double portrait of the two kings from the Jagiello dynasty. This must have been completed after Vladislav's death, most probably about 1522. Apart from the Knights' Hall, another significant interior space is that of the castle chapel (built before 1495, its structural woodwork being added until 1522), which is a direct embodiment of the spirit of the Central European Late Gothic style. Its architecture forms a harmonizing unity with the wanton profusion of stone décor in the foliated Danubian style, supplemented by sixteen wooden statues of apostles and saints, imitating stone, and with a wooden polychrome hanging boss. Reality is again simulated by a painted *coulisse* on the back wall of the presbytery (also executed before 1522), in front of which an altar-piece rises whose central part carries a woodcarving depicting the Assumption of the Virgin Mary (about 1495). The design of the oratory of this chapel is a variant of that in St Vitus's Cathedral. Both of them point to the South German school, from which Ried also came.

Benedict Ried, now the dominating figure in Prague, became Vladislav's Court architect, and was raised, in acknowledgement of his workmanship, to the ranks of the nobility. His work was justly appreciated by a sovereign of a refined artistic taste. Sensitively he soon discovered that Ried, originally preoccupied with fortification building, was an artist able to execute his patron's high requirements in a masterly manner. In the course of over twenty years Ried managed to realize not only the fortification and the palace near the western Romanesque White Tower (only inconsiderable fragments have survived *in situ*) but also, and more especially, the reconstruction of the former Royal Palace of Charles IV, in which he designed his most accomplished work — the Throne Hall, called the Vladislav Hall. Historians have not hitherto paid due attention to the fact that the main stage of the construction works in Prague coincides with the very time when the King moved for good to Hungary. Prague Castle was deliberately built up as a symbol of the existence of Bohemia as a state, which was, after all, suggested by Vladislav himself when he said that he was building it "in honour and for the pleasure of himself as well as of the future Czech Kings."[1] It is impossible not to see a guiding spirit behind such an ambitious programme.

In the reconstruction of the palace, the former building, dating from the time of Charles IV, must needs have been taken into account. The solution of this formidable problem displays astonishing audacity: Ried abolished the interior division of the second storey of the palace and built one enormous hall instead of the three which had been there before. The modern conception of this space, with the five boldly erected cupolas-like vaults with a network of ribs springing upwards from massive piers drawn inwards and forming rotating star-like patterns, became an embodiment of the architect's genius. In this connection it has been aptly remarked that the dynamic curves of the ribs convey an image of the movements of celestial bodies in the cosmos, as if in anticipation of what was to be scientifically formulated by Nicolaus Copernicus later on. Not surprisingly, the influence of contemporary humanism is clearly evident here. To be sure, Corvinus's splendid residence in Buda, where Vladislav resided without interruption until his death in 1516, continued, even under the latter's rule, to be a seat of the court humanists from the learned society *Sodalitas Danubiana*. It was undoubtedly Vladislav himself who enabled his court architect — thanks to the Buda heritage — to acquaint himself with the principles of the Italian *quattrocento*. There is archaeological evidence of this in Buda. In this connection it is further necessary to consider the stimulating effect of the Court of Duke Federigo da Montefeltro in Urbino, whence a number of artists came to Corvinus, a relation of the Duke. There were, for example, Giovanni Dalmata and Benedetto da Maiano, to mention just two of the best-known names. The earliest evidence of Renaissance elements can be seen in the northern façade of the Prague Castle palace, where the walls of the Vladislav Hall are pierced by big rectangular windows, the easternmost of them bearing on the lintel an official inscription with the date of the completion of this part of the building: VLADISLAVS. REX. VNGARIE. BOHEMIE. 1.4.9.3. The southern façade is, however, more advanced in style. The magnificently lit eastern wall with a window, bearing the painted date of 1500, recording the completion of the building, has been unfortunately impaired in later alterations. Immediately after this year the work on the ceremonial northern Riders' Staircase was also completed; the staircase which was used by mounted participants in court tournaments, gave access to an open Renaissance loggia, surmounted by a Gothic vault[2] opening into the hall. The programme of the reconstruction of the royal residence was far from being completed. Another costly building, begun in 1501, was a new residence wing, called the Louis Palace. This last big undertaking of Ried's is the purest example of his grasp and expression of Italian Renaissance principles, for it is every inch a piece of Renaissance architecture, the first of this kind in the country. Its completion may be dated to the time of the coronation of Prince Louis (1509), as is shown by his initial on the lintel of one of the portals.

From what has so far been said it follows that the reconstruction of the Prague royal residence must have been motivated by higher ideas. Besides following purely practical purposes, the building up of the palace and the adaptations of and additions to the Cathedral deliberately linked up with the Luxembourg tradition. Thus Vladislav pursued aims similar to those of his "ancestor and

Prague — Castle, Royal Palace, the official inscription VLADISLAVS. REX. VNGARIE. BOHEMIE. 1.4.9.3. from the easternmost window of the north elevation, a cast

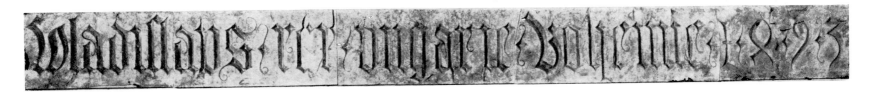

great-grandfather" Charles IV. He, too, focused his attention on the sacred place that was also of state significance — St Wenceslas's Chapel. There is no need to emphasize here the well-known fact that Emperor Charles IV had it built, in the fourteenth century, over the tomb of the patron saint of Bohemia, nor the role that was assigned to it in Charles's Coronation Order. However, it is necessary to remark on the fact that over the still surviving paintings from Charles's days an extensive cycle was painted, at Vladislav's instigation, depicting scenes from the legend of St Wenceslas. It displays the hitherto secret world of the most hidden desires of the sovereign, and his actual position in contemporary Europe, as will shortly be demonstrated. The wall paintings added in the chapel were another stage in the realization of a grandiose plan that was to be crowned by the construction of the corpus of the nave of St Vitus's Cathedral. The foundations of the piers of the nave and aisles and of the northern tower were laid in 1509, as we can read in a contemporary record. However, these works had to be interrupted as early as 1511, evidently for lack of money. (By this time as much as forty thousand threescores of groschen had been drawn from the mint of Kutná Hora, to be used for the reconstruction of Prague Castle.) The project can be almost securely established as a production of the *"nobilis Benedictus lapicida regis"* (royal stone-mason Benedict (Ried), raised to the nobility), rendered in one of the scenes in St Wenceslas's Chapel with a pair of compasses and a square in his hand.

What the Luxembourg tradition must have meant for Vladislav is further demonstrated by the former Augustinian Church at Karlov in Prague. The remarkable centrally planned structure, founded by Charles IV, obviously on the model of the octagonal Palace Chapel in Aachen, and consecrated to St Charlemagne, was fundamentally remodelled under the Abbot Matthew, King Vladislav's confidential adviser. The year 1498 saw the consecration of the presbytery, which had been given a new vault (H. Spiess); although the present appearance of the star-shaped vault dates from the late sixteenth century (1575, B. Wolmut?), it was an undertaking of a unique spiritual significance. Of the Late Gothic furnishings of the Karlov Church only two paintings on glass have come down to us, showing Charlemagne and the emblem of Anne of Foix (1502—06, Museum of the City of Prague). They show that even the Jagiello King had through his French wife, who was related with the houses of Navarre, Aragon and Bourbon, as famous a lineage as the first founder of the church.

One year after the works at the Castle had been interrupted, the self-assured burghers of Kutná Hora contracted the royal architect Benedict Ried to finish the construction of their second parish church, the Church of St Barbara (1512), begun on a cathedral ground-plan as far back as the pre-Hussite time. Ried changed the original design of a basilica with nave and two double aisles into a hall-church with nave and two aisles of equal height, surmounted by a uniform vault, as he did in the Vladislav Hall. Considering the fact that it was the only sacred building whose essential part he designed, we may indulge ourselves in the hypothesis that it was perhaps the unused design, originally intended for Prague Cathedral, that was built here. But let us now go several decades back. The completion of St Barbara's Church, the beginning of which is linked with the Parlerian lodge in Prague, was started in 1488. The *director fabricae* was Michael Smíšek of Vrchoviště, a rich mine-owner and from 1488 onwards Administrator of the Royal Mines. Three years before he attained this high post, he bought a chapel on the southern side of the ambulatory in which he was buried in 1511. The wall paintings in the Smíšek Chapel prompt

us to ponder a number of problems, the solution of which is closely connected with the general historical and political principles put forward in the Introduction. These paintings agree with the findings based on the architecture of Prague Castle, and even become a sort of an important historical source which must be treated like any other authentic document. It has to be deciphered, for we can at once perceive the discrepancy between a burgher's intellectual equipment and the pronouncedly court character of the paintings. The established explanation has not taken into account some significant, though well-known, facts, above all the very position of the royal town of Kutná Hora, second only to Prague in significance. Might we not be right in supposing that here too the artistic production reflected the sovereign's intentions? The paintings in the Smíšek Chapel in St Barbara's Church are unparalleled not only in this country, but also anywhere in the countries north of the Alps, it seems. The lower part of the walls of the Gothic choir chapel is covered with a scene in an accomplished perspective, with illusionistic architecture, in which predominates the figure of Michael Smíšek of Vrchoviště (in the function of the sacristan of the church) with his two sons preparing a mass. This zone — an imaginary sacristy — communicates a most compelling impression. It makes one compare it with the similarly conceived Italian inlaid panelling, especially with those in the *studiolo* of Federigo da Montefeltro in Urbino (about 1476), or with those from Gubbio (about 1480, now in the Metropolitan Museum, New York). Moreover, the treatment of the three-quarter figures suggests striking affinities with the renowned *uomini famosi,* the ideal portraits of the most famous intellectuals of the past, placed in the Urbino *studiolo* above the panelling, and commonly ascribed to the Netherlander Joos van Gent, who may have been working in Urbino with the Spanish painter Pedro Berruguete. The discovery that the painter who was active at Kutná Hora may have had first-hand knowledge of the cultivated milieu of the ducal court of the famous *condottiere* Federigo is surprising. The background of such illusionistic *trompe-l'œil* is much broader in pre-Classical Italy. It has its roots in the Late Classical painting of what is called the Second Pompeii Style (the beginning of the first century B. C.), well known in the late Italian *quattrocento.* Particularly interesting comparison can be made with Pintoricchio's frescoes in the Bufalini Chapel in Santa Maria in Aracoeli in Rome (about 1483), or in the Appartamento Borgia in the Vatican. They are full of illusionistic details, the upper scenes being distinctly delimited from the spectator. The same can be found at Kutná Hora, where the "real" lower zone, displaying the donors, is surmounted by the majestic upper scenes in the following relationship; the *Arrival of the Queen of Sheba before Solomon* with its counterpart, the *Crucifixion;* above these *Trajan's Justice* and *Augustus with the Tiburtine Sibyl.* It appears that the somewhat flat treatment is intentional, and was intended to emphasize the noble vision.

Themes of this kind had long been of a pronouncedly sovereign, imperial character. Scenes from the legend of the Holy Rood, linked by Sibylline prophecies, had always been connected with certain sovereigns who brought the Crucifix to triumph, introduced peace and defended the laws. (Such is the motivation of, for instance, the frescoes by Piero della Francesca in Arezzo, 1442—66). When we realize how great towards the end of the fifteenth century were the efforts to achieve social reform, peace and security, and how much faith there was in apocalyptic traditions prophesying the coming of a sovereign-redeemer, we may come to some concrete conclusions. The redemptive ruler was to be Emperor Frederick III

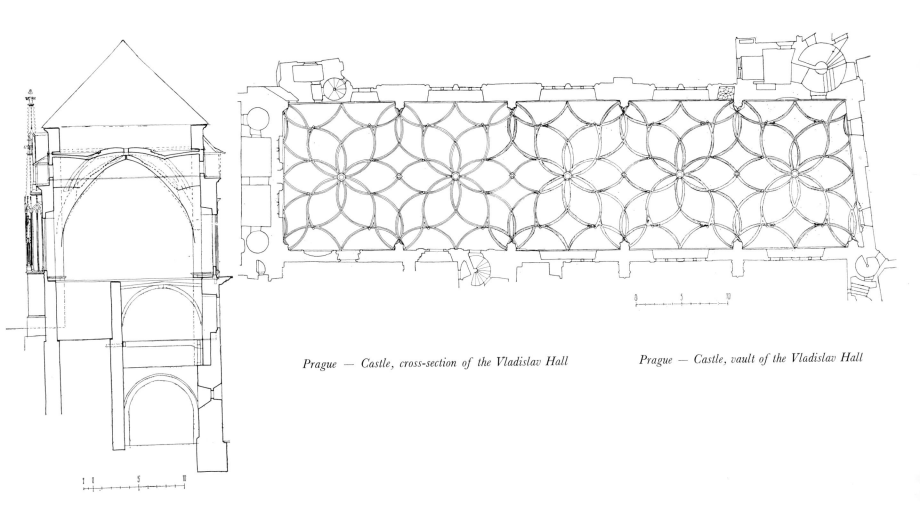

Prague — Castle, cross-section of the Vladislav Hall

Prague — Castle, vault of the Vladislav Hall

who, in the Pope's words, wanted "to conquer the world sitting down", and after his death Maximilian I, whose concerns were the Empire and a new ideal of the Holy Rood, together with the elimination of the Turkish menace. In the light of this, let us reconsider the personality of King Vladislav as we have seen him with his ambitions and his position on the European political stage. In the town of Kutná Hora, where St Wenceslas's Crown was assigned to him as a result of his election by the Czech Estates, he promised, the paintings tell us, above all to be a good, just and, so to speak, redemptive ruler. This is supported by his crypto-portrait depicting him as Emperor Augustus, in front of whom sits an imposing peacock as a symbol of immortality and paradise. A cycle of frescoes conceived in this way must have been based on a programme elaborated by a contemporary humanist, apparently from Buda, who ingeniously managed to interconnect two distinct intellectual and figurative systems: of a burgher and of a ruler. The financing of the paintings was undoubtedly undertaken by the ennobled burgher Michael Smíšek who, while not forgetting to emphasize his own position, rendered the highest honours to the King as a token of gratitude. An immediate impetus must have obviously been provided by the events of the years 1494—96, when Smíšek was thrown into jail and found himself in danger of losing his life. However, he was soon pardoned by the King's personal letter. During the three years mentioned above, repeated uprisings of the miners were taking place which culminated in an armed rebellion in July 1496, the execution of the hostages from among the miners near Poděbrady being the bloody finale[3]. It is not impossible that the cycle in the Smíšek Chapel was carried out at the King's personal wish and was to be a sort of justification. That is why Vladislav is symbolically rendered as Trajan, taking

under his protection the Administrator of the Royal Mines and his wife; the latter also appears in the Crucifixion scene. The capitulation and loyalty of the miners are also to be seen in the wall paintings in the adjacent Winchers' Chapel, where Vladislav's well-known crowned initial appears above the coat of arms of the town, bearing an inscription glorifying the King. Thus the wall-paintings in both chapels (which agree stylistically) can be dated about 1496.

The international character, typical of the architecture of Vladislav's time, clearly also predominates in the paintings at Kutná Hora. In spite of their Italianizing appearance, their authorship must, after all, be ascribed to a painter from the North; his production is marked by syncretism, so typical also of other court arts of this transitional period. Like Ried, who became acquainted with the principles of the Italian *quattrocento* through the structures in Buda (and there are even hypotheses that he worked for King Vladislav in Hungary), this painter too (or a group of painters) active in Kutná Hora might have known this milieu. Speaking about Buda, we should point out the bonds of kinship which were of determining significance for the exchange of artists between individual courts. Enthroned as King of Hungary, Vladislav Jagiello found himself in an environment dominated by the Italian *splendor,* in which the direct touch of the classical heritage could be felt. Although he had refused to marry Corvinus's widow Beatrix, who fifteen years before had introduced herself to the Hungarian King Matthias by a charming marble bust by Francesco Laurana (1474—76), bearing the inscription DIVA BEATRIX ARAGONICA, he nevertheless accented much of what had come to Hungary through her. It was in the year of her marriage (1476) that the strongest wave of Renaissance thinking

came to Buda. A daughter of Ferdinand I of Naples, she was a sister-in-law of the humanistically educated Ippolito from the house of the Sforzas of Milan and of Lionello d'Este of Ferrara, the husband of her sister Eleanor. Her home was Naples which, in the last quarter of the fifteenth century, experienced a short period of splendid Renaissance court culture, cultivated by Ferdinand and by his son Alfonso, Duke of Calabria. The aim of the ambitious plans was to turn Naples into an illusion of an Antique city. The artists active in Naples, who were called, in particular, from Lorenzo the Magnificent's court in Florence (of whom Ferdinand speaks as *mio amato amico*) can be encountered at all related courts, fostering humanistic culture: in Ferrara, in the Urbino of Federigo da Montefeltro (whose wife was Battista Sforza), and finally in Buda in Hungary. Emerging everywhere are the names of Giuliano da Maiano and his younger brother Benedetto (the architect, sculptor and woodcarver who contributed most to the *opus regis Matthiae*), of the versatile Francesco di Giorgio Martini, Tommaso Fiamberti (identified with the Hungarian Master of Marble Madonnas), Luciano and Francesco Laurana, Baccio Pontelli, and finally Gian Cristoforo Romano of Ferrara (the sculptor of the famous marble relief busts of Matthias Corvinus and Queen Beatrix), or Giovanni Dalmata (who co-operated with Mino da Fiesole on the tomb of Pope Paul II in Rome). This rich cultural and artistic milieu must have made a powerful impression on King Vladislav. At his new court he met Platonic humanists, and even found a prolific illuminators' workshop. Last but not least, the ideas of Corvinus survived his sudden death at the Hungarian court, where he cleverly used for his efforts at centralization the teaching of humanism as conceived by the first disciples of Petrarch. The idea of the old Roman law, the *viva lex* of imperial times, when the most important criterion of the state was *Iustitia*, was still vivid. That is why the philosopher Bonfini, in his work *Rerum Hungaricarum Decades* portrayed Corvinus as Hercules, Alexander the Great, Julius Ceasar, Augustus, Trajan (compare with Vladislav — Augustus, Vladislav — Trajan in the Smíšek Chapel).

Vladislav's period in Hungary is thus not separated from that of Corvinus by any clear dividing line. For example, the master of the Buda illuminators' workshop, Felice da Ragusa, was entrusted in 1501 with a delicate task, namely to propose in Vladislav's name to the French Anne of Foix-Candale. It is this human relation that seems to have motivated Vladislav in completing the Buda royal palace, the summer palace at Nyék, as well as the residence in Visegrád. For Anne he wanted to maintain the court in Buda, but the Queen's death in 1506 brought a critical break in his life. From that time Vladislav's interest in the artistic sphere of Hungary began to diminish. It is, however, noteworthy that he concentrated his interests more purposefully on Prague. He was well aware of the key position of the Czech Lands in Europe; he did not forget the fact that under Charles IV Bohemia had been the most important country within the Holy Roman Empire. And he set out to prepare the Prague residence with the apparent intention of making it a place worthy of the hereditary sovereign of Jagiello blood. The contemporary records, too, tell us this. Vladislav, heartbroken after the death of his wife Anne of Foix, lived only for his children, Anne and Louis.

This is illustrated by the *Epistolae* by Bohuslav Hasištejnský of Lobkovice in which the following passage about Prague Castle occurs: *"Sed Wladislaus rex eam muro, fossis et aggere mirae magnitudinis cinxit: extruxit praeterea quottidie secto saxo, picturis ornat et tanto sumptu atque impendio aedificat, ut intra paucos annos cum praestantissimis Europae*

operibus certatura videtur".[4] Thus the stately stone residence, which was to equal the foremost ones in Europe, even had paintings as ornamentation. The fact that there existed a stone-masons' lodge in Prague Castle headed by Benedict Ried has already been mentioned. After our account of the King's plans for the reconstruction of the Prague residence and of his achievements in St Vitus's Cathedral, we now move logically on to discuss the participation of the court painters, who were given enough commissions in Vladislav's service.

About 1500 an exceptional painter emerged in Bohemia, who has so far been shrouded in anonymity, and for this reason is still known as the *Master of Litoměřice*. He proves to have been a mature artist, well versed in Augsburg and Danubian painting and that of the Alpine countries, and it is not impossible that he also had first-hand knowledge of the milieu of North Italy. All his characteristics put him at first sight above the average of all the production in the Czech Lands of that time. He was head of a prolific workshop producing panel as well as wall-paintings. His major works were created in the short space of time of about ten years. At the beginning we find the work called the *Litoměřice Altar-piece,* depicting scenes from the life of the Virgin and from the Passion of Christ, executed shortly after 1500 and surviving only in fragments (today in the Litoměřice Gallery; one panel is in the deanery church in Litoměřice, and the carved central part is missing). There is now common agreement that the chief artist of this relatively coherent work must have been a Court painter to King Vladislav. And so we must now put forward a conjecture that the altar-piece had originally been destined for Prague and not for Litoměřice. There is a record that at the time of the Thirty Years' War (1633) the Imperial Magistrate of the town of Litoměřice, Herold of Stod, donated to the Church of All Saints a greater number of altar panels displaying scenes from the Passion.[5] These panels, which were to be used on the high altar, must obviously have been the wings of the dispersed fivepart Litoměřice Altar-piece. It is not difficult to imagine that all the premises of the Prague Castle called for new furnishings. It is a known fact that the Register of the Prague Old Town Brotherhood of Painters contains, shortly after 1500, more and more names of German origin, which accords with the situation in architecture, whose roots, of course, lie somewhat farther back. The extraordinary individuality of the Master of Litoměřice can, to a certain degree, be taken as a parallel to Benedict Ried. He, too, had evidently been called from the area of South Germany. Let us at this point make a conjecture, the verification of which might help to fill one of the biggest voids in the map of the art of Vladislav's time. About 1511, i. e. when the works at the Castle had ended, the Prague guild of painters accepted as a member, "at the intercession of his influential friends, in the first place of Master Duchek, provost at All Saints' Church at the Castle", the painter *Hans Elfelder*, who had been enjoying a high reputation for some time, and working as a privileged artist in the King's service. The records clearly show that he could not comply with the Utraquist "spiritual orders".[6] That means he was a Catholic, as were all artists coming at that time to the Czech Lands from the German regions. (The guild's register gives the names of about forty painters who were active in this country at the time of the Jagiellos.)[7] This Hans Elfelder might be identical with the greatest painter of the Late Gothic and Renaissance in Bohemia, the Master of Litoměřice. His monumental altar-piece, commissioned by the King, can with greater justification be imagined as belonging into All Saints' Chapel. This would also explain why it was the

provost of this chapel who recommended him to the Prague guild. Moreover, could the King, so interested in the reconstruction of the residence in Prague, be unconcerned about the official court chapel? Lastly, the catastrophic fire in the Lesser Town and Hradčany on 2nd June, 1541 (in which the chapel was heavily damaged, with even a part of the vault falling down) would also provide an acceptable explanation of why only six panels (transferred from Prague in the end) have survived of such a fair-sized altar-piece. In painting as in architecture the top place was attained by the most mature artist. The older Master of the Křivoklát Altar-piece would thus in a certain sense experience a fate similar to that of Ried's older predecessor Hans Spiess.

These connections naturally give rise to the important problem of the historical imports in the Czech Lands and to their relationship to the commissioner. From among the numerous German panel-paintings of that time it will undoubtedly be possible to select many works whose links to the sovereign will prove more or less likely. Let us give two examples at least. Between 1499 and 1504 Hans Holbein, Hans Burgkmair and the Monogrammist L. F. were given a commission by five Dominican nuns to paint for their Augsburg Monastery of St Catherine a cycle of seven Roman basilicas, one of which is that of Santa Croce (1504, H. Burgkmair, the donor being Veronica Welser). The workmanship of the recently restored panel lunette, gracing St George's Church in Prague Castle and displaying the same theme, does not exclude the possibility that it may be not a later copy, but a studio replica executed for the nuns of the Prague Benedictine Order, which, having regard to the atmosphere of that time, is not surprising. Bearing this in mind, we ought to reconsider also the altar wings showing St Henry and St Kunigunde (before 1510) that were executed within the circle of the Nuremberg painter Hans von Kulmbach and which have always been connected with the Prague Church of Our Lady of the Snows. Let us now leave aside the possibility (already suggested in literature) of the Prague panels belonging to the altar of St Peter and St Paul in the Uffizi Gallery in Florence, the main parts of which are Kulmbach's work. With regard to the given historical circumstances — the Church of Our Lady of the Snows, together with the monastery, was heavily damaged during the Hussite wars and given a new vault as late as 1611 — one is forced to think of the Prague Church of St Henry and St Kunigunde as the original destination of these altar wings; after the Church at Karlov it was the second sacral dominant of the New Town. According to the preserved records, Vladislav already had contact with this church in the 1490s. It is interesting that it was its parson Búchal (who visited the King in Buda in 1509 and 1513) who set out a ceremonial procession after Vladislav's death on 13th March 1516, and officiated at a requiem for the deceased King buried in Székesfehérvár.[8] If we further realize what Kulmbach and his assistants executed for Cracow, the facts mentioned above justify our entertaining the possibility that the mediator in the commissioning of the Prague panels might have been Vladislav again.

The wall-paintings in St Wenceslas's Chapel in Prague Cathedral had been completed by 1509 at the latest. While the paintings at Kutná Hora reflect pure Italianism (the connecting link here was Buda), very soon the contacts between Italy and the Czech Lands were again predominant via artists coming from South Germany and the Austrian Danubian countries. Such were the affiliations of the group of artists working in St Wenceslas's Chapel. They executed almost thirty paintings depicting scenes from the Legend of St Wenceslas, including two slightly under-life size portraits of Vladislav Jagiello and Anne of Foix. The leading master, who in this monumental commission even more accentuated the Renaissance traits of the South German Augsburg tint, with its marked North Italian components, is identical with the main artist of the altar panels housed today at Litoměřice[9] (Hans Elfelder?). The work, the most significant accomplishment in wall-painting north of the Alps, was the climax of the artist's development. A direct analogy of the paintings in style and significance is afforded by numerous woodcut illustrations executed for Maximilian I (particularly for the autobiographical novel *Weisskunig*), done by, among others, Hans Burgkmair and the young Leonhard Beck who is supposed to have also worked on the Prague commission. The paintings possess both Augsburg and "Maximilian" traits, which provides an explanation for their relatively early dating.

The contemporized cycle from the life of the country's patron saint St Wenceslas, having the nature of a state legend, represents a document that must be carefully read. The interpretation offers surprising findings. The wall-paintings in the Smíšek Chapel displayed the traditional idea of a just, wise and chosen Christian ruler. In contrast to this abstract concept, the Prague paintings are much more concrete, especially in illustrating the state of contemporary European politics. Vladislav is depicted here as a sovereign who has been through many agreeable, but more frequently grievous, experiences both as a ruler and as a man. The year 1506 saw the death of Anne of Foix, Vladislav's great support in life, on giving birth to the long-desired heir, Prince Louis. The decoration was probably started by the portraits of the sovereign couple on the eastern wall of the chapel, placed above the painted kneeling figures of the Emperor Charles IV and Elizabeth of Pomerania. It is perhaps not necessary to relate in greater detail what such an ostentatious place indicated and what the connections were with the Luxembourg tradition. This tradition was, among others, also followed in the series of portraits of Czech kings, which Vladislav had painted in Prague Castle, as Charles IV did in Karlštejn Castle. They were destroyed in the fire of 1541, but their approximate appearance is shown in the drawings of the Hasenburg Codex in Vienna. And it is not unlikely that the first impulse for the demanding adaptations of the key sacral state building was provided by the intended coronation of Anne as Queen of Bohemia (which never in fact took place). Vladislav's wife is depicted here in a way which is redolent of the renderings of the Virgin in Spe of that period. Vladislav seems to personify simultaneously Charles IV, Prince Wenceslas and Christ.

The legend *Vita et passio sancti Venceslai martyris* is unfolded in the paintings as follows: the west wall, opposite the royal double portrait, is covered by a narrative central scene showing the Arrival of Prince Wenceslas at the Diet at Regensburg. The paintings on the two lateral walls mostly illustrate that part of the legend which depicts Wenceslas as a good and just ruler, endowed with personal qualities which Vladislav, as the legitimate descendant of the Czech Prince, symbolically claims to possess. A key for the decipherment of the individual layers of meaningful significance can be found in the ostentatious scene on the west wall. Wenceslas, who arrived at the Diet after some delay because he had been saying his prayers, was to be disgraced in that none of the six Electors present would make room for him next to himself. However, the presence of two angels accompanying Wenceslas and the halo round his head commanded such respect in Henry the Fowler that he invited him to sit down on the throne beside him. If we

accept the thesis that the St Wenceslas legend is contemporized, a fact which is fully justified in the case of narrative cycles of paintings of about 1500 (e. g. Carpaccio's famous Venetian cycle on the Life of St Ursula which was so significant a source of inspiration for the above mentioned Augsburg Roman basilicas), then we can pass to the second layer of significance which remains obscure to the spectator of today. The question suggests itself; did King Vladislav not experience in his life an event that would mean a political victory, as was the case with Wenceslas in his complicated vassal relationship with the Empire? It seems that such an event did take place. After the Hussite wars, Vladislav was the first Bohemian king once more to be given a vote as an Elector (1474) by Emperor Frederick III in acknowledgement of the help he gave him against the latter's Austrian subjects. Thus the King of Bohemia became again one of the "seven pillars and candle-sticks of the Holy Roman Empire". It was undoubtedly an event of paramount significance, for Bohemia's relationship with the neighbouring German countries was one of the dominant features of Vladislav's policy. Notwithstanding, when Frederick's son Maximilian I was crowned in 1486, Vladislav's right to vote was ignored in an offensive way. But like Wenceslas, he too was given an official apology (1489) and even a guarantee of financial reparation.

A satisfactory decipherment of the programme of the paintings might be supported by an attempt to identify some of the actors, particularly those posing in the central zone of the west wall. The majestic figure of the Emperor Henry the Fowler evidently represents also Frederick III shaking hands with Vladislav. Emphasized on Frederick's right is a young man, the Emperor's son Maximilian I, clad in a magnificent cloak lined with ermine and holding in his hands the Imperial insignia. This *homo ferrus et leoninus* is rendered in this manner elsewhere too. Looking up to him is a figure with a golden cap and a golden chain, holding another symbol of Imperial power — a big sword. This figure bears a resemblance to Jacob Fugger the Rich, with whom Maximilian had many financial links. In the left-hand part of the wall, the presumed Maximilian is paralleled, in his position in the painting, by a man from the Orient, representing here a good prophet, a just Eastern sage, a mediator between East and West. With the evergrowing Turkish threat, a "converted pagan" became a symbol of the time. It is not impossible that the figure in St Wenceslas's Chapel represents symbolically Sultan Bayazid II, whose pacific disposition distinguished him from the other Ottomans and with whom a seven-year armistice was concluded in 1503. The lower zone shows Prince Wenceslas as Vladislav and the other six Electors as Vladislav's actual contemporaries, as we can see them with their emblems in, for instance, the Hansa Book of Copies made by a Flemish illuminator of the end of the fifteenth century (Historical Archives, Cologne). The *dramatis personae* mentioned here emerge in the other scenes of the legend as well. There remains one question to be asked: when did the Hungarian and Bohemian King Vladislav find himself in a situation which made it possible for him to demonstrate his relatively well re-established relationship with the Empire and also to manifest his modern conception of European citizenship? As we have seen, he had already established closer relations with the Habsburgs in 1474. One year after he had become King of Hungary, an agreement was concluded in Bratislava (Pressburg) in 1491, stating that, if Vladislav should have no male successor, Hungary would pass after his death to Maximilian. It was a promising beginning of the marriage policy which proved

to be so profitable for the Habsburgs later on. Complicated circumstances obtained in 1505. In the spring and summer of that year Vladislav's state of health was so critical that after an attack of apoplexy he was expected to die. This automatically precipitated the claims resulting from the agreement of 1491, and an armed uprising took place in Hungary. This highly tense situation was finally resolved by the birth of a legitimate heir of the throne, Louis Jagiello (July 1506), whose coming into the world was as longed for as the birth of the Messiah: *Nascere unica spes patriae, nascere parve puer.*[10] Peace was re-established, for the whole previous dispute had lost any sense, and a double marriage was agreed upon immediately between Vladislav's children, Anne and Louis, and Maximilian's grandchildren, Ferdinand and Mary. (This contract was then ceremoniously sealed in Vienna in 1515; artistic evidence of it can be seen in the well-known Group Portrait of Maximilian's Family by Bernhard Strigel, produced in the same year in Vienna.) This was just the time when Vladislav had weighty reasons for getting St Wenceslas's Chapel in the Cathedral in Prague Castle decorated with paintings of such conception and import. Even though the original impetus might have been the coronation of Anne of Foix, the impulse for the completion must have been provided by the events just recalled. Therefore, the year 1509, the date of Louis's coronation, is to be taken as the date *ante quem.*

The ideal of knighthood was of prime importance in the German countries and in Central Europe, but it had been a mere imitation for a long time. It was a sort of historical throw-back. A particularly distinctive embodiment of this idea was Emperor Maximilian I, appropriately called "the Don Quixote of his century" (Grillparzer). To find some resemblance between Vladislav and this political partner of his is not so difficult. Both Vladislav, King of Bohemia and Hungary, etc., and the Holy Roman Emperor Maximilian were first and foremost people living at a critical and shifting time. Their spiritual world was still strongly affected by medieval ideas, which were, however, gradually being permeated by the present. Hence the curious contradiction between dream and reality, hence the sovereigns' many ambitious plans, artistic ideas and monarchical aspirations, which did not come to fruition. Maximilian's frenzied efforts to publicize his personality and to glorify himself *(Ehrenpforte, Theuerdank, Freydael, Weisskunig)* or his yearning, after the death of Julius II (1511), to don the papal tiara, which he would gain by means of the Fugger family's capital, are sufficiently known. However, Vladislav's longings and his political and royal ambitions, each contrasting equally sharply with the objective possibilities, have hitherto been shrouded in mystery. Some of them have been partially revealed by the analysis of artistic "sources" outlined above. It is beyond all doubt that — like Maximilian — Vladislav, too, felt obliged to protect the Christian world against the scourge of heathenism represented by the Turks. The old idea of crusades, kept alive in the fifteenth century by the knights with their cult of St George, was thus revived. When Maximilian was baptized in 1459 (i. e. six years after the fall of Constantinople), there was some doubt whether to give him the name of this favourite saint or that of the first Christian Emperor Constantine. And let us further note that Emperor Frederick III founded, in connection with the defence against the Turks, the Order of St George, which was also generously supported by his son. He even had himself painted by Hans Daucher in about 1508 as St George on horseback (Kunsthistorisches Museum, Vienna).

The Wallace Collection, London, has a suit of armour bearing

1 Prague—Castle, north façade
of the Royal Palace with Renais-
sance windows of the Vladislav
Hall, Benedict Ried, 1493

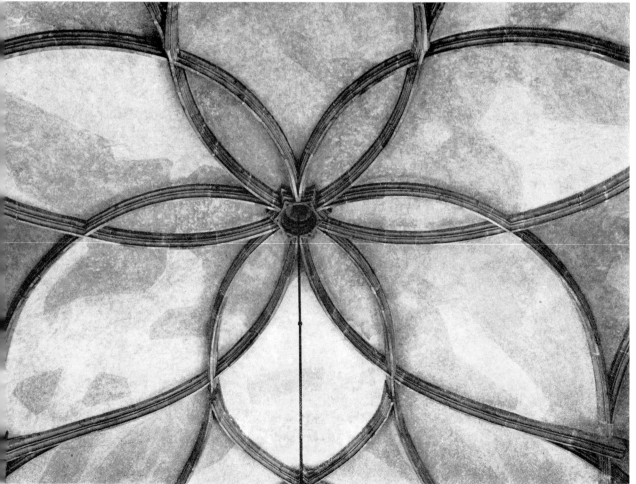

2 Prague — Castle, south façade of the Royal Palace with Renaissance windows of the Vladislav Hall, Benedict Ried, 1493

3 Prague — Castle, Royal Palace, detail of the vault of the Vladislav Hall, Benedict Ried, 1500

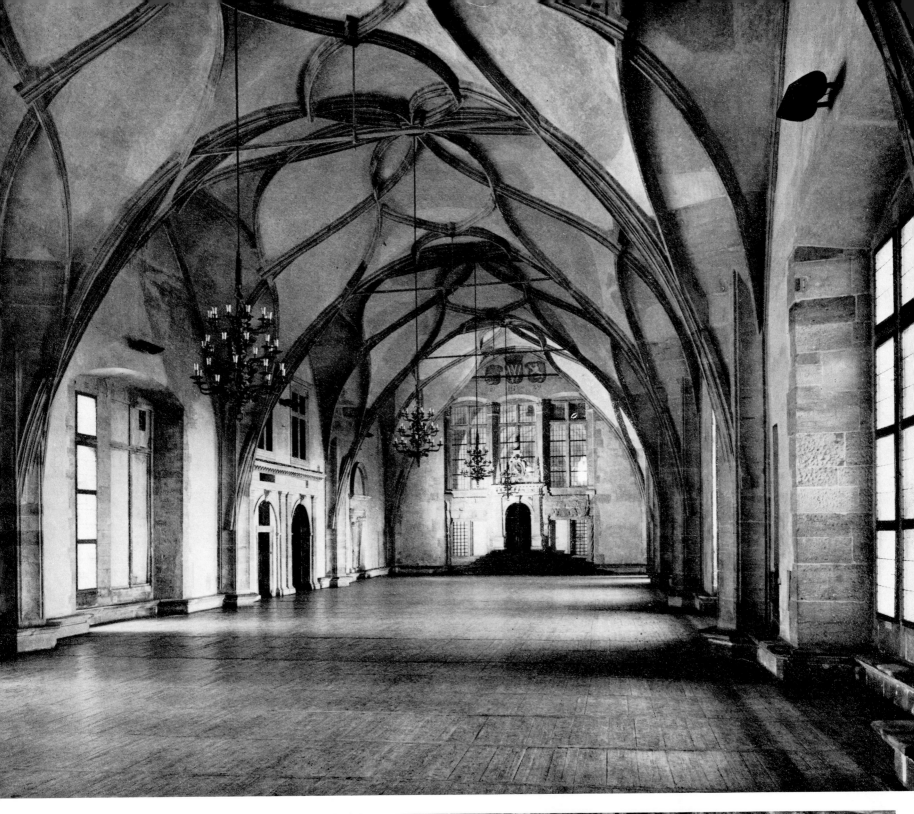

4 Prague — Castle, Royal Palace, interior of the Vladislav Hall, view of the entrance, Benedict Ried, 1493—1500

5 Prague — Castle, St Vitus's Cathedral. Portrait of Benedict Ried, detail of the scene Meeting with the Danish King Erich, wall-painting on the south wall of the St Wenceslas's Chapel, by Leonhard Beck, c. 1509.

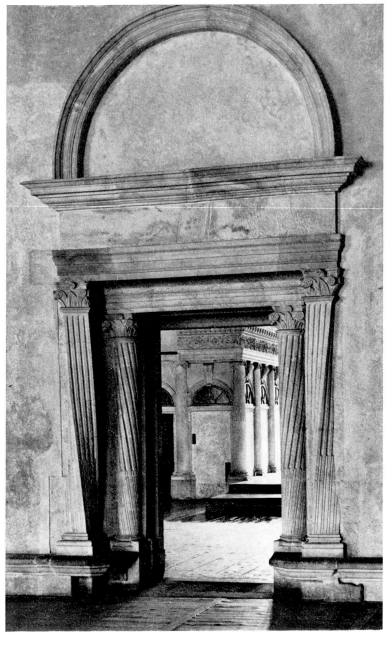

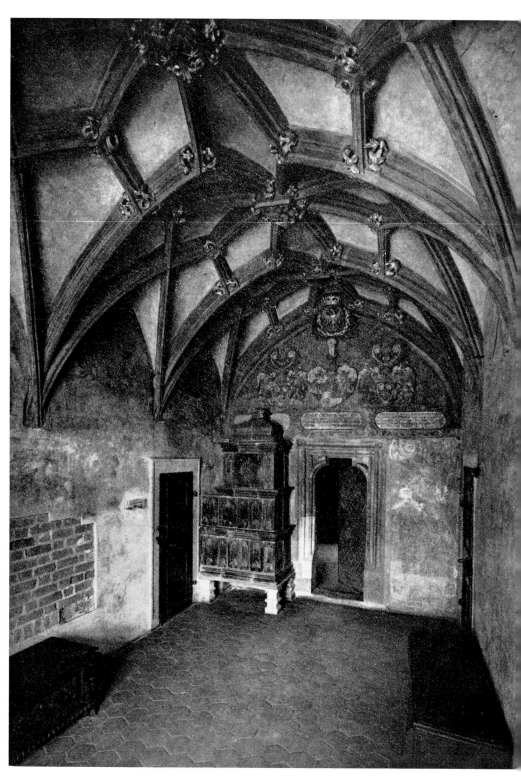

6　Prague — Castle, Royal Palace, portal from the Vladislav Hall into the Old Diet, by Benedict Ried, c. 1500 (later copy)

7　Prague — Castle, Royal Palace, King Vladislav's reception room, by Hans Spiess, before 1490

8　Prague — Castle, Royal Oratory in the south ambulatory of St Vitus's Cathedral, by Benedict Ried — Hans Spiess, 1490—93. Detail of a pendent boss with crown initial of King Vladislav Jagiello.

9　Prague — Castle, Royal Oratory in the south ambulatory of St Vitus's Cathedral, by Benedict Ried — Hans Spiess, 1490—93

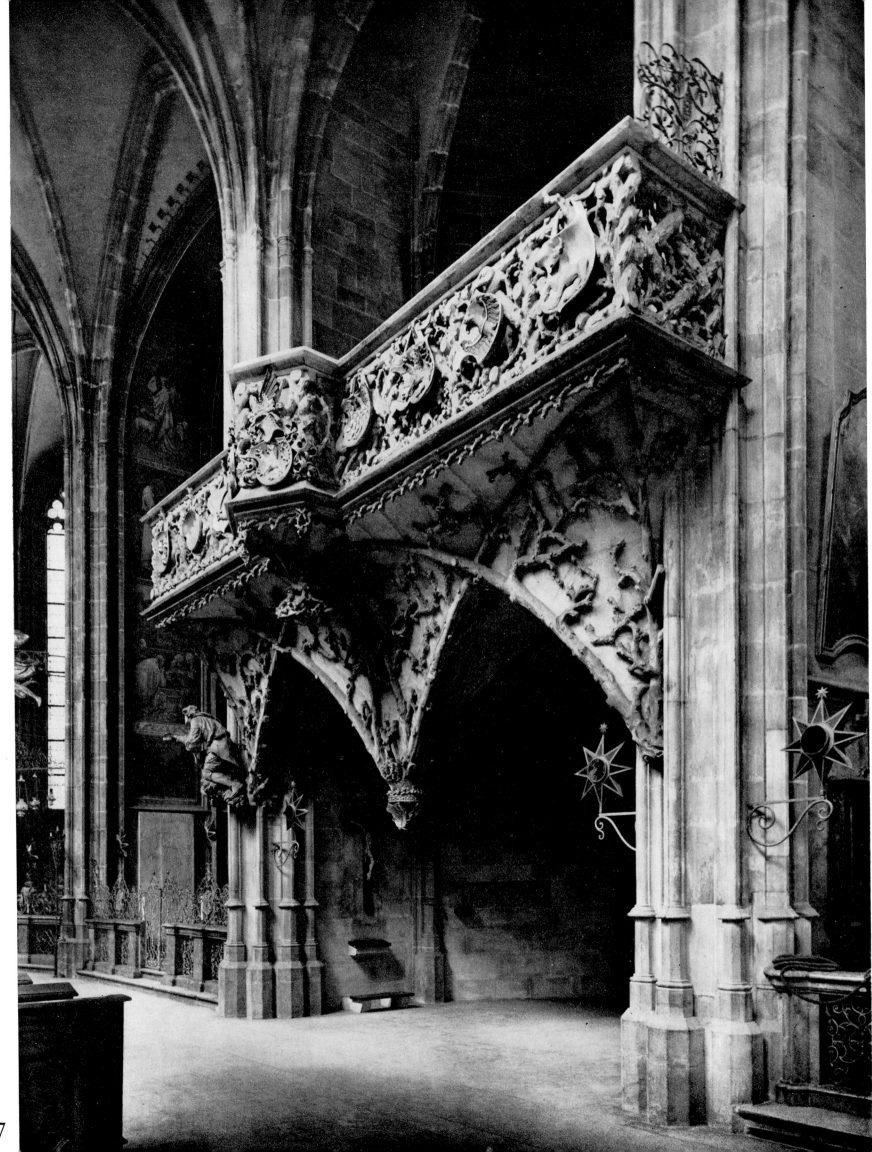

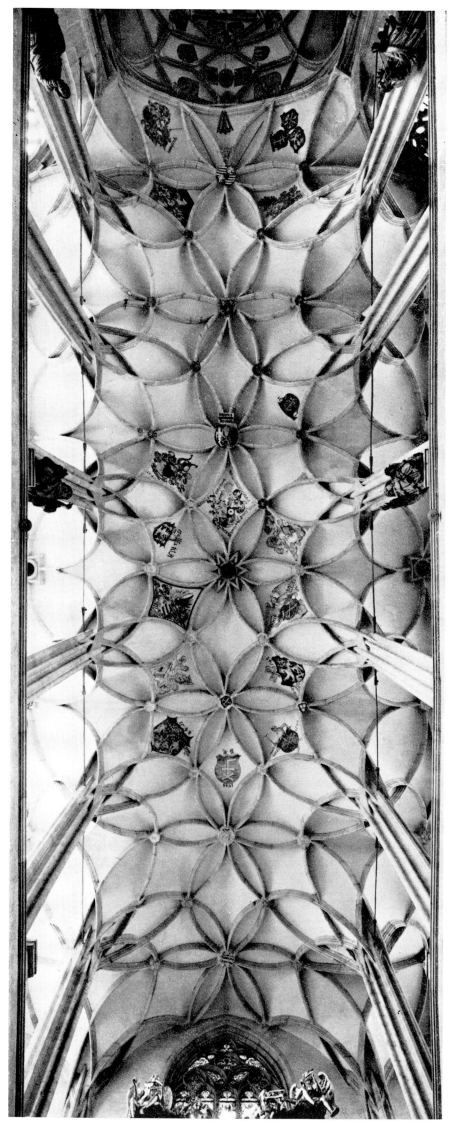

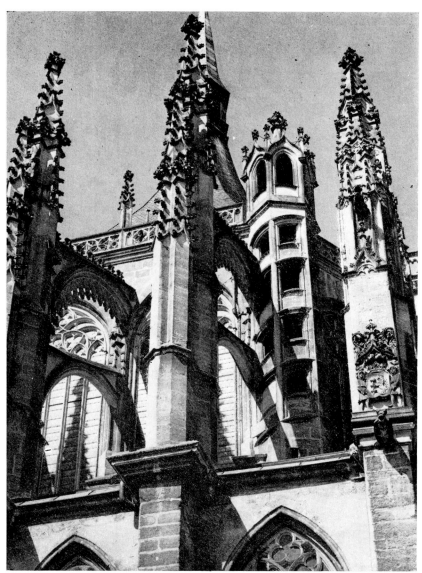

10 Kutná Hora, Parish Church of St Barbara, vault of the hall with a nave and two aisles, design by Benedict Ried, after 1512; the building was completed in 1548

11 Kutná Hora, Parish Church of St Barbara, detail of the buttress system

12 Kutná Hora, Parish Church of St Barbara, exterior

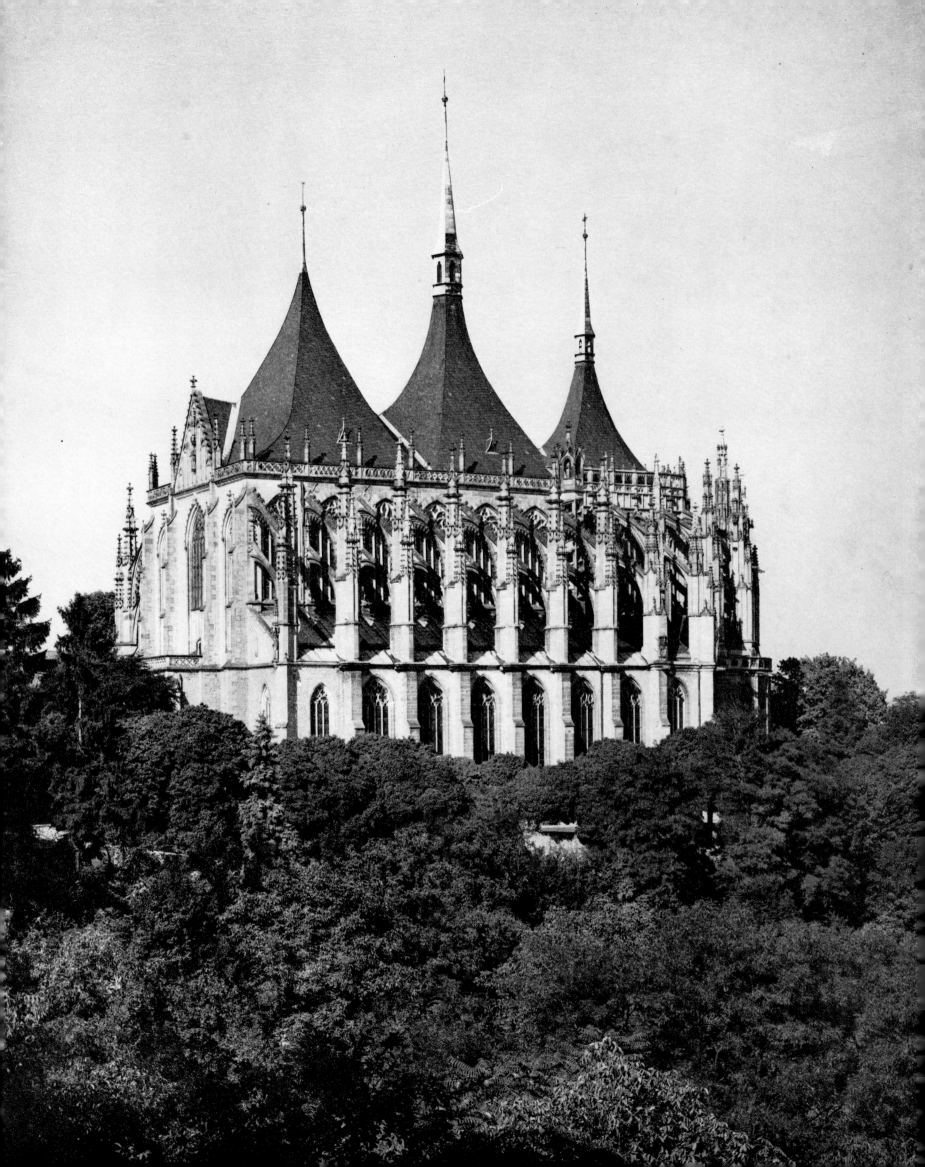

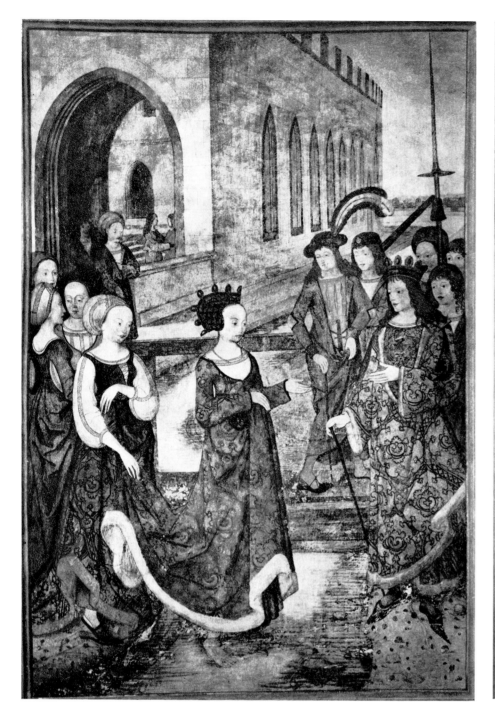

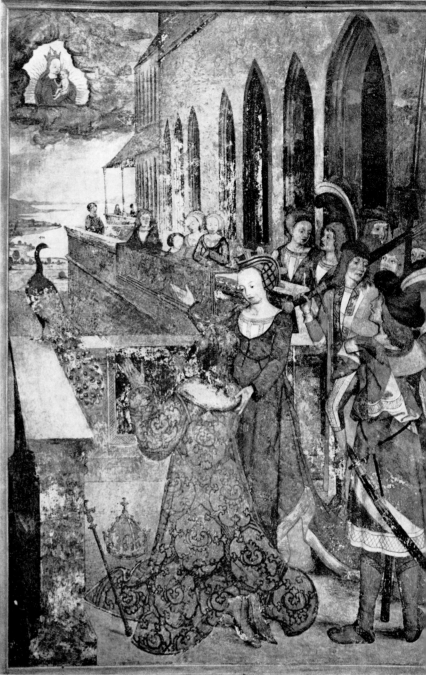

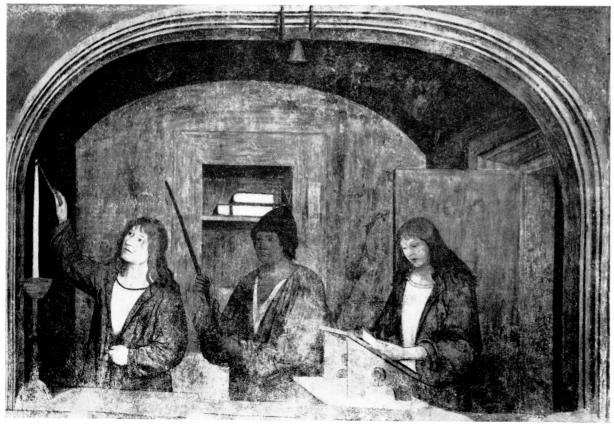

13 Kutná Hora, Parish Church of St Barbara, Smíšek Chapel. The Arrival of the Queen of Sheba before Solomon, detail of wall-painting, about 1496.

14 Kutná Hora, Parish Church of St Barbara, Smíšek Chapel. Augustus with the Tiburtine Sibyl, wall-painting, about 1496.

15 Kutná Hora, Parish Church of St Barbara, Smíšek Chapel. Votive picture of Michael Smíšek of Vrchoviště, wall-painting, about 1496.

16 Kutná Hora, Parish Church of St Barbara, Smíšek Chapel. Votive picture of Michael Smíšek of Vrchoviště, detail of wall-painting, about 1496.

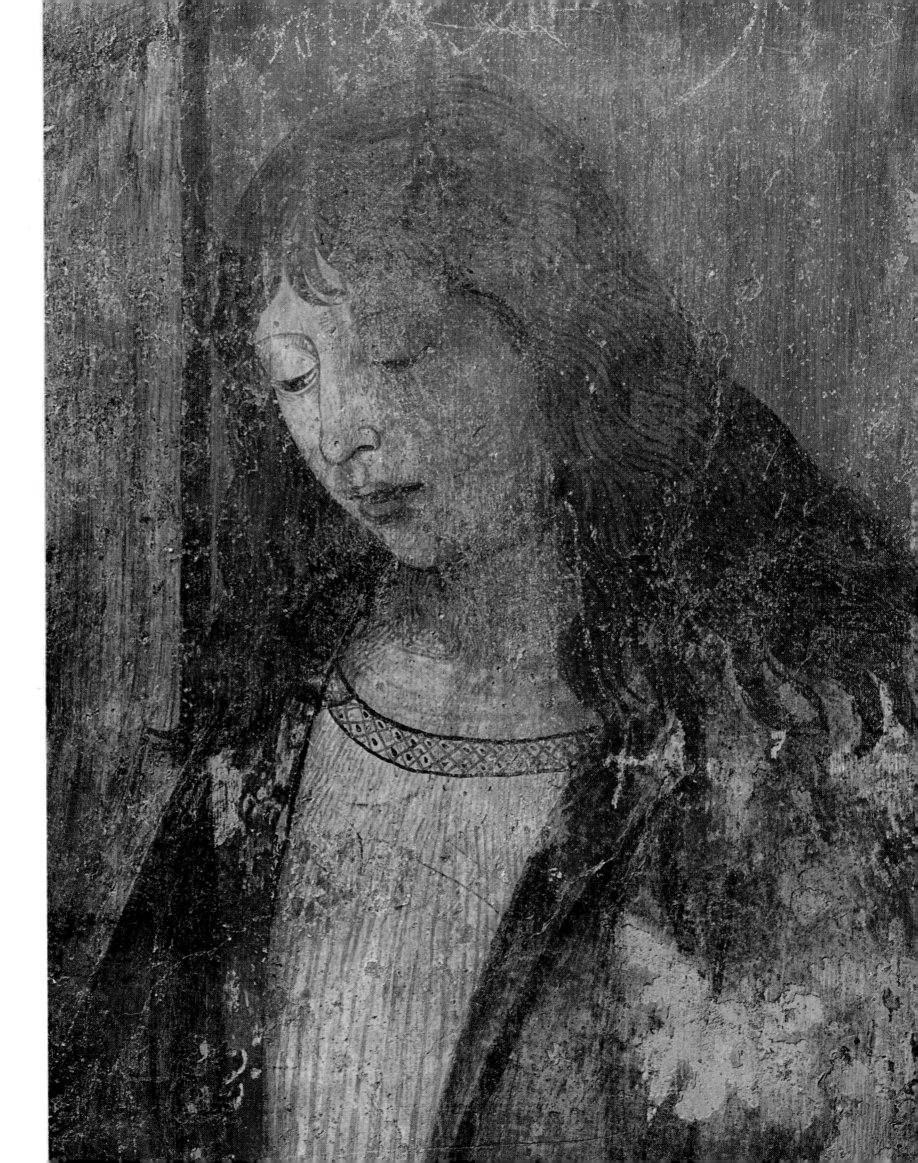

on the chest and on the back Vladislav's well-known crowned initial; pointing to it is God's finger with the inscription IHESVS NAZARENVS REX IVDEORVM. The device formed by the letters D.I.D.M.E. might perhaps be read as "*DOMINUS IESUS DOMUS MEA EST*". This interpretation of the device, which is, we emphasize, only subsidiary for the time being, is supported by the borders consisting of tiny roses, symbols of Christ. It was in this armour that Vladislav, as a ruler who would defeat the Antichrist, was to march against the Turkish hordes. Artistically, the austerely smooth armour is treated in as modern a manner as are Maximilian's well-known suits of armour, which are brilliant examples of the skill of the Innsbruck armourers. We cannot even exclude the possibility that it was presented to him by the Emperor, as Maximilian was in the habit of doing. The Pope, too, presented Vladislav with a magnificently chiselled Italian sword, housed today in the National Museum in Budapest. Perhaps one more fact should be mentioned in this historical connection. The south portal of St George's Basilica in Prague Castle is evidently a work of Ried's court lodge, as can be seen from its Italianate "Buda" form. Contrary to the statements found in older literature, its execution can be dated to 1510, i.e. ten years earlier. Thus it too can be ranked among Vladislav's undertakings. The relief of St George in the tympanum was evidently to record the role that Vladislav in actual fact played in the fight against the Turks and which was not regarded merely symbolically, as is confirmed by the successful war of 1502. If we take into account what the cult of this knightly saint meant in the second half of the fifteenth century, when St George began to be thought of as the archetype of the vanquisher of the Turks, we cannot omit either the well-known equestrian statue of St George in the third courtyard of Prague Castle, which has been the subject of many serious scientific discussions. It is not the purpose of this study to deal with the core of the problem: the dating, the provenance, the original destination of the statue. Nonetheless, it is expedient to recall the theory according to which the statue, produced within the orbit of Anjou Court art of the third quarter of the fourteenth century, was not brought to Prague until the time of King Vladislav.[11] Viewed in this light it would acquire a new, significant role. Placed against the entrance to the Riders' Staircase leading into Vladislav's throne room (which was also used for knightly tournaments), it would convey the same idea as the portal of St George. Might it not then be an ostentatious gift, such as Vladislav was in the habit of making? A positive stimulus may have been provided by Louis's coronation, an act of which Vladislav expected so much. To be sure, Louis, on whose head St Stephen's Crown was placed so shortly after his birth and who was even considered as the possible future King and Emperor of the Romans, theoretically had all the prerequisites to become the long-expected, God's own ruler. His disgraceful death in the small river Czel near the battlefiled of Mohács, where he was drowned when fleeing before Soliman II, is one of the numerous paradoxes of history.

29th August 1526 saw the end of the Jagiello period in Bohemia. It was not to be granted to Louis to carry out his father's plans, not even a small part of them. He did not come to Bohemia until five years after his father's death, in 1521, to take again one year later the royal oath in St Wenceslas's Chapel in Prague Castle, and to take on the rule of the country. Married to Maria Habsburg, daughter of Philip the Handsome and sister of Charles V, he maintained a court of much power and gaiety in Prague for a short time. In the sphere of art, the King's interest was no longer

Armour of King Vladislav Jagiello, 1505—10, London, The Wallace Collection

focused on monumental building commissions. An exception here is Křivoklát Castle, where he had the northern wing called the Queen's Palace, built (1516—22) with its typically Saxon "curtain" windows (it collapsed later and was reconstructed by Kamil Hilbert in 1911), and where also the unusually rich decoration of the chapel was completed (1522), as we have already mentioned. At the same time also the Church of St Peter and St Paul below Křivoklát Castle, founded under Vladislav, was consecrated (1522).

However, the predominating concern of the King continued to be ostentatious self-glorification through the medium of art. This manifested itself in particular in painting. Painters working for King Vladislav had mostly been of South German orientation, which, let us recall, had begun, even before the Master of Litoměřice, with the author of the well-known St George's Altarpiece (about 1470, National Gallery, Prague), and continued by the painter of the winged altar-piece of the Grand Master of the Order of the Knights Hospitallers, Nicholas Puchner (1482). Under Louis Jagiello, art underwent a change, influenced by the penetrating Luther's ideas. Very soon the tendencies of contemporary Saxon painting were gaining the upper hand. (Economic factors naturally played their role here. The function of the Czech mint at Kutná Hora was taken over by the mining town of Jáchymov in the Ore Mountains, where a new coin began to be minted, called the Jáchymov (Joachimsthal) thaler.) Of the altar-piece by Lucas Cranach the Elder, apparently a triptych of monumental dimensions with the central scene of the Assumption, only four fragments have survived (two in Prague, one in Karlsruhe and one in Aschaffenburg; the altar was destroyed by Calvinists in 1619). The lower part of the central scene with the kneeling figures of female saints (National Gallery, Prague) suggests that

it must have been a grandiose work on which the master evidently worked with the utmost care. The altar-piece was executed very delicately and with exceptional workmanship. Its dating to 1520—22 leads us to the hypothesis that a commission of such significance might have been in connection with the coronation of Maria Habsburg in St Vitus's Cathedral in 1522. (It might have taken the place of that one of the two high altars of the Cathedral for which a place had been reserved since the time of Charles IV in the axis of the ambulatory.)[12] For this solemn occasion, and as part of the sumptuous celebrations,[13] the sophisticated young royal couple had themselves portryaed by *Hans Krell*, then active in Prague, in a number of double-portraits which were presented as gifts to other sovereigns and high officials. This *Fürstenmaler* (painter of princes), who had earlier been invited by King Louis to Buda to execute portraits for which he "*khain phennig nie empfangen hat*" (had never received a penny), was the only painter to portray Louis as he really was. Thus he produced at the beginning of his career a few, very fresh portraits that differ from his later routine Saxon work. We know that the humanistic Maria, Queen Dowager of Hungary and Bohemia, who later became the regent of the Netherlands, was a great patron of the arts. The portraits she commissioned after Louis's death include, for example, one by *Barendt van Orley*, with an inscription and the date 1526 (private collection, Switzerland). And it was at that time that the beautiful medals were made in memory of Louis, one of which has been ascribed to the Augsburg sculptor and medallist *Hans Daucher*.

Jagiello Court art has been displayed to us in a unity which it was possible to discern by interpreting the individual layers of significance of first-rate works of art, all of which are, from the formal viewpoint, well-known. This art has its own quite specific background. When the greatest artistic commissions were executed in the King's name, he was present in this country as it were only in spirit, i. e. mainly in his intention to build up again a dignified royal residence in Prague. To be sure, one of the conditions of Vladislav's mounting the Hungarian throne stipulated that the seat of the Hungarian-Bohemian personal union would be Buda. As we have noted, after 1490 the King was a rare guest in Bohemia: in 1497, for a short time in 1502, the year of his marriage, and lastly on the occasion of Louis's coronation in 1509—10. And it can be said that each of these visits can be linked to a particular work, obviously commissioned by the King himself. As to Louis, he spent only a short part of a seemingly carefree reign in Prague: from 1523 on, he appointed as Regent George of Poděbrady's grandson, Prince Charles of Münsterberg. It is sufficiently known that immediately after the battle of Lipany (1434) Bohemia saw an exceedingly rapid growth of aristocratic power. It was the same in Germany where the emperor was, for the princes, merely a majestic figurehead. And even the position of the vigorous Corvinus in Hungary did not differ very much in his relation to the exceptionally strong and covetous magnates. Vladislav's Land Laws of 1500 are a splendid example of jurisprudential skill. This code, attempts at which had already been made by Wenceslas II and even by Emperor Charles IV and which also became a model for similar regulations in other countries, actually only confirmed the privileges of the nobility, among whom the king was to be, in essence, just *primus inter pares*.

"In this kingdom he does not reign, he is just a king: and due to our discord and, moreover, due to our shameful intrigues he cannot achieve or do anything good in Hungary either. But if our conduct were good in this kingdom, so our lord, too, would have, with our help, a good position in the Hungarian Kingdom," writes William of Pernštejn to Ladislas of Šternberk one year before his death.[14] Just as Corvinus's Court art infiltrated into works commissioned by high nobles, so in Bohemia the court artists worked for the members of the aristocratic oligarchy as well as for some markedly prosperous royal towns. If we review the most remarkable works of art that have come down to us from that time, we shall find conspicuous links between the patrons who commissioned them, the King and the artists, who are known to have at first been working for the sovereign. *Hans Spiess* was working in Mělník in the years 1480—88 (the château and the Church of St Peter and St Paul), being paid from the bequest of Queen Johanka of Rožmitál, widow of George of Poděbrady. After Ried had been forced to abandon the realization of the project for the nave and aisles of St Vitus's Cathedral, his reputation brought him numerous other very good commissions, even abroad. As far as sacred architecture is concerned, we have already mentioned the ambitious completion of the Church of St Barbara at Kutná Hora. (On the basis of records found in the archives, the church at Louny can be now ascribed to Ried's disciples, not to the master himself).

If we focus our attention on the building commissions of three prominent aristocratic families, the Švihovskýs of Ryžmberk, the Šternberks of Bechyně and the lords of Rožmitál, whose members occupied the highest posts in the country, we again meet the name of the King's first architect, Benedict Ried, this time as a builder of fortifications in the first instance. The Supreme Judge of the Kingdom, Půta Švihovský (1479—1504), and later his sons Henry and Wenceslas, from the end of the fifteenth century onwards began to reconstruct in a fundamental way the sizable castle of Rábí (until 1526—30?), particularly its strategically well-designed fortifications, the final building stage being carried out by Ried. Not long afterwards, Půta's sons completed, again with the participation of Ried, the fortification of the family's castle of Švihov (by 1530 at the latest). Similarly, the hand of the court stone-masons, especially of *Wendel Rosskopf*, can be recognized in the works commissioned by the High Chancellor Ladislas of Šternberk (1510—21) at Bechyně Castle. To Rosskopf can be ascribed the famous hall on the ground floor of the north part of the castle (1515), whose swirling vault with its ribs imitating dry branches is upheld by a central pillar in the shape of a massive tree-trunk. One of the doorways in this chamber (about 1520) strikingly resembles those in the Louis Palace in Prague. And let us note that the same master carved, in the spirit of the time, the naturalistic holy water stoup in the monastery church of the Franciscan Order at Bechyně; we can also find his work in the nearby Tábor where his sign and monogram are to be seen in the town's coat of arms from the years 1515—16. Vladislav's biggest money creditor and leader of the Catholic party and of the Estates, Zdeněk Leo of Rožmitál, a nephew of Půta Švihovský, who for years actually personified the royal power in the country (in 1507—23 and 1525—28 he was the Supreme Burgrave of the Kingdom of Bohemia), set out to build a sumptuous residence at Blatná. No less a personage than the King's architect himself was summoned. According to his designs a magnificent two-storey palace was erected on the southern side of the courtyard and a modern system of water defences constructed. These works can be dated to the years 1523—30 (at this time Ried is mentioned in the patron's correspondence).[15] A letter[16] of Prince Charles of Münsterberg of 1529, in which master Benedict is denoted as "*der Baumeister zu Prage*", the Prague architect, warrants Ried as the designer of the Renaissance château at Frankenstein in Glatz (1524—32).

In 1491, the Supreme Governor of the Kingdom and the chief

statesman of Vladislav's time, William of Pernštejn (1487—1514), added to his large estate the town of Pardubice, thus becoming its second founder. After the great fire in 1507, an ambitious systematic reconstruction of the town was begun, supervised by *Master Paul,* a disciple of Ried. By 1515 not only the whole of the town had been built, but also the château with the water defences had been essentially altered, forming an independent complex extending to the north of the town centre. While this stage of the construction was still dominated by Late Gothic ideas, William's sons Adalbert and John employed stone-masons whose work exhibits an Italian, or rather a Buda, influence, in this case via Cracow, for Hungary was occupied by the Turks. We should remember that Vladislav's younger brother Sigismund lived in Buda between 1502 and 1504, from where he later summoned stone-masons to his Cracow residence at Wawel Castle. But we must not let our imagination outrun the course of events. Under William of Pernštejn, an excellent economist operating with modern methods, whose fortune was three times as large as was that of the South Bohemian Lords bearing the coat of arms of the Rose, bigger than that of all the estates in Silesia as well as of a number of German princes, even his family castle of Pernštejn was given basically its present appearance. The medieval castle was turned into a comfortable residence with typical picturesque oriel windows and a magnificent set of marble doorways, on which Italian stone-masons already worked at that time.

Within the Danubian orientation, remarkably fresh artistic impulses started to flow into the Czech Lands from the end of the fifteenth century onwards. A group of illuminated manuscripts, of marvellous workmanship and in a considerably advanced Renaissance style, was commissioned by Ladislas of Šternberk for the Franciscans at Bechyně in about 1499—1516. The last of them especially, the *Lives of the Holy Fathers in the Desert* (University Library, Prague), translated by the Czech humanist Gregory Hrubý of Jelení, shows pronouncedly Danubian traits. The same can be said of the renowned *Litoměřice Hymnal* of the Latin lay-singers' brotherhood (1511—14), whose chief illuminator seems to have been influenced directly by Altdorfer's workshop.

These tendencies are mostly to be seen in the sphere of sophisticated wood-carving, which represents their climax. The Rožmitál coat of arms on the small altar-piece, probably executed for the Chapel of Our Lady at Blatná (the new presbytery was completed by 1515), links the name of Zdeněk Leo with the most prominent sculptor of that time — the *Monogrammist I. P.* (Only the central scene of *The Virgin and Child with St Anne,* and the relief of *The Adoration of the Magi* on the predella, about 1524, have survived; they are now in the Aleš South Bohemian Gallery at Hluboká.) A distinguished anonymous artist, who had come from the area of Salzburg-Passau and was naturally also conversant with the Italian art (e. g. A. Mantegna), executed in Bohemia in about 1521—25, i. e. under Louis, several works, homogeneous in style, that rank among his masterpieces. When working on the fascinating *Zlíchov Epitaph* (about 1524, National Gallery, Prague), he was guided by the humanist idea of reconciliation with death. A kneeling man, clad in armour and wearing a fashionable South German Renaissance wire cap (as was worn, for example, by Jacob Fugger the Rich), having passed through the gate of earthly life, resigns himself in wise comprehension to the majesty of death. In this figure, safeguarded by Christ, the Virgin and St Andrew (the latter need not be explained as being the patron saint of the deceased), we sense an affluent patron, a magnate with a humanist education. This could only have been someone with close contacts with the Royal Court. There are records that a number of important people died in the relevant years: in 1521 the wise and conciliatory William of Pernštejn and Ladislas of Šternberk, two years later Rožmitál's best friend Peter of Rožmberk, in 1526 at Mohács, besides the King, Stephen Šlik and several others. At approximately the same time the altar-piece of St John the Baptist was executed for the Prague Church of Our Lady before Týn. In this connection we may recall an event which in its time was of basic significance for Prague: after incessant efforts to achieve the union of the Old and the New Towns of Prague, this became a reality on 30th August 1518, and a new council of one hundred men was elected with its chamber in the Old Town Hall. "Since the foundation of Prague there has not been a more significant and memorable day", declared the parson Jacob Uher to a congregation in the Týn Church.[17] Further adaptations of the Old Town Hall must have been closely linked with this event, as is shown, in particular, by a Renaissance tripartite window with the inscription PRAGA CAPUT REGNI. The same motif might have led to the commissioning of the precious altar for the main town church of the united Prague by some high Utraquist official, by the town, or even by the King. If we recall Vladislav's previous donations, especially those to the Cathedral, we must naturally assume that Louis, too, pursued a similar policy. It is really a striking fact that it is to the year 1521 that the masterly reliefs of the Monogrammist I. P., graphically conceived and inspired by German woodcuts (Dürer, Altdorfer, Huber), are dated. Also his only signed and dated relief, *The Original Sin* (Kunsthistorisches Museum, Vienna), was created at that time. Similar cabinet pieces were executed for collectors, for example a small signed tablet with *The Visitation* (National Gallery, Prague). It is worth considering the possibility whether some of these relatively numerous exclusive works, scattered today in many collections round the world, could have been made for the King and Queen during their stay in Prague. What we have in mind are especially those provocative reliefs of The Original Sin, imbued with the Danube vegetal style, which were based on Dürer's print of 1504. However, let us leave the field of guesses and assumptions and revert to facts. And it is a fact that the work of the Monogrammist I. P. coincides in time with the portraits of Louis Jagiello executed by Krell. Like Krell, this outstanding woodcarver, too, left the country after the death of the young sovereign.

Considering the architecture and sculpture connected in one way or other with the Royal Court, it is not surprising that the paintings of that time, mostly executed at the instigation of the patrons already known to us, are also of a pronouncedly court character. A portrait of the High Chancellor Albrecht Libštejnský of Kolovraty (1503—10) dates from 1506 (the original is in the Kisten Collection, Meersburg, a Baroque copy in the château at Rychnov-on-Kněžná). It is of interest that the origin of this earliest Czech portrait coincides with the wall-paintings in St Wenceslas's Chapel, which contain such a number of individually characterized faces. Nevertheless, the main focus of our attention must be the wall-paintings commissioned by the members of the nobility. These frescoes of predominantly secular subjects, though naturally there are still religious scenes too, continue in essence the Late Gothic style. The earliest of them, dated 1479 (reconstructed in 1902), are the iconographically comprehensive wall-paintings in the Early Gothic Knights' Hall at Písek Castle. This royal castle, founded by Přemysl Otakar II, had been from 1459 onwards in the possession of Leo of Rožmitál, brother-in-law of King George of Poděbrady and the Supreme Governor of the Kingdom (1467—

80). In 1477 the castle was pawned or left as burgraviate to Henry of Jenštejn, it is true, but the identity of the person who commissioned the paintings and apparently also the author of their programme, who must have been an experienced politician, is obvious. The over-life size figures of George of Poděbrady, of his predecessor Ladislas the Posthumous and of the Polish Casimir, Vladislav's father, are evidently related to the political activities of George of Poděbrady, which Lord Leo so devotedly advocated. The portrait of the French King might then represent Louis XI with whom George, in spite of the resentment of the Pope Pius II, managed to conclude a friendly treaty of co-operation in 1464.[18] The two battle and tournament scenes also seem to have the same origins. In the expensively renovated residences it became fashionable to have a special room built, the so-called green chamber. Its walls used to be covered with paintings depicting court entertainments, particularly knightly tournaments and hunting scenes, set against landscapes with views of towns and castles; some of the views were not imaginary but real. The rich green plant ornamentation, filling up all the free spaces, was intended to convey an image of a close relationship with nature, typical of Italian Early Renaissance humanism. Everywhere here we find an anachronism, which is not without a certain charm. At the end of the fifteenth century, the Czech nobility wanted to imitate the exaggeratedly sophisticated life cultivated especially at the courts of Philip the Good and Charles the Bold, Dukes of Burgundy. Inspiration for many frescoes in the Czech Lands was drawn from Franco-Flemish miniatures of about the mid fifteenth century (which were, in many respects, indebted to the *Très Riches Heures* of the Duke of Berry), mainly via woodcut versions of them which spread along the Rhine valley.

It cannot have been a mere coincidence that Leo of Rožmitál (died 1485) had a banquet hall on the second floor of the old palace in his castle of Blatná and a cell in one of its towers decorated in this way with exclusive wall-paintings. The programme of the paintings seems to have direct connections with Rožmitál's famous journey to the West, comprising Germany, the Netherlands, England, France, Spain, Portugal, Italy and Austria; he was the head of a forty-man delegation, sent out from Prague on 25th November 1465 with the task of winning support of these countries for King George's remarkably modern concept of a unified Europe. During his stay abroad, which lasted roughly eighteen months, Rožmitál's suite earned golden opinions for their refined chivalry and bravery, which they proved, above all, in many tournaments and military games. Thus the wall-paintings at Blatná Castle, just like the scenes at Písek Castle are, so to speak, illustrations for Lord Leo's biography, written in Czech by Wenceslas Šašek of Bířkov who seems to be portrayed as a scribe at Blatná Castle. The requirements of the ambitious patron were in accordance with the high level of sophistication reflecting the sublime Burgundian Court art with its chivalric ideas. Of the extensive complex of the fifteenth century wall-paintings at Zvíkov Castle, it is mainly the frescoes in the chapel (there are several layers made at different periods) and in the two-storey gallery that have come down to us; the frescoes with secular themes in other rooms of the castle, together with the reconstructed Heraldic Hall, were linked, as regards their meaning, with what we can see today in the crude overpainting of the Electors' Hall (also called the Green Chamber or the Banqueting Hall). These frescoes are to be dated before 1490 because it was in that year that the most probable patrons, Bohuslav of Švamberk and his son Hynek, died. It is not easy to explain the meaning of these paintings. Like the Dance scene (hence

also the name Wedding Hall), the figures of the four secular Electors, beginning with the King of Bohemia, were taken over from older woodcuts used in 1493 in Schedel's *Chronicle*. (Similarly, a woodcut of Prague was reproduced in his *Liber Chronicarum*, showing not the contemporary state but the Castle as it appeared before Vladislav's reconstruction.) Perhaps we should also mention here that, a long time before, Bohuslav had forsaken Matthias who required from him services that were incompatible with his moral principles; and that after 1478 he was, like most Czech noblemen, a follower of Vladislav. Zvíkov being a royal castle, he held it only as a pledge (hence, perhaps, the theme of the Electors), and its adaptations were partly financed from the royal treasury, as was also the reconstruction of the royal castle of Hluboká, undertaken by William of Pernštejn.[19] The *post quem* date of the frescoes in the Red Bastion at Švihov Castle, only fragments of which survive, is the year 1489, when the interior of the castle was completed. The treatment of the painted knightly tournaments, the scene of *The Judgement of Paris*, the supplementary illusionistic details and the quotations from Classical authors suggest a gifted painter. The fresco on the north wall of the chapel here (the 1520s) is of pure Danubian character. The figure of St George, rendered as a contemporary knight (Henry of Ryžmberk?), is shown against a fresh landscape with the recently completed Švihov Castle, including its fortifications built by Ried, rendered in a perfectly realistic way, and two other castles, presumably Skála and Ryžmberk.

Close behind the kingdom's nobility came the ennobled Smíšeks of Vrchoviště, the officials of the royal mines, who managed the silver production of Kutná Hora. As has been already said, the paintings in the Smíšek Chapel were commissioned and financed by Michael Smíšek, the Administrator of the Royal Mines. The name of his nephew John is connected with the paintings on the walls and ceilings of the Hrádek ("Small Castle") at Kutná Hora (1493—94) which seems to have been built as a pendant to the Royal Italian Court in the same town; paintings decorated the chapel and, in particular, the hall on the first storey whose painted ceiling is a copy by Benedetto da Maiano of the marble ones in Buda (in style it carried the same type of coffers with rosettes as can be found on St George's portal in Prague).

Quite unique among the wall-paintings are those at Žirovnice Castle which was in the possession of the mine owner Wenceslas Vencelík of Vrchoviště, the close relative of Michael Smíšek. Only a small part of the painted decoration of the residence, which he bought in 1485 and reconstructed, has so far been revealed. The Late Gothic frescoes in the chapel, with their brilliant delineation and the resplendent colour are an extraordinary work of art. Apart from the votive picture of the Madonna with the donor's family (dated 1490) and the numerous lyrical, graceful figures of the saints, the main scenes are *The Annunciation*, *The Adoration of the Magi*, *The Crucifixion*, *The Last Judgement* and *Purgatory*. Vencelík, a moderate Utraquist who had active contacts with the Catholics could have found a painter who was obviously from the middle reaches of the Rhine with its Netherlandish component, only through his relations with the owners of the nearby estate of Jindřichův Hradec.[20]

Unfortunately, only inconsiderable fragments have survived of the painted decoration ordered by Lord Henry IV for his castle of Jindřichův Hradec. The paintings in the Red Tower, predominant among which was the picture of the Land Court, no longer tell us anything of the artistic gifts of the painter. Nevertheless, Peter Maixner's watercolour from the nineteenth century (State Ar-

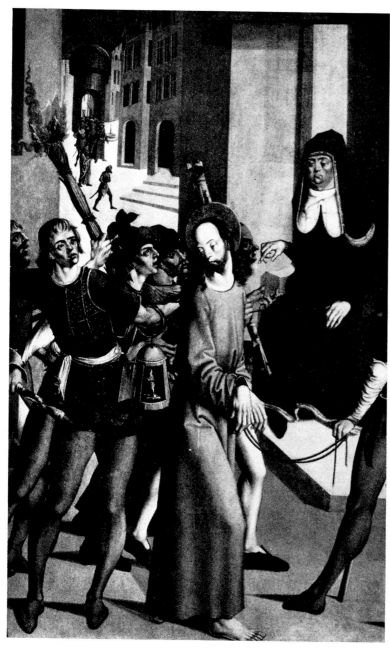

17 Christ before Caiaphas, by the Master of Litoměřice, panel-painting, 146 × 94 cm, after 1500, Regional Gallery, Litoměřice

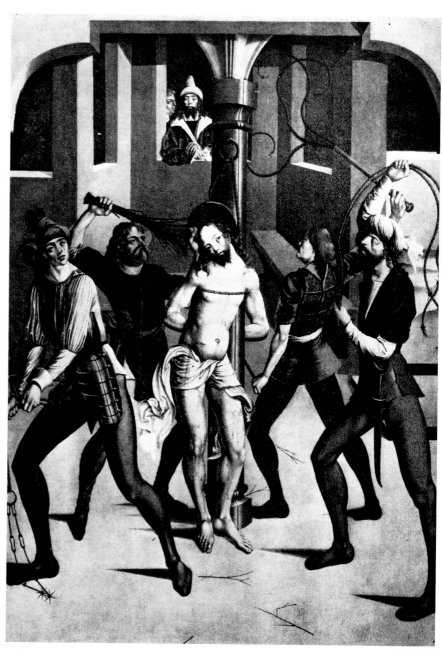

18 The Flagellation, by the Master of Litoměřice, detail of panel-painting, 180 × 130 cm, after 1500, Regional Gallery, Litoměřice

19 Christ, by the Master of Litoměřice, detail of panel-painting, after 1500, Regional Gallery, Litoměřice ▶

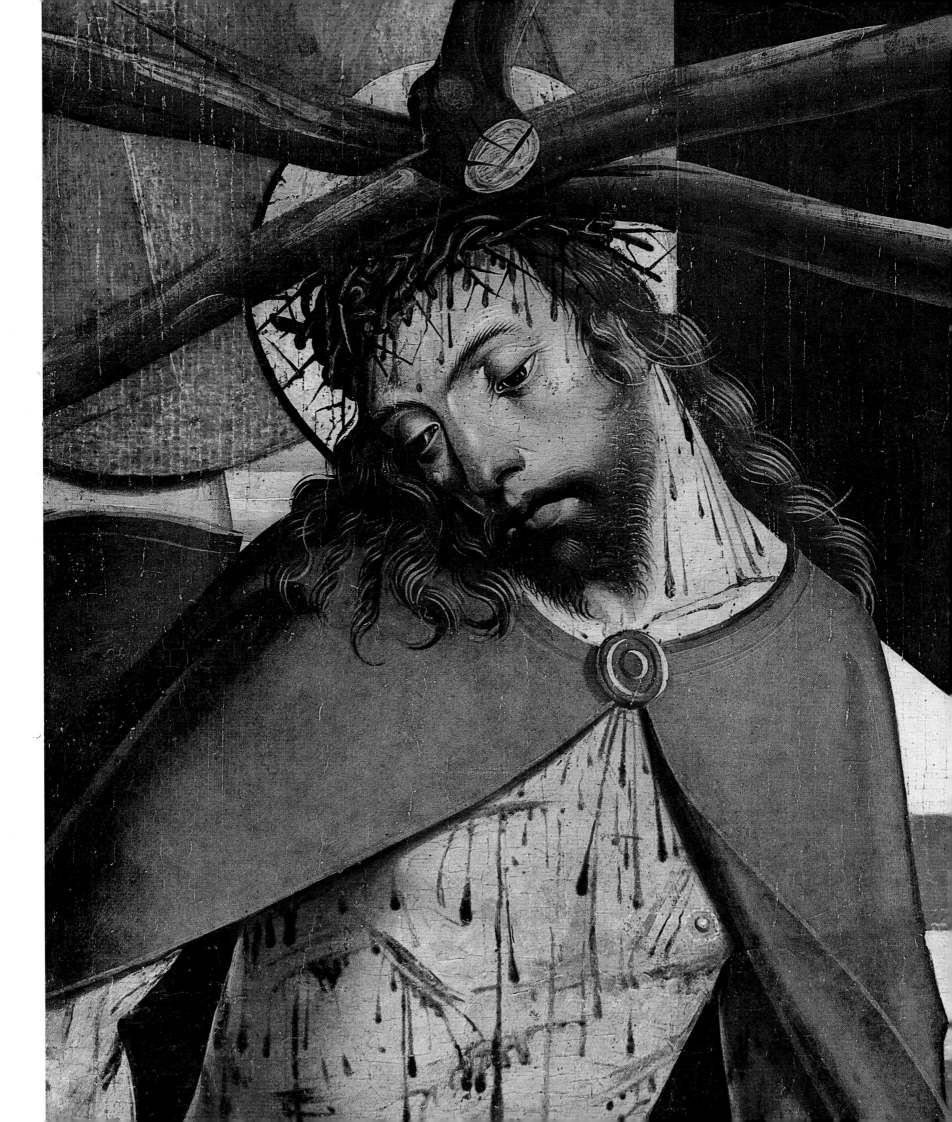

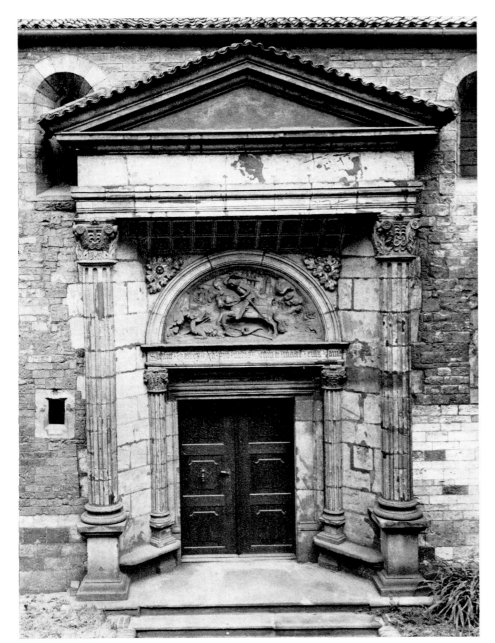

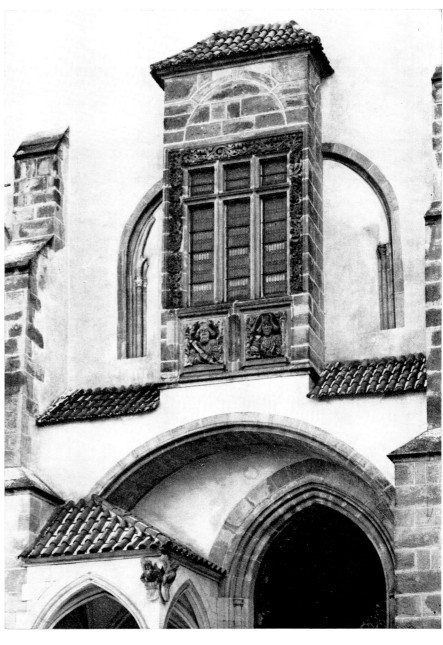

20 Prague — Castle, south portal of St George's Basilica, by Benedict Ried's workshop, by 1510

21 Křivoklát Castle, entrance block. Detail of the oriel window with relief portraits of King Vladislav Jagiello and his son Louis.

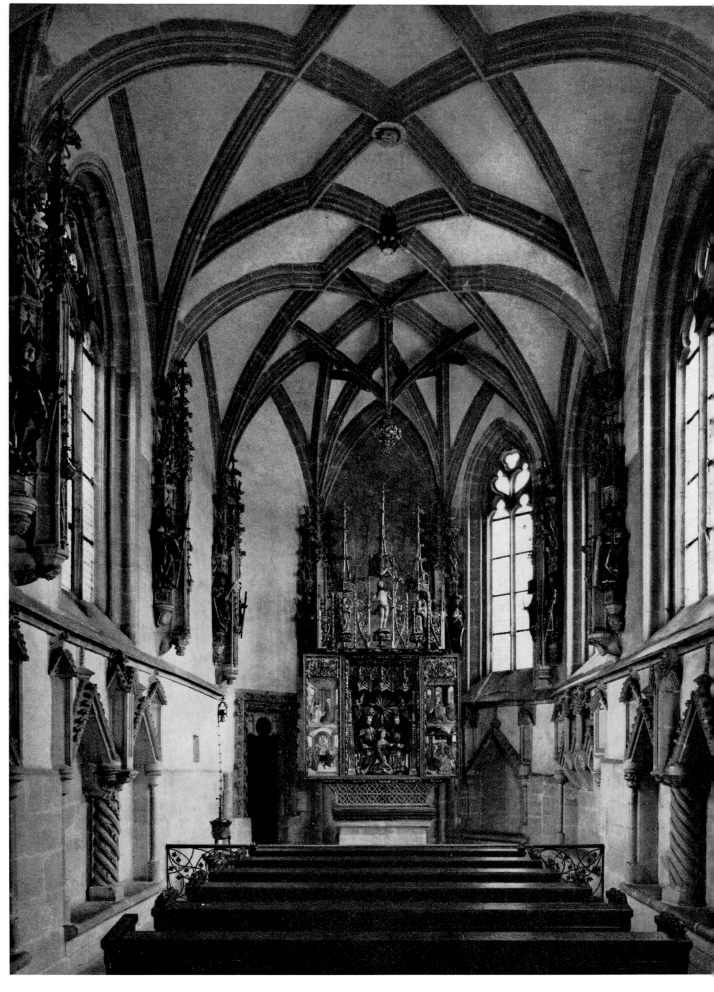

22 Křivoklát, Castle Chapel, interior, detail of stone decoration 23 Křivoklát, Castle Chapel, interior, view of the main altar

39

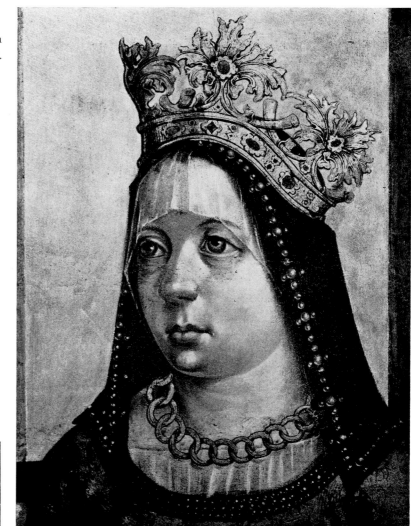

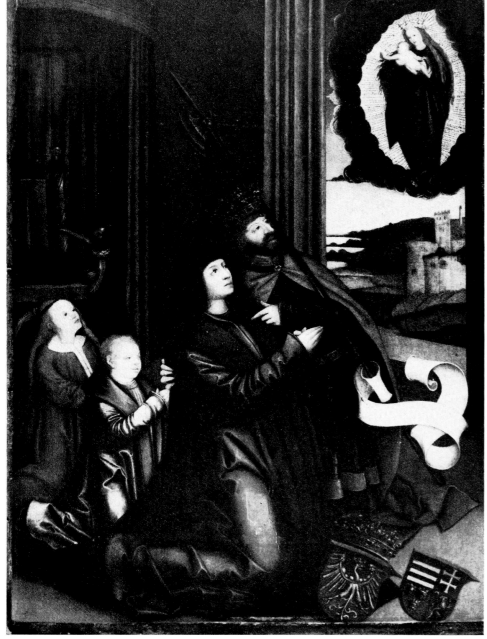

◀ 25 Bernhard Strigel, Vladislav Jagiello with St Ladislas and Children (St Ladislas is the patron saint of Hungary, the Children are Anne and Louis Jagiello), 1510—12, Museum of Fine Arts, Budapest

26 Prague — Castle, St Vitus's Cathedral, wall-paintings on the west wall of St Wenceslas's Chapel ▶

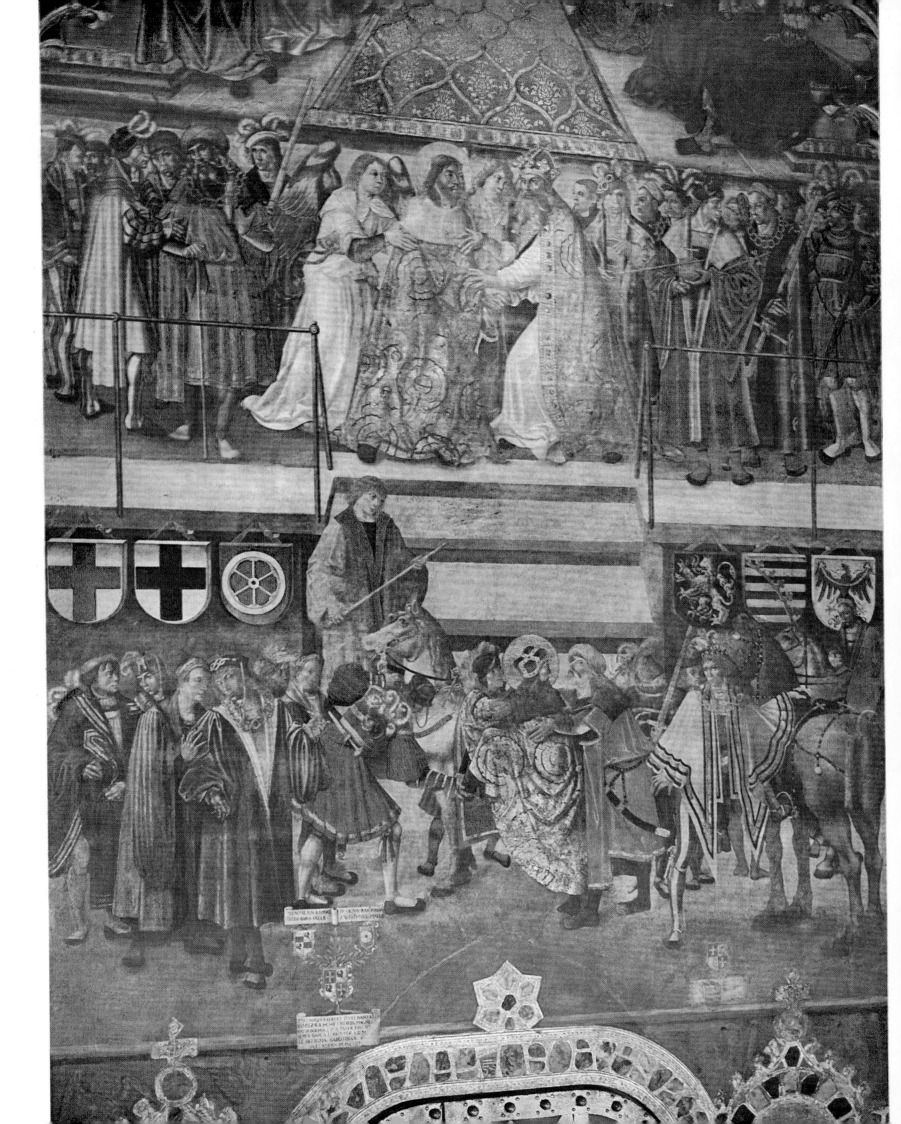

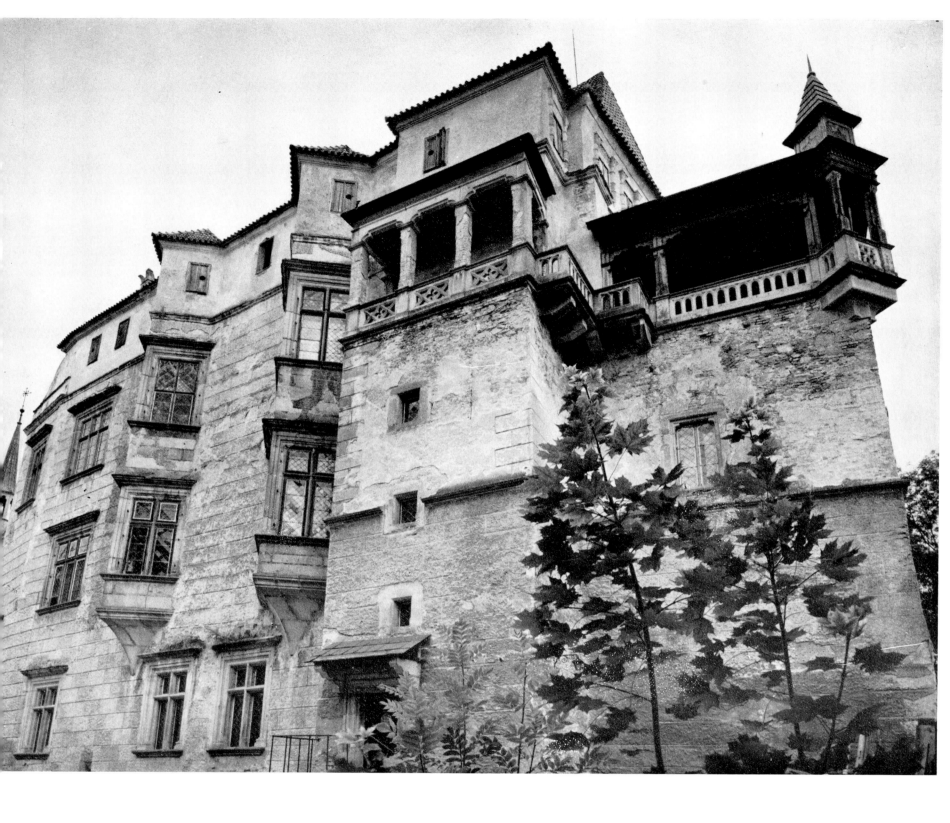

27 Blatná, Palace of the Lords of Rožmitál, by Benedict Ried, 1523—30

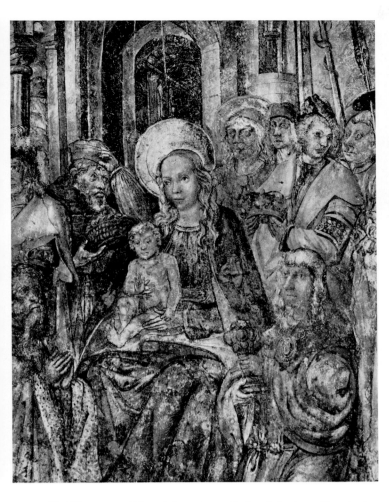

30 Olomouc, The Adoration of the Magi, wall-painting in the cloister of the St Wenceslas's Cathedral, 1504

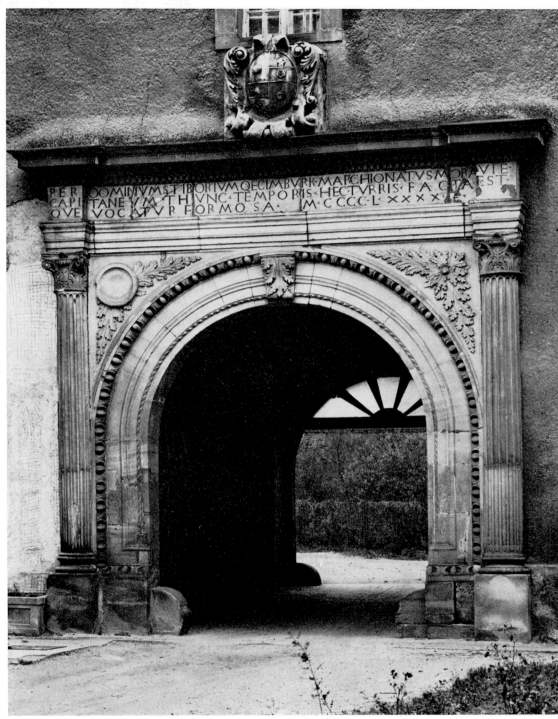

29 Tovačov Château, Renaissance portal, 1492

◄28 Moravská Třebová Château, Renaissance portal, medallion with portrait of Magdalene Berková of Dubá and Lipá, 1492

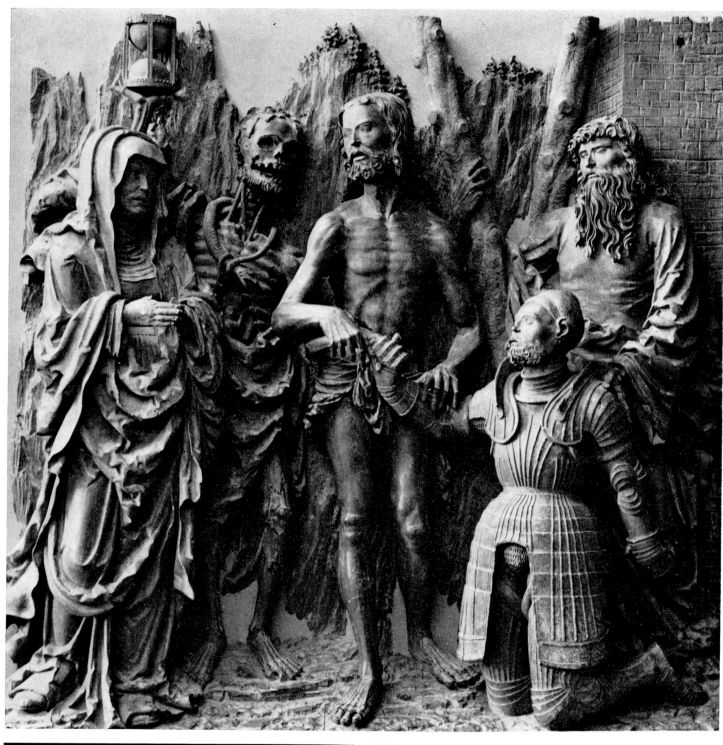

31 The so-called Zlí-
chov Epitaph, by the
Master I. P., wood,
98×99 cm, 1524—26,
National Gallery, Pra-
gue

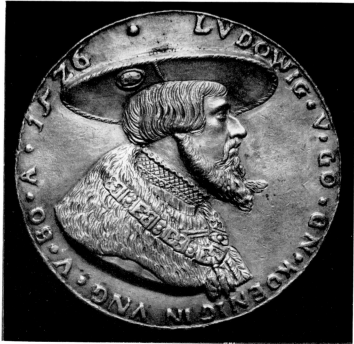

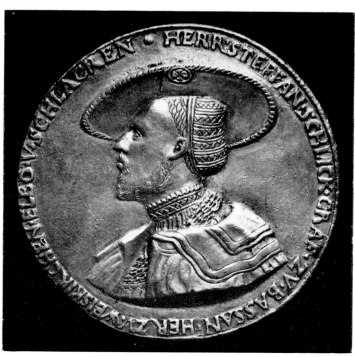

32, 33 Commemorative
Medal of Louis Jagiello,
by Hans Daucher, 1526,
obverse with the portrait
of King Louis Jagiello,
reverse with the portrait
of Stephen Šlik, Nation-
al Museum, Prague

44

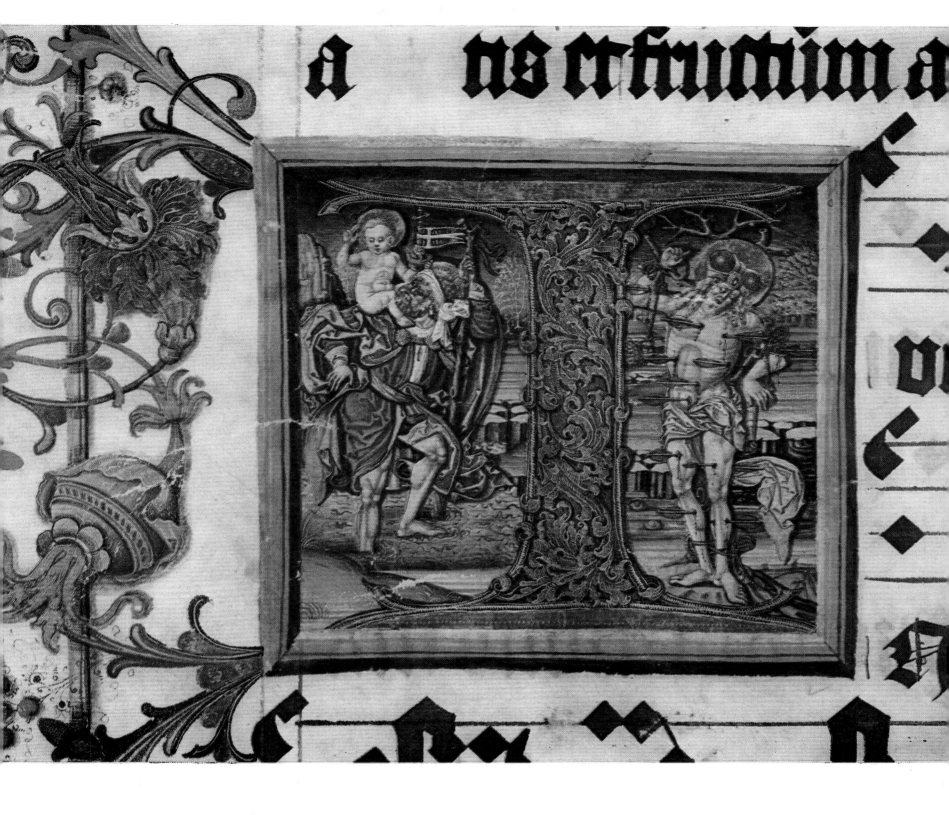

34 Antiphonary of Louka, fol. V, initial with St Christopher and St
Sebastian, 1499, University Library, Olomouc

chives, Jindřichův Hradec) shows that it was a painting from real life, based on King Vladislav's verdict in a dispute concerning the way of sitting at the Land Court. (In 1487 this verdict was entered in the Land Book in the presence of Lord Henry IV, the Supreme Chamberlain of the Kingdom,[21] and later included in Vladislav's Code as its first paragraph.) The frescoes in Henry's private Chapel of Our Lady, carried out after 1492, show (in spite of insensitive restoration at the end of the 19th century) the hand of perhaps the same painter who worked fot Vencelík. This outstanding Late Gothic painter may have come to Henry via his third wife, Magdalene of Gleichen, a member of one of the oldest Thuringian families. (She was buried in 1492 in the Minorite Church of St John at Jindřichův Hradec, and her beautiful tombstone of Salzburg marble is today in the Aleš South Bohemian Gallery at Hluboká.) Vencelík's contacts with the Lord of Hradec are, moreover, demonstrated by the fact that above the doorway leading into Vencelík's spacious green chamber — a banqueting hall, again — was painted a lily (part of the coat of arms of the Lords of Hradec) and a white lion on a blue ground (the coat of arms of Magdalene of Gleichen). These Žirovnice paintings display themes similar to the frescoes at Blatná and Švihov Castles; in addition the sizeable *View of Žirovnice* has in the foreground a scene showing a special working method used by the iron-ore miners at this period, so that it is a unique document in this sense. The ambitious Vencelík, an independent manager of his estate on the Bohemian-Moravian border, whose deep forest he made full use of for his business activities, evidently sought to rival the high nobility in the sphere of the visual arts. However, all these people of the "wanning of the Middle Ages" (viewed by Central European standards) eventually shared the same fate. Žirovnice, burdened with debts, was bought in 1544 by the Lords of Gutštejn. Even more dramatic was the economic crash of the most powerful of Czech noble families. Some wit at the time remarked that it was easier for one lioness to feed ten cubs than for the Czech Land to sustain one "Leo". The whole immense property of Zdeněk Leo of Rožmitál, who was, with Adalbert of Pernštejn and Charles Münsterberg a candidate for the Bohemian throne in 1526, was parcelled out among his creditors immediately after his death (1535). His brothers-in-law at Švihov and Rábí lastly also met the same fate. Like the King years before, these people, too, had exceeded the limits of their possibilites.

In order to make the image of artistic life of the Jagiello epoch as complete as possible, we should not ignore the precious Renaissance imports to Moravia. They are again connected, above all, with Vladislav's high officials who maintained direct contacts with the King and his Buda residence. Humanistic ideas and the new artistic opinions penetrated to Moravia through direct channels. (Let us note at this point that two Moravian manuscripts of a pronouncedly "Corvinus" type had come from the wider circle of the Buda illuminators' workshop: the *Antiphonary of Louka*, dating from the year 1499, and the "Municipal Book" — *Liber municipalis* — of the town of Znojmo, illustrated by *Wolfgang Fröhlich* of Olomouc in 1523—25.)

The inscription of 1492 in the frieze of the Tovačov portal, executed in pure Roman majuscules, announces that the tower, into which the portal was set, was called "beautiful" (*"haec turris . . . que vocatur formosa"*). The Governor of Moravia, Ctibor Tovačovský of Cimburk, could have rightly been proud of this work. It was the first production of this kind in the country, and its refined forms point to Italian stone-masons from Buda. Yet another Moravian lord, Ladislas Velen of Boskovice, the Supreme Chamberlain of

the Kingdom and the King's confidential adviser, also showed his interest in art; he was provost in the Church of St Peter in Brno but resigned, with the Pope's permission, his ecclesiastical office and bought, in 1486, the estate of Moravská Třebová, where he built up excellent collections of works of art. The building activity of this humanist educated in Italy can be seen today only in a portal (1492) which, compared with that at Tovačov, is rusticated to some extent. However, it bears two Italianate stone medallions portraying the patron and his wife Magdalene Berková of Dubá and Lipá, and the year 1495. (During the authors' work on this book similar medallion portraits were found in Tovačov, too.) They are affiliated to the well-known marble relief busts of Matthias Corvinus and Beatrix of Aragon (1485—90, Castle Museum, Budapest) executed by Gian Cristoforo Romano. Both the Moravian medallion portraits are, however, especially akin to the works of Giovanni Dalmata, at that time active in Hungary, as we have already mentioned.

Italian artists, summoned from Buda, no doubts worked also for Stanislas Thurzo, a great patron of the arts. This vigorous and well-educated man, who had contacts with Erasmus, clearly studied at Padua University and also spent some time at the Hungarian Court, as is shown, among other things, by the *Sodalitas Marcomania* which he founded in Moravia on the model of Buda. In 1497, at the age of twenty-six, he was enthroned as Bishop of Olomouc, which post he occupied till his death in 1540. He came from a Hungarian noble family. His father John Thurzo de Betlenfalva, born in Levoča, settled in Cracow from where he managed to secure, through his connection with the Fuggers, profitable positions for all his sons. Stanislas's brother John was from 1506 onwards the Bishop of Wrocław, George, who in 1497 married Anne Fugger, became the administrator of the Hungarian silver mines, and Alexander became Viceroy of Hungary. Once enthroned, Stanislas set out to convert the old Early Gothic episcopal castle at Kroměříž into an ostentatious Renaissance residence; its appearance we can see in a woodcut of 1593 in Paprocký's genealogical work entitled The Mirror of the Glorious Margraviate of Moravia. Its regular four-wing ground-plan with corner turrets is basically of the type of the Italian Renaissance castello, such as used to be built at that time in Hungary and which we can also see at Ried's Frankenstein. The building was completed about 1510, when King Vladislav, returning to Buda from Louis's coronation in Prague, stayed some time at this residence at Kroměříž. Incidentally, it was Bishop Stanislas, together with his brother John and the Bishop of Nagyvárad, John Filipec, who crowned Louis, since the Prague archiepiscopal see was vacant at that time. Nonetheless, Thurzo's ambitious building plans were doomed to survive only in meagre fragments, hidden today in the Liechtensteins' Baroque reconstruction. Parts of the portal (of the same type as those at Tovačov and at Moravská Třebová) were a frieze with a Latin inscription, and Thurzo's coats of arms with Renaissance *putti* below naturalistic Late Gothic branches preserved in the tower of the original thirteenth-century donjon. Two fragments of stone-masonry (the Castle Lapidarium, Kroměříž) with pure Italian ornamentation also suggest the route Naples-Urbino-Buda mentioned before. Some panel paintings, gracing today the Kroměříž Gallery, seem to have been part of Thurzo's collection. This is particularly evident in the case of four early works of Lucas Cranach the Elder, bearing the painted coats of arms of the patron: the signed *Decollation of St John the Baptist* (1515), *The Martyrdom of St Catherine* (1515), and the altar wings with *St Catherine* and *St Barbara* (1516—18).

46

Thurzo may also be linked with the wall-paintings in the cloisters of the Cathedral in Olomouc, dating from the very beginning of the sixteenth century. Earlier literature[22] cites a letter of Stanislas I, Bishop of Olomouc, requiring that the Cathedral be decorated, and states that this task was entrusted to *Jörg Breu the Elder*, who was summoned from Augsburg. In spite of the many reservations advanced by later authors we favour the view that some of the paintings of clear, bright hues can be ascribed to him. (According to Steiff, Breu also executed, during his stay in Moravia, the frescoes in the cloisters of the Minorite Monastery in Brno, dated 1504.) As the cycle containing eight scenes from the Life of the Virgin and from the Passion of Christ has survived, although in a bad condition, let us dwell for a while on the scene of the *Adoration of the Magi*, the most significant as regards meaning. The composition of this scene is handled in a way that reminds one of Dürer's *Feast of the Rose Garlands* of 1506, imbued, to speak in the most general terms, with the idea of reconciliation between the ecclesiastical and the secular powers, between the Pope and the Emperor. The central scene in St Wenceslas's Chapel in Prague Cathedral displayed, as we have said, King Vladislav in the political context of that time; the satisfactorily established relations with the neighbouring German Empire were expressed here in the King's contact with the Emperor and his son. Something similar can be found in Olomouc. Old Frederick III is traditionally rendered as the first Magus in the Adoration and his imperial crown is held by Maximilian standing behind him. It is the same iconographic arrangement that also occurs elsewhere (for example in the *Adoration of the Magi* by Niklas Reiser, Kunsthistorisches Museum, Vienna). Kneeling before the Virgin to the right is a Magus, over whose head another of the figures in the scene holds a crown of the St Wenceslas type: he is consequently King Vladislav Jagiello. A hint at the Turkish threat, much more real for Moravia than for Bohemia, is contained in the group of soldiers in the background, carrying a banner with the crescent. Like the paintings in Prague Cathedral, this scene also includes a converted pagan, here in the role of the third Magus. Thus it is not a historical source found in the archives but the hidden meaning of a work of art that allows us a glimpse behind the scenes of Vladislav's time. With one stirring event following another and with the sovereigns being interlinked by a network of complex diplomatic relationships, it was unthinkable that the King of Bohemia and Hungary should not take part in the political game. One of the protagonists was also Bishop Stanislas Thurzo who, being a near relative of the Fugger family, certainly had a golden chance to use the same artistic sources. It was probably in this way that he acquired his Cranachs (the Fuggers were keen collectors of Cranach's paintings), found Augsburg artists for Vladislav, and finally, in later years, was able to give advice to King Louis.

In his biography of Erasmus, Stefan Zweig wrote: "History does not very much like moderate men, mediators and pacifiers, representatives of humanity. Its favourites are indomitable fanatics, wild adventurers of spirit and action." This statement is an appropriate introduction to our closing remarks. In the harsh light of history, Vladislav Jagiello has always been judged and condemned as a ruler of limited abilities. Such an opinion was not entirely justified, and consequently the picture of his time necessarily remained blurred. It became clearer and more complete only when subjected to historical reconstruction, in which the bare facts were brought to life. It is only logical that what we see and read in a work of art tends to be more informative and enlightening — if only because of the emotional effect of art — than all the statements in chronicles, no matter how well-founded they are. In Vladislav's time, Bohemia, after a 100-year break, found itself again on the European cultural stage. In the sphere of the fine arts, works emerged that can be measured against the highest criteria. When compared with the rich native production in Late Gothic style, they are instantly recognizable by their totally different and exclusive character. Everything inspired by the monarch himself or by those maintaining the closest contacts with the Court can be singled out with remarkable clarity.

It may be said that a reinterpretation of the hitherto rather sketchy account of King Vladislav has resulted in a much more favourable judgement of him. It was the man who managed to bring to life in Bohemia a monumental Court art to some degree akin in its programme to that of Charles IV's time. It is — *mutatis mutandis* — appropriate to draw a parallel between the two Courts, that of the Luxembourgs and that of the Jagiellos. Like the art of Charles's time, Jagiello art, too, must be interpreted mainly from the international point of view, for even in the Jagiello period it is not possible to work from an exclusively Czech viewpoint. We are well aware that everything that has been discussed in this study (the work of art and its ideological background) belongs to the world of aristocratic concept, i. e. to the King and the Court elite. That means to a narrow circle of the "chosen ones", who did not give a thought to the virtues of the other social classes. Each stratum is assigned its unchanging role and duties. With the monarchs it is, above all, power which they are, ideally, to use for the protection of the law. A generalized approach like this is entirely based on the thinking of the Late Middle Ages as well as of the approaching new era. Actions are not grasped totally and dynamically but are viewed statically, like a black and white woodcut. It is only natural that noble idealism as well as catastrophic disenchantment are at work here. Both of them permeate the art. The sublime Court culture of the dying Middle Ages, apprehending life as a noble play, is afflicted with the *danse macabre*. There certainly existed a contradiction between the imaginary world and reality; a contradiction between Vladislav's dream to build up a seat of the Jagiello dynasty in the centre of Europe, and the fact that his son resided there only for such a short time; a contradiction between the dream of a redemptive ruler as presented in the Smíšek paintings and the fact that historians were to use for this King even so abusive an epithet as "reed shaken with the wind". The final tragedy was the disharmony between the mission to beat the "Great Turk" and the cruel reality of Mohács. Much of this can be seen quite concretely in the political concept of that time, known to us from the St Wenceslas's Cycle in Prague Cathedral. However, any feelings of futility we may have, should be modified by the words of Johann Huizinga: "Where would we be if our thoughts never surpassed the strict boundaries of the attainable?"

Even though the trend of the historical development did not permit Central Europe to follow the mainstream of the Renaissance movement in the true sense of the word, we cannot overlook the fact that it was possible, after all, to transplant a pure Renaissance phenomenon into the cultivated milieu of the Czech Lands. True, one of the fundamental and determining attributes of this turbulent time was that the young plant was put into soil which was not destined to become really invigorating. A reflection of this in the ideological sphere is the short duration of Czech humanism. On the one hand we can see the intellectual scepticism of the "Latin" Bohuslav Hasištejnský of Lobkovice, a Catholic, who appears not to have been able to achieve intellectual and personal

integrity throughout his life; on the other hand there is the inconsistency of the Utraquist Viktorin Kornel of Všehrdy, writing in Czech, or the backward conditions at the Prague Utraquist University.

A quite specific feature of Court art under the Jagiellos, especially under Vladislav, was the fact that the ruler who instigated it did not reside in Bohemia. Thus, in principle, it is not possible to speak about true Court life. Nevertheless, Court art did originate in Bohemia for reasons already given, and in character it was akin to the art cultivated at the other European Courts. The question whether the Czech Lands of about 1500 were still dominated by the Middle Ages, or whether this hold was already giving way to the approaching new age, cannot be answered in an unambiguous way. In a certain sense Vladislav continued the Luxembourg tradition with its idea of *renovatio Imperii*. He wanted to revive what Charles IV had already had in mind and what has recently been so well described as a "court in heaven".[23] It was necessary that the ruler's power should be ratified from the heaven; in the art of Charles' period, the royal and the celestial seemed to be interwoven. It is typical of the multifarious Italian Renaissance, whose art becomes a mirror of earthly existence, that its Courts are "courts on earth". This was the case of the aristocratic Florence of the Medici, of Federigo da Montefeltro's Urbino, of Ferrara, of Naples and of the Mantua of the Gonzagas and elsewhere. Vladislav accepted even this ideological orientation, thanks to his Buda heritage. Lastly, at this time an essential role was played by the "publicity of the monarch". We have only to remember what Maximilian of Habsburg, who wanted to appear to the world as a proud, regal, apocalyptic man, was able to do for the glorification of his person. Subject though he was to the mystic world of knightly romanticism, he abandoned the concept of the medieval sovereign as an image of Christ, in favour of realistic principles to be expressed so pregnantly by Niccolò Machiavelli later on. Vladislav was well aware of the position he occupied in Europe as King of Hungary and Bohemia. He also knew that the Czech Lands were the key to the Empire. This is confirmed by the mass of artistic productions brought into being at his instigation. To be sure, the very existence of this art is a sort of publicity. (Let us recall the great number of the King's crowned initials, which, so to speak, sign all the buildings having any connection whatsoever with Vladislav.)

However, this production was not an end in itself, for the basic purpose of Jagiello Court art was its programme. And we must admit that its results were objectively of a longer duration than those of Maximilian's efforts.

It is a far-reaching significance that Vladislav as a ruler did not correspond entirely to the contemporary model of a ruler. This sovereign, who was able to secure for the Czech Lands external peaceful conditions at least, if not real internal peace, possessed the characteristic traits of a peace-lover. He was devoid of despotism, fanaticism and pride, and, with his quiet and unaggressive disposition, not even his constructive ambition could mislead him in a dangerous direction. It is hardly possible to imagine that, under all the prevailing unfavourable circumstances, another ruler could have achieved more than Vladislav did. The policies of the Polish Casimir and his sons Vladislav and Sigismund were affected by the ideas of the great humanist Erasmus. His ideas of concord, of reconciliation of contradictions, of the solution of conflicts in a peaceful way, by which understanding can be achieved among individuals as well as among nations — all this was to replace bloodshed and wars, and European nations were thus to be united under the peaceful reign of a Slav dynasty. However, the Jagiellos were not fated, and it was beyond human power, to realize these noble aims.

Arts in the Renaissance and Mannerist Periods

The year 1526 marks a significant turning-point in the history of the Czech Lands as well as in the history of their arts. It was in this year that the Czech Estates, followed by the representatives of the other lands of the Crown of Bohemia, elected to the throne Archduke Ferdinand, the husband of Anne Jagiello and younger brother of Emperor Charles V. By this act the Kingdom of Bohemia, together with the Margraviate of Moravia, as well as Silesia and Lusatia, fell to the Habsburgs for four hundred years. Prague, the capital of Bohemia, at that time the dominant state within the monarchy which comprised many nationalities, had to give way to Vienna as the seat of the sovereign, temporarily at first and permanently from the 1620s. Thus the once-powerful kingdom was gradually assigned the role of a mere province. In the sixteenth century, however, Bohemia had lost only little of its significance, as is shown by the artistic production of this period as well as by the tomb the Habsburgs had erected for themselves in Prague Cathedral. And when Rudolph II once more chose Prague as the centre of his Empire and as his permanent seat, it resounded to the old glory it had enjoyed under Charles IV.

The year 1526, so significant from the political viewpoint, brought an essential change in the sphere of culture as well, especially in the fine arts. While in the Middle Ages Czech art had been linked through mutual exchanges with various cultural centres of Central and Western Europe and of Italy, at this time it began to be predominantly orientated towards the south, not only in architecture but also in Court sculpture and painting. This orientation determined most of the architectural works carried out in the Kingdom throughout the whole period of both the Renaissance and the Early Baroque. The fact that the arts were orientated to the south does not of course imply that influence and solutions were accepted in a passive way, even though Bohemia and Moravia were the most receptive of all the countries north of the Alps in adopting the Renaissance style from Italy for their buildings and frequently also for their decoration. The works of architecture and decoration, mainly sculptural, not infrequently followed contemporary or recent models, but of course the results only exceptionally reached the same high level. Faithful though the Czech Lands were to Renaissance Italy, they maintained a characteristic approach of their own, even when taking over complete designs or employing (in most cases) Italian master builders, bricklayers, stone-masons, sculptors and stuccoers. This southern orientation is to be credited, though not exclusively, to the King in whose veins circulated the blood of Maximilian I, a passionate patron of the arts, as well as that of his Romance ancestors. After all, he was not the only monarch to open wide his country to the new style and Italian artists. The first significant symptoms of the Renaissance penetrating beyond the Alps — to Hungary under Matthias Corvinus and Vladislav Jagiello, to Russia under Ivan III, to Poland under Sigismund I, to France under Charles VIII — were all in connection with Royal Courts where Italian artists were summoned and works of art imported. It was only in the painting of the Netherlands and Germany that the great individuals worked their way up to the Renaissance style in an independent development. Nevertheless, the Landshut residence, the first German construction to be carried out which was pure in style, advanced in development and comparable with the architecture south of the Alps, was erected by Italian artists for the Wittelsbach family. A similar situation existed in Bohemia where Ferdinand I could express his inherited liking for art in a material and monumental way, with his buildings and their decoration, whereas his grandfather on his father's side was only able, due to his unsettled way of life, to acquire for himself mostly portable monuments, especially on parchment and paper.

Naturally, the sovereign was not alone in introducing the Italian Renaissance to the lands of the Czech Crown. Many Italian artists and craftsmen had passed through Bohemia and Moravia in the first third of the sixteenth century, i.e. even before the King started his various undertakings there. Unfortunately, the evidence these masters left is very scarce: sometimes a name (the painter Roman the Italian as early as 1502, and Pietro Bulan in Prague, Master Lorenzo, a stone-mason from Milan, with an Italian journeyman in Moravia in 1533), or merely the "Italian" description, as was the case in West Bohemia in 1530 and more frequently in the 1530s in north-east Moravia and in the Silesian regions which had strong ties with Wrocław and the Neisse; elsewhere it was an architectural detail, exceptionally a whole building. Italians appear to have most probably come to the Czech Lands from the south-east, from Hungary — after the Hungarian Court had been occupied by the Turks — as well as from the south At. the beginning of the 1520s, they worked in Austria where they were summoned by Ferdinand to reconstruct the castle and build an armoury at Wiener Neustadt; in the following decade they worked in Innsbruck. In the Czech Lands they were employed by noblemen, by towns, burghers and church institutions. They were given plenty of commissions and so they used to come in groups, mainly from Lugano and the area round it, as well as from places between Lakes Lugano and Como, from Valtellina and Mesolcina, the valleys on the Italian-Swiss frontier; in isolated cases they came from other places in Italy as well. They settled and became naturalized in Czech and Moravian towns, or they were in the King's or a nobleman's service in the summer and returned home for the winter, thus not losing touch with Italian artistic developments. They could not learn much about them in their native mountains or lake communities, but they acquired some knowledge of them in the towns of Lombardy, from Como and Milan as far as Genoa in Liguria, where their families used to seek work; or through their more famous fellow-citizens and relatives who gained reputations for themselves as far away as in Rome and Sicily. Members of these families, where arts and crafts were handed down from father to son, who left their homes for Central Europe were not as a rule truly creative artists; usually they drew inspiration from contemporary theoretical books — the taking over of someone else's ideas was, of course, a general custom at that time. These treatises on artistic theory and practice, which could be found in both the King's and the nobles' libraries, were other, not insignificant, carriers of Italian ideas and models to the whole of Europe, just as illustrated books, pattern-books and prints of various provenances provided models for painters and sculptors. Architectural handbooks by German, French and Netherlandish authors had a considerably cooler reception in the Czech Lands.

The King had the most opportunities as well as the resources to carry out grandiose plans and to obtain capable artists and craftsmen (many of whom also worked outside his Court); naturally, too, opposite cases can be found, namely that the King asked some of the aristocratic patrons, as for example John of Pernštejn in 1537, to lend him their master builders. The works carried out for this enterprising patron of the arts represent a sort of interlude between Vladislav's period and the production linked with Ferdinand's Court. The latter naturally outclasses Pernštejn's undertakings, which are mostly of local significance only, and ranks among the most advanced and remarkable achievements of that time in Central Europe; sometimes it even exceeds its frame, as, after all, only befitted the Court of a land which was still one of the most significant of those the Austrian Habsburgs ruled.

THE COURT OF FERDINAND I AND MAXIMILIAN II AT PRAGUE

Ferdinand was well aware of the importance of Bohemia. True, towards the end of 1533, i. e. shortly after his brother gave him Austria in fee and after he became also King of the Romans, Ferdinand transferred his seat from the old residence of the Kings of Bohemia to Vienna, but he continued to pay as much, if not more, attention to Prague Castle and to the other royal castles in Bohemia as he did to the buildings in his hereditary lands, to the castles at Innsbruck, Vienna and Graz in Styria.

Ferdinand's half Spanish and half Central European origin, his Castilian birthplace and childhood spent in the Iberian peninsula, the Netherlandish education — in which even the famous humanist Erasmus participated — and the many journeys about Europe had contributed to the philological education of the future King of Bohemia as well as to his wide interests in art. He inherited his grandfather Maximilian's delight in collecting and in the arts, which resulted in his renowned collection of coins, antiquities, books and works of art, and in many architectural undertakings; the King was able to indulge in his tastes mainly due to the revenue from the Kingdom of Bohemia.

His building and artistic undertakings in Bohemia, the execution of which he followed step by step, reserving for himself decisions about the smallest details, was much influenced by Archduke Ferdinand, a younger son of Emperor Ferdinand. Ruling in his father's and later his brother Maximilian's stead as viceroy, he negotiated with artists and supervised the realization of the King's ideas. Born in 1529, he was educated with his many brothers and sisters in the Tyrol and related, through his morganatic marriage, to the south German banking family of the Welsers. According to Montaigne he was a *"grand bâtisseur et diviseur"* (great builder and planner). He was a passionate dilettante in architecture, like so many of his aristocratic contemporaries. He designed triumphal processions and arches, small works such as architectural piscines, and sometimes even whole buildings. He systematically kept abreast of theoretical treatises on architecture, as is shown by his library containing first editions of the treatises by Sebastiano Serlio, so significant for the architecture north of the Alps, and works by other authors, such as Alberti, Vignola and Cataneo. More detailed information about his personality as well as about his tastes can be gathered in the Tyrol (among others, from the decoration and the collections in Ambras Château), which fell to him on the division of the Habsburg hereditary lands after his father's death in 1564. It was to this land that the Archduke took his Prague collections, his Czech servants and the architect Giovanni Lucchese and where a painter from Bohemia sent him "histories" (designs?) made for the decoration of the château. Many Czech noblemen were his guests at Ambras; William of Rožmberk even took the château's main courtyard as a model for the painted façades of his castle at Český Krumlov. The Ambras Court was renowned for its pageants, dramatic plays and music; similar cultural activities and social life can also be expected to have taken place at the Archduke's country manors in Bohemia and are documented at Prague Castle.[24] The large incomes allotted to him from the Kingdom of Bohemia he expended on his collections — of rarities, illuminated manuscripts and printed books, works of art, armour, which he already began to accumulate in Prague. Ferdinand even tried his hand at literature; the year 1584 saw the publication of *Eine schöne Comoedi: Speculum vitae humanae* ("A Fine Comedy: The Mirror of Human Life"), which *'ir fürstlich durchlaucht selbst erdacht und gemacht'* ("devised and created by His Ducal Highness himself"). It is to his credit too that the tomb of Maximilian I in Innsbruck was completed (he even followed Alexander Colin's work on the reliefs in the latter's studio) and that the Prague tomb was made by the same sculptor. The Archduke's interests and talents were apparently shaped by the artistic disposition of his great-grandfather Maximilian, which most of his descendants had inherited, by the works of art he had left to his progeny, as well as by his father's tastes and undertakings.

In Bohemia, the interests of the latter are seen predominantly in works of architecture and sculpture, whereas paintings, though often planned, were not carried out at all or were destroyed. There were exceptions here in a number of portraits of the members of the royal family and of the highest officials of the Kingdom from among the nobility — either individual or group portraits, a new form at this time — which were painted by Jakob Seisenegger who worked for many years as a Court painter for Ferdinand I and survived him by only three years. Seisenegger travelled a great deal about Europe: in Austria, his native country, Bohemia, Germany, the Netherlands, Italy, and even in Spain. He thus drew inspiration from various sources which all permeate his works in some way or other. It was certainly no chance that he created the type of a representative full-length portrait of the Habsburgs — as a parallel to the French and Spanish court portraits whose whole collection was housed by Lord Chancellor Vratislav of Pernštejn. This kind of portrayal, which originated in the sixteenth century, became a favourite in many countries north of the Alps and also in Upper Italy. It was in Prague Castle that Seisenegger, a representative of international Mannerism, portrayed many of his clients. Two of his pictures preserved in Bohemia bear witness to the wide span of his production: the portrait of young Archduke Maximilian, of about 1545, is stiff, strictly dignified, firmly enclosed by the outlines, each detail treated in a minutely descriptive manner in a transparently cool atmosphere which enhances the iridescent tones; whereas the portrait of Vratislav of Pernštejn, dated 1558, shows Venetian influence, in particular Titian's, especially in its colours.[25] Naturally, several painters worked in Prague Castle, summoned

from many different areas: from Italy, from Zittau in Saxony or Olomouc in Moravia, from Austria as well as from Wrocław in Silesia or from Cologne. Among them were Giovanni Battista Ferro, Francesco Terzio, Domenico Pozzo and Florian Abel. Still in his father's lifetime, the young King Maximilian brought in a painter from Milan, Giuseppe Arcimboldo, whose fantastic works found a great admirer in Rudolph II.

Ferdinand I's acceptance of the Renaissance was unconditional not only in the sphere of the arts; even his concept and practical execution of the rule and the administration of the country was characterized by a departure from the medieval tradition. However, his efforts at achieving an absolutist reign met in both Austria and Bohemia with resistance on the part of the Estates, whose old rights were being restricted. Ferdinand's orientation to southern art is usually explained by his religious and political attitudes, his faithfulness to Rome, which this Habsburg wanted to demonstrate even in his choice of a style and artists (the German Protestant princes did not begin to employ Italians until the 1540s, and then only hesitant at first), as well as in the fact that this ruler educated in Spain saw his ideas of royal pomp and splendour implemented in buildings carried out by Italian masters. The way of life and culture of that striking country under the Castilian sun had been shaping young Ferdinand for fifteen years and must have left permanent traces in him.

The grandson of Ferdinand of Aragon and Isabella of Castile brought with him from Spain a love of gardens which the Renaissance could express in so many different grand creations;[26] even in Central Europe the Renaissance evoked a liking for nature, particularly for nature shaped and embellished by human hand. The young sovereign founded a garden at the Viennese Court Castle and another at the medieval seat of the kings of Bohemia in Prague. It is characteristic of him, and of the Renaissance man in general, that this was the first significant undertaking through which he entered the history of Prague Castle.

The Castle complex, built centuries earlier on a hilltop, did not offer enough space for a garden within its medieval fortifications. Ferdinand, therefore, had it established outside the Castle moat in the middle of 1534, when he hired Italian master builders after the death of Benedict Ried. It extended over a large area and was connected with the Royal Palace by a new bridge. The gardeners, summoned successively from Italy, Flanders, Spain and Alsace, gradually constructed independent sections in the oblong, slightly sloping, terrain and in the Castle moat — a botanical garden, a herb-garden and a decorative *giardinetto* with exotic plants. Even orange, lemon, fig and pomegranate-trees were imported, for which a wooden orangery and later, under Rudolph II, a brick building were built, perhaps the first architectural orangery in the whole of Europe. The size and appearance of the garden were shaped for several decades until Rudolph's time, other plots and buildings being gradually added: a summer-house, ball courts, a lion-house, fountains, piscinas, a maze, a shooting-gallery, with wooden communicating corridors painted in green. All of them are indicative of the fancies and amusements of the nobility of that time, some of them being significant also from the artistic point of view.

The garden area was originally orientated in one direction and, in the fashion of the Late Renaissance — like many Mannerist gardens in Italy — crowned by a summer palace. From 1538, this was being built at the east end of the garden, at right-angles to the longitudinal axis of the whole ground-plan, in accordance with the dynamic concept of the *cinquecento* and in the centre of a symmetrical, static plan, so favoured by the Early and High Renaissance. The ground-plan of the building is also advanced in style; it resembles Antique temples, especially that of Poseidon in Paestum in southern Italy, which was exceptional in the sixteenth century, and is reminiscent of the portico villa of the old Roman type. As far as we know, an arcaded gallery running all around an oblong building containing a single suite of chambers was something not quite usual in the first half of the *cinquecento*. The Summer Pavilion of Charles V in the garden of the Alcazar in Seville is built according to a similar design, it is true, but the conception follows a central plan; its higher square core is surrounded by a column arcade corresponding to the local Moorish tradition. There was even a group of châteaux with external galleries in France (the most important of them, that of Madrid, was begun in 1528), but of a different origin and shape, the galleries running between turrets, and the edifices being high.

Nothing is known of either the exact appearance or the function of one of the oblong buildings in the game reserve of King Matthias and King Vladislav in the Hungarian Nyék, which was designed similarly, apparently having one storey only. As both the buildings there as well as the pavilion in the gardens of Buda Castle have been destroyed, the Prague Summer Palace is the earliest significant surviving, purely Renaissance garden structure in Central Europe and even one of the first Late Renaissance suburban villas in Europe. True, the arcades in the suburban villa of Andrea Doria in Fassolo in Genoa carried a terrace with a balustrade running all along the south façade as early as 1530, but it was not until the second half of the *cinquecento* that the "Basilica" by Andrea Palladio in Vicenza and the Villa Morosini Cappello in nearby Cartigliano were built with galleries going all round both the ground floor and the upper storey (like the Palazzino della Viola in Bologna). Both these buildings, in particular the villa, also emphasize, in the Mannerist way, the horizontal as opposed to the vertical which was quite usual in Veneto in the sixteenth century (in Bohemia, another structure, modelled on a similar conception, was Rudolph's Summer House in the Old Royal Game Preserve in Prague-Bubeneč). Ferdinand's building suggests this north Italian region also in its opening of the building to nature and in the picturesque play of light and shade which was so appreciated in suburban villas by Sebastiano Serlio, the architect and theorist linked with Venice; his treatises, well-known in all countries north of the Alps, were significant sources of inspiration also for architecture in Bohemia and Moravia. His Fourth Book, published in 1537, provided the architect of the Royal Summer Palace in Prague with the form of the windows and portals derived from Classical Roman architecture. Thus the ideas of ancient Greece and Rome meet here in a form remodelled by the artists of the *cinquecento* of Upper Italy, Venice and Lombardy — with their preference for sculptural décor, delight in columned arcades, balustrades and open-work parapets, i. e. in lightened and picturesque forms.

These elements have prompted Mrs R. Wagner-Rieger to identify the designer of this building with the equally anonymous architect of the Porzia Château in Spittal an der Drau in Carinthia, which was designed about 1533 for the King's confidential adviser, secretary and chancellor, Gabriel of Salamanca. She assumes him to have been an artist from the area of Ceresio in Lombardy, west of Lake Como, who was familiar with Venetian art and capable of complying with the requirements and traditions in countries north of the Alps. It is possible that he did make the plans for the Prague Summer Palace, but certain differences argue against an

identification of the Prague and Carinthian architects. Even though the designs of both these remarkable buildings, begun nearly at the same time and under construction for many years, had the same starting-points, there are essential differences, for example, in the canon of the columns of the arcades as well as in the relationship of the arches to the supports. Besides, in neither case was the original design carried out without any changes. The ground floor of the Prague building was erected according to the original plans between the spring of 1538 and the year 1552 (this slowness being due to the lack of money, the campaigns against the Turks and the fire in the Castle in 1541). To be quite accurate, the ground floor was built according to a model which was made in the winter of 1537—38 in Genoa by Paolo della Stella, an architect and sculptor from Meride on Lake Lugano. It was this artist who took over the supervision of the building works on the Summer Palace in the Royal Garden, after the departure of the first Italian master builder, Giovanni Spazio. His countrymen Giovanni Maria Aostalli from Pambio and Giovanni Battista Aostalli from Savosa had been working under him, and he designed and carved the stone components and the rich cycle of reliefs as well.

Their themes, consisting of scenes from Antique mythology and history, seem not to have been chosen arbitrarily, but more probably as allusions to the patron and his family, whose members from Maximilian I onwards had proudly identified themselves with the progeny of Hercules. Hunting motifs, scenes symbolizing the Classical virtues, the heroic deeds of Hercules, Perseus and Cadmos, and in particular the military achievements of Alexander the Great, were linked here to events from the lives of Ferdinand I and his brother Charles V. The latter's African expedition against Barbarossa's Moslems in 1535 and the liberation of the enslaved Christians which was just celebrated at this time, seem to have been compared here to the military art of the ancient King of Macedonia, to whom the Emperor deliberately likened himself, though in a different sphere. The idealized double-portrait of the royal couple fits into the context of the mythological compositions from Ovid's Metamorphoses, mostly love adventures. It is possible that Ferdinand saw his ideal in the ancient hunter and brave fighter Meleager.

These reliefs, though made by several artists and consequently of varying workmanship, show a substantially similar dependence on patterns; they exhibit a mixture of stylistic elements taken from Classical Antiquity, from the work of Raphael and his school, and from the expressive style of Giulio Romano, all transformed into an original expression. The compositions, with the figures often shifted to the edges from the centre, where they leave a characteristic vacuum, or with a group of figures counterbalanced by a solitary protagonist, not infrequently with a marked diagonal, as well as the expressive over-emphasis and eclecticism, show marked traces of Mannerism in spite of a certain degree of rustication. These reliefs represent the most extensive cycle in Central Europe to have survived and probably the largest executed by Lombard masters in the second quarter of the *cinquecento*. In their brilliant carving, several scenes of this series and particularly the decorative elements with figural motifs are not inferior to contemporary sculpture in Italy, even though the artist, undoubtedly Stella, had to adapt his designs to the unusual medium of the soft local sandstone. This cycle, as is characteristic of Renaissance man, links the glorification of the sovereign and his family with a revival of Classical themes. Unfortunately, the original design of the whole building is not known; for this reason we cannot know for certain whether the patron, a collector of Roman relics, did not perhaps want to erect, in glorification of himself and his brother, a small temple of Classical type, a glorification to which the coats of arms carved and painted on the roof also contributed.

It is not known how the King and his architect had originally conceived the upper storey of this building. Boniface Wolmut, the architect to the Prague Court from about 1555, in co-operation with Italian masters built the upper storey according to a new design in 1556—63. In the Mannerist sense, he impaired the balance of the whole organic structure by burdening the light Ionic order with the heavy Doric one. From the design of Bramante's Tempietto in Rome, reproduced in Serlio's treatise, he adopted the terrace running above the arcaded columned gallery and the system of articulation of the upper storey, with alternating rectangular windows and niches in aediculae. He was perhaps the first in Central Europe to articulate the façades by means of niches, the old Classical motif, even the walls of the hall, used among other things for dancing: its wooden ceiling followed the curve of the roof which was picturesquely bowed in the northern manner. The programme of the painted decoration in the hall — comprising stars, planets and signs of the zodiac — was to have been worked out by an astronomer. (The Archduke's idea, not realized here, was implemented later by Giovanni Battista Fontana in one of the ceilings in Ambras Château, and preceded by a similar theme applied on the vault of the Sala di Zodiaco in the Ducal Palace in Mantua.) The interplay of light and shade was to be enhanced by the use of red and white paint on the roof.

Thus co-operation of a number of artists created in the Summer Palace in the Royal Garden of Prague Castle a work in which Bohemia in one leap made up for the lag in development behind Italy, both in architecture and in sculpture; it even preceded some Venetian achievements. It was a building which faithfully interpreted the ideas of the Italian Renaissance, even of its late stage, and was at the same time one of the most accomplished and graceful structures north of the Alps.

The fountain in front of the Summer Palace, called the Singing Fountain, was inspired by similar creations of the Tuscan *cinquecento*. It was originated in 1562—68 as a result of co-operation between artists of three nationalities: designed by Archduke Ferdinand's Court painter Francesco Terzio, it was cast in bronze by Thomas Jaroš of Brno from wooden moulds carved by the sculptor Hans Peisser, the chasing being a work of the Court sculptor Antonio Brocco of Campione. Similar compositions were known from prints and pattern-books, for example Du Cerceau's work of 1561. The two basins and the connecting shaft of the fountain are adorned by Antiquizing decorative and figural motifs, executed in high relief (Pan, the god of hunting and of springs, a satyr with shepherds, a *genre* bagpiper); they are accompanied by typically Mannerist fantastic forms.

Both these tendencies, the Mannerist and the Antiquizing, interpenetrate in another summer palace, the hunting lodge called Hvězda (The Star), built in the New Royal Game Reserve (founded in 1539) at Liboc near Prague. Both in its function and in its location outside the city, this building was a suburban villa in the Italian sense. Archduke Ferdinand's design was carried out in 1555—56 by the Court master builders Giovanni Maria Aostalli and Giovanni Lucchese, under the supervision of Hans Tirol who was soon replaced by Boniface Wolmut. The latter also designed a ball court, the "gallery", which was erected on a garden terrace below the summer palace and completed in 1558. Due to Renaissance man's preference for centrally planned structures, in whose

Prague — Liboc, plan of the Hvězda Summer Palace in the New Royal Game Reserve

formal perfection he sought security, beauty and harmony (and characteristically in the middle of the century this conception of the Early and High Renaissance found a new expression), the aristocratic dilettante based his design on a regular geometrical figure. By superimposing two equilateral triangles he produced a six-pointed star, perhaps inspired by the star-like plans of ideal fortified towns, so popular at that time. Because of its unusual ground-plan, this building ranks among those fantastic Mannerist caprices which were appreciated for their originality and inventiveness and whose designers paid more attention to formal aspects than to functional ones. Although such buildings were designed in great variety, often with symbolic implications, they were seldom built. A polygonal ground-plan was chosen by Vignola for the Farnese Palace at Caprarola, and by the Viennese Court painter and architect Pietro Ferrabosco — who was also sent to Prague several times — for the Hungarian Kanisza fortress; the French château of Maulnes-en-Tonnerrois was rebuilt into a high pentagonal structure with ancones on the corners, the Citadella in Turin was based on a pentagram, and a star-like plan was used for the town of Hanau built for the Netherlandish refugees in Germany — all these in the second half of the sixteenth century. But Francesco di Giorgio drew his conception of Castel Sant' Elmo in Naples in the form of a six-pointed star already in 1492 and realized it from 1495 on.

In the Prague building, the body of the structure follows strictly the ground-plan on which it is erected, both components being in harmony. The rooms are concentrated round a central hall, as can be found in some centrally planned buildings in Italy (the Rotonda in Vicenza, the Rocca Pisani at Lonigo, Casino di Viboccone in Turin). In contrast to these Upper Italian villas, the hall in Prague is not cylindrical and, above all, not accentuated: it does not go up through the whole building and its cupola does not form a dominant feature of the structure. It is polygonal, occupying only one storey on each floor, being, therefore, of the same importance as the other rooms. In this spatial co-ordination the Hvězda Summer Palace differs from the centrally planned Baroque buildings, too, some of which it influenced. Its individual elements are also Mannerist: the hall opens on to relatively long corridors through the axial windows of which the interior space seems to mingle with nature outside. And each chamber, placed in a point of the star and separated from each other by the corridors, is, owing to its rhomboidal ground-plan, a sort of dynamic, post-Classical centrally planned space. In the basement, by contrast, the rounded core is ringed by a "gallery", and impressive vistas disturb the integrity of the individual spaces; this complicated lay-out surpasses even the basements of the Italian villas. Mannerism is also to be seen in the contrast between the deliberately austere exterior and the profusely decorated interiors, an effect of surprise so appreciated by the Mannerists; the stuccoes of the ground floor, too, are conceived in the Mannerist way.

This stucco decoration, carried out in 1556—60, is the work of unknown Italian stuccoers; one of them may have been the sculptor Antonio Brocco, who was active in Prague for many years and, as the Archduke's stuccoer, perhaps in the Tyrol as well. The Antiquizing style is consonant with the themes taken from Classical history and mythology, of which the Mirror of Virtues on the vault of the hall was composed, to be seen in the lay-out of the stucco fields, their framing and the composition of the scenes against an abstract background. It also shows itself in the relationship between the form and the size of the surface, in elongated figures, in rendering of drapery and ornamentation (acanthus tendrils, festoons, plant motifs, terms, masks, the latter two being favoured by the Mannerists as well). It is a style akin to Classical Roman stucco of the first and second centuries. Stucco decoration *alla romana* was relatively frequently employed in Italy in the *cinquecento* — and the sculptors, largely from Raphael's school, also brought it from Rome to Mantua, Genoa and even to Venice; nevertheless they were not usually inspired by Antique stucco of the delicate monochrome type (with slender frames and forms scattered sparsely on the white vaulting) to be found in that group of Classical buildings, whose technique, manner and spirit were so successfully hit off by the artists in the Hvězda, an isolated achievement in the Czech Lands. Moreover, they created one of the earliest, most coherent and brilliant stucco cycles beyond the Alps.

The patron who commissioned the château at Nelahozeves, Florian Griesbeck, who was connected with the Prague Court, chose similar themes and compositions for the vault of one of its chambers shortly afterwards, probably in the early 1560s; however, the scenes there are more massive, although they, too, are reminiscent of some works, particularly reliefs, of Imperial Rome and although the sculptor, undoubtedly one of the Prague group, was also able to grade the relief of the forms from fully developed to the merest suggestion and thus to produce an impression of spatial depth, without using a perspective construction. A connection between Ferdinand's building and these stuccos is seen in the same technique, in the similar themes and compositional patterns, as in the manner of framing the fields, either by festoons or frames with consoles illusively increasing the depth of the coffers. Coffers with consoles, common in the Italian *cinquecento*, were also employed in the Hvězda, yet there, mainly in the corridors, the system of the articulation of its vaults with a complicated pattern of variously shaped frames tallies with the ancient designs preserved in Hadrian's villa in Tivoli or in the "Basilica Sotter-

ranea" near the Porta Maggiore in Rome. The system of coffers at Nelahozeves hollowed out between continuous beams was derived from another type of Roman vaulting, known as *lacunare,* represented mainly by the Pantheon and modified in many variations in Veneto. The stuccoers summoned to Prague knew both systems and were the equal of their colleagues working in Italy.

But this was not the only way in which the Antiquizing style showed itself in Bohemia. The first to choose this style for architecture was the owner of the Nelahozeves estate, secretary and later counsellor of Ferdinand I, Florian Griesbeck of Griesbach, in contradiction to the other courtiers who drew on quite a different Italian source. A native of the Tyrol, Griesbeck attained an important position in the state administration of Bohemia from the early 1530s. He settled down permanently in Bohemia, and his many children became naturalized there. From the fortune he gained there, this "patron of the Muses", educated at Paris University, had several residences built in his new home, and two of them, the châteaux at Kaceřov and Nelahozeves, were noteworthy as regards ground-plan and style.

Lord Florian Griesbeck had the château of Kaceřov reconstructed out of a castle-fortress from the beginning of the 1540s till the end of the 1550s as a massive enclosed quadrangle near a little village in the seclusion of his West Bohemian estate. In both its massive block and its location, this building is nearer to the conception of a medieval fortified castle than of a Renaissance château which used to be integrated into its dependent town; this impression is supported by the corner bastions and sgraffito rustication, optically strengthening the façades. In contrast, the design of the building as a whole as well as of the arcades shows an advanced style. In accordance with Late Renaissance practice it is designed with the depth axis predominating. This is emphasized by the concentration of the mass in the bastions at the corners of the entrance wing, by the elongation of both the block and the court-yard into a rectangle, by the location of the gateways on the axial line into the two shorter wings and by situating the arcade on the upper storey in the side wings only.

In the countries north of the Alps, this general design, to some extent, has a precedent in Porzia Château in Spittal an der Drau, including the entrance hall with arcades opening into the court-yard (the same lay-out, also with loggias in the side wings, can be found in the palace of the Rožmberks, built almost at the same time in Prague Castle), and has a successor, too, in the Valdštejn (Wallen-stein) family Château at Dobrovice, built in the 1570s. But the type of arcade used at Kaceřov has no precedent in Central Europe. It is a Classicizing system combining arched pillars with half-columns supporting entablature which was used in Classical Rome, mainly in the Imperial period, above all on triumphal arches and theatres. This system was later adopted, not without the influence of the Florentine Proto-Renaissance and Vitruvius, by artists of the Italian *quattrocento,* in particular by L. B. Alberti and by designers of some of the Roman arcaded buildings. From about 1530, Falconetto, Sansovino, Sanmicheli and later Palladio introduced it in Veneto, where it was, however, also known from ancient times in Verona. The spread of this classical structure, codified by Vitruvius, was considerably helped by Serlio — an artist from Bologna who worked in Venice and later in France. His eclectic treatises with their repertory of motifs familiarized the transalpine countries with contemporary solutions — among others with corner bastions — as well as with many of the monuments of Classical Rome. These treatises were followed by prints of Andrea Palladio published, however, after the Czech château

had been completed; in addition, Rivius's German translation of Vitruvius was published in 1548.

For the upper storey of Kaceřov Château its designer, unlike Vitruvius, chose a light column arcade belonging to another cultural region, mainly to the Tuscan Renaissance whence it penetrated into Lombardy, Liguria, Veneto and other areas, including Rome. The combination of these two systems, so different, is completely subjective. Perhaps the architect has here exaggerated his efforts to depict the supporting and the supported elements — i. e. the tectonic principles of the architecture — usually expressed by the classical gradation of the superimposed orders; but he has emphasized the function of the supporting system in an almost Baroque way, for the column loggia is too light a burden for the massive system of the ground floor. Or it was the patron's delight in multiformity, in the combining of different components, that asserted itself here, a delight which stamped his other commissions as well. With its dynamic ground-plan, Classicizing arcades and the other formal elements, this château of Griesbeck's is among the most advanced examples of mid sixteenth century architecture in Central Europe. Chronologically, it precedes Ferdinand's under-takings of this kind at the Viennese Court (Schweizertor and Stallburg), the Classicizing arcades of the Diet House in Graz and the façade of the Ottheinrichsbau in Heidelberg, which is markedly Mannerist in style. This style showed itself in other Classicizing works in Bohemia as well. At Kaceřov Château it can be seen, for example, in the design of the portal and the gate, contrasting rustication with the smooth shafts of the columns (unstably balanced on high plinths) and thus combining, in the Mannerist sense, "the work of nature" with "the work of human hands".

A system of arcades of various types and origins is also characteristic of the connecting wing built in the courtyard of the château at Kostelec-on-Černé Lesy. Its history has not as yet been authori-tatively established, but this relatively monumental three-storey building was apparently erected when the estate was still in the possession of the Czech Chamber and when the older building was being extended for Ferdinand I; this was in the 1550s, before the château was bought by Jaroslav of Smiřice in 1558. The latter completed and rebuilt it into a four-wing block with cylindrical corner towers, obviously influenced by the Italian *castello.* He also added a terrace with a loggia, again decorated with carving, and a small château church which has Renaissance vaults and fittings, but a polygonal apse and traceried windows, as in nearly all transalpine sacred buildings of the sixteenth century. The former splendour of this residence of Jaroslav of Smiřice, who attained high posts in Ferdinand's service, is attested by old records and by various details such as the hall lighted from both sides with semicircular headed windows and the front facing the orchard beyond the ramparts. Its last storey is decorated by a blind arcade with pilasters (columns were flattened to this shape already in the Early Renaissance), bearing Mannerist features. These are also visible on the courtyard loggia. It is a combination of rusticated arched pillars, which were popular in Veneto, with a Classicizing type of arcade on the second and a columned gallery on the third storey, treated in an accelerated rhythm, frequent in Bologna. If this arcaded coulisse really dates from the middle of the century, then it is contemporary with and akin to similar compositions in Veneto, mainly by Jacopo Sansovino and Andrea Palladio (the inorganic addition of the last floor being left out of consi-deration); analogies can be found in the drawings of Serlio's treatise, too. A pillar arcade was also designed at that time by Paolo

della Stella for the castle at Brandýs-on-Elbe — one of the royal châteaux, which were being rebuilt into hunting seats for the king[27] — again in combination with a columned loggia on the second storey, and shortly afterwards by Griesbeck's master builders at Nelahozeves.

Of greater significance are the buildings which Ferdinand I had erected at Prague Castle from about 1556 onwards. This was after an interval during which only those parts were repaired which were destroyed in the fire of 1541. The fire had considerably damaged the complex of the Castle as well as the Lesser Town. After the sudden death of Paolo della Stella (1552) and the not very significant activity of Hans Tirol who supervised the works at the Castle as well as on the royal estates in the 1550s, the King summoned Boniface Wolmut from Vienna and entrusted him with the office of Court master builder. Wolmut held it, with a short break, until 1570; but he did not stop working even after this date and remained faithful to Prague till his death at the beginning of 1579. Born in Ueberlingen in Baden, he had, it seems, already shown his skill in Ferdinand's residence in Vienna (evidence of his presence in this city dates from as early as the 1530s); nevertheless, neither his works nor those of other local master builders of that time have so far been reliably identified.

In Prague he was immediately given several important tasks. The artist was able to approach them equipped with his knowledge of stone-masonry and the Gothic ribbed vault, as well as of the scientific literature of the time. (In his knowledge of stone-masonry he resembled his famous contemporary Palladio; and he approached the latter also in the solutions he arrived at in the 1550s and 1560s, though these were not on such a high creative level.) This skilled stone-mason possessed a great number of books, some of which, when still in Vienna, he had translated into German at great personal expense; apart from pattern-books, these were treatises

Kaceřov, plan of the Château

on mathematics, astronomy and astrology, among others some by Girolamo Cardano, the mathematician and natural philosopher. The surviving fragments of Wolmut's library testify to the fact that like his Italian and French colleagues, he followed both classical and contemporary intellectual currents which, according to the views of that time, were significant for architecture. These intellectual currents often represented fantastic combinations of Neoplatonism with hermetic, cabbalistic and alchemistic theories which bordered upon heresy; combinations in which scientific findings of the astronomers were linked with the magic of numbers and the mysticism of harmonies based on musical relations; combinations interpreting cosmological conceptions. Many a theorist or adviser invited to work out a programme of a planned architectural design, relied on such medleys of ideas. The preserved volumes which Wolmut acquired at the expense of his own personal welfare, also provide evidence of the fact that artists working in the Czech Lands were acquainted with the latest topics in the learned world of that time. This was not a privilege restricted to the commissioners, educated members of the aristocratic families and bourghers-humanists, from whose residences collections of books have come down to us.

Apart from the above-mentioned work on the royal summer palaces and the adaptations of the Castle, Wolmut was given other important tasks in Prague. In order to get these commissions, however, the master had to compete with Italian artists who had been working for the Prague Court for many years. The King decided to reconstruct the Diet Hall and some of the rooms abutting onto the Vladislav Hall in Prague Castle, also to erect an organ-loft in St Vitus's Cathedral. For the latter Wolmut made a design at the end of 1556; work on it continued till about the autumn of 1560; the completion is recorded in the summer of 1561. Master Boniface built the loft between two Gothic pillars against the wall temporarily closing the choir of the uncompleted Cathedral on the western side. He adjusted the vaults of his structure to the style of the Cathedral. But before the space of the loft iself, still conceived in Late Gothic style, was placed a monumental coulisse consisting of a Classical façade. It was the first time in the Czech Lands that a system of orders was applied in superimposition as formulated by Roman Antiquity and adopted by the Italian Renaissance. The latter, as was stated by L. B. Alberti, saw in the columns applied to the wall (represented by a pillar) an "ornament", a decoration of the building. In this structure Wolmut produced a work which in its time was well abreast of developments in Italian architecture.

True, his design was possibly influenced by Palladio's book on ancient Rome which was published in 1554 and doubtless by the Third Book by S. Serlio; the latter's reproduction of Marcellus theatre provided Wolmut with the basic compositional scheme as well as with an example of the Classical gradation of the orders. (This Roman theatre was also an inspiration for Sansovino in building the Garzoni villa at Pontecasale, and for Palladio's arcades in the Convento di S. Maria della Carità in Venice, begun a little later than the Prague loft.) But Wolmut did not copy the model slavishly; he worked with the *licenza*, which was required by Serlio and Palladio in artistic creation, as well as with the *ars combinatoria* appreciated at the time. In opposition to the principles of Roman architecture — following the spirit of Venetian picturesqueness — he designed open-work parapets popular throughout the *terra ferma*, and vegetable motifs for the friezes (not executed). He also emphasized the importance of the upper storey by plastic elements, as was often done by Palladio. But that

was not all. By placing a massive half-column above the flat, optically "weaker" pilaster of the ground floor, he impaired the true tectonic function of his orders (the heavier Doric or Tuscan order carries the lighter Ionic one). And this he did deliberately. The infringement of the basic tectonic rules of architecture — evoking a sense of instability of the whole structure and shocking the spectator — was one of the manifestations of Mannerism. Other architects too outweighed the mass of the ground floor by superimposing a more plastic storey. Peruzzi on his Palazzo Massimi in Rome, Sansovino on the Dolfin Palace in Venice, G. Alessi on the façade of the Church of S. Barnaba in Milan, Count Palatine Ottheinrich on his wing of the castle at Heidelberg, or the designer of Kirby Hall in England. Also showing a Mannerist tendency are the efforts at a gradation of effect and the protraction of the supports, corresponding to the figural canon of the Mannerists; this tendency is also apparent in the deliberate contrast of two styles (their combination, also applied on sacred buildings, was planned even by the foremost architects of Mannerism, Peruzzi and Vignola, and carried out by Giulio Romano), and finally in the construction of the coulisse which does not coalesce with the structure proper. All this and its monumental conception give this small work a place of honour in the development of architecture in Central Europe.

The big organ which crowned the loft has, unfortunately, not come down to us. Its front (apparently Classicizing again) was gilded by the Archduke's painters Hans Getschingen (Goldsching) and Francesco Terzio, who also carried out the painted wings in 1560—63. Among his other recorded works in Prague are three portraits of Queen Anne and the design of the fountain at the Summer Palace. Also the façade of the loft was decorated with painting. But the remarkable design preserved of the frescoes of one of the chapels of the Cathedral, that of St Sigismund, presumably by an Augsburg artist (Hans Tirol presented it to Ferdinand in 1553), was not carried out; wall-paintings were made in this Chapel, but by a local hand, and not until the end of the century. The massive southern tower of the Cathedral was completed by Wolmut in 1560—63 during the reconstruction of the Cathedral after the fire of 1541.

Similar principles, as were used on the loft, marked another of Wolmut's buildings from these years, namely the Diet Hall of the Castle. At the end of 1558, or the beginning of the following year, Master Boniface worked out a design for the reconstruction of the Late Gothic room, also damaged by the fire, and a new vault. At the same time he designed an extension — from the Riders' Staircase to the courtyard of the Palace — and made a plan for raising the whole wing adjoining the Royal Palace and its Vladislav Hall on the northern side. His design won over a counter-project by Italian masters who had it worked out by painters; the latter also drew in the scheme of the decoration. The conception of the Italians, combining niches and half-columns on the walls with a Renaissance lunette vault, was purer in style and more articulated, it is true, but Wolmut's historicizing design achieves a more imposing effect. Boniface Wolmut intentionally likened this hall to the adjoining Vladislav Hall; by the complicated ribbed vault he wanted to compare his abilities with those of his predecessor, Master Benedict Ried, for whose post (in the Prague Castle lodge) he had applied after Ried's death in 1534. Wolmut's design was appreciated by the Emperor and the Archduke, as well as by two Italian experts sent from Vienna to judge the model and estimate the expenses at the end of January of 1559. "Sarà tutto bene e bona opera" was their comment. The master builder

completed the vault on September 5th, 1563; the interior was not, however, completed until the following year, although he used the masonry and two rectangular windows of the old building, to which he adapted three new ones.

The vault is, of course, a Gothicizing one only; its construction is Renaissance in technique, and the dense net of intersecting ribs, hung up on the vaulting in several places, is only decoration. Renaissance also are the round windows, by which Wolmut wanted to achieve better lighting of the vault, the Tuscan pilasters and two big consoles with long volutes between which Wolmut and the stone-mason proudly placed their busts. This was not only a manifestation of the self-confidence of the Renaissance artist. The master builder regarded this ambitious work as evidence of his superiority to his Italian colleagues at the Prague Court, and as his epitaph, as he said himself. It was very probably Wolmut who in 1575 — towards the end of his life — also vaulted the nave of the Gothic Church of the Augustinians at Karlov in the New Town of Prague. In its technical and artistic treatment, this is a no less ambitious vault; of a Renaissance construction again, it extends broadly over the centralizing octagonal plan, carrying a net of ribs which form a star[28].

In the Old Diet Hall the contrast of Gothic and Renaissance forms was to be enhanced by other elements as well. Wall-paintings, to be carried out by Domenico Pozzo, were to render the series of Ferdinand's predecessors on the Royal throne of Bohemia, and there were to be some scenes on the vault, unfortunately designated as "histories" only. Pozzo, who came from Valsolda near Lake Lugano, and decorated many churches in his native region, made the designs in 1563. The following year he intended to go to Italy and bring back some assistants, but the sketches were never carried out. Nevertheless, the intended contrast between the stylistic forms and views was attained quite markedly in the hall by the tribune for orators and scribes. (Wolmut had already planned it when working on the design of the room, but it was not erected until the Old Diet Hall was being completed, from the autumn of 1563 till the spring of 1564.)[29] In its logical construction, corresponding to the rational tectonic principles set down by Greek and Roman Antiquity, it represents a direct opposite to the arbitrary, imaginative sweep of the remarkable Late Gothic tissue of ribs, which moreover has only a decorative function here. This tribune — originally an open pillar arcade with Ionic half-columns carrying a high entablature — resembles in its conception not only the upper-storey arcade of the St Vitus's organ-loft, but other works by Wolmut as well. The seriousness and loftiness of the coulisse in the Cathedral are substituted here by refinement, almost decorativeness, which can be appreciated because of the small size of the whole, making it accessible from a short distance. The structure is derived from the ancient Roman architecture in its conceptual scheme as well as in its individual components, but transformed in a manner approaching the Venetian conception. Venetian artists designed smaller structures in a similar way: Sansovino his Loggetta or Palladio the five-axial public loggia he drew. (Several details of this wing of the castle are influenced by Veneto, moreover, for example the twin-windows divided by a central column.) The prototype of all these compositions was, of course, the triumphal arch of Imperial Rome.

This affiliation is even more markedly suggested by the northern façade of the Large Ball Court which was built by Wolmut in 1567—69 above the moat near the Summer Palace in the Royal Garden, parallel with its main axis. (The uni-directional disposition of the garden area was thus changed into a cross-plan.)

35 Portrait of Maximilian II in Boyhood, by Jakob Seisenegger. Oil on canvas, 188 × 84,5 cm, about 1545, Picture Gallery of Prague Castle, Prague.

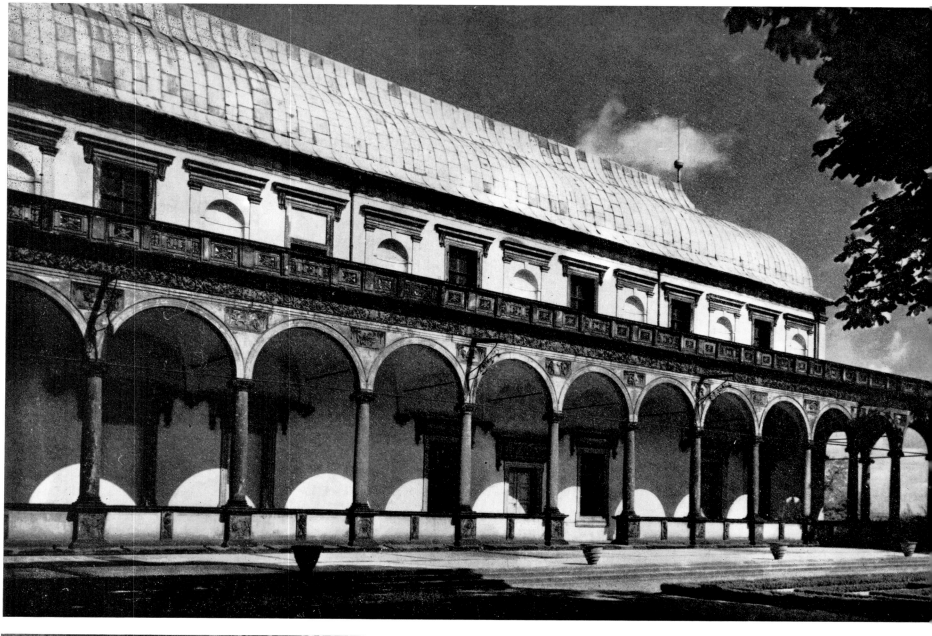

36 Prague — Castle, The Summer Palace (Belvedere) in the Royal Garden. Ground floor from 1538—52 on the model of Paolo della Stella, the upper storey from 1556—63 to the design of Boniface Wolmut.

37 Prague — Castle, The Summer Palace in the Royal Garden. Ferdinand I, detail of a relief.
◄

38 Prague — Castle, The Singing Fountain in the Royal Garden, to the design of Francesco Terzio from 1562, cast by Thomas Jaroš in 1564—68 ▶

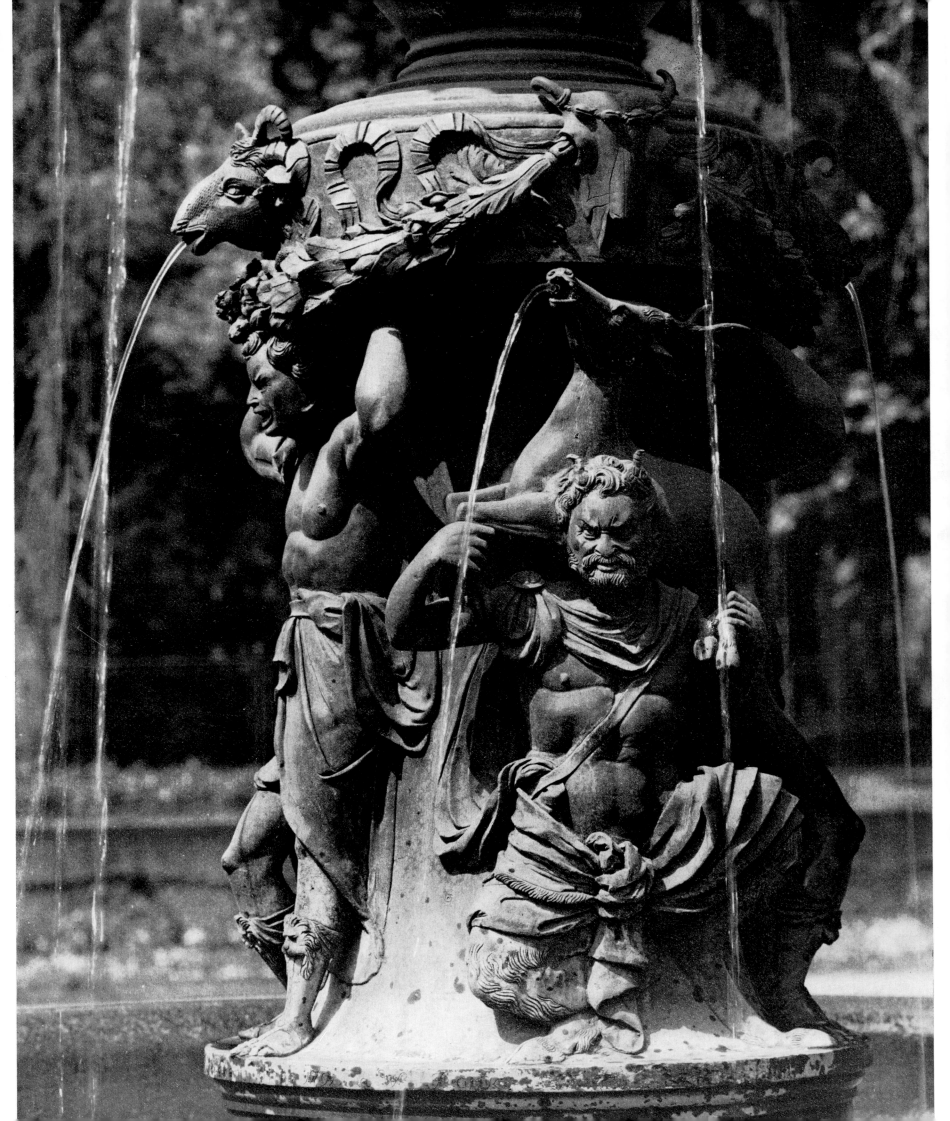

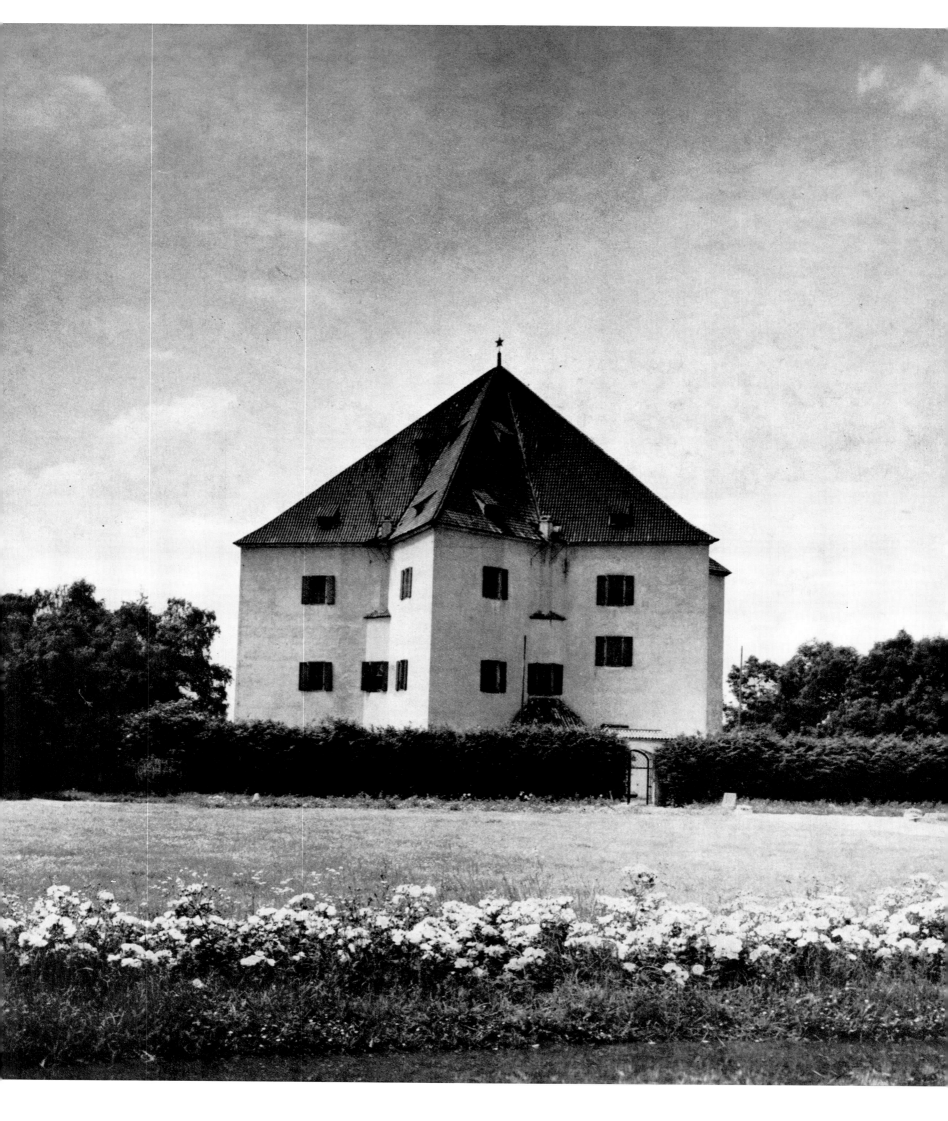

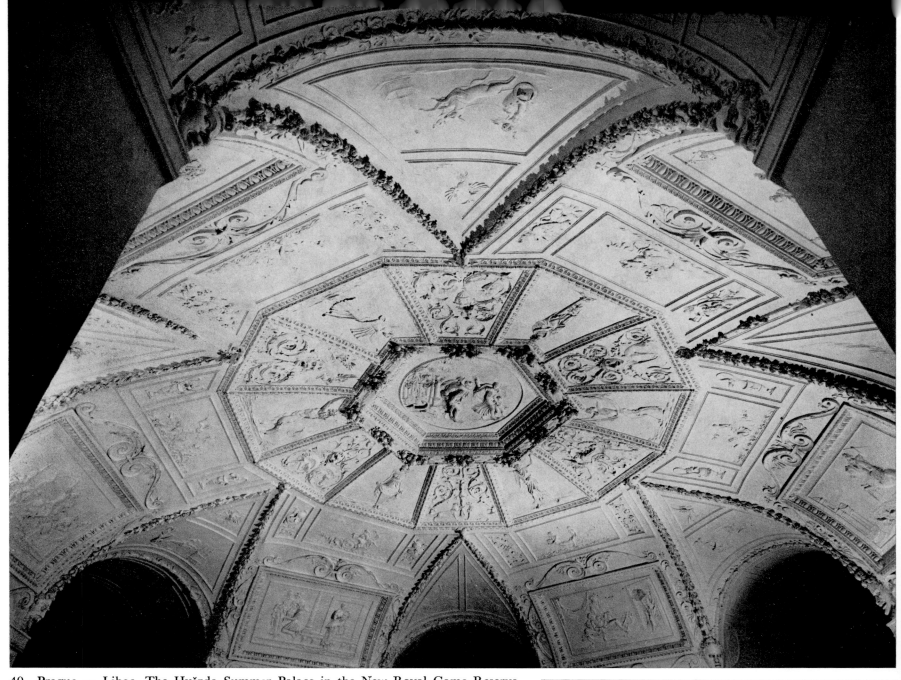

40 Prague — Liboc, The Hvězda Summer Palace in the New Royal Game Reserve, vault of the central hall on the ground floor, stucco from about 1556—60

41 Prague — Liboc, The Hvězda Summer Palace in the New Royal Game Reserve, detail of the vault of a corridor on the ground floor ▶

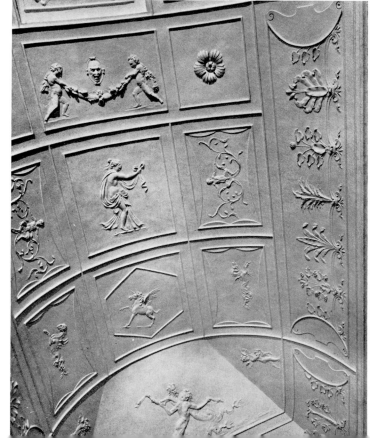

◀ 39 Prague — Liboc, The Hvězda Summer Palace in the New Royal Game Reserve, 1555—56, to the design of Archduke Ferdinand of the Tyrol

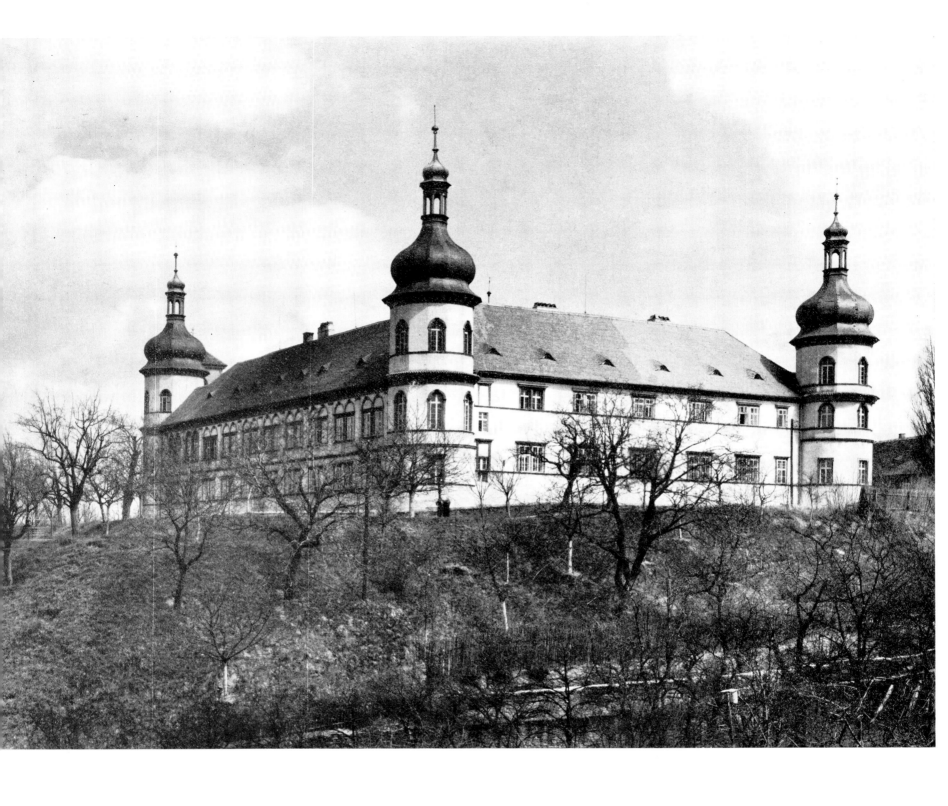

42 Kostelec-on-Černé Lesy Château, 1549—58 and the 1560—70s. (Baroque reconstruction in the 2nd quarter of the 18th century.)

43 Prague — Castle, The Large Ball Court in the Royal Garden, by Boniface Wolmut, 1567—69

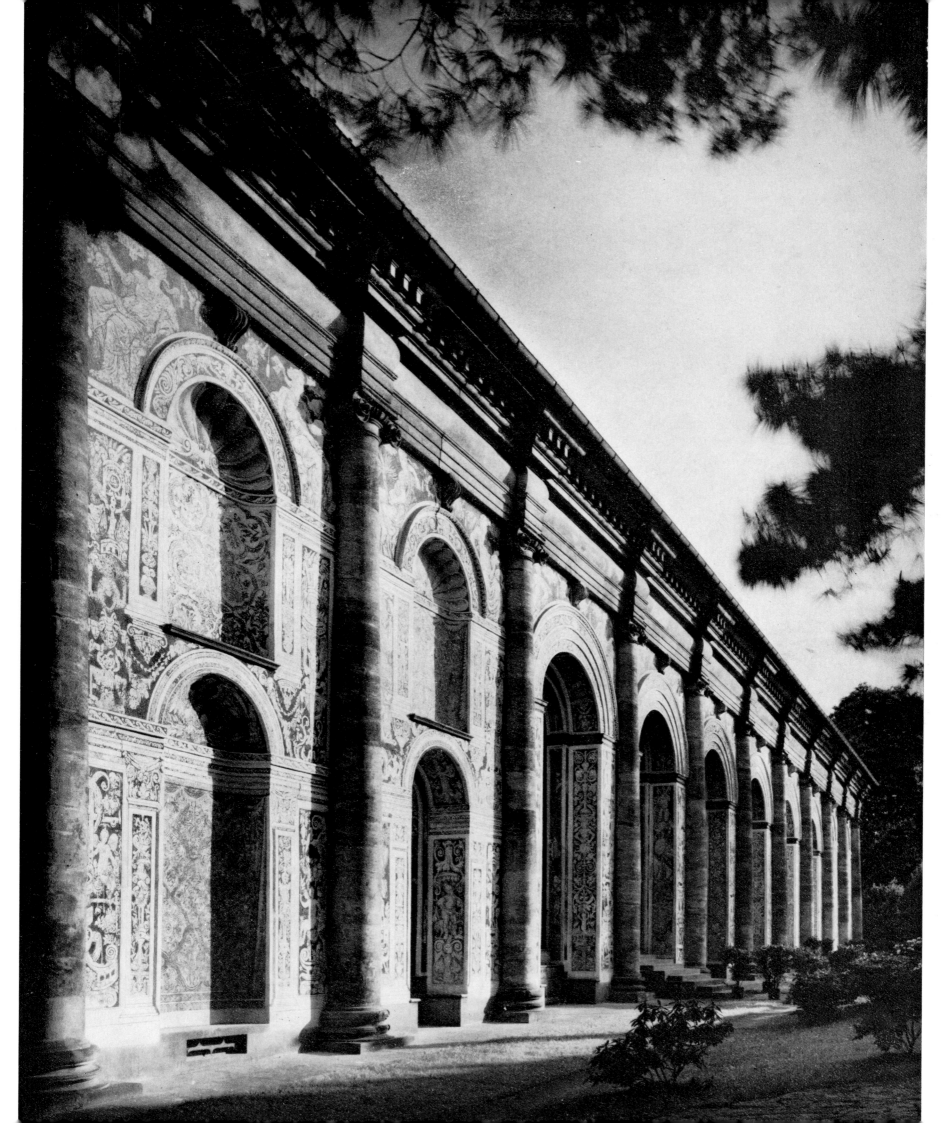

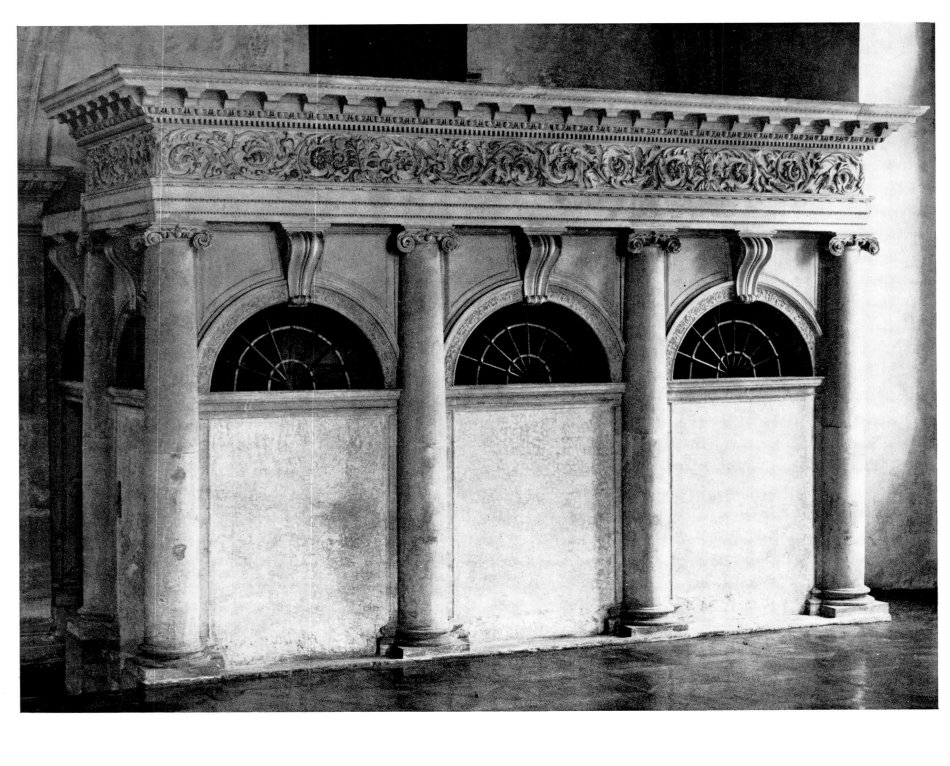

44 Prague — Castle, Orators' Tribune in the Diet Hall in the Royal Palace, by Boniface Wolmut, 1567—69

45 Prague — Castle, Organ-loft in St Vitus's Cathedral, by Boniface Wolmut, 1556—61

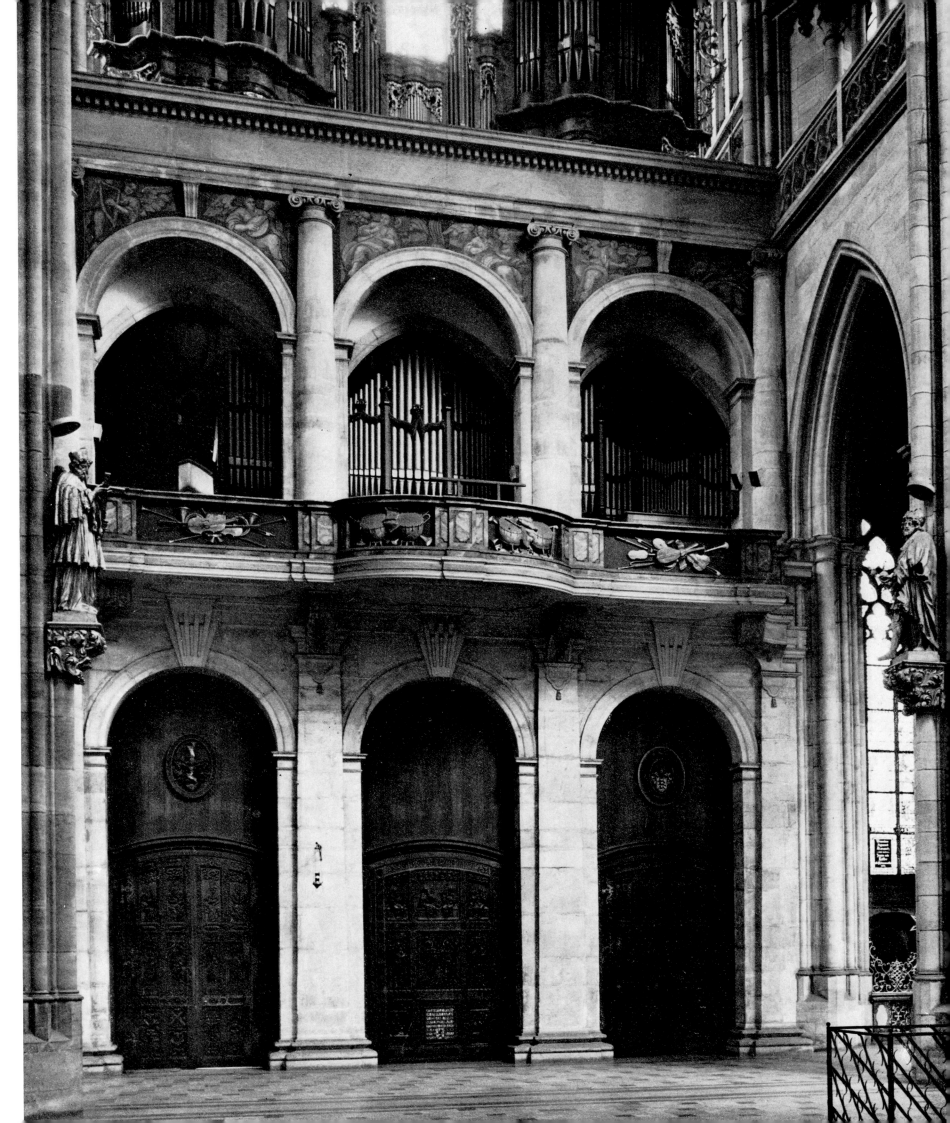

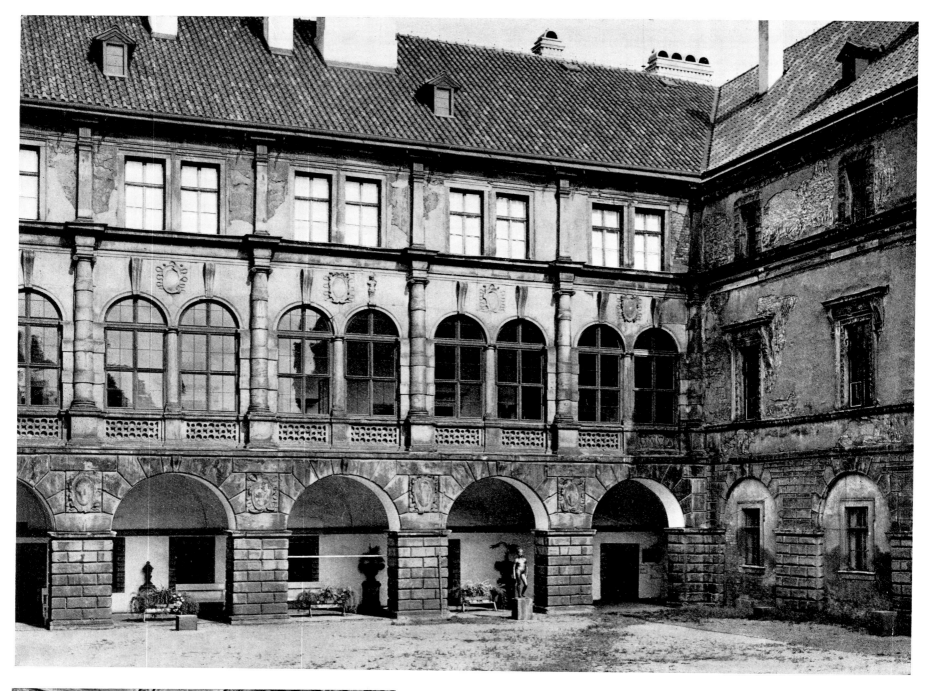

46 Nelahozeves Château, the arcade of the north wing, probably by Boniface Wolmut, after 1560

47 Nelahozeves Château, a room in the north-east bastion, perhaps about 1564

48 Kralovice, the Church of St Peter and St Paul. The west and a part of the south façades, Renaissance reconstruction in 1575—81, probably to the design of Boniface Wolmut. ▶

49 Kralovice, the Church of St Peter and St Paul, the nave ▶

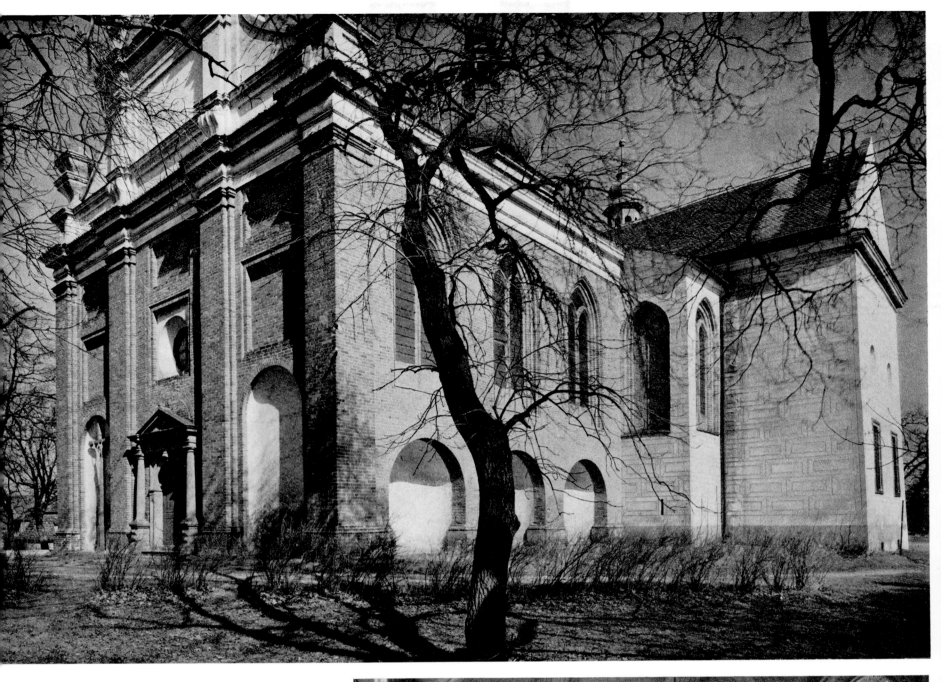

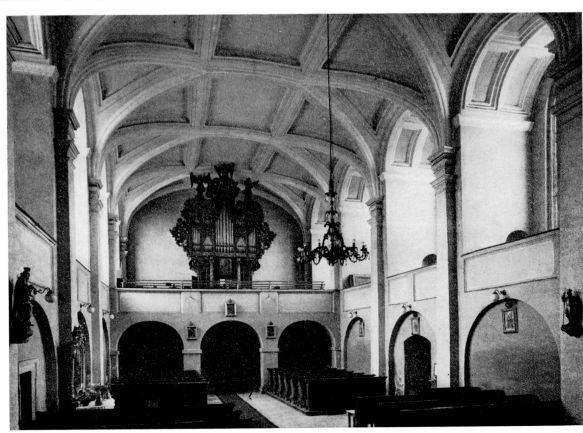

50 Prague — Castle, sepulchre of Ferdinand I, Anne Jagiello and Maximilian II in St Vitus's Cathedral, by Alexander Colin, 1566—89

Wolmut built it roughly at the same time as the Small Ball Court, completed in 1567. (This building used to stand in the front part of the garden and we can get an idea of its appearance from the mention of the "*Palnhaus mit etlichen Zimmern*" and a drawing from the eighteenth century.)

This took place under the new ruler Maximilan II, who ascended the throne at the age of thirty-five when his father died in 1564. This king, who was religiously more tolerant than Ferdinand, was only a rare guest to Prague. Educated together with his siblings in the Tyrol, he married Maria, daughter of Charles V and sister of Philip II in Madrid in 1548, and resided mostly in Vienna. He was educated in humanistic thoughts and knew seven languages, but was attracted not only by Antique monuments which he eagerly collected but also by the natural sciences. In Vienna he kept exotic animals, including an elephant, and birds, and grew exotic plants brought from as far as Constantinople. He was especially taken up with the construction of the large summer palace Neugebäude. It is, therefore, not surprising that he left his mark in Prague in a monument of garden architecture. It is not known when the Large Ball Court was conceived. (His father had already planned to build a covered *curator* for Spanish ball games in April of 1563, but he postponed it owing to some other works which were under construction.) If it was designed under Maximilian, then this was scarcely without the initiative of Archduke Ferdinand, who sojourned in Prague until 1567 and certainly took part in deciding on its appearance and style.[30]

The oblong block, vaulted by a barrel vault with lunettes and containing a tribune for the spectators, was built pre-standing by the coulisse of the northern façade, which again is an independent organism. This is indicated, among other things, by the Wolmutian frontally conceived capitals of the corner columns, a detail which had its forerunners in the organ-loft as well as in the tribune in the Old Diet Hall. The Classicizing formation of the powerful pillar arcade with half-columns running up the whole height of the façade and carrying an entablature with projects above them and with a moulded frieze, a design adopted from triumphal arches, was combined with another motif derived from the Roman architecture of Imperial times, namely the solid sections at both sides of the façade, notably doubled here. Their recesses and niches above them evoke an impression of two storeys, and give the columns a monumental stature — in the sense of Italian Renaissance (which used it, as a rule, to connect two real storeys) from Alberti through Raphael, Sangallo, Michelangelo, Peruzzi, to Andrea Palladio. The whole of this system is affiliated to Palladio, to some extent, although it originated before his famous Four Books were published. Thus Boniface Wolmut was one of the first in Central Europe to use the colossal order which was relatively rare in this area at this time. He was preceded by the Italian designers of the residence in Landshut and by the Palace of the Count Palatine Ottheinrich at Heidelberg; but in the façade of the latter building, overburdened with articulation, the colossal pilasters and the half-columns do not stand out so markedly as on the Ball Court in Prague.

In this work Wolmut created not only a model for the numerous later solutions in Early Baroque style, but also one of the most remarkable compositions of transalpine Classicism of the middle of the sixteenth century, which is even suggestion of Palladio. It is a composition in which Mannerist tendencies manifested themselves again in a distinctive manner: by the emphasis on the horizontal in the conception of the whole building, by the central opening and the concentration of the mass on the sides, by the coulisse of the façade, by the pretence of two storeys as well as by the protracted canon of the columns and some other details. This Mannerist transformation of Classical concepts links it with the other works by Wolmut, particularly with the St Vitus's organ-loft and the Ball Court near the Hvězda Summer Palace; from the flat treatment of its façade (the regularly alternating arcades and niches of the same height are separated by flat framing strips) the architect arrived in the ten years separating the two buildings at a more dynamic conception, emphasizing the three-dimensionality of forms.

Also subject to the Mannerism is the decoration of the façade of the Large Ball Court. The painters covered the surface of the walls and the archivolts with a dense tissue of tinted sgraffiti. Motifs of fantastic grotesque scrollwork predominate. (The Netherlanders — especially Cornelis Floris and after him his namesake Bos and others — had been ingeniously composing complicated patterns of strapwork from the 1540s onwards.) These were interlaced with fruits and festoons and enlivened by figures of people, fauns and animals trapped in the labyrinth of the winding forms. The sgraffito-workers used motifs from pattern-sheets — by Jakob Floris,[31] Cornelis Bos and probably by other countrymen of theirs — and combined them into new ensembles with considerable freedom. In the same way they drew creative inspiration from graphic patterns (including the series The Liberal Arts by Frans Floris from the 1550s) for the cycle of allegories of the Elements, the Liberal Arts and the Virtues in the spandrels round the archivolts. These figures seem to be treated with good workmanship, but only torsos have come down to us, and those in a state altered by later restorations.

These sgraffiti were Mannerist not only in their world of images and forms, but also in the manner of their application. By their dense interweaving they seem to conceal, if not directly negate, the massiveness of the wall, this basic component of Renaissance architecture. As a result the stone half-columns stand out all the more, with the sgraffito creating a sort of lace curtain behind. It is not a manifestation of northern misunderstanding of or indifference to pure architectural forms. The same process of visual "corrosion" of a wall and sometimes of the whole system by sgraffito decorations, often too profuse, was applied at the same time also in Italy, more precisely in Tuscany, on the projects of one of the outstanding Mannerists, Giorgio Vasari and his circle. This technique of Italian origin became incredibly popular in the Czech Lands. It is not known whether the idea of such an embellishment of the monumental structure of the Prague Ball Court should be ascribed to the patron or to the architect. In any case, the result is an encounter of two contrasting worlds of art: of the strictly logical system of Classical Rome, transformed in the Mannerist way, and of the unfettered imagination of the Netherlands, which, in its turn, also drew on the motifs bequeathed by Antiquity.

Many different stimuli lay behind the conception of another country seat of Florian Griesbeck which is in many respects related to Wolmut's production, namely the château at Nelahozeves, looking down from a hill on the Vltava river. Its probable building history can be surmised up to a point on the basis of the appearance of its parts. The three wings of the château rose gradually from 1553 onwards: the east one with a rusticated pillar arcade and high windows in the *piano nobile* in about 1554—58; the northern wing with a complicated loggia from about 1558 until the middle of the 1560s; the west wing seems to have been built after the project had been changed, apparently in the 1570s. Works on the completion of the whole can be followed until the beginning of the

seventeenth century. Thus a Late Renaissance, or rather Mannerist, three-wing structure arose. The organism of the building, usually closed in the Early and High Renaissance, opens into the surrounding nature, the barrier between the courtyard and infinite space being removed. Such three-wing dispositions were more frequent in France; but they were not unusual even in Italy or, surprisingly, in the Lands of the Bohemian Crown; they were also drawn by Sebastiano Serlio in his Seventh Book, which was published by the Imperial antiquary Jacopo Strada in 1575.

The courtyard of the building at Nelahozeves contrasts with the external appearance of this massive block. The latter suggests a fortress — Griesbeck proudly called it Floriansburg — with its four corner bastions, strengthened on the angles by rustication, which also borders the windows, as often on the buildings of Tuscan Mannerists. But this austere external face is made more picturesque by figural and ornamental sgraffito and by the interplay of light and shade in the lunette cornice; this ancient Roman motif was revived, after centuries of oblivion, in Northern Italy, from where it came to the Czech Lands and soon took root there. Post-Classical influence is visible not only in the tree-wing scheme, with its intentional contrast and the pretence of a function which this building cannot and is not meant to fulfil, but also the extension of the courtyard and the intersection of the two axes — the one on which the gate is situated, shifted out from the centre of the façade, and the main axis on which the whole building is orientated.

Also conceived in the Mannerist style is the courtyard façade of the main north and west wings, which date from the time when Wolmut was already working in Prague. He seems to have designed them for the owner of the château. The west wing is the connecting line between the central part and the gate, and a sort of gallery, too, a formation of French origin and rare outside France. The rusticated pillar arcade of the ground floor carries a storey articulated by high half-columns which also separate the windows with alternating straight and curved pediments. All these elements were adopted from Roman architecture in the *cinquecento* by architects of the Veneto region, G. M. Falconetto, A. Palladio, Antonio da Ponte, and also published by Serlio. The Mannerist approach shows itself mainly in the tension evoked by the alternation of the shape of the window pediments — both the commissioner and the architect may have seen this motif on the Landshut residence — and in the "imprisoned" Ionic columns girdled with bosses. This form, derived from ancient Rome, fascinated the architects of Italian Mannerism: Peruzzi, Romano, Ammannati, Vignola and in the Venetian *terra ferma* Sansovino, Sanmicheli and Palladio. The architect's orientation is, however, fully demonstrated in the northern façade of the courtyard of the castle, the main one both in appearance and significance, and the most complicated composition of its kind in Bohemia.

The slim Ionic half-columns of its principal storey are again tied by stone rings to the mass of the building. These bands strengthen the column and reinforce its supporting function, at the same time, however, they visually decompose its shaft into independent units. Moreover, the architect has rhythmically articulated the arcade into double sections and combined a giant order with a small one. Thus, he imbued his structure with the movement and tension typical of Mannerist conceptions. They were introduced into sixteenth-century architecture by Michelangelo, but nearer to the author of the Czech design were the more picturesque Venetian solutions from the territory of the *Serenissima,* namely those by Palladio or Sansovino. The double arcades, which are often bound together by a common semicircle on the twin windows of Venetian palaces, are here tied to the architrave by a long volute, also typical of the city of lagoons. While in the courtyard of Kaceřov Château the arch was connected with the pillar in the Roman way, and with the column in the Renaissance manner separately on individual storeys, on the north wing in Nelahozeves these two systems alternate on the same floor. The patron and his architect thus had in mind a complicated formation, composed with a true *ars combinatoria* into a picturesque and impressive whole, which is moreover consumated by a half-storey, another element adopted by Mannerism from Imperial Rome. Not only the Doric order, again atectonically placed above the "lighter" Ionic *piano nobile*, but other features of the two wings as well point to the influence of Wolmut. He is the only one of the architects of the mid sexteenth century in Central Europe to include them in his production in a convincing manner. His conception may have been influenced by a journey to Venice, which was not very far off from Vienna where he had worked; there, column tied to the masonry behind it could be found on the Classicizing gate of the Schweizerhof in the Castle as early as in 1552.

Also in accordance with Wolmut's compilatory way of work, which was not unusual at that time, is the conception of the interior of the north-western part which projects like a bastion and is the only room whose original decoration has been preserved. The walls of this centrally conceived room are articulated by window recesses alternating with high flat niches of Antique origin. Niches of this kind are known especially from Bramante's and Palladio's works, where they are slightly different from those in the treatises by Serlio and Palladio, which had obviously inspired the designer in Bohemia. The painted pilasters give an illusion of holding up the projections of the entablature; it was probably intentional that real ones were not carried out, as was the case in some Italian designs, in order to evoke the impression of lability of the whole structure. The burden of the vault with lunettes rests namely on the entablature, the weight being emphasized by the moulded frieze of the latter. The niches and the vault were decorated with

Nelahozeves, ground-plan of the Château

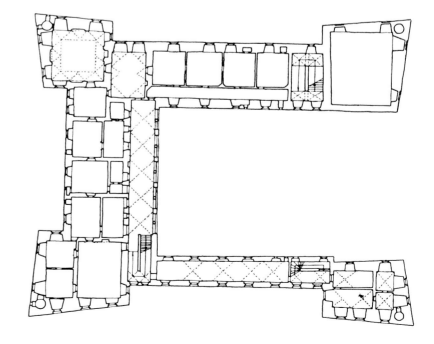

paintings, the subject-matter of which, as evidenced by the pre-served warriors in Antique armour and by a series of caesars, was related to the stucco allegories of the Roman virtues in the Antique style mentioned above. The Doric fireplace in this room with massive volute ancones and ornate overmantel surpasses the level usual in the Czech Lands. The unknown sculptor may have learned his lesson from Serlio's Fourth Book, yet he produced a work which, by its general scheme and the delicacy of the stone-work, would occupy an honorable place among the numerous and varied fireplaces in the palaces and villas of Veneto, with which it bears affinities.

The same Court architect, already retired at that time, seems to have been entrusted by Lord Florian with the project for the Church of St Peter and St Paul at Kralovice near Kaceřov, or to speak more accurately, with the reconstruction of the nave of this Gothic church, and the erection of a mausoleum of the Griesbeck family alongside it. The project was carried out in 1575—81. Wolmut's hand can be discerned not only in the indi-vidual components but in the basic conception of space, the so-called *Wandpfeilerkirche*. Wolmut was the first to conceive this design, which was applied several times in Germany and Austria, as a free-standing Renaissance building, remarkable in both pro-portion and craftsmanship, preceding even so significant and monumental a structure as is that of the Jesuit Church in Munich. But the usual scheme of the *Wandpfeilerkirche* — a nave with side chapels and sections of tribunes separated by in-drawn but-tresses — was transformed here in an original way: the interior chapels were replaced by large niches on the outside, and the tribunes above them projected outwards from the organism of the building. The architect made use of the old Gothic masonry and buttresses. The big pointed windows with simple tracery and the indication of the ribs are the only reminiscences of the Gothic, whose formal methods and conception of space predominated in sacred architecture, above all in churches, in all countries beyond the Alps in the period between the Late Gothic and the Baroque. In fact, these components were designed here as an effective con-trast to the other parts. The massive vault has stucco coffers, distinctly related to those of Roman Antiquity as well as to the vaults of the Italian *cinquecento* derived from the same source. Coffers were used in several places in Italy, from Rome to Genoa and Padua where Lord Florian's two sons had studied. The vault rests on high pilasters, unusually slender in proportion to their heavy burden, as if the architect had intended to impair the sense of equilibrium between the load of the vaulting and the supports and thus give an illusion of fragility and unstableness to the whole structure. Mannerism delighted in shocking the spectator in such way.

Giant pilasters are repeated also on the west front, the first church façade in Central Europe — and perhaps in any country north of the Alps — to be designed in the Classicizing style without any Gothic residua, and making use of the colossal order. The tripartite division, the pilaster running up the full height and supporting an entablature with a moulded frieze and projections, the giant niches and the illusion of two storeys, are all again an echo of the Roman triumphal arches. These had made themselves felt indirectly several times in the Czech architecture of the third quarter of the sixteenth century; in this case it was on a path commanded by the majesty of death, on a path leading to the family tomb.

The choice of formal means and their composition on the façade also seem to have been influenced by the Landshut residence

mentioned above (an exceptionally advanced work in Germany, carried out by artists from the circle of Giulio Romano from Mantua), which both the travelled patron and the architect most likely knew. This remarkable front which, in its stylistic purity, good composition and sober monumentality, was long to remain unmatched in Bohemia and the neighbouring countries, was again shaped as a coulisse. This feature, together with the singu-larly conceived Classicism which penetrates the whole reconstructed part, justify our attributing this work to Wolmut. Also, the cof-fered vault has affinities with the vaulting system used in the Nelahozeves Château. Another variation is the vault in the cen-tralized chapel of Griesbeck's mausoleum which has a rib motif and is more dynamic. It is perhaps not without significance that the ground-plan of this vaulting reminds one of the graphic re-cords of the horoscopes of that time, an important factor in six-teenth-century life. The epitaph, which was carried out in 1558 by two average artists from Regensburg and Augsburg, mentions Florian Griesbeck's artistic preferences, one of which seems to have been for collecting. The last storey of the Nelahozeves Château — which was a centre of humanistic writers — used to house a library and a picture gallery, which cannot be reconstructed.

Nor do we know the original appearance of Griesbeck's house in the vicinity of Prague Castle, which Ferdinand I bought from him with the intention of building the seat of the Archbishop there, or of his later palace in Karmelitská Street, in the Lesser Town of Prague. Boniface Wolmut seems again to have designed the Archbishop's Palace for Anthony Brus of Mohelnice in 1562. This building, too, has been changed in later reconstructions.

The Chapel of St Adalbert, which this Archbishop had erected in front of the temporary façade of St Vitus's Cathedral, has disappeared. This is an especially great loss, for it was a significant work in the development of architecture, and not of that of Bo-hemia only. It rose over the grave of one of the patron saints of the Kingdom in 1575—76 but its design had probably been made a number of years earlier. For it was in 1563 that Ferdi-nand I promised Anthony Brus to have the old dilapidated chapel replaced by a new one for which the patron was to provide designs. However, the execution was postponed owing to the Emperor's death in the following year. There is unfortunately no evidence to suggest whether the Archbishop had the designs made in the same year, i. e. in 1563, or in the first half of the following decade, before the works were actually started. But we cannot discard the first possibility. Brus of Mohelnice was certainly interested in architectural problems at that time — one year before he gave Wolmut a precise conception of his palace. Moreover, it was at the same time that he was participating in the Council of Trent which also formulated the views of the Catholic reform on sacred architecture, subsequently interpreted (in 1577) and applied by Carlo Borromeo. Thus Brus had the possibility of acquiring some knowledge of the northern Italian production, not only from writings (he was a collector of books and left a big library behind) but also from his own experience. However, this structure seems not to have had a parallel in Italy at that time.

It is not impossible that after his return to Bohemia the Archbishop commissioned the design from Boniface Wolmut, the Court architect, who also worked for him. And this despite the fact that this building, which though not very big produced a monu-mental effect, was derived from the most topical Italian ideas of the second half of the *cinquecento;* in these, many different factors combined: scientific knowledge, symbolic cosmological and religious values, psychological insights as well as aesthetic views.

St Adalbert's Chapel was built as a centralized structure — as was usually the case with memorials and tombs — but its ground-plan was an elongated decagon inscribed in an oval. This was a dynamic figure, in accordance with the marked shift in ideas on the lay-out of sacred buildings, which took place in the mid sixteenth century. The Early and High Renaissance emphasized static, harmonic and strictly symmetrical centralized designs — being influenced by the cosmological conceptions of Florentine Neoplatonists — and identified the image of the ideal temple with the symbolic form of the circle; they sought certainty in its centre. The theorists and architects of Mannerism were attracted by a dynamic, though still centralized, form, in which the single centre was substituted by two foci on the principal longitudinal axis running from the entrance of the church to the altar. This was a form which in its elongated design and mobility was akin to the figural canon of that time: the oval and the ellipse. While the artists and theorists of the High Renaissance derived the form of the circle anthropomorphically from the perfect man, Christ, their Mannerist colleagues seem to have derived the oval rather from the most graceful woman, the Virgin. Thus the Mannerists, both painters and architects, were led by a number of quite divergent factors from the perfect, still circle, symbolizing sovereign, ideal beauty, to what was in the eyes of the Renaissance man the "imperfect", "irregular" dynamic oval. This form seemed to embody best their idea of grace and corresponded with the new findings about the system of the universe and of the movements of celestial bodies. A great contribution in this respect were the discoveries which Johannes Kepler made during his long stay in Prague. This form did not contradict the Counter-Reformational conception of the church, which rejected the circular structure as a pagan one; and it also expressed the anxiety of man having lost his firm position in the centre of the universe. Moreover, it enabled the artist to demonstrate his abilities by carrying out a design more difficult in construction than a circle — and *difficoltà* was a property that was particularly appreciated by the Mannerists.

The oval had, of course, been penetrating into Italian architecture from the first decade of the *cinquecento*[32], but the process was slow and this geometrical figure was applied at first only to the lay-outs of gardens or as a detail in the decoration of buildings. In sacred architecture it was not until the period between the 1550s and 1570s that this form was introduced by Giacomo Barozzi da Vignola. (Michelangelo and Baldassare Peruzzi had chosen it before him for designs which, unfortunately, were not carried out; and Serlio used it as one of the variants of church lay-out in his treatise published in 1547.) Vignola applied the oval in several ways; however, many of his ideas remained as drawings and only three of them were carried through. They have two shells: an oval vault or space is suspended in an oblong, i. e. the interior is emancipated from the exterior. St Adalbert's Chapel, the shape of which was derived from these contemporary ideas and solutions, has one shell only — the exterior betrays the arrangement of the interior, of the space. In transforming the oval into a dynamic polygon, however, it had no direct predecessor, with the exception of Palladio's choir cupola in the Vicenza Cathedral from 1565. As late as the beginning of the seventeenth century, Alessandro Pieroni was concerned with such polygonal patterns in Florence and a similar ground-plan was used for the sepulchral chapel of Carlo Borromeo under the Cathedral in Milan, while in Prague this dynamic form appeared several times. Indirect evidence of the progressive character of the ground-plan of St

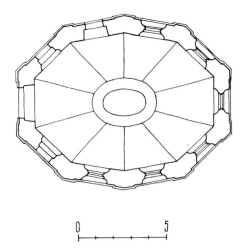

Prague — Castle, plan of the Chapel of St Adalbert

Adalbert's Chapel is provided by Egnazio Danti who, at a time between the probable dates of its project and execution, admired the oval plan of his brother Vincenzo's church in the Escorial in Spain as an exceptional design.

Not only the lay-out but also the system of articulating of this Prague building are remarkable. The colossal order of pilasters alternates with high flat niches, both elements taken over by the Italian Renaissance from the Roman Antiquity. Wolmut used them both, in connection or separately, on the Ball Courts of the Hvězda and of the Royal Garden, on the upper storey of the Summer Palace at Prague Castle, in the Kralovice Church and at the Nelahozeves Château. The niches of the chapel are pierced by small windows in a quite arbitrary way, which is heretical from the viewpoint of Classical ideas but not entirely isolated. In a centrally planned church, which was published in the *Libro di Architettura* of Antonio Labacco, an unknown artist designed the same motif on similar arbitrary lines, as did Vincenzo Scamozzi in the year 1576 when designing the central hall of the villa Rocca Pisana in Veneto or Andrea Palladio when planning the Valmarana Chapel in Vicenza, and the side chapels of Il Redentore in Venice; all of them seem to have been inspired by Roman thermae. In the Prague Chapel, where the angular ten-sided dome of an oval plan was fitted on rather low, these oculi were in the apexes of the interior niches but roughly mid-way along their height as seen from the outside.

The system of articulation as well as its individual elements can be seen as the work of Boniface Wolmut's. Both historical and stylistic consideration point to him as the author of the design, which was undoubtedly influenced to a marked degree by the Archbishop's ideas (the execution of the project was then entrusted to Wolmut's successor in the royal service, Ulrico Aostalli). Both the dynamic conception and the breaking of an oval into a polygon would seem to have been familiar to this northern artist, who was apparently responsible for the substantial vault over a polygon in the Augustinian Church at Karlov in the New Town of Prague. Whether it was the royal architect or an artist from northern Italy who designed St Adalbert's Chapel, the fact remains that its author enriched not only Prague, but all transalpine countries by a very advanced work — a structure unusually free of all Gothic residua and, in its lay-out as well as its articulation, following the contemporary currents in Italian architecture. This was no inorganic introduction of a new formation into Czech architecture,

as is attested by a series of centrally planned spaces, all conceived in this dynamic way; the series began in the 1550s with the lozenge-shaped rooms in the Hvězda Summer Palace and ended with the Church of St Rochus at Strahov, also polygonal in plan, on the one hand, and with the Italian Chapel in the Old Town of Prague on the other; the latter represents an outstanding and pure rendition of the idea based on the oval. These two Prague monuments of course already belong to the Rudolphine period, which promoted the capital of the Kingdom of Bohemia to the metropolis of the Empire and to a significant centre of Mannerist culture.

There were many works in Prague which Rudolph II could take as a basis. For forty years, innumerable artists, mostly Italian but also Czech and German, had been enriching the seat of the Kings of Bohemia under the creative leadership of two individualities, in particular, Paolo della Stella and Boniface Wolmut. Their works fulfilled many functions: public and ecclesiastical buildings, garden architecture, not to mention dwelling-houses. Most of the works were redolent of Antiquity, either in the conception of the structure or in the style of decoration, and many of them were treated in a directly Classicizing style. The term Classicizing must of course be understood in the particular Central-European Mannerist interpretation of Boniface Wolmut.

Wolmut, who was familiar with Antique architecture from treatises by his contemporaries and Vitruvius, and perhaps also with buildings in Veneto and the ancient monuments of Verona, seems to have designed a relatively comprehensive set of works intentionally following the traditions of Imperial Rome, in their overall organization as well as in detail. His designs have an amazing variety, ranging from a relatively pure and sober paraphrase of Antique styles to an eclectic but completely individual multiplicity of forms. This diversity of conception always answered to the purpose of the building — as was the case with his Italian Mannerist contemporaries — and to a certain degree it corresponded with the duality of Mannerism in general, with its Classicizing and expressive, its rational and emotional, its sober and animated currents. Wolmut's method of work naturally partook of the contemporary approach to art as a craft that could be learned from books, in which the latter could provide the artist with sufficient models for his compositions and compilations (it was after all for this very reason that many treatises or pattern-books were published). It was also influenced by the appreciation of the works of famous masters for the then artistic activity. This manner of designing naturally found the greatest response among architects less endowed with truly creative gifts. And Wolmut's works are evidently those of a man from the north who did not have such an innate sense of rational tectonic principles as his colleagues south of the Alps with their heritage of an ancient and established tradition.

Such a large group of Classicizing buildings was not to be found anywhere else in Central Europe in the third quarter of the sixteenth century, be it in Vienna, the residential city of Ferdinand and Maximilian, or Dresden or Munich. Undoubtedly, in Prague this style was chosen as part of a deliberate programme. This may be assumed particularly in the case of Ferdinand I. He was the first ruler from a new dynasty in Bohemia which only a short time before had reacquired European significance. He owed the acquisition of the most important country in his realm to his election by her Estates (although he asserted his claim on the basis of his marriage to the daughter of the previous royal family). And he was a Catholic king in a predominantly Protestant milieu.

For all these reasons he strove to show his dignity and to glorify himself as well as his house in all possible ways.

As early as in 1548, when at the instigation of P. Stella and the Archduke he was thinking of having the Vladislav Hall decorated with paintings, he planned a succession of Czech dynasty, to which he wanted to add his portrait with Queen Anne and the children. His concern was for his own *"gedechtnus"* — a memorial erected for eternal remembrance. Giovanni Battista Ferro did the design and intended to bring twelve assistants from as far as Rome, The Marches and Lombardy but he had no opportunity to carry through this extensive work. The intention was not to paint a cycle of entirely fictitious portraits but to work after a series of paintings of the Kings of Bohemia which had been in the Castle before the fire of 1541, and were preserved in small copies. It was not to be a family gallery but a succession of the rulers of Bohemia conceived on broader terms. A similar monument was later erected by Archduke Ferdinand for the sovereigns of the Tyrol; the cycle of paintings raised the Spanish Hall of Ambras Château to a memorial of the government of the Tyrol as against that of the Empire. Ferdinand I returned to his original idea in 1563, when he entrusted Domenico Pozzo with the decoration of the Diet Hall at Prague Castle, mentioned above.

Not only did he strive to demonstrate his legitimate place in the series of Bohemian rulers. In Prague, which had been the home and seat of the Roman Emperor as much as two hundred years before, he made overt allusions to his title of King of Rome and, from 1556, Emperor of the Holy Roman Empire. This he demonstrated not only by triumphal processions and triumphal arches, but also by his choice of architectonic style. The processions took place on the occasions of the sovereign's spectacular arrivals in the city, with allegorical scenes and floats, often on Antique themes. In its return to the Roman tradition, this type of glorification was a typical feature of the Renaissance.[33]

It cannot be by chance that this change in his orientation took place just after the Schmalkalden War when the King intensified his struggle for an absolutist and centralized rule; and particularly from the moment when the Imperial crown was put on his head after his brother's abdication. The choice of the Classicizing style, relating to the traditions of Imperial Rome, seems to have been linked not only with Ferdinand's artistic orientation and his pursuit of self-glorification in the current sense of that time. It also matched his ideological and political intentions, his belief in the continuity between his person and the caesars of the Roman Empire, with their virtues and their triumphs. (A triumphal arch accompanies him in one of his portraits preserved in Bohemia.) He was their heir in title after all. A collector of antiquities and a lover of Roman and Greek history, he had intimate knowledge of the Antique world. It was from this world that he had already drawn the stimulus for the scenes on his Summer Palace (if not for the type of the whole building). They were intended to glorify among others Charles V — in whom Italy, at least in the writings of Giangiorgio Trissino, saw a new Justinian, a liberator of Europe. For the Hvězda Summer Palace he or his son Ferdinand chose a cycle of stuccos which are a pronounced allusion to Antiquity and their virtues of its rulers, an allusion whose effect is further enhanced by the Antiquizing style.

The fact that Ferdinand was artistically oriented in this way especially in Bohemia, was hardly a matter of accident. He obviously wanted to vie with his old predecessor on the Imperial and Bohemian throne, Charles IV, a descendant of the native dynasty on his mother's side at least, and renowned for his cultural

achievements. He seems to have also tried to compare with the artistic milieu of Prague Castle under Vladislav Jagiello. The significance which he attached to the Kingdom and the Cathedral with its tombs of the Kings of Bohemia is also attested by the tomb constructed for himself and Anne at his request in the choir of St Vitus's Cathedral at Prague Castle. His successor Maximilian II (who later found his last rest here at the side of his parents) entrusted this work in 1566 to an artist who was to complete the multipartite sepulchral monument of Maximilian I in Innsbruck.

The Prague tomb has a long history: the first part was executed in the Innsbruck workshop in 1571—73; in 1581 Rudolph II had the original project extended for his father and the tomb adorned with reliefs, carved in 1587—89. Alexander Colin from Mecheln, who had already participated in the Mannerist decoration of the façade of Ottheinrich's Palace in Heidelberg and later on, in 1562, had become a Court artist to Archduke Ferdinand in the Tyrol, designed the Prague work similarly to the sepulchre of the old Emperor: as a free-standing marble tomb. But while his Maximilian I is revived in the Renaissance manner, kneeling, deep in prayer, the trio of Habsburgs in Prague are lying like medieval *gisants,* but sleeping, not dead. The patron rejected the other variant proposed by the artist, namely to render the deceased revived on Renaissance lines and *accoudés,* resting on their elbows. This pose was originally Spanish, appearing towards the end of the fifteenth century, and combined, by Andrea Sansovino, with the Antiquizing manner in Rome in the first years of the *cinquecento,* also penetrated to France and particularly to Poland.[34] Colin gave a masterly rendering of the facial features of the deceased as well as the vivid movement of the putti shield-bearers and Christ as Victor over Death. This liveliness of movement is an intentional formal contrast to the lying posture of the dead. Instead of biographical relief scenes, which glorify the life and achievements of Maximilian I in such a masterly manner on the Innsbruck cenotaph, Rudolph II chose busts of some kings of Bohemia in Prague: Charles IV and his four wives, Wenceslas IV, Ladislas the Posthumous and George of Poděbrady. Thus the old theme reappears again and again: the Habsburgs await here their resurrection above all as the rulers of the Lands of the Bohemian Crown. The decoration is supplemented by scrollwork cartouches of the international type and by festoons, and the whole sarcophagus is surrounded by an original grille. The Prague work, in which Colin was assisted by two Italian sculptors, does not attain the quality of the tomb in Innsbruck, but together with the mausoleum of the Rederns at Frýdlant it is a worthy representative of monumental funeral sculpture in Bohemia. (The Czech Lands were relatively poor in large monuments such as can be found in Germany, or in the kind of interesting constructions to be found in Poland.) The front of the organ-loft once formed a visual coulisse to the Habsburg tomb, in counterpoint to the Gothic choir which rose above it like a baldachin. And by its reference to the Imperial Rome it placed Ferdinand and Maximilian in the broader context of world history.

THE RENAISSANCE OUTSIDE THE ROYAL COURT

Prague Castle was not, of course, the only significant centre of Renaissance culture in the lands of the Bohemian Crown. Neither was it an isolated enclave. Festivities and social duties, administrative posts and membership in the Diet and the Land Courts which held their sessions here, brought to the Castle and its precincts representatives of the towns and, in particular, knights and members of the nobility. These were thus at least temporarily tied to the capital, especially during the ruler's presence — which was relatively frequent under Ferdinand I and permanent under Rudolph II. They therefore built themselves palaces in Prague for temporary stays, while having permanent residences on their estates. At home many noblemen attempted various enterprises — agriculture, pond-construction, forestry, brewing, the mining and working of iron-ore, and particularly of silver and gold; the Šliks in West Bohemia even engaged in coinage. On their estates the nobility also radically reconstructed their medieval family castles or built châteaux in the new style and often agricultural buildings as well. The lord frequently influenced the appearance of his subject towns, mostly by the example of his own architectural undertakings, but in isolated cases by direct interference and even by major town-planning.

This extensive building activity was a manifestation of the new way of life and of a seeking after ostentation, but also not infrequently of the new cultural orientation. It was a reflection of the revolutionary changes in thought and style which the sixteenth century had brought with it. Some of the patrons received higher education at home, mainly in schools run by the Unity of Bohemian Brethren or Jesuits (in the predominantly Protestant country the Jesuit schools were founded, in keeping with the spirit of the Counter-Reformation, by both the monarch and the representatives of the small Catholic minority). Others studied at German, Swiss, French, Italian and English universities and academies.[35] Many of them were well-educated or much-travelled people; tasks in the king's service and diplomatic missions, as well as their own interest and religious motifs led them to remote countries — Italy, Spain, England, France, Turkey, Palestine and Egypt. Thus there were people in the country who enjoyed a knowledge of foreign culture, foreign ways of life and artistic production.

The most significant of the noblemen's residences vied with the royal court as cultural and social centres; some of them became renowned for their buildings and their decoration, their orchestras — Lord Christopher Harant of Polžice was even famous as a composer — or their theatrical performances. The foremost families even had their own artists, in particular master builders and painters. Many publications of that time, both fiction and scientific literature, bear dedications to the noble patrons who contributed to their publication. The castle inventories from this period not only provide evidence of the rising standard of living and comfort in the late sixteenth and early seventeenth centuries; they also record collections of paintings, prints and books. These libraries often contained many hundreds, even thousands, of volumes, for example those of the Rožmberks, Pernštejns and Žerotíns or of Archbishop Brus of Mohelnice. At Březnice Château even the original furnishing of the library of the Lokšans has been preserved. All this, together with the costly service at the court, travels and anti-Turkish campaigns, must have put a great financial burden on the families (the best examples being the leading

houses of Pernštejn and Rožmberk). Thus it happened that the period about the year 1600 witnessed a disintegration of big aristrocratic domains, as well as the extinction of a number of old Czech and Moravian noble families. Many others vanished from the history of the Czech Lands as a result of persecution after the Battle of the White Mountain and during the Thirty Years' War.

As at the Court, so in the upper strata of society, the changing way of life gave rise to new species of architecture (châteaux, summer palaces, garden architecture) and the new style affected the character of the old ones (palaces, chapels, churches, town halls and houses). The medieval castles reconstructed as châteaux and the newly built seats of the leading families provide a parallel to the ducal residences in Italy and Germany, especially by their inclusion in the organism of the town. The most important town palaces are echoes of those in Italy, even though their designs were more modest and showed deviations caused by the local tradition. The Italian villa and garden also made its appearance in the production which developed outside the Court. The garden was sometimes architectonically shaped and equipped with a pavilion, an arcaded loggia, a fountain, with statues and exceptionally also with a summer house (at Opočno, Třeboň, Teplice, Buštěhrad). In a few cases it was already designed on the axis of the building, as for example at Bučovice, Kratochvíle and Krásný Dvůr. Also inspired by these noble patrons was the kind of sacred architecture in which the new style found its greatest application, the sepulchral chapel; there are examples at Telč, Olomouc and Frýdlant. In the architecture of the middle class there was little enrichment of building types, but there was some modification of the existing ones, of the town hall, house and town-gate, and exceptionally there were attempts at more substantial town-planning schemes.

With few exceptions, the buildings of the Czech and Moravian nobility differ in their stylistic orientation from the majority of court architecture. They are also oriented predominantly towards Italian architecture, that is to its many different areas, but not to its Classicizing stream. It is characteristic that even a patron who had first-hand knowledge of Rome — as for example Lord Chancellor Vratislav of Pernštejn — was not impressed by the monumentality of Antique monuments and their Classical systems to such a degree as to prefer it to the lighter structures of truly Renaissance origin. In this respect he was in agreement with the other patrons among the Central-European nobility, just as the Italian master builders in Bohemia and Moravia were in agreement with their colleagues working in the other countries of Central Europe. But while in some areas the domestic tradition and a marked decorating tendency made themselves felt much more, the Czech countries did not indulge in the unrestrained prodigality of fantastic décor typical of northern Mannerism, even though the northern type of ornament did penetrate the Czech artistic production of the end of the sixteenth century.

Like the royal master builders, the artists working outside the Court followed, after a short Pernštejn interlude, the late, post-Classical stage of Italian architecture. From the 1550s onwards, buildings of an advanced conception sprang up, designed on principles similar to those used in Italy at that time, i. e. on the principles of the Late Renaissance, especially Mannerism. However, no apparent evolution of style, of the conception of a building's configuration or of the formation of space can be recorded throughout the second half of the century. This was undoubtedly due to the fact that the Czech Lands of that time, like the rest of Central Europe, had no outstanding artistic talents, no creative architects in the Renaissance sense.[36] The creations of the artists invited from northern Italy are not comparable with the important works in Italy, which formed artistic development in a decisive way, but they often stand high among the works carried out in the transalpine, Central-European countries. The most significant of them can claim importance through their priority in time or their artistic quality, or as a group developing a certain type — the arcaded court or the centrally planned formation. The Czech and Moravian commissioners enabled many an Italian master to develop his creative talent, and the local atmosphere did not deform its expression to such an extent as in some neighbouring areas, for example in Silesia.[37]

Thus the châteaux and palaces of the leading families did not follow the tradition of Roman Antiquity (only some details were patterned in Vitruvius), but were built under the influence of the art of northern Italy, Tuscany and Liguria; some mediated influences of the Roman Mannerism can be recorded also. This orientation was greatly influenced first by the origin of the master builders and second by the travels of the patrons, in particular the journey lasting several months by a numerous retinue which in 1551 went through Trent and Milan to Genoa to meet the new Czech Queen Maria of Castile, the young wife of Maximilian II. Bohemia shared this orientation with the Moravian Margraviate, the second most important land of the Bohemian Crown, which to a great extent lived its own life. Its leading representatives built houses and palaces in two centres, Brno and Olomouc, where the Diet and the Moravian Courts held their meetings; the latter was also the seat of the episcopate. Naturally, the estates as well as the building projects of many patrons extended over the frontier between Bohemia and Moravia.

THE PERNŠTEJN INTERLUDE

Prominent among the patrons in both these states were the Pernštejns, one of the most powerful families in the Kingdom, at a time when building was generally stagnant in the 1520s and 1530s. The sons of William of Pernštejn inherited not only their father's possessions, but also his predilection for artistic activity. Together with the office of Lord Chamberlain, Adalbert inherited the estates in eastern Bohemia. John, Governor of Moravia, received the large domains in the Margraviate, to which the county of Glatz was added as a security in 1537. (After his brother's death in 1534, John also inherited the Bohemian estates where he continued the works started by his predecessor.) He shaped a number of castles and châteaux, particularly the Pernštejn Castle. Near this seat, at Doubravník, John also began to build an impressive church for his family in 1535. In the marble Late Gothic interior of this Pernštejn mausoleum, only the details were in Renaissance style, mainly the balusters of the altar grille and of the organ-loft; the new conception of the aedicula of the portal was still imbued with the traditional Gothic feeling, too.

Educated in the humanist tradition, Adalbert even tried his hand at literature. In the 1520s and at the beginning of the 1530s, he equipped his castle at Pardubice, the centre of his possessions, with reception rooms in the new style, with carved ceilings and wall-paintings in fresh local colours. The large figural scenes include Samson and Delilah, an allegory of the relation of the Old and the New Testament — a summary of Christian learning according to the fifth chapter of Paul's Epistle to the Romans. These, together with the figure of Fortuna Volubilis, which is the first nude in Czech monumental painting of the Renaissance period, the ornamental components of Italian origin, obviously mediated by the South-German graphic art, and the illusive constructions, have parallels in the interiors of 1520—40 in southern Germany, Switzerland and Austria.[38] The stone portals, combining the forms of a Late Gothic baldachin with Renaissance ones — as in Wawel Castle in Cracow and some other buildings in Czechoslovakia — were enriched by fictitious painted pediments and even whole monumental aediculae.[39] The latter tended, if only by deception, to add weight to the aesthetic feeling of the new style.

The small carved portal in the courtyard, with its Italianizing candelabra motifs, acanthus tendrils and relief busts, is executed completely in the Renaissance only as is the main portal of the château. Its curved pediment is derived from Italy, above all from Veneto, while the influence of Lombardy is seen in the rich ornamentation and the skittle-shaped columns. This form, exaggerating the entasis in a decorative manner, was common in Lombardy in the fifteenth and sixteenth centuries (in Bergamo it even acquired monumental dimensions and was used for supporting a vault). In the first quarter of the *cinquecento* it penetrated into the countries beyond the Alps, where it seems to have been appreciated mainly for its non-Classical picturesqueness. From the 1520s it started to be used in Bohemia and Moravia, in stone-masonry, in graphic art and on the title-pages of books which inspired painters, carvers and stone-masons. The craftsmen at Pardubice were probably of Lombardian origin. Dated 1529, their work preceded the gate of the Dresden Château which resembled it to some extent in both its scheme and decoration and had a great influence on productions in Saxony and Silesia. However, the Pardubice portal differs from the German gate in its plasticity as well as in its moderate ornamentation, which does not impair the mass or cover the tectonic structure, as is the case with the Saxon work. This was a difference which distinguished the German Renaissance generally from the Czech, which had more in common with what was being produced in Austria. Leading to the portal, which was fitted in place as late as 1541, is a bridge finished two years later. In their naive tone and their vernacularization of stimuli from Italy and southern Germany the reliefs on its parapet resemble the decorated façade of the U rytířů (At the Knights) house at Litomyšl, carried out by the local master, Blažek, also in the 1540s. Sculptural decoration was characteristic of the buldings erected on the Pernštejn estates. (Later the castle got arcades and a pavilion by U. Aostalli.)

Adalbert and John were also renowned for their ideas of town-planning. In 1527 Adalbert influenced the reconstruction of the recently founded town of Nové Město-on-Metuje; the houses were linked together by a continuous front with an arcaded cloister and crowned with an attic, thus forming a unified façade running round the whole square. John tried to apply a unifying influence in the construction of the town of Pardubice after the fire of 1538; the appearance of every house was to fit into the integrally conceived whole envisaged by the lord, who agreed to equip the buildings with standardized elements; the realization was to be supervised by his builder Master George from Olomouc. It is this idea, as well as the concepts which John of Pernštejn used to justify his interference, that reveal to what extent he had adopted the principles of the new style. The conception of the "ideal town" was one which fascinated many Renaissance theorists as well as commissioners. However, their plans seldom became reality and if they did so, it was mostly later, in the second half of the sixteenth and at the beginning of the seventeenth centuries (with the exception of the Pienza of Aeneas Silvius Piccolomini and the Fuggerei in Augsburg).[40] The idea of unifying the buildings round a square by common coulisse-like fronts had already been carried through in the late *quattrocento* at Bramante's Vigevano in Lombardy, partly also in the Piazza dell' Annunziata in Florence and later on in Ascoli Piceno. A most grandiose example, dating from 1605, was the Place Royale in Paris. All of these had the characteristic arcades. However, with the coming of the new style, this idea was soon applied in two eastern Bohemian towns as well.

A prominent element in their constitution is the horizontal termination of the façades (which differs so markedly from Gothic vertical gable). At Nové Město this is achieved by a continuous attic-zone, composed of northern Italian elements — semicircles and "swallow's tails". These, derived from the battlement, often surmounted medieval buildings from Lombardy through Verona as far as Veneto. But here their regular sequence was interrupted by small gables in roughly the same manner as on the new town hall built at Prostějov on the Moravian estates of the Pernštejns in 1538.[41] Nearer to the Italian conception than this attic-zone, into which the small gables bring a vertical moment, is the strip of alternating swallow's tails and semicircles crowning the arcaded wall which the Margrave George of Brandenburg had constructed on the town walls at Krnov. The work was carried out simultaneously with the reconstruction of his castle (the portal of which is dated 1534). Attic-crowns had appeared in several contexts[42] in Central Europe in the 1520s, to find popularity in the next decade. In Silesia, this type of attic continued to be used for a longer time until replaced by a high formation of the "Polish type", also common in Germany, Slovakia and northern Moravia, and by a gabled attic popular in Bohemia, where it was gradually ousted by other forms. Arched gables in which the Venetian scheme, known for example from the Scuola di San Marco,[43] is modified by the arrangement of semicircles, were built after 1538 on houses in Pardubice, while the outer gate of the Green Gateway was still terminated by a horizontal bearing a reminiscence of the attic-wreath on the Cathedral of Halle. The town hall at Litoměřice was surmounted by an imposing band of gables at about the same time.

As has been said, sculptural decoration represented a significant component of the Pernštejn buildings. Such decoration appeared, for example, on the tribunes which Lord John had placed in the Gothic nave and aisles of the Church of St Bartholomew at Pardubice, thus creating a conspicuous Renaissance horizontal. (Tribunes with a similar decoration and balancing function were built in the Church of Our Lady at Most in North Bohemia.) He

51 Pardubice Château, main portal from 1529 and a bridge with relief decoration from 1543

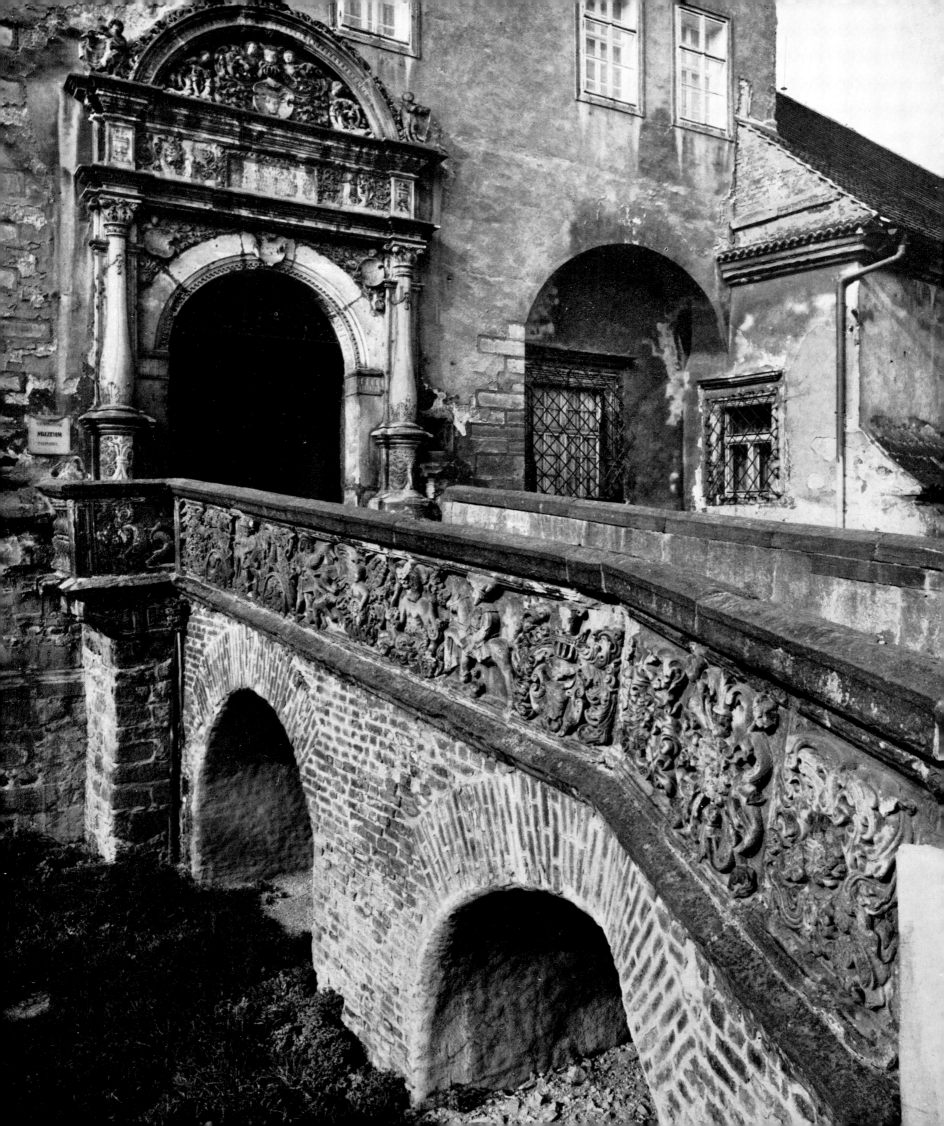

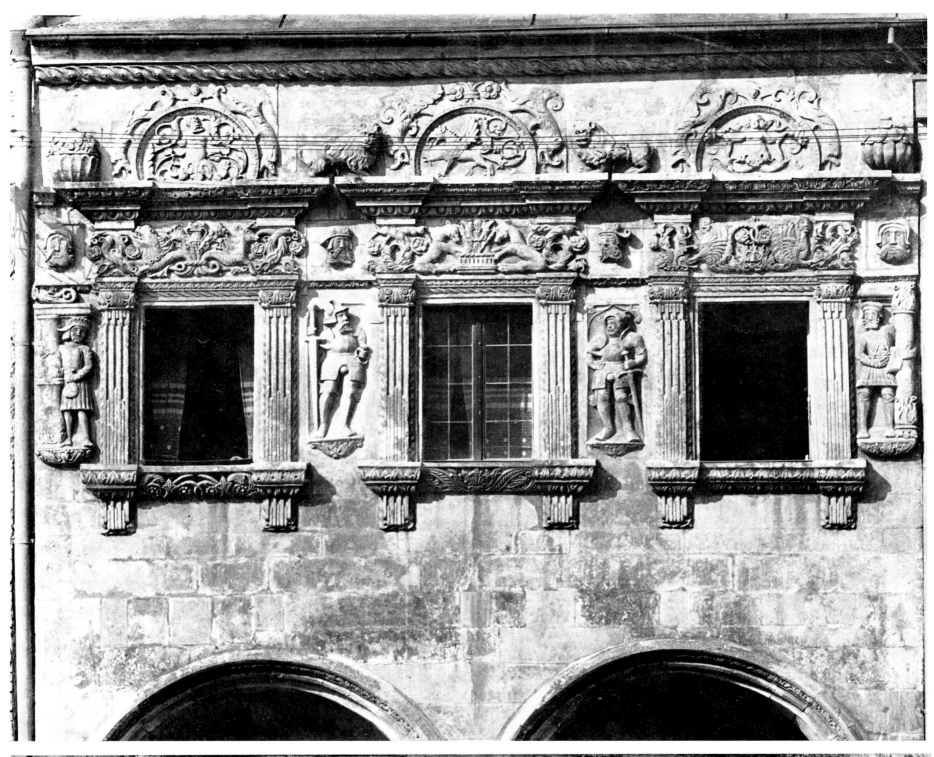
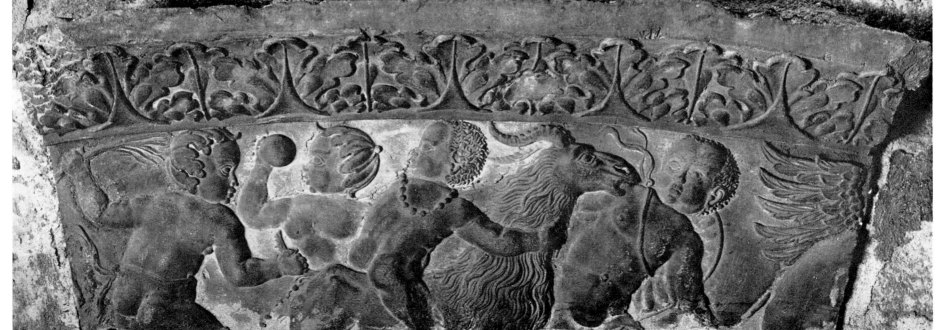

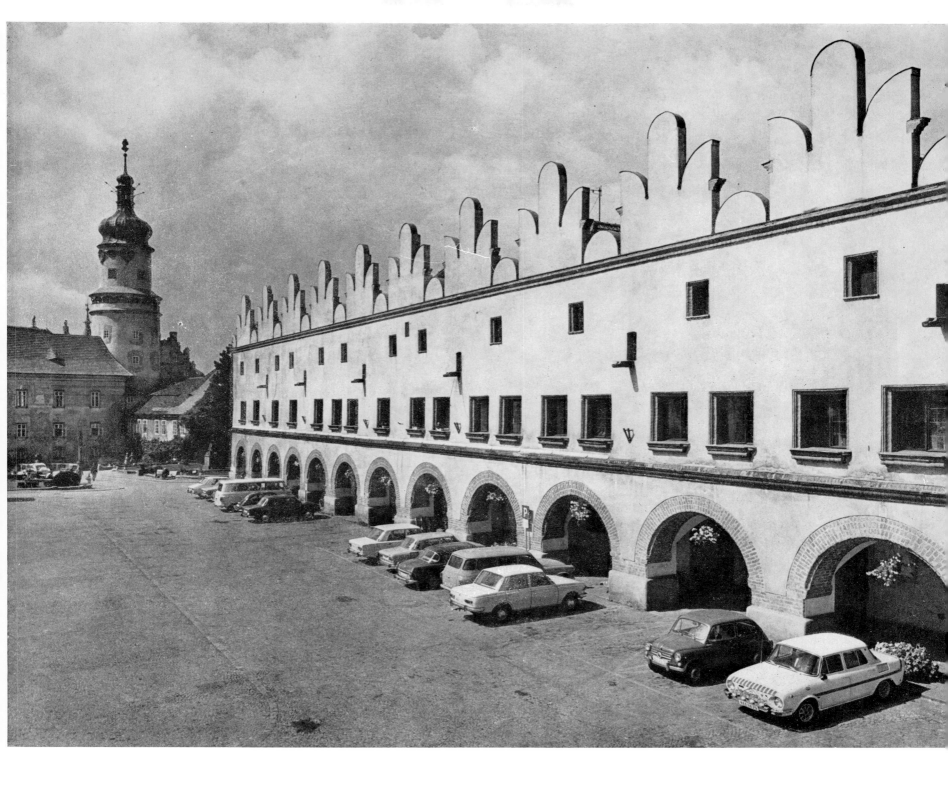

52 Litomyšl, the U rytířů (At the Knights) house, No. 110. Detail
of the façade decoration, by stone-mason Master Blažek, 1546.

53 Prague — Castle, the Palace of the Lords of Pernštejn. Detail
of terra-cotta decoration, about 1540, Prague, the Lapidarium of Prague
Castle.

54 Nové Město-on-Metuje, houses with a unified façade on the square,
after 1527

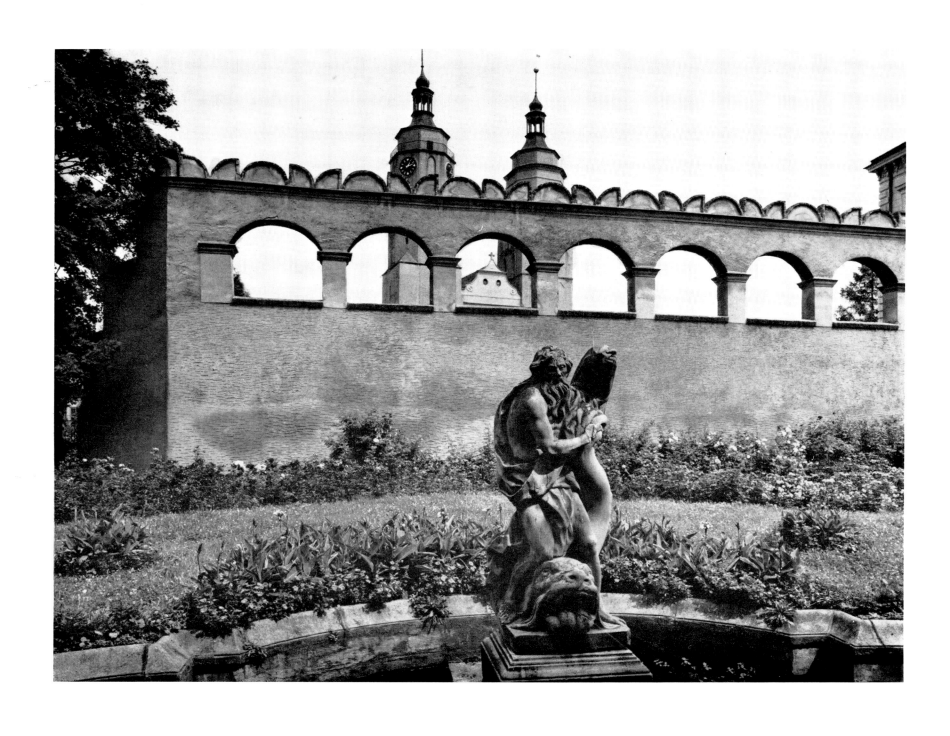

55 Krnov, an arcaded wall, about 1534

had also a marble tomb erected there for his brother, which bore Renaissance forms and details, although the recumbent figure was conceived in the traditional way. Other fragments found in the town point to a flourishing workshop of stone-masons, but the masters employed by John also worked in terra-cotta, which they used in decorating the façades of houses in Pardubice as well as in other towns in East Bohemia. Not only the standardized window-frames and a portal, but also plaques with figural reliefs have come down to us. The terra-cottas on the Pernštejn Palace in the Prague Castle complex, executed probably at the turn of the 1530s and 1540s, are the most significant work of this kind both in artistic treatment and number. They seem to have formed a whole architectonic system — portals, window frames and perhaps even the archivolts of the arcades.[44] Only fragments have reached us, but these include ornamental motifs (the Classical egg and dart, foliage, acanthus, tendrils with intertwined dragons and dolphins), candelabra compositions and figural forms, mostly of Classicizing nudes. Similar formations had already been known in some transalpine countries, partly through the artists summoned to Buda; but the Italian compositions (which also influenced many German works) seem to have been derived from pattern-prints, most probably from southern Germany. One relief in Pardubice was inspired by Aldegrever's engraving of 1538. On the other hand it is not impossible that one of Stella's assistants was active here, since the Kings' Italians did not work for the ruler only. Together with Ottheinrich's Château in Neuburg an der Donau dating from the 1520s and the Salm Château in Neuburg am Inn built in the following decade the Prague palace is one of the first Renaissance buildings in Central Europe to make extensive use of the techniques popular in Lombardy and Emilia, and it did so not only for ornamental effect but also for purposes of articulation. Terra-cotta seems to have been quite common in Bohemia, for as early as 1525 a Czech brickmaker had been summoned to Görlitz[45] to do similar work there. It came to be widely used only later on, mainly in northern German towns; in Austria it is represented above all by the arcades of the Schallaburg Château. Thus in the Prague Castle complex the Pernštejns had one of the most imposing buildings erected in Bohemia in the first half of the sixteenth century, perhaps the very first with a Renaissance arcaded courtyard.

THE PALACE AND THE CHATEAU

The Pernštejn Palace was not to remain isolated for a long time. In the vicinity of Prague Castle and all around it the foremost families built themselves city seats which between them indicate different degrees of assimilation of the style brought from Italy. In 1545—56, the Lords of Rožmberk, the foremost house in the Kingdom, built themselves a palace next to that of the Pernštejns on a post-Classical ground-plan, which resembles that of the châteaux at Kaceřov and at Spittal in Carinthia, and to a lesser degree of the Tuscan Villa Petraia. It has columned loggias architecturally emphasizing the side wings which are less massive than the full front façade, and an entrance hall also opened by an arcade. This palace also provides evidence of the fact that the Italian masters endeavoured to adopt themselves to the Czech tradition: they enriched the enclosed four-wing block by polygonal towers erected on the medieval bastions of the Castle's fortifications, which added articulation to its silhouette. And the crown of gables connected to an attic-zone suggests that they tried to moderate the steep outline of the transalpine roof and make it more picturesque, introducing a marked horizontal constituent into the composition of the whole. (This solution has variants in the German buildings with the so-called *Zwerchhäuser* or gabled attic-storeys, mainly in the basin of the river Weser.) A large group of Ticino masons was led by Giovanni Fontana from Brusata in Mendrisiotto, whose work Ulrico Aostalli supplemented in 1573—74 for William of Rožmberk with a large, architectonically laid-out garden, the first of its kind in Prague. The Rožmberk Palace suggests much about the appearance of the local noble residences in the Renaissance, in particular of the châteaux.

They are characterized by a great diversity of ground-plans, ranging from a one-wing arrangement up to complicated formations which were, however, usually erected in several stages and not according to a unified plan. Often they represent picturesque but not really composed wholes, many of them having been influenced by the preceding building stage. The Renaissance striving after a regular and harmonious shape manifested itself in the reconstructions of medieval castles which were given new wings round new courtyards (Jindřichův Hradec, Český Krumlov, Bechyně, Telč, Hluboká, Náměšť-on-Oslava), and particularly in the designs of new buildings. They did not always adhere to a strictly symmetrical ground-plan and to the arrangement of window axes resulting from it. But this was characteristic of Central Europe; the perfect compositions of the German châteaux of Augustusburg and the later one at Aschaffenburg, influenced by French art, or the Augsburg Town Hall were exceptions in this area. Nevertheless, the Czech Lands did not lack organically coherent architectural complexes designed on a longitudinal axis. Examples can be found at Litomyšl, Krásný Dvůr, Kratochvíle, and above all at Bučovice, where the architect even employed gradations in the height of the building blocks. The rooms were usually simply ranged in *enfilades* or along the arcades, but sometimes (at Litomyšl, Bučovice, Jindřichův Hradec) they were even grouped into apartments like in Italy, France or Germany.

The most significant châteaux were designed around a central courtyard, the psychological and architectural focus of the building, and the rooms and the arcaded corridors connecting them were arranged around it. This solution was not suitable for the climate in the transalpine countries (serviceability often had to give way to form at that time), but it created a representative space and an "amphitheatre" for various performances. The quiet and perfectly symmetrical design with arcades running all round a square court, typical of the Early and High Renaissance, was replaced by a dynamic conception consisting of an oblong courtyard with loggias on three sides at most and one contrasting façade. This might be the front one, as (nowadays) at Litomyšl where it is emphasized with sgraffito, or that of the entrance wing, as is the case at Moravský Krumlov, Dřevohostice and Bučovice; in this way one axis stands out. Only exceptionally did the architect plan the gradation of light, the complicated tonal transitions achieved in Italy by passing from a dark carriage-way into a half-lit loggia and then into a floodlit courtyard. Instead, he reckoned with the effect of the sky, of nature.

In this respect, and having arcades on all storeys, Bohemian and Moravian courtyards have affinities with the large courts of Italian monasteries, hospitals (St Spirito in Rome and Maggiore in Milan), universities and colleges (in Padua, Rome, Pavia) and public administrative buildings, though these usually have loggias on two floors only. They have little in common with the high, shaft-like courtyards of the town palaces of the Tuscan *quattrocento* from which nature was almost completely excluded — with arcaded corridors hollowed out in the mass of the ground floor and sometimes of the uppermost storey as well. Only the top arcade opens into nature in the Buonconsiglio Castle, in Trent, with which many commissioners in Bohemia and Moravia were familiar; it was one of the few courts south of the Alps which had a loggia on more than two superimposed floors, while courtyards with arcades on several storeys are characteristic of Bohemian and Moravian châteaux.[46]

Their lay-out, which was not to be grasped at one glance and from one viewpoint only, was moreover sufficiently advanced to reckon with the active co-operation of the spectator in accordance with contemporary developments in Italy. It assumed a gradual process of perception, the spectator moving round his own vertical axis as well as along the path laid down by the architect, making a transition from one axis to the other and ascending. By following this path the spectator discovers a series of views with scenic effects — artful compositions of open, half-covered and enclosed spaces, and even views through the body of the building as well as out into the garden and the urban organism. The most perfect examples can be found at Litomyšl, Moravský Krumlov and Telč. Their manner of breaking through solid barriers and interconnecting internal space and nature is a trait of the architectonic production of the Late Renaissance, especially of Mannerism. These formations can compete with the works of the best architects of the Italian *cinquecento* — Sansovino's villa at Pontecasale, Peruzzi's Oratory in Siena, Romano's Cortile della Cavallerizza in the Ducal Palace in Mantua, Ammannati's Palazzo della Provincia at Lucca, Vasari's Uffizi in Florence and Michelangelo's grandiose project for the Farnese Palace in Rome. Some Roman designs, such as Mascarino's houses and Lunghi's Borghese Palace, are of even later origin.

A still more radical connection of the building with nature is provided by three-wing structure, such as the château at Nelahozeves already mentioned, even though the former's courtyards seem to have been fenced on the open side by a low wall. This type was chosen surprisingly often in Bohemia and Moravia. The most important examples are at Mělník, Opočno, Velké Losiny, Račice and Moravská Třebová; the Častolovice Château was built on a plan of two three-wing blocks facing each other. Their closest parallels in Italy are some Tuscan and Lombard villas, such as La Simonetta in Milan, the Mozzoni at Bisuschio and I Collazzi at Scandicci, all of them with column arcades and built in the *cinquecento*; this shape of building had already also attracted the imagination of Leonardo. An intermediate link between the opened and the enclosed lay-outs were the châteaux at Bučovice and Hranice, which had lower front wings.

The master builders showed unusual ingenuity in designing the courtyard arcades. They were not satisfied with the possibilities offered to them in treatises after Vitruvius, nor with the schemes they saw in northern Italy. They combined various systems freely and in an unorthodox way. They mostly adhered to the basic rule concerning the gradation of orders in superimposition, if sometimes in a singular manner, but they did not always follow the maxims about the width of the intercolumniations. The prevailing type is that of a light arcade connecting the column with the archivolt. This type had not been unknown even in Antique times, but for the Renaissance it was shaped in Tuscany in the *quattrocento*; and from there it penetrated into the other areas, including Rome. Many other possible combinations are represented in this country, too: the Greek combination of column and entablature already recommended by Alberti, used only on the uppermost storey; the Roman connection of the arch with the pillar; and the Classical combination of these two systems, as well as an arbitrary amalgamation of individual principles into an ensemble of several floors.

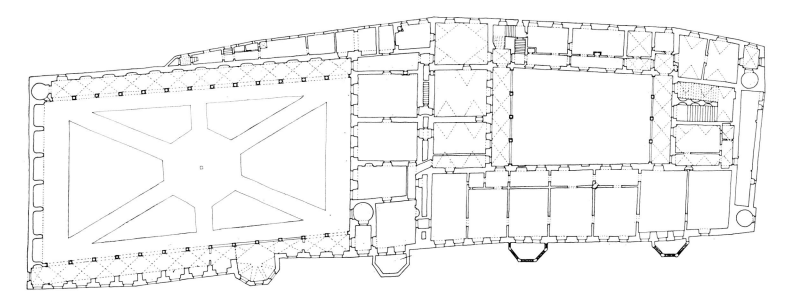

Prague, plan of the Palace of the Lords of Rožmberk in the area of Prague Castle, as of 1738

In the latter case architects nevertheless took care to superimpose lighter forms on heavier ones. Thus a great number of buildings erected from the mid sixteenth century until the beginning of the *seicento* used the heaviest, Tuscan order, consisting of a rusticated pillar arcade, to support the slender columns carrying archivolts on the upper storeys (there are examples at Brandýs-on-Elbe, Litomyšl, Pardubice, Třeboň, Náchod, Dřevohostice, Uherský Ostroh, Ivanovice and elsewhere). This basic arrangement was not, of course, a Czech speciality only, it can be found in the courtyard of Broletto at Brescia in Lombardy or in the Austrian Estates' House in Linz as well. The author of the Small Arcade at Jindřichův Hradec elaborated this type into a complicated design by replacing arches with an entablature on the last storey and doubling the number of supports there. Two parallel trends can be discovered in the conception of the loggias. One tends to a greater attenuation of mass and to the abolition of the dividing line between the corridor and the court by the use of open-work balustrades and other devices. The other, on the contrary, emphasizes the massiveness of the heavier forms, which it even introduces into the system of column arcades by using the motif of rustication. The structure is sometimes optically impaired, however, by the Mannerist loosening of the tight bond of the rustication. The portals show the same tendencies.

In contrast to the courtyard, the building as a whole is generally intended to catch the eye by its mass alone. The mass is not active however as later in the Baroque, nor even structurally articulated as in Italy and France. (In the second half of the *cinquecento*, a lack of interest can be observed in architects' treatments even of the façades of secular buildings in Rome.)[47] The mass is emphasized at most by bossage at the corners, or by rustication carried out over the whole surface in plaster or simulated by sgraffito. This solution imitates the fortress-like palaces of Tuscany. And it was Tuscany, too, that supplied the Czech Lands, just like Rome, Veneto and Lombardy, southern Germany, Switzerland, the Tyrol and Austria, with the alternative possibility of sgraffito and chiaroscuro. This solution replaces the real system of articulation by a fictitious one, or breaks the mass down by a dense net of figural and ornamental patterns. Thus the portal is often the only significant component of the exterior from the architectural viewpoint; it endows the building with dignity and increases its value and respect.[48] Countless variants of a number of types have survived, mostly inspired by the models of such men as Serlio, Vignola and Du Cerceau. These types include a simple rusticated frame and a Classicizing aedicula, a Mannerist formation of several layers with interpenetrating components, a triumphal scheme or a composition making use of the human figure. Unique, as far as we know, is the addition of the full-length figures of the patron and his wife to the aedicula of the portal of the château at Třemešek.[19] A more common phenomenon was the support which was given the appearance of a human being in accordance with the anthropomorphic tendencies of the time, whether it was a term, as at Prostějov, Ivančice, Brno and in some portals of the second half of the *cinquecento* in Italy, France and Germany, or a full-length figure, as at Rosice and Znojmo. The latter tended to be reserved for the interior in Italian art. But shortly after the middle of the century, pairs of such statues had already been applied to the entrance of Ottheinrich's Palace in Heidelberg and in the years 1589—91, i. e. nearer to the time when the Moravian group of portals originated, they appeared on the portal of the Gymnasium at Rothenburg an der Tauber in Germany. Figural reliefs adorn the entrace aedicula of the cemetery at Slavonice.

Many devices were used to enrich the silhouette of the residence of a nobleman. Rarely, an oriel was used. More often it was a gable, whose form and composition were supplied by the sacred architecture of northern Italy; or a whole gable system forming attics along a horizontal composed of dormers. Elsewhere one finds a lunette cornice, a chimney treated in a pretentious manner, sometimes also arcaded gazebo (at Opočno and Náchod), or a terrace covered in by an arcade (at Kostelec-on-Černé Lesy and at Jaroslavice, where it is of the same type as at Rosenburg in Lower Austria). A significant component of the mass of the building was the tower, which was, of course, often a remnant of the preceding medieval castle and was only transformed in the Renaissance. However, an axial tower over the gateway appeared even in some new buildings — at Ivanovice, Stará Ves, Dřevohostice, Třešť, Bechyně, Třeboň and Kratochvíle. Relatively scarce is the castello type with corner towers, which was known to the Italian *quattrocento* and later became common in Germany, Poland, Austria and Slovakia. Its most important examples in Bohemia are the châteaux at Kostelec-on-Černé Lesy and at Vrchlabí; a Moravian variant is found in the castle of Dívčí Hrad. A characteristic dominant feature of noblemen's residences, churches and town halls was a tower with an arcaded gallery under the roof, of which a great number have survived. This formation, which the Italian masters arrived at by combining the local Gothic tower-gallery with the Italian column arcade, spread from Bohemia and Moravia to the neighbouring regions.

The ostentatious character of the building was enhanced by the pretentious treatment of the stairs. The earliest interesting staircase, at Dolní Kounice, is spiral one with an open well. It is a modest enclosed parallel of the monumental open staircases of the French châteaux in Blois and Nevers, as well of the staircase pavilion at Torgau, built under the influence of the former two in the years 1533—36. The Kounice variant, carried out about the same time as that in Saxony, is adorned with ornamental and animal motifs, associated with the name of George Žabka of Limberk, Vice-Chancellor of the Kingdom (Žabka means "little frog" in Czech). This décor, the fragments of the original balustrade and the cupola set on eight lunettes with coat of arms in the lantern, are already treated in the Renaissance style, whereas a similar inner staircase in the castle of Freyburg a. d. Unstrut in Germany, which was built later, is still impregnated with the Gothic. In contradistinction to Germany and its traditional staircase towers, the Czech and Moravian château staircases were mostly drawn into the organism of the building, thus being of an advanced conception. (The ancient part of the castle at Telč was, however, given a staircase annex in the form of a pavilion resting on arcades, but with a straight flight of steps already.) They are usually of the type called "Italian" in Germany, which was introduced into the Renaissance architecture by F. Brunelleschi, but had been known even in Antiquity, namely of the type consisting of two flights of steps, the axes of which are sometimes — at Pardubice or at Bučovice — catched up by niches like in Italy. The sections are separated by a wall. At Klimkovice, this was substituted by a structure of pillars, arches, pillasters, half-columns and balustrades, thus by an advanced formation, which allows looks-through, and communication like spiral staircases with the inner wall pierced into the well. One of these, that of Rudolph II at Prague Castle, was oval-shaped, two others, in the towers of the Lutheran church in the Lesser Town of Prague, were erected on a circular ground-plan. On the contrary, the sections of one of the staircases in Bučovice Château, of square plan, were bordered by walls on the

outer as well as on the inner side. Palladio's Four Books offered both these possibilities.

The straight outside staircase in the courtyard of the House of the Estates in Brno was apparently inspired by Italian public buildings. But it was common also in Germany; in France, two of them, flying in opposite directions, faced at Primaticcio's Aile de la Belle Cheminée of Fontainebleau. In Bohemia, in the courtyard of the château at Poděbrady, it was combined with arcades on three floors (its drawing by Hans Tirol was realized by Giovanni B. Aostalli and Giovanni da Campione in the 1550s); a similar solution was to appear in the House of the Carinthian Estates in Klagenfurt some thirty years later.

Two free flights of stairs, sometimes with a columned baldachin (which also covers the small staircase of the château at Třeboň), used to be attached to the doorways on the upper storey of town halls, as they were in Switzerland, Germany and Silesia. External double-flight staircases were also designed by Michelangelo for the Palazzo dei Senatori, by Vasari for the Palazzo dei Cavalieri in Pisa and by Pirro Ligorio for the Villa d'Este at Tivoli. Two broken arms of stairway lead along the side wings to the upper storey of the loggia of the château at Uherčice, dated 1581.[50] On the front of the château at Náměšť two flights of steps rise in opposite directions from a common base to meet again at the massive portal. This complicated idea has only few parallels in Italy (where it recalls Bramante's design for the Vatican Belvedere and Vignola's conception in Caprarola), and forms an impressive transition from free space to the mass of the building. It was followed by a similar idea in the Austrian château of Hellbrunn near Salzburg. But it was the architect of the staircase courtyard at Moravský Krumlov who produced the most interesting and most monumental work in Bohemia.

The reception rooms, and often the living rooms as well, competed with one another in the lavishness of their decoration, which consisted of paintings and less frequently of stuccoes, above all on the vaults. The halls in particular were notable for their pretentious ceilings. The most complete sets of the latter have been preserved in the castle at Dobrovice and in the residences of the Lords of Hradec and Rožmberk. These Czech and Moravian ceilings, most of them painted or decorated with carving (as in Telč), are of many types: beamed ceilings with decorative mouldings, and also with landscapes or mythological scenes arranged in long bands (as in Prague); panelled or coffered ceilings with compartments of the same basic form, or of various shapes disposed centripetally to produce a symmetrical whole. This cost arrangement had been produced many times in Italy, mainly in Venice; sometimes carved rosettes and cones make the system more picturesque. Even a scheme forming a sort of net can be found, a type made popular by Serlio in his Fourth Book in 1537, perhaps after one of the ceilings in the Roman Cancelleria. Soon afterwards it was used in the castle at Pardubice, after the middle of the century in the vault of the town hall at Mladá Boleslav, and about 1600 on the vault of the entrance passage of the castle at Hranice and in the château at Častolovice. The system of "interlinked frames" is also represented: the most complicated example, carried out on one of the ceilings of Dobrovice,[51] was inspired, through a reproduction by Daniel Hopfer, by the pattern created in the Venetian Church of S. Maria dei Miracoli after a design by Pietro Lombardi who drew on the Antique heritage. Thus there is a great diversity in the conception of the ceilings, even though only fragments of the original riches have been preserved.

The system of "interlinked frames" was also used on vaulting, particularly on barrel vaults, mainly in the second quarter of the sixteenth century in Veneto. On the smooth surfaces of the barrel vaults, Jacopo Sansovino combined stern geometrical forms, interlinked by connecting reglets. (Giulio Romano applied a single motif in a regular sequence in a similar way on the vault of the portico of the Palazzo del Tè in Mantua.) This kind of decoration was popular in Poland, in north-west Bohemia and in particular in Moravia at the turn of the sixteenth and seventeenth centuries. Undoubtedly the same hand enriched it on the vaultings in the Moravian castles at Hranice and Tatenice with ornamental elements in polychrome stucco, a medium much used by Venetian artists. This system of "interlinked frames" was elaborated into a complicated formation on the large vaults of the churches at Strážek, Velké Losiny and Branná. Also renowned for their vaulting decorated with figural stuccoes were the structures of the Lords of Rožmberk and of Hradec and the château at Bučovice, the sculptural decoration of which is of an extraordinary level.

Except for the noblemen's seats in southern Bohemia which rose somewhat later, the most significant of the Moravian and Bohemian châteaux (Moravský Krumlov, Opočno, Litomyšl, Bučovice, Náměšť-on-Oslava, Telč and perhaps even Rosice) were designed and started in the third quarter of the sixteenth century and completed at the beginning of the 1580s at the latest. The speed at which they were built one after another and their high level of artistic achievement can most probably be explained by the patrons' first-hand knowledge of Italy, and above all of course by the contribution of Italian artists. In spite of various inconsistencies — imposed by the limited abilities of the artists, by the former appearance of the building, or by the commissioner's directions — the Italians produced here a worthy and multifarious set of feudal residences, whose large arcaded courtyards interpret in a fairly faithful manner the ideas of Renaissance Italy.

Many a characteristic feature of these buildings of the noble families can be traced in one of the early châteaux, at Horšovský Týn. From 1547 onwards John the Younger of Lobkovice and after him his son Christopher, the educated major-domo of Rudolph II, got gradually extended the local Early Gothic castle into a four-wing seat. First the north wing was hung on the wall of the fortification by means of a bold corbel construction. Its suite of rooms was decorated with glazed terra-cotta consoles with figure motifs derived from Italian models of the second half of the *quattrocento* in Tuscany, Urbino and Milan. To these scenes of the Passion were added in 1554—57, executed in rapid draughtsman's manner in local colours. The east wing had been completed by 1559; designed along similar lines to the front of the Rožmberk Palace, it has a crown of gables and a tower. (The paintings of the reception rooms recall the significant post Lord John held in the country's administration.) As far as its style is concerned, new forms still contend with the Gothic feeling and the interesting defensive gallery, drawn into the organism of the buildings, is still influenced by the conception of medieval fortifications. Along the south side of the courtyard of this three-wing structure, a dwelling block was later built with a Classicizing pillar arcade, a lunette cornice and volute gables of advanced form. It has affinities with the palace which the same master — Agostino Galli, probably from Massagno near Lugano — built for John of Lobkovice near Prague Castle in the 1560s.

Four wings were planned for this Prague palace, with a loggia

56 Dolní Kounice Château, a spiral staircase with relief decoration (the original balustrade has been removed), the 1530s

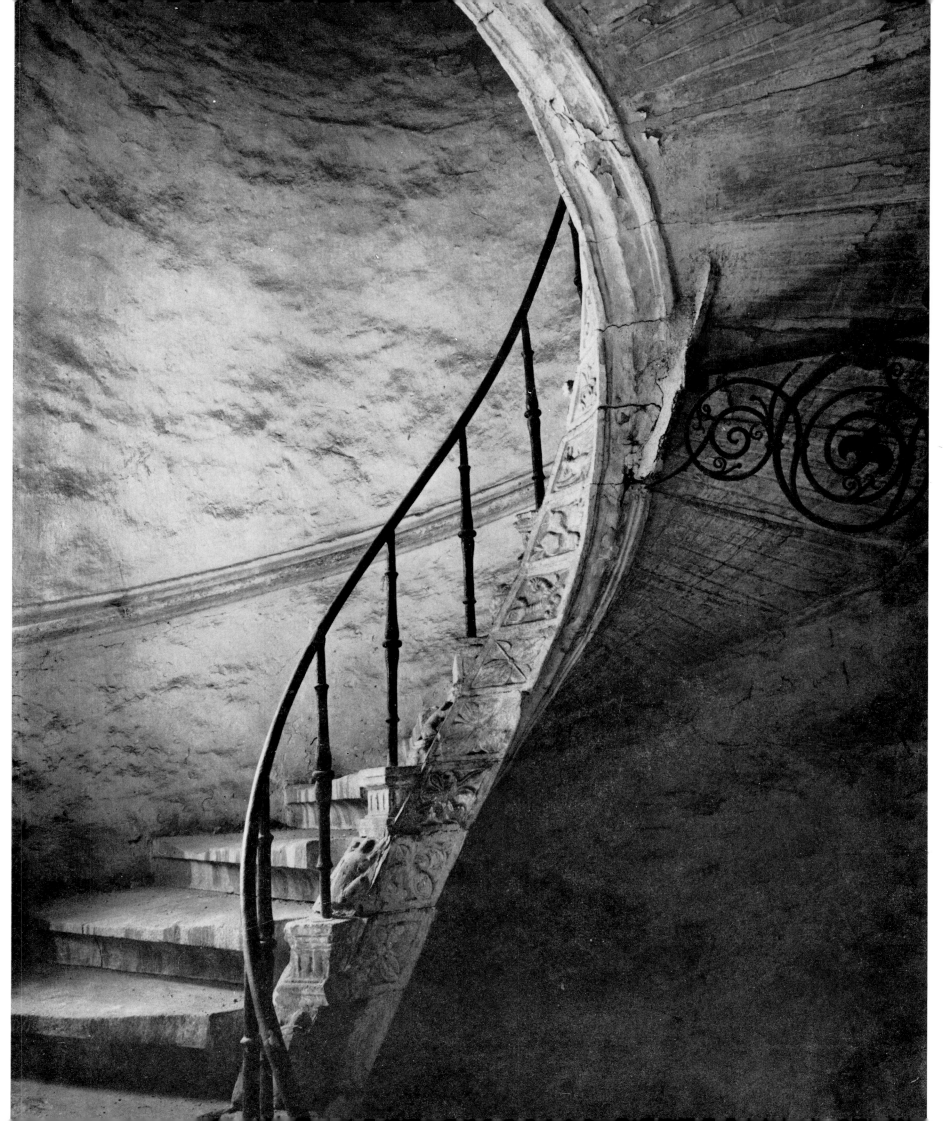

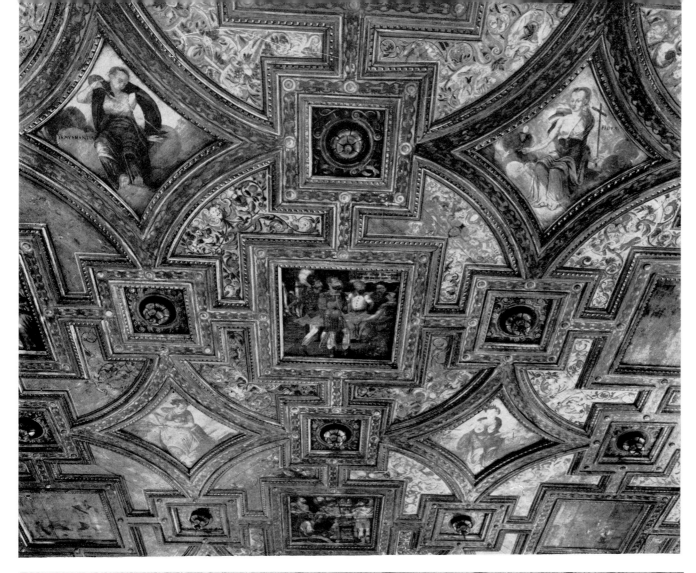

57 Švihov Castle, hall with a coffer ceiling from Dobrovice Château, 1578

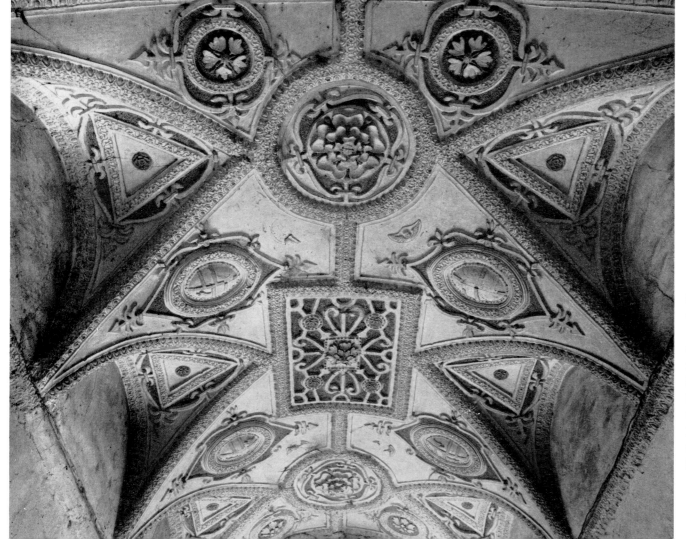

58 Tatenice Mansion, the vault of the entrance passage, about 1606

59 Alonso Sánchez Coello, portrait of Maria Maximiliana of Pernštejn, born Manrique de Lara, with her daughter Polyxena, about 1570. Oil on canvas, 135,5 × 101 cm, Nelahozeves, the Middle-Bohemian Gallery (from the Roudnice collection).

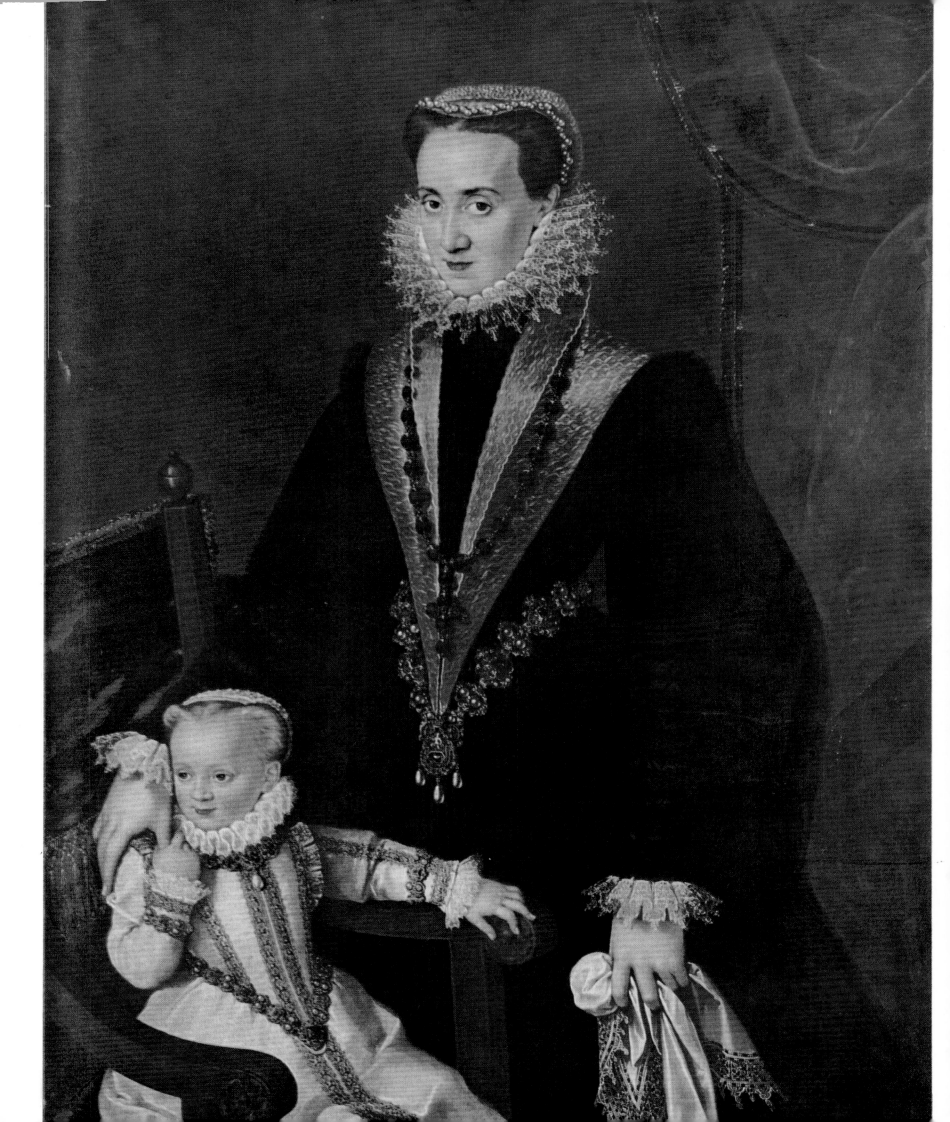

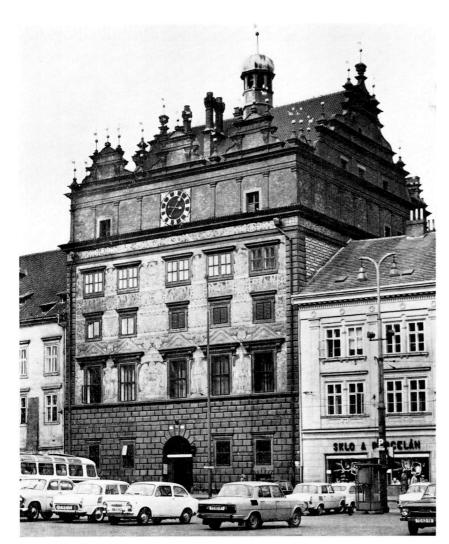

◀ 60 Plzeň, Town Hall, main façade, perhaps Giovanni Stazio, 1555—58

61 Klimkovice, staircase of the castle, 1578 ▶

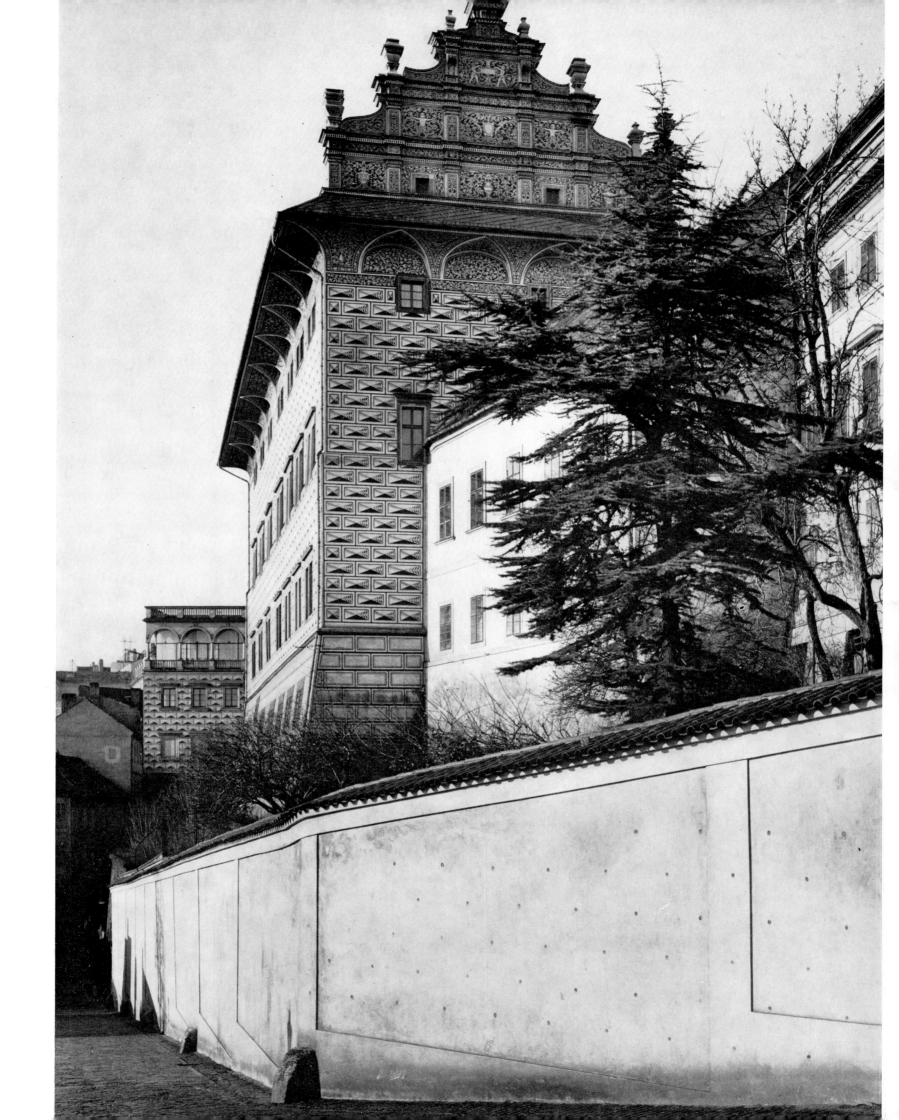

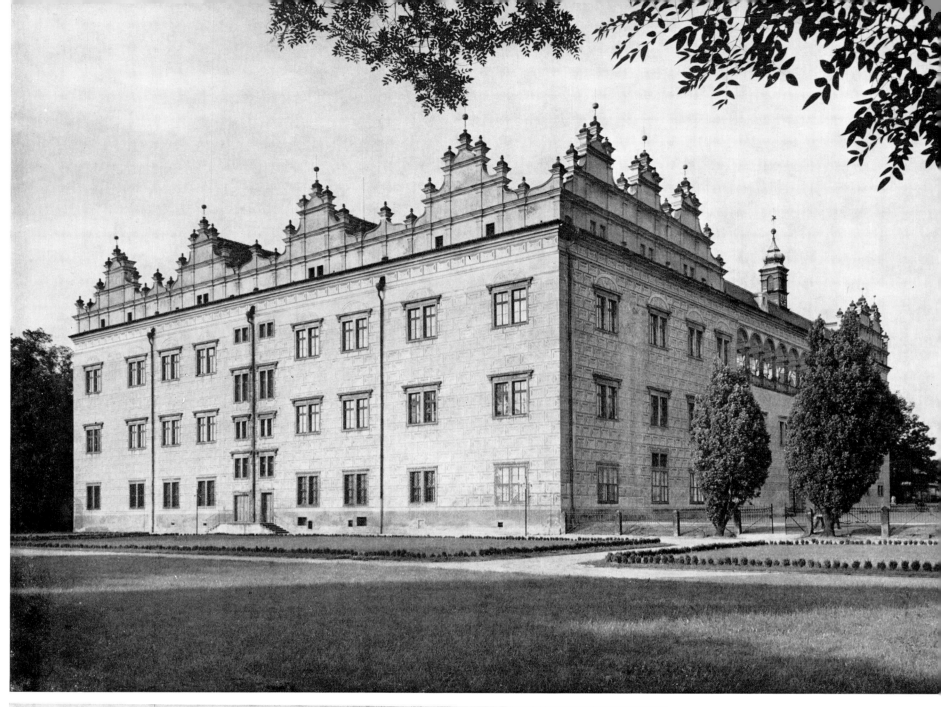

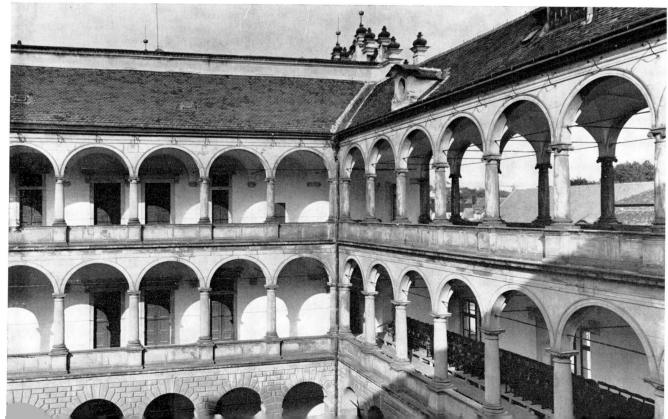

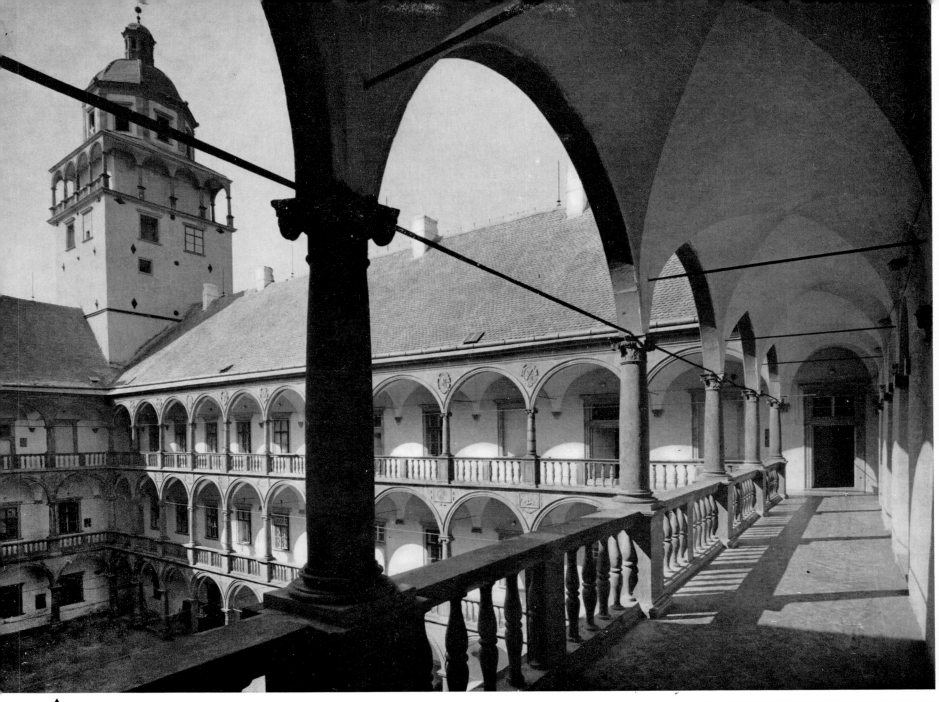

65 Moravský Krumlov Château, the main courtyard, about 1560 (the date of 1562 on the first storey)

66 Moravský Krumlov Château, the staircase courtyard with a vista into the main courtyard

63 Litomyšl Château, the west and the main façades, by Giovanni B. Aostalli and Ulrico Aostalli, 1568—81

64 Litomyšl Château, arcaded courtyard

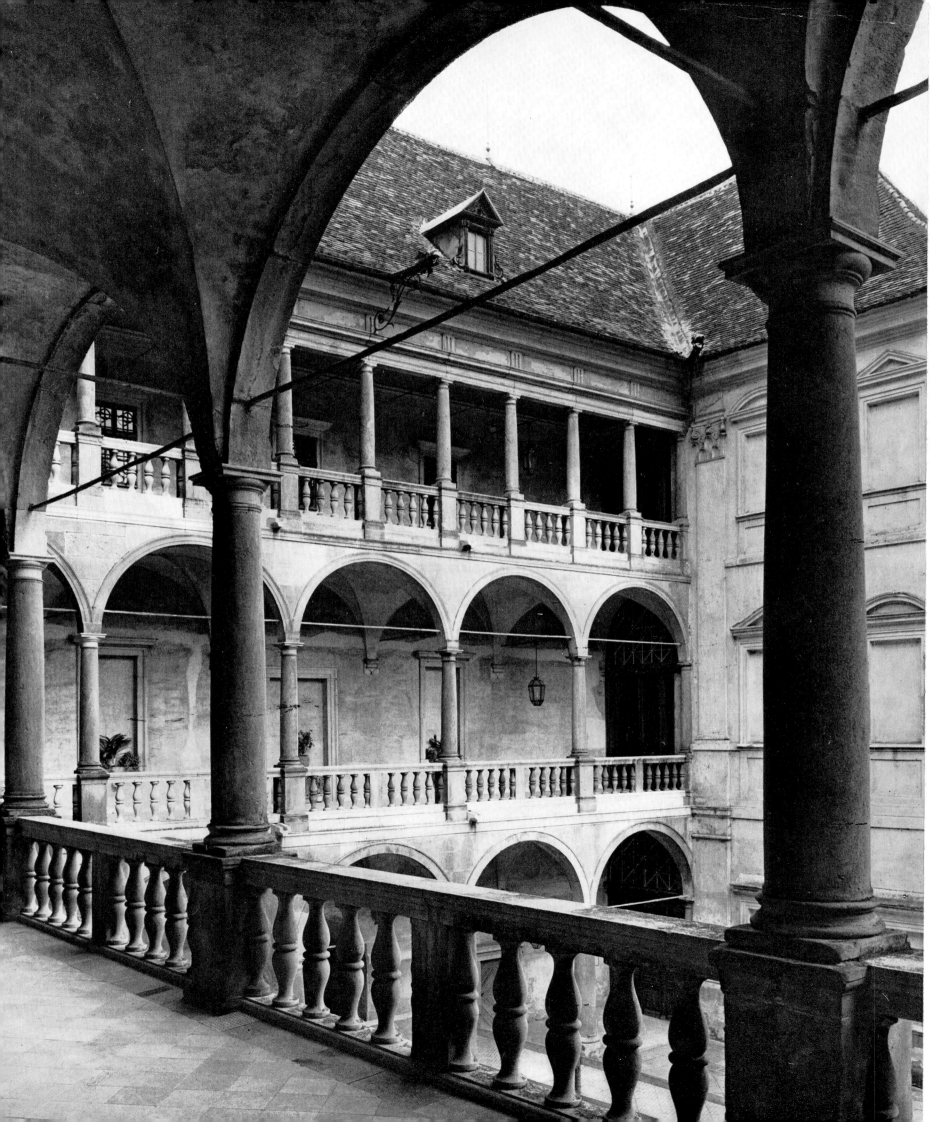

67 Opočno Château, arcaded courtyard, 1560—67 (Baroque adaptation about 1700)
◀

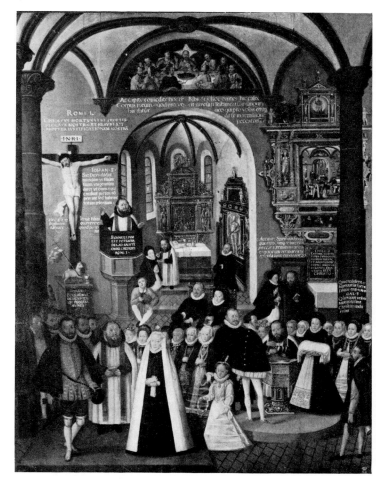

68 Epitaph of John Jetřich of Žerotín, by a Central-European painter, 1575. Oil on wood, 183 × 142 cm, Opočno, the Gallery of the Château. ▶

69 Bučovice Château, arcaded courtyard, between 1567 and 1581 (the date of 1581 on the second storey)

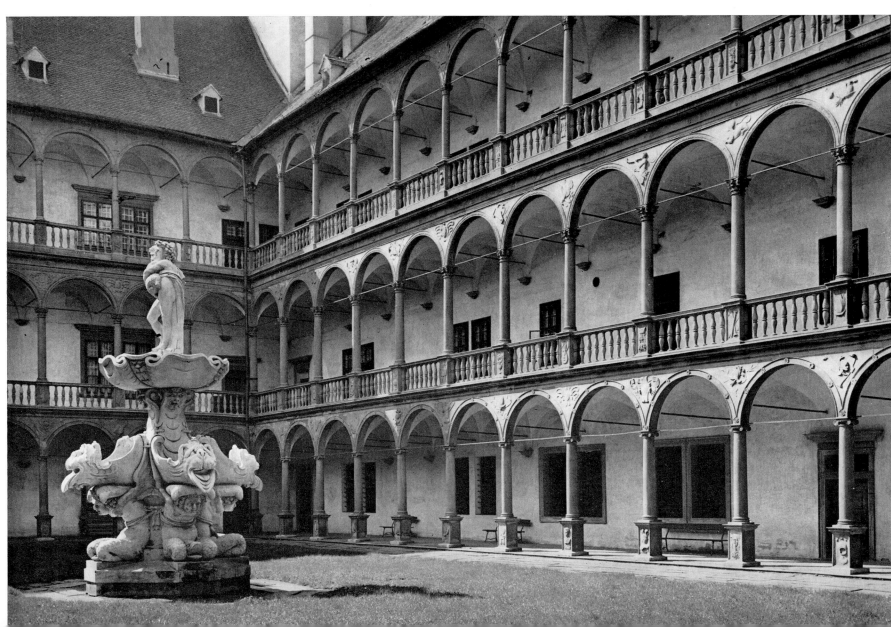

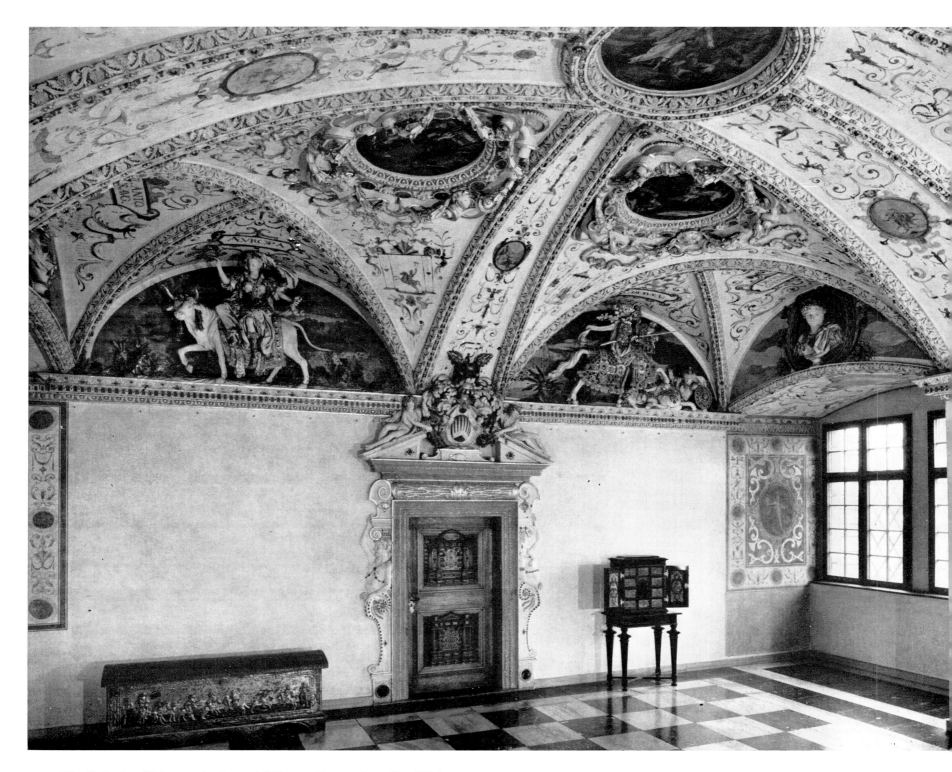

70 Bučovice Château, the Imperial Room. Decoration after 1583.

71 Bučovice Château, the Imperial Room. Lunette with Europa, after 1583.

72 Bučovice Château, the Imperial Room. Lunette with Charles V, after 1583.

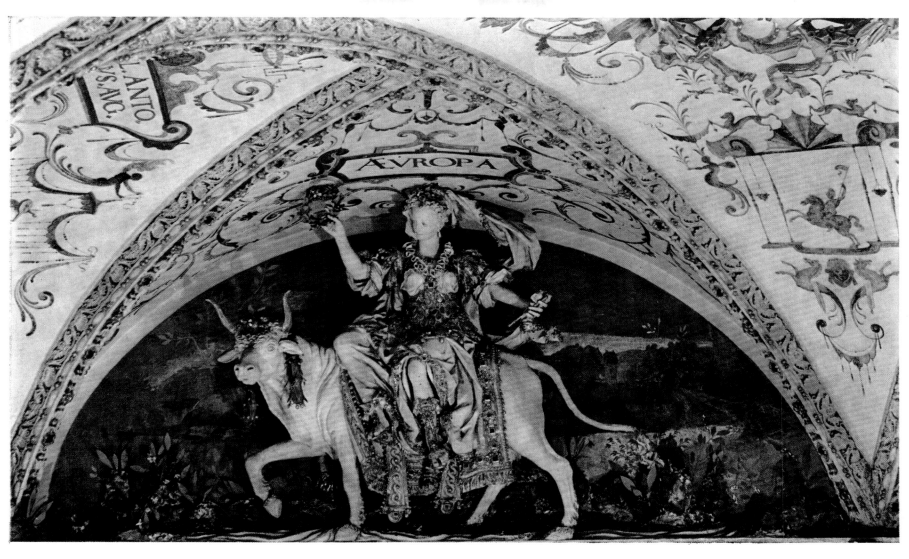

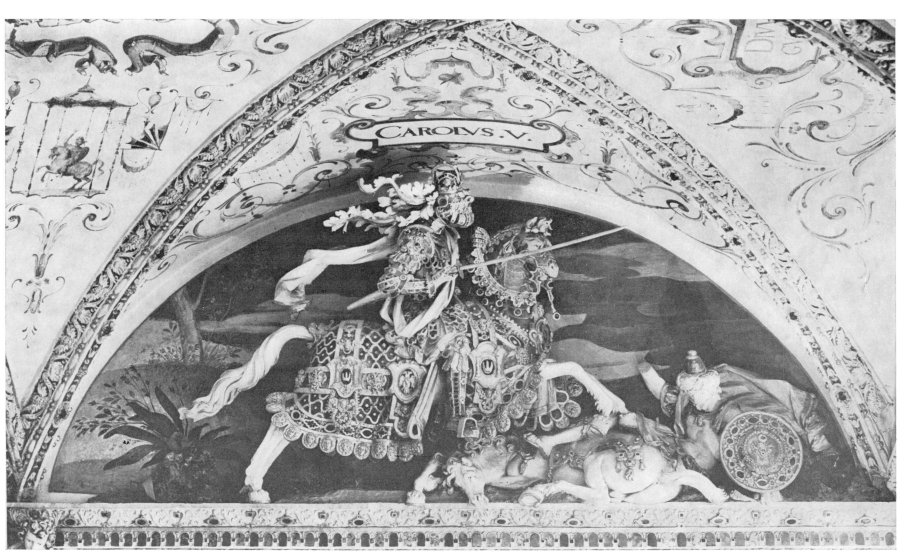

95

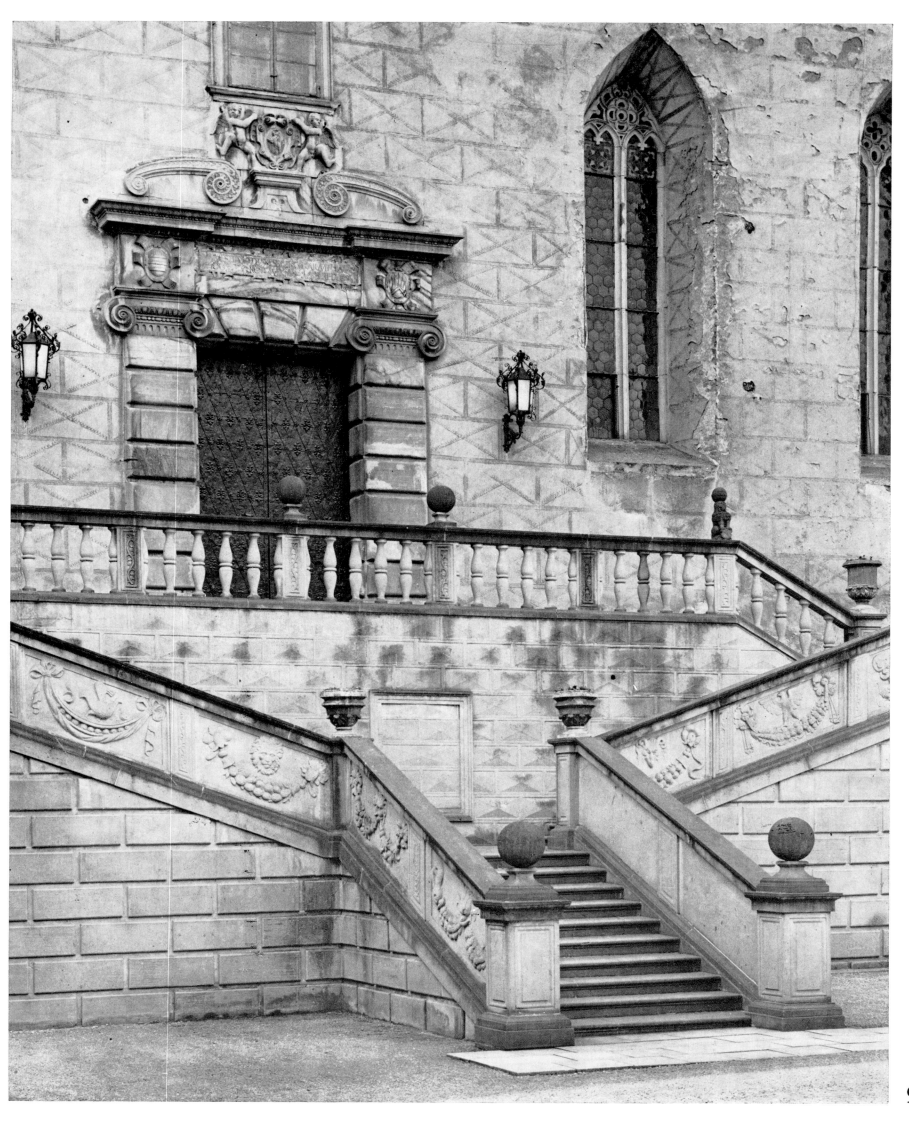

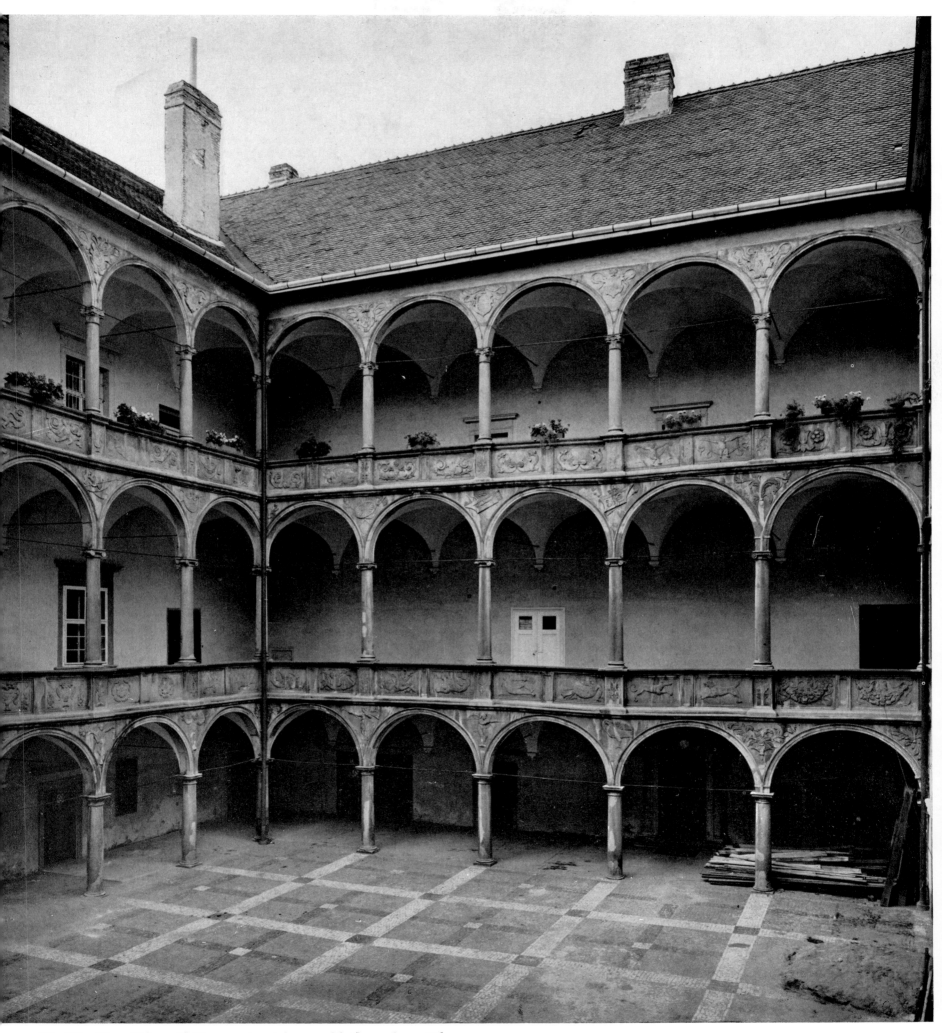

73 Náměšť-on-Oslava Château, outer staircase with the main portal,
about 1577 (reliefs replaced in the 19th century)

74 Rosice Château, courtyard arcades, about 1580

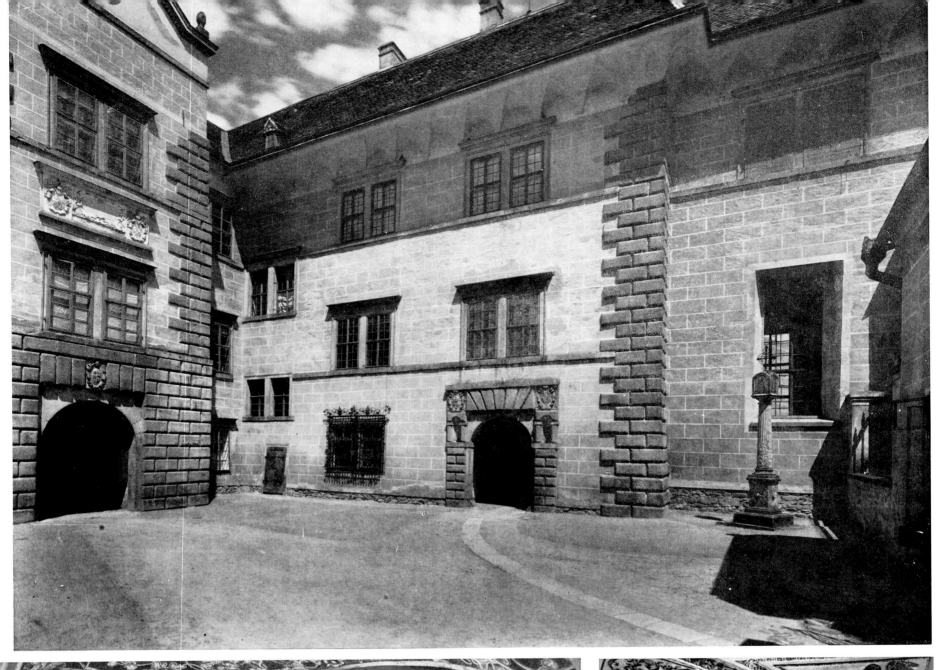

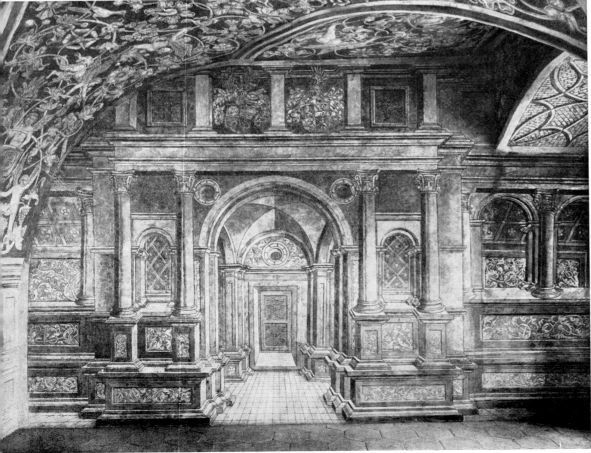

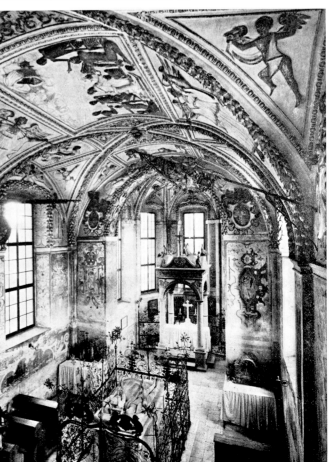

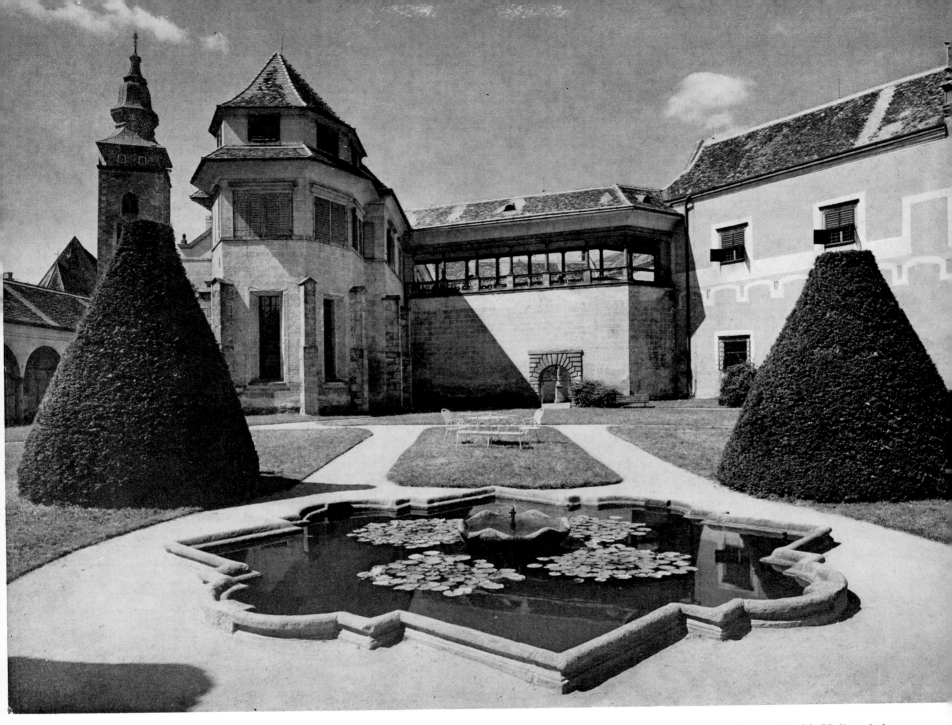

78 Telč Château, the garden with the chapel, the Marble Hall and the connecting link

75 Telč Château, forecourt, 1566—68

76 Telč Château, medieval palace. Treasure Chamber, sgraffito illusive architecture, about 1553.

77 Telč Château, All Saints' Chapel, completed in 1580, with the tomb of Zacharias of Hradec and his first wife Catherine of Wallenstein

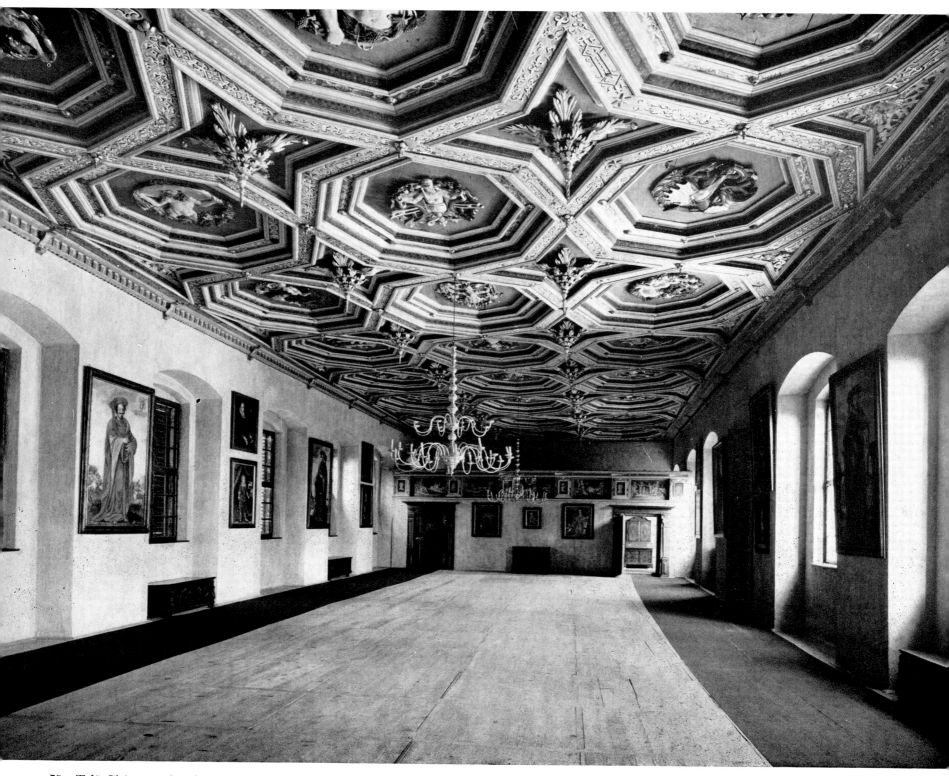

79 Telč Château, the Golden Hall with the coffer ceiling and the musicians' gallery, 1561

of a similar type on the ground floor. Only two were erected however and these were supplemented with a lower wing and a wall closing the oblong courtyard on the side adjoining Hradčany Square.[52] The south wing, towering above the road leading to the Castle, is monumental in the Italian manner, both in its proportions and in the sobriety of its regular articulation, which is confined to double windows. Its fortress-like character, which is reminiscent of the Tuscan palaces, is reinforced by the diamond-pointed rustication imitated with sgraffito (which the transalpine countries learned of through Rivius's treatise Vitruvius Teutsch in 1548), the weighty forms of the stone portals, and details in the interior. The austere block is made picturesque by a north-Italian lunette cornice and a structurally conceived gable from the same area. The appearance of such a gable, derived from the sacred architecture, on a secular building and the resultant multiple outline of the whole are, of course, specifically transalpine phenomena.

Akin to the Lobkovice buildings is the town hall in Plzeň, which was erected in 1555—58, most probably by Giovanni Stazio from Massagno (with whom Galli may have come to Bohemia); it is again a massive block strengthened with rustication, reminiscent of the Tuscan palaces of the first half of the *cinquecento*. Its monumental design differentiates it from all other town halls and makes it a proud representative of this powerful Catholic royal city. Among the features it has in common with the Prague palace are the ranging of the windows on the axes and the lunette vaultings, which together with the rustication and the form of the windows bring it close to Griesbeck's building achievements, too. The attic zone with a sequence of gables seems to be an addition raised in the 1570s; its advanced design had a parallel namely in the gable of the church at Kralovice.

At that time, also, the most significant of the Pernštejn buildings, the château of Vratislav "The Splendid" of Pernštejn at Litomyšl, was surmounted by a crown of gabled attics. This educated Lord Chancellor, whose journeys with Maximilian II and missions for the Habsburgs took him as far as Rome and Spain, Germany, Poland and Austria, was fascinated by the charm of Romance, and especially Spanish, culture. In 1555 he married Maria Maximiliana Manrique, daughter of Don García, Governor of Piacenza and member of the prominent Hispanic family of Mendoza. Not only was she an ardent supporter of the Catholic minority in Bohemia but she also brought to the country the core of a portrait gallery, which introduced the Spanish type of official court portrait to the Czech Lands.

In this collection, which was enlarged over many years, two foremost painters of the Madrid Court, Alonso Sánchez Coello and his disciple Juan Pantoja de la Cruz, were represented by works from various periods of their activity. There were portraits of the Pernštejns, of their Spanish relatives and also the Habsburgs. The large canvases render the persons depicted as full-length figures, austerely dignified and simplified in a monumental way, isolated in their pictorial world, in a subdued and reserved atmosphere. They show people almost lost behind the significance ascribed to their robes, rendered with descriptive care and in the smallest detail, but without the sparkle of similar subjects, in Netherlandish painting, however; it is the robe that, in its turn, enhances the significance and rank of the person portrayed. The paintings evince the mysterious atmosphere of the aristocratically exclusive court bound by a stern and complicated etiquette, as well as the self-evaluation of the commissioner and his craving for grandeur. Coello's almost sculptural approach is characterized by a rigidity

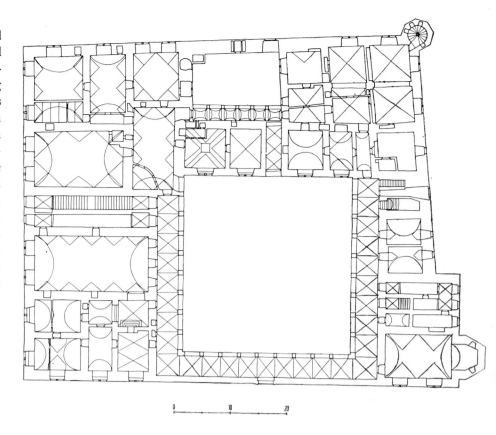

Litomyšl, plan of the Château

of line, open and complicated outlines and a flatness of conception, which takes space as a mere convention. These elements were slowly replaced in the work of his disciple by efforts towards a suggestive, almost deceptive, animation, and a gradation of effect achieved by unifying the colour tones and suppressing the details; there is also a greater interest in the face, which is modelled more softly, and in perspectively delineated space.

The works of these two painters were apparently something of a revelation in this Central European country and considerably influenced the production of the local portrait painters. This was, surprisingly enough, extensive, but it borrowed in an eclectic way from various sources — Saxony, northern Italy and the Netherlands. Only seldom did the local artists produce a work which was above average (this was true of painting of that time in general). An exception is the portrait of Mary Magdalene Trčková of Lobkovice, Vratislav's sister Elizabeth Těšínská, Catherine Redern and un unknown woman called the Lady of Dobříš. The Pernštejn family gallery also contained paintings depicting other subjects, as well as other works of art. Remarkable were the three rooms of the library, too, with 1500 printed books in Czech, German, Latin, Italian and French, further manuscripts, volumes of copper-engravings, woodcuts and drawings.[53]

The château of Litomyšl itself is also of interest. It was worked on by Giovanni Battista Aostalli from 1568 until his death in 1575, to be completed six years later by Ulrico Aostalli. In this large building, again, elements imported from Italy are interwoven with local ones. The design of the block is Italianate (with a large courtyard concealing the irregularity of the preceding structure), as are the form and significance of the arcades. The gabled crown is of local origin, as is the shape of the chapel with its pointed windows which disturb the sequence of the Renaissance openings in

the façade. This last feature is apparently deliberate as it also appears on the château at Náměšť. The arcaded courtyard with its square ground-plan still adheres to the balanced formations of the Early and High Renaissance, but the loggias do not run all round it. They are attached to three sides only, whereas the front wall of the courtyard is solid, as in the Rožmberk Palace or at Spittal an der Drau, and emphasized by rich sgraffito decorations of admirable quality. The latter even include large compositions, such as were typical of Italian and southern German façades, one of them depicting the Battle of Constantine at the Ponte Molle; it was inspired by a print of the wall-painting by Giulio Romano in the Vatican. Thus accent is laid on a single axis of the architectonic composition running through both entrances, the southern as well as the northern one (the latter originally probably being the main), and through the passage which connects the small, apparently entrance, courtyard with the large arcaded one.

The extent and significance of this open space equals the closed parts of the ensemble. The arcades are monumental in their simplicity, with rusticated pillars on the ground floor and columns on the two upper storeys. Their stern character, underlined by solid parapets, is relieved by a loggia on the second floor of the southern wing (which is in fact only an arcaded communicating link), opening to both sides in the Mannerist way and augmenting the role of the sky in the whole composition. An arcade in the front of a building is no exception in Italy, being found mainly in Veneto, but also in Siena, Rome, Lombardy and Trent; and many palaces, especially in Tuscany, have an open columned hall on the uppermost storey. But here the arcade connects the architectonically delimited space with infinite space, into which it escapes and is, in return, penetrated by it. The same phenomenon can be found in the designs mentioned above by Sansovino, Michelangelo and Romano, and in the palace of Franco Lercari in Genoa,[54] built at the same time. Thus the Czech loggia was an implementation of an advanced idea which was not even common at that time in Italy, the cradle of the Renaissance (it seems to have been inspired by the château of Trent; of Italian origin is also the symmetrical, monumentally shaped façade of the newly erected west wing).

Nevertheless, this idea was applied in the very first big residences of the nobility, in particular at Moravský Krumlov. The castle there, the reconstruction of which had started in the first half of the sixteenth century, was turned into an intricately composed structure in about 1560, under Pertold of Lipá, hereditary Marshal of the Kingdom of Bohemia. Its architect is unfortunately unknown, unless it was Leonardo Garovi from Bissone on Lake Lugano, who is known to have worked there before his death in 1574. The big courtyard, markedly extended in width, features column arcades on three storeys, with Classically superimposed orders, on three sides; a view of the loggias is already offered from the entrance passage. One wing is again a mere arcaded communication link; it is pierced on both sides, by arches on pillars extending right through into a small courtyard surrounded on the first two floors by pillar arcades and on the third storey by column arcades. A long, straight and arcaded flight of stairs was built in one of the wings of the courtyard.

This unusual configuration of two interconnected courtyards and the singular shaping of the staircase even preceded some Italian designs, such as the staircased courtyards in Genoa, which are of course of a somewhat different type, and the idea expressed by Palladio in his *Quatro libri* of a staircase, with a well which is lighted from above making it possible for those upstairs to communicate visually with those going up. The Moravian staircase is, as it were, a monumental expression of this conception, which was realized by Bramante in the Vatican and, concurrently with our château, by Vignola in Caprarola in the shape of a spiral cylindrical form with arcades opening into the well. Those were,

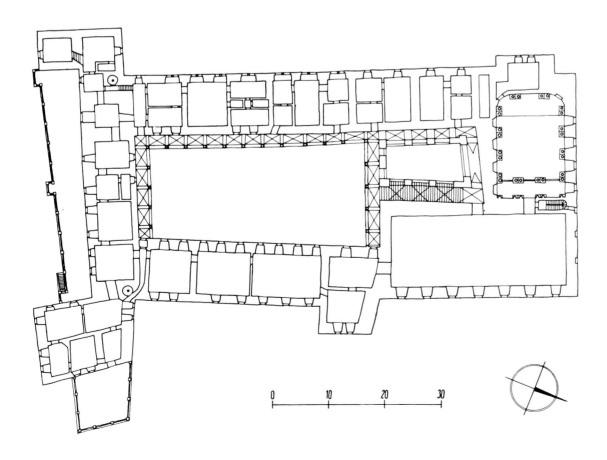

Moravský Krumlov, plan of the Château

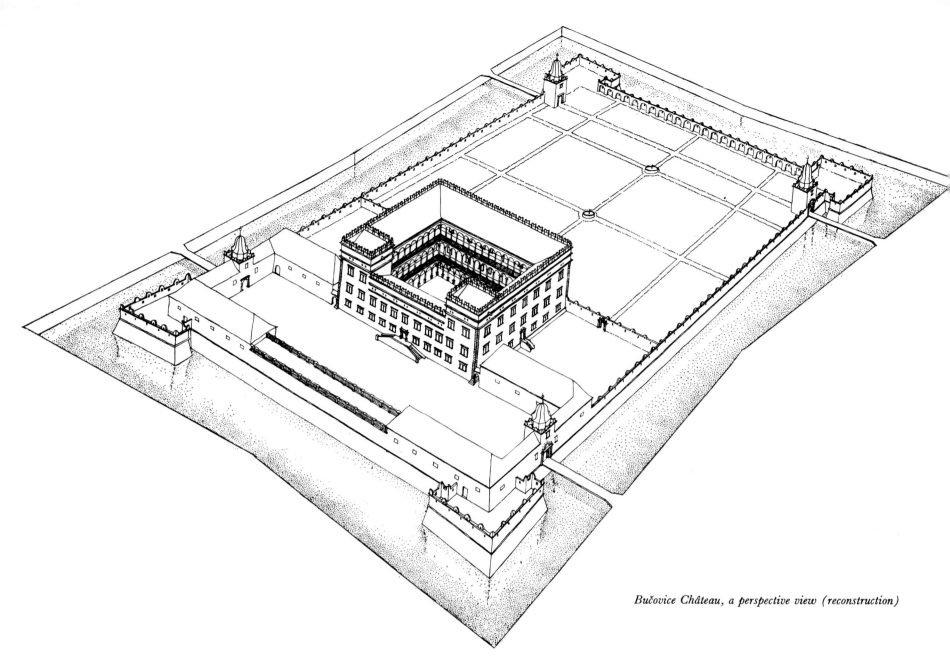

Bučovice Château, a perspective view (reconstruction)

of course, conceived as parts of the organism of the building, while the Moravian staircase is an independent structure which is not, however, attached to the block as are the Venetian, French and German tower-like staircases.

As far as we know, its conception is exceptional. It permitted access to the loggias of the big courtyard as well as to the big hall, and represented a significant component in the complicated scenographic design. It was sensitively fitted in the building as a whole — the straight line of the flight of steps roughly divides the narrower side of the château on its axis, separating the free space of the smaller courtyard from the enclosed space of the hall. A terrace supported by pillars was stretched between the two towers of the lateral façade opposite; an arcaded gallery, one of the first in a long range, enriches the silhouette of the south tower and softens it by an interplay of light and shade. Predated only by the Pernštejn Palace and Prague Belvedere is the sculptural ornamentation of the arcades with carved coats of arms and decorative motifs, which is typical of Moravia. In this decoration, the Moravian buildings acknowledge the mother-country of their creators, Upper Italy, where it was commonly applied in Lombardy and Veneto.

At the same time, in 1560—67, William Trčka of Lípa, one of the participants in the mission to Genoa, started to build a new château at Opočno. It is chiefly the courtyard which has preserved its original appearance as is the case with the majority of Renaissance residences of the Bohemian and Moravian nobility (the gables and towers were taken down in the seventeenth century). The courtyard was again extended in width, but closed on three sides only, as we have seen at Nelahozeves. As at Nelahozeves, Moravský Krumlov and Opočno, too, the designer took advantage of the intersection of the axes: the entrance passage lies on the longer latitudinal axis so that, as was usual in some late Italian buildings, the view of surrounding nature through the fourth side (completely free since the reconstruction in Baroque style) opens only gradually to the entering person. The system of arcades is a proof of the combinative ingenuity of the Italians active in the Czech environment; the columns carry archivolts and on the uppermost storey a straight entablature with triglyphs, in an accelerated rhythm. In comparison with the two preceding structures, the relationship between mass and space has changed; space now seems to merge the corridor, the courtyard and nature almost without any material division. An open-work balustrade has superseded the solid parapet, the columns have got more slender and the building has been opened into the nature. This process was to culminate in the château at Bučovice.

An interesting memorial picture of John Jetřich of Žerotín, dating

from about 1575, has been preserved from the original furnishings of the château of Opočno which were partly recorded in old inventories. Its artistic value is not very great, although it surpasses the quality of many works of this type, of altar-pieces and epitaphs of the second half of the century. "It is a memorial picture and, at the same time, a representative one; it is a group portrait and, at the same time, a picture of the life and customs; it is a historical scene and simultaneously a genre; it is a depiction of the culture which flourished in the châteaux of the nobility and simultaneously a manifestation of Reformation piety in the spirit of Lutheranism" (the commissioner is participating here in the sacraments admitted by Protestantism)[55]. The whole scene is repeated on a painted epitaph as a picture within a picture. Both the figures and the milieu are rendered in a matter of fact manner, namely the three-naved interior of the Opočno château church, in which the Renaissance is still permeated with the Gothic, producing an ensemble of unusual lightness. The effect is due to the giant columns supporting the vaults; they were intended to carry tribunes as well but these were replaced by a three-sided choir loft attached to the peripheral walls, also resting on Ionic columns.

Only drawings (from about 1690) and a Baroque picture have, unfortunately, come down to us of the appearance of the château at Slavkov near Brno.[56] It was a two-storey structure with column arcades round an oblong courtyard and a staircase tower in one corner. Its owners, the Kounice family, were related with Pertold of Lipá and with the family of John Šembera of Boskovice who lived at nearby Bučovice. The château of Bučovice, under construction from about 1567 until the beginning of the 1580s, was designed as a part of a large complex with a forecourt and an extensive garden. The large oblong of the whole, conceived in depth, was bounded by a wall, simulating fortificatory function, with bastions on all corners and with two pairs of gates. (A modest variant of this arrangement, akin also to the Neugebäude Summer Palace in Vienna, was the villa of the Kolovrats at Krásný Dvůr.) The Mannerist approach is also found in the sequence of the axes intersecting at right angles, on which the Bučovice complex was composed, and in its dynamic conception,

requiring the co-operation of the visitor. There is also a Mannerist double opening of the structure, which was graduated from the forecourt, the centre part of which was lower than the sides, to the three-storey cube whose lowered front wing — shut in by the higher mass of the sides — affords a view from the arcaded courtyard, as at Litomyšl. In its proportions and its detil, this courtyard is one of the most beautiful in Central Europe. The entrance through the full wing offers a view of the almost non-material system of column arcades on three storeys, whose delicate network and carved decoration contrast (in the Mannerist sense) with the stern character of the exterior (the original attic of which was pulled down later).

The artistic value of the stucco decoration of the rooms on the ground floor is likewise of more than local significance. It surpasses the murals, a part of which reveal Venetian influence, which were apparently executed by the court painters of Lord John Šembera, Marcus Khaytzen, who lived in Brno, and Lorenz Pukl Plucar. Among the paintings, mainly on the vaults, are scenes from the Odyssey and from mythology, allegories (after Italian and Netherlandish compositions), emblems and scenes of the "reversed world", in which animals act as human beings.[57] One vault is transformed to give the illusion of a pergola. The workmanship of the stucco is unique; large three-dimensional figures with accompanying sculptural details are incorporated in the painted landscapes of the vault lunettes. Charles V and Mars, Diana and Europa, Leda and Zeus, with the corresponding animals, are treated in a masterly way. They are brilliant works showing Mannerist traits in composition, in the figural canon, in the complicated patterns of movement, in the sensual tone as well as in execution. In a veristic way the sculptor has combined stucco, colour, semi-precious stones and other materials into unusually impressive ensembles. They are unequalled among surviving examples of monumental stucco sculpture in spite of the fact that they are in essence based on the Italian (mainly Tuscan and Lombard) combination of painting and three-dimensional form, which was also applied by Elia Castello in Salzburg towards the end of the century. They are all the more precious in that they seem to enable one to imagine the decoration of the Neugebäude in Vienna,

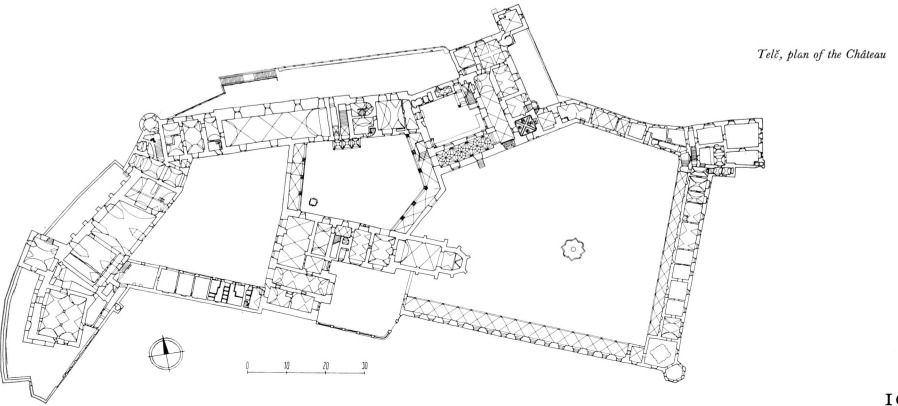

Telč, plan of the Château

0 10 20 30

carried out for Maximilian II by Bartholomeus Spranger and Hans Mont and since destroyed. It is not impossible that the still unknown sculptor who created the set of stuccoes in the Bučovice Château was one of the Viennese group.[59] His work, influenced by Giambologna, together with the stucco decoration at Hvězda which it even surpasses, belongs to the greatest achievements of the *cinquecento* in plastwork in both the Czech Lands and the whole of the transalpine area. The sculptor having been entrusted with the leading part, the stuccoes, and the painter with the accompanying landscapes, the scenes have only few analogies: in Fontainebleau Château, and later, towards 1600, in the German funeral chapel of the Wettins in Freiberg; both of them were carried out by Italian artists.

Sculptural decoration was typical of Moravian châteaux in general. The balustrades of the Bučovice arcades did not offer so many surfaces for carved reliefs as did the full parapets of the two residences of the Žerotíns. These were another leading, much ramified. family of the Margraviate of Moravia, with whom a number of Renaissance buildings are linked. Their castle at Náměšť-on-Oslava was transformed into a château from about the beginning of the 1570s, the other at nearby Rosice at the end of the same decade; in both cases the older structures influenced the vertical arrangement of the courtyards. During a further stage of construction, at Náměšť about 1580, at Rosice towards the end of the century, these seats were completed and given the form of enclosed four-winged blocks.

The commissioners were the Lord Chief Justice John of Žerotín and his famous son Charles the Elder, who received excellent education during the ten years he spent in Strasbourg, Switzerland, Italy, France, England, the Netherlands and Germany. Both at that time and during his repeated journeys to Italy and France later on (when he actively supported Henry IV) he made friends with the leading personalities of the Protestant courts as well as with Theodor de Bèze, the Swiss reformer and successor to Calvin. He was a far-sighted politician, but the Counter-Reformation, having just seized the key positions in Bohemia, permitted him to play a role in the administration of the country for a short time only. Both the Žerotíns were members of the Unity of Bohemian Brethren; John, the father, greatly contributed to the development of its printing-office, which he established at Kralice on his estate; about seventy excellent prints were made there, charming in their Renaissance character. Both were also renowned for their libraries.

Among the master builders in the service of Charles the Elder is recorded Jerome the Italian who returned from Italy in 1603; another builder active in his subject town of Přerov was "Gregor architector"; yet the builder of the Náměšť and Rosice châteaux is unknown. Both of them have column arcades on two sides of the courtyard, with a graded order and decoratively adorned parapets and spandrels. This ornamentation, as well as fragility and Mannerist elongation of the columns at Rosice makes the Žerotín loggias reminiscent of those at Bučovice. The arcades at Náměšť, built in 1573—74 also have affinities with those at Moravský Krumlov, in the application of the same orders, in the shape of the capitals of the columns and of the cartouches with coats of arms. It is therefore not impossible that their author (Leonardo Garovi?) worked at Náměšť after having completed his work at Moravský Krumlov.[59] His death in December 1574 would explain different details in the second building phase of the Náměšť château, as well as some divergences in the arcades of Rosice. At Náměšť, the carved decoration was also applied in the exterior, on the corner oriel and the outside staircase. The exterior

of the château is very impressive, with its monumental mass towering above a steep hill and strengthened by corner rustication, and its portals of sober form, made of big ashlars. Only fragments of the sculptural part have survived the reconstructions of Rosice Château: figural torsos from a fireplace, executed by the same hand which decorated the house of the Lords of Lipá at Ivančice, and two full-length Mannerist figures from a portal. The Lombard decorativeness is also found in the Žerotín's residence at Hustopeče-on-Bečva, built between 1580 and 1596, in the three-wing arcades of the château at Račice which was erected in three phases, and elsewhere. It seems certain that the same group of artists worked at both Rosice and Náměšť. After all, the Lords of Lipá, Boskovice and Žerotín, interrelated by marriage, were undoubtedly inspired by the buildings of their relatives and friends, and probably employed the same master builders and stone-masons, as did, for example, the Rožmberks and the Lords of Hradec.

These two families, related by their coat of arms — the rose — as well as by blood, ruled over a major part of southern Bohemia and south-west Moravia and occupied the highest offices in the country. Both of them also stood out in the cultural life of the Czech Lands in the second half of the sixteenth century. Like William and his brother Peter Vok of Rožmberk, Joachim of Hradec and his son Adam at Jindřichův Hradec as well as his brother Zacharias at Telč were all ardent commissioners of new buildings. The last-named who later on held the office of governor and was in fact the top man in Moravia, began to rebuild the medieval castle at Telč when he came back from Genoa in 1552. In the first phase the works were confined to an adaptation of the Gothic buildings; in their rustication of Italian forms the details betray the hand of local artists. The most remarkable work of this phase is the sgraffito decoration of two rooms. In the larger one, a didactic programme was composed after southern German engravings by H. Aldegrever and V. Solis. It comprises allegorical figures of the Vices and scenes of the Decollation of St John and Orpheus Playing to the Animals (Orpheus was a humanistic symbol of the ideal principle of life and of the humanization of cruel hearts). The smaller room has been fictitiously extended by perspective architectural constructions bearing Mannerist features, constructions which are the first surviving Renaissance evidence of the illusive kind of mural painting in Central Europe. (Unfortunately, only fragments are known of Altdorfer's frescoes in Regensburg.)

In the 1560s and 1570s, the Italian artists working at Telč gradually added to the old castle two big palaces, a northern and a southern one, two extensive courtyards, a forecourt, an architectonically laid-out garden and a chapel, perhaps a rebuilt existing structure. In the small court of the old castle they built a covered staircase in the form of a pavilion. The massive wings, particularly the southern entrance wing, articulated by the axes of double windows and by band cornices, are optically strengthened by sgraffito rustication and real bossage on the corners (here we can discern the influence of Tuscan palaces and, in the combination with a lunette cornice, an affinity of conception with the contemporary Nelahozeves Château). A contrast is provided by the courtyard arcades — the arcaded connecting links change the irregular space into a symmetrical pentagon. The formers' unusual and unclassical appearance is due to their function which is to connect the reception rooms on the third storeys of the opposite palaces; but it is also subject to Mannerism, in the tension between the vertical and the horizontal, in the lability of the structure, the preponderance of the burden over the support, as well as in the

opening of the whole complex. The column arcade, balancing on high plinths as in the open halls of Peruzzi's Oratorio in Siena, rises up two storeys and carries a colonnade. The western one is separated from the agricultural yard by a wall with windows, while the eastern colonnade opens completely on to the garden, also affording a view of the square of the town. Thus the individual spatial units interpenetrate each other once more; the space of the courtyard merges with the space of the garden, which is in its turn bordered by an arcade (which was analogous with the destroyed garden of the château at Klášter Hradiště-on-Jizera).

The garden is dominated by a picturesque building, unusual in its combination of a sepulchral chapel on the ground floor and the Marble Hall on the second storey above it, as well as in the gradation of mass. The chapel, completed in 1580, has a polygonal apse, but its forms are entirely un-Gothic — the high oblong windows, the decorative paintings with scrollwork cartouches in Late Renaissance style, and the rustic polychrome stucco depicting the Last Judgement. Of a similar quality are the marble altar with a ciborium and the tomb with the traditionally conceived, stiff recumbent stucco effigies of Lord Zacharias and his wife. The stucco relief of Neptune on the garden façade is of a similar character, although the sculptor has managed relatively well to catch the movement of the team of four horses. The earlier stuccoes in the small chapel of St George are of better qualities. Dating from 1564 they include a relief figure of the saint on horseback and a group of figures in the recess of the altar.

The ceilings in the château of Telč are of many different types. Carried out in 1576 and the beginning of the 1580s, they represent a rare combination of painting and sculptural form. The relief busts on one of them are vaguely reminiscent of the concept realized by Sebastian Tauerbach in the Wawel in Cracow, but they do not reach the realism and expressiveness of his heads. The carved figures interlaced with Mannerist scrollwork in the deep coffers of remarkable quality and fantasy on the ceiling in the Golden Hall, advanced in style (dated 1561), have affinities with the inventions of Cornelis Bos; also derived from Netherlandish patterns are the painted allegories of the Five Senses on the music loft in the front part of this long low room. The hall above the old palace is dominated by a powerful built-in structure of unclear purpose, bearing paintings of southern German character from an earlier period, perhaps from the 1550s. The regular network of coffers on the ceiling in this hall is adorned with masks combined with scrollwork, and its walls are fictitiously hung with pictures of Petrarch's Triumphs — a typically Renaissance theme — inspired by a series by G. Pencz.

The combination of enclosed spaces, free arcaded corridors and open areas infuses the Telč Château with unusual southern charm. This complex presents the most extensive and varied collection of building components and decorative techniques, sgraffito, painting, carving and stucco, in Bohemia and Moravia. The most extensive if not the most accomplished, it remains anonymous. It is not impossible that the arcades and the chapel with the Marble Hall above it were designed at some time in the 1570s by Baldassare Maggi, who from about 1575 worked for the Lords of Hradec and of Rožmberk in southern Bohemia; his authorship is corroborated by a number of features, above all by the gradation of mass which is characteristic of two of his works, and by Mannerist traits.

Together with a group of his countrymen this architect from Arogno in a valley above Lake Lugano extended the medieval family castle at Jindřichův Hradec into a large Renaissance residence for Zacharias's nephew Adam II of Hradec, Lord Chancellor

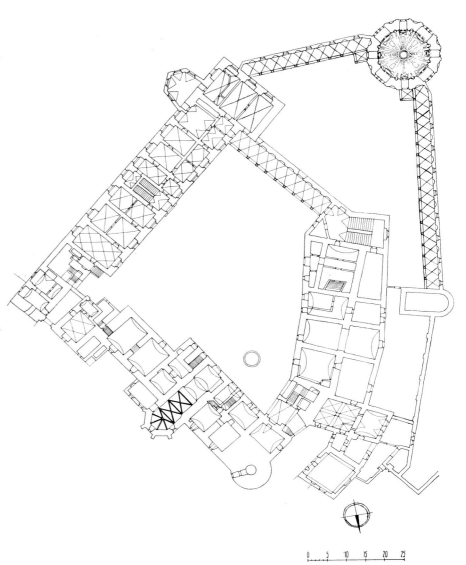

Jindřichův Hradec, plan of the Château

of the Kingdom. (The building works done here by his Italian predecessors in the middle of the century were less significant.) From 1580 onwards Maggi was engaged in creating a large courtyard behind the Gothic wing by an adaptation and the construction of three new wings. On two sides two palaces arose, facing each other; the massive block of Adam's New Building, begun in about 1564 by Baldassare's predecessor Antonio Drizzan, is reminiscent of the entrance palace at Telč and of the château at Náměšť in its corner rustication, the manner of articulation and originally also in the lunette cornice. The simpler but equally monumental exterior of the Wing of Green Chambers opposite had formerly sheltered a well-known large hall with a music loft. The Large Arcade from 1586—91 connects both palaces, closing the courtyard like a coulisse. The Wing of Green Chambers was connected to the medieval building by the somewhat later Small Arcade. The combination of rusticated pillars, column arches and entablatures makes this small structure one of the most complicated systems of arcades in Bohemia. The Large Arcade on the other hand, with three storeys of columns, is an almost classically monumentalized variant of the arcades of the most significant Czech and Moravian château courtyards — a variant enriched by large niches and windows which intensify the interplay of light and shade.

The windows of the Large Arcade look out onto a garden laid out on the spur of a headland. As in the palace of the Rožmberks in Prague as well as at Telč, this patch of nature is fitted in the organism of the building and bordered by a column arcade. It is dominated by a pavilion called the Rondel, built in 1591—92 by Maggi's two assistants and countrymen, the master builder Giovanni Maria Faconi and the stone-mason Antonio Cometta. It is a rather small structure, combining elements of divergent origin (those of the Italian *cinquecento* predominate while the high roof and the gable dormers are typical of the transalpine countries); but it is a work of complicated spatial conception and of great artistic value. The massive shell erected on a circular ground-plan is pierced by deep window recesses of two forms, the larger of which opens with an articulated serliana pattern; the composition also includes a system of pilasters, niches and entablatures in several layers. Thus lightened in the Mannerist style, the shell supports a heavy dome of an unusually complex shape with rhythmically alternating fields of three kinds. Its massive stucco decoration in Late Renaissance forms, the work of Giovanni Pietro Martinola, likewise contrasts with the delicate and fantastic terra-cotta grotesques on the walls executed by Georg Bendel in his workshop at Český Krumlov. In this complicated combination of architectonic and decorative components, the contrasts of light played an important part, intensifying the general impression. This charming yet monumental looking building, which had apparently been designed by Baldassare Maggi before he returned to his mother-country, is among the most complicated of the many centrally planned structures to be found in Bohemia and Moravia.

In its gradual exterior it bears affinities with the composition and articulation of the cylindrical tower with which Maggi enriched the austere silhouette of the castle at Český Krumlov. This he reconstructed for William of Rožmberk (Adam's uncle), Lord High Burgrave, the first man in the country after the king. A real architectonic syntax is replaced here on the façades of the courts and the Small Castle by a system of members, reliefs and statues imitated by chiaroscuro, dating from 1577 and 1588, and in the interiors by mural paintings (on the exteriors the commissioner seems to have been inspired by the courtyard of the Archduke's Château of Ambras).

The most significant master builder outside the Court, besides the unknown author of Bučovice Château, Maggi found a suitable means of expression for the transalpine delight in the picturesque, without losing the Italian sense of tectonics. However, some of his many works, such as Hluboká Castle, have lost their original appearance. For William of Rožmberk, Master Baldassare built Kratochvíle, a summer palace in a game reserve near Netolice in the years 1582—89. It is a large complex composed on the depth axis, which is emphasized by the tower of the gateway, surmounting the entrance wing of one storey; attached to it is a small church of a traditional type but Renaissance in shape. The extensive oblong garden, bounded by a wall with niches and several small houses, contained a dwelling block surrounded by a moat and "water works", most probably fountains. The basic arrangement, similar to that of Bučovice Château, seems to have been derived from the Neugebäude in Vienna; the palace, which has rooms on three sides of the transverse lower and upper halls, is a variant of the Italian villas. The façades with a lunette cornice were again articulated by painters, who in this case applied the motifs of rustication and of a column standing in front of a niche.

The interiors were decorated in about 1590 by Georg Widman from Brunswick and his assistants, with paintings of varying conceptions and themes. There are hunting and mythological scenes as well as those of the Old Testament; the charming grotesques are somewhat akin to the ornamentation in Venetian villas and in the Bučovice Château. Although the compositions were supplied by German and Netherlandish prints, Widman proved able to approach the work creatively, as can be seen chiefly from the free-standing figures on the upper storey and the delicately executed, nearly dreamlike landscapes, which (again with exception of those at Bučovice) are almost the only ones to be preserved in wall-painting outside the Court. Landscapes, which were a genre in their own right in Italy, particularly in the fresco-decoration of villas, are rarely to be found in buildings in Central Europe. Also working on the upper storey of Kratochvíle Summer Palace was a stuccoer; according to the signature it was Antonio Melana, or an Antonio with an unknown family name, from Melano near Arogno, an area which gave Italy many masters of this trade. On the vaults of three rooms he created allegories of the Virtues, the Four Seasons and many scenes from Roman history. These transfer into three-dimensional forms (graded from a full shape to an engraved drawing) the compositions by J. Bocksberger as interpreted by Amman's woodcuts; through their simplification, the compositions have acquired a monumental character. The best of these reliefs, influenced by Upper Italian decorativism and Mannerist tendencies, are close in quality to the decoration of the Hvězda Summer Palace.

Antonio's assistant, who decorated the small church, probably also carried out an unusual programme in Bechyně Castle in about 1590. This was composed of moralizing stuccoes with the theme of *memento mori* (adopted from a Huguenot book of emblems by Georgette de Montanay) and of the Virtues conceived as victors over the Vices; the ethical-moralistic idea was also applied in the main hall of the same castle building. At Bechyně the significance of the paintings again surpasses that of the massive block structure by which Maggi extended the Gothic castle in 1580—83 for William's brother Peter Vok of Rožmberk, a member of the Unity of Bohemian Brethren and a keen bibliophile. The exterior of the castle is adorned with illusive window frames of the Vries type, and the walls of the new courtyard are decorated with fantastic monumental niches in the Mannerist vein, in which a high column supported by a *putto* replaces a statue, and with a coulisse with a deceptively projecting terrace and columns. Yet owing to inconsistent composition, the painters (perhaps Bartholomew Beránek and Anthony Valter) did not quite achieve the illusive effect of the grandiose constructions of their model, the façade painting of southern Germany and Switzerland.

Outstanding in the interior decoration of Bechyně Castle is the Mannerist cycle of antithetical pairs of the Virtues and the Sins, and of Old Testament figures in the window recesses of the main hall, dating from about 1590. The leading master seems to have been influenced not only by the graphic work of H. Goltzius and his conception of the figure with its characteristic exaggeration of some parts (such as the hands), but also by leading Rudolphine artists. The accompanying figures on the small vaults (in their rendering of the subject from below, their protrusion into space and their complicated movements) and the *sfondato*, revealing an illusive view of the sky with a form depicted *di sotto in su* (illusionistically foreshortened) prove that the painter was able to command even such effects as were achieved by Italian fresco painters from Mantegna to Tibaldi. These fictitious effects, until that time, had perhaps only been known in Central Europe from the paintings by

Giulio Romano's disciples in the Landshut residence, by Sustris and Ponzano in the house of the Fuggers in Augsburg and perhaps also from those by Spranger in the Viennese Neugebäude. This assumption is supported by the only fresco by Spranger to be preserved in Central Europe, in Prague, a work somewhat earlier than those at Bechyně,[60] and by his drawing of Antique gods.

The circle of artists active at Rudolph's Court may also have influenced the unknown painter[61] who worked on Rožmberk Castle for the nephew of the last two Rožmberks, John Zrinský. The latter was apparently conversant with the decoration of interiors in Mantua where he used to travel to see his mother and step-father. The work of this artist combines two components of different origins: Netherlandish and Italian. The former, in accordance with his models by Crispin de Passe and Martin de Vos, can be discerned in the cycle of murals depicting The Ten Stages in Human Life (in window recesses of the hall), in the series of the Five Senses (on its walls), and in the hanging pictures of The Planets. On the ceiling of the hall, grotesques after Lucas Kilian, trophies by Jan Vredeman and allegories of human characters after Vos[62] can be found together. The other, Italian, component, can be seen in the large scene of Music, painted freely in irridiscent tones, and especially in the illusive effects. Figures are painted as if they were coming in from the adjoining rooms, and the small space is transformed pictorially into a pavilion opening onto fictitious nature. The latter is extended by side niches with statues imitated by the painter's brush, and raised by means of a perspective construction which was derived from works of architectonic painting in Bologna and Rome though these are much larger and more significant of course.

These examples are the most worthy representatives of the rich collection of wall and ceiling paintings in the residences of the Lords of both Roses which is the most complete in the Czech Lands.

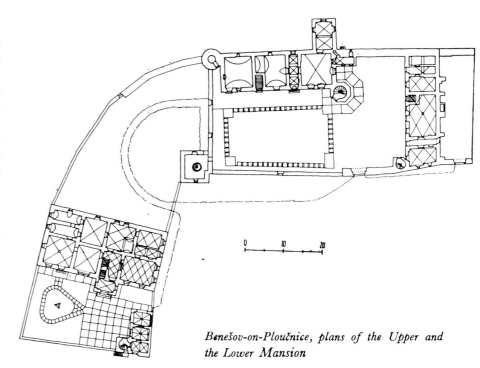

Benešov-on-Ploučnice, plans of the Upper and the Lower Mansion

Moravská Třebová, plan of the Château

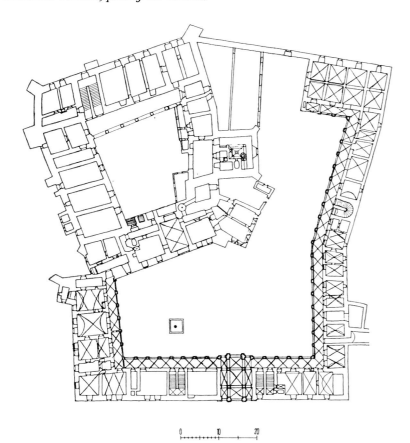

Together with the decorations of Bučovice Château, it is also the best in quality, although varied in conception, value and origin. The mediocre level of the local painting of that epoch is best demonstrated by the fact that in most cases foreign artists were summoned to do the work (with exception of Bartholomew Beránek). From Germany came Georg Widman, from Germany or Austria Raimund Paul, who decorated the ceilings in Jindřichův Hradec, Bechyně and probably in the Marble Hall at Telč with monumental figures. From the Rhineland, perhaps, came Gabriel de Blonde who in 1576—77 fictitiously opened one of the rooms in Český Krumlov Castle with large scenes from the Old Testament; the authors of the Bechyně and Rožmberk cycles probably came from the Netherlands and southern Germany and were of course conversant with Italian frescoes. The works of these painters cannot naturally be compared with the masterpieces of Italian fresco painting; but they are comparable with its common production, such as that of Veronese's school in the Venetian villas, and also with the decoration of the Austrian and German palaces, châteaux and residences. From Hans Fugger we know that a Central European patron appreciated a directness of expression and comprehensiveness, a verisimilitude in the events depicted, rather than showy creations displaying formal perfection and mastery of treatment. We do not find here the complicated, often enciphered, iconographic programmes, the large cycles that Italy and the Fontainebleau school were famous for. Neither was a uniform system laid down for the scheme of the decoration, not even in the halls for which Germany and Austria had evolved a twofold decorative principle, corresponding to the programme. Many different Italian systems were applied in the Czech Lands, as if following Armenini's recommendation that a painter should harmonize his work with the given space and with the personality he is working for.

Rather different from the southern Bohemian group and the big châteaux of the third quarter of the sixteenth century are the buildings which were erected in the north of Moravia in a second wave from about the 1580s onwards. They differ by the diversity of their stylistic character, although it is also of Italian origin, and

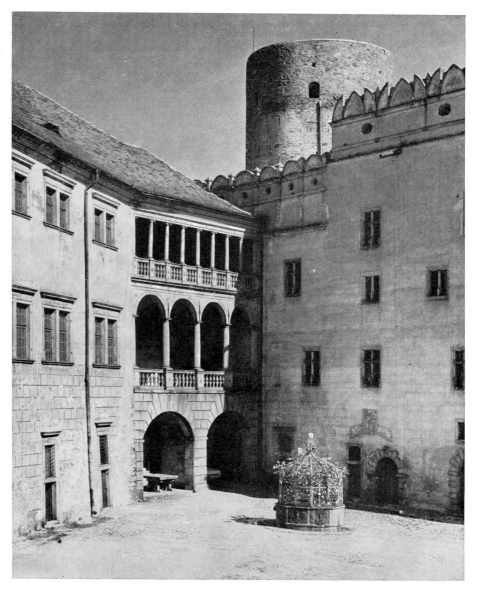

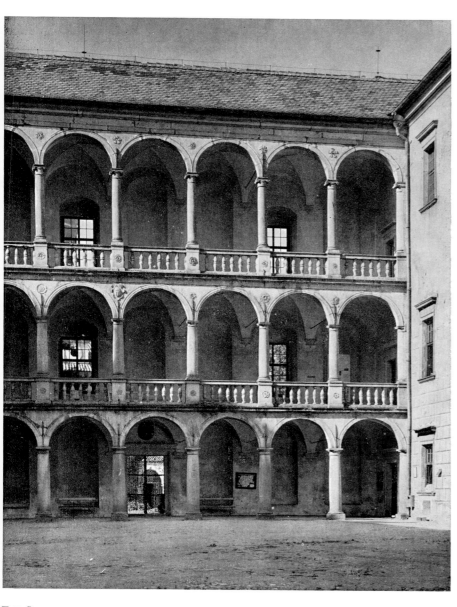

80 Jindřichův Hradec Château, the Small Arcade, 1590—91, probably on the design of Baldassare Maggi, executed by stone-mason Antonio Cometta and builder Giovanni M. Faconi

81 Jindřichův Hradec Château, the Large Arcade, 1586—91, probably on the design of Baldassare Maggi, executed by stone-mason Antonio Cometta and builder Giovanni M. Faconi

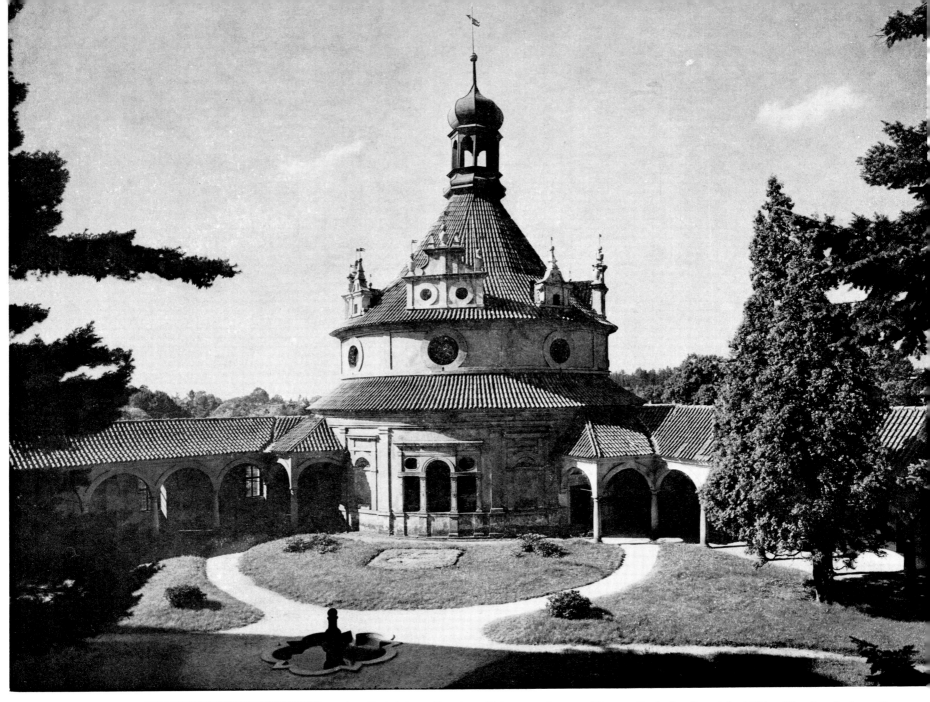

82 Jindřichův Hradec Château, the pavilion called the Rondel, 1591—93, the design of Baldassare Maggi executed by Giovanni M. Faconi and Antonio Cometta

83 Jindřichův Hradec Château, the pavilion called the Rondel, 1591—93, detail of terracotta decoration by Georg Bendel, from 1596—1600
◄

►

84 Jindřichův Hradec Château, the pavilion called the Rondel, interior, terra-cotta by Georg Bendel from about 1596—1600, the stucco of the cupola by Giovanni P. Martinola from 1594—96

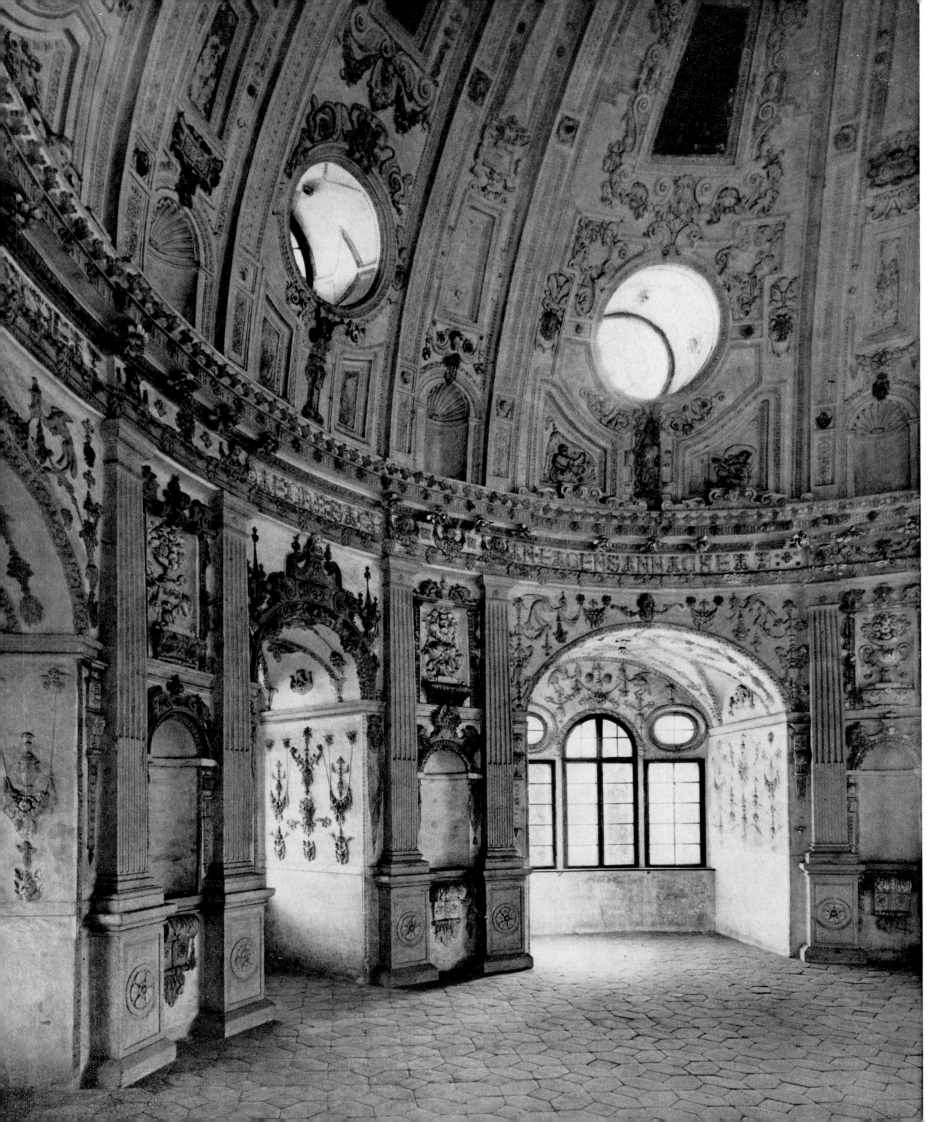

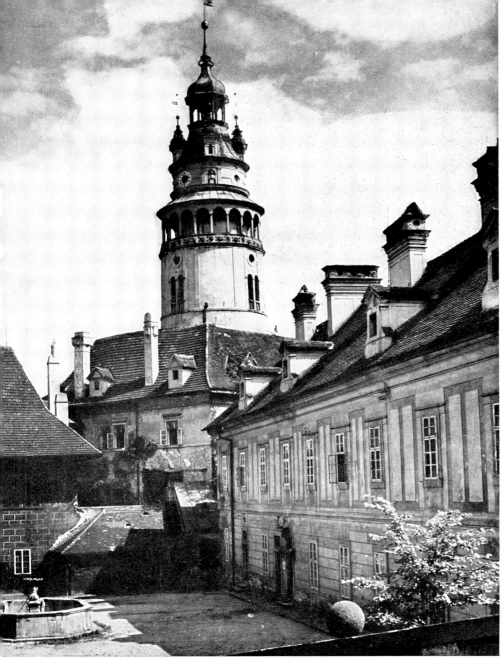

85 Český Krumlov Castle, the tower of the Hrádek (Small Castle), Baldassare Maggi, completed in 1580

86 Bechyně Château, the hall. Detail of the painted decoration on the vault of a window recess, about 1590.

87 Kratochvíle Summer Palace. Detail of a painting with the veduta of Netolice and Kratochvíle, presumably by Henry Verle, from 1686, Kratochvíle, Summer Palace.

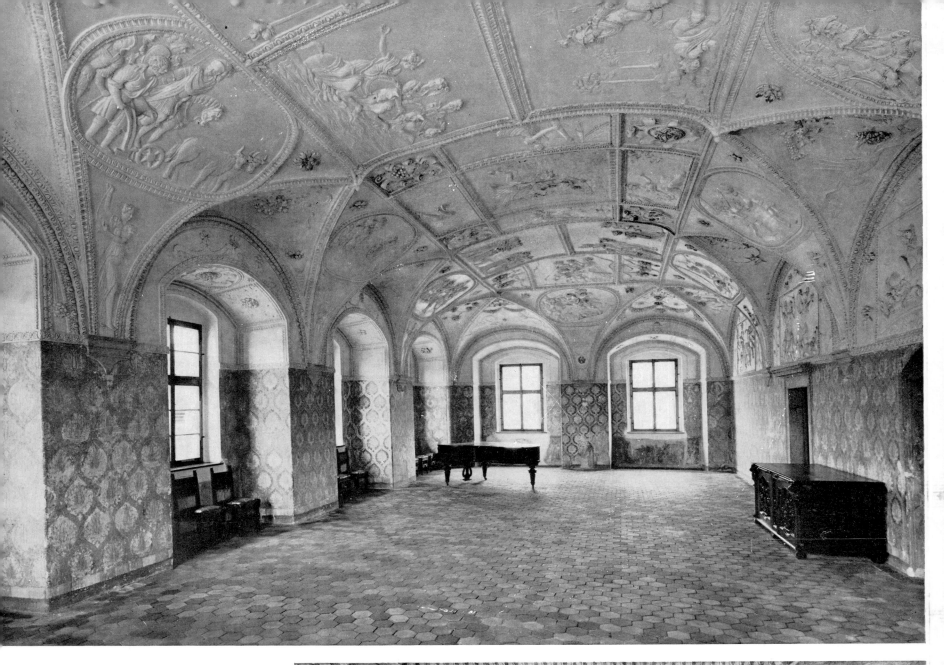

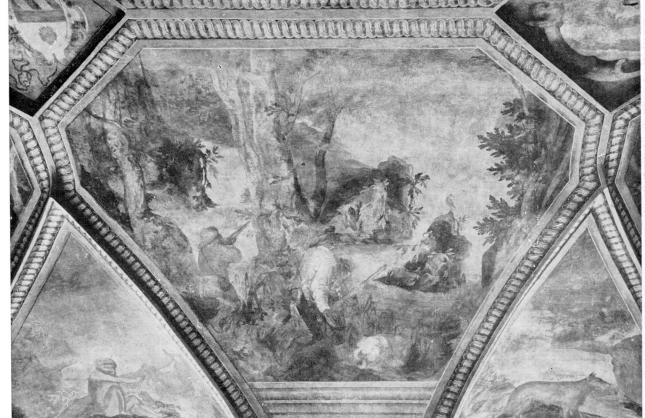

88 Kratochvíle Summer Palace. The Golden Hall. Stucco by Antonio Melana, by 1589.

89 Kratochvíle Summer Palace. The entrance hall. Waterfowl Shooting, painting on the vault, by Georg Widman, 1589.

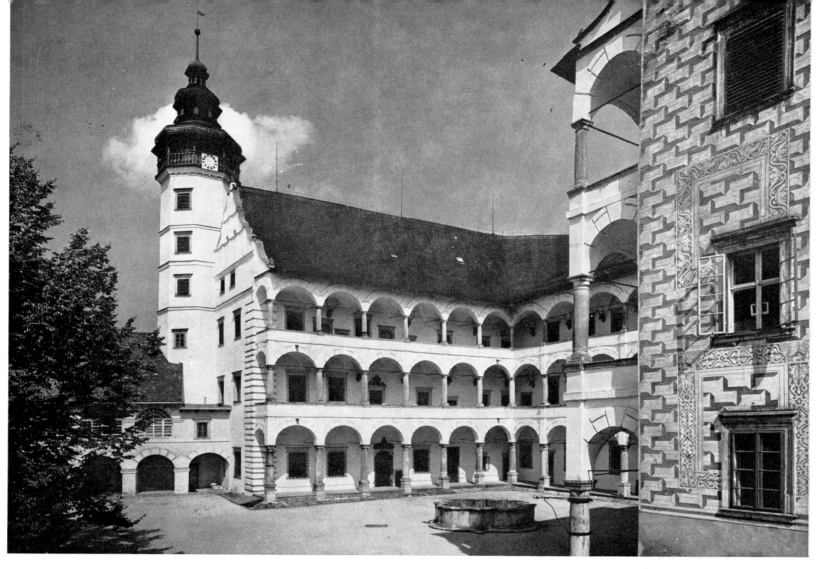

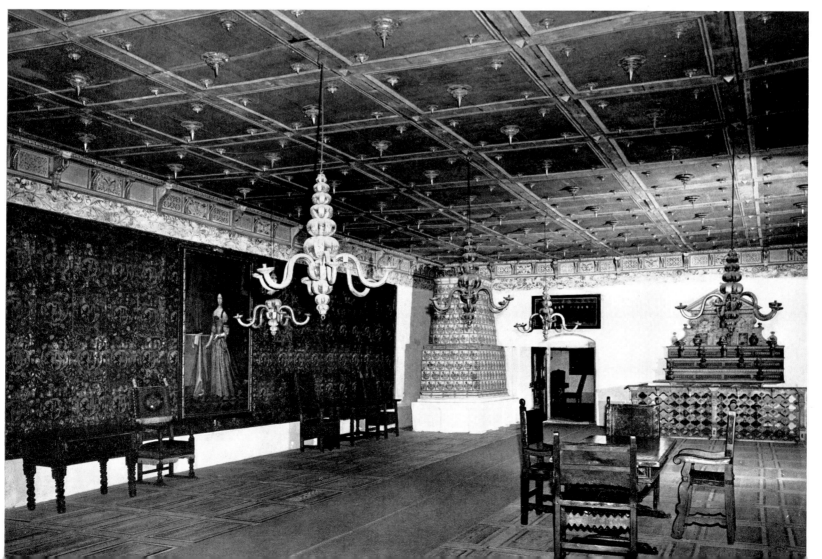

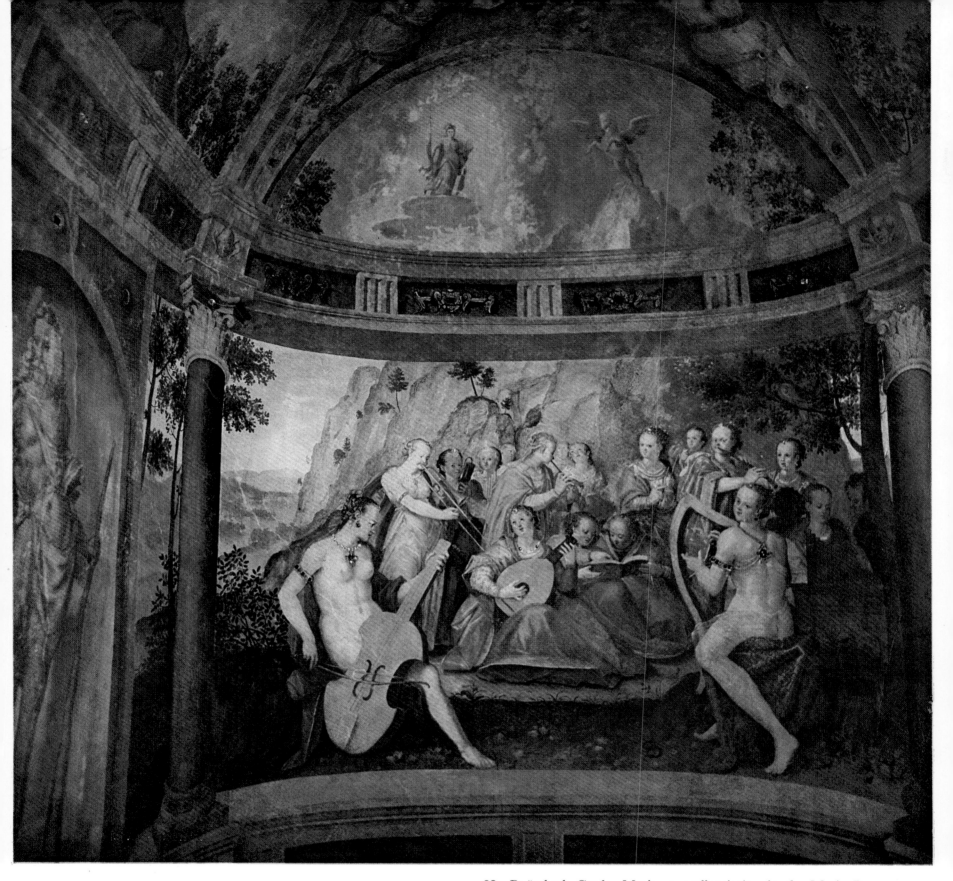

92 Rožmberk Castle, Music, a wall-painting in the Music Recess, about 1610

90 Velké Losiny Château, arcaded courtyard, before 1580—89

91 Velké Losiny Château, hall with a panelled ceiling, Renaissance leather wall-coverings and period furniture

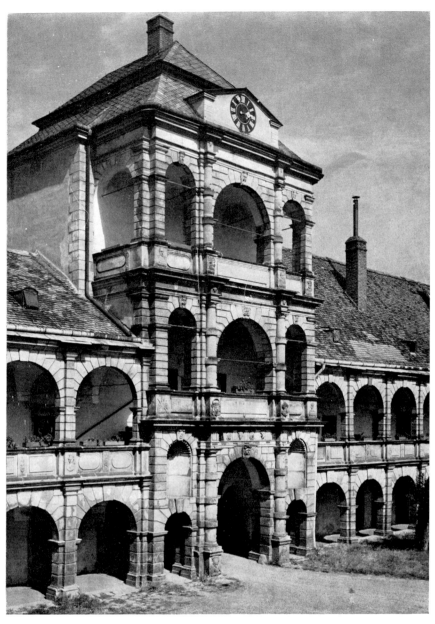

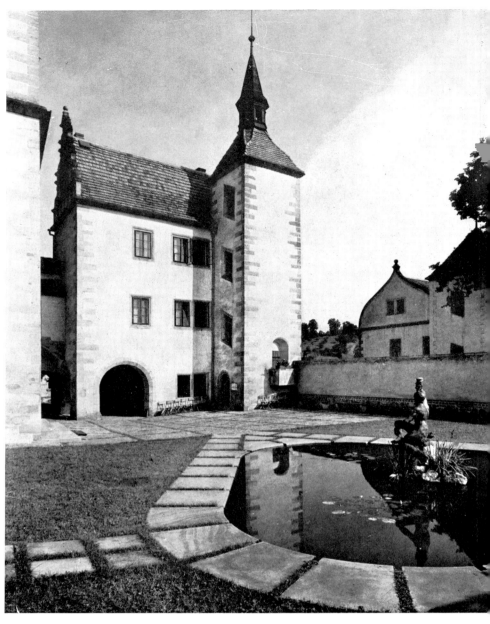

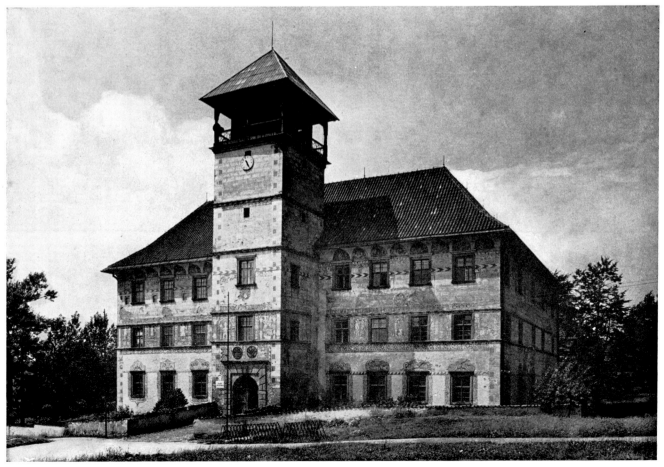

93 Moravská Třebová Château, fore-court with arcades and the entrance pavilion, second decade of the 17th century

94 Benešov-on-Ploučnice, the Palace of Wolf of Salhausen in the Lower Mansion, 1578

95 Stará Ves-on-Ondřejnice, Mansion, the main façade, probably from 1560—70, the second storey from about the end of the 1580s

by the fact that most of them do not achieve outstanding quality. The three-wing château of the Žerotíns at Velké Losiny was the result of a rebuilding of an older stronghold, completed by 1589. Its arcades are Mannerist, as were many of those which preceded them, but here the Mannerist trait is manifested in a different way: the columns, which are thick in comparison with those at Bučovice, carry the heavy burden of a rusticated archivolt. (Rustication also asserted itself markedly in the immediate neighbourhood of the loggias, where it has no functional justification.) It is an Italian combination which the master builders from the circle of Giulio Romano in Mantua had brought to Landshut as early as the second quarter of the sixteenth century, but they shaped it in a much nobler way; about twenty-five years later it was used by Rocco Lurago when building the Doria Tursi Palace in Genoa and then by an unknown author in the arcades of Schallaburg Castle in Lower Austria, in a structure of transalpine character. The unclassical emphasis on the vertical achieved by connecting the capitals of the columns with the plinths of the next storey by means of strips was also of Italian origin. This idea met with great response in Germany where it corresponded with the tendencies to verticalism of the previous development. It had already been known in the Ferrara of the *quattrocento,* and as a decoration in Genoa in the second half of the sixteenth century. In 1549 the Italians applied it in the project for the Court Hospital in Vienna. At Velké Losiny Château, the fronts of the wings were given gables according to local tradition, and the position of the building in a remote mountain landscape made it imperative to build a sort of watch-tower whose slim and polygonal appearance is of transalpine character also.

Some similar features can be found in the château of Hranice; its construction proceeded in several stages, from about 1570 till the beginning of the seventeenth century. During one of them a three-wing building of three storeys was erected. On the two lower floors the rustication, which again has a free structure, is linked with slim pillars, while on the third storey a light column supports plain arches. Thus the same open disposition and rusticated archivolts can be found here as at Losiny, but the gradation of weight upwards is logical, as it is in the other arcades which superimpose a column on a pillar. The lower transverse wing belongs to another building stage; it closes the courtyard, but only up to the second storey, as is the case at Bučovice. The delicate carved decoration of the column arcades on its second storey, contrasting with the rusticated structure of the other parts, is repeated on the columned aedicula of the portal. The stucco ornamentation of the ceilings mentioned above probably dates from the last building stage at the beginning of the seventeenth century. Italian master builders, masons and stone-masons are recorded as working in the town when the château was being built. A similar structure of arcades consisting of rusticated archivolts and pillars, high and slight, and of plain columns, was inserted into the courtyard of the castle at Bruntál.

A culminating link in the series of these arcaded courtyards is the château at Moravská Třebová, where Ladislas Velen of Žerotín had a new building erected around an extensive forecourt next to the enclosed block of the old castle. The commissioner, one of the richest nobles in Moravia before the Battle of the White Mountain, had studied, like his cousin Charles, at Protestant schools in Strasbourg, Basle and Heidelberg, and had also spent two years in Padua and Siena. His travels abroad, where he had the opportunity to observe the historical sights, and especially his contacts with Italian culture considerably influenced his cultural

endeavours; his inheritance from the humanist Ladislas of Boskovice, particularly the latter's collections and library, also played a not insignificant part. Velen's court was a centre of the sciences and art. He invited and entertained both German and Italian poets, theologians, musicians, alchemists, physicians and artists. The château was built in the second decade of the seventeenth century according to the design of an architect who undoubtedly came from northern Italy. It is one of the most significant examples of Mannerism in the Czech Lands. Its open three-wing groundplan emphasizes the horizontality of the scheme and the nonfunctional application of rustication completely covers the pillar arcades as well as their pilasters. (The same feature was used by Pellegrini in the courtyard of the episcopal palace in Milan and by Palladio in one study after Vitruvius.) The rustication contrasts with the smooth surfaces of the parapets and the small pillars decorated with figural reliefs.

Especially important is the gateway, the outside portal of which has three entrances in rusticated frames with girdled columns, introducing a theme which is fully developed on the court side. Here there is a monumental three storeyed structure of the pavilion type, which towers above the two storeyed wings and is emphasized by the plasticity of the tripartite articulation. This represents a variation on the motif of the triumphal arch or on that of the portal of Vignola's Villa Giulia in Rome and of Serlio's rusticated gates in his *Libro extraordinario* and in his Seventh Book. The façade is composed of several layers: in front of the rusticated wall pierced by arches and hollowed out by niches, the architect placed halfcolumns with their plinths and the projections of the entablature; the columns are tied by stone girdles to the "underlying" pilasters. (A simpler variant of this pavilion is found in the castle at Branná, not too far from Třebová.) The passage, divided by rusticated pillars into three naves, is close to the porticos of some Venetian villas. The château at Moravská Třebová represents a worthy final link in the series of Renaissance residences of the Czech and Moravian nobility. However, in its ground-plan and its application of a single dominating element it foreshadows the designs to be developed in the architecture of the Baroque period. Records written by the contemporaries are the only source of information about the furnishings of the château; there was precious, partly gilt furniture, a great number of Persian and Turkish carpets, gilt upholstery, twenty-two large Italian tapestries with historical scenes, and two important rooms called The King's and The Count's Chambers.

The foremost families of the Kingdom were followed in their building activity by the gentry. The economic situation often forced its members to accept posts in the service of the great feudal lords and the architecture of the latter's courts naturally influenced them when they came to chose a design for their own houses. And though less ambitious both in scale and artistic achievement, the latter were often interesting. Thus for example James Krčín of Jelčany, the regent of the Lords of Rožmberk, had a fortified seat built at Křepenice on a ground-plan modelled on that of Kratochvíle in 1580—84. In 1588 he had the interior decorated with giant figures on Antique themes, which seem to vie with those in Venetian villas and can certainly rank with the murals in southern Bohemian castles.

Many such diminished copies of the large residences of the aristocracy were built in Bohemia and Moravia at that time. Among those remarkable from an artistic point of view are the houses at Stará Ves near Ostrava, at Třemešek and Ivanovice in the Haná region, all of them in northern Moravia and linked with the related

families of Bukůvka and Sirakovský. The mansion at Stará Ves was constructed about 1560—70, with the third storey rebuilt towards the end of the 1580s. It has the same articulation of the exterior by cornices and lunette cornice below the roof line as were found at Třemešek Castle. (The latter also has a remarkable portal with very rare and beautiful full-length portrait figures of the commissioners, and stuccoed vaults.) It has the same block ground-plan as the castle at Ivanovice with an axial entrance tower and an arcaded courtyard. While the building at Stará Ves attracts in particular by its exterior, not least by the rich and charming sgraffito, stylized and of a naive and folkish character, the most arresting element at Ivanovice is the courtyard arcades. They had been built prior to the year 1608 by the master builder Antonio Paris and the stone-mason John Foncum from Steinsberg in Lower Engadin, the former having settled in Brno and the latter at Valašské Meziříčí. In the limited space of the courtyard they repeated the scheme known from Litomyšl and Uherský Ostroh. But here the stern combination of pillar arcades on the ground-floor and column loggias on the upper storeys is relieved by a baluster parapet and by carved decoration, as can be found in the Žerotín castle at Drevohostice.

Among these more or less enclosed formations with arcaded courtyards a number of others, often extensive ones, might be mentioned, where the original idea was, however, suppressed by local tradition or by insufficient skill on the part of the builder. They contrast markedly with the fortified seats and small castles in western and north-western Bohemia. The designs of the latter with one or two wings, and their artistic treatment show connections with the neighbouring German regions. (However, a four-wing design was no rare occurrence even in Germany.) A striking example in this respect is the interesting group of separate palaces of individual members of the Salhausen family at Benešov-on-Ploučnice, built gradually along the town fortifications from the first quarter of the sixteenth century onwards; the gables, oriel and staircase tower as well as the carved details clearly exhibit links with Saxony and Silesia. Saxon workshops had a strong influence on Bohemia in painting and supplied it with a number of sculptural works as well. Another of the interesting small castles, that at Ahníkov, consists of one wing; its pavilion-tower as well as the gables and dormers are articulated by a Clasicizing system of half-columns and Mannerist popular in north-western Europe, while the opposite façade is opened by usual column arcades.

THE TOWN

The Renaissance style penetrated into towns as well, even though it did not preserve its pure Italian form there, as was the case with the residences of the aristocrats. This period represented a golden age for many towns, especially the subject ones. For these enjoyed the support and protection of their lords who, in turn, benefited from the prosperity created by their citizens as craftsmen or merchants. Most of the subject towns suffered much less in the sixteenth century than the free royal towns, especially those which took part in the rebellion against the King in 1547 and whose rights and economic possibilities were then considerably restricted. Intensive building activity can be observed everywhere. Town halls, schools, churches, hospitals, fortifications were being built not only for the sake of their actual function, but also as symbols of the economic and social position of the community. This was also impressed upon visitors by the town gate which, in most cases, still had the traditional form of a tower, and only exceptionally was of the modern type advocated by treatises, as at Český Krumlov. The ostentatious character of the houses was intended to add dignity to their owners.

The way of life, the adherence to the guild system, the ideological and sometimes even religious subjection to the late Middle Ages[63] so remote from the humanistic ideas of the Italian Renaissance, all these factors were so strong that they could not but influence the character of the edifices produced. As a result the latter bear the seal of local tradition more markedly than the seats of the foremost noble families. The building activity was incredibly extensive: the historic centres of many towns, the entire frontages of streets and squares, are still delimited by this time or marked by its artistic expression. Naturally, the ground-plan of a building was dependent on the medieval plot and influenced by functional requirements.

The house is usually a massive block or it may be pierced by an arcaded cloister, which follows the local customs but in form corresponds with similar designs in northern Italy, from Bolzano

and Lugano in the Alps as far as Bologna. More pretentious houses have arcaded courtyards, imitating the residences of the nobility. They were popular also in Slovakia. The mass of the usually two or three-storeyed, but often even higher, building is sometimes enriched by an oriel, as in the neighbouring lands. If placed on the corner, it enabled to look out in several directions and created a dominant in the organism of the street or of the square. Here and there even a whole floor was projected, not only for practical, but also for aesthetical reasons. It was not a novelty of the 16th century; this solution had an old tradition dating back to Antiquity.

The quality of the buildings depended on the abilities of the artists, which were not infrequently rather limited. The builder tried to graft elements of Italian origin, most of which he had only seen and not understood, onto the traditional scheme of a gabled house. The result was a heterogeneous combination of components of different origins. The Central European liberty in the conception of the ground-plan and sometimes even in the arrangement of the window axes, so contradictory to the Italian striving for symmetry and regularity, produced structures which are often irregular (the façade even follows the broken terrain), picturesque and sometimes even bizarre. This is seen chiefly in their gables, attics and decoration. Structures are produced in which one can observe the rustication and vernacularization of imported elements into combinations which in their unintentional deformation of the classical system are closer to Mannerism than to the logical and tectonic principles of the Renaissance. The bizarre appearance, still Late Gothic in substance, is, however, restrained, for not even the burghers' building activities plunged into the unbridled decorativeness and fancifulness which is typical of many German and Polish houses. Nor did the column orders, applied sometimes to the façade or at least to its high gable, emphasize the vertical tendency in such a way as on the patrician houses in Germany, Belgium and the Netherlands.

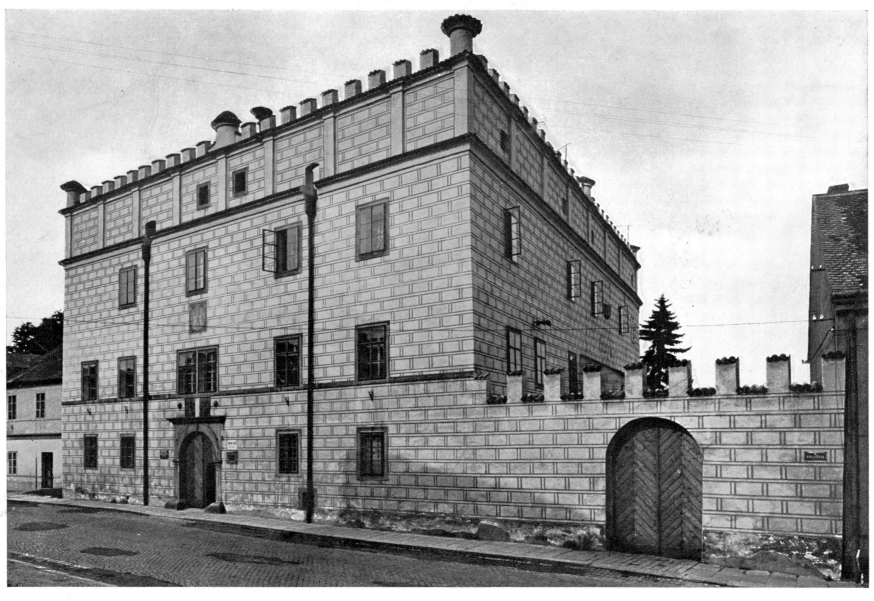

96 Dačice, Old Castle, 1572—79

97 Telč, house No. 61 on the square, the sgraffito dated 1555

The lay-out developed from the scheme of the medieval house, its core being a presentable hall, on the ground-floor and on the storeys as well. This was usually vaulted, connected with the staircase and often opened into the corridor leading to the court-yard, which was not once bordered with further wings. The hall used to occupy the front part of the building, if not the whole ground-floor; the dark middle zone was filled with a kitchen and lumber rooms and the hinder one with rooms facing the court-yard.

Of a similar character are the town halls, which only seldom rose above the common level of craftsmanship. The town hall at Prachatice in southern Bohemia, dating from the years 1570—71, excels among them in logical, genuinely Renaissance, construction. With its rusticated quoins, large windows on continuous cornices arranged regularly on axis lines, its projecting main cornice and chiaroscuro decoration, this town hall ranks with the palaces of the southern Bohemian and southern Moravian castles (as do also the massive palace-like blocks of the Jesuit colleges at Český Krumlov and Jindřichův Hradec). A similar façade of the town hall of Telč, dated 1574, is monumentalized by pilasters of a colossal order. The town hall at Stříbro got in 1588 a crown

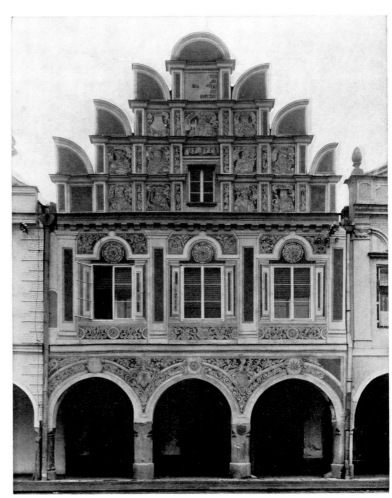

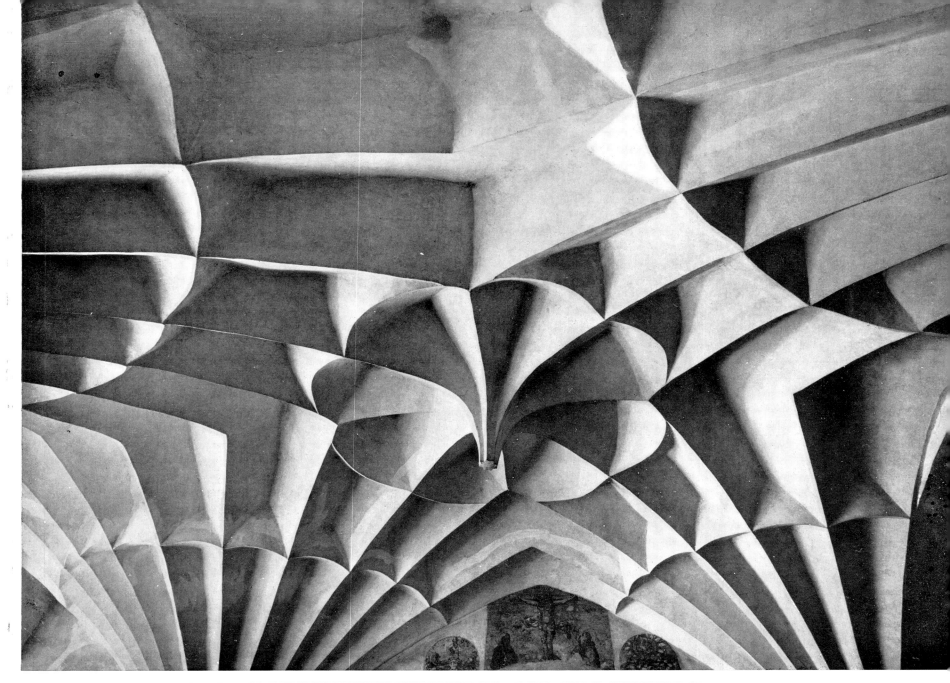

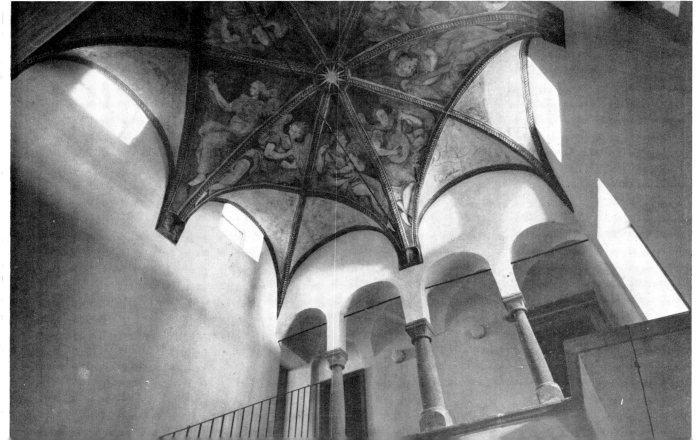

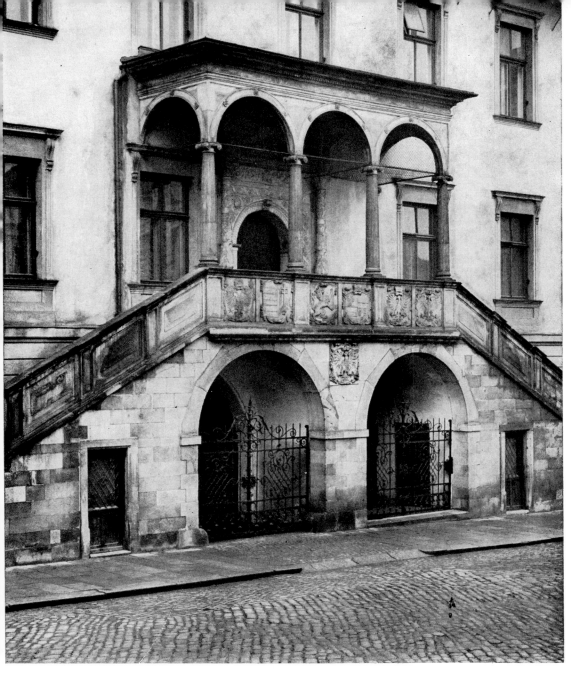

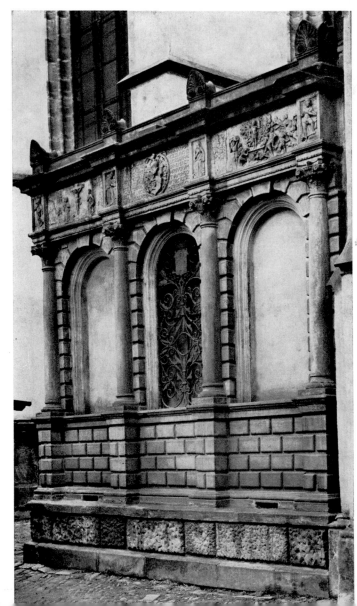

100 Olomouc Town Hall, outer staircase with a loggia, completed in 1591

101 Olomouc, Church of St Maurice, tomb of Wenceslas Edelman's family, 1572 ▶

◀
98 Slavonice, house No. 46 on the square, hall with a "cellular" vault by Master L. E. (Leopold Österreicher), 1543—49

◀
99 Jihlava, house No. 10 in Komenský Street. Vaulted staircase court with paintings of angels playing music, dated 1577.

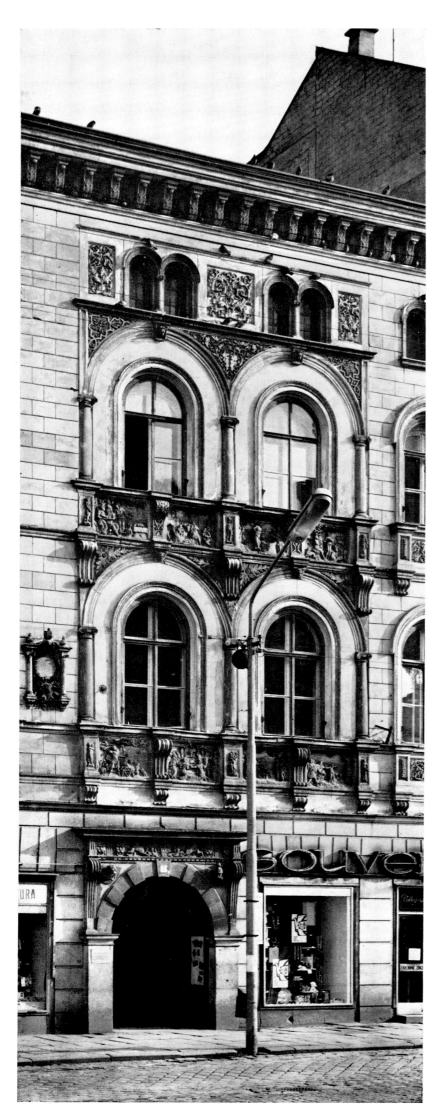

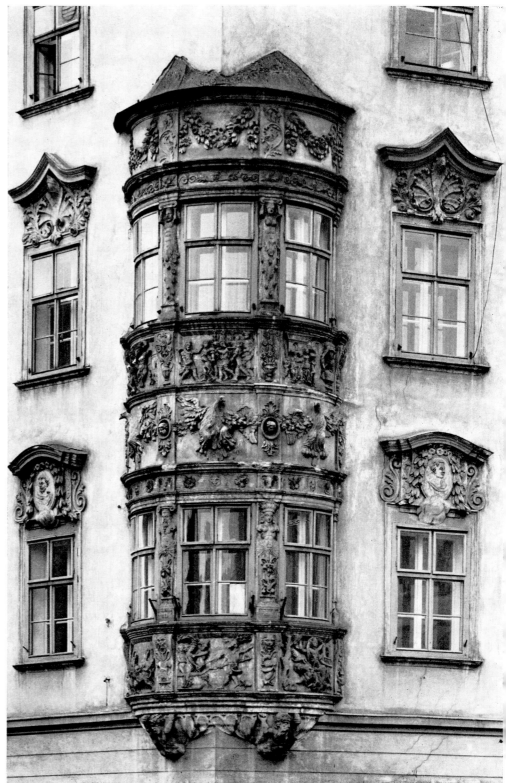

102 Olomouc, the house of Wenceslas Edelman, No. 5, Náměstí Míru (Square of Peace). Detail of the façade with relief decoration, after 1575.

103 Olomouc, the House of the Haunschilds, No. 38, Náměstí Rudé armády (Red Army Square), oriel with relief decoration, the end of the 16th century

104 The Krocín Fountain from the Old Town Square in Prague. Detail of the central part with the statues of Four Elements completed in 1596. Red Slivenec marble, height of the central part 455 cm, Prague, Lapidarium of the National Museum.

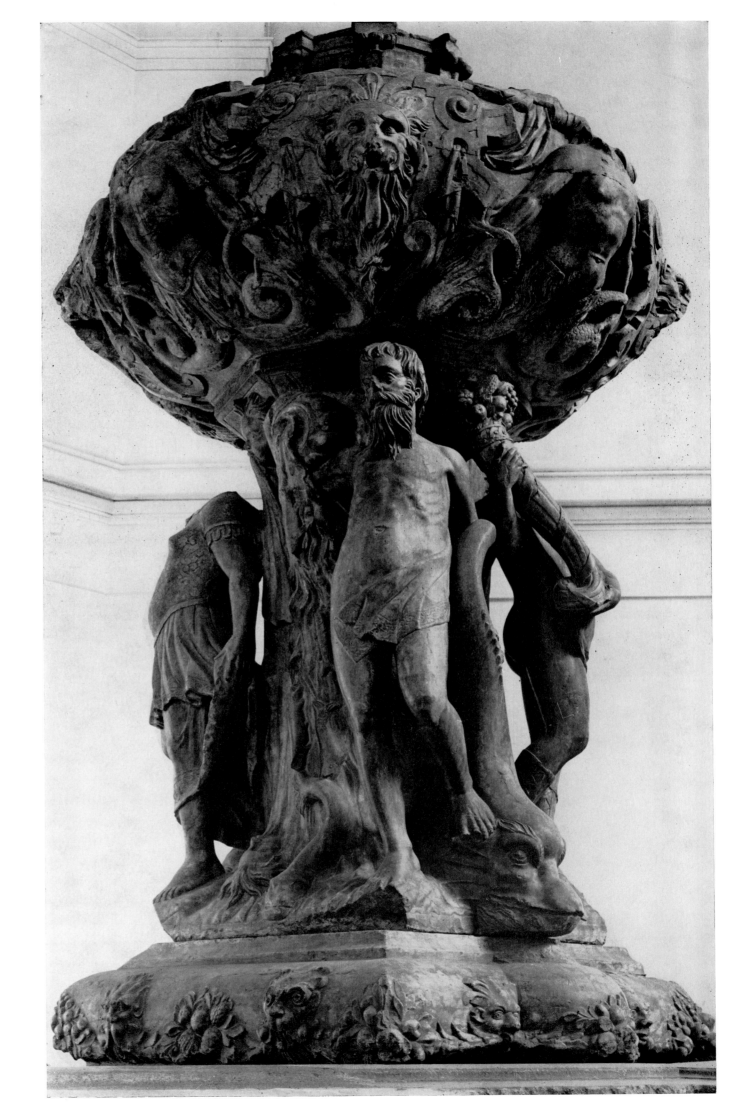

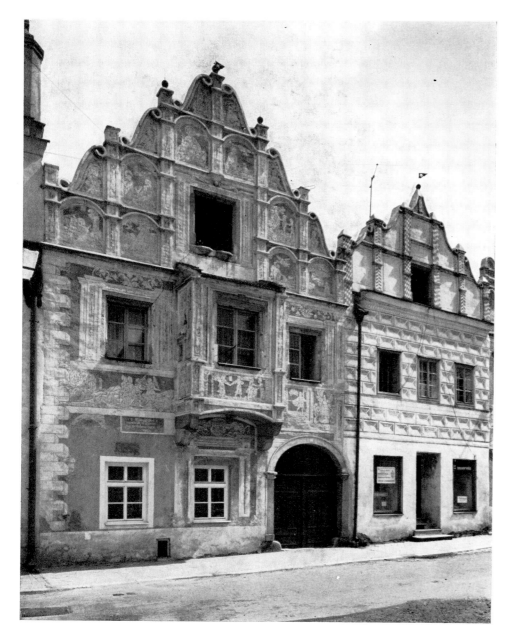

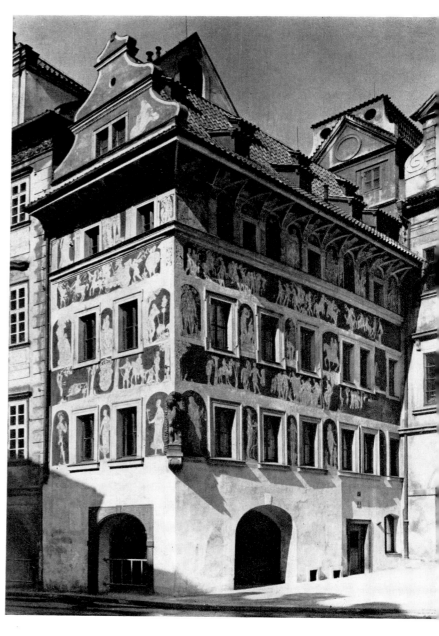

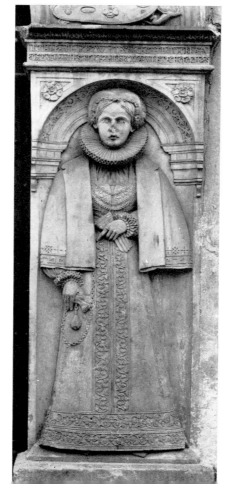

105 Slavonice, houses, after the middle of the 16th century

106 Prague, the U Minuty (At the Minute) house, No. 3—1, Old Town Square. Sgraffito from the last third of the 16th century, on the last storey from the beginning of the 17th century.

107 Třemešek, the portal of the Castle, 1578, details

108 The Decollation of St Barbara, by the Master I. W., after 1540, the central panel of the tripartite altar called the Osek Altar, after 1540. Tempera on canvas covering fir wood, 141×111 cm, National Gallery, Prague.

124

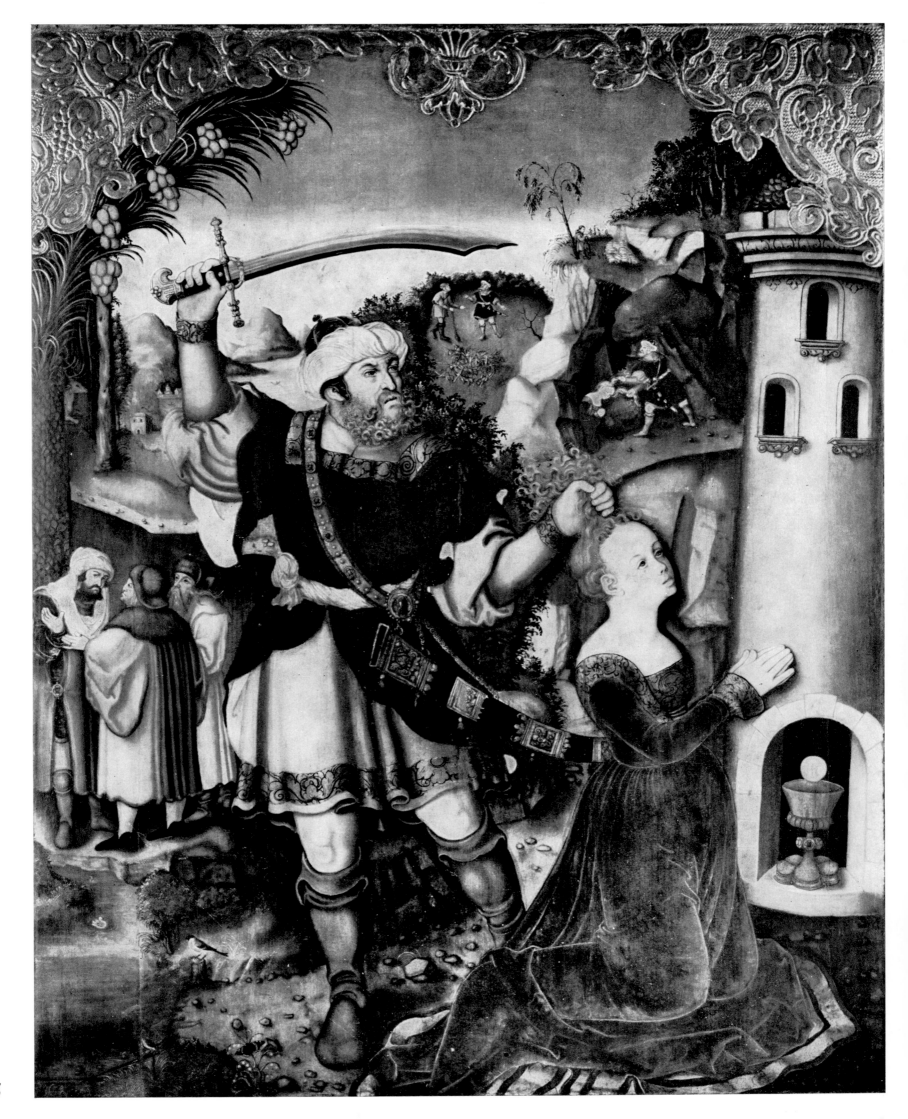

109 The Hymn-book of Český Brod, Fol. 386b. Miniature Furriers at Work, probably from the workshop of Fabian Puléř, the third quarter of the 16th century, State Library of ČSSR, Prague.

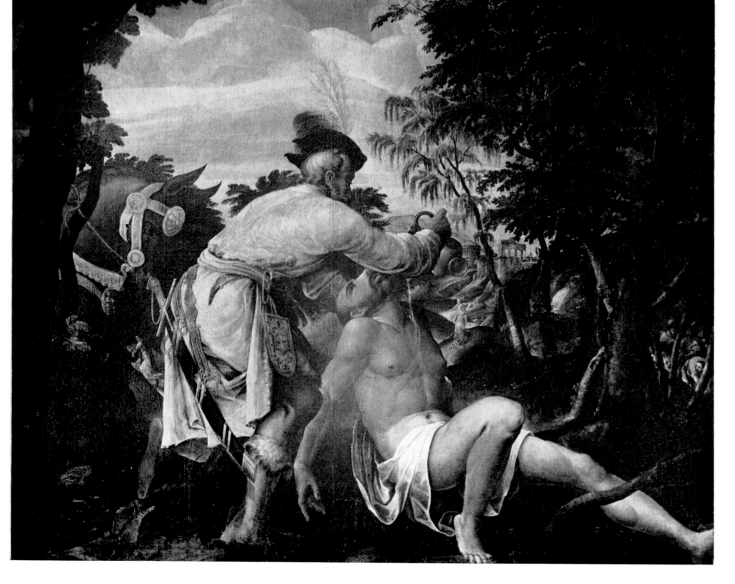

110 Unknown Netherlandish painter, The Good Samaritan (epitaph of Nicholas Wunderle of Deblín), about 1570. Oil on canvas, 245×255 cm, Municipal Museum, Brno.

126

of gables, that of Moravská Třebová in the years 1559—64 interesting "faceted" vaultings. The horizontal shape of the town hall at Most was emphasized by its arcaded cloister and a row of gabled dormers. Many a town hall was accompanied by a watchtower provided often with an arcaded gallery; the function of that at Hostinné is accentuated by giant figures of guards.

The situation was often rather different in the royal towns, mainly in Prague, Plzeň, Olomouc, Brno and Jihlava, where there were stately houses belonging to burghers raised to the nobility who tried to imitate the building enterprises of the nobles in a competitive way.

Of course, this production is not homogeneous; individual regions created their own peculiarities, but these often spread over the border of the country, which did nor represent a barrier to culture. The southern Bohemian and southern Moravian towns, so close to the Danubian ones, have become renowned for their sgraffito and painted fronts, often with large-scale subjects but of a rustic level as well; they can also boast of volute and arched gables of the most diverse forms, as well as attics, sometimes surmounted with battlements or interposed with small bastions. The Krajířs (Kreiger) of Kreig at Dačice chose a design like this to crown the massive block of their Old Castle in 1572—79. Elsewhere, the attic was formed by variously shaped small gables, as for example at Slavonice. Until the mid sixteenth century, an impressive interplay of light and shade was produced in the entrance halls of the houses in this southern Moravian town by picturesque cellular vaults, while at Moravská Třebová in the north of Moravia these patterns, still Late Gothic, changed into the flatter system of "faceted" vaulting. The rich town of Jihlava on the border betwen Bohemia and Moravia, where the draper's craft flourished, had created an unusual type of house; the rooms are centred round a stairwell, surrounded by balconies or arcades and covered with a vault, sometimes painted. An analogue formation can be found also in two other drapers' towns, at Jindřichův Hradec and at Görlitz in Saxony. The vertically conceived rich burghers' dwellings in the royal town of Plzeň, with their Classicizing portals and volute gables, articulated with column orders, bear affinities with similar buildings in some German regions and proudly vie with the palace of the town hall. At Litoměřice, a town in northern Bohemia, we find the Saxon type of portal with seats in side niches (which, of course, penetrated into other towns as well) and imposing attics composed of gables. A high attic storey of this type still articulated in terms of the predominant Gothic vertical, had already been used by Master Paul on the town hall in this town in 1537—38.

The sculptural component of the buildings in Olomouc represents a remarkable exception. The outside portal of the Olomouc town hall, apparently carved about 1530 and newly assembled during the modification in 1564[64], has baluster-shaped columns and ornamental decoration which suggest the influence of Lombardy, chiefly the cathedral at Como, which was a training school for artists from the area round Lugano; similar motifs came from this region as far as Saxony and Silesia. The decorative forms of the portal contrast with the new, moderately conceived outside staircase, completed in 1591, with carved sunked fields; a charming baldachin with Ionic columns was simultaneously erected on its top landing. Staircases like this were commonly built on the town halls of that time.

A special feature of Olomouc, however, is the cycles of reliefs on the façades. The earliest to be preserved adorns the tomb of the rich middle class family of the Edelmans, dating from 1572. A remarkable feature of this structure is the architectonic shaping of the exterior; the blind three-arched arcade carrying an attic band is reminiscent of similar coulisse-like Italian compositions, such as Sansovino's Loggetta in Venice and Fontana's later Acqua Felice fountain of 1585—87 in Rome. In the Mannerist way, in the spirit of Giulio Romano, it contrasts here with the disencumbered structure of the rusticated walls. The motif of an attic with reliefs may have been taken over from the Venetian Loggetta, for the commissioner Wenceslas Edelman was also inspired by Venetian façades when he had the front of his new house pierced by a double arcade on both floors. It cannot have been by chance that these motifs from the city of lagoons appeared in Olomouc and indeed a certain Girolamo of Venice is recorded as being in this city in the 1570s.[65] Of course, the impulse for the attic of the tomb may also have come from Saxony, the source of the idea of decorating the parapets of the arcades on Edlman's house with reliefs from the Old and New Testaments, modelled on German and Netherlandish patterns; a similar cycle, with themes from the Exodus after B. Salomon's biblical illustrations, has survived whereas the building which it decorated has been pulled down.

Relief bands from the sixteenth and the first half of the seventeenth centuries are common on house façades throughout Germany, from Constance as far as the coastal region. They were not unknown even in Italy, where figural scenes were predominantly applied in courtyards.[66] From Italy they came to Saxony, where in 1552—56 Hans Walther carved scenes from the Old Testament for the parapets of the arcades and a composition of the Resurrection for the attic of the portal on the chapel of the château at Dresden. (It must have been from this northern neighbourhood that this type of decoration penetrated to the town hall at Ostrov near Karlovy Vary, but it appears also at Chrudim in eastern Bohemia, on the façade of one of the burghers' houses.)

The deep coffer-like reliefs at Olomouc, graded from three-dimensional forms to engraved ones, show a marked effort to depict space and are close to the transalpine works as well as to their religious and didactic programmes; they even recall the roodscreen by Cornelis Floris at Tournai, dating from 1573. But they are above all akin to the scenes at Dresden and to other similar scenes on portals, epitaphs, altars and pulpits carried out by Hans Walther and the members of his ramified family; also to the series done on the Biblical House at Görlitz in 1570 by their disciple Hans Kramer the Younger. Another member of his family, related to the Walthers, was Michael Kramer, who used similar decoration for the Pernštejn castle at Prostějov. In 1568 he was summoned from Brzeg (Brieg) in Silesia together with the builder Gaspare Cuneo to carry out the reconstruction of this building. (His co-worker, the Olomouc stone-mason Stanislas Ludwig, then worked permanently in Olomouc and at Prostějov.) Of the sculptural works, completed in 1572, only a portal with terms and a relief frieze akin to Hans Walther's works, and some fragments, have survived. The incomplete relief of Samson Overpowering the Lion is of the same conception as both the cycles at Olomouc (which can be dated to the 1570s, and the series from the Exodus ascribed to M. Kramer); the same group of sculptors may have decorated also the castle at Plumlov. These cycles, surpassing the average sculptural works in the Czech Lands of that time, seem to have influenced the carved scenes from Ovid's Metamorphoses, inspired towards the end of the sixteenth century by V. Solis's illustrations and executed on the corner oriel of the house of the Haunschilds in Olomouc. It is the most complicated and the most ambitious oriel in Bohemia and Moravia.[67] Affinities with the Central European circle are also revealed by the column

aedicula of the portal of this house with its Mannerist instability and hammered-on Northern ornamentation.

Differing from the two most significant members of the Olomouc group are the reliefs of biblical and historical commanders, among other figures, on the oriels of the palace of Christopher Schwarz in Brno, built by Antonio Gabri. They differ mainly by their non-spatial conception, which is nearer to the decoration of Italian buildings. The decorative component is akin to that on the oriel of the castle at Náměšť-on-Oslava, dating from about 1580. The Brno reliefs and two pairs of figures on the portal of the house were carried out prior to 1596 by the sculptor Giorgio Gialdi, who before 1582 had worked in Olomouc, where his brother Antonio, a builder, and the stone-mason Jacopo Gialdi, apparently their sibling, were also active. The only recorded evidence of Giorgio's activity at Olomouc is the figural decoration above the grille door of St Stanislas's Chapel, which was commissioned from him in 1591. The artist soon moved to Brno where in the years 1586—91 he carved a fountain with four Antique gods personifying the elements, which has unfortunately not survived.

A similar group was the core of the decoration of a slightly later fountain in the Old Town of Prague, the most monumental town fountain in the Czech Lands. Its two basins were adorned with two groups of statues including the inevitable Neptune on a Dolphin, St Wenceslas, the patron saint of the city, and the Elements. These combined with busts of the Virtues and reliefs bearing the zodiac to make up a partly cosmological, partly ethical programme. The figures are done in an accentuated *contrapposto* and conceived in a body, their roundness and plasticity being accentuated by the clinging drapery. To this unknown transalpine sculptors, the most capable of whom is known at least by his signature — L. W., added scrollwork cartouches and a Northern style of ornament. The authorship of other sculptural works from the turn of the sixteenth and seventeenth centuries is uncertain also: works such as the figural portal and oriel with genre figures on the house of the Lords of Lipá at Ivančice, the fireplace (done by the same hand) and the portal with Samson and Heracles in the château at nearby Rosice, and the portal with Adam and Eve on the Goltz House at Znojmo, a town where the sculptor Anthony was active. In all these cases we are concerned with works on about the same level and of similar conception, showing an easy mastering of the construction of the human body which is often stubby rather than elongated in the Mannerist way.

Little has survived of the Brno of the Renaissance, where the foremost Moravian families and a number of artists had their houses and palaces: a few courtyards with column arcades, some portals (both to be found in the palace of the Bishop Stanislas Pavlovský) and the outside straight staircase to the Land Court hall (executed by Pietro Gabri in 1582—85); originally it led to the large balcony with a balustrade and five free-standing columns. In contrast, the charm of the historical part of Prague is partly created by numerous Renaissance monuments: both column and Classicizing arcades, a rich choice of stone portals, gables and attics, but also traditional transalpine oriels and, less frequently, carved figural decoration such as used to adorn the loggias of the printer Melantrich's house in the Old Town of Prague. The gables are of various types, ranging from the Venetian arched type (on the Týn school), akin to those at Pardubice, to later versions broken in the Mannerist style. Also the attics are either simple, consisting of small arches (such as surmounted the Smiřický House in the Lesser Town), or composed of a row of gables, like that of the Saxon House in the same part of the capital, most probably by U. Aostalli.

Though fragmentary, these remains of the Renaissance city give evidence of the prosperity of the wealthiest burghers, as well as of an abundance of different types. We find the closed lay-out with a central court but also the multiple northern house with tower-like parts surmounted with gables and a lower front wall enclosing the forecourt. This type is represented by the house U zlaté labutě (At the Golden Swan) in the Lesser Town and the house of the Mettychs of Čečov, both from the 1580s. The silhouette of the city was enhanced by picturesque pavilions on houses and towers.

Many buildings have preserved their painted ceilings, some of them even their decorated façades. The U Minuty (At the Minute) house in the Old Town has a rich but heterogeneous selection of sgraffito allegories, scenes from the Old Testament and Antiquity, and portraits of French kings (after German and Italian prints, the latter being relatively rarely used in Bohemia). Those on the lower storeys date from the last third of the sixteenth century; those on the uppermost floor and the lunette cornice apparently date from the first years of the seventeenth century. Their fragmentary and disfigured apperance does not offer any indications as to the origin of their authors who were probably Italians; but it betrays a monumental conception and a ouality which only the sgraffitoes of the châteaux at Litomyšl, Nelahozeves and Benátky-on-Jizera can boast of, the only ones which might be compared with Tuscan works carried out in this technique. The common façade painting is surpassed by the chiaroscuro works on the house of the family Granovský in the Old Town of Prague, dating from about 1560, which simulate architectural components and imitate figural sculpture, at the same time unfolding large compositions with themes from the Old Testament. The technical skill, the Mannerist features in the canon of figures and in the complicated patterns of movement point to a foreign, perhaps Italian, painter. Francesco Terzio (in the years 1560—64) and Domenico Pozzo (in 1563—64) were working at the Castle during this period and it is not impossible that the commissioner James Granovský of Granov, who was in the King's service for many years, managed to get one of their assistants.

Czech and Moravian painting, which had flourished in the Gothic period, now sank to a routine level which was typical of other transalpine countries as well and marked by a general eclecticism. It was a level not even surpassed by the works of the Prague scriptoria and their illuminators, such as Fabian Puléř, Matthew Ornys and Matthias Hutský, who embellished with miniatures a number of hymn-books commisioned by lay singers' brotherhoods, mostly Utraquist ones, up to the beginning of the seventeenth century. This specifically Czech practice, surviving from the Middle Ages, borrowed the themes for its painted scenes mostly from the Old Testament, from woodcuts in printed bibles and later also from free copper-engravings. There is hardly any difference, though, between a genre scene in the Hymn-Book of Český Brod, probably produced by Puléř's workshop in the third quarter of the century,[68] and the series of illustrations, presumably from the circle of the Rudolphine Court, glorifying the ceremony of bestowing the Order of the Golden Fleece at Prague Castle in 1585.[69]

Nor was the situation any better in panel-painting which concentrated on the extensive production of epitaphs, especially from the 1580s onwards, when there were practically no more commissions for the altar-pieces with which the previous period had so abundantly furnished the church interiors. As late as the second quarter of the sixteenth century commissions had enabled the leading painter of Bohemia, known by the initials I. W.,

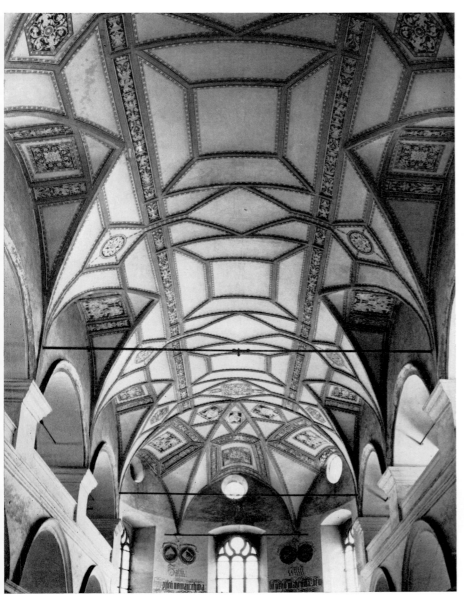

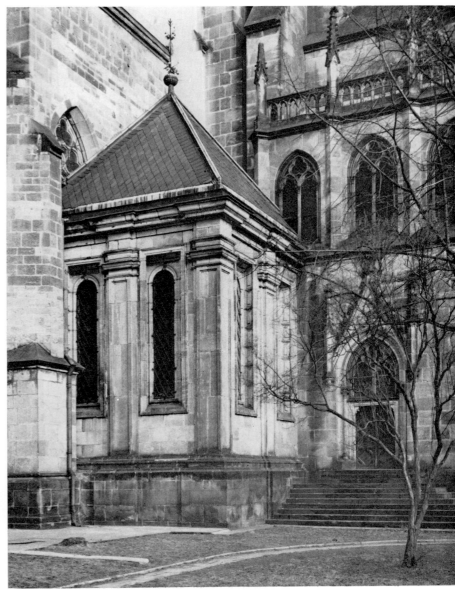

111 Mladá Boleslav, Church of the Unity of Moravian Brethren. Interior with sgraffito decoration, probably Matteo Borgorelli, 1544—54(?).

112 Olomouc, St Wenceslas's Cathedral. Chapel of St Stanislas, 1586—91.

113 Olomouc, St Wenceslas's Cathedral. Chapel of St Stanislas, 1586—91, detail.

to develop the knowledge he had brought from Lucas Cranach's workshop in a number of big altar-pieces and votive panels. All his production was stamped by a dependence on the master whose most talented pupil he was. In the 1540s it was further strengthened by the arrival of an assistant coming from the same Saxon studio, who imparted to the Master I. W. the lesson of Cranach's late style. His influence can be felt in the greater unfolding of space, the more natural incorporation of the figure and the beauty of local tones, apparent for example in the Decollation of St Barbara from the Osek Altar-piece.[70] In view of the decline in creative powers of artists in Bohemia, Moravia and Central Europe in general, the rich burghers of Brno turned to artists from other areas, particularly the Netherlands, when commissioning a number of epitaphs which exceeded the standard then common both in size and in quality. An example is the Epitaph of Nicholas Wunderle of Deblín, with the scene of the Good Samaritan in an ideal landscape, executed by some of the Romanized Netherlanders in about 1570. Its special charm is achieved by its luminous colouring.

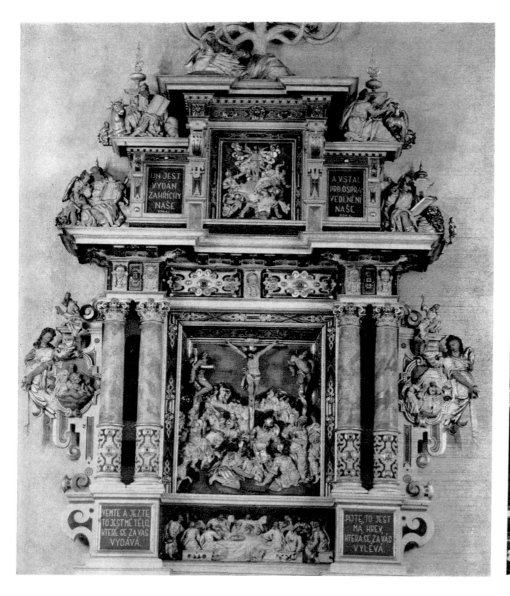

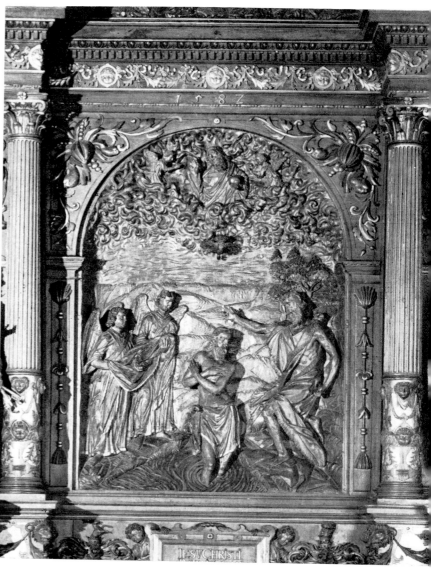

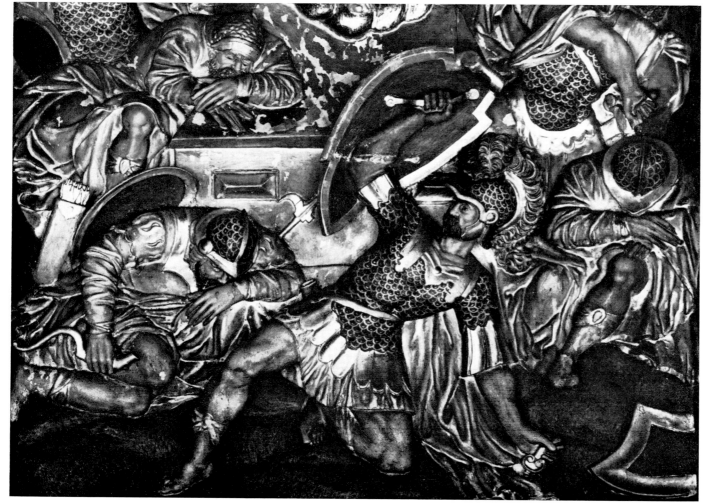

114 Děčín — Podmokly, the altar from Krásný Studenec in the Church of St Francis of Sales, by Franz Dittrich from Freiberg, the end of the 16th century

115 Staré Hrady, altar in the Castle Chapel, 1582, detail

116 Most, Resurrection on the altar in the Church of Our Lady. Detail of the central relief (originally the epitaph of Chr. Rajský of Dubnice — Paradisius), by Franz Dittrich from Freiberg, 1597.

117 Olomouc, the tomb slab of Bishop Mark Kühn in St Wenceslas's Cathedral, by Hans Straubinger from Nuremberg, about 1565 ▶

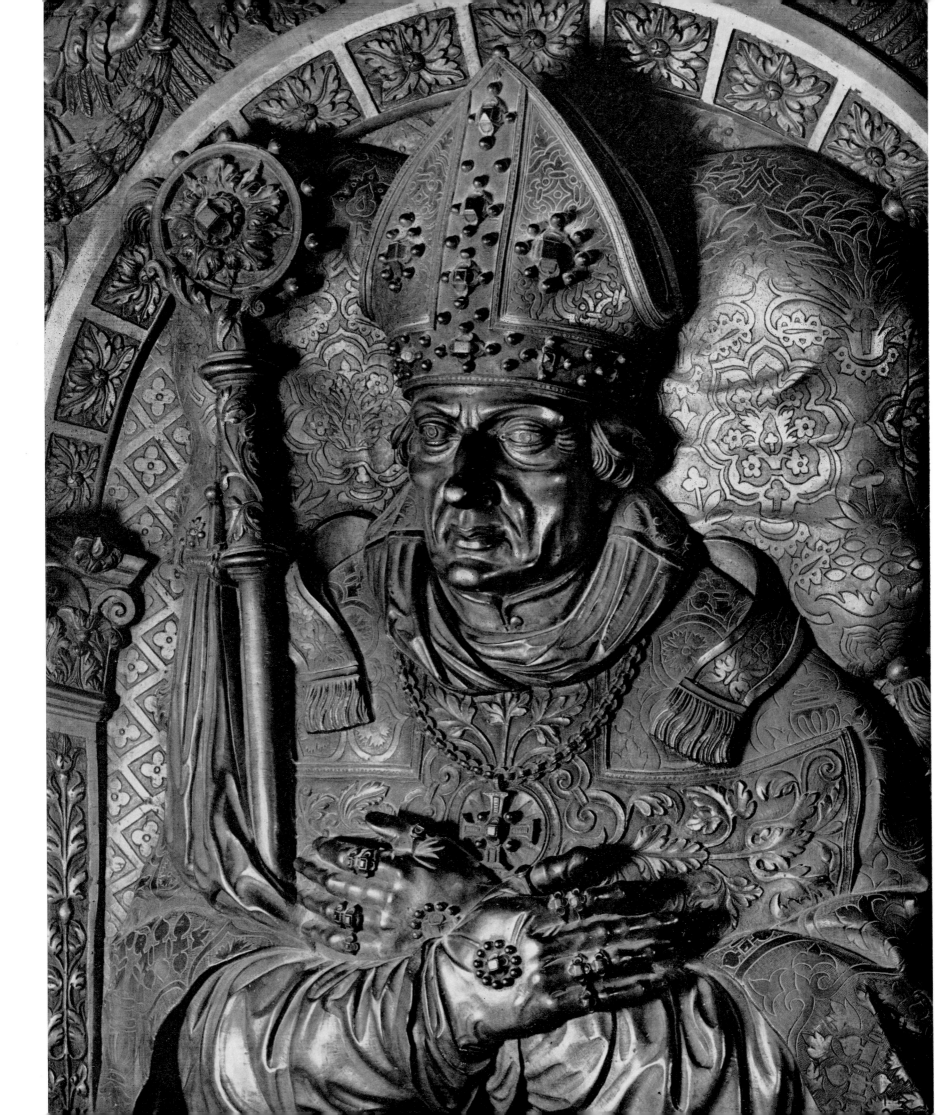

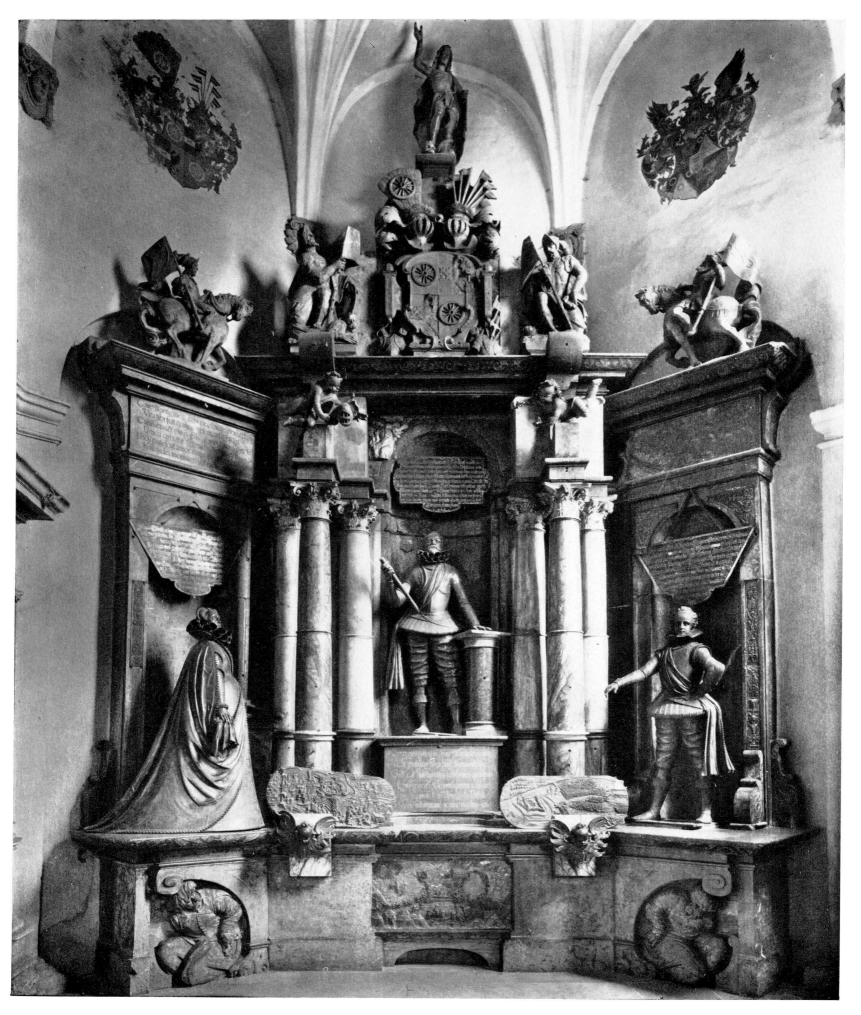

118 Frýdlant, sepulchre of Melchior, Catherine and Christopher of Redern in the Church of the Holy Rood, by Gerhard Heinrik from Amsterdam, 1605—10

THE CHURCH

Strangely enough, the building of churches did not decline in a country possessing so many medieval sacred buildings. On the contrary, many great works of the Late Gothic period were not completed until the late sixteenth century. Besides, the Gothic style continued to determine the ground-plan, the elevation, the shape of the windows and the pattern of the vaulting until the beginning of the next century. The new style penetrated this structure only through the stone, terra-cotta or stucco members, the scheme of the choir loft (those for the lay singers' brotherhoods often had three arms), and sometimes through the construction and form of the vault. It is a phenomenon common to all transalpine countries and to all church buildings in the Czech Lands, Catholic, Utraquist and Lutheran, even the Jesuit church in the capital. Only two houses of prayer of the Unity of Bohemian Brethren, at Brandýs-on-Elbe and at Mladá Boleslav, depart from the traditional conception of a church, and those are relatively early, before the mid sixteenth century. They are the first free-standing Renaissance church buildings beyond the Alps. The basic scheme of the house of prayer at Brandýs, a three-naved structure with cross vaults and a semi-cylindrical apse, seems to have been developed at Mladá Boleslav by the same builder, Matteo Borgorelli, into an extensive pseudo-basilica with an apse, tribunes, a barrel vault with lunettes and sgraffitos and a volute gable. He was apparently influenced by the Romanesque architecture of Lombardy, his homeland, and obviously regulated by the historicizing ideas of a church trying to resume the early Christian tradition.

On the contrary, the Jesuits respected the Central European tradition, doubtless for tactical reasons, when erecting the first monumental church of their order beyond the Alps, that of St Saviour in the Old Town of Prague, in the years 1578—83. Only the originally planned dome and the main façade from 1601 were marked by the new style in a decisive way. The latter, with colossal pilasters and a triangular gable (a richer variant of that of Kralovice Church) was reminiscent of triumphal arches.

The interior of the churches, especially of the Protestant ones, used to be shaped by a horizontal component, by the tribunes carried by pillars and inserted into the whole width of the aisles, while their Late Gothic predecessors, often narrow and shifted to the walls, usually do not influence the character of the space, the church of St Barbara at Kutná Hora being an exception. Renaissance tribunes were introduced into older structures from preceding epochs, as in 1539 at Pardubice, 1559 at Mladá Boleslav, in 1575 at Pelhřimov, and into newly erected ones as well: so in the years 1544—54 at Mladá Boleslav (the house of prayer), 1567—72 at Ostrov, about 1577 at Králíky, in the years 1611—14 in the Old Town of Prague; also the church at Rudolfov may have had them already in its original form dating from 1556—83. In 1581 tribunes enriched even the Jesuit church of Prague, which outran in this respect churches of that order in Germany and Austria and the University Church in Würzburg as well.

The so-called *Wandpfeilerkirche*, with drawn-in buttresses, the type chosen at Kralovice, got further response in Bohemia: in 1569 by the castle chapel at Grabštejn, in the years 1580—83 by the Church of St Margaret at Strakonice, built by V. Vogarelli, in the second half of the century at Klášter Hradiště and in the second decade of the following one by a whole groupe: the house of prayer of the Bohemian Brethren in Prague, the Lutheran church and the Catholic one of the Italian hospital (its unusual vault, with lunettes resting on consoles, is akin to the castle chapel in Trent), both in the Lesser Town of Prague, and the church at Vranov near Brno are of this type. Sometimes — at Sobotka in the years 1590—96 or in the house of prayer of Prague — it was provided with tribunes above the lateral chapels.

The tending to a unified sacred space, easily perceivable and monumentalized by an imposing barrel vault, which was perceptible after 1550 in Italy and somewhat later also in Central Europe, became evident between 1551 and 1601 in the church at Třebenice and after 1600 in several churches in Moravia (large tribunes in those of Velké Losiny and Branná are carried by column arcades). One of them, the chapel of St Anne in Olomouc, from 1614, is pure Renaissance, articulated by pilasters and "thermal" windows. Similar tendencies can be found in Protestant churches destined for preachings — hall-like spaces without choir — at Jáchymov as early as 1534—40, at Třeboň as late as 1610; some of these were provided with a wooden choir loft.

Other exceptions were to be found among memorial and sepulchral buildings, outstanding among which were the previously mentioned Chapel of St Adalbert at Prague Castle, the palace chapel at Telč and the tomb of the Edlmans at Olomouc, where the Chapel of St Stanislas is also exceptional in conception and treatment. Bishop Stanislas Pavlovský, who had become a follower of Tridentine ideas and an ardent commissioner of new buildings during his studies at Rome, had it built next the St Wenceslas's Cathedral in Olomouc as a sepulchral family chapel in 1585—91. He undoubtedly commissioned the design from an outstanding Italian architect, who articulated the exterior of the building by a well-considered and well-composed system in stone, which is exceptional in Central Europe. It is a Mannerist system which dynamically breaks the surface into several layers and impairs the individuality of different components by a process of interpenetration. Moreover, the artist makes use of illusive and deceptive effects such as turning the window recesses towards the plane of the façade at oblique angles to give the impression of greater depth, and this is even extended to the conception of the whole structure. He enhances them by a uniform composition, aiming to make a total impression even if the spectator should change his position. Here we have an interesting example of illusionism in architecture, of which Bramante made such grand use in the interior of the Church of S. Maria presso S. Satiro in Milan. On exteriors it was applied more sparingly and in partial solutions such as that used by Lombardi on the Scuola di S. Marco in Venice or by Sangallo on the passage of the Farnese Palace in Rome, rather than in the whole organism as on house No. 46 in the Via G. B. Morgani in Padua.[71] The small Chapel of St Stanislas has unfortunately lost the onion-shaped roof. But its remarkable articulation gives it the status of a monumental structure, and it ranks among the foremost transalpine works of the second half of the sixteenth century. Significant sacred buildings either with predominantly Renaissance components or completely devoid of Gothic survivals, such as the Italian Chapel or the churches of the Holy Trinity and of St Saviour in Prague are works of Rudolphine epoch.

Even the furnishing of churches with sculptural works was continued; the interest in pulpits, fonts, epitaphs and tombstones, less frequently in altars as well, was greater than the number of capable hands. The commissioner therefore had recourse to famous

foreign workshops or summoned foreign masters. About 1565, Hans Straubinger executed a remarkable signed bronze tombstone of Bishop Mark Kühn for the Olomouc Cathedral. Like some of his Italian colleagues he was unable to overcome the contradiction between the recumbent figure, here shown *au vif* — alive — and the aedicula, moreover treated in perspective. However, in the successful design, the delicate modelling, and particularly in the portrait treatment of a face bearing the marks of age, he was a worthy representative of the renowned Nuremberg metal-founders. Saxon workshops, at Freiberg, Pirna, Dresden and Meissen, gained ground in north western Bohemia. Hans and Sebastian Walther, Hans Köhler, Melchior Jobst, Samuel Lorentz, Laurentius Hörnig were all masters practised in the use of noble materials for delicate ornamentation and of rich polychromy for enlivening wood. They supplied several interesting altars, pulpits and fonts as well as a great number of tombstones and epitaphs. Sets of these have been preserved at Brozany, Valtířov, Svádov and Benešov-on-Ploučnice — simple plaques with coats of arms as well as designs of many layers combining column aediculae with figures and reliefs. On both altars and epitaphs the international scrollwork, the Northern "hammered-on" ornament and fantastic forms, adding to the articulation of the outline, slowly permeated the Classicizing lay-out of the Italian type. In 1615, David Schwenke placed in front of an aedicula treated in this refined style a contrasting free-standing group of the Bock family, the realism of which is enhanced by polychromy in an almost verist manner — one common in Saxony at the time.

The sculptors realized their patron's ideas of magnificence and immortalization in the other regions as well. The master of Wrocław, V. Strašryba, who settled in Louny, produced a two-storeyed epitaph of John of Lobkovice in St Vitus's Cathedral in Prague, and an unknown master the altar-tomb of the Zástřizly family at Boskovice in Moravia. There the standing portrait effigies are combined with Mannerist architecture and accompanying figural motifs. The number of types of these monuments is naturally immense. In contrast to the Saxon decorativeness, the author sometimes emphasized the tectonics of the aedicula, as on the epitaph of George of Lobkovice, also in St Vitus's Cathedral; sometimes the figure was emphasized, perhaps under the influence of painted portraits, as on the tombstone of Wenceslas Berka in the Týn Church in the Old Town of Prague. The sculptor treats the figure either in the traditional way, i. e. recumbent, or erect, usually alive, in the Renaissance manner and standing or kneeling in front of the Crucifix. *Memoria* epitaphs with the bust of the deceased such as that of the builder Leone Garovi at Moravský Krumlov are rare, though they were common in Italy in the second half of the *cinquecento*. Members of some houses, standing in rows, were placed into niches or arcades which form a whole architectonic structure, as at Frýdlant, Klimkovice, Stará Ves-on-Ondřejnice.

Even the sarcophagus, which had a famous tradition in Bohemia, was relatively scarce; it is represented by the tombs of Adalbert of Pernštejn at Pardubice, Zacharias of Hradec at Telč, Hermann of Buben at Horní Jelení, William of Doupov at Vilémov; of the tomb of the Lord of Vlašim in Olomouc only a plaque with a sculpturally treated effigy has survived. The sarcophagus of Vratislav of Pernštejn in St Vitus's Cathedral was inspired by a scheme common in Italy in the sixteenth century and published by J. Vredeman de Vries. The sepulchre of Joachim of Hradec at Jindřichův Hradec, of which only the Classicizing coulisse of the triumphal arch has survived (the sarcophagus with kneeling figure has been destroyed), familiarized Bohemia in 1570 with the altar-tomb, which was created in Venice in the fifteenth century and adopted by Rome at the beginning of the *cinquecento*. Of grandiose conception was the canopy-like monument of William of Rožmberk, made of marble, terra-cotta and copper. This structure was carried out in the years 1593—97 by the sculptor Georg Bendel and the goldsmith John Dorn; surmounted by the figure of the Rožmberk rider, it reached up to vaulting of the Church of St Vitus at Český Krumlov. A simpler and later analogy can be found in the German Doberan.[72]

The greatest achievement of funerary sculpture outside the Court was the monument created in the years 1605—10 by Gerhard Heinrik of Amsterdam, who had settled in Wrocław, in the chapel attached to the church at Frýdlant, commissioned by the lords of that estate. The marble architectonic coulisse is a variation of the Venetian altar-tomb as is the famous mausoleum at Freiberg in Saxony. Here the tripartite scheme even has a functional substantiation; three niches form aediculae for the triad of statues representing the members of the Redern family. The clustering of columns and the emphasis on the centre already suggest Early Baroque tendencies. No less ambitious is the sculptural component. The lively marble equestrian and walking figures of flag-bearers, the Resurrected Christ and angels, the masterly high relief of Turkish prisoners on the pedestal and the delicately carved relief scenes supplement the central triad formed by the stern descriptive and three-dimensional bronzes of Melchior, Catherine and their son. These differ from most portrait figures of the deceased, rendered alive, as kneeling in piety or meditating, in their proud, nearly contemptuous posture indicating eloquently the self-confidence of the Renaissance nobleman. (In this respect they surpass another triad representing the family of the Margrave Karl von Baden in the château church at Pforzheim.) In spite of all the hesitation that marked a work caught between two styles we can say that at Frýdlant Heinrik created the most monumental sepulchre in the Czech Lands, a worthy counterpart of the royal tomb by Colin and the closing link in the development of Renaissance sculpture in Bohemia. It is a work which, however, already belongs to the period of Rudolph II.

THE ARCHITECTURE AT RUDOLPH II'S COURT

Oddly enough, it has long been denied that Rudolph II had any interest in architecture. Yet he was an ardent commissioner of new buildings. A passionate patron of all kinds of art, he must have been aware of the contemporary view of architecture — either as the noblest, the most necessary and the most useful of the arts, or as a norm and yardstick for judging the other arts, or as a science which in its organizing function is near to God, who introduced order into the chaotic world.[73] It is after all unlikely that this ruler, who had inherited so many of his father's inclinations, would not have also shared his liking for building. One cannot believe that a mind so alive to artistic manifestations of all kinds would not have been charmed by the Moorish buildings

and the architectonic works of Philip II in Spain or by the creations of Italian builders at Trent, Milan, Genoa and Mantua, which he had seen as a twelve-year-old boy on his journey to Castile in 1564 and on the return trip to Vienna in 1571. Many years later the Emperor even asked his uncle for pictures of Spanish châteaux, especially of the Escorial. (Similarly, Maximilian II had ordered from Rome pictures of buildings, summer houses, antiquities, fountains and grottos.) And Philip II sent him paintings of his summer residence of Aranjuez, which his nephew knew, and of the hunting lodge in Segovia. Rudolph had also buildings in Bohemia modelled or painted, particularly those on the Rožmberk estate in southern Bohemia which he acquired in 1601. It is not impossible that the eleven wooden models of houses, summer houses, bridges and fountains, recorded as belonging to the Castle collections, originated in his time when their execution would have been entrusted to the joiner Konrad Engler.[74]

In fact, building activity under the reign of Rudolph II did not subside even in Vienna, nor at the Neugebäude, or the château in Linz, so it would have been the less likely to do so at his permanent residence. The number of building enterprises undertaken in the Rudolphine period was considerable, but most of them shared the misfortune which befell the works of art the Emperor surrounded himself with during the following ages. Notwithstanding, even the fragmentary records show clearly that throughout Rudolph's stay there, Prague Castle and its environs formed a building site alive with the combined activities of master builders, masons and stone-masons. In the course of those thirty-five years they restored, adapted and newly erected innumerable buildings.[75] The Emperor himself even drew his idea of the transformation of the castle in Linz and of the church there.

The new sovereign took over his father's master builder Ulrico Aostalli, who supervised the building works at the Castle as well as on the royal estates until the year 1597. After his death this post was given to Martino Gambarini from the Lugano region, who apparently died towards the end of 1617, and temporarily — at the turn of the century — also to Orazio Fontana from Brusata in Mendrisiotto. The designs of the more ambitious structures were entrusted to Giovanni Gargiolli from Fivizzano in Tuscany and to Antonio Valenti, whom Rudolph II summoned to Prague in 1585; he sent also Gargiolli to Italy to consult designs there before he had them made up into models in 1588. After Valenti had gone to Hungary and Gargiolli, in 1594, to Vienna and from there to Livorno, the Emperor commissioned designs from artists who were active at his court either permanently or only temporarily. According to records he obtained some from Jan Vredeman de Vries and probably from Joseph Heintz who was also an architect but stayed in Prague only sporadically. It would have been surprising if he had not also requested some projects from Vincenzo Scamozzi, the well-known follower of Palladio, who came to Prague Castle with the Venetian envoy at the turn of 1599 and 1600, probably paying another short visit in 1604 when in Salzburg. In his treatise Scamozzi mentions some of Rudolph's buildings, but is critical in his evaluation of his countrymen's contribution. Early in 1602 another architect, Giovanni Maria Filippi from Dasindo in Trentino, was summoned to Prague Castle from Rome. Without breaking his contacts with Italy, this artist stayed in Prague also under Rudolph's successor until the year 1616. A not insignificant part in the realization of the projects was played by the stone-mason Giovanni Antonio Brocco from Campione, who had been working at the Court for more than thirty years (he died in 1613), and of course by a number of other masters, mostly Italians.

The architecture of Prague itself was considerably aggrandized during the time that it was the Imperial residential city and entertained a great many missions and deputations. This applies not only to the Hradčany quarter which Rudolph raised to the status of a royal town (and which shortly afterwards had its own town hall built), but to the other quarters as well. Not only new houses, palaces and whole streets, but new churches, too, were erected one after another — churches of the Jesuits, the Lutherans and the Bohemian Brethren in the Old Town, of the Lutherans in the Lesser Town, of the Capuchins at Hradčany. The abbey church of the Premonstratensians at Strahov was modified and improved; the Lesser Town Church of St Thomas and the Old Town Church of St James were restored with the Emperor's assistance. In the ghetto, flourishing at that times, a series of five new synagogues was built and one, that of rabbi Pinkas, was enlarged and enriched with the Mannerist motif of window aediculae.

Sacred buildings marked both the beginning and the end of Rudolph II's reign. On his accession to the Bohemian throne, the Chapel of St Adalbert in the courtyard of the Castle was finished with his financial aid, and in the same decade his sister had the Church of All Saints restored in Gothicizing forms and revaulted (the style of vaulting, with lunettes and a stucco network, was later applied to two secular buildings as well). When the Emperor was dying here in 1612, his ex-voto, the Church of St Rochus at nearby Strahov, was being finished.

The first of the significant architectural enterprises linked with his name is, however, a garden work, namely the Summer House in the Old Royal Game Preserve at Bubeneč. Thus history repeats itself. Like his father and grandfather, Rudolph II took great delight in gardens, game preserves, hunting castles and summer houses. He had the Prague Royal Garden extended — mainly with the western section near the large yard and the tilting ground; for his favourite beasts he had a new lion court built in 1583—84 on Aostalli's well-conceived design from the previous year; he enriched the garden with an orangery, an aviary and, in 1604, with two fountains, each probably modelled on one of the seven variants designed for him by Jan Vredeman in 1598. Also the Emperor's gardener, Hans Puechfeldner, presented him with seven projects and three books on gardens in the 1590s. The orangery, followed soon by others (at Český Krumlov, Loučná-on-Desná, Opočno) seems to have been the first one in the whole Europe, orangeries being usually disassembleable constructions at that time.

However, the projects for the Bubeneč game preserve were perhaps even more grandiose. The hunting lodge built there in Vladislav's time had been reconstructed by Aostalli as early as 1578—79 into a summer house conceived like that in the Royal Garden. Around the oblong core (consisting of a large rectangular hall with a reticulated vault and a square one with octopartite vaulting of an interesting double rhythm) Aostalli built a gallery, this time on both storeys and with more massive pillar arcades. From the old structure he took over the corner tower which he pierced with six circular windows. The ground-plan of both Prague buildings seems to have inspired Beer and Schickhardt's New Summer House in Stuttgart dating from 1580—93; as far as we know, this configuration is otherwise unparalleled in Central Europe. The Bubeneč conception influenced also the commissioner of the summer house adjoining the castle of Opočno as late as 1602. In the game preserve, Rudolph II had yet other edifices erected and a large pond with an island established below the Summer House; he also added an extensive orchard and a pheasantry,

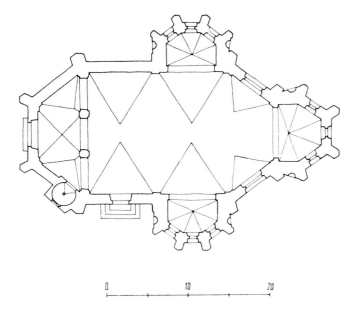

Prague — Strahov, plan of the Church of St Rochus

and had the whole complex connected with the Castle by a direct road, bordered from 1616 onwards by an avenue of lime trees.

Near the mill on a branch of the Vltava river, bought by the Czech Chamber in 1584, a complex grew up called the Imperial Mill which also included glassworks and a mill for grinding crystals and precious stones. There, below a slope, in the years 1589—90, Aostalli erected a long building consisting of a low ground floor and an arcaded storey, with a sequence of twenty-two arches on pillars with pilasters repeated almost *ad infinitum* in the Mannerist style; the formation is reminiscent of the free-standing French galleries of the sixteenth century and of the Italian Classicizing loggias. It is not known whether there were internal decorations which would have turned this building into a gallery in the contemporary sense. Two indispensable components of Mannerist gardens supplemented the new building: a large oblong water-basin faced with ashlars and bordered by a parapet and a paved road, perhaps even with an arcade on one side (made by Aostalli and G. A. Brocco), and a grotto created in a rock by Brocco in 1594.

The configuration of this grotto is unique among the garden designs which the *cinquecento* was so rich in. Moreover it is the only one from the 16th century to be preserved in Bohemia as well as one of the few recorded in Central Europe. In contradistinction to the fantastic grottos of Italy and France, Rudolph II had this one built as a sort of a small, circular temple with the walls and cupola covered with rustication and articulated by high stone niches. The internal space is arresting in its austere stereometry, in the rationalism of its severe stone structure. A not dissimilar effect is achieved in terms of the function of the building also by the corridor of Sansovino's Venetian Zecca and Sanmicheli's interior of the Porta Nuova in Verona. It is a structure composed as a "work of art and hands", as opposed to the usual treatment of the grotto as a product of nature. Like the pavilion in Jindřichův Hradec, this grotto is an exceptional, monumentally conceived building based on the circle — the form considered to be the most perfect one by Renaissance theorists, endowed with many symbolic meanings and recommended chiefly for sacral designs. Only sparingly illuminated via the high lantern and a sort of a portico, the interior thus surprised the visitor in the fashion so much favoured in the Mannerist period. Its function is not known. The unusual shape — as if following the contemporary idea of a Roman temple

or an Antique tomb — seems to have been linked with the delight in astrology, magic and hermetic science, which the Emperor, known as the New Hermes Trismegistus, was renowned for. Water was not brought into the grotto until the first years of the seventeenth century, when (probably) the front was modified to give the impression of a triumphal arch.

The powerful portal, again rusticated, is accompanied by two niches with contrastingly flat frames. Instead of a capital, its pilasters have a triglyph accentuating the character of the order (as was usual at that time, particularly in Italy). The latter had been a heroic one since Antiquity and its supports used to be compared to a hero or a warrior — here as if it were trapped by stone girdles. The buildings of the Imperial Mill may have belonged among those designed by Valenti and Gargiolli, but we cannot exclude the possibility that this front was shaped after 1600, the idea being perhaps supplied by Scamozzi or — more probably — by Filippi. The basic pattern and the contrast between "the forms made by human hand" and those "made by nature" which imprison the former, were made monumental by the emphasis on three-dimensionality and dynamic by the main gateway of this court, originally situated directly by the river. With its powerful girdled half-columns and slanting voussoirs penetrating the entablature, the gate belongs in the group of Mannerist portals and gateways designed by Serlio and Vignola, recommended for buildings outside the town boundaries; but it is more advanced in style. It was designed in 1606 most probably by Filippi, an artist who had learned much in Rome. Several variants of the scheme of the gate and the components of the front of the grotto appeared in Prague during the next decade.

Also, in about 1580—1600 a number of country buildings belonging to the Bohemian Chamber, particularly hunting seats, were adapted and extended. From 1582 onwards a towered hunting lodge equipped with Imperial chambers was coming into being at Hlavenec, according to a design by Pietro Ferrabosco. About 1590 Aostalli rebuilt the castle at Lysá-on-Elbe with seven new gables and Karlštejn Castle, the new features of which included a pavilion with five gables, sgraffiti and interior paintings. A hunting lodge was built at Lány. The remarkable sgraffiti of the castle at Benátky-on-Jizera, which the Bohemian Chamber acquired in 1599, create a sort of coulisse of several levels and layers, with a fictitious arcade

119 Prague — Bubeneč, Rudolph II's grotto in the Imperial Mill, the design probably by Giovanni Gargiolli, executed by Giovanni A. Brocco by 1594 ▶

Prague — Old Town, plan of the Italian Chapel

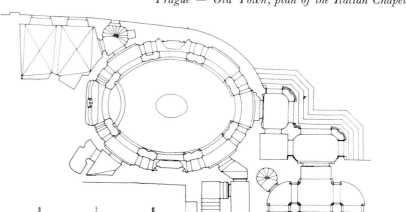

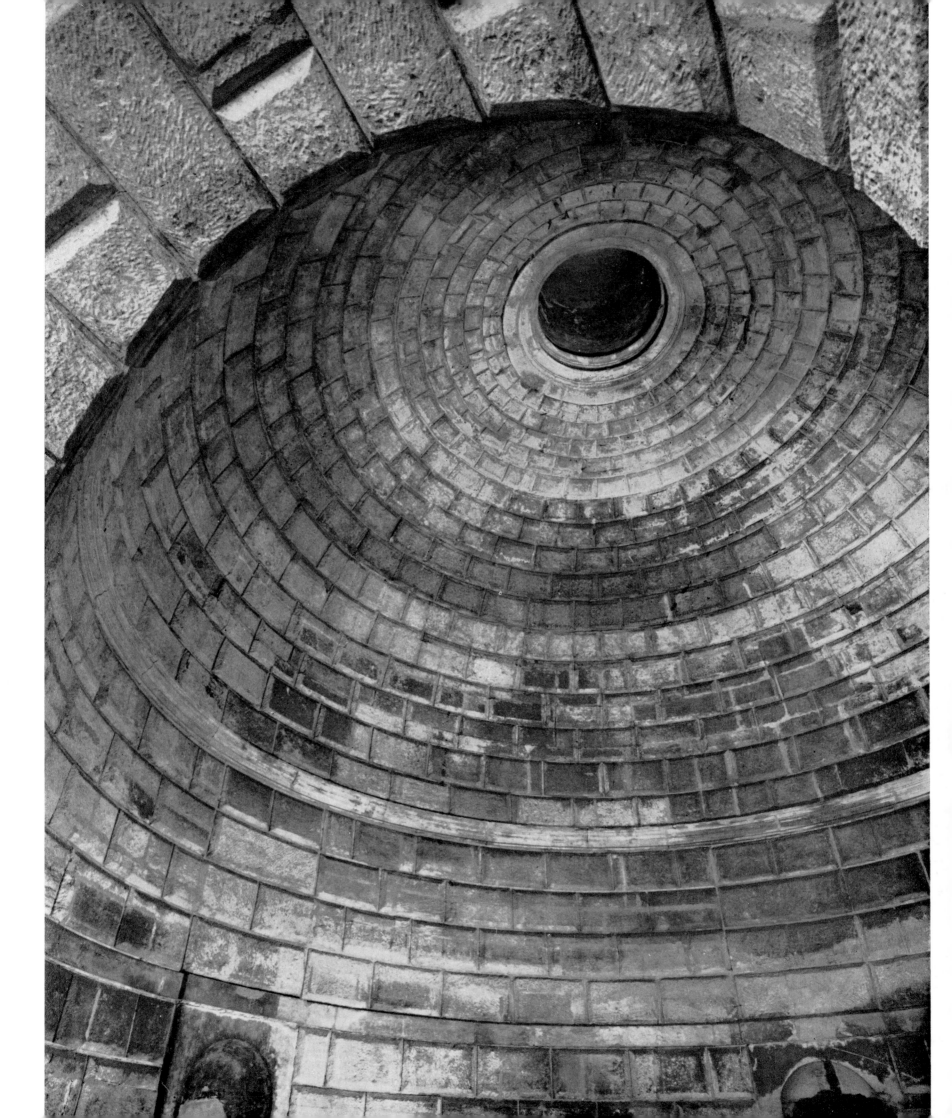

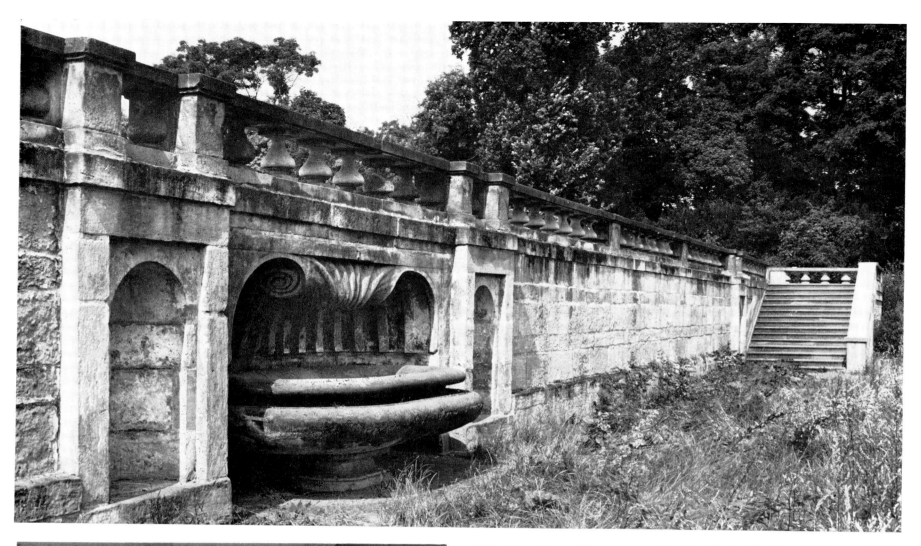

120 Brandýs-on-Elbe, terrace in the Castle Garden, design probably by G. Gargiolli, executed by G. A. Brocco, 1589—90

◀121 Prague — Castle, vault of the New Stables of Rudolph II, by Giovanni Maria Filippi, 1601—06

122 Prague — Castle, Office of the Burgrave, detail of the ceiling, painted frieze landscape with a fisherman, apparently the 1590s ▼

123 Prague — Castle, Matthias Gateway, by Giovanni Maria Filippi, 1613—14 ▶

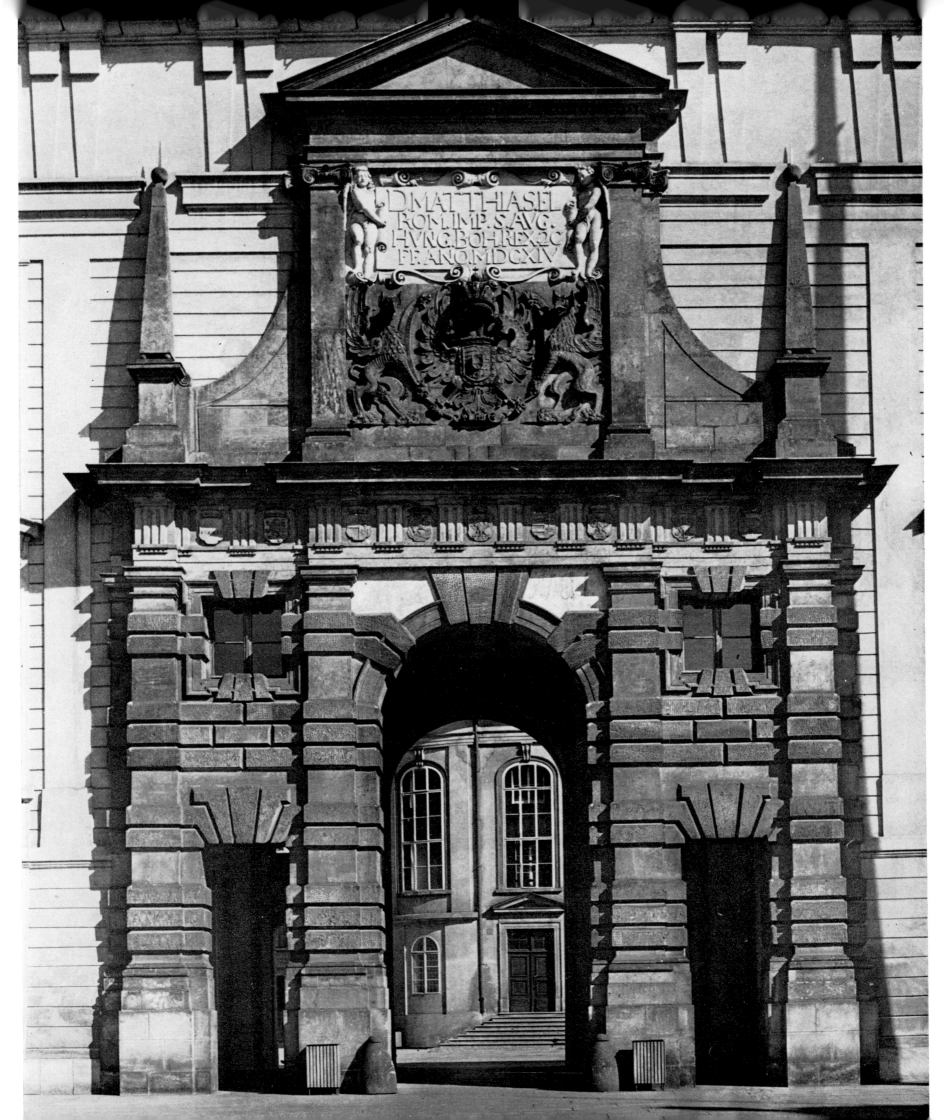

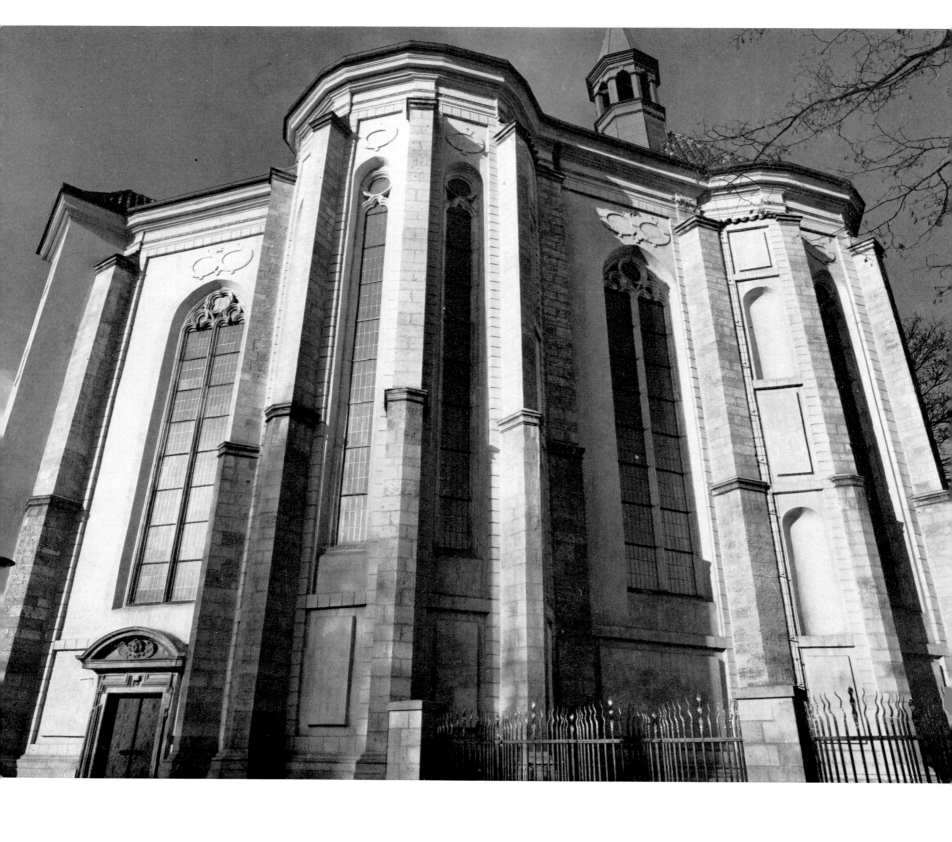

124 Prague — Strahov, south-east view of the Church of St Rochus, 1603—12

125 Prague — Old Town, the Italian Chapel in the Klementinum, interior, 1590 (adapted in 1715 and 1773)

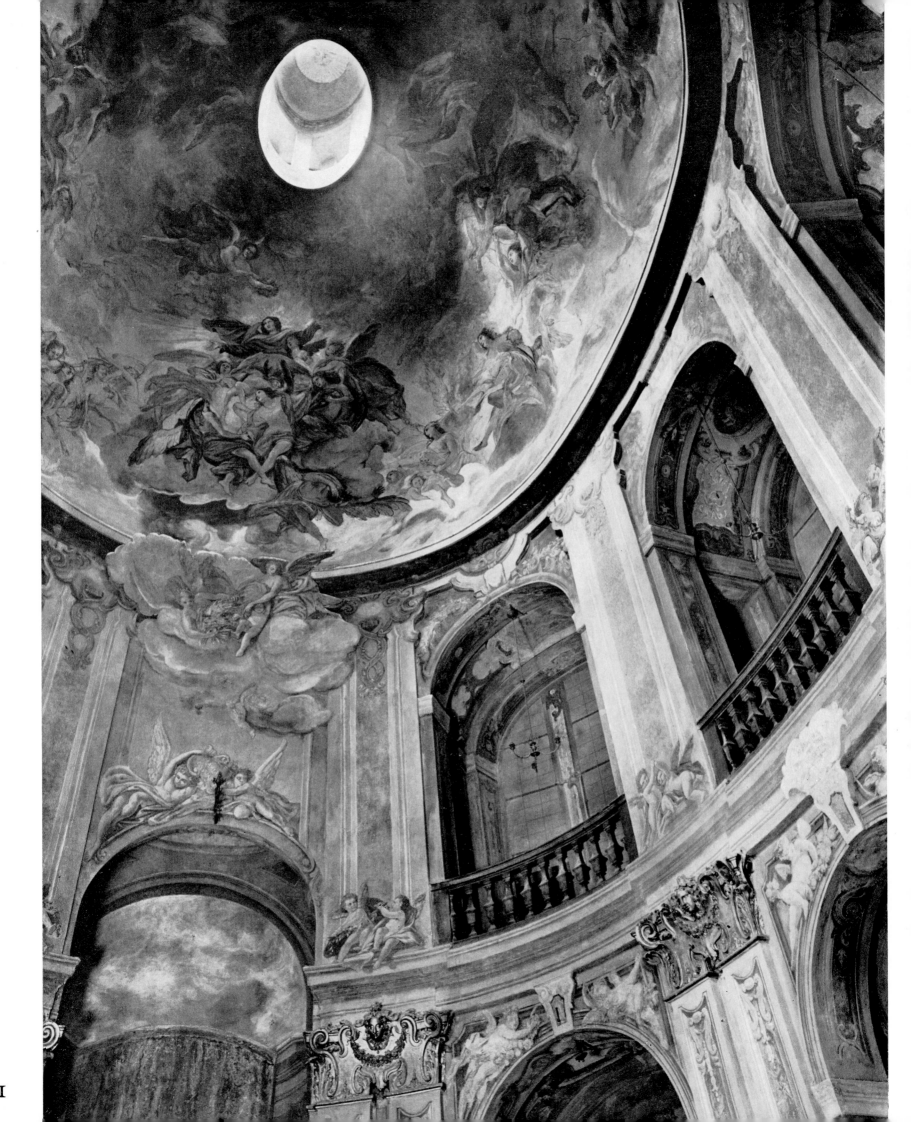

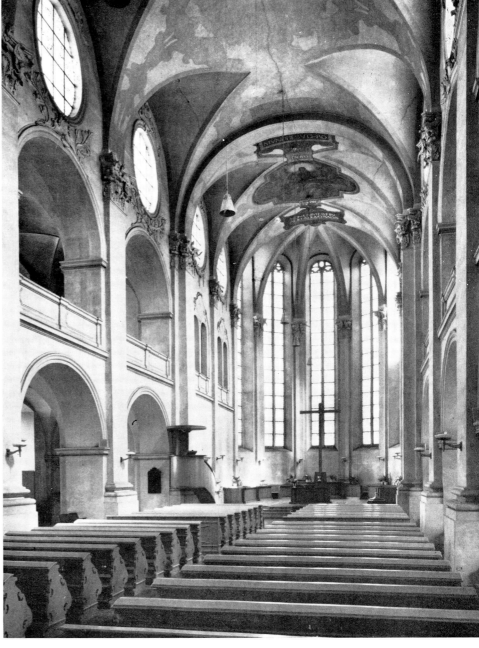

126 Prague — Old Town, The U pěti korun (At Five Crowns) house, No. 465, Melantrich Street, the façade 1615

127 Prague — Old Town, the Lutheran Church of St Saviour, 1611—14

128 Prague — Lesser Town, Town Hall, design probably by Giovanni M. Filippi, 1617—19

129 Prague — Old Town, The Teyfel House, No. 463, Melantrich Street, the arcaded courtyard, between 1603—15
►

130 Giovanni M. Filippi, Castrum Doloris of Rudolph II, engraving, 1612 (akin to Seregni's catafalque of Charles V)
►

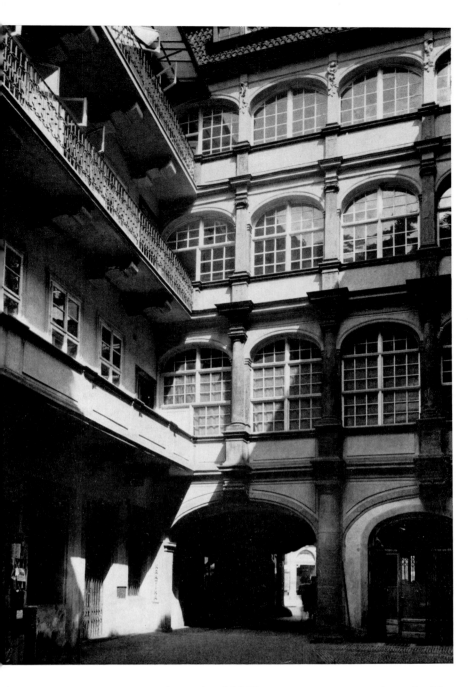

designers of Italian terraced gardens. They demonstrate that he had an understanding not only of the traditionally flat designs, but also of the new conception in which a terraced garden of Antique origin was connected with the Renaissance motif of the staircase. This conception penetrated from Rome to Veneto, but mainly to Lazio and Genoa, and may once have been admired by the young Habsburg in that Ligurian city. The design may have been made by Valenti and Gargiolli, who seem to have also designed the big stables of 1592 and other buildings at Brandýs, such as the tripartite gate to the garden, revealing triumphal arches. (Julius Heinrich of Sachsen Lauenburg had an important Mannerist garden complex created next his castle at Ostrov after 1625 and another at Toužim about 1630, not without impulses of Rudolphine gardens.)

However, their greatest accomplishments were the plans for an extensive adaptation of Prague Castle, as well as for some new buildings inside its walls. The Castle complex consisted of tens of structures of varying age, size and appearance. Rudolph made the first step towards its unification into more coherent wings, and also built a worthy counterpart of the medieval palace and its Vladislav Hall. In the southern part, the Imperial bedroom,

within which scenes from the Old Testament are enacted, and with very long bands of forest landscape enlivened by riders and game. These large compositions divide the storeys, as on the château of Litomyšl and Frýdlant or in the façade painting of Italy and southern Germany.

The Emperor had a special liking for Brandýs-on-Elbe where he enjoyed hunting in the new game preserve. Ferdinand I had already the fortified castle there rebuilt into a four-wing Renaissance château with an arcade on one side and a tower which was completed in the Rudolphine period. Ettore de Vaccani from Porlezza on Lake Lugano connected the Imperial chambers with the new garden by a covered corridor. The big upper orchard — such utility garden sections used to be common at that time — was separated by a terrace from the lower "entertaining" part. The latter used to have flower beds, fountains, palms, olives, cedars and other exotic trees, and also a summer house of nine rooms, a ball court and a vivarium. The preserved terrace dividing this decorative section, carried out at the outset of the 1590s by G. A. Brocco, is a work of remarkable artistic merit; its front wall is from carved stone and has a balustrade, staircases, niches and two fountains in shell-like recesses. Both the overall lay-out and the terrace indicate how successfully Rudolph II competed with the

Castri doloris delineationem RVDOLPHO erecti Amoris Testimonium, MATTHIA CÆS. et hinc Mortalitatis cõis meæ fidelit: clementis, accipere, dignare. Johannes Maria Philippus de Defando Archit: Invet.

143

a study, a council room and three summer rooms were built *en suite;* their erection is recorded in 1587. The New Hall, recorded six years earlier, may perhaps have belonged to the same part of the Castle.

From about the year 1586 works went on in the transverse wing between the second and the third courtyards in the neighbourhood of Rudolph's Palace and in the northern wing adjoining it.

In the former wing, along the western side of the Romanesque fortification wall strengthened with two prismatic towers, the Emperor had spaces created for a *Kunstkammer* (art chamber) which was to house his collections. At the beginning of the seventeenth century, about 1602, he had long gallery corridors added along the total length of its west side on two storeys. According to van Mander's testimony, they were erected by one of the Vries family, perhaps inspired by those of the Uffizi.

The northern of the two towers, reconstructed after 1600, was incorporated into the new structure and divided the corridors. It was given an oval spiral staircase with an open well and four niches, probably according to plans in Palladio's Four Books; leading to it from the courtyard was a portal with two columns and a segment pediment. Over the roof, the tower formed a sort of pavilion (a formation then popular in Prague), which had close affinities with those of Roman palaces. The composition of its façades, unusually complicated for Bohemia, even surpassed their articulation. Giant half-columns in the first zone separated oblong windows with alternating pediments and square ones placed above them. Thus the interior space was lit by a double sequence of openings. The second zone over the high entablature formed the triumphal arch motif; it was pierced between the pilasters (or half-columns) by an arcade, and in the side axes by oblong windows, supplemented with rectangular sunken fields; the moulded main entablature obviously formed a balustrade for a terrace.[76] The author is not known but both the staircase and the articulation and its constituents have analogies in Scamozzi's production and in his treatise *L'idea dell'architettura universale,* which was published

in 1615. However, Filippi and Heintz may also have brought the inspiration for this composition from Rome. In the spring of 1603, Bartholomew Beránek from Český Krumlov designed a painted ceiling for the Emperor's chamber in this "new" tower. The high prism of the southern tower — with corner rustication, a gallery and a bell-shaped roof — stood out markedly beside the wing with the Imperial chambers in old views of Prague Castle; in 1607, this tower was made similar to the lower northern one by putting down the roof and building a terrace instead.

About 1585 Bartholomeus Spranger embellished the flat cupola in its interior with the figures of Hermes and Athene, rendered *di sotto in su* (seen from below). Probably also linked with his workshop were the freely painted chiaroscuro scenes from Greek mythology on the ceiling of the house of Lorenzo Nero in the Lesser Town, which date from the end of the century and surpass the average Bohemian production. Also the Office of the Castle Burgrave was decorated at that time with similar long, frieze-like compositions on the ceiling beams (sketched landscapes with figures, reminiscent of paintings on majolica); the vigorously rendered allegories of the Senses and the scene of Solomon's Judgement on the walls, with clearly differentiated faces, refer to trials which were held there. Arcimboldo's designs of grotesque decoration with working motifs for the house of Ferdinand Hoffman of Grünbühel and Strechau, dating from 1587, were unfortunately never realized.

In the year 1590 Rudolph II started to build his most monumental and artistically most ambitious structures: the northern wing of the Castle, its stables, halls and a gateway in the middle. The large Spanish stables with barrel vaulting crested with a network of stucco rose east of the gateway linked with the transverse wing; they were completed by 1596. Above them was the hall of the picture gallery, called the Spanish Hall after the stables, later the *Bilder Saal* (Picture Hall) and finally the German Hall (now Rudolph's Gallery). It was a long room with a marble fireplace, opening to the north — perhaps following Vitruvius, who recom-

Giovanni Maria Filippi(?), a perspective view of the Lutheran Church of the Holy Trinity (Church of Our Lady Victorious) in the Lesser Town of Prague. Wash ink-drawing from about 1611 on the leaf of the plans of this church, Prague, Museum of the City of Prague.

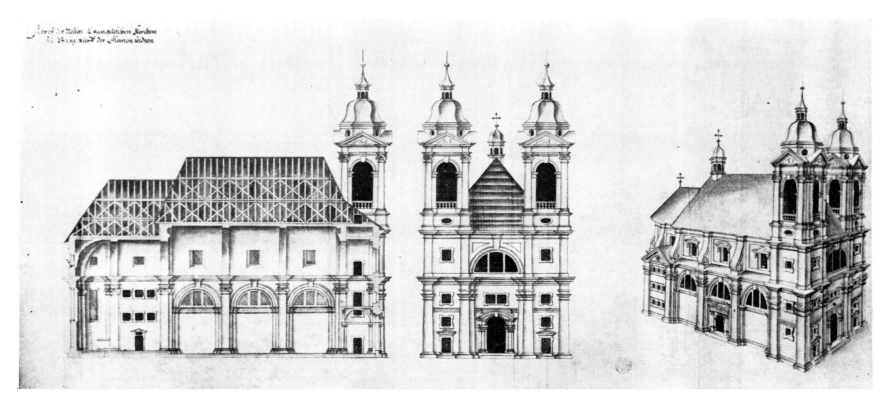

mended north light for picture galleries. On its façade, eleven high round-headed windows alternated with girdled pilasters or strips.[77]

On the wooden ceiling of the hall, made by the Court carpenter Bernhard Erhart in 1596, Paul Vredeman de Vries painted, by 1597, an illusion of a vault with a large perspective vista in the centre and the grotesques so popular in the *cinquecento*. It was the first recorded attempt on a grandiose scale at the illusive transformation of an interior space by a pictorial method in Central Europe. This form of illusionism was based on a masterly utilization of perspective and was much favoured in the period of Mannerism in Bologna, Venice and especially in Rome. As well as indulging in such difficult tasks Mannerism was often concerned to deceive and embarrass the viewer as to the real appearance of a room. Vredeman, however, made an attempt here at a monumental illusory solution in terms of the *cinquecento* phenomenon of *quadratura* brought to a climax by the brothers Alberti in the Vatican at the very time. Prague thus preceded the Munich residence as well as the Archbishop's Summer Palace of Hellbrunn near Salzburg. Together, these works formed a modest group of Central European representatives of pre-Baroque *quadratura* painting, a group which came to include the small Music Recess in the castle of Rožmberk in the first years of the seventeenth century. On another ceiling de Vries painted the Four Elements and Twelve Months around the central *tondo* dominated by Zeus (the subjects formed into a cosmological programme, corresponding with the character of Rudolphine collections), rendered from below in an illusive way, and on one wall he conjured up a "perspective" — a view into a colonnade and a garden with a fountain. Thus he optically extended the given space and joined it fictitiously with the macrocosm of nature, as many of his Italian colleagues did in their homeland and also at Hellbrunn near Salzburg. The appearance of the Prague work, which obviously could not belie the Netherlandish origin of its author, is confirmed by period descriptions, especially that of van Mander. Indirectly it is also proved by the illustrations depicting the design of illusive vaults and "tunnel" perspectives of loggias in the treatise *Perspectiva theoretica et practica* by Jan Vredeman de Vries, the well-known painter, decorator and theorist who was often commissioned with tasks of this kind. His son Paul co-operated with him on the illustrations. Their perhaps joint Rudolphine work also influenced the production of the local painter Daniel Alexius of Květná, notably his Mannerist paintings in the Chapel of St Sigismund in St Vitus's Cathedral, dating from 1599, with illusive motifs and deceptive perspective constructions.

Illusive tendencies had appeared in some foregoing works as well, in the sgraffito structures in Telč Château, in the fictitious pergola with foreshortened putti and birds, seen from below, in Bučovice Château, revealing Italian inspiration, as do also the *sfumati* in the hall of Bechyně Château. "Perspectives" were documented also in the castle of Peter Vok of Rožmberk at Třeboň.

Apart from designs for fountains, Jan Vredeman also produced two architectural projects for Rudolph; it is not impossible that one of them was a design for the Castle's northern gate house. Giant bosses girdled and reinforced the smooth stone forms on its originally round-headed entrance, in the passage as well as on the portal wall. Again this was done in the contrasting way so much appreciated by the Mannerists, but here in accordance with the function for which this combination was recommended by the theorists of the time. Not infrequently it was chosen by Italian architects, Vignola, Ammannati, Vasari, and, with a similarly powerful effect, by the author of the Villa Contarini in Piazzola

sulla Brenta near Venice. Also Serlio and Jan Vredeman drafted such designs. There is even a project by G. Gargiolli which cannot be excluded. Also G. M. Filippi's Matthias Gate shows forms to a great extent related to those of this northern passage, but the latter was erected already in the 1590s, prior to the New Building — with Rudolph's western stables on two levels and a large hall on the storey above them, initially called the New Hall, in 1650 the New Spanish Hall, and now the Spanish Hall.

Works on this edifice are recorded in the years 1601—06. They were supervised by Filippi with the assistance of M. Gambarini and a number of other, predominantly Italian, masons, stucco artists and sculptors, in particular G. B. Soviana and G. B. Quadri. The brilliantly carved portals and the windows of the stables, which were designed by Heintz or (more probably) by Filippi in keeping with the Italian architecture of that time, were the work of the stone-mason G. A. Brocco. The powerful barrel vault of the lower stables, with a rhythmical sequence of sunken coffers also adheres to the Roman style, which (inspired by the Pantheon, the Basilica of Maxentius and other Antique buildings) also penetrated to Mantua, Pesaro, Genoa and Padua.

The appearance of the New Hall can be found in two old ground-plans and in the engraving "The Baptism of the Son of Frederick of the Palatinate in 1619", which, unfortunately, is not very reliable. The hall, roughly as long as the facing picture gallery but twice as wide, was articulated along the whole of its perimeter; the nine window embrasures in the northern wall were matched by the same number of niches on the opposite side. Niches also alternated with the two portals which were shifted into the corners of the shorter walls in the Mannerist fashion. Pilasters carrying a high entablature and a system of rectangular fields supplemented the basic articulation. This composition resembles that of the façades of the northern tower of the transverse wing, their author being apparently one and the same person. A row of massive columns supported the ceiling, dividing the hall into two naves.[78] An interior with the walls articulated in such a complicated way was a rarity in Central Europe (inspired perhaps by plans of Antique temples in Palladio's Four Books); it preceded the hall of the Dresden Summer Palace and surpassed the Antiquarium in the Munich residence. Nor were there halls of this kind in Italy; similar compositions were conceived, it is true, but the halls mostly had painted decoration. The nearest to it were perhaps the galleries in the Farnese Palace and the Medici Villa in Rome and the Galleria dei Mesi in the Ducal Palace in Mantua, which originated roughly between 1565 and 1580 and were mostly designed to house collections of sculpture. The hall of the Prague Castle, too, had stucco and sculptural decoration and Adriaen de Vries placed statues of mythological subjects in its niches. But there were perhaps even closer affinities in form between this room and the oratories of some confraternities in Italy.

It seems to have been the first accomplished monumental, architecturally shaped, example of the so-called *Platzsaal* — a square-like hall, whose walls were conceived as showy, presentable façades. Its predecessors in Germany, halls with niches in long walls, at Kirchheim, Kassel or Trostburg, missed a consistent, articulating structure, which was only simulated by murals even in the renowned town hall in Augsburg (and in the castle of Třeboň as well), simultaneous with this Rudolphine edifice.[79]

Both by its architectural articulation and by the manner of linking it with the staircase on the west side and with the gallery by means of a transversely placed anteroom (reminiscent of the Sala delle quattro porte of the Doge's Palace in Venice), this

monumental hall might have occupied an important place in the European architecture of that period. The grandiose conception of the stables and of the halls and their painted and sculptural decoration, as well as their connection with the imperial chambers by long galleries, belonged among the most significant architectural solutions of the period. There was apparently no uniform project in Prague but a series of successive designs, each influenced by the complex as it stood, with buildings from the preceding periods. Unfortunately, later adaptations have impaired this remarkable group of Rudolphine structures, which was to have been supplemented by a monumental coulisse formed by a Classicizing arcade of two storeys; but only a part of it was built and not even a fragment preserved. It was to monumentalize the second courtyard of the Prague Castle and probably also to represent the Imperial dignity of the commissioner, together with the New Hall, referring back to Antiquity as well.

The work started by Rudolph II was continued by his successor according to plans by G. M. Filippi, dating from 1613. The Emperor Matthias extended Rudolph's Palace in the south wing of the Castle towards the west; he also built a cylindrical summer house, with the emblems of his lands on the ceiling, in the garden below its windows, and erected the west Castle gate. The latter was completed in 1614 and named after the commissioner. Filippi conceived it as an independent structure, modelled on Roman triumphal arches. He designed it on a Mannerist theme, several variants of which appeared in Serlio's *Libro Extraordinario*. (Serlio's designs both in this book and in his Seventh Book, inspired not only Domenico Cometta in his project for the Budějovice Gate at Český Krumlov, dating from 1589, and the author of the mentioned pavillion-like formation of the château at Moravská Třebová, but also many Italian architects, such as O. B. Revese whose work in Vicenza in 1600 is the closest to the Matthias Gate.) Its elegant elongated proportions are matched by the pure treatment of the stonework; rhythmically grouped stone bosses already point to the approach of Early Baroque. Thus Matthias celebrated his victory over his brother in a truly triumphal manner. However, he could not overshadow the artistic undertakings of the man he had defeated.

Even a few sacred buildings in Prague are linked to Rudolph's Court in several ways: by the personality of the commissioner, of the architect or the people carrying out the work. The Emperor himself had a church built in the complex of the Strahov Abbey, consecrated to St Rochus and St Sebastian. This small but significant structure, started in June 1603, was more or less completed before his death. Several factors seem to have influenced its remarkable ground-plan. The dynamic polygon of the Castle Chapel of St Adalbert apparently served as an example for the elongated octagon of the latter, which is also derived from an oval. At the same time a trefoil of polygonal chapels transforms it into a Latin cross, which the Counter-Reformation considered the most befitting shape for a church building. Here it also seems to represent a symbol of the Curia's victory, if only temporary, over the sovereign's will after his protracted disease, which postponed the realization of the promise made in 1599, the year of the plague. This three-lobed formation, simultaneously strengthening the basic centralizing tendency of the building, was apparently also connected with the consecration of the church to the protectors against infectious diseases. The three of them — St Rochus, St Sebastian and St Anthony — were given altars in independent spaces. Even the elevation is stamped by a counterpoint of two antagonistic moments: contrasting Gothic and Late Renaissance elements in the Mannerist fashion. Like many other Mannerists, the unknown author combined the antithetical components into a whole full of tension and mutually balanced tendencies, into a multiple and picturesque formation — despite its stern linear character. In 1617 it was enriched by two stylistically advanced portals of several layers. They were apparently designed by G. M. Filippi who knew similar forms from Rome, where they were in vogue at the beginning of the *seicento*, and carried out obviously by the stone-mason and builder of the Lesser Town, Giovanni Battista Bussi from Campione. It was most probably the latter who supervised the works on this building and in 1600—05 also the reconstruction of the neighbouring abbey church.

In Rudolph's time, Prague and consequently the whole of Central Europe, was given a unique centralized work, dynamically based on an oval in its pure form. This was the chapel consecrated to the Assumption, which the congregation of Italians settled in the Czech metropolis had built at the Jesuit church in the Old Town. (The sizeable Italian community also erected a hospital with an arcaded courtyard and a church in the Lesser Town at the beginning of the seventeenth century.) The oval ground-plan, which was so rare in realized sacred buildings of the *cinquecento* even in Italy and hardly known until that time in the countries beyond the Alps, is enriched with an interior gallery of two storeys, producing shallow chapels on the ground-floor. It was a complicated shape which had already been considered by Baldassare Peruzzi and later particularly by Ottaviano Mascarino, but was not carried out anywhere else in the sixteenth century. It was probably Mascarino, an architect to the Pope for many years, who provided the design for the congregation; the Jesuits may have acted as intermediaries, or perhaps the Papal Nuncio who also laid the foundation stone for the chapel in July 1590. The structure was completed in the same year, but its furnishing with altars and the decoration of the oval cupola with stuccoes and paintings which have not survived, dragged on until the year 1600, when the chapel was consecrated. Other features of this building corresponded with the basic conception, so typical of Italian Mannerism. These include the flat geometrical articulation of the exterior — common in Roman Mannerist architecture — as well as the dynamic lighting effects coming from impressively situated sources. Both the disposition of the chapel and its individual components stand as a work of Mascarino's. Particularly notable are the big "thermal" windows (called after the Roman *thermae*) which, having been hesitantly adopted from the architecture of Imperial Rome in the first half of the *cinquecento*, came to be used mainly in the work of Andrea Palladio. The chronicler of the Escorial, P. Sigüenza, recommended them as especially suitable for church buildings because they are based on a segment of a circle. The Italian Chapel, the most significant work of Rudolph's period from the viewpoint of both architectural development and art, introduced this form into Bohemia at a relatively early date being perhaps the first in Central Europe and in the transalpine countries in general. In the second decade of the seventeenth century the same form was applied by the designer of the Lutheran church in the Lesser Town and the pilgrimage church at Stará Boleslav. (But a motif of this form appears in the inner articulation of King Sigismund's Chapel in Cracow, built as early as 1517—33.)

The original appearance of the Lutheran Church of the Holy Trinity in the Lesser Town from the years 1611—13 (it was considerably altered after the Battle of the White Mountain) was derived from Italian, chiefly Roman patterns from the circle of Domenico Fontana and Giacomo della Porta. Its front was drawn

mainly from the arresting coulisse of the Church of S. Trinità dei Monti. The interior of Giacomo da Vignola's Church of Il Gesù in Rome also seems to have exercised some influence on the design, the variant in Prague being however reduced and spatially unified. A hall-like space with a basilican cross-section, shallow side chapels and a presbytery closed with a semi-circular apse, the Prague building, again with inner buttresses, had a predecessor at Loosdorf in Lower Austria, however, it was one of the first churches without any Gothic survivals in any country beyond the Alps. The articulation in several layers already suggested a tendency towards the Bohemian Early Baroque, namely by the accumulation of the architectural members and the emphasized moulding. The basic ground-plan scheme is supplemented by two pairs of prismatic structures — two towers in the front and two sacristies flanking the presbytery. The Church of the Virgin Mary at Stará Boleslav is a variant of this shape; it was started in the same decade and completed by Giacomo de Vaccani at the beginning of the 1620s. But its towers were shifted to the presbytery and the side chapels were conceived as more independent units. Both designs seem to have been linked with Rudolph's Court architects Heintz and Filippi, with the plans these two had made for the Protestant church in Neuburg an der Donau and with the design Filippi executed in about 1613 for the church in Arco, in his native Trentino.[80] As Heintz died towards the end of the year 1609, the definitive projects of both Bohemian buildings were probably done by Filippi.

The disposition characteristic of this group, which was exceptionally pure in style and advanced for a transalpine country, is also found in the design of another Lutheran church in Prague, consecrated to St Saviour. This one, together with a school, was erected near the Old Town Square in the years 1610—14, but the plan may have been made soon after Rudolph's religious Charter was issued in 1609. In the contrast of verticals and horizontals, of Mannerist and Gothicizing features, and in some of the details, this church is akin to the Church of St Rochus at Strahov, but the lay-out of both the ground-plan and the mass is similar to that of the Church of the Holy Trinity. As the congregation was more numerous, it was necessary to build aisles with tribunes as was the case with the Neuburg church. The Prague building has several features in common with this structure: with its first project, by Josef Heintz, it shares the many "annexes" and "corners", and also the buttresses; with its second project, probably adapted by Filippi, it shares the tribunes on pillars and the front with two towers. The interior of the Church of St Saviour is also closely related to the Neuburg building. The giant pilaster order joins the arcades of the aisles and the tribunes and supports a lunette vault of the same height in the nave and the choir. The apse behind the section screened by the annexes is similarly lighted by tall windows.[81] The niches in the main façade are of Italian origin, as are the ornamentation of the friezes with foliated and figural motifs, the oculi, the Mannerist arbitrariness in the composition of elements and the slim appearance of the architectural members. Some minor components also point to the two Castle architects — the window frames with accentuated corners, the triglyphs on the pilasters, the broken triangular pediments and obelisks which Italian Mannerism had adopted from Imperial Rome. Both Heintz and Filippi used them; the latter, as recorded, on the Castrum doloris of Rudolph II from 1612, on which even the flat volutes, which frame the oculi on the church, can be found as well. But while these different motifs seem to have been compiled without a real creative power, the interior is imposing in its monumental

coherent conception of the whole space and in the ballanced relations of its parts.

Thus it might be deduced either that the design for the Church of St Saviour was made together with those for the other churches of similar disposition and then altered according to the commissioner's desire, as was the case in Neuburg (the buttresses had apparently been found necessary for technical reasons, whereas the Gothicizing apse was undoubtedly required by the patron), or that the author was influenced by the basic scheme of the sister building in the Lesser Town, by the production of the Court architects and the Church of St Rochus. Unfortunately, the elders of the Lutheran congregation commemorated in writing only the work of the master builder, John Bartolomeus Kristoffel (Cristoph) from Graubünden; there is no record to the effect that Giovanni Domenico de Bariffo from Lugano area, to whom the church has recently been attributed, also took part in the building. If it is true that this Old Town master builder invented and not only carried out the design for the ostentatious house of the financier John Teyfel in the Old Town between 1603 and 1615, then he was one of the foremost architects of Rudolphine Prague; however, the monumental Classicizing arcade, conceived in the Mannerist style and surpassing many a château of that period, has little in common with the church. This house and the adjoining one, U pěti korun (At Five Crowns), dating from 1615 and with a façade reminiscent of some projects in Augsburg, provide evidence of the fastidious character of rich patricians' architecture in Prague before the Battle of the White Mountain.

The burghers of the Lesser Town, among whom were some well educated personalities, had their town hall reconstructed in 1617 and equipped with architecturally articulated, well-composed façades, which are not common in the Czech Lands. Their main feature are the motif of a broken window pediment (such as were found on many Bohemian buildings of that period) and the system of superimposed orders, executed according to the Mannerist conception of a pilaster with a Doric triglyph instead of a capital and with an Ionic capital rendered as a schematic bust. These anthropomorphous motifs, often to be found in the architecture of Italian Mannerism and, at a different level of expression, also in Germany and France, have obviously been used here as a symbolic interpretation of the orders of columns. The only recorded author of this remarkable building, which was additionally crowned by a gabled attic with towers (after 1628) is the master builder Pietro Piscina from the Milan region, one of the members of the numerous community of Italians in the Lesser Town. Others included G. B. Bussi, from 1620 the administrator of the Building Office of Prague Castle, and Domenico Bossi from Monte in Val Muggio. During the first two decades of the seventeenth century, these two were reconstructing the adjoining monastery of the Augustinian order and built the Italian hospital, and most probably took part in the building of the town hall as well. But its unusual design, conceived in the Italian style, seems to have been produced again by Giovanni Maria Filippi, who worked as a building advisor to the town council of the Lesser Town.

All the significant monuments built in Prague during the reigns of Rudolph and Matthias were linked in one way or another with the Court. It was a notable centre of architectonic production, in which the knowledge of the contemporary Italian and particularly Roman architecture found a specific application. The stimulus provided by this Mannerist centre was then developed in the buildings of Albrecht of Valdštejn, which were, however, already impregnated with components of Early Baroque.[82]

Artistic Crafts in the Period of the Renaissance and Mannerism

Commemorative objects, and also documentary records of the large range of activities in the artistic crafts during the reign of Vladislav Jagiello, show that signs of the Renaissance in Bohemia are not confined to architecture and the fine arts only, but are part of an artistic expression. The decorative arts show the humanism and the break with Gothic stylization that mark the Renaissance search for the Classical ideal of beauty and for an objective description of the reality of nature. But the source of these trends was not the king who, for diplomatic reasons, considered it expedient first of all to strengthen his unstable position in Bohemia by demonstrating his political and cultural continuity with the work of his great predecessors, Charles IV and Wenceslas IV of Luxembourg. Like Charles IV, Vladislav thought first of the St Vitus's Treasure.[83] This was where his excess personal wealth was flowing and where Renaissance trends in goldsmith's work are found. The advanced style appearing here is the result of a good choice of artists rather than of the King's conscious cultural tendency. First of all, a set of six silver reliquary busts of saints gradually enriched the inventory of the Treasure, beginning in 1484. Of this series only three pieces have been preserved, the busts of St Vitus, St Wenceslas and St Adalbert, whereas the other three, of St Bartholomew, St Philip and St Servatius, mentioned in the Treasure inventory for the last time in 1683, later disappeared. The fact that the set was consistent in style as well as in time, is seen in a copper-engraving of 1672,[84] showing the most remarkable objects in the Treasure, among them eight busts, six of which have a common motif of brackets in the form of kneeling angels. Such brackets appeared in Rhineland goldsmith's work about 1450, as in the adaptation of the pre-Romanesque reliquary of St Willibrord in the church at Emmerich,[85] whence it spread eastwards. The angel brackets of the Prague busts are casts of two models, which unite the whole set in both equilibrium and style.

All three surviving busts were recorded in 1503 in the Treasure inventory as Vladislav Jagiello's donation. The other three, which have not come down to us, were undoubtedly made slightly later, since they were not mentioned in the list. The surviving busts are the works not of one, but of at least two goldsmiths of different training and artistic orientation.[86] The bust of St Adalbert shows the greatest amount of Late Gothic naturalism. It resembles the bust of St Gregory of Spoleto, the work of an unknown goldsmith who was active in Cologne towards the end of the 15th century; it is now in the Treasure of Cologne Cathedral.[87] The likeness between the two busts is so striking that it suggests either that the bust of St Adalbert was commissioned somewhere in the Rhineland, or that the creator of the bust of St Gregory was invited to Prague to chase the bust of St Adalbert, and possibly even one of those not preserved, on the spot; there would not have been anything unusual in this in the artistic practice of that time. There is a likeness especially in the physiognomy of both saints; they are beardless old men with noble faces, protruding cheekbones and conspicuous folds of sagging muscles round their mouths and chins. The technical skill of the goldsmith is also characteristic; he was able to emboss sheet silver to obtain a convincing, characteristic and realistically faithful likeness of an intelligent human being and to give it an expression of gracious kindness. This goldsmith must have been an excellent woodcarver as well, since only the contemporary woodcarving used in the making of reliquary shrines could reproduce such psychological traits. The other parts of the busts are identical too, for instance the structure of the rounded shoulders, the treatment of the amice round the neck, etc.

The same can be said about the busts of St Vitus, dating from 1484, and of St Wenceslas, recorded in 1487. Both are the results of a common set of stylistic and modelling principles. Its source is to be found in the region of Lake Constance, where the goldsmith's art developed into a highly diversified specific form towards the end of the fifteenth century.[88] This art reveals contemporary features of the Renaissance view penetrating from Italy northwards through Switzerland and Austria. The most advanced in this respect appears to be, above all, the workshop of master Hans Schwartz of Constance who executed the bust of St Placid for the town of Chur in 1480 (to which a bust of St Lucius was added in 1499, undoubtedly from the same workshop). This is where we find the nearest analogy of the Prague busts of St Vitus and St Wenceslas in the modelling of the face, hair and beard, in the engraved design of draperies, in the spatial adjustment by means of brackets and even in the use of paste imitations of gems. The youthful features of St Placid, refined in the Renaissance manner, are a true prefiguration of St Vitus and the only Central European one, and it is thus the most probable source so far established of the latter's stylistic and formal inspiration.[89] St Wenceslas again is linked with St Lucius by the common features of the oval face with hollow cheeks, the shape of the nose, the trim of the beard, and the loosely flowing hair. The majestic calm of the ruler, betraying the influence of the portrait busts of the Early Florentine Renaissance, emanates from both of them. This impression is enhanced by an engraved design in the form of a pomegranate, customary in Italian brocades of the 15th century. Only in St Vitus does the Late Gothic stylization of the hair, symmetrically disposed in spiral curls, disturb the Renaissance impression of the bust which is more a portrait than a reliquary shrine.

Other analogous pieces of goldsmith's work confirm the connection between the Prague busts and the Upper Rhineland: there are, for instance, the form and the decoration of the foot-shafts (newly made in 1522) of the so-called Crown Cross and the Cross of Urban V in the St Vitus's Treasure,[90] and especially some Czech and Slovak chalices in Late Gothic style. The fertile soil of this southernmost German region, enriched by the spirit of the Italian Renaissance, produced no less remarkable flowers of artistic craft than did the ambitious sphere of the royal court in Buda. It was the historical mission of Bohemia, situated on a crossroads of cultural influences, to absorb such influences and to combine them in a harmonious artistic stream.

In the artistic activities at the Prague royal residence, the Upper Rhineland region also had an effect on the creation of stained windows. In the court buildings that the King favoured, four stained glass windows have been preserved, of identical artistic conception and provenance, which as early as this represent a new, Renaissance way of glazing church windows. Two of them are

in the Karlov Church in the New Town of Prague, the other two in a window of the Chapel at Křivoklát Castle.[91] All these stained glass windows are of similar composition, except for the coat of arms of Vladislav's wife Anne at Karlov (which dates the whole group to the short period of the King's married life, 1502—06). The figures of the saints — that of Charlemagne at Karlov and those of St Wenceslas and of St George Fighting the Dragon at Křivoklát Castle — are closely packed into an arcade of small twin columns. In comparison with the preserved Bohemian stained glass windows of the 14th century and the beginning of the 15th, a considerable technical and formal progress can be seen here in terms of what is called, not always correctly, "painting on glass". The stained glass windows from the period of the High Gothic retain the system of translucent glass mosaic; the subjects are composed of small panes of different colours, only the details being completed in *schwarzlot*. In the windows mentioned above an advance can be seen, made possible by the progress in glass-making technology in the course of the 15th century; the glass panes are larger, the colour scale is more complex, and there is a development of the pictorial component not only in the figural but also in the ornamental themes. The French-German borderland, long noted for its glass manufacturing, with centres in Cologne and Strasbourg, was the first to reach this stage of evolution.[92] In the windows of both these Vladislavian buildings, the influence of the Alsace region and the Upper Rhineland can be found in the general composition, in the articulation, in the tones of colour surfaces and in their lead outlines, in the detailed drawing, in the typology of the figures and in the forms of the foliated ornamentation. These stained glass windows might have been executed by a local glazier (such as, for instance, Master Thomas who glazed the windows of the Chapels of St Anthony and St Odilia in St Vitus's Cathedral in the 1480s), but the cartoons were the work either of an artist from the Rhineland, or of a painter who became thoroughly acquainted there with the more advanced way of executing stained glass windows in accordance with their subject, paying more attention to Renaissance ostentation than to medieval religious fervour. These four Vladislavian stained glass windows mark the beginning of a new period in Bohemian creative production which can be qualified as "painting on glass" in the real sense of the phrase, and are clear examples of the trend away from medieval piety and towards a more independent artistic expression, revealing the human personality, the naturalness of things and the beauty of terrestrial life.

The inventory of St Vitus's Treasure of 1503 lists separately the valuables presented to the Cathedral by Vladislav during his stay in Prague in 1497.[93] Among them are liturgical vestments, antependia and funerary cloths, made of expensive imported textiles, mostly Italian, with the then favourite pomegranate design embroidered in coloured, or gold, thread and even pearls. The second inventory item is a chasuble, together with an amice with the inscription "AVE MARIA". This inscription was woven, as expressly stated, in *literis italicis,* i. e. not in the Gothic minuscule commonly used in this country, but in the Renaissance Latin majuscule which, at that time, was used solely on the King's seals. This is clearly intended to emphasize the preciousness of the King's gift. At the same time, Vladislav gave St Vitus's Cathedral a number of tapestries with scenes from the lives of Titus and Vespasian. St Vitus's Chapter had a big cupboard made,[94] to house these tapestries which were only hung in the choir of the Cathedral at Easter and on St Wenceslas day. In this gift, too, the King followed the example of the great Luxembourg monarch,

Charles IV, and his wives from whom the Cathedral had in the past received many wall hangings woven with just a pattern (they were lost in the Hussite period). The form of this donation is, however, not traditional, since the representation of a famous period in Roman history is a theme belonging solely to the Renaissance, as is known from the later Brussels tapestries of the 16th and 17th centuries. There is no doubt that Vladislav's tapestries were imported from the West, since the manufacture of such decoration and practical protection of cold living-rooms or sacred interiors had not yet been introduced in Bohemia, in spite of the attempts during the reign of Vladislav's predecessor, George of Poděbrady, to attract weavers from France. The use of tapestries in Bohemia at that time is known from the wills of Prague burghers of the 16th century, as well as from a report on the festive decoration of the Old Town Hall in 1509,[95] during the visits of Louis, Count Palatine of the Rhine, and George, Duke of Saxony, to King Vladislav who, after several years, left Buda to spend some time again in Prague.

The isolated threads of Renaissance art at the Courts of Vladislav Jagiello and his son Louis combined to form a general style after the accession to the Bohemian throne of Ferdinand I of Habsburg, Vladislav's son-in-law, the husband of Anne Jagiello, in 1526. Educated in the atmosphere of the High South European Renaissance, Ferdinad was a combination of a despotic and art-loving ruler of the type abounding in Italy in the 15th and 16th centuries. He was a man from another world, which, more progressive socially and culturally, was going through the initial phase of its new political, economic and cultural expansion both in Europe and overseas, in which men were gradually breaking away from the rigid scholasticism of the Middle Ages, and were seeking to unravel the secrets of nature and the universe. Ferdinand brought into Bohemia a coherent stream of pure Renaissance architecture with its more comfortable living conditions; around his Prague residence he established a Royal Court, the members of which were equally enthusiastic about the new style and its forms. This is why the Renaissance was not confined to the Court art, as it had been in the time of the Luxembourgs and Jagiellos, but became an expression of the life style of the nobility. The great fire of the Lesser Town and Hradčany districts in 1541 made it possible to appropriate the sites of the burnt-out houses and to erect family palaces in their place, designed and also built by Italian architects assisted by Italian painters and stuccoers. The furnishings of these palaces were mostly a medley of things imported from Italy and from various other parts of Renaissance Europe: furniture, Central Italian ceramics, Venetian glass, Nuremberg silver and Flemish tapestries. It must be said to the credit of these Czech propagators of Renaissance art that they displayed real cultural consciousness not only in Prague but also on their family estates in Bohemia and Moravia. The imported foreign products of various kinds and execution improved and enriched the comfort of the Royal Court and of the nobility and, at the same time, inspired the local artistic crafts. Rich burghers were deserving in this respect, too; Ferdinand I suppressed them politically, it is true, but he did not deprive them of the means of joining in the new art.

Ecclesiastical art was least touched by the spirit of the Renaissance. The Gothic period with its overproduction of works of art of all kinds had created an inexhaustible stock which could satisfy the needs of the Church, both Catholic and Utraquist, throughout the next century. In addition, a notion subsisted, according to which there was something pagan in the Renaissance, which made its styles unsuitable for ecclesiastical purposes. Renaissance aesthetics could

only gain ground where piety, patronage or the desire for immortalization added new creations to the inherited Gothic current.

As to the liturgical vessels, architectural Gothic types were retained, the new style finding its only application in ornamental detail. Chalices are particularly characteristic in this respect, as far as one can judge from the still incomplete research into commemorative objects of applied art. The Kadov chalice, dating from 1526 (Museum of Decorative Art, Prague), is usually regarded as a prototype of the Czech Renaissance chalice. Its lower part, i. e. the stem and the node, does not depart from the traditional Late Gothic shape, but the cup is entirely Renaissance in its outline and, above all, in its embossed foliated ornament. Similarly, the node and stem of the chalice of 1529, in the church at Rané, indicate its fidelity to the Renaissance. The provenance of both these chalices is problematic. The Kadov chalice especially is decidedly a masterpiece in its fine design of leaves, derived from typographic and other bookbinder's borders on German *incunabula*. It is no doubt the work of a goldsmith who had learned his craft in neighbouring Bavaria. This influence continued in Bohemian ecclesiastical goldsmith's work even in the second half of the 16th century, as is shown by the Drahov chalice. When, in the years 1561—65, Joachim of Hradec and his wife Anne had a chalice made,[96] this was a truly Renaissance work of art, deriving, however, from a design by Dürer's Westphalian disciple, the goldsmith and engraver Heinrich Aldegrever (died 1555). It was not until the Rudolphine period that Bohemian goldsmith's work designed for liturgical purposes became more original.

In secular goldsmith's work, besides hollow-ware, jewellery was produced, too. Renaissance jewellers extended the techniques of cutting precious stones and improved the settings. Unfortunately, only a few important works of the sixteenth-century jeweller's art have reached us. First of all, there are two pendants: the first, from Chrudim with St George,[97] made of gold, pearls and gems, with a rich enamel decoration, is a foreign work of the Late Renaissance, most probably of South German provenance; the second, similar to it, formerly the property of the Lobkovice family (now in the Museum of Decorative Art in Prague),[98] seems to be of the same origin. The bulk of the preserved goldsmith's and jeweller's work from the time of the Czech Renaissance consists of rings, mostly with a typical head in the form of a broad square setting, sometimes enamelled, with a faceted gem, a pearl or a piece of crystal in the centre of it. The demand for jewels was enormous at that time, as we can see from the goldsmith *S. Šmidrych's* account of 1572 of the jewel-case of Jane, the widow of the miller Paul Severin of Kampa Island and from the wealth of the Court goldsmith *Nicholas Müller* (1565—86), the owner of three houses, who made plates of various kinds for the Court and lent money to the Emperor himself. Among the scanty works preserved are two silver vessels in St Vitus's Treasure,[99] and the crosier and the crown of the abbess of St George's Abbey (1553); they are the work of a goldsmith who was obviously trained in Nuremberg. The other craftsmen who also probably came from Nuremberg were the clockmakers *Jakob Zech*, the maker of the table clock for the Polish King Sigismund I (1525), and *Hans Stein-Meissel*, who made a tower-like table clock in 1549 (now in the Museum of Decorative Art in Prague), the most remarkable work of its kind in Europe.

A similar conservative attitude is also to be found in the art of embroidery, where lay home-production was carried on beside that of professional embroiderers. During the Renaissance period embroidery was extremely popular and had many applications, from bed clothes and table linen to carpets and furniture coverings.

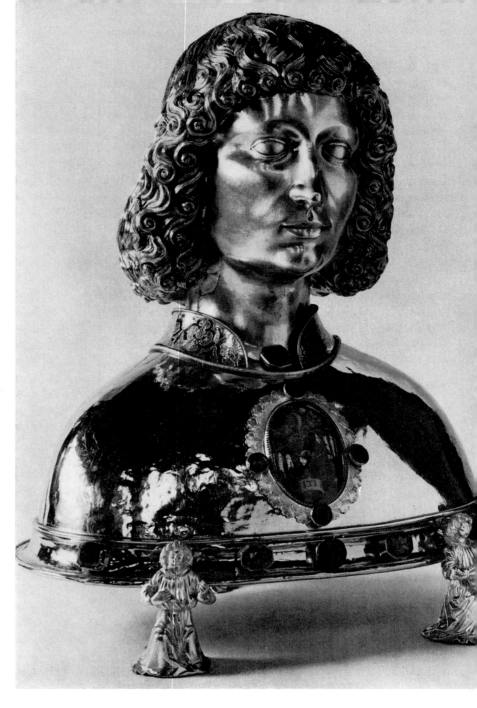

131 Bust of St Vitus, embossed silver, partly gilt, Prague, 1484, h. 51 cm, Prague, the Cathedral Treasure of St Vitus

132 Bust of St Wenceslas, embossed silver, Prague, before 1487, h. 59 cm, Prague, the Cathedral Treasure of St Vitus ▶

This was part of the delight in textiles in general. The importation of carpets, not only oriental or "Turkish", but also Hungarian ones, increased considerably, as did the importation of tapestries, mostly of Flemish origin. Tapestries played an important functional and decorative role in the furnishing of the reception rooms in the seats of the nobility, where tapestry vied with wall-painting. Where tapestry proved too expensive, it was even imitated by painting, as can be seen in the court-room of the former Burgraviate in Prague Castle.

But, to return to embroidery, besides the linear coloured needlework drawing, such as that of the women saints of the antependium now in the Museum of Decorative Art in Prague, executed in the style of embroideries of the Austrian region, the full-blooded needlework painting and pearl embroidery continued. There was

more and more embroidery with gold thread, the production of which was perfected by "wire-makers", an independent branch of the goldsmiths' guild from 1596. Throughout the 16th century the Late Gothic custom continued of applying raised figures in the warp of an embroidered dorsal cross or on the surface of a chasuble. This type of embroidery is represented by the Calvary on the chasuble of Skřiváň, or on that of John Bořita of Martinice. On the chasuble of the Osek monastery, a Late Gothic figure of Christ can be seen, which is, however, applied on a background of tendril embroidery and surrounded by the symbols of the evangelists, executed entirely in the Renaissance style. This chasuble is to be regarded as dating from the end of the 16th century, when Gothic influences were still strong, as is shown by the Calvary on the chasuble of 1597, donated by Wenceslas Hora of Ocelovice.[100]

The most important work of Czech Renaissance embroidery is in the Lobkovice collections; it is the so-called Hasištejnský Lobkovice three-winged altar-piece of 1574,[101] with a raised pearl embroidery on silk and green velvet on the inner side, representing Christ riding a triumphal chariot as the victor over Hell. Around this scene are Renaissance tendrils embroidered in gold thread (of the same type as those on the Osek chasuble), the Lobkovice coat of arms, and, below, an inscription in a cartouche, announcing that the altar-piece was donated by Bohuslav Felix Hasištejnský and his wife Anne in 1574. The wings carry the Annunciation and, in the oblong compartments below, two pairs of figures: St George

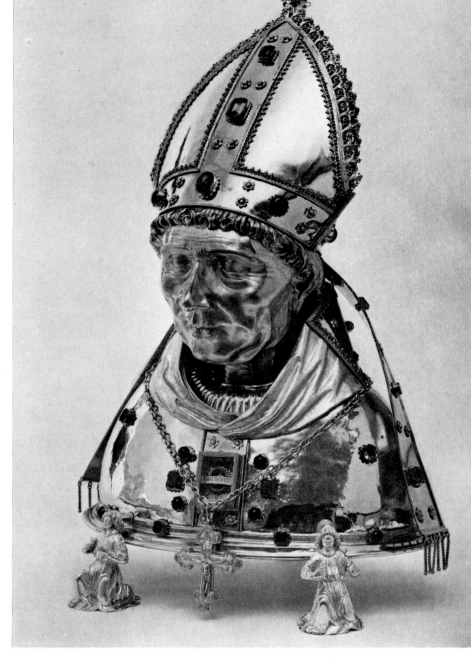

133 Bust of St Adalbert, embossed silver, Prague, before 1500, h. 53 cm, Prague, the Cathedral Treasure of St Vitus

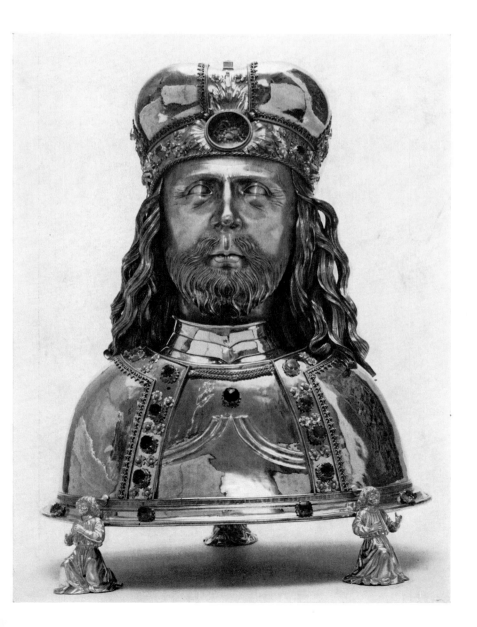

with St Mary Magdalene and St Erasmus with St Ursula. True, the themes, typology and treatment of the figures reflect a belated influence of the painting of the German Cranach school and of the Upper Rhineland embroidery[102] of the turn of the 15th and 16th centuries, but the altar-piece as a whole, with its segmented arcades covered with novel Italianizing plant ornamentation, produces an entirely Renaissance effect.

This fusion of the Gothic and the Renaissance is characteristic of Czech art in the 16th century; this local usage continued until the Rudolphine period. The altar-piece is an excellent example of professional embroidery originating in one of the cultural centres of the North Bohemian border region. The three-winged altar-piece is a traditional type there, and it shows that a retable in the form of a columned porch, brought from Italy to Central Europe by Dürer (in 1508), had not as yet struck roots in Bohemia. The 16th century altar-pieces mostly have fixed wings with a panel extension carrying a picture or a work of sculpture. The Renaissance can be seen in these altar-pieces only in the architectural details.

One designed in this way, as early as after 1519, was the altar-piece with paintings in the style of Cranach in the hospital church at Jáchymov; and as late as the beginning of the 17th century, an unknown joiner thus constructed the altar-piece of St John the Baptist in the Týn Church in Prague as a frame for the excellent reliefs with themes from the legend of this saint by the anonymous Master *I. P.*, dating from about 1520.[103]

A remarkable joiner's piece is the altar-piece of the cemetery church of St Gallus near Zbraslav. It is the work of the Monogrammist *A. T.*, who worked for the former Cistercian abbey at Zbraslav in the middle of the 16th century.[104] The winged altar-piece, covered with carved wooden figures, is noted for its rich Renaissance ornamentation and architectural forms. Unfortunately, the Counter-Reformation dispersed what were regarded as heretical Renaissance altars from Bohemian churches, so that, to learn about them, we must have recourse, apart from a few objects which have been preserved, to old representations of them on wall monuments with epitaphs in churches or in illustrated books. It was the frames of these monuments that linked up, in a greater degree than the altar-pieces, with the Italian models and paved the way for the porch-type and the columned or pilastered aediculae in the altar architecture of the Mannerist and Early Baroque periods. The aediculae show, in most cases, a strong influence of Nuremberg joinery, as can be seen in the frame of the Epitaph of Nicholas Pyckler (after 1579) in St Vitus's Cathedral,[105] as well as of the

joiner's craft of north-west Germany, the influence of which in the Czech Lands is shown by the presence of the Dresden joiner *Peyser* in Prague in 1581 and of *Emerich Thurn* of Rastadt (Rhineland) in Brno in 1604,[106] where, according to J. A. Du Cerceau, he made pews for the Jesuit church and for the church at Královo Pole, similar to those in the Holy Trinity Church at Regensburg.

From records in the archives as well as from several surviving pieces of furniture, we learn about the way in which Czech society of the 16th century planned their comfortable living conditions. The furniture decorated with flat carving was still in use, as we can see from the document cupboard in Prague Castle dating from 1567. Besides this, however, inlay began to penetrate into the Czech Lands from Italy either directly or through Germany. The technique of inlay suited the Bohemian kinds of wood better than woodcarving did, and also accorded with the Renaissance as a more pictorial two-dimensional style rather than sculptural one. Inlay prevailed in the decoration of doors, wainscots and furniture. The Lobkovice (Schwarzenberg) Palace at Hradčany, built at that time, had inlaid doors with arabesque motifs as early as the middle of the 16th century (now in the Třeboň Château); several such doors dating from 1564 were in the château of the Griesbeck family at Nelahozeves, others can be found in the former office rooms of Prague Castle, and even the buildings of the Vineyard Office in Prague was given inlaid doors in 1619. At the turn of the 16th and 17th centuries, inlays are often conceived as stereotyped

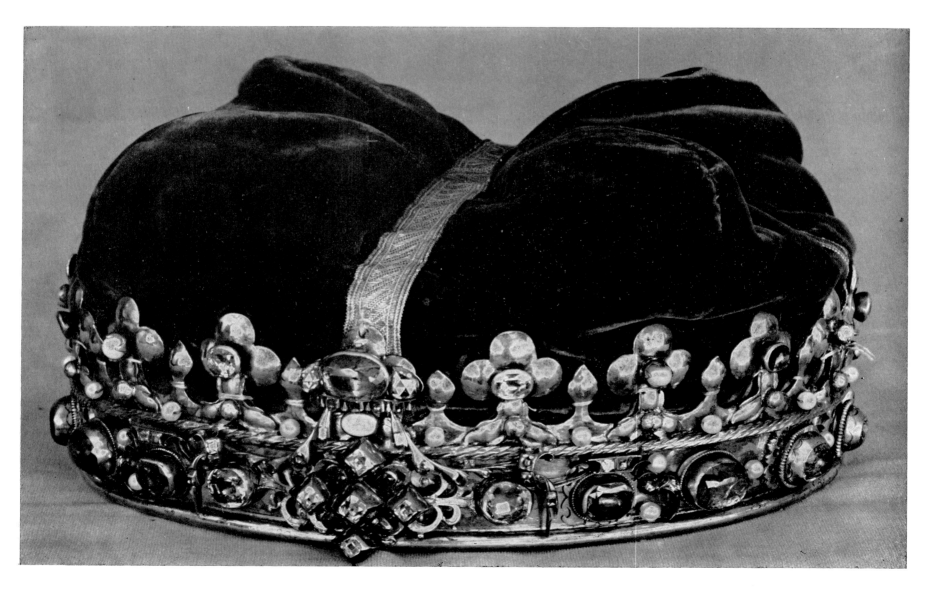

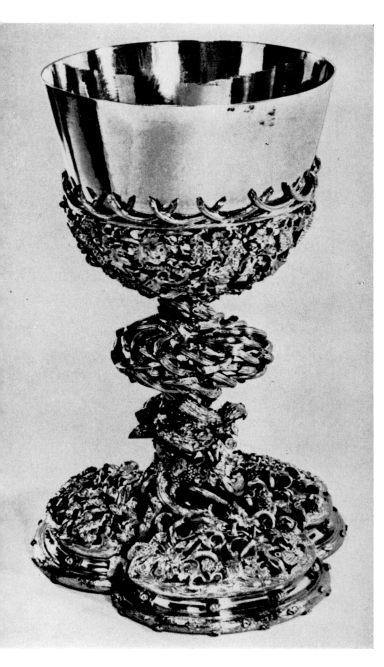

135 Chalice of Ursula of Lobkovice, by the Master A. K., silver, Prague, 1575, h. 24 cm, Berlin, Staatliche Museen, Kunstgewerbemuseum, Schloss Charlottenburg

136 Stained glass window with the coat of arms of Queen Anne of Foix-Candale from the Church at Karlov, Prague, after 1502, Prague, the Museum of the City of Prague

◄ 134 Crown of the Abbesses of the Monastery of St George at Prague Castle, gilt silver, gems, Prague, 1553, Prague, the Cathedral Treasure of St Vitus

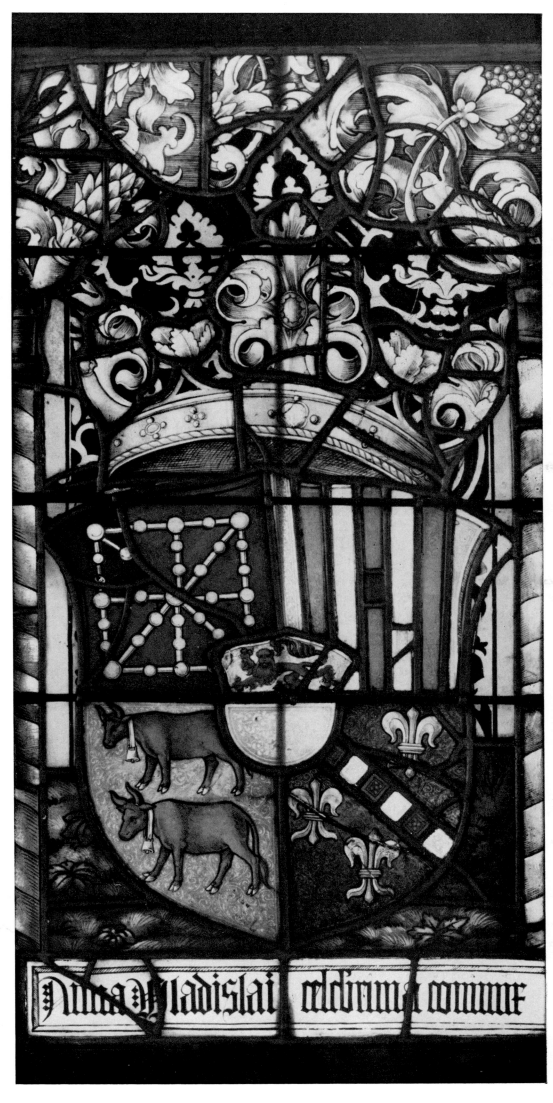

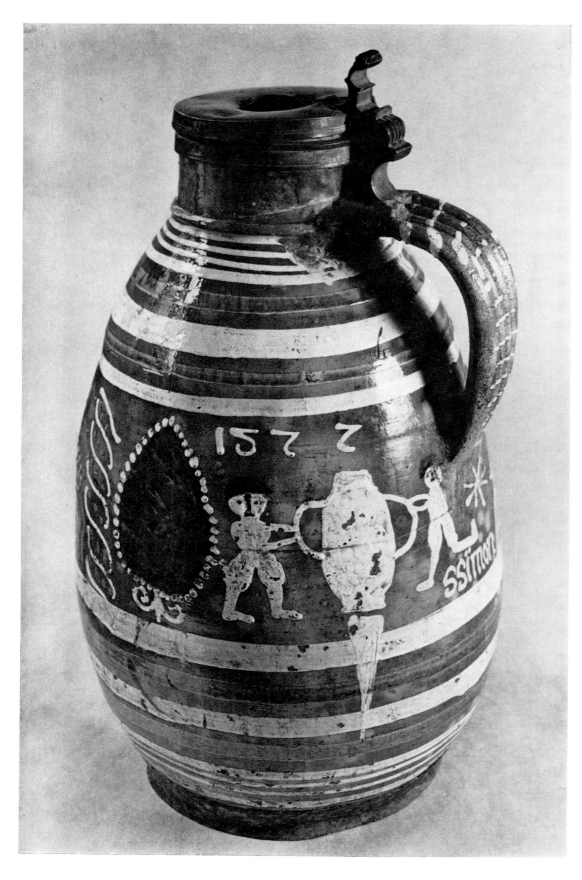

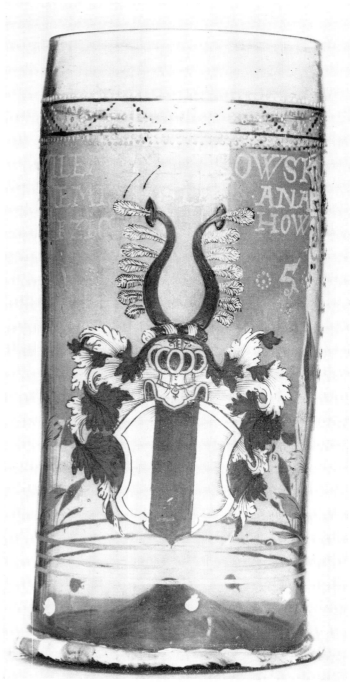

137 Faience clay jar of Simon Nemazal, Plzeň, 1577, h. 60 cm, Prague, Museum of Decorative Art

138 Beaker goblet of William Mitrovský, enamelled glass, Bohemia, 1589, h. 30 cm, Frankfurt-am-Main, Museum für Kunsthandwerk ▶

139 Tankard of the guild of painters, tin, Prague, 1599, h. 21 cm, Prague, Museum of Decorative Art ▶

140 Faience open-work bowl with the coat
of arms of the Zástřizly family and the Counts
of Vrtba, "Haban" work, South Moravia,
1602, Prague, Museum of Decorative Art

141 Guild chest, inlaid wood, Prague, 1612,
h. 60 cm, Prague, Museum of Decorative Art

motifs of perspective views of streets. Such motifs appear in the designs of *Peter Flötner* of Nuremberg as early as about 1535; the patterns for these designs were published by *Lorenz Stöer* in Augsburg in 1567. The Late Renaissance doors in the halls of Prague Castle, as well as the arcades on the chest now in the Museum of Decorative Art in Prague, are decorated in this way.[107] In the art library of the Staatliche Museen in Berlin there is a pen-and-ink drawing signed "Joan. Vredeman Vriese invenit 1574", representing a street scene like this. In view of the fact that *Jan Vredeman de Vries*, the author of the book *Perspectiva teoretica et practica* published in Amsterdam, worked directly for Prague Castle, it is not difficult to infer who brought such surface decoration, found on Italian furniture as early as the 15th century, to the Bohemian milieu.

Furniture of Bohemian origin derived from Italian and German models in other respects as well. It was influenced by Italian immigration and, after 1550, mainly by the importation of showy Italian, and later also of South German, pieces of furniture. The imported kinds and the new techniques gradually shaped the artistic treatment of the local decoration of furniture as well; the importance of the local production is shown by the fact that Czech joiners passed on their experience even to German journeymen. At that time, the cupboard comes to the fore. The two-part cupboard with the coats of arms of Adam I of Hradec and his wife, dating from the 1530s, in the château of Jindřichův Hradec, has the verticality, articulation and elegance of the pure Italian Renaissance style; only the gables with carved coats of arms derive from the local tradition. From the point of view of contemporary joinery, this is an unusually advanced and ambitious work. Cupboards of this type served as ostentatious pieces of furniture in a Renaissance household, but only few people were in possession of all kinds of them. From a record dated 1579, we learn that a rich Prague burgher's wife had no more than two cupboards, but as many as eleven chests. Thus chests retained their privileged position in interior furnishing. Only a few cupboards have come down to us. Besides those mentioned above, there are, for instance, two office cupboards, with embossed arcades and the year 1612 inlaid on each, in the inventory of Karlštejn Castle.[108] But they were not of the same artistic level. The only coherent Bohemian Renaissance set of furniture, the fittings of the Land Book Office and the former Imperial Chancellery in Prague Castle, are more or less of a functional character. They consist of smooth tables made of soft wood, of chests and various chairs and armchairs of Italian type. As we learn from documents in the archives, there were writing-desks in Czech households, made in Bohemia or imported from either Nuremberg or Italy, with drawers in the upper part which could be closed by a hinged flap. The writing-desk with silver mounting made for the Emperor's Chamberlain Philip Lang by the joiner *Nicholas Pfaff* is evidence of the ambitious character of the contemporary burgher's interior furnishings.

A similar specialization could be noticed in chests as well: besides those with inlaid decoration, there were a great number of simple chests made of various kinds of wood and designed for various purposes (specimens can be seen in the Museum of Decorative Art and in the National Museum in Prague). Guild chests had a special purpose, and, for this reason, much was demanded of their decoration. Works from as late as the Mannerist period at the turn of the 16th and 17th centuries have been preserved, showing the stages of artistic treatment (City Museum and Museum of Decorative Art in Prague). They combine maple-wood and walnut inlay with wood-carving and are designed, on all four sides, as free-standing pieces. This sculptural decoration is derived, in details, from Swabian wood-carving and goldsmith's work, more especially from Augsburg (M. Walbaum), and points to a wood-carver of foreign origin, most probably from that town, who settled in Prague; several such craftsmen are recorded in the town registers of this time.

Other works of this type include, first of all, the pew in St Vitus's Cathedral in Prague, or rather a kneeler designed as the front of a chest; its surface is divided by pilasters, supporting a common entablature, into five arcade bays covered with foliated inlay. Dating from a later period the pew in the priory church at Mělník[109] is more elaborate. There were many different kinds of seats in the Renaissance period; about ten types of various kinds of benches can be named, and even a round table with a set of ten stools is recorded.[110]

Finally, small inlaid cabinets for coins ought also to be mentioned here, for they were in great vogue in the Late Renaissance period. Two cabinets, obviously coming from one workshop, may be given as examples: the first, with coloured inlay and eight drawers round a central cupboard with its own door, dates from 1614, once the property of an unidentified family denoted by the monogram ARBZB; the other, identical with the first except for the inlay and the monogram[111] comes from the Lobkovice family. A cabinet similar to those in Prague, formerly the property of Ferdinand of the Tyrol, is in Ambras Château in the Tyrol.

Bookbinders, too, took part in the decoration of leather furniture-coverings and living-room accessories. About 1600, armchairs, tables and even inkstands were covered with decorated leather, and, after the Italian pattern, also coloured and gilt leather wall-coverings appeared in Bohemian towns.

Blacksmiths', locksmiths' and pewterers' guilds also contributed with the joiners to the furnishing of Czech Renaissance houses. The Renaissance is the first great epoch of Czech smiths' work in the service of architecture. Its technique and composition schemes even outlived the Renaissance period and continued, with small stylistic alterations, until the end of the Early Baroque period. The importance of these crafts is shown by the fact that there were locksmiths' guilds even in small market-towns. In the years 1526—1620, there were 207 locksmiths in Prague alone. Of course, only a small number were occupied with artistic craft, involving, mostly, the production of locks, keys, door-knockers, door-hinges, brackets for lamps and sign-boards, and also of guns and clock-works. Their masterpieces, however, were grilles, fountain-cages etc. Here, more than anywhere else, the result depended on the maker's imagination and technical skill. An unusually fine product was copied and reproduced in other places, as we know from the case of *Schmidthammer's* grille round the tomb of Anne Jagiello in St Vitus's Cathedral,[112] which was repeated round Maximilian's tomb in Innsbruck. The basic formal elements (cylindrical iron rod, pilars with prismatic or round cross-section, sheet iron forged into plant or figure shapes) were simple, but wonderful results were obtained by combining them. Stylized branches, flat, symmetrical and strictly geometrical, formed the compositional basis. A typical feature was the interpenetration of the iron rods in circles, figures of eight and spirals; the effect of the work was heightened by colour and gilding.

A prototype of these works is the fountain-cage in Small Square in the Old Town of Prague,[112] dating from 1560 (its top with the Czech lion and one of the fields are of a hundred years later). The supporting capacity, from the artistic point of view, rests here on the spiral-shaped fields, resembling some fields of the most

brilliant Czech locksmith's work, Schmidthammer's grille, set up by the locksmiths *Melchior Wagner* and *Louis Hunter* of the Lesser Town of Prague in 1590.[114] They probably also executed some additional parts (after 1587), for the original conception of the mausoleum was gradually extended. A perceptible swing can be seen here away from the dense stylized geometrical form of the mid sixteenth century towards a more open design of big spirals, typical of the first half of the 17th century (e. g. the window grille on the first floor of the big tower of St Vitus's Cathedral). The large plant motifs and the thin spiral warp point to a shift from the functional to the decorative.[115] The example of the Prague locksmiths had an effect on the country as well, as can be seen in the fountain-cage in the château of Jindřichův Hradec, made in 1610 by the locksmith *Andres*. The purest piece of sixteenth century locksmith's work in Bohemia is the door with a grille in the Adam's Building of the château of Jindřichův Hradec, executed in 1597 by *Jacob Göringer*[116] on a symmetrical Renaissance design, which can also be seen in the grille on the tomb of Zacharias of Hradec in the château of Telč.[117] A systematic artistic approach is also noticeable in the design of objects of everyday use. A classical example of this is the pair of scales of 1607 with engraved ornamentation, now in the Museum of Decorative Art in Prague.[118]

The bell-founder's and pewterer's crafts, in which smithing and the working of non-ferrous metals are combined, had a time-honoured tradition in Bohemia, where tin was plentiful; a tradition which was strengthened in the Late Gothic period and, above all, in the Renaissance. It can be said that in the 16th century this craft reached its climax. Like goldsmith's work, the founding of metals also offered great possibilities to the burghers who wished to distinguish themselves by ostentatious donations. On church bells especially, the donors could immortalize themselves in votive inscriptions, a custom from which bell-founders could only profit;[119] there was a similar situation with pewter baptismal fonts, too. Metal-founding is the first sphere in which a work of art was signed and dated almost regularly. The specialization into bell-founders and pewterers did not deter a craftsman from carrying on both crafts, which were united by the fact that the metal-founder's basic profession was the manufacture of firearms. On the periphery of the noble craft of metal-founders stood artisans specializing exclusively in the production of pewterware (although these products had, in the 16th century, the greatest vogue in the history of their existence).

The importance of metal-founding in the period of the Bohemian Renaissance is shown by the fact that these craftsmen in Prague, with their own Pewterers' Street, numbered 150, and that each of the bigger towns could boast of a more or less noted metal-founder at that time. Often there were whole dynasties, in which the craft was handed down from father to son, as was the case in the family of the most famous Prague metal-founder of all times, *Brikcí of Cimperk*.[120] The originator of this family, *Bartholomew Berounský*, executed between 1516 and 1526 the King's bell for St Vitus's Cathedral at the expense of King Louis. His grandson Brikcí made in his active years, 1553—1590, about 80 bells for different sanctuaries, not only in Prague but also in Central Bohemia and in remote country places. And not only bells: he also made candle-sticks, coffins, epitaphs with inscriptions or emblems, clock-chimes, table bells (in the Museum of Decorative Art in Prague), pewter baptismal fonts and bronze votive plaques.[121] Brikcí advanced the art of bell-casting as to shaping and decoration. While his grandfather Bartholomew had continued to put Late Gothic inscriptions in friezes round the periphery of the upper part of the bell, under which he occasionally placed figures of saints, Brikcí broke with this practise by applying his own individual decoration. On the surface of the bell, he placed friezes either with scenes from the Bible after Hans Beham, with tritons, with *putti* after the patterns by Peter Flötner of Nuremberg, with medallions bearing portraits of rulers, or with emblems, cartouches containing inscriptions and casts of Jáchymov medals. He often used one and the same model (The Massacre of the Innocents, The Marriage at Cana, The Conversion of Saul, The Good Samaritan) and, following the example of Western craftsmen, he also put his portrait medallion and coat of arms on the bell (e. g. the bell at Dubany of 1580).

His only serious rival, *Thomas Jaroš*, called himself a gunsmith but cast all kinds of things.[122] His most famous work is the Singing Fountain in Prague Castle; he cast it in the years 1564—68 with the help of the theorist in metal-founding *Lawrence Křička of Bitýška* and the journeyman *Wolf Hofprucker*.[123] Thomas Jaroš, from Brno, appeared in Prague in 1543 and became known in 1547 by his first signed work, a bronze gun made for the town of Domažlice. A year later, he was entrusted with the founding of the main bell, called "Sigismund", for St Vitus's Cathedral,[124] the biggest bell in Bohemia and admirable in its artistic execution which ranks it among the most outstanding works of its kind in Europe. Besides the friezes with figurative scenes, the medals and the traditional figures of saints sealed in, Jaroš enriched the bell with plaques representing The Annunciation and The Holy Trinity, after Dürer, and, above all, with the kneeling figures of the donors, Ferdinand I and Anne Jagiello. In the years 1550—68, Jaroš made a number of other bells, among which was "Mary" of 1553, the biggest bell of the Týn Church in Prague.[125] Besides his signature, the replicas of the decorative motifs from his "Sigismund" can also be seen on them. Other remarkable works by Jaroš are the bell of 1555 at Řapice, on which the busts of a man and a woman wearing contemporary costumes and hats alternate, and the bell at Libotenice, of 1562, with the portraits of Ferdinand I and Anne. Towards the end of his life, he resumed his original profession, that of a gunsmith, in the service of the Habsburgs who where fighting against the Turks in Hungary.

Besides these high priests of the craft of metal-casting in Bohemia in the 16th century, a number of others were prosperous, as well. In Prague there was *Master Stanislas* who founded the bell called "St John the Baptist"[126] for St Vitus's Cathedral in 1546, as a counterpart of the "Wenceslas" bell, the work of Brikcí's father *Andrew* of 1542. Another Prague metal-founder was Brikcí's son *Bartholomew*, who made several pewter coffins for the nobility and several bells, remarkable for their reliefs with scenes from The Legend of the Lost Son, after Beham and after the sculptor Leonard Danner of Nuremberg. The bell-founder *Daniel Tapineus*, foreman of Bartholomew of Cimperk,[127] first worked in Brikcí's foundry. Originally he had been a bell-founder at Kutná Hora; his best bell at Tuněchody, dating from 1593, is rich in figural motifs. Having left Brikcí's workshop, he set up a foundry in 1603 in the garden of the Emmaus Monastery in Prague; this foundry, however, became the property of the bell-founder *Balthasar Hofmann* in 1606. The latter used not only friezes with biblical motifs of the same kind as Brikcí, but also moralizing scenes from country life after Beham's engravings. From among the country bell-founders the following ought to be mentioned: *Andrew* and *Jacob Ptáček* (1472—1535) at Kutná Hora, *Thomas Litoměřický*, active until 1535, and *Wenceslas*, called *Hytych*, at Mladá Boleslav. In their bells designed in the traditional way, the Renaissance reveals itself only in restrained

figurative and ornamental motifs and in the typographical arrangement. Their production is more or less of local importance.

Unlike traditional metal-casting, Bohemian Renaissance ceramics and glass achieved an artistic and technical expression independent of the past. Ceramics had adopted not only the Italian style but Italian technology as well in the composition of the body and the treatment of the surface. Multicoloured lead-glaze, which gave vivacity and gloss to the ceramic products, and later on white tin-glaze as a ground for coloured painting found application here. The first method was used mainly in artistically designed stoves. Stove-heating is typical of Central Europe, and the stove developed into a distinct architectural piece of equipment for ostentatious dwellings as early as the Late Gothic period. The Renaissance enhanced the effect of figurative, heraldic and ornamental stove-tiles with a coloured glaze; some evidence in the Czech region (the stoves at the châteaux of Vrchlabí, Bechyně and Smečno, and a document concerning a stove ordered by Archbishop Brus of Mohelnice in 1573), shows a conscious feeling of style.[128] This reveals itself still more pronouncedly in ceramics, where beside vernacular pottery such as *Simon Nemazal's* jug (in the Museum of Decorative Art in Prague), Italian faience also gained ground. The furnishings of the Renaissance châteaux and palaces in Bohemia and Moravia called for pottery consistent with them in style, which was supplied by Italian ceramic workshops (such as the majolica of Roudnice with the coat of arms of the Pernštejn family, or by the Meggau family majolica).[129] However, these products were so expensive that the Czech nobility promptly made good use of the abilities of Anabaptist potters called "Habans" who had been expelled from South Europe, to start local majolica production on the patterns of the ceramic workshops at Faenza in Central Italy. This production found a new domicile in South Moravia on the estates of the Utraquist nobility and from the 1590s soon replaced the imports from Italy. Open-work dishes, jugs, tankards and other wares were not inferior to Italian faience and even produced a characteristic style of painting. At the turn of the sixteenth and seventeenth centuries "Haban" faience became the basis of all majolica production in Moravia and Slovakia, where the "Habans" emigrated after the Battle of the White Mountain (1620).[130]

Renaissance glass-making in Bohemia ran a similar course. Venetian painted glass evoked here a retarded but extraordinarily vivid response in the second half of the sixteenth century. Glass production became a profitable source of income for sixteenth-century noblemen, who were enterprising men and tried to make money out of their fields and woods not only in the agricultural, but also in the industrial way. The abundance of woods specially stimulated glass production which developed into a complex branch of decorative art. "Jewels" made of thin-walled Venetian glass became a fashion in the Czech Lands at the turn of the fifteenth and sixteenth centuries; the transparency of this material and its suitability for shaping and for painted decoration kindled interest in hollow glassware, too. Records speak of the most varied Venetian glass products, vessels and mirrors, supposedly made of crystal, in Czech sixteenth-century households.[131] The noblemen were no longer satisfied with local products made of "forest" glass and sent their orders to Venice instead. As the import of Venetian glass was expensive and undermined the prosperity of local glass-factories, more economical ways of replacing these imported products were sought. With the help of Venetian glass-makers and German technologists, the chemical decolourization of the greenish glass-metal was discovered, together with a way of imitating Venetian glass by enamel painting, fired on the surface of local hollow glassware and window glass. The earliest evidence of this in the Czech Lands, a beaker with the Imperial eagle, dates from 1572 (Museum of Decorative Art, Prague).[132] Enamelled glass thus became for almost a century the typical ostentatious glass product and also a stimulus for further advances. In the windows of aristocratic residences, discs with the owners' enamelled coats of arms appear, the same emblems being used as marks on family glassware. Besides coats of arms, Imperial eagles, a portrait of the Emperor with the Electors, allegorical, biblical and genre scenes are to be found here, mostly patterned on German engravings brought to the Bohemian glass-works by German technologists and prospectors (the *Schürers*, *Wanders*, *Preuslers*, and others); these raised Bohemian glass production to European standards and, in turn, affected the development of glass manufacture in neighbouring Germany. Glass-painting acquired certain specific features which allow us to identify many products as originating in the glass-works in the border regions of Bohemia and Moravia. Moravian glass-works can be credited with those glass products in which painting has been replaced entirely or partly by engraving, executed with diamond tools in the Venetian manner (the *Žerotín* goblet in the Museum of Decorative Art in Prague).

DECORATIVE ART AT THE COURT OF RUDOLPH II

Emperor Rudolph II was not content with the mere utility character inherent in decorative art, nor with the average level[133] which existed in his residential city and which corresponded more or less with the contemporary European standard; for his planned artistic activities he made use of decorative art, equally progressive in style and in technique. However, only some exclusive branches of decorative art were of any concern to him. He was not interested in those materials which were accessible to the burghers and the gentry, such as clay, pewter, iron or wood, because they did not offer sufficient possibility of achieving material or artistic effect nor of the Mannerist metamorphosis from the standards of decorative art into those of fine art. He showed no appreciation of the basic principles of perfection of any work of decorative art, of functionality combined with adequate material, corresponding to the technology of production, and, consequently, with proper form. His love of splendour and his sense of pomp and dignity required that each vessel, device or object used at the Emperor's Court should bear the sign of an individual, elevated artistic treatment, even at the cost of its natural utility. Works of decorative art lost the objective component of usefulness and crossed over into the sphere of subjective artistic exquisiteness. The age-old balance between the decorative and the fine arts was being disturbed. The notion of decorative art, in which the artistic form is both the purpose and the reason for production, appears for the first time. The commission for a work of decorative art, an instrument or mechanism, is often only a pretext for the realization of a free artistic intention, for the demonstration of artistic will. This phenomenon reached its maximum intensity in the production

of Rudolphine decorative art. An object of everyday use changed into a work of art in its own right and aligned itself with the fine arts, sculpture and painting, cultivated at the Court.

The Emperor's will alone would not have been sufficient, of course, to unite the decorative and fine arts on a uniform stylistic level, if it had not been for the fact that decorative art by itself was best suited to fulfil the Mannerist intentions, as regards both ideas and form. Max Dvořák's definition of Mannerism as "subjectivity of spiritual contents, connected in multiple ways with objective means of expression" has most force in the sphere of decorative art. Artistic subjectivity here often reaches real licence, which negates not only the function, but also the material itself and the traditional methods of production. The modesty and humility of artistic craftsmen are replaced here by the conscious and subjective feelings of sculptors and painters pursuing the realization of original and attractive artistic ideas restricted neither by tradition nor by material. In this respect, the sculptor's methods of working are more suitable than those of a painter. For this reason, the art of the goldsmith and jeweller, which originally reflected medieval ostentation, had a better chance than anything else of satisfying these aims.

Artistic subjectivity did not remain satisfied with only the traditional material, with precious metals, gems or pearls. The art of the jeweller needed novelties, exotic objects, natural rarities, such as sea-shells, corals, narwhal's tusks, concretions found in the stomachs of certain animals (bezoars), ostrich eggs, coconuts, and also new kinds of traditional materials, for instance a precious stone such as the Bohemian garnet. Opinions about the nature of gems in the service of art led to the treatise *Gemmarum et lapidum historia* by the prominent expert Anselm Boethius de Boot in 1609. The combining of precious materials, contrasting in value, rarity, form and colour, reflected the Mannerist taste for surprise, for a gradation of the emotional effect of a piece of decorative art. This was no longer merely interest in a rare original curiosity (as could be seen in the case of some exotic objects as early as the fourteenth century), but, above all, an attempt to make use of its form and optical effect, mostly to produce hollow vessels. The cavity of the nautilus shell made it suitable as a drinking vessel, and the shell itself with its spiral shape was effective as a Mannerist exquisite form, which was further emphasized by graphic and sculptural means. As early as 1570, the Nuremberg Court goldsmith *Wenzel Jamnitzer* produced his famous "Turbokanne" (now in the Residential Treasury in Munich) by combining a shell with a golden figurative stem and neck.[134] This early prototype of a formally conceived hollow vessel which originated in Italy, foreshadowed the Mannerist period of Central European goldsmith's work.

There is no way of deciding to what extent Jamnitzer was also the designer of this piece. But, in any case, he expressed the trends then developing as a result of the publication-books of patterns, such as the one of a short time before (1565) by Jamnitzer's fellow-countryman *Erasmus Hornick*. His album consisting of eighteen plates of designs for jugs, goblets, candle-sticks and other things, mostly of fantastic forms based on a shell-like spiral combined with animal creation, certainly inspired Jamnitzer and his equally famous son *Christoph*, the author of the remarkable work *Neuw Groteszken Buch* (Nuremberg, 1610). Printed copies of Hornick's album obviously circulated about the workshops all over Central Europe, as shown also by the copy in the collections of the Museum of Decorative Art in Prague (Inv. No. 20.429/1—18). However, in the time of Rudolph II, Prague had its local designers as well. One of them was *Hans Vredeman de Vries*, a sculptor working at the Prague Court and compiler of various designs in the field of sculptural decorative art. In the Victoria and Albert Museum in London, there is his design for a hydria[135] with a bulky upper part twisted into shell shapes and with a neck in the form of a sculptured griffin, derived from a pattern by Cornelis Floris (Antwerp, 1563), and also one for a jewel cabinet in the form of a miniature sarcophagus covered with animal and plant ornamentation, deriving from North Italian miniature furniture. Only the third Vredeman design, that of a silver dish on a stem, is an original one, corresponding to similar pieces in his home country, the Netherlands. Such an exploitation of someone else's creative ideas was not considered to be beneath a master, the pattern-books being a source of inspiration in every reputable craft workshop (e. g. the workshop of the Prague locksmith *Lazar* of Budějovice).

At Rudolph's Court, even the administrator of the Emperor's collections, *Ottavio Strada* himself, inspired the fantasy of the craftsmen. As early as 1597, he did a set of designs for the Emperor, called *Libro de dissegni per far vasella di argento et oro*, the contents of which were rather restrained in comparison with the contemporary Mannerist vogue; they were based on Classical models, in accordance with the views of Italian designers. The artistic conceptions of one of these, Polidoro da Caravaggio, became known through the graphic work of *Egidius Sadeler*. The way in which Strada compiled and published his very different artistic ideas, is best seen in his *Selectarum inventionum collectaneum ex diversis auctoribus* (Strahov Libary in Prague, DL III 3)[136]. This background to the goldsmith's work does not detract from the quality and the progressive character of the pieces made for the Emperor. If we apply Birnbaum's law of transgression here[137], we can find here yet another confirmation of the fact that it was only in a prolific sphere like this that all the tendencies of Italian Mannerism attained their consummation, as was once the case with Gothic architecture and later with the High Baroque. Unfortunately, material documents of this regular artistic process are nowadays, with a few exceptions, far from their origin, being scattered all over Europe. Most of them are in Vienna, where the Habsburgs brought the family treasures created by the skill of their subjects in the Czech Lands[138]. Works of art made of precious materials particularly became the booty not only of the Habsburgs, but also of their friends, the Bavarian Elector Maximilian and his family,[139] and of their enemies, the Saxon and Swedish rulers and their armies. Even though most of the artists active in Prague stayed there only temporarily, their work cannot be detached from the development of Czech art, since the milieu of Prague Castle had provided all the spiritual and material preconditions for its birth. Rudolph himself would hardly have amassed so many valuable works of art of his own accord and by his own means, had it not been for the life-giving material and cultural background of the Czech Lands and their capital, with their rich productive soil and age-old tradition of artistic fastidiousness. It was only in a climate like this that specifically Rudolphine branches of applied art, goldsmith's work and jewellery, glyptography, art glass-work and fine mechanical works of art such as clocks, could flourish so admirably. As we have already said, the Emperor had, from his young days, a special liking for precious materials which changed into a morbid obsession with the course of time, as did his craving for exotic objects and curiosities of all kinds. It is known that as early as the year of his accession Rudolph asked the Bishop of Eger, Stephen Radetius, to get him fine minerals of all kinds from Hungarian mines. We know from later records that he reserved for himself the preferential right to all Czech garnets found. His

efforts to acquire a large diamond from the Roman Jesuits[140] were totally pathological. The administrator of his collections, Ottavio Strada, negotiated the purchase of works of art in Europe, including crystal vessels in Venice. Gold, silver, pearls, precious stones, singly or in groups, were mobilized by the artists in an attempt to appease the Emperor's insatiable hunger for works of art.

The finest works of this kind were the new personal crown jewels of 1602, the crown of Rudolph II,[141] his sceptre and orb. Rudolph's crown is now in Vienna (Schatzkammer), while the rest became as early as in Matthias' reign part of the crown jewels of the Kingdom of Bohemia, in preference to the old Gothic ones, when Matthias had a new, more sumptuous, sceptre and orb[142] made by the Prague goldsmith *Andrew Osenbruck* in the years 1612—15, which were to accompany Rudolph's crown. The commission for Rudolph's jewels called forth a sort of competition, as we can see from the drawings by three artists, one of whom, *William van der Blocke*,[143] even used some figurative motifs derived from patterns by Wenzel Jamnitzer. The form of these jewels, however, was not new. In the crown, the form of a diadem with an arch and a built-up cap has been repeated, while the orb and sceptre are stereotypes. On the other hand, they excel in the combination of gold, gems, pearls and enamels and, above all, in the skill of the artist and the goldsmith, in the figurative reliefs on the gold surfaces of the crown and the orb; in the crown there are scenes from Rudolph's coronations, on the orb scenes from the Creation of the World. The jewels are the work of a group of artists-craftsmen; since Chytil's times, the Court jeweller *Jan Vermeyen*, of the Lesser Town of Prague, has been considered their designer and maker. The creator of the reliefs and of the enamel decoration, though, is disputable. E. Kries has put forward the hypothesis that the reliefs may have been the work of the most renowned jeweller working for Rudolph II, *Paulus van Vianen* from the Netherlands.[144] True, he was still in the service of the Archbishop of Salzburg, Wolf von Raithenau, at the time when the crown was made (before 1603), but this certainly might not have prevented him from creating for the sovereign a work requiring the highest level of artistic conception and treatment. Apart from this, E. Steingräber[145] attributes the enamel decoration of the crown to *Hans Karl*,[146] another artist working at the same time for the Archbishop of Salzburg. Thus it cannot have been a coincidence that both of them, Vianen and Karl, appeared in Prague in 1603 as Rudolph's Court artists. There is no reason for doubt as to Karl, for he was the enameller of Rudolph's sceptre as well.[147] The shapes and colours of the enamels are identical with those of the gold vessels made for Wolf von Raithenau (Pitti Palace, Florence). As to the reliefs, there is no doubt about one thing at least, namely that they are of South German provenance. They clearly exhibit the style which was characteristic of the work of two most eminent Augsburg goldsmiths, *Cornelius Erb* and *Paul Hübner*[148] as early as the end of the sixteenth century.

The crown jewels of Rudolph II represent the climax of all kinds and techniques of goldsmith's work. In the wake of them there follows a long line of countless pieces of goldsmith's work and jewellery showing the high level of the jeweller's art at Rudolph's Court, which disposed of fine artists, materials and technical equipment, such as the grinding mill at the Emperor's Mill in Prague where the crystal-cutter *Tortori* and the gem-cutters *M. Kreatsch* and *Peter Hýbl* worked.[149] In less than two decades, dozens of pieces of goldsmith's work and jewellery were executed in assiduous competition at the Prague Court. Today they grace galleries and museums all over the world. In Stockholm there is a small crystal boat-shaped vessel with a cut geometrical pattern, on a stem with enamelled gold mount;[150] the British Museum has an amber tankard with cut allegories of the Virtues, formerly the property of the Nostic family of Prague (it came to them with other works via Rudolph's collections[151]), a boat-shaped vessel, similar to the one in Stockholm but made of jade, and a shell made of agate. In the Museo Lazaro Galdeano in Madrid is a small crystal dish on a stem from the Prague Rudolphine collections, with a lid surmounted by a statuette of Neptune,[152] resembling several others which have remained in Prague and are now in the Museum of Decorative Art. The Residential Treasury in Munich contains about twenty vessels made of crystal or topaz in gold or silver mounts; they are of Prague origin and date from the years 1610—20.[153] The Rothschilds in Paris have two silver reliefs by Paul van Vianen, also from the Rudolphine collection. The largest collection of Rudolphine goldsmith's work and jewellery is now in the Kunsthistorisches Museum in Vienna and the adjoining Court Treasury.[154] They comprise works of art of almost all kinds which formed the core of the Emperor's collections. Pure goldsmith's work is represented by the lobed gold jug with a dish, called Rudolph's jug, by Christoph Jamnitzer, with figures on surface, a work of sculpture rather than hollow-ware.[155] Of similar type is the jug combining gold with a coconut, made by another Court goldsmith, *Anton Schweinberger*. The distortion and exaggeration of form, a typical feature of the Mannerist subjectivity, attains an almost Surrealistic expression in these works. Similarly, a silver galley, which plays a tune and moves along the table, made by *Hans Schlotheim* of Augsburg, reminds us of modern kinetic art.

Compared with these goldsmith's and sculptor's inventions, which seem designed only to attract attention, other works are more functional. The jasper jug by O. Miseroni and Paul van Vianen[156] achieves its effect with the natural beauty of the precious material rather than with the figurative gold mount; this is also true of Vianen's dishes made of bloodstone and onyx. It was a certain artistic restraint, characteristic of the art of the Northern Netherlands and corresponding with the Italian approach, which artistically enhances the natural character of the material, even though the function of the objects is ignored. This restraint was also characteristic of *Ottavio Miseroni*, a member of the large Milanese family of gem-cutters, who, from 1589 to his death in 1624, was active in Prague, where he founded a family line of his own. His skill ensured his prosperity not only in the artistic sphere, but also socially. Miseroni, too, used precious stones; the rosary with a medallion of the Saviour in St Vitus's Treasure is the only piece from his workshop to have remained in Prague. Though an anonymous work, it shows a striking resemblance to Miseroni's pendants bearing the Saviour and the Madonna in the Munich Residential Treasury,[157] as well as to the cameos set in two signed domestic altars in the Schatzkammer in Vienna.[158] The columned aediculae with extensions show not only the skill of Miseroni at grinding and cutting and at composition, but also the many-sided character of his profession; Neo-Classical proportions, however, can be seen in the detail, in the faces of the saints as well as in the treatment of their robes.

Whereas Miseroni's artistic expression was concentrated on the

142 Crown of Rudolph II, gold, gems, Prague, 1602, h. 28.6 cm, Vienna, Kunsthistorisches Museum, Weltliche Schatzkammer

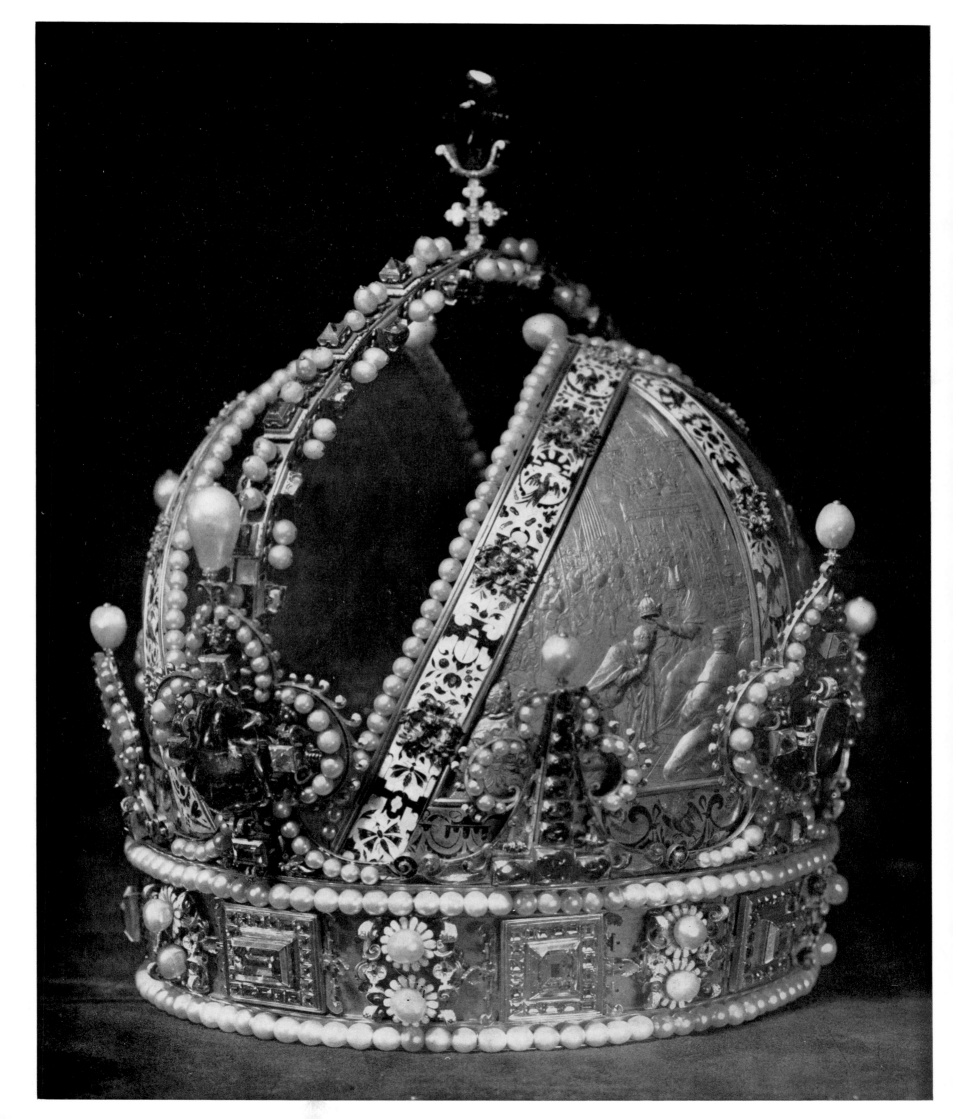

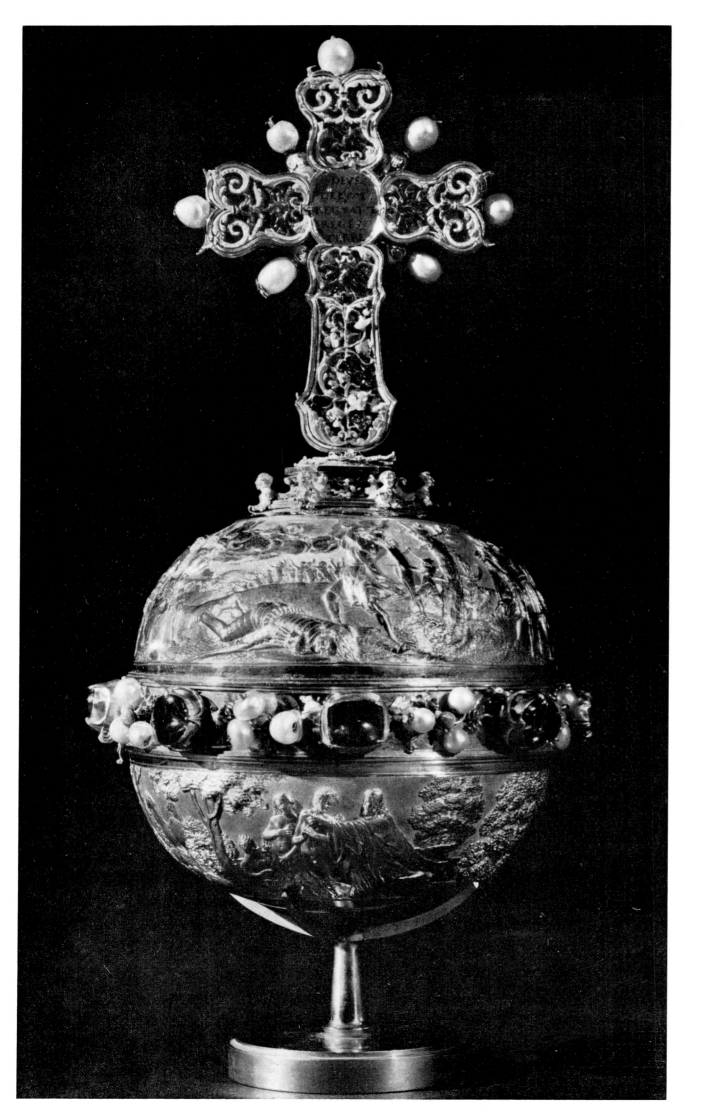

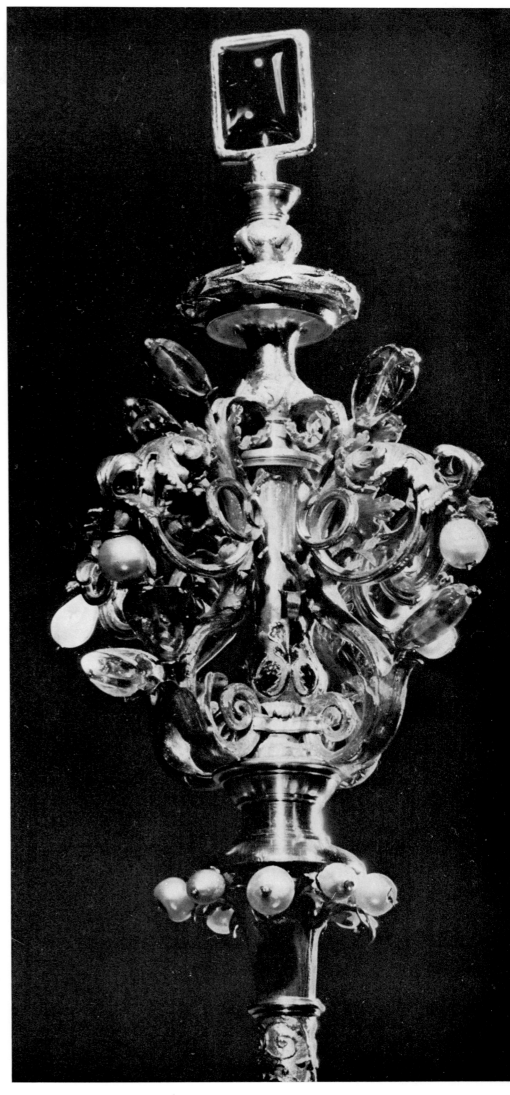

144 Bust of Rudolph II, mother-of-pearl, Prague, after 1600, h. 4.2 cm, w. 3.5 cm, Prague, Museum of Decorative Art

145 Sceptre of Rudolph II, gold, gems, Prague, 1602, l. 62 cm, Prague, St Vitus's Cathedral

◄
143 Coronation Orb, the side with the inscription, embossed gold, gems, Prague, 1602, h. 16.8 cm, Prague, St Vitus's Cathedral

146 A small altar, by Cosimo Castrucci — Ottavio Miseroni, wood, gems, Prague, about 1600, h. 64 cm, Mělník, State Château

147 A house altar, by Ottavio Miseroni, gilt silver, jasper, agate, gems, Prague, before 1610, h. 30.5 cm, Vienna, Kunsthistorisches Museum (Geistliche Schatzkammer)

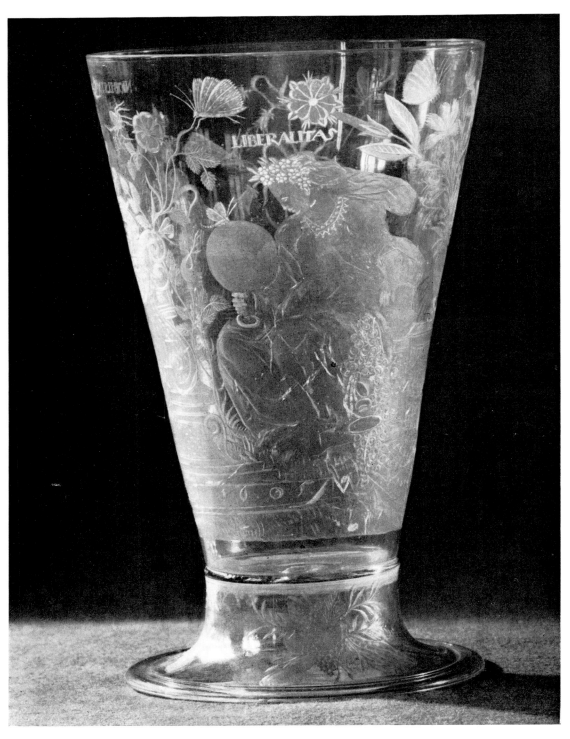

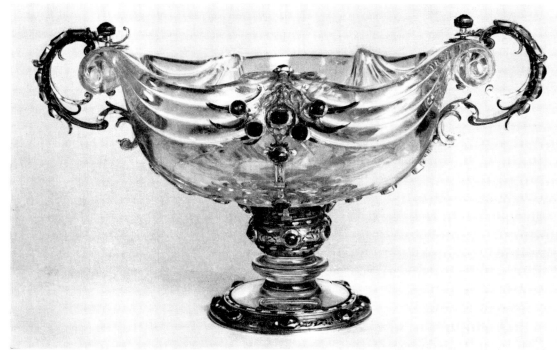

148 The goblet of Wolf Z. of Losenstein, by Kaspar Lehman, cut glass, Prague, 1605, h. 23 cm, Prague, Museum of Decorative Art

149 A boat-shaped vessel on a stem, crystal, gold, Bohemia, about 1625, h. 14.7 cm, Stockholm, the Royal Château, Kungl. Husgerådskammaren

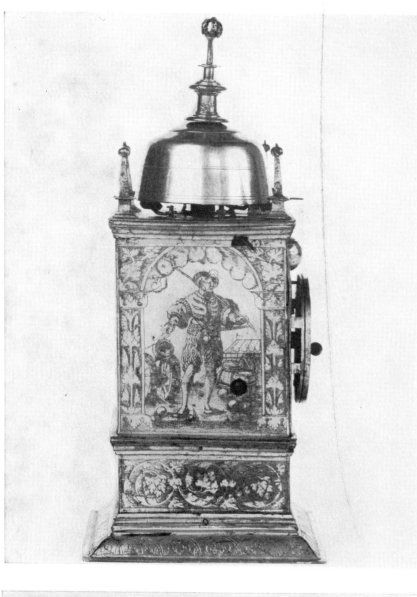

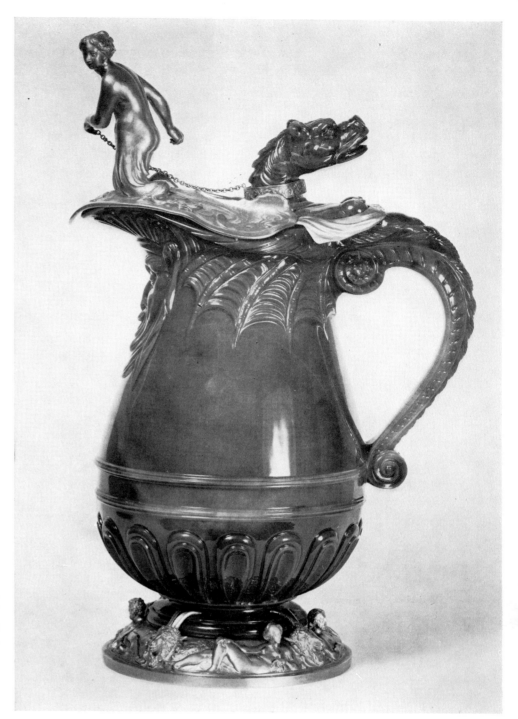

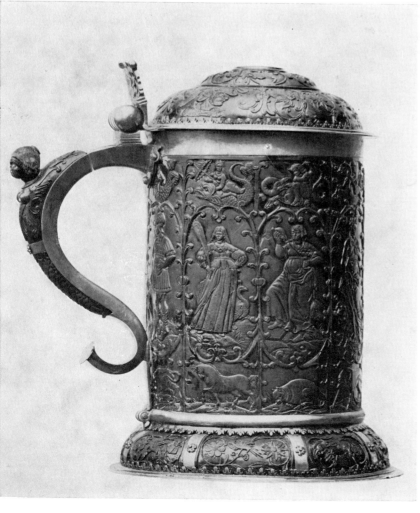

150 Table tower-clock, gilt brass, Prague, 1549, h. 24.5 cm, Prague, Museum of Decorative Art

151 A jug, by Paulus van Vianen — Ottavio Miseroni, jasper, embossed and chased gold, Prague, 1608, h. 39,5 cm, Vienna, Kunsthistorisches Museum

152 A tankard with the figures of the Virtues, amber, Prague, the biginning of the 17th century, h. 29 cm, London, British Museum

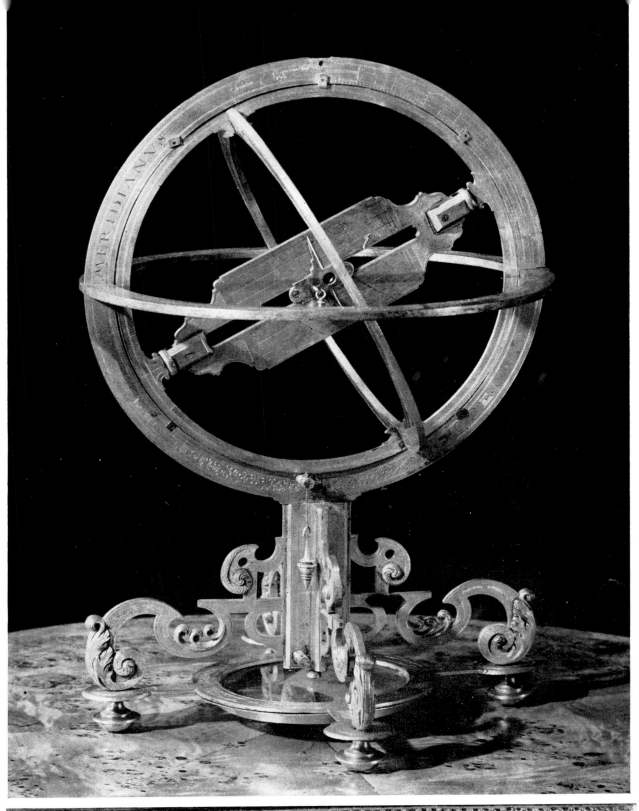

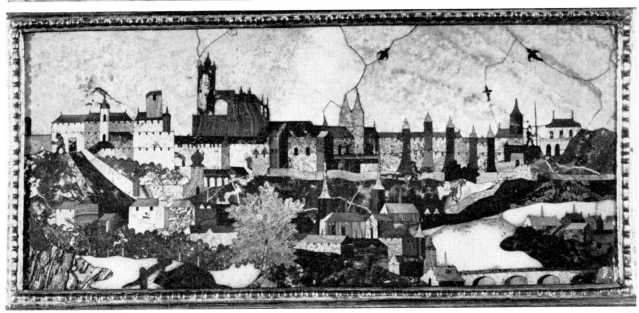

153 Armillary sphere, by Erasmus Habermel, gilt brass, Prague, about 1600, h. 40 cm, Prague, Museum of Decorative Art

154 Prague Castle, by Cosimo Castrucci, incrustation of gems, Prague, about 1600, 18 × 34 cm, Prague, Museum of Decorative Art

168

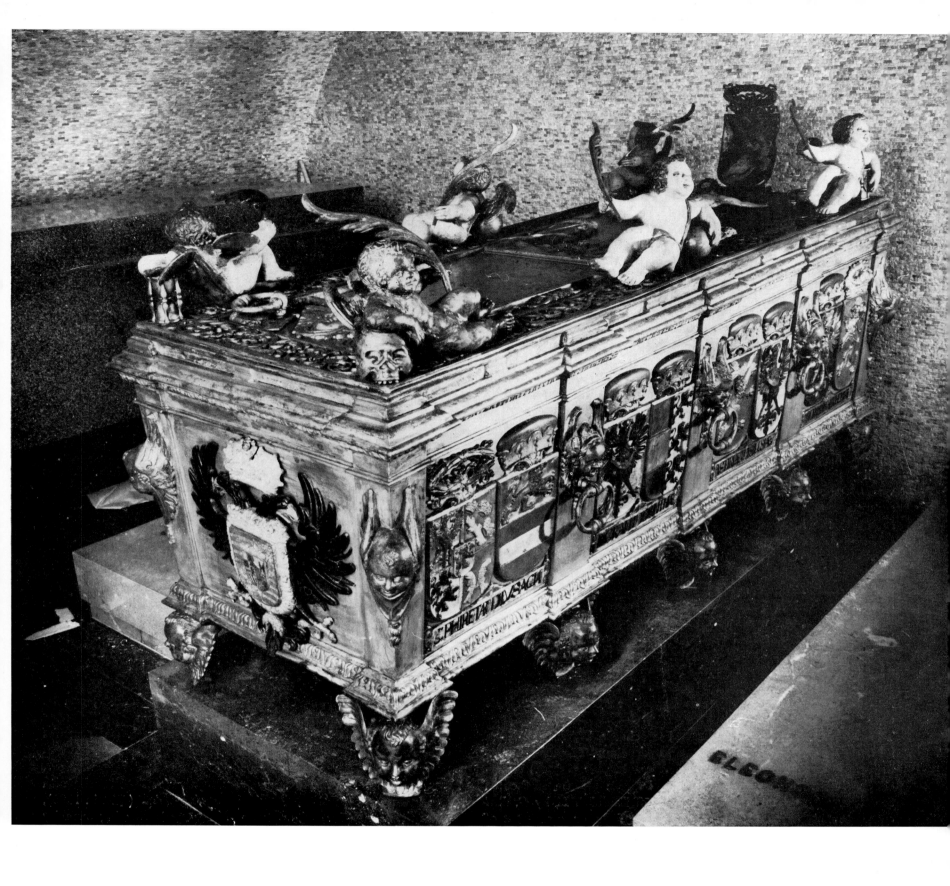

155 The coffin of Rudolph II, tin, partly painted, Prague, 1612/13, l. 195 cm, Prague, St Vitus's Cathedral

sculptural sphere of reliefs, his countryman and collaborator at the Imperial Court in the years 1605—14, *Giovanni Castrucci*, took advantage of the natural colouring of gems for two-dimensional, pictorial purposes. In Prague he developed the art of the Florentine mosaic, *pietra dura*, using minerals of various colours to compose landscape and town *vedutas* and possibly figurative compositions as well. This art had been brought to Prague by *Cosimo Castrucci*. As early as 1600, Giovanni Castrucci decorated for Rudolph II a domestic altar, presented as a gift to Zdeněk of Lobkovice in 1603.[159] In 1607, Castrucci executed two landscape mosaics (now in Vienna), modelled on contemporary Netherlandish landscape painting. The most important of Giovanni Castrucci's works is a cabinet made for Rudolph II (now in the Kunsthistorisches Museum in Vienna), concise in form, combining landscape painting with pictures of flowers in its massive decoration. Linked to this decoration are other works in the same museum and in the Liechtenstein collections; there are also two pictures of Prague Castle there,[160] connected with a similar work in the Museum of Decorative Art in Prague, undoubtedly the most valuable work of Castrucci's Court workshop from the artistic point of view. In Bohemia, Castrucci is, surprisingly enough, still represented by a relatively large number of works.[161] He has been established as the maker of the cabinet in the Museum of Decorative Art in Prague, which had been regarded as anonymous until recently; and we may attribute to him the domestic altar of the Lobkovice family, mentioned above, dating from 1603.[162] The mosaicists' workshop led by Miseroni after 1610[163] can be credited with the sumptuous table-top which passed from the collection of the Nostic family to the Museum of Decorative Art in Prague in 1945. The table-top, executed in *pietra dura*, follows the style and working manner of the Castruccis; it has their flower decoration, but the *veduta* motifs are stylized. In view of the fact that, in the seventeenth century, Otto Nostic came into possesision, in some unknown way, of many valuables from the Court collection, it seems possible that this table, too, was included in the Prague Castle inventory, harmonizing with it in both style and decoration. Several cut crystal vessels were also in the possession of the Nostic family — a set of goblets and bowls (in the Museum of Decorative Art since 1945) which, together with the table and Castrucci's cabinet, have been preserved in Prague as a precious residue of Rudolph's Court collections.

This residue also includes several mechanical devices, whose appearance was harmonious in form and colour. The demand for coloration was satisfied by gilding, engraving, or perhaps enamelling. The modelling of the static elements on the surface of the objects (as on the terrestrial globe of Rudolph II by *G. Roll* of Augsburg), expressed in an interesting form or a contrast of light and shade, produced an interesting optical effect. Although the importance of the mechanical devices of this time for the advancement of knowledge and the study of the cosmos cannot be denied, they would long since have sunk into the grey history of technology had it not been for their artistic treatment. This made them timeless works of art, surpassing their original practical function and acquiring ever greater aesthetic value in the course of time.

The fact that the co-operation between the mechanic and the artist-craftsman was not due only to purely cultural motifs cannot be passed over without a word. It was, for a great part, a matter of convention based on the love of luxury on the part of the ruler of the Roman Empire, with whom only the monarchs of the Orient could compare in this respect; their missions were received osten-

tatiously at the Prague Court. Their arrival was the source of much material gain and of political advantage, as well as an impetus for increased luxury and splendour. It influenced even the outward form of the organs and other musical instruments made about 1602 by Court instrument makers, *Hans Leon Hassler* from Nuremberg and *Hans Hayden*, the maker of war machines and, later, of more than twenty musical instruments.[164] Their works are known to us only from copies and descriptions, it is true, but we can get an idea of them from other musical instruments of this time; the mechanism used to be encased in lacquered boxes, often decorated with painting. Clock-cases were treated in a similar way. *J. Metzger* of Nuremberg and *Hans Stein-Meissel* of Prague, (and after him *Jonas Pirkbrunner, William Thürhammer, Paul Glocker*, and others) had contributed to this craft as early as the first half of the 16th century, but it was only the clock-makers working for Rudolph II whose original artistic conception transcended the then usual system of tower-shaped metal boxes covered with engraving. *Christoph Markraf*, the Emperor's chamber-clock-maker, inventor of the rolling-ball escapement, hid the movement in a metal case, surpassing in its interesting technical treatment the engravings after C. Floris's patterns, or in a lacquered case with miniature paintings.[165] *Jerome Metzger* proceeded in a similar way, but all of them were excelled by *Jost Burgi*, clock-maker to the Court and Rudolph's instrument-maker and astronomer from 1604. He came from Kassel and during his stay in Prague he invented logarithms, the cross-beat escapement and new triangulation devices. He was one of Kepler's collaborators, and simultaneously an artist who, like his Augsburg colleague Georg Roll, knew how to deck out his devices in accordance with the high artistic requirements of the Imperial Court. Evidence of it is Burgi's globe and his famous clock[166] produced in co-operation with a crystal-cutter. Burgi's companion, *Matthew Sneeberger*, and above all the mechanic *Erasmus Habermel*, also oscillated between science and art; all that is known of Habermel's rather obscure personality comes from his signature on some astronomic instruments. As early as 1598 he was recorded in Prague as a wealthy burgher of the Lesser Town.[167] His works, now in the Germanic Museum in Nuremberg and in the Museum of Decorative Art in Prague, especially the splendid armillary sphere[168] in the latter, decorated with engraving, show how a purely functional object, such as a measuring device, can be given an artistic appearance.

It was natural that Rudolph II should commission portraits of himself and thus have the Emperor's majesty glorified. He was portrayed in pictures, in sculpture and in works of decorative art. For this work he inherited from his father a skilful goldsmith and diesinker for coins and medals, *George of Řásná* (died in 1595), from the town of Kutná Hora.[169] As George's working capacity could not cope with the Emperor's demands, Rudolph induced the experienced medallist and goldsmith *Antonio Abondio*, who had portrayed the Emperor in Vienna as early as 1577, to enter the service of the Prague Court, but, it seems, for a short time only. In about 1603 *Paulus van Vianen* became the Emperor's official medallist, working in metal, while Abondio's work was taken over by his son *Allessandro* as early as 1600. Alessandro won his reputation, above all, as ceroplastic medallist (i. e. one working in wax), which was very fashionable at this time.[170] He is mentioned in this capacity as late as 1615 in the list of artists who remained in Prague after Rudolph's death. It was obviously the painter Hans von Aachen's widow who detained him here; he married her a year later, leaving Prague then for Vienna and Munich. His art can be seen in a portrait medal of Rudolph II, in an

allegory of the Victory over the Turks in Vienna and in ceroplastic works in Budapest.

Bohemian glass-work, which flourished in the second half of the sixteenth century from the economic, technical and artistic points of view, was also linked to the Mannerist art of the Court of Rudolph II. Many members of the painters' guild in Prague and elsewhere came to the fore as specialists in painting on glass. In Prague alone, where two glass-works were recorded in the second half of the sixteenth century, twelve painters of sheet-glass and hollow glassware are known; this number rose in 1598, when Rudolph II founded another glass-works in the Imperial Mill at Bubeneč,[171] run by *Benedict Rosmann*. An improvement in the metal produced a new kind of glass, called "crystal" glass after the practice in Venice; it was ordered from Prague by the Saxon Court in about 1610.

It seems that the chemical improvement of glass, which brought it close to the clear Venetian soda-glass, accounted to a considerable extent for the success of cut-glass at Rudolph's Court. The Court gem-cutter, *Kaspar Lehman*[172] from Uelzen, who worked in Prague from the end of the sixteenth century and became a burgher of the Lesser Town in 1602, was considered to be the originator of this technique; from 1602, he worked for the Emperor, too. The fact that his court salary was twice that of Ottavio Miseroni (15 guilders a month) shows the reputation he enjoyed at the Emperor's Court, where he was ennobled as early as 1595 and given a glass-cutting franchise in 1609. In his letter to Wilhelm of Bavaria in 1608, he admitted to have been trained in Bavaria — where he probably worked on imported Venetian glass. This, however, does not diminish his contribution to the quantitative and qualitative development of this technique. His studio produced also rare sheets of hollow glass on which he, alone or with the help of his journeymen (such as *Georg Schwanhardt the Elder*, active in Nurem-berg from 1622), engraved figurative and ornamental designs with a copper wheel, as on crystal. He used as patterns the copper-engravings of his colleagues at the Court, for example, of *Jan Sadeler*, who supplied the design for Lehman's most famous work, a beaker made in 1605 for Baron W. of Losenstein and his wife (the beaker is now in the Museum of Decorative Art in Prague).[173] Lehman's other works include the panels with portraits of Rudolph II, dating from the years 1606—08 (in Vienna), and of Christian II, Duke of Saxony,[174] and perhaps also the panel with the Liberation of Andromeda (Victoria and Albert Museum, London), analogous to that with the Judgement of Paris, of 1611 (private collection, Vienna), which is undoubtedly his work.[175]

Besides Lehman, the gem-cutter *David Engelhardt*, working mostly for the Rožmberk and Švamberk families, also engaged in glass-cutting in Prague. Under the rule of Rudolph II, Prague became a centre of this glass-working technique. Its products and, above all, the technique itself foreshadowed the imitative spirit which was to become typical in the Baroque period. The method of cutting pictures in precious stones, following the Classical tradition and linked up to this period with the beauty and the individual character of the gem, attained here a point at which even cheap glass could convey technical and artistic virtuosity. The value of a piece shifts from the dual appraisal of the material and the artistic workmanship to a single field, in which the implementation of the creative intention becomes the only criterion of the worth of a work of decorative art. A growing respect for the artist's work and a need of its wide distribution are noticeable here. The technical and artistic constituents and the social significance of cut-glass, a curiosity of Rudolph's Court, made it, in the second half of the seventeenth century, one of the most valuable contributions of Czech Mannerism to the cultural treasure of mankind.

It is still true of the art which developed in Prague under the rule of Rudolph II that it is more famous than really known and appreciated in a just and objective way. There are many difficulties in the way of research, arising from the complex nature and the particular stylistic structure of Rudolphine art. In addition, the fact that it was the work of artists coming from abroad, a product of an international group of artists, and that, seemingly, it was out of the main stream of traditional Czech art in the strict sense of the word, became an obstacle as early as in the National Revival period (end of 18th — first half of 19th century). This nationalist prejudice, reinforced afterwards by a latent or overt antipathy to the questionable personality of the Habsburg ruler who had brought this creative activity to life, accounted for the fact that Czech art historians, long after having reached a judgement on the significance of Gothic and Baroque art, are beginning to realize the important place of this period in the domestic tradition of the fine arts and to observe more precisely that this period, too, participated in the historical continuity of Czech art and in the creation of its specific qualities.

The question, what might have arisen from Rudolphine art if it had not been for the fatal break caused by the Thirty Years' War, is of merely academic validity and is unanswerable. It is certain that in spite of its shortness we no longer consider the history of Rudolphine painting and sculpture a mere episode,[176] however splendid, and we find more and more evidence of its influence upon all the subsequent development of art in Bohemia. Even the immediate response to Rudolphine art appears to have been deeper than it has usually been admitted. In its late phase the works of its painters (Spranger, Aachen, Heintz) and sculptors (A. de Vries) prepared the ground stylistically for the overthrow of Mannerism and for the creation of a new artistic concept — the Baroque. The standards it set were of greater importance than its direct influence. After the convulsive beginning of the Thirty Years' War and after the stringent measures imposed by the Counter-Reformation Decree of 1627, by which a significant part of the Czech intelligentsia were expelled from the country, the Baroque style in Bohemia would hardly have found its great European orientation so quickly, had Rudolphine art not prepared the ground for it in this respect by its links with the great currents of European creative art and, above all, by the incessant probing of new methods. Another contributing factor here was the fact that Karel Škréta, having acquired his first education as a painter in the still lively atmosphere of the Rudolphine art, probably as a disciple of Egidius Sadeler, could avail himself of the vast experience acquired in Italy and thus arrive successfully at his own synthesis, so characteristic from both the local and the national points of view. Rudolphine art retained its validity as a model for a long time. It is symptomatic that at the beginning of Czech landscape painting J. J. Hartmann reverted to the type of landscape and to the stylistic trends of the Rudolphine art of one hundred years earlier, that can be found in Bohemia after 1600 in the works of R. Savery and P. Stevens. A more profound analysis, however, will show that Rudolphine art had laid down, for a considerable time to come, certain guide lines and tendencies, to which the Czech artistic milieu remained sensitive. In its theory and practice, it brought to Bohemia mature humanistic principles, mostly of Italian prov-

enance, and in the complicated period between the Renaissance and the Baroque it allowed Classical principles which usually gained ground in Bohemia only with difficulty to take root there in a Mannerist form. The short period of thirty years in which these trends developed intensely did not lose, even after centuries, its relevance and stimulative quality. Under the new historical and artistic conditions of the 19th century, Josef Mánes, an artist most sensitive to Classical feeling, revived, in the cultivated line of his drawings, in his figurative types and, to some extent, in his refined melodious compositions, something of the Rudolphine heritage; he brought it to a new creative level where it could work as a live force in the national art of the new age. The high esteem, in which the Czech National Revival movement held the Rudolphine period can be seen, for instance, in the fact that Mikoláš Aleš gave it a prominent place in his Prague Cycle, where this period represents the time of the greatest flowering of the city's art and culture. Allegories by the artists of the generation of the National Theatre (Vojtěch Hynais) had a surprisingly close relationship to Rudolphine painting, following its example.[177] The varied and reverberating response which the seemingly exclusive Court production evoked in the Czech art of the new age, is a symptom of its vitality. After all, the complex world of suggestions, symbolic meanings and art magic of the Rudolphine form of painting exerts its influence with undiminished force, even if in quite different ways, in the various currents of contemporary art. These facts themselves throw light on the past and suggest forcefully that the Rudolphine period — at the beginning as well as later on — rooted more deeply in the Czech Lands and drew in more nourishment from the domestic soil than it has generally been supposed. Rudolphine art was not only an artificial creation of the ruler's will, but also, at the same time, a peculiar phenomenon typical of Prague culture.

Thanks to the great artistic tradition of the city, Rudolph II (1576—1611) succeeded in a short time in making Prague one of the most important centres of international Mannerism, a centre whose receptiveness, freedom from prejudice and admirable syncretic capacity attracted artists. In the whole spiritual life of that time, the surviving aims of medieval views were in conflict with the thought of the new era; urban exclusivity and the narrow interests of the Estates clashed with an increasing absolutism; faith and superstition with the revolutionary discoveries concerning the universe, nature and man; mysticism and magic with a bold rationalism.[178] The complex art of Late Mannerism came out of the deep crisis of the general view of the world as well as from the bewildering prospects of the new learning; Janus-like, in its two faces it combined artistic creation with penetrating directness; magical bewitching power with vivid humanistic ideas; abstractly based speculation with sensual lyricism in harmony with the domestic environment.

In the works of the prominent figure-painters *B. Spranger, H. von Aachen, J. Heintz* and the sculptor *A. de Vries*, Mannerism of an Italianizing nature established itself in Prague. It was conceived as a style of cultivated grace, elegant perfection and exquisite refinement, which conformed to the views of the educated élite, especially to those of Court society, and was accompanied by a liberalism of culture and thought and an aesthetic Epicureanism. In the 16th century, the *bella maniera* was a style which sought to eliminate

the imperfections of nature by means of idealization and ornamentally effective abstraction.[179] A specific trait of this stylistic conception was the effect of a conscious refined artificiality, perceptible in the subject as well as in the form. It revealed itself in the sublimely elongated types of figures with small heads on long necks, with undulating mellifluously limbs and accentuated hips, fine hands with exaggerated slim fingers, and in affected, gracefully relaxed, or, on the other hand, strained postures of exceptional complexity, perhaps an asymmetrical, artificially balanced *contrapposto*, or twisting movement *(figura serpentinata)*. The modelling of live bodies was being assimilated to the appearance of statues with their clear smooth metallically lustrous or enamel-like surface. The Prague Mannerists, too, delighted in a complicated language full of allusions and suggestions, with a liking for capricious fantasy. They professed technical perfection, stressed rich invention, valued perfect knowledge of anatomy and strove after the impression of ease which became a hallmark of artistic exellence. They admired not only the world of magic and surprise, but also the magnificence of nature and of the works of Man and sought *multum in parvo*. Famous Classical or later works of art were often quoted (in motifs of movement, etc.) by Rudolphine Mannerists, but this was not at variance with the stress put on invention; it was, in the spirit of the time, evidence of the artist's education, of his ability in variation, and his sense of metaphor and poetic transformation, giving, in the new context, another sense to the borrowed element. Style had been, in the Renaissance period, a more or less involuntary result of new tasks, new knowledge and new ideals in art, and now, in the period of Mannerism, became for the first time actually an artistic programme, and thus a problem, too. With the return to the great ideals and to the different periods of the past, historicism, motivated this time mostly by aesthetic considerations, appeared in art with a new force, together with attempts to make earlier styles relevant again. In this respect, the attempt to devolop further Dürer's style and the work of Pieter Bruegel was typical of Rudolphine art. The intellectual approach brought artistic production nearer to literature and, at the same time, caused works of art to be conceived as ambitious allegorical compositions, often resembling rebuses. Some authors point out that, while in the narrative cycles of the Renaissance the literary programme was fully embodied in the visual form and absorbed by it, in Mannerism it seems to have resisted such a synthesis and remained to a certain degree independent.

Only in our own day (thanks, above all, to R. J. W. Evans[180]) are we beginning really to understand the complex mentality of this time and the roots of Rudolphine art. It would be premature, though, to try to estimate at this time the share of the individual intellectual streams, running through the maze of ideas of that period, in the form and orientation of the Court art. At that time, the ideas of Luther's, Melanchthon's and Calvin's Reformation and those of the *Unitas Fratrum*, the Church of the Brethren, met and clashed in Prague with the different currents of tolerant and militant Catholicism; the Neo-Stoical humanism of Erasmus continued to assert itself here too; and all this went on against the background of sectarian tendencies as well as cabbalistic and astrological speculations. R. J. W. Evans proves that Rudolphine art grew out of a spiritual climate created by educated people of all three principal religious confessions in Bohemia: "It was, essentially, the question of a uniform conceptual view of the world, which could have hardly been brought in harmony with the Church schism, for it contained elements of mysticism and magical, occult symbolism."[181] The Prague Mannerists proceeded from natural philosophy, reflected in their realistic and naturalistic perfection, but, at the same time, they did not know how to get away from theoretical speculations in abstract aesthetics. The images and ideas of this time after all nourished the literary imagination, too, *(The Labyrinth of the World)* as well as the pansophic and didactic concepts of J. A. Komenský (Comenius), from whose work mystical and magical elements, proper to Rudolphine art and culture, cannot be detached. In his project for a learned world academy *(Collegium lucis)* and in his striving after an all-embracing reform, a clear echo can be heard of the efforts which had been gaining ground in the sphere of Rudolph's Court.

The Rudolphine community of artists and intellectuals itself resembled an academy and corresponded to the foundation of art academies and learned societies elsewhere in the world at that time. It was typical of the Court atmosphere that there was a close connection between intellectuals and artists, erudition and artistic invention, inventive spirit and sensitive skilled execution. Equally typical was the variety of artistic activities which influenced and inspired each other. As a force uniting the arts to produce a uniform effect, Rudolphine art formed a prologue to the later efforts of the Baroque period. Architecture was not underestimated either, as some of the older historians believed; if no distinct and artistically valuable traces of it have come down to us, it is because most of its achievements at Prague Castle fell a victim of later reconstructions. In contrast with the synthesis of the arts in the Baroque period, their harmony in the time of Rudolphine Mannerism was, of course, of a more intimate, but also more secular, character, in accordance with the spirit of late humanism. The works of art decorating the palace rooms were expected to be objects of individual aesthetic contemplation rather than ones producing a monumental effect on a wide range of people. In its emphasis on the aesthetic function and personal experience, Rudolphine art foreshadowed the situation of art in Bohemia — in new historical circumstances and without the monarch's support — after the Baroque period had come to an end. By his patronage and privilege, Rudolph II gave painting the status of art. His Imperial Charter of 25th April 1595 put an end to the medieval view which classified painting as one of the crafts, the *artes serviles*; it consummates the modern concept in classifying painting as the foremost among the seven "liberal" arts, the *artes liberales*. The Baroque, on the one hand, took the art of the new age away from the subjective uncertainties and individualistic artistry typical of Court Mannerism towards a new objectivity and new collectivism, but, on the other hand, as a vehicle for propagating didactic and apologetic religious servitude and in its dogmatic views, it represented a step back towards earlier, medieval thinking.

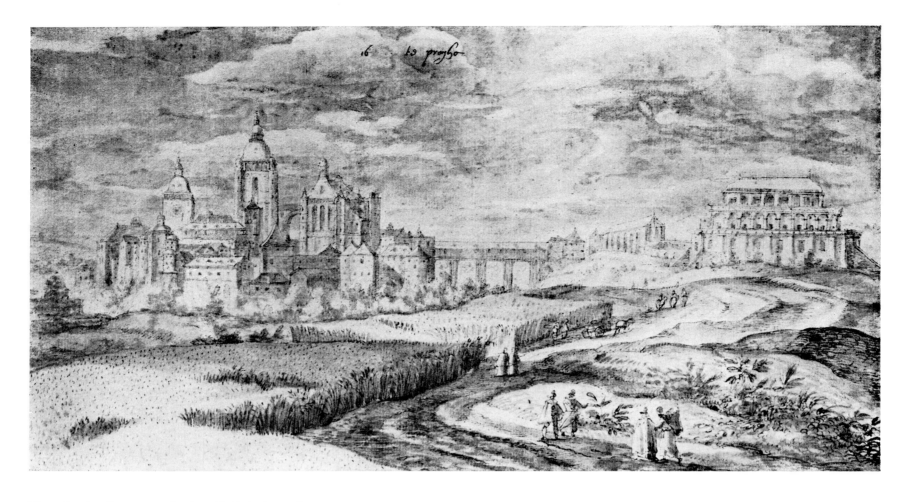

Pieter Stevens, Prague — Castle with Belvedere, after 1600. Drawing, Prague, Museum of the City of Prague

THE EMPEROR AND ART

We do not find in the history of Czech art any other example of a stylistic form and a general character of Court art so deeply penetrated by the patron's views. It is true that comparisons with the times of Charles IV and Wenceslas IV are not out of place here, but they are valid in part only. The choice of artists and the conception of the themes of their works were closely linked with the Emperor's demands and aspirations. The intense influence of the sovereign-patron on Court art was made possible by the time being pervaded by the idea of Renaissance individualism, but the character itself of the exceptional personality on the Imperial throne was of great importance as well. However, it is at this very point that misunderstandings arise. Until lately, historical research has qualified Rudolph's mental instability and melancholic depressions as lunacy, and this unfavourable appraisal has distorted the view of Rudolphine artistic production. Rudolph's contemporaries, perhaps with the single exception of the Papal Nuncios who were frightened by the Emperor's occasional sallies against Church and faith, did not attach such importance to his crises as modern historians have done. We do not consider their restraint unjustified. It was only after his serious mental crisis in 1598—1600 that the attacks of melancholic depression showed the symptoms of schizophrenia, a congenital predisposition which Rudolph had inherited from his mother and his great-grandmother. However, to project these pathological phenomena into the works of art which Rudolph originated and collected, is to contradict modern psychology as well as the results of an unbiassed aesthetic and historical analysis of Rudolphine art. Though the fits of depression left their mark on the activities of Rudolph II as a ruler, in which capacity he was then faced with insoluble problems, in his activities as a patron and collector of the arts, by contrast, his mental state manifested itself in its positive aspects. His inhibitions and failures in government were balanced by an increased concentration on and comprehension of the world of science and art, where the Emperor found a generally beneficial way out of his distress. His sensitivity to the contradictions of the world of his time and the basic tendency of his unstable nature to restore in the world of the imagination the balance which had been disturbed in the real world, proved to be effective and stimulating factors in the formation of Rudolphine iconography and of the character of Prague Court Mannerism in general.

To Rudolph art obviously meant something more than to any other great patron of art of this time. It offered him a possibility of escaping from the world of harsh conflicts and duties; but it was also to him a healing remedy and a guiding-light showing him the way out of the labyrinths of the soul and the world. Like bezoars which, it was believed, had the power of healing palpitations and protected their bearer against tormenting melancholy, and like precious stones, art had for Rudolph a magic power, though in a sublimated and refined form, a function of art which has never disappeared completely since its very beginnings. Here, he grasped a reality which escaped him in his activity as ruler; in the works

156 Giuseppe Arcimboldo, Summer, 1563, oil on wood, 67 × 50.8 cm, Vienna, Kunsthistorisches Museum ▶

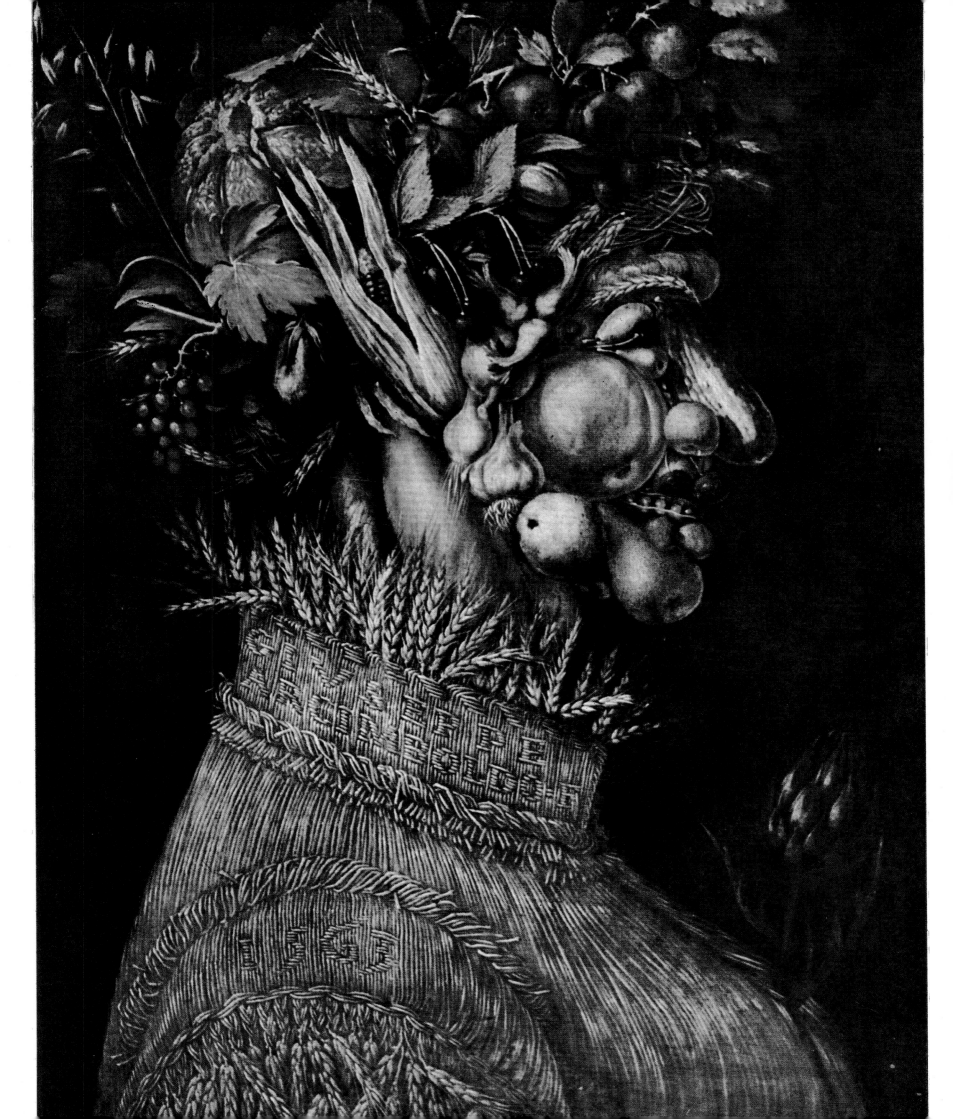

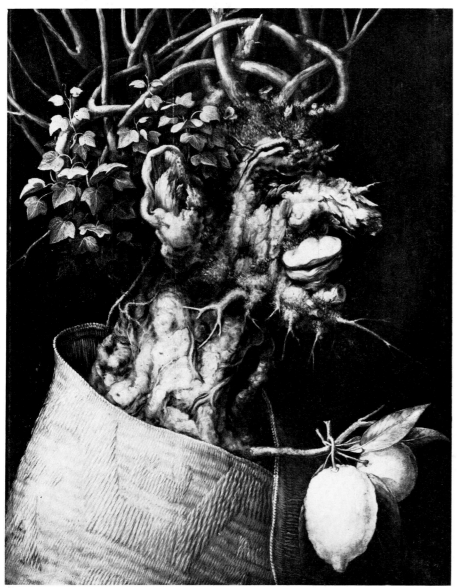

157 Giuseppe Arcimboldo, Winter, 1563, oil on wood, 60.6 × 50.5 cm, Vienna, Kunsthistorisches Museum

158 Giuseppe Arcimboldo, Water, after 1563, oil on wood, 66.5 × × 50.5 cm, Vienna, Kunsthistorisches Museum

159 Giuseppe Arcimboldo, Vertumnus (Portrait of Rudolph II), after 1587, oil on wood, 68 × 56 cm, Skokloster Château

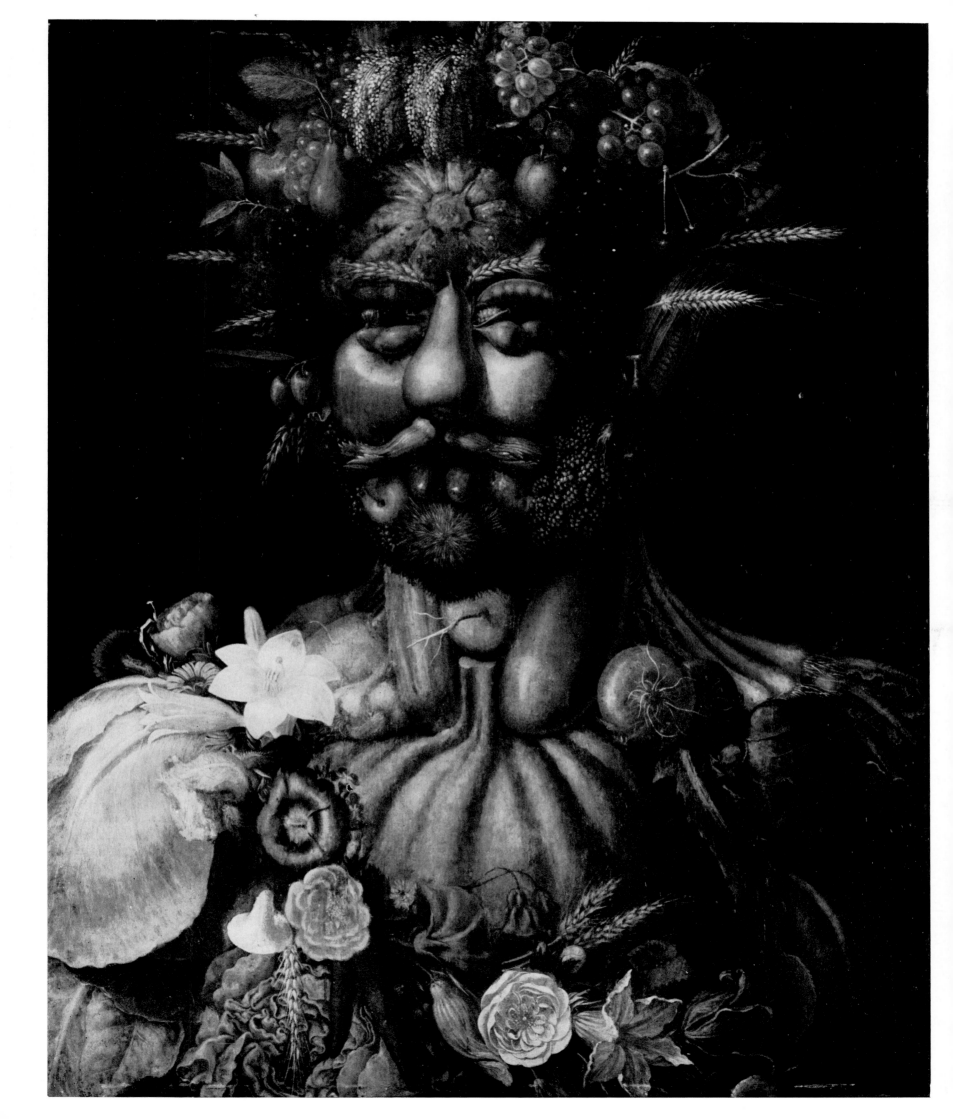

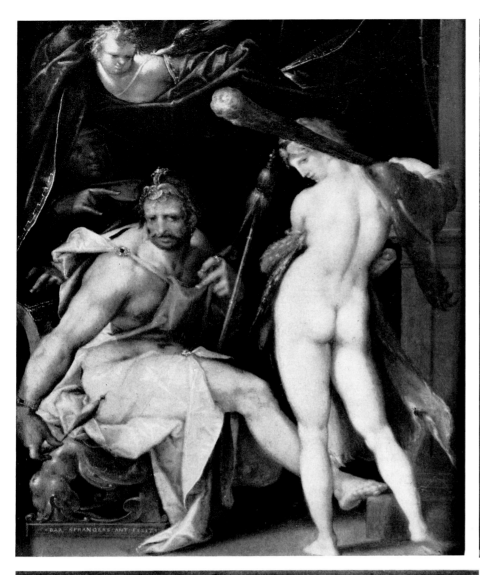

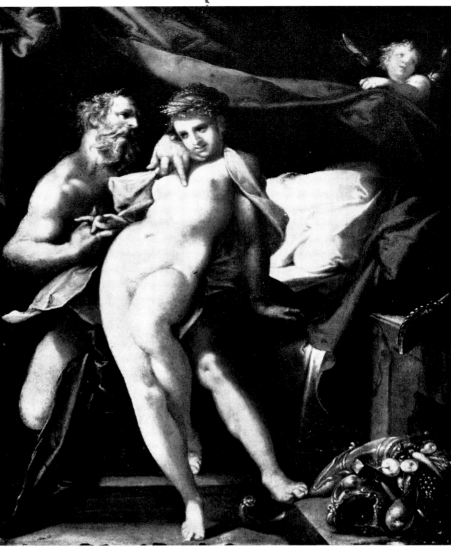

160 Bartholomeus Spranger, Hercules and Omphale, about 1576, oil on copper, 23 × 18 cm, Vienna, Kunsthistorisches Museum

161 Bartholomeus Spranger, Volcano and Maja, about 1576, oil on copper, 23 × 18 cm, Vienna, Kunsthistorisches Museum

162 Bartholomeus Spranger, Self-portrait, about 1590, oil on canvas, 62.5 × 45 cm, Vienna, Kunsthistorisches Museum

163 Bartholomeus Spranger, The Resurrection, 1576, oil on wood, 112.5 × 85 cm, Prague, National Gallery ▶

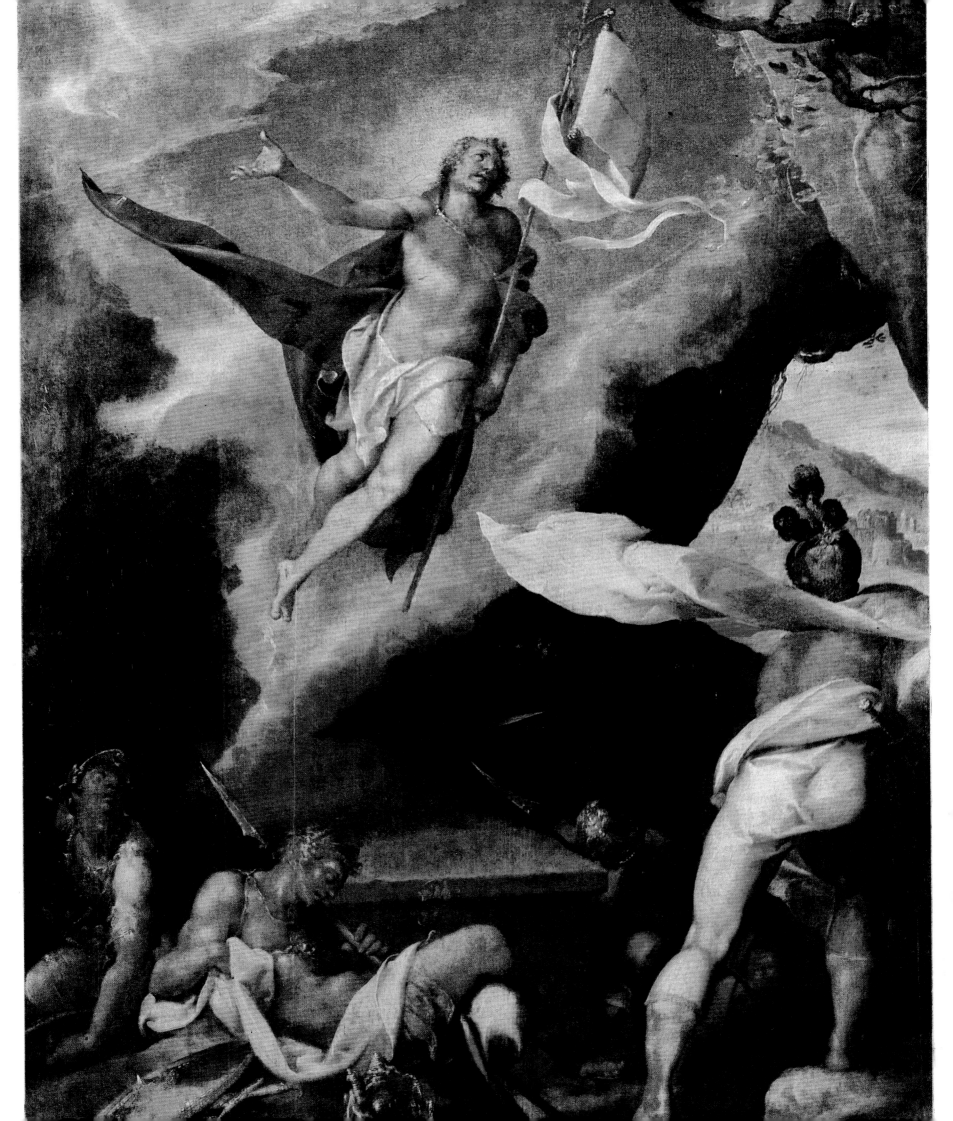

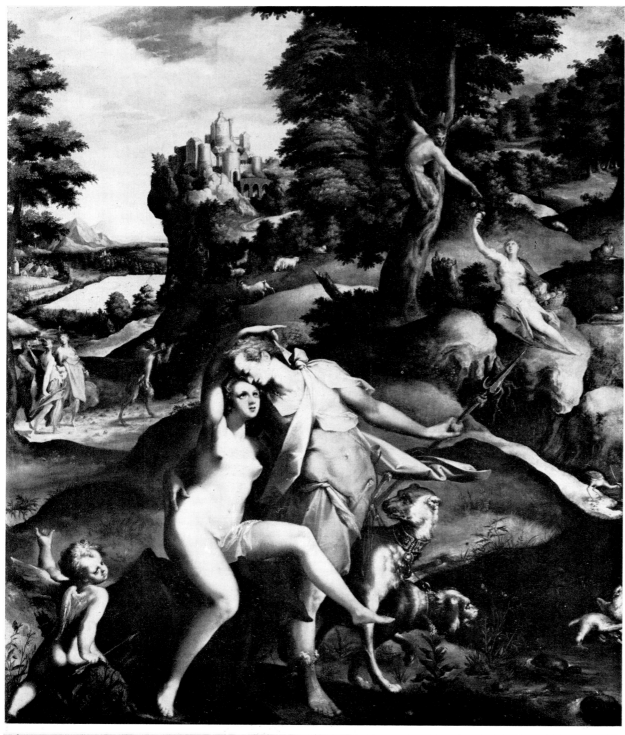

164 Bartholomeus Spranger, Venus and Adonis, about 1576, oil on wood, 135 × × 109 cm, Amsterdam, Rijksmuseum

165 Bartholomeus Spranger, The Judgement of Paris, about 1580, drawing, 16 × 27.9 cm, Prague, National Gallery, Collection of Graphic Works

166 Bartholomeus Spranger, Hermes and Athena, about 1585, fresco, a circle, 275 cm in diameter, Prague — Castle, White Tower

167 Bartholomeus Spranger, Venus and Amor on a Dolphin, about 1575—76, drawing, Vienna, Graphische Sammlung Albertina

all, a sensitive and educated art-lover with a sense even of artistic creation and, it seems, also of the spiritual and psychological tensions which, for the artist, are connected with it. This approach to art "from within" was an important historical novelty. The unusual degree of comprehension and the wide sphere of action he left to his artists furnished him with another, "higher", authority than that of an emperor only, and with an influence upon the Court artists, enabling him personally to approach Court art from a point on the borderline of creative identification.

The evaluation of Rudolphine collections, as well as the interpretation of Rudolph's patronage of art, has followed a similar line — from embarrassment and reservations to high appreciation. Formerly historians were inclined to look upon the collections as a cabinet of curiosities, an odd conglomerate of great works of art, material treasures and *mirabilia*,[182] but the present investigation, on the contrary, continually discloses the wide horizons, the clear-

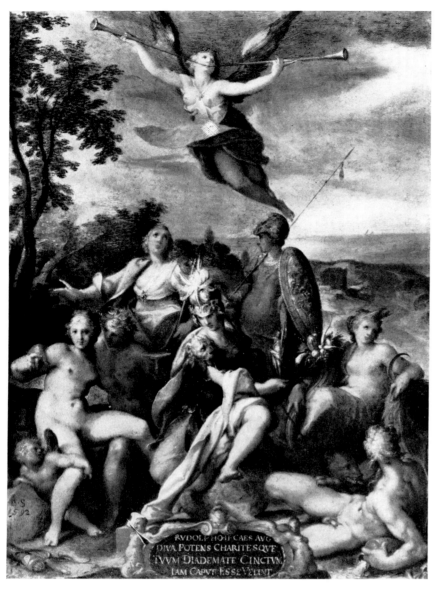

168 Bartholomeus Spranger, Allegory on Rudolph II, 1592, oil on copper, 22 × 17 cm, Vienna, Kunsthistorisches Museum

169 Bartholomeus Spranger, Epitaph of Goldsmith Müller, about 1590, oil on canvas, 240 × 160 cm, Prague, National Gallery ▶

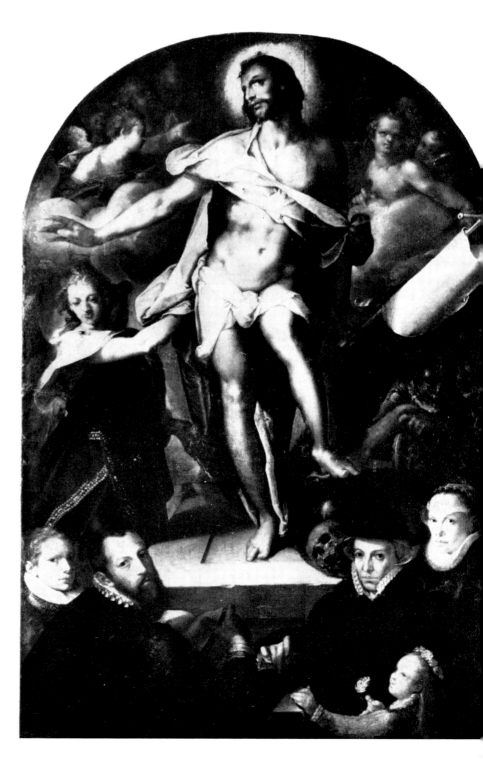

of Court painters he triumphed over the Turks whom he dreaded; in allegories glorifying him he impersonated the virtues in which he believed, and fulfilled, at the same time, his great mission in serving the public welfare which he sincerely wished to promote. In the world of art, he did away with distress and fear and fought the powers of darkness which, as he often believed, were surrounding him. We would say, in modern terms, that art to him — as an art-lover, patron and collector — was a means of coming to terms with the world, as well as a chance of self-realization. However, art was not only a magical remedy, but, above all, an instrument of perception and of experiencing the world as a whole, with all its diversity and contradictions. Rudolph did not underestimate any of the cognitive functions of art given to it by the Renaissance, even if their order of importance (in Prague Mannerism) was altered in favour of the subjective components. He understood the many-sided impact of art on human thought, as well as all the appeals of art, in a way which resembles the modern age to that extent and with those differences that connect and separate the art of the sixteenth century and that of the twentieth. From his patronage of art and his collecting it follows that he was, above

sightedness and the erudition of Rudolph as a collector. An inventory from the years 1607—1611, which has been lately found and which was probably compiled by *Daniel Fröschl* as early as during Rudolph's lifetime, shows the encyclopaedic nature of Rudolph's collections, in which three principal categories were clearly differentiated: *naturalia*, natural objects; *artificialia*, works of art; and *scientifica*, scientific objects. It was this classified variety that was a significant forerunner of the type of museum to be founded in the 19th century.[183] True, the universal character of Rudolph's collections and of his patronage of art was influenced by family traditions, but it was also closely connected with a factor pertaining to the history of art: Mannerist art itself, with its protean character, its sense of experimentation, the importance accorded to novelties and the artistic past, created favourable conditions for unbiassed views, a spirit of open-minded enquiry and a wide range of tastes.

Rudolph's tolerance had a particularly favourable effect upon Court art, scientific research and the whole cultural life of Prague at that time. In spite of his strict Catholic upbringing and the long years (1563—1571) he had spent at the Spanish Court in his youth, Rudolph did not follow the policy of the Council of Trent; on the contrary, in his respect for an unrestricted search for truth, he rather approached those against whom the Council's policy had been directed. The astronomers invited by him to Prague were Protestants — Kepler a Lutheran, and Tycho Brahe a Calvinist. The prominent Court painter Bartholomeus Spranger was a Catholic, while Joseph Heintz, who was no less appreciated, retained his evangelical (Augsburg) denomination. According to Sandrart, it was the Emperor's proxy which saved the goldsmith Paul van Vianen from the Inquisition in Rome when he was accused of blasphemy. Together with Rubens's patron, Vincenzo Gonzaga of Mantua, Rudolph tried to rescue Torquato Tasso, who declared that he did not know whether he was a Catholic or a pagan, from the lunatic asylum where he had been put by the Duke of Ferrara. Rudolph generously rewarded Tycho Brahe, whose assertion that the Earth really was the centre of the universe set him at ease; on the other hand, however, he also supported the disturbing research work of Kepler, who professed Copernicus's opposite, heliocentric view and who made great astronomical discoveries in Prague (such as ascertaining that the orbit of Mars is elliptical).

The tormenting historical and personal contradictions Rudolph experienced — together with the desire to uncover inaccessible secrets — brought him to astrology and also to alchemy, the traditional art of kings. Alchemy, to him, was not a primitive superstition; it attracted him with its deeper philosophical thought, with the ideas of purgation, of human rebirth, of the "recovery of the universe", and also with the vivid images corresponding with the world of art, especially with the process in which works of art come into being. Another aspect of interest to him, in alchemy as well as in art, was the drama of seeking *(quaerere)*, inventing *(invenire)*, persistence in progress *(operatio)*, and the realization of an idea in a work, i. e. the final transformation resulting in the birth of a new quality, the transmutation into an opus. There is no evidence, though, of any deeper influence of alchemist views on Rudolphine iconography, and it is a significant fact that this kind of literature was never provided with illustrations in Prague, although ready and capable artists were not lacking here. The Court art in Prague was influenced, above all, by the cultural and philosophical ideas of humanism, an inseparable part of which were, of course, magic images, typical of the natural philosophy, cosmology and the theory of art of the Late Renaissance period.

Georg Hoefnagel, Emblem of Rudolph II, miniature in the pattern book of beautiful script by Georg Bocskay, 1591—94, Vienna, Kunsthistorisches Museum

The importance attached to alchemy and astrology cannot, therefore, reduce the significance of the scientific discoveries made at the Prague Court under the rule of Rudolph II. Nowadays, historians of natural science rightly regard the excellent works by Rudolphine masters of the arts and crafts, such as clocks, globes and various instruments, as important sources of the present technical age; and among the people who, until recently, have been dismissed as charlatans and adventurers, they often find remarkable research workers and pioneers of science.[184] The great number of findings obtained by observation and practice in the fields of astronomy, mechanics, chemistry, medicine, psychology, zoology, botany, mineralogy, metallurgy and other disciplines, is imposing in comparison with both the previous and the following periods; the fact that they only hint at modern methods and are still dependent on the *a priori* cosmological system does not diminish their importance, if we want to judge this period and its possibilities from a historical point of view.

Owing to this atmosphere, the art of the Court retained the Renaissance craving for knowledge, and the intense research into nature and the whole universe also influenced the character of artistic interests. We can understand, from this point of view, why the monarch's taste was bounded, on the one hand, by a delight in

stylistically refined form and firm order and, on the other hand, by an interest in works covering the widest and deepest spheres of reality, the macrocosm of the multifarious outer world as well as the microcosm of human complexity. Parmigianino's and Giambologna's cultivated Mannerist form interested him in the same degree as Bruegel's cosmic visions and Dürer's humanistic meditation about the world. Being a man of refined perception and great sensibility, he understood well what Venetian art had to reveal about people, especially that of Titian in his "painter's poetry" and in the splendour of his musically resounding use of colours.

In his predilections as a collector and inclinations as a patron, Rudolph II was nurtured by the example of his Habsburg predecessors. He continued the activities of his father Maximilian II who had collected classical works of art, beautiful paintings and books; he had before him the example of the systematic care and wide-ranging tastes of Archduke Ferdinand of Tyrol, but it was the comprehensive collections of Philip II in Spain that made the most decisive impression on him; they influenced his predilections and taught him to appreciate the great masters of art, whose works

he continued to acquire with tireless zeal for the rest of his life.[185] These masters included the Netherlanders, Pieter Bruegel the Elder and Hieronymus Bosch, from among the Italian masters Raphael and Correggio and, above all, the Venetians, Titian, Veronese and Tintoretto, whose works, as well as those of Dürer, attracted him in a particular way. The strong influence of the atmosphere of the Spanish court is also illustrated by the fact that Rudolph's brother Ernest, whose collections the Emperor was to inherit for a great part, followed a similar course in his activities as a collector in the Netherlands, later on. Apart from his Spanish experiences, there was the deep impression left by the large Italian collections which Rudolph saw on his way back in Genoa and in Milan, and especially in the ducal palaces of Mantua and Ferrara. In the person of Rudolph II the activity of the Austrian Habsburgs as art-lovers reached its summit, for none of his successors ever managed to combine so coherently their activities of a collector and patron of the arts with an interest in old and contemporary art, and to pursue them with such zeal and freedom from prejudice.[186]

THEMES AND IDEAS OF RUDOLPHINE ART

A characteristic of the art of the Prague Court was the polarity between idealizing painting, i. e. painting proceeding from an idea in Zuccaro's sense and tending to allegory, and the realistic tendency based on empirical knowledge and an interest in natural science. However, the two currents were connected by common ideas, perceptible in the world of emblems and symbols and bearing upon all artistic production. As in the works of the School of Fontainebleau, the highest religious and profane ideas were equivalent and even interchangeable. If the Resurrected Christ on the Epitaph of the Goldsmith Müller by *Spranger* could appear in the same pose as Minerva in his Triumph of Wisdom, it was because the two figures belonged to the same level of a higher world of ideas. Between them they expressed an idea of Ficino's Neoplatonism according to which there are two equivalent ways leading to the cognition of truth — the light of nature (wisdom) and the light of grace (Christ).[187] Wisdom was the supreme virtue, ignorance one of the worst vices. The Rudolphine period appreciated both knowledge and art, as can be seen from the favourable conditions of life offered to scientists and artists and from their social emancipation expressed in numerous ennoblements. At the same time it also attributed to knowledge a high ethical position.

If Minerva and Mercury usually displace Apollo from Rudolphine allegories, it is a proof that at the Prague Court wisdom and intellect (personified by Minerva) as well as skill (represented by Mercury) were valued higher than inspiration (embodied by Apollo). According to this view, art was based not only on talent, but, above all, on knowledge and diligence. This is why Wisdom is seen in many allegories triumphing not only over Ignorance, but also over Indolence and Envy. *Lucas Kilian's* engraving after *Joseph Heintz*, entitled Tandem virtus obtinet (1603), evinces the idea that art could be attained only with the aid of time, love and work. Appearing again and again was the idea that the mere preoccupation with art and science leads to virtue and to noble elevation above low material interests. This view corresponded with the teaching of Erasmus, according to which the gift of wisdom could only be paid for by diligent work, spiritual effort and renunciation.[188] This is why art could be a permanent value and a guide in the life of man. In the spirit of the stoical view, it was possible, by means of art and wisdom, to face the uncertainty of fate which so worried the Central Europe of the time by its menacing metamorphoses. That is why, in the works of Prague artists, art was connected with virtue and its active implementation. Mercury, embodying moral activity as well as inventiveness and skill, appeared in Rudolphine works not only as a protector of art but also as a friend of the virtues, a partner and mentor of Venus and a defender of men against the malice of fate. That is why in *Sadeler's* engraving of *Aachen's* Hermathene the scene of the victory of Perseus over the Gorgon (in the background) is conceived as a triumph over sin; Pegasus, born of the Gorgon's blood, ascends the Helicon as a symbol of fame *(fama)* which is a reward of virtue.[189] From this point of view it is easier to understand why Rudolphine monarchic allegories, such as *Spranger's* charming picture celebrating the victory over the Turks in 1592 (Vienna) or *Ravesteyn's* glorification of the rule of Rudolph II of 1603 (National Gallery, Prague), link the theme of a prosperous and justly governed empire with that of peace secured in a defensive war against the Turks and with the flourishing patronage of art, welfare and love, which can thrive only in peacetime. As shown by the engraving by *Jan Muller* after *Spranger's Apotheosis of the Arts* (1597), two conceptions of life and politics stood against each other in Prague at this time: the patronage of art, which is a sign of an empire flourishing in peace and wisdom, on the one hand; and the dark barbarism of war, personified by Turkish ignorance and violence, on the other. The way of apotheosising art is characteristic: as love (Amor) raised the soul (Psyche) to Olympus and endowed it with eternal life, so the idea, from

170 Bartholomeus Spranger, The Triumph of Wisdom (Minerva Winning over Ignorance), about 1591, oil on canvas, 163×117 cm, Vienna, Kunsthistorisches Museum

184

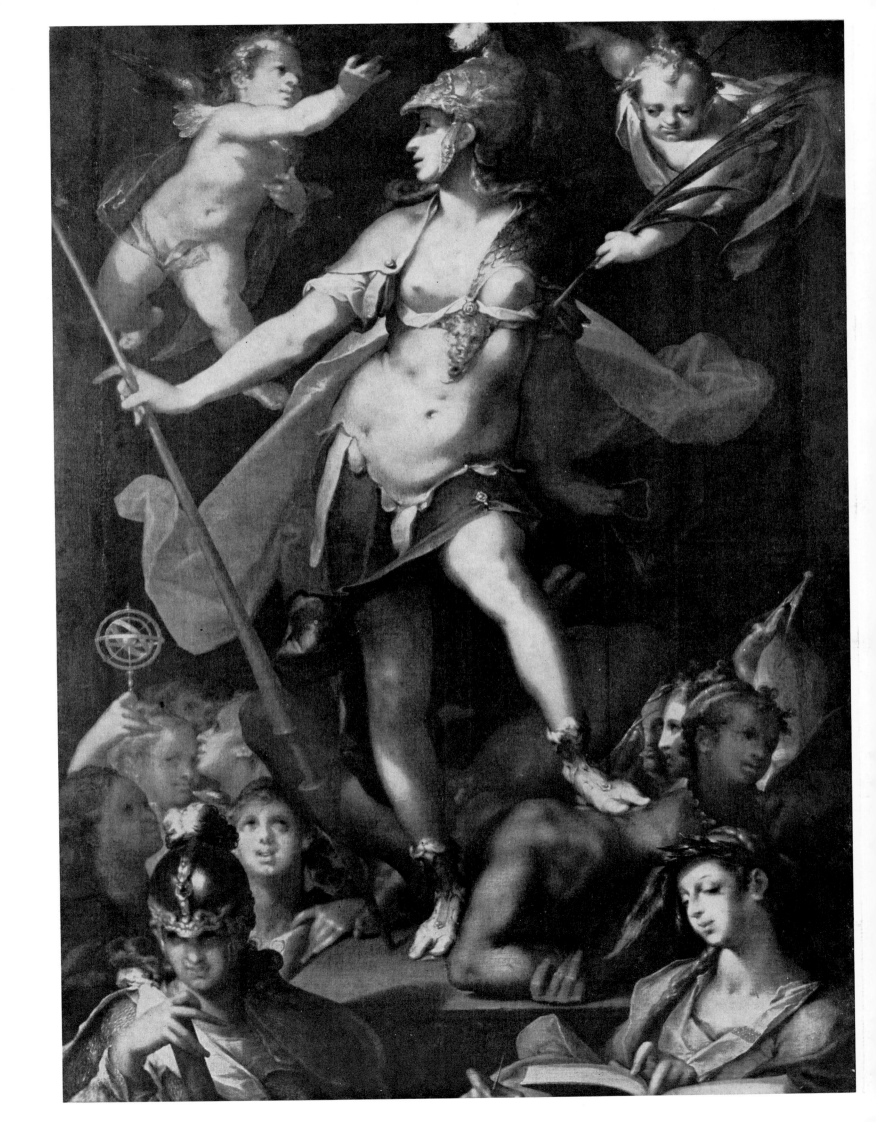

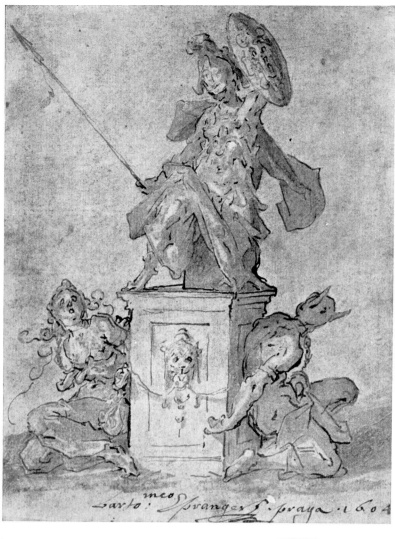

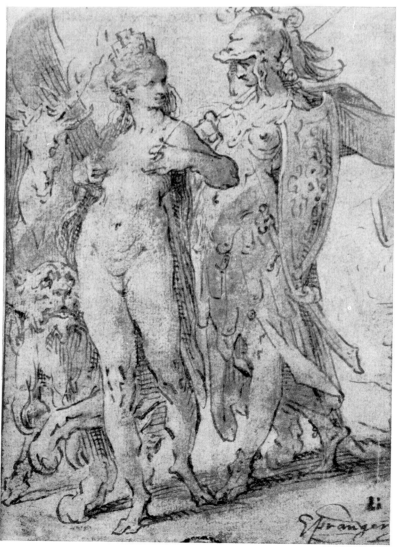

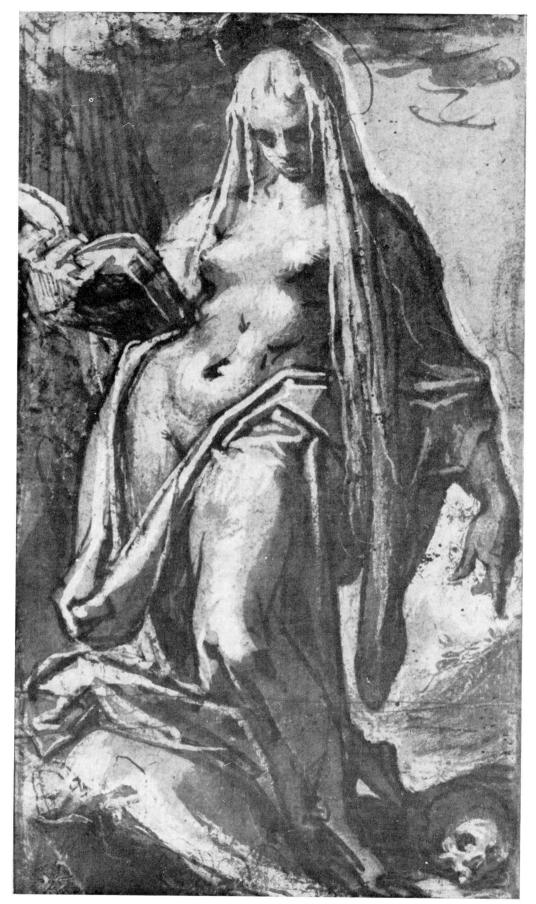

171 Bartholomeus Spranger, The Triumph of Athena over Ignorance and Envy, 1604, drawing, 18.5 × 13.3 cm, Karlsruhe, Staatliche Kunsthalle

172 Bartholomeus Spranger, St Mary Magdalene, drawing, 25.5 × × 14.4 cm, Besançon, Musée des Beaux-Arts

173 Bartholomeus Spranger, Cybele and Minerva, drawing, 19.5 × 13.2 cm, Düsseldorf, Kunstmuseum

174 Bartholomeus Spranger, Venus and Adonis, after 1590, oil on canvas, 163 × 104.3 cm, Vienna, Kunsthistorisches Museum ▶

186

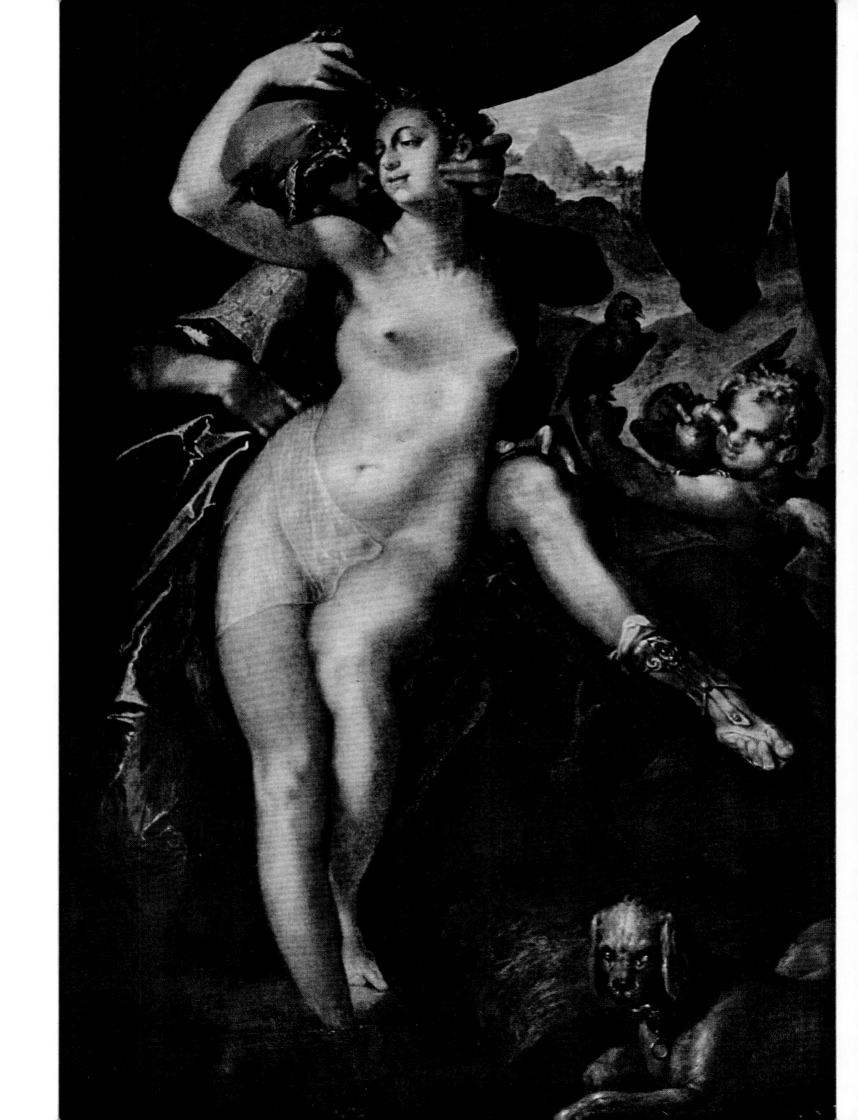

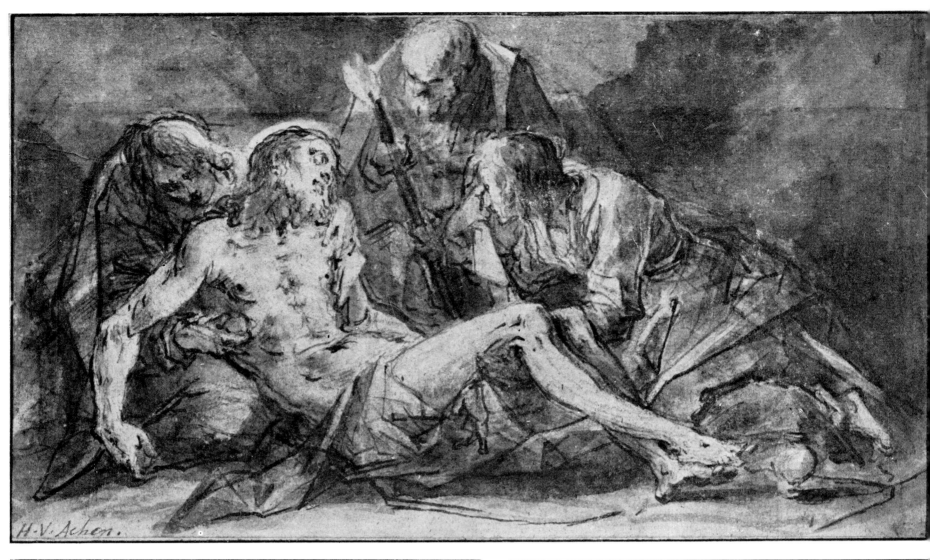

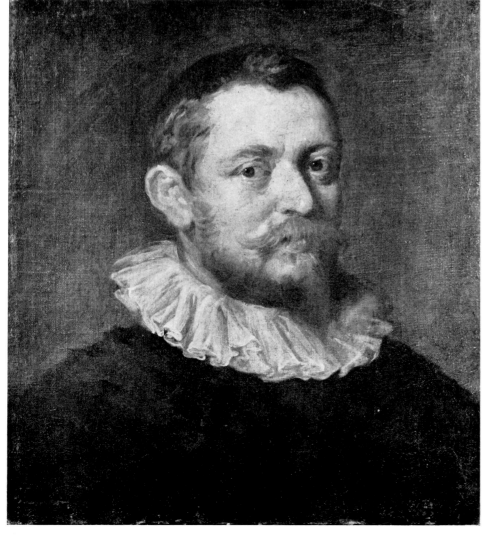

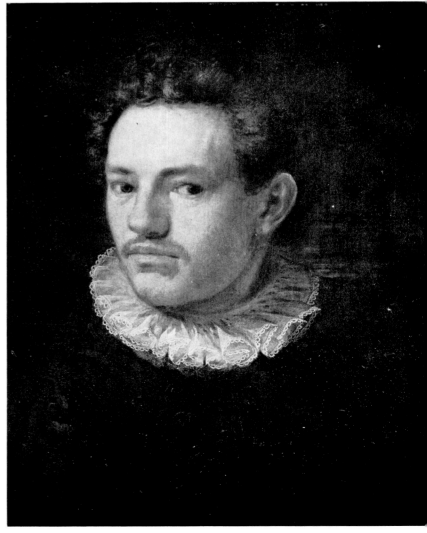

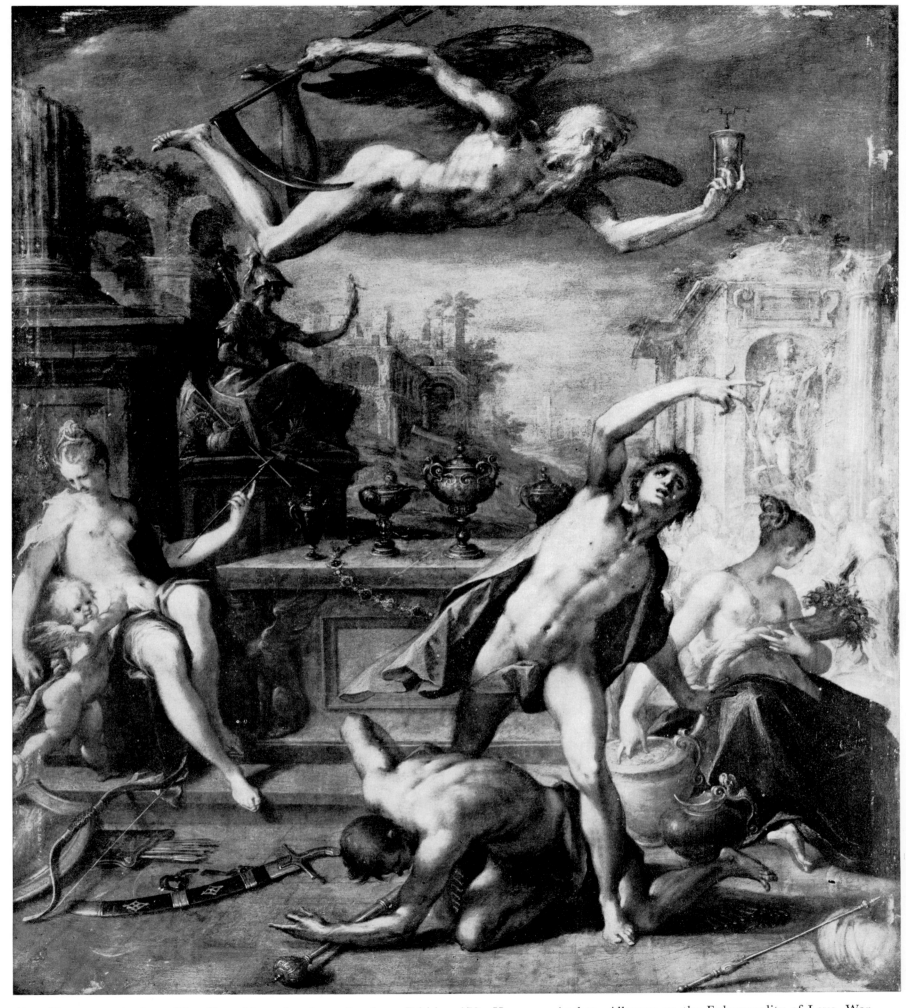

175 Hans von Aachen, The Deposition, drawing, London, British Museum

176 Hans von Aachen, Portrait of the Painter Caspar Rem, about 1574, oil on canvas, 49 × 41.5 cm, Vienna, Kunsthistorisches Museum

177 Hans von Aachen, Self-portrait, about 1574, oil on wood, 51 × 36.5 cm, Cologne, Wallraf-Richartz-Museum

178 Hans von Aachen, Allegory on the Ephemerality of Love, War Triumphs, Wealth and Honours, about 1600, oil on copper, 55.5 × 47.6 cm, Stuttgart, Staatsgalerie ▲

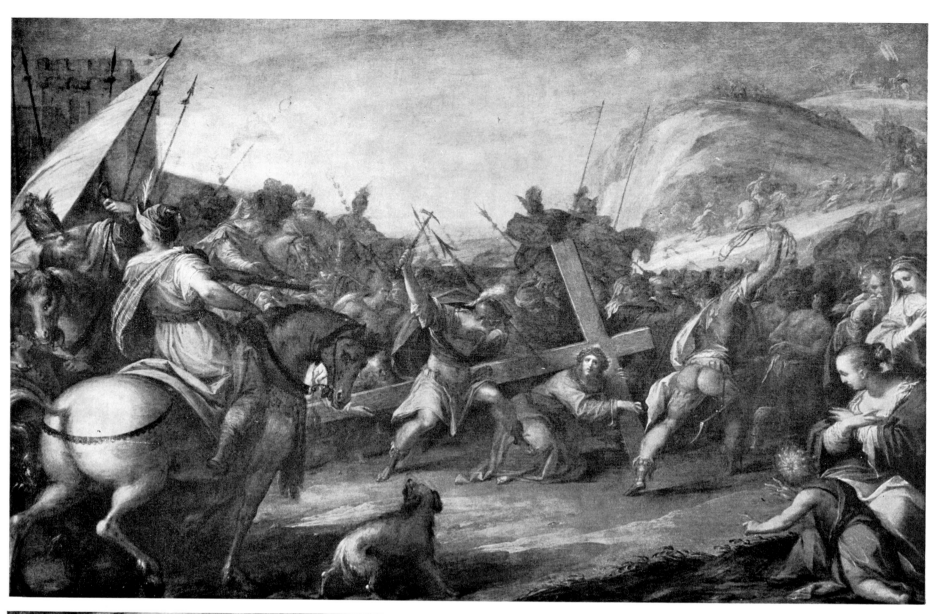

179 Hans von Aachen, The Bearing of the Cross, 1587, oil on wood. 42 × 59.6 cm, Bratislava, Slovak National Gallery (lent to the National Gallery in Prague)

180 Hans von Aachen, The Annunciation of the Virgin Mary, 1605, oil on canvas, 122.5 × 89 cm, Munich, Bayerische Staatsgemälde-sammlungen

181 Hans von Aachen, The Bearing of the Cross, detail, Bratislava, Slovak National Gallery (lent to the National Gallery in Prague)

which art is born, makes it immortal with the aid of Fame.[190] This conviction remains valid even where the Baroque notion of the evanescence of all that is human starts to penetrate the Rudolphine conception. In *Aachen's* picture in Stuttgart, imprecisely called *The Allegory of the Transience of Wealth*, neither love nor war triumph, neither wealth nor honours, resist the power of time — only wisdom and art are out of its reach, only they withstand its destructive effects, and that is why, in Rudolphine art, they are raised above all scepticism.[191] A similar theme can be found in *Spranger's* print (engraved by *Sadeler*) dedicated to the memory of his deceased wife (1600): Painting defends the artist against the arms of time and death, and Fame guarantees victory for his name and his work in the cruel fight.

In this context, the fine arts occupied a privileged position. In *Vries's* relief called *Rudolph II — Patron of Art*, dated 1609 (Windsor), the fine arts stand in the foreground, before the other liberal arts and are rendered as the three Graces holding each other by the hand as a sign of their mutual dependence. The support of art is represented as an act of wisdom, a victory over ignorance realized in the victorious fight of virtue against vice. A more detailed analysis, for which there is not enough space here, proves that Rudolphine allegory, as an heir to the allegoric art of Italian Mannerism, was able to express not only these basic and recurrent principles of the Imperial doctrine of ideas and morality, but also a maze of historical actions, in which it discovered conflicting forces and general principles of life. We may include in this category *Aachen's* cycle of *Allegories of the Turkish Wars*, painted on parchment, of which only fragments have been preserved in Vienna and in Budapest; or the relief *Allegory of the Turkish Wars* by *Vries* dating from about 1603 (Vienna), which derives from Aachen's conception. Concrete events in war are the starting point here but the sense of these works is more general. Once one has comprehended the vocabulary and grammar of the allegoric languages, one can read in the relation of divine and allegorical figures as well as in the combination of epic, heraldic and emblematic allusions to actions and persons, a coherent text, a report and an explication, a dramatic description and assessment of the contemporary military and political clashes.[192]

The erotic scenes from mythology which are so typical of Rudolphine art reveal an ambivalent conception of love. They are, as a rule, permeated by the idea of realizing a perfect harmony of contradictions *(concordia discors)* in the relationship of two different beings; but the unity is incessantly impaired by the variability and internal disunion of human beings *(discordia concors)*. For that reason the world of love is at the same time a world of tension and mutual struggle of different human qualities. An illustration of this theme is found in the loosely connected series of paintings by *Spranger* with themes of gods' and heroes' loves taken from Ovid, Homer and Ariosto, only part of which can now be reconstructed. The series decorated the Emperor's private rooms, probably in a similar way to the paintings in Francesco Medici's *studiolo* in Florence or those in the rooms in Venetian palaces. In these couples or triads, conceived in accordance with the contemporary verse of Marino

as "knots of love" *(nodi d'amor)*, we find a hidden drama behind the magic attraction of their physical beauty. In one, the unsuspecting Hermaphroditus is unattainable for the lovesick nymph Salmacis, in another Scylla ironically gives herself airs of superiority over the enamoured but harmful Glaucus (both paintings in Vienna). While Phyllis rides on Aristotle as if on horseback *(J. Sadeler's* engraving after *Spranger)* and Amor shackles Mercury at the command of Venus to prove that love binds the reason *(Lucas Kilian's* engraving after *Spranger)*, the clever Odysseus delights in the charm of the enchantress Circe but does not yield to it (picture in Vienna). The intellect (Mercury) must mobilize its forces all the time to defend its rights, to penetrate into the mighty empire of Venus and to become an effective partner there.[193] The relationships between the principles personified by the various gods were not unambiguous. The favourite connection of Venus, Bacchus and Ceres, as we find it in *Spranger's* and *Aachen's* works, stemmed from the device of Terence *Sine Cerere et Baccho friget Venus* and was based on the old idea of Lucian that the union of these gods — the life forces — gives rise to a particular joy in life. Sometimes, the issue was to prove the superiority of wine (Bacchus) over the amorous feeling, as in *Aachen's* picture in Vienna, at others to point out that love profits from abundance and wine *(Spranger's* picture in Graz) or that, on the contrary, it suffers after their departure *(Spranger's* picture in Vienna in which Bacchus and Ceres leave Venus shivering with cold over a small fire). But the relationship between these deities could also have a more complicated moralizing background, such as can be found in *Spranger's* painting *Bacchus and Venus* in Hanover.[194]

Venus herself, occupying a special place on the Rudolphine Olympus beside Minerva and Mercury, was conceived, on the one hand, as the giver of sensual pleasure and, on the other hand — in connection with Eros — as a refining force in the Neoplatonic sense, as can be seen from many Rudolphine representations of the myth of Eros and Psyche. Here, the stress was laid on the central idea of a union by love that makes Psyche (the Soul) immortal, promoting her among the eternal gods. It is characteristic that among the first works painted by *Spranger* for Rudolph II was a picture on this theme (until recently in the Gurlitt collection in Munich). Moreover, *Spranger's* richest figure composition which effectively propagated the stylistic conception of Rudolphine Mannerism in the Netherlands was the *Feast of Gods at the Wedding of Eros and Psyche*, engraved by *Goltzius* himself. The first great works executed by *A. de Vries* for the Emperor in 1593 dealt with the myth of Eros and Psyche as well. The fact that Psyche was raised to Olympus by Mercury who, in the art of the Rudolphine period, was regarded as a personification of wisdom, must have influenced the choice of the theme. This is why the fable by Apuleius could inspire *Spranger* to create a similar action, in which, thanks to Idea-Eros and with the help of Fame the fine arts were raised to Olympian immortality. From this point of view, the close connection between love and art in Rudolphine iconography and in the Rudolphine world of ideas acquires a more profound substantiation. (What this connection meant to Rudolph II personally, is suggested by his relationship with Catherine Strada who was herself connected with the world of art.)

In Prague, the cult of Venus and love was not, of course, of the ostentatious and demonstrative character typical of the Italian Courts. In accordance with the different conditions prevailing in the transalpine world, the absence of the Classical tradition, and the influence of Rudolph II himself who considered *eros* to be a feeling which belongs to the concealed, private sphere, these

Egidius Sadeler, Allegory on the Death of the Wife of B. Spranger, 1600, copper-plate, 29.5 × 41.5 cm, Prague, National Gallery, Collection of Graphic Works

themes found application in works of an intimate character rather than in monumental decoration.

In allegorical and mythological subjects, Rudolphine art adapted into a specific form the ideas of Italian court art (Rome, Florence, Mantua), and expressed the general ideas and principles of life in visual form, following the spirit of contemporary theorists (Vasari, Lomazzo, Zuccaro, K. van Mander). In the conception of mythological stories, it employed the device of assimilating painting to poetry — *ut pictura poesis* — and used different levels of significance: that of history, of natural history, and of moralizing and allegory.[195] The programmes of Rudolphine works were based — as we can now judge — on contemporary commentaries on the Metamorphoses, and especially on three much-read mythographers, Lelio Gregorio Giraldi *(History of Gods, 1548 and 1580)*, Natale Conti *(Mythology, 1551 and 1568)* and Vincenzo Cartari *(Pictures of Gods, 1556)*. The general ideological conception of Rudolphine works was derived, as a rule, from humanistic principles orientated towards the natural and moral principles of human society.

If the allegorical and mythological works represented an attempt to settle the harsh contradictions of contemporary society, this was truer to an even greater extent of the emblematic works,[196] the underlying symbolic function of which was to serve as a redeeming moral lesson and a form of philosophical instruction. This esoteric, but for its period very typical intellectual and artistic activity consciously linked word and picture; by mutually potentializing their significance it created a symbolic language used in allegorical works as well as in the other spheres of the fine arts. The emblem as a visual representation of an abstract thought or a philosophical principle could, like paintings, be interpreted on several levels — literally, symbolically, or from the allegorical and anagogic viewpoints. As a rule it required a verbal commentary. The hieroglyphic world of Rudolphine emblems is connected, above all, with the names of the Emperor's antiquary *Ottavio Strada* and the historiographer *Jacob Typotius*. The manuscript *Simbola Romanorum Imperatorum Occidentis et Orientis* from the year 1596. accompanied with fine pen drawings (Museum of Decorative Art, Prague), provides evidence that its main author was O. Strada,

who collected, arranged and, with some ingenuity supplemented a great assortment of emblems relating to rulers and religious hierarchs of all times. This collection was published by Jacob Typotius under the title *Symbola Divina et Humana Pontificium, Imperatorum, Regum (Ex museo Octavii de Strada civis Romani)* with engravings by *Egidius Sadeler* in the years 1601—02 in two volumes with a commentary by the publisher himself; the third and final volume, published after the death of Typotius (1602), was supplemented in 1603 by an explication written by Rudolph's Court physician, mathematician and mineralogist *Anselm Boethius de Booth*. The sources of Rudolphine emblems were Antique medals, cameos and gems, products of Rudolph's activities as a collector; the ideological starting point was the Italian view identifying the emblem with the *impresa* (device), in contradistinction to the conception developing in Germany and the Netherlands where the emblem tended towards the *genre*. To symbolize the individual spheres of Rudolph's activity, Strada gathered and invented altogether sixteen different emblems confronting the Imperial power and qualities with the forces of the world in such a way that the symbol would represent an ideological accomplishment and a moral support. The best-known emblem is the badge representing the Imperial eagle with an arrow in its talons, accompanied by the device *ADSIT*, which was interpreted, first of all, in an anti-Turkish sense: A**d**iuvante **D**omino **S**uperabo **I**mperatorem **T**urcarum (With the help of God I shall defeat the Turkish Emperor). At the same time, also in the general spirit of Austrian piety, it could be taken to mean *Divinum enim* ADSIT *auxilium ubi humanum deficit nos, necesse est* (The help of God is necessary, where human help fails) or A**u**xilium **D**omini **S**it **I**niqui **T**error (Be God's help a menace to the enemy). The three-headed monster, against which the shield and sword encircled by a wreath are turned, represents the Turk ruling on three continents and the Imperial power facing him and not retreating, suggested also by a quotation from the Aeneid: TU · NE · CEDE · MALIS — Do not retreat before the evil (but face it bravely). An eagle in clouds looking up to the sun and accompanied by the inscription SALUTI PUBLICAE represents the sovereign complying with God's wishes for public welfare. An emblem with an astrological flavour, represented in Strada's collection in two variants, was impressively rendered by *Georg Hoefnagel* in his fine miniature in the calligraphic miscellany of Georg Bocskay. Touching the terrestrial globe, symbolizing the world, are a goat with a fish tail on one side and a lion sitting in the sun on the other, with the Imperial eagle hovering above. The goat alludes to the zodiacal sign under which the Emperor Augustus was born; in this respect, the emblem corresponds to the Augustan motifs often appearing in Rudolphine monarchic allegories. Besides, it is among the educated authors of emblematic works, the antiquaries and historiographers, such as O. Strada, J. Typotius and A. Boethius de Booth, that the intellectual originators of these allegorical programmes are to be looked for.

Only in this light can many Rudolphine allegories, and particularly portraits, be understood. Among the latter is the famous bust of Rudolph II in armour by Vries, dating from 1603 and conceived as a counterpart to a similar portrait of the Emperor Charles V by *Leone Leoni* dating from 1549 (both works are in Vienna). This heroic portrait of a state representative can be interpreted in terms of the emblematic apparatus (Jupiter, Mercury, the eagle, the zodiacal sun-lion and the griffin), celebrating the Emperor not only as a supreme ruler of the Christian world and heir to Charles V, but also as a patron of wisdom and art. It has been suggested that the bust might perhaps have a hermetic sense as well, which

can be discerned in the allusion to the philosophers' stone and in the homage to the Emperor as a new Hermes.[197] Emblematic science also made itself felt in the natural-historical pictures of documentary accuracy which represented the opposite of the idealizing figural compositions.[198] In the vivarium of the Prague botanical garden, the artists who had entered the Emperor's service learned to know closely the diversity of the animal and the vegetable worlds. In this environment, *Georg Hoefnagel* and his son *Jacob* made drawings of exotic animals, and in one of his drawings of 1608 *R. Savery* has left us the likeness of an extinct bird, the dodo of Mauritius *(Didus ineptus)*. Hoefnagel's decoration of prayer-books is based on a direct study of rare flora, but it would be a mistake to qualify these works only as artistically impressive representations, faithfully imitating nature. In 1592 Georg Hoefnagel obtained the Imperial privilege and support by virtue of the fact that his works, besides their elegant workmanship, also had a hieroglyphic, mystical and moral meaning, as stated explicitly in a contemporary document. The miniatures in the Missal of Ferdinand of Tyrol (1580—91) interpret the text in a mystical way; a recent monograph has elucidated how subtly ramified Hoefnagel's emblematic world was.[199] Only later on, in the work of Georg's son *Jacob Hoefnagel*, did the orientation towards natural history suppress the emblematic symbolism.

An interest in nature and documentary art were among the motifs that led to the invitation of prominent landscape painters to Prague. In *Savery's* paintings and prints, in the works of *Stevens* and *van Vianen's* fine drawings, typical Prague themes can often be discerned; the romantic character of the surroundings of Prague found its way into their works as well.[200] A counterpart to the awakening realism of landscape in Savery's production is to be found in his figure drawings, which give us the first detailed idea of the appearance, human characteristics and costumes of the inhabitants of the Czech countryside and towns.[201] Thus for the first time the Czech environment was touched by a view that represented an important component of the pioneer efforts of Netherlandish art. To complete a general picture of these currents in Prague one might mention the flourishing of the *veduta*, as evidenced by the fine miniatures of *Georg Hoefnagel* and the big, minutely executed engravings, such as the so-called *Sadeler's View of Prague*, engraved in 1609 by *J. Wechter* after a drawing by *Philip van den Bossche*. An encouragement for the accurate and convincing conception of the town *veduta* was the development of surveying and cartography, evidenced, for instance, by the large town plan of Vienna made by *Jacob Hoefnagel* in 1607—09. Documentary aspects were also developed in the reproduction of graphic art, brought to an outstanding level in Prague by *Egidius Sadeler* with his masterly copper-engravings of Prague Court art of all types and subject matters.

Thus the subjects of Rudolphine art represented a wide range extending from the complex Court allegory and mythology, through profane and religious works to the sphere of nature, rendered with scientific naturalism in the spirit of the newly emergent realism. The theoretical starting-point of the figural painting, which manifested itself most typically in allegorical and mythological paintings, was the Mannerist doctrine of the idea *(concetto),* arising in the artist's mind endowed with fantasy and making his works similar to God's creations. The theory proclaimed by G. P. Lomazzo[202] after the example of Ficino was expounded by Federico Zuccaro,[203] whose views stood near to those of Spranger and other Rudolphine painters. According to this doctrine, the artist should vie with nature by making pictures independent of reality, by a free invention of ideas and fantastic objects. This conception influenced the prominent painters of the Prague Court, who tried to match the production of the contemporary masters

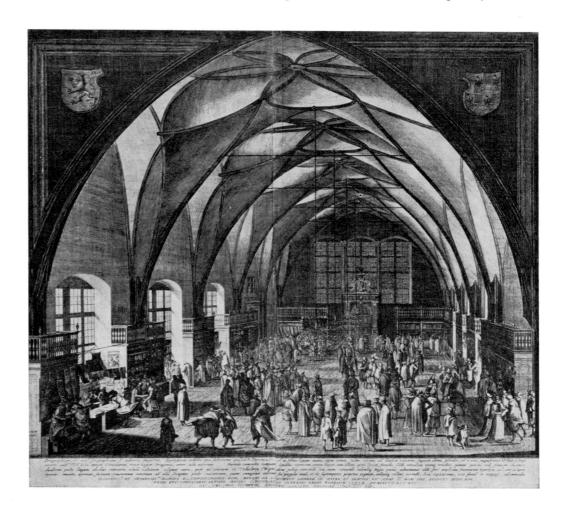

Egidius Sadeler, The Vladislav Hall in Prague Castle, 1607, copper-plate, 61.5 × 58 cm, Prague, National Gallery, Collection of Graphic Works

with experimental zeal and who took delight in testing new possibilities suggested by the production of their colleagues at the Court. "Concettism", a notion proceeding from the spiritual concept of the artist's imagination, became extremely important in the work of Lomazzo's friend *Giuseppe Arcimboldo*. Arcimboldo's heads composed of animals, fruits or other objects are the result of an intellectually focused fantasy and philosophical speculation about the formation of human nature by tendencies which are dispersed everywhere in nature. Here, macrocosm is tied by microcosm: the universe is projected by the painter into the human creature, and the whole cosmos is shaped after the human being and his bodily structure. In the spirit of the view already formulated by Pico della Mirandola that man is an animal of a variable, multiform and dissoluble character *(animal variae et multiformis et dissolutoriae naturae)*, Arcimboldo tried to compose of fragments from the animal, vegetable and mineral worlds an artistic whole which was a parable of the forces active in the universe as well as in man.[204] He was possessed with an idea of the profound disunity of created individuals. His work implementing the Mannerist doctrine of the metaphorical and fantastic "inner drawing" was of a hermetic, experimental character. But it was also an expression of the situation of the human spirit, ever eager for knowledge, which had lost the support of the existing view of the world and was trying to build up a new one from the fragments of old and new knowledge. It was because of their ambition to interpret the world in a mystical and philosophical way and to surpass the existing limits of artistic expression, that Arcimboldo's paintings called forth literary interpretations (Paolo Lomazzo, Gregorio Comanini),[205] which helped to solve the rebuses which they contained and, at the same time, drew far-reaching ideological consequences from their symbolical suggestions. The close connection between the picture and the world, typical of emblematic writings, manifested itself explicitly in this case in the close union of the painter's expression and the theory of art.

On the basis of the writings of Arcimboldo's court collaborator G. B. Fonteo Thomas da Costa Kaufmann has recently pointed out that Arcimboldo's paintings were regarded as belonging to the pictorial style called *grilli* by Pliny. Also the term *chymaerae* was used for them, for they remind one of the monsters created by a connection of various animal forms. They contained an element of joke and play (like the antique *grilli*), but not in the sense of modern jokes; it was play with most serious intentions, aspiration to wisdom, which Caspar Dornavio, in a writing from 1619, suitably defines as joyfully serious *(sapientis joco-seria)*.

The elements from which Arcimboldo's paintings were created themselves give evidence of the degree to which this period was fascinated by nature and by things. "Concettism" represented but one component of the Rudolphine conception of artistic expression. Another component of no less importance was the accurate, reverently faithful cognition of the outer form of nature and of man's environment. In this sense, too, the Rudolphine period had the face of Janus. In its artistic practice, it combined two ways of artistic cognition, which Vincenzo Danti differentiated theoretically in the most persuasive way in 1567, when he maintained that art captures reality by the faithful rendering *(ritrarre)* of imperfect nature on the one hand — which corresponded with the inclination towards realistic re-creation, and by the idealization of nature through the reproduction *(imitcre)* of perfected reality on the other hand — which corresponded with teachings about the idea and the independent spiritual concept.[206] At the Prague Court the respect for these two approaches and their polar unity corresponded to the combination of the Italian view, of which "concettism" was a typical component in the second half of the sixteenth century, and the Northern, especially the Netherlandish, conception in which a "portrait-like" realism gained more and more ground towards the end of the sixteenth century. Apart from the origin and training of the artists, a decisive factor was the historical position of Rudolphine artistic production at the meeting-point of two epochs, at the historical close of Mannerism and on the threshold of a new stylistic conception of the Baroque, which in the dialectic of the artistic image once more allocated an important place to the objective cognition of the world.

In Prague, the polar contradictions of artistic views often came into contact in a way already approaching Baroque art. This showed itself especially in the illusionist tendencies in painting, represented by the architectonic paintings of *Hans* and *Paul Vredeman de Vries*, by certain paintings by *Spranger* and, above all, by wall decorations. Well imbued with the advanced views of the sixteenth century, Rudolph II understood that the value of art is inseparable from the specific variety of expression of individual artists. Following the theoretical standpoint of the time, this view can be summed up in the words of Lodovico Dolce who in 1557 said that there is no single form of perfect painting: "As the qualities and nature of man differ, so different manners come into being, with everybody following the one to which he naturally inclines. This generates different painters, some agreeable, others disturbing, some graceful, others magnificent and majestic, just as can be seen among historians, poets and orators."[207]

THE DEVELOPMENT AND THE PERSONALITIES OF RUDOLPHINE PAINTING

The changing profile and the general development of Rudolphine art are modelled by the dates of arrival of individual artists in Prague, by the combination of their training and knowledge of contemporary art with the tendencies already present in the city, and, finally, by the deeper artistic relationships developing among those who settled in Prague and became naturalized here. Since the nucleus of the group of Rudolphine artists was formed by personalities who had already been summoned by Maximilian II (B. Spranger, H. Mont, G. Arcimboldo, W. Jamnitzer, A. Abon-

dio), it is not surprising that the first steps towards a definite Prague Court style were made after Rudolph's coronation in the 1570s, still in the Viennese environment.

An artist standing rather to one side of the main stream and yet a figure characteristic of the Prague milieu was the Milanese *Giuseppe Arcimboldo* (1527—1593) mentioned above.[208] He entered the Emperor's service in 1562 as a portraitist and designer of masquerades, carrousels, tournaments and stage decorations, and in this capacity he undoubtedly contributed to the outer form of

the festive ceremonies held at Rudolph's Court in Prague. This is suggested by the series of wash drawings of designs for costumes, masks and personifications, dedicated to the Emperor in 1585, now in the Uffizi Gallery. A more important facet of his activities than the conventional portraits ascribed to him in Vienna were, however, the grotesque "composite heads", of which *Summer* and *Winter* are dated 1563; from a later period come *Fire* (1566) and *Water* (in Vienna). Belonging to them were also *Spring* and *Autumn* (Louvre); belonging to the Viennese Elements, Fire and Water, are *Air* (previously in the collection of Wenner Gren in Stockholm) and *Earth*, seen today in the picture formerly deposited in Graz (Joanneum). Of these works, some of which are known in replicas, two cycles — *Elements* and *Seasons*, donated to Maximilian II in 1569 as a New-Year present — have been reconstructed. They expressed not only a sort of visual dialogue between the elements and the seasons and their mutual affection and engagement, but on the basis of a universal analogy between the macrocosm and microcosm they glorified the emperor who governed both the seasons and elements; they were an imperial representation as well as a form of court praize.[209]

The face composed of various animals and fishes has been interpreted as Calvin's portrait, but in fact represents the Emperor's Vice-Chancellor Johann Ulrich Zasius whose face was marked by the "French disease" or by an injury (the painting is now in Gripsholm). The human figure composed of books (in Skokloster) is a caricature of pseudo-humanistic wisdom and probably an allusion to the Court historiographer Wolfgang Lazius. Here philosophical speculation is combined with social criticism, seriousness with pungent humour and even with satire. Among the reversible heads which can be viewed from two sides, the grotesquely conceived picture of the *Cook* (Djursholm) is worth mentioning, appearing from one side as a piece of roast meat between two dishes, and from the other as a man in armour. Among the best works of the late period is the bust of *Flora* composed of flowers (two variants of which used to be in A. Wenner's collection in Stockholm), and particularly its counterpart, *Vertumnus*, from 1587 (Skokloster), composed of different garden fruits and vegetables and representing, at the same time, a remarkably true portrait of Rudolph II; it is a bold and witty metaphor, well characterizing the complexity and the contradictory character of human qualities. It seems to have been a hermetic homage to the Emperor, a connoisseur and admirer of metaphors, capable — according to this picture — of playing all parts and winning every beauty, since he could, in the sense of Ovid's verses, be young and handsome and assume any aspect whenever he liked.[210] According to Fonteo's writings, the Emperor appears in this picture not only as Vertumnus but as Jupiter as well. The connection of these two gods in Rudolph's person and the composition of his face of the fruits of different seasons is to manifest his majesty harmoniously reigning over all seasons, and to proclaim a time of peace and prosperity. It is an Ovidian prophecy of the return of the golden age in which the division into seasons, carried out in the silver age, will be abolished again. Rudolph II thought highly of Arcimboldo's works; in 1580 he confirmed his noble origin and in 1592 he conferred upon him the noble title of Count Palatine. Arcimboldo had appeared in Prague as early as 1566, but later he probably fluctuated between Prague and Vienna. In 1587, "tired by Court life", he asked for permission to return to Milan, from where he kept sending paintings to Prague. Arcimboldo left a work that has become both an object of admiration to modern artists and an eloquent symbol of the

Prague of the Rudolphine and later periods, of its eagerness for new knowledge and its acute perceptiveness of inaccessible secrets, a symbol also of its respect for original artistic invention and of its sense of humour.

Accompanied and stimulated by his friend, the sculptor Hans Mont, Bartholomeus Spranger had already become an influential artist in Vienna. Both summoned to the residential city of Prague in 1580, they did not find there the same vividly pulsating milieu as their colleagues would later on in the 1590s. Mont was disappointed not to receive the commissions he had longed for, and having lost one eye he left soon after, probably in 1582. It was *Bartholomeus Spranger* (1546—1611) who can be considered the founder of Rudolphine art[211] and who, in the 1580s, stood in the very foreground of artistic activity in Prague, but stood largely in isolation without any substantial artistic support. He was to play the principal role in the domestication of the Italian Mannerist view in Prague and in preparing the ground for those who were to come ten and more years later. As one of Rudolph II's favourite painters he kept in close contact with the monarch and, in this decisive early phase, produced important works of different types — mythological and allegorical paintings, frescoes and epitaphs, drawings and patterns for engravings — which exerted a great influence on the taste of Rudolph and his Court. His work became of decisive importance as the starting-point of the newly emerging Court art and as one of the bases of its tradition. After his studies in the Netherlands and a stay in Paris, Milan and Parma, this native of Antwerp spent ten years in Rome (1566—1575), a period which was decisive for his artistic career. But even there he did not forget the years he had spent in the Netherlands (1560—1564), in the studio of Cornelis van Daalem; this can be seen in his unusual landscapes, now at Karlsruhe, one of which is dated 1569. He was deeply impressed by the frescoes of Federico Zuccaro, whose art, together with the school of Parma, had the greatest influence on the formation of his figural style. The follower of Parmigianino in the Netherlands, Hans Speckaert, showed him the way to a particular reassessment of the Italian example, while the sculptor Giovanni da Bologna, also of Netherlandish origin, influenced the formation of Spranger's figural types and acquainted him with the Mannerist *contrapposto* and spiral movement. Spranger came to Vienna with Mont in 1575, and the works he created there represent the first phase of what was to mature into a characteristic style later on in Prague. As evidence of the appearance and quality of the fresco decoration (now destroyed) in the Neugebäude summer house near Vienna we have the beautiful drawing of *Venus and Amor on a Dolphin*, probably dating from the years 1575—76 (Albertina, Vienna). The sponatenous character of its execution, combined with a sophisticated virtuosity, is reminiscent of the drawings of Rosso and Cambiaso. A study sheet with sketches for *The Judgment of Paris* (National Gallery, Prague), is related to it in time and style, illustrating the importance and attraction of Speckaert's art for Spranger's conception of the figural type. Belonging to the same period are the refined paintings of *The Resurrection* (National Gallery, Prague) and *The Parting of Venus from Adonis* (Rijksmuseum, Amsterdam). The latter is arresting in its movements, the figures being set in a landscape of a historical character derived from the example of Leonhard Beck. The small-scale mythological pictures *Jupiter and Ceres* and *Hercules and Omphale* (Vienna) are of special importance in the development of his works. Their refined colouring and elegant web of curves represented, as it were, a preparation for the vast series of paintings, now dispersed all over the world, on the subject

of the loves of gods and heroes, to which the painter devoted himself after his arrival in Prague (from 1580 onwards). In the complex tangle of bodies, sculptural form was bound by the decorative division of the surface. The place which these paintings were to grace brought Spranger close to Veronese who executed some important works on similar themes for Rudolph II (four *Allegories of Love,* apparently ceiling decorations, in the National Gallery, London). Of Spranger's wall-paintings, in which one feels both the inspiration of Zuccaro's art and a connection with Veronese, the nobly coloured fresco *Hermes and Athena,* executed in a pure Italian technique, has been preserved on the ceiling of the White Tower of Prague Castle (about 1585), probably a part of a larger decorative cycle.[212] A rapprochement with the circle of the Prague burghers is suggested by such works as the *Epitaph of the Printer Michael Peterle of Annaberg* (1588) in St Stephen's Church, and especially the *Epitaph of* the Lesser Town *Goldsmith Nicholas Müller* (about 1590). The excellently composed latter work is now in the National Gallery in Prague and was executed by Spranger in memory of his father-in-law. With its ingenious conception of subject matter and form, the stylistically related allegory of the *Triumph of Wisdom Over Ignorance* (about 1591), in the Kunsthistorisches Museum in Vienna, belongs among the most eloquent works of Rudolphine art. The distinct scheme of the surface divison is combined here with an advanced feeling for three-dimensional form; light underlines space much more than before, but not to the detriment of the pictorial surface; the movements have acquired a lightness and a relaxed grace, corresponding with the central idea of the noble superiority of spirit and knowledge. Considerable changes in Spranger's art were brought about by his contacts with his new companions at the court of Rudolph II, Hans von Aachen and Joseph Heintz, who acquainted him with the new currents in Roman and Venetian art and with the importance of chiaroscuro, binding volumes and colour qualities. In the picture *Venus and Adonis* (Vienna) Spranger showed that he could compete with Aachen and Heintz by their own methods, the rich gradation of flesh-tints, the fine subdued colouring and the Classical restraint of composition (characteristic of Aachen). However, none of his companions could surpass him in his ability to highlight the melody of curves by ingenious, expressive accents and to imbue the scene with a magical atmosphere, changing a quiet caress into a gamble with Fate. His works of the late period are characterized by a dark colouring and a velvet tone illuminated by dim phosphorescent lights, as in the picture of *Sophonisba* in the Prague National Gallery. At that time, Spranger's art oscillated between an intellectually based Mannerist conception and a growing inclination towards the Baroque Classicism related to the school of Bologna. The allegory of *The Triumph of Faithfulness Over Fate* from 1607 (in the Gallery of Prague Castle) also reveals the growing influence of Baroccio's and Heintz's conceptions. Yet in his sketchy and soft drawings from that period, such as the lightly drafted *Triumph of Wisdom over Envy and Ignorance* of 1604 (Kunsthalle, Karlsruhe), Spranger did not forget the old example of Parmigianino's Mannerism. The latter is found also in the breadth of conception of *The Penitent Mary Magdalene* (Besançon), a telling document of Spranger's mastery as a draftsman as well as of his late style.

Spranger also occupied himself with portraits, if less often, the most outstanding being his *Self-portrait,* now in Vienna. In the time between Mont's departure and Vries's arrival, Spranger received commissions for sculpted works, too, and his sculptures, mostly small in size, contributed to the formation of the Rudolphine

style. His finely executed terra-cotta relief representing *The Dead Christ Held up by an Angel* has recently been authenticated in a private collection in London.[213]

The significance of this artist, who became fully naturalized in Prague and whose last will was written in Czech, reached far beyond the boundaries of Central Europe. In the 1580s, his influence, extended through the medium of Goltzius's engravings, brought about a complete change of views in the Netherlands, the so-called Spranger revolution of 1583. It was also a decisive factor in the formation of the style of Late Mannerism at Haarlem (Goltzius, Cornelis Cornelisz van Haarlem) and at Utrecht (Bloemaert, Uytewael).[214] Also, without Spranger's contribution, we could not explain the genesis of the gristle ornament from which the lobe style developed.

In comparison with Spranger all the painters who came to Prague in the 1580s recede into the background. The significance of the illuminator *Fabritius Martinengo,* active in Prague in 1582—86, was only of short duration; still more restricted was the sphere of activity of the historically-orientated imitator of Dürer's style, *Johann Hoffmann,* who, from 1584 to his death in 1592, acquainted Rudolph II with Dürer's art.

A more distinct artistic profile is offered by the Dutchman *Dirck Quane van Ravesteyn,* who, according to written records, lived in Prague in 1589, and, after a temporary absence, again in the first decade of the new century (1602—1610).[215] His works dating from the later period reveal that he adopted the style which had been developed from the beginning of the 1580s by the leading group of figure painters, and that he mainly followed the example of Joseph Heintz. His big canvases *The Glorification of the Rule of Rudolph II,* dated 1603 (National Gallery, Prague) and the so-called *Three Graces* (Landesmuseum, Münster) lead us to the conclusion that the two pictures of recumbent women (Venuses) in Vienna and at Dijon, conceived as complementary, are not the work of Heintz, as has so far been supposed, but much more probably by Ravesteyn.

Though Heintz had been appointed Court painter in 1591, a year before Hans von Aachen (1552—1616), the latter's influence on Spranger and his part in the formation of Prague Mannerism showed themselves at the very end of the 1580s, perhaps as a result of his supposed visit to Prague. When he became Court painter in 1592, he began to establish wider personal contacts, although, at first, he operated from the outside, "von Haus aus", being entitled to work outside the Prague Court; and it was not until 1596 that he took up permanent residence in Prague, after having met his obligations in Bavaria.[216] After Heintz moved to Prague in 1598, the trio of leading painters (representing the Italianizing tendency) was complete, and the harmonious interplay of the best talents increased in force. Of great importance was the fact that a few years earlier art in Prague had begun to be influenced by the sculptor *Adriaen de Vries,* an artist of Dutch origin, whose style derived from the work of Giambologna. De Vries, who is said to have been working for Rudolph II as early as about 1590, executed his first monumental sculptures in Prague depicting the story of Psyche in 1593. Though he was not summoned to Prague as Court artist until 1601, his artistic views contributed to the

183 Hans von Aachen, Bacchus, Ceres and Amor, before 1600, oil on canvas, 163 × 113 cm, Vienna, Kunsthistorisches Museum

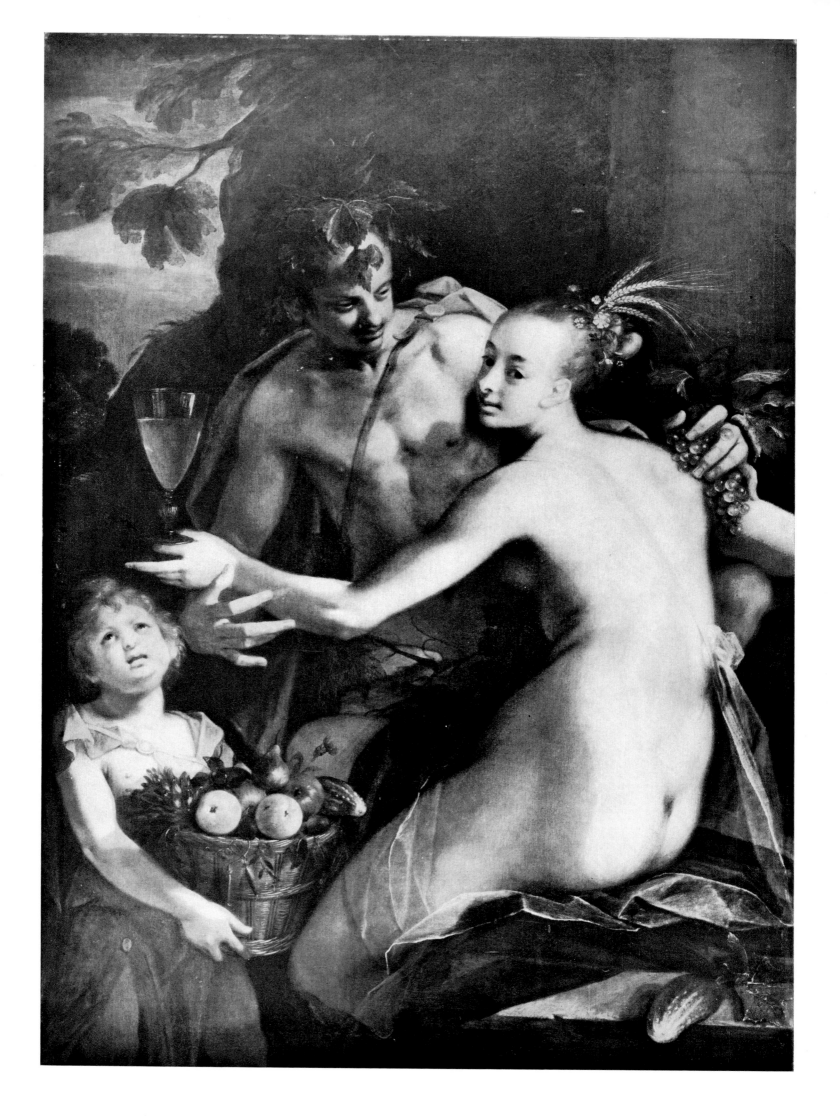

184 Hans von Aachen, Head of a Girl, after 1610, oil on canvas, 51.3 ×38 cm, Prague, Picture Gallery of Prague Castle

185 Joseph Heintz, Venus and Adonis, about 1600, oil on copper, 40 × 31 cm, Vienna, Kunsthistorisches Museum

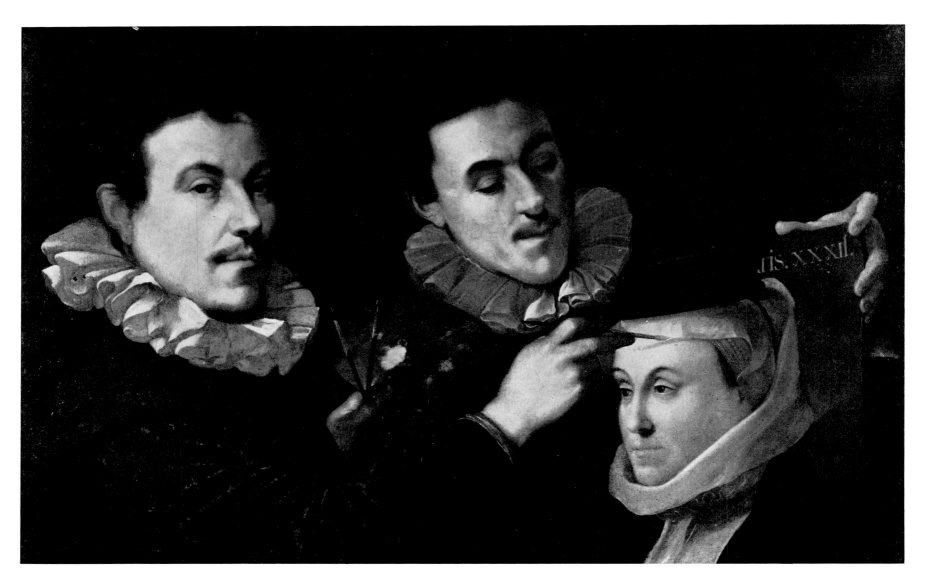

186 Joseph Heintz, Self-portrait with Brother and Sister, 1596, oil
on canvas, 66 × 107 cm, Bern, Kunstmuseum

187 Dirk Quane van Ravesteyn, Lying Woman (Venus), probably after
1600, oil on wood, 80 × 152 cm, Vienna, Kunsthistorisches Museum

188 Dirk Quane van Ravesteyn, Sleeping Woman (Venus), probably
after 1600, oil on wood, 70 × 146 cm, Dijon, Musée des Beaux-Arts

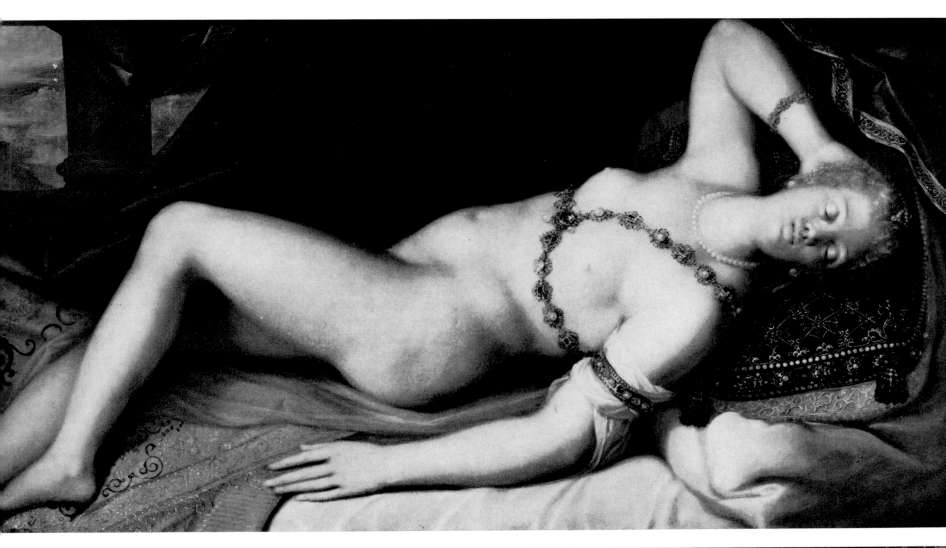
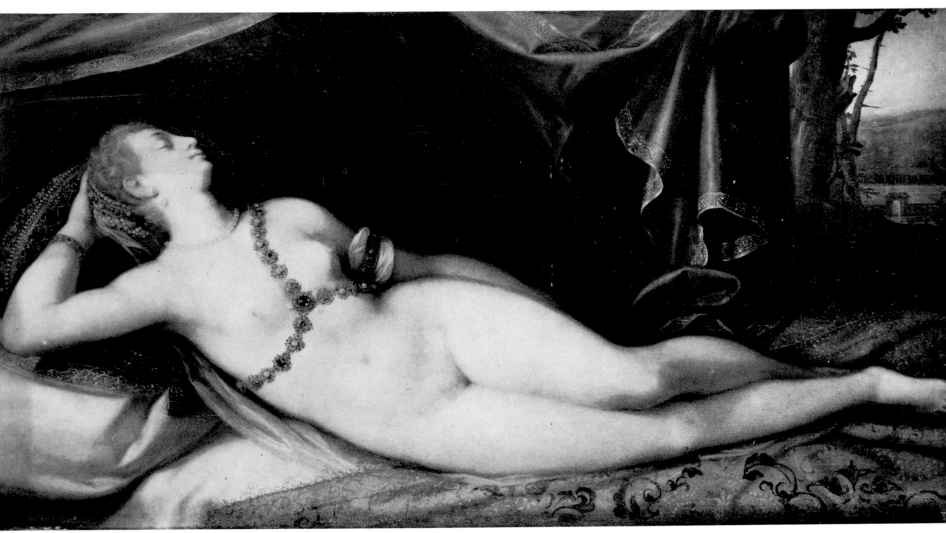

189 Matthäus Gundelach, Adam and Eve, after 1600, oil on copper, 28.7 × 24.2 cm, Olomouc, District Gallery

191 Roelandt Savery, Mountain Landscape with a Woman Selling Fruit, 1609, oil on wood, 40 × 32 cm, Vienna, Kunsthistorisches Museum ▼

190 Roelandt Savery, Old Houses, after 1602, drawing, 23 × 24 cm, Edinburgh, National Galleries of Scotland

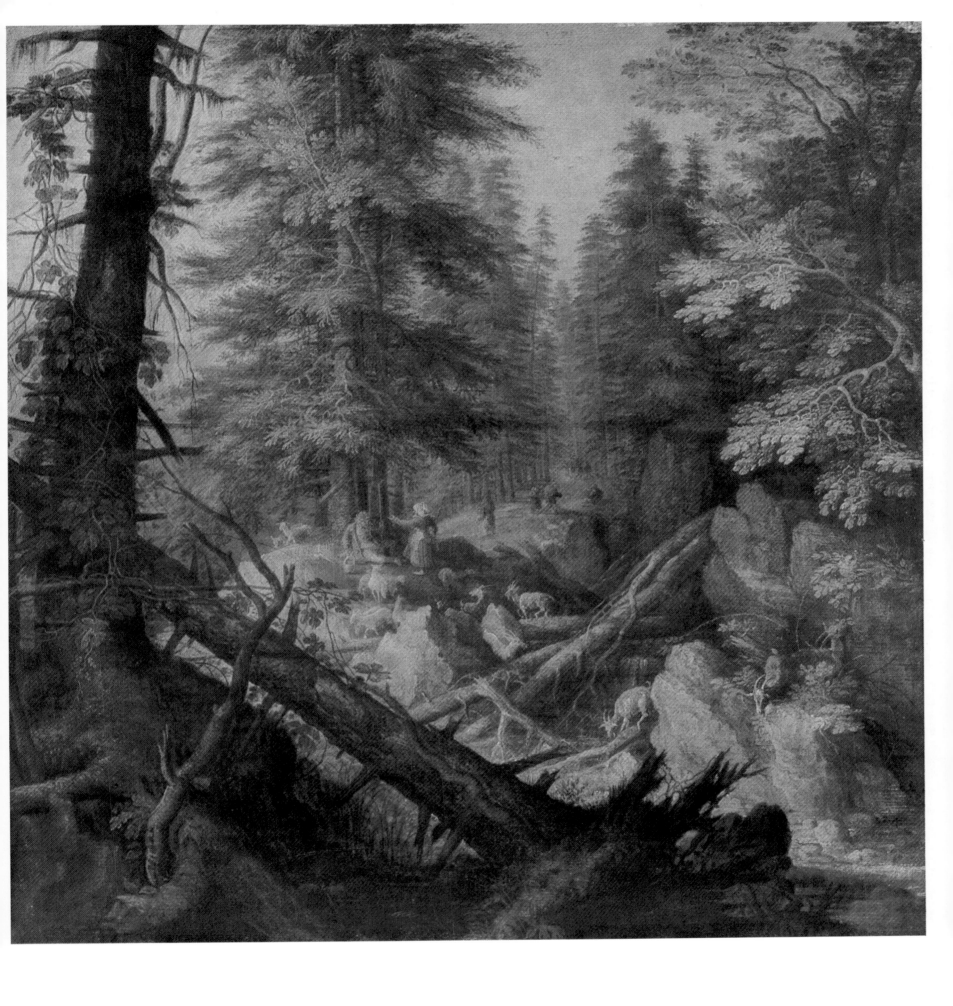

192 Roelandt Savery, Forest Torrent, about 1608, oil on wood, 37 × 35.3 cm, Prague, National Gallery

formation of the character of Court art as early as the 1590s, influencing the most prominent of Rudolph's painters.

Hans von Aachen was first educated in Cologne. Close to the Netherlanders in his starting-point, he had, like his six years older fellow-artist Spranger, adopted an Italianized style which was probably due to thirteen years spent in the South. Unlike Spranger, he tended more to portraiture and to *genre* scenes from everyday life. His stronger tendency towards individualization of the painting, to the matter which Danti called *ritrarre* somewhat subdued in his work the monumental decorative concerns that meant so much for Spranger. Instead, some excellent portraits have come down to us from his Italian period, such as his *Self-portrait* in Cologne, executed at the beginning of his stay in Venice. Another example is the characteristic head of the painter Caspar Rem (Vienna), attesting to his innate sense of the immediacy of pictorial execution; or the humanely perspicacious portrait of the sculptor Giovanni da Bologna (an authenticated version of which is in a British private collection, and a smaller, rather doubtful, version in the Douai Museum, traditionally ascribed to Bassano or his circle [216a]) which attracted the attention of Rudolph II. Shortly after 1585, when in Rome, he painted a remarkable portrait of the painter Joseph Heintz (National Gallery, Prague), who was to become his companion in Prague. This portrait recalls the frequent artistic contacts between the two painters. In the vivid colouring, in the immediacy of movement and the sensitive psychological characterization, Aachen arrived at a conception related to the contemporary portraits by Annibale Carracci, and, simultaneously, to the Baroque view as well. His knowledge of the art of Rome and Florence was coupled with a closer acquaintance with Venetian painting and, above all, with Veronese, who influenced Aachen's art of composition as well as his colour scheme. This is evidenced by the impressive rhythm and the careful composition of *The Bearing of the Cross* (Slovak National Gallery, Bratislava) executed in 1587 at the time when Aachen transferred his activity from Italy to southern Germany. In the impulsive, exploratory atmosphere of Prague, Aachen found, besides his talented colleagues, an environment which was all the more inspiring since the Emperor had extraordinary confidence in him, and on occasion gave him the opportunity of carrying out confidential diplomatic negotiations, involving numerous journeys which increasingly widened the artist's horizon. Besides portraits, such as that of Rudolph II in Vienna, or the touching *Head of a Girl* in the Prague Castle Gallery[217], Aachen was also preoccupied with mythological, allegorical and *genre* painting in Prague. To the first group belong the sensual couple of *Bacchus and Venus*, conceived in the Flemish vein, and especially the Classicist and monumentally conceived composition of *Bacchus and Ceres* (both paintings in Vienna), referring to Italian examples of an advanced style. The second group includes the iconographically interesting cycle of smaller allegories on the motif of the Turkish Wars, mentioned above, and especially the paintings on the themes of *Truth* (Munich) and *Ephemerality* (Stuttgart). Well-balanced in composition and subtle in treatment, they are characterized by a great precision of drawing and an almost Rococo-like lightness. In the third group can be placed the *Procuress's Scene* at Karlsruhe and its replica at Rychnov-on-Kněžná, as well as the remarkable painting of *The Laughing Peasants* from Roudnice, recently stolen from Nelahozeves, dating from the period after 1600. This group gives evidence of the fact that in the sphere of *genre* painting, Aachen participated in the historicism of Rudolphine art showing a tendency to refer to older Netherlandish and German masters.

Aachen's Classicist conception, which influenced Spranger, was strengthened in Prague by new elements foreshadowing the ways of Baroque painting in Bohemia (*The Annunciation of the Virgin Mary*, Munich, Bayerische Staatsgemäldesammlungen).[218] Baroque artists found in Aachen a realistic objectivity and a sense of painting which had been incited by the example of Venice; especially in Škréta's work, the latter remained one of the starting-points of the new style. Like Spranger, Aachen excelled in draftsmanship; in his works he combined clear construction with freshness of execution, a sense of sculptural form and supple elegance of line. An obvious example of this is *The Deposition* (British Museum, London).

Shortly after Aachen, the Swiss *Joseph Heintz* of Basle (1564—1609), the youngest of the trio of Rudolphine painters, settled for good in Prague. He was the son of a stone-mason and builder coming from the meeting points of two-language areas, the German and the Italian.[219] Like both his older Prague colleagues, Heintz spent the decisive period of his growth as a painter in Italy; and among those he chose as his models we find artists respected by Spranger and Aachen as well: Correggio of Parma, the Zuccaro of Rome, and Speckaert of Antwerp, an innovator whose interpretation of Italian Mannerism inspired the prominent Rudolphine artists. Thanks to his inclination towards a freer pictorial treatment and his knowledge of advanced Italian models, Heintz contributed considerably to widening the range of Rudolphine mythological-allegorical and religious painting. In 1591, he went to Dresden on the invitation of Christian I, but, as the Elector suddenly died, Heintz entered the service of Rudolph II. He did not yet stay in Prague permanently, though. After another stay of four years in Italy (1592—96), where he acquired works of art for the Emperor, he worked in Bern and Augsburg, and it was not until 1598 that he settled in Prague for a longer time. His *Self-portrait with Brother and Sister*, dating from 1596 (Kunstmuseum, Bern), contains elements characteristic of Carracci whereas the mythological paintings, also executed during his second stay in Italy, such as the *Diana and Actaeon* (in Vienna) or the *Abduction of Persephone* (in Dresden) drew the inspiration of Venice, especially Titian, in a characteristic form. Heintz further developed this conception in Prague in brilliantly executed pictures which are among his best pieces, such as the oval-shaped *Satyrs and Nymphs* of 1599 (Munich), resembling a varicoloured gem, or the *Adoration of the Shepherds* dating from 1598—99 (National Gallery, Prague), in which the historicizing inspiration by Holbein the Younger combines with a soft and pictorially advanced form. In the painting of *Venus and Adonis* (Vienna), belonging to the erotic mythologies of the Spranger type, Heintz achieved, in the vigorous combination of bodies, colours and atmosphere, a pictorial unity foreshadowing the direction of further development. Conceived in the manner of the Italian pictorial type of *sacra conversazione*, his *Holy Family with St Barbara and St Catherine* from the chapel of St Barbara in St Thomas's Church in Prague (about 1600) is a successful synthesis of Italian examples ranging from Baroccio to L. Carracci. The ornamental eurhythmics of the supple lines and the cool, iridescent tones of the refined colouring, imbue the painting with sublime elegance, without weakening the emotional urgency which already takes it towards the Baroque. Conceived in the Venetian manner, *The Last Judgment* (before 1609, National Gallery, Prague) also belongs to the late period of this artist's production. In its nude figures it reveals a considerable incentiveness, characteristic of Rudolphine Mannerism. Heintz's soft drawings as well as some

Paulus van Vianen, Forest Landscape, after 1603, drawing, Budapest, Szépmüvészeti Múzeum (Museum of Fine Arts)

copper-engravings executed after his drawings and paintings, suggest some insight into the future. In its spirited lightness and brilliant tone, the engraving *Venus and Satyr*, executed in 1600 by Lucas Kilian after Heintz, is not inferior to the best prints of the Rococo style. These works, too, testify to the main contribution of Heintz to Rudolphine painting: he managed to relieve the sternness of Spranger's and Aachen's art by playful fantasy and fresh sensuality, anticipating the artistic views of the eighteenth century.

The period following the year 1590 was thus one of deep changes in the development of Rudolphine art, for in the course of a few years the number of Court painters was increased by the addition of some great personalities, and the group of individual painters grew into a community and a school of art which was different from other centres in Central Europe. This manifested itself both in the standard of stylistic methods, enriched by stimuli from modern Italy and the Netherlands, and in the clear-cut Rudolphine iconography. The close cooperation of the leading artists — Spranger, Aachen, Heintz, Vries, G. Hoefnagel, E. Sadeler — and soon after of the other members of the Court group, promoted an incessant exchange of mutual stimuli and was not very far from the idea of an art academy. Such an academy had been founded as early as 1583 in Haarlem by one of the theorists and historiographers of Rudolphine art, K. van Mander, together with artists who were strongly influenced by the Mannerism of Spranger, by Goltzius and by Cornelisz van Haarlem. True, in Prague, where the Imperial patron himself was the central figure, no such academy was founded, nor did suitable conditions arise for its foundation. The close artistic bonds between the Prague artists were of a somewhat different character, but they resembled the contemporary artists' societies at least in that they were imbued with the belief that art could be learned, and that theory, artistic rules and, above all, good draftsmanship were of great importance; moreover, they developed outside the guild system.

The range of individual branches of painting and pictorial types kept on increasing. The most important Rudolphine illuminator, *Georg (Joris) Hoefnagel* of Antwerp (1542—1600), had been in the Emperor's service as early as 1591. In the ten years of his activity in Prague, Vienna and other places, he enriched Court art with fine miniatures of flowers and animals, emblems and town *vedutas*.[220] A realistic representation of nature, characterized as the naturalistic or rustic style,[221] was becoming more important in this period as an antithesis of the Italianizing "concettism" of the figure painters, although Hoefnagel, too, started from emblematic symbolism. This man from Antwerp, son of a diamond merchant and of a wealthy goldsmith's daughter, was typical of the much-travelled *dilettante*, educated in the humanist tradition, who worked his way up to a clear-cut specialization and a masterly perfection of painting from a broad cultural base, in which natural-historical, topographical and ethnographical interests were combined. But the term "scientific naturalism"[222] does not entirely describe his art, for in most of his works he remained a "disguised symbolist".[223] His earlier works for Albrecht V (a prayer-book) and for Ferdinand of Tyrol (a missal in Vienna) astounded Rudolph II by their fine execution as well as by the ambitious conception of their contents. The main work which Hoefnagel executed for the Emperor in the years 1591—94, was his decoration of a pattern book of beautiful script done as early as 1574 by the Hungarian calligrapher Georg Bocskay (Vienna). Views of towns, portraits, emblems and allegories, accurate representations of plants and animals accompany the calligraphic text and the ornamentation in a loose but sophisticated manner, creating an impressive whole. Georg Hoefnagel's drift towards the new way of observation is visible in his systematic representations of animals, arranged for Rudolph II in four quarto volumes (now scattered all over the world), and dealing with mammals (I), birds (II), fish (II) and, finally, with beetles and butterflies (IV). Yet it was only the meticulous descriptiveness of his son *Jacob*, free of the attachment of symbolism which raised this delicate ambivalent art to the level of a document of natural history.

Landscape painting, too, began to rouse an intense interest, supported by wide-ranging studies of nature. Some time after 1590, the Netherlandish landscape-painter *Pieter Stevens* of Mecheln came to Prague and was appointed Court painter in 1594 (born about 1567, died probably after 1624).[224] He became domiciled in Prague and founded a fruitful family of painters who later on influenced the form of Baroque art in Bohemia (Anton Stevens of Steinfels, John Jacob Steinfels). Pieter Stevens was apparently trained in Antwerp, extending his knowledge at the beginning of the 1590s in Italy. Under the influence of the Czech invironment, he became more and more interested in wooded landscapes, at first influenced by Coninxloo, and his sense of nature grew rapidly. While he composed his scenes largely of motifs observed in real nature, the pictorial whole took on greater and greater organic integrity. His expression came to acquire, in the course of time, an ever broader and looser character, as evidenced by the *Landscape with a Mill* dating from after 1610 (Prague Castle Gallery). Some contact with Venetian painting may be supposed here, facilitated by the travels of Prague Court painters to Italy. But the most momentous of Stevens's modes of expression was the art of drawing. The increasing role of brushwork and the use of light washes betray an acquaintance with the art of Jan Bruegel, who stayed in Prague in 1604. Stevens's vivid perception found application in his drawings of Prague (previously attributed erroneously to Savery): the view of Prague Castle with the Belvedere, of the Charles Bridge with Kampa Island (both in the City Museum, Prague) or of the New Town from the Lesser Town riverside (F. Lugt Collection, Paris). An Zwollo has recently shown that Stevens's interest in light effects, unique in his time, was later developed by the Dutch masters Goyen and Ruisdael, and that engravings after the drawings of Stevens and Savery were of no small importance for the development of the classic Dutch landscape painting.

In 1596 another Netherlander of universal abilities came to work in Prague for a short time, a specialist in fountains, triumphal gateways and gardens, named *Hans Vredeman de Vries* (1527 — about 1606).[225] Together with his son *Paul* (1567 — after 1630), he introduced into Court art the perspective painting of architecture, applied in pictures as well as in the wall decorations of the interior of Prague Castle. Paul's decoration of the New (Spanish) Hall (1596—97), since destroyed, belonged to the pioneer works in Central Europe which widened real space by the painting of illusive spaces, and left a distinct trace in the work of the local artist *Daniel Alexius of Květná*.

With the arrival of the copper-plate engraver *Egidius Sadeler* of Antwerp (1570—1629)[226] in 1597, Prague acquired an accomplished master of graphic reproduction who effectively disseminated the art of the Prague Court to consumers all over Europe, laying open that which had hitherto remained so jealously guarded in Rudolph's inaccessible chambers. Crystalline clarity of forms, elegance in the tracing of lines, and a beautiful, consistent tone, were characteristic of his engravings which were influenced by the development of Rudolphine painting in their growing interest in the effects of chiaroscuro. Sadeler made his permanent home in Prague and did not leave it even many years later, when conditions got considerably worse. This "Phoenix among copper-plate engravers", as he was nicknamed, was responsible for maintaining the continuity of the Rudolphine tradition in Prague, for it was probably he who guided the first steps of Wenceslas Hollar and Karel Škréta in the sphere of art.

The flow of artists coming to Prague in the last decade of the Rudolphine era was not as great as it had been in the 1590s, which witnessed the greatest florescence of Prague Court art, both in quantity and quality. Even after 1600, however, noted personalities arrived in Prague, including several artists whose presence was an essential contribution to Rudolphine arts. It was as late as 1601 that A. de Vries took up residence there. Soon after 1600, the Swabian *Daniel Fröschl*,[227] came to Prague from Augsburg. A painter whose artistic profile has, until recently, remained unclear, he was appointed miniaturist to the Imperial Court in 1603. This artist, educated in the humanist tradition, became antiquary to the Court in 1607, after the death of Ottavio Strada, and was the author of the systematic inventory of Rudolph's "Kunstkammer" from the years 1607—11 (kept in Vaduz). Besides portrait miniatures, he also painted in the style of Dürer and became — after Johann Hoffmann — another representative of the historicizing revival of Dürer's art. This movement, influenced by the Emperor's high regard for Dürer's work, was of great significance, for it also made itself felt — if in a different way — in the work of Spranger and Vries, and affected the Rudolphine landscape painters as well. Also active in Prague was a copyist of P. Bruegel's and Dürer's works, *Jeremias Günther*, who was appointed Court painter in 1604.

As early as 1602, the most important representative of Rudolphine landscape painting, *Roelandt Savery* (1576—1639),[228] appeared in Vienna and probably immediately after in Prague. This son and brother of a painter was educated in Holland and came to Prague as a follower of Pieter Bruegel, whom the Emperor held in high esteem and whose style Savery was developing. The works which can be attributed to the period of his stay in Prague (about 1602—12) are marked by a rapidly growing interest in nature and in the local environment. Like Stevens, Savery was a better draftsman than painter. Whereas in his washed pen-and-ink drawings he followed the Netherlandish tradition (*Landscape with a Church and a Pond*, Rijksmuseum, Amsterdam), his large reddle drawings are original in expression and inventive in the transcription of various natural motifs, such as old trees and strange rock formations. Precisely executed and well-balanced in colouring, the depictions of woodland scenes, such as the *Woodland Torrent* in the National Gallery, Prague, dating from about 1608, represent a change from the schemes of the former compositions, which were done in the Netherlandish manner, to a natural, organic form of composition, already approaching the modern seventeenth-century view. The works of this type do not illustrate a Tyrolean setting, as has been thought hitherto, but make use of the impressions gathered in the woods in the environs of Prague. In his drawings, Savery faithfully rendered the appearance of Prague both in panoramic views (*View of Prague from Letná Plateau*, dating from about 1615, now in a private collection) and in intimate representations of its quiet and picturesque corners (the drawing *Old Houses*, most probably from the Lesser Town, now in Edinburgh). In the years 1606—08, Rudolph II sent him to the Tyrol, where he executed characteristic drawing studies and paintings, manifestly different in their conception of the subject from the works done in Prague (*The Landscape with a Woman Selling Fruit*, in the Kunsthistorisches Museum in Vienna). It was not until later, especially after his return to Holland (1616), that he systematically occupied himself with the painting of animals — which he had painted from the very beginning — and, above all, with "Paradise" motifs, combining the symbolisms of Neoplatonism and Christianity. His move away from the study of reality, and the higher degree of stylistic schematization, characteristic of his later pro-

duction, argue for the fact that Savery's most original experiences as well as the highest pictorial values of his art are connected with the years spent in the inspiring atmosphere of Rudolphine Prague. Savery's activity in Prague suggests conclusively that in the first decade of the seventeenth century there was a growing emphasis in the Court milieu on faithful and realistic cognition; and that, simultaneously, a shift occurred towards a new stylistic manner of observation. The latter can also be discerned in the Baroque and at the same time Classicizing tendencies of figure painting in the work of Spranger, Aachen and Heintz. Somewhat earlier, in 1603, the presence of an excellent goldsmith and medallist, *Paul van Vianen*[229] is recorded in Prague. Having previously worked in Nuremberg and Munich, van Vianen became known in Prague as an excellent draftsman of landscapes, and further developed the tendencies found in Bruegel's drawings from the Alpine area. Savery, Stevens and P. van Vianen formed a trio of cultivators of Netherlandish landscape painting. Each inspiring the other, they represented a counterpart to the great triangle of figure painters, Spranger, Aachen and Heintz. With surprising courage and consistency, P. van Vianen moved away from the usual schemes of composition and space, always proceeding from an absorbing study of reality, which can be compared with the practice of the nineteenth century. The artist's attention remained undiverted by decorative considerations as, by the sparing and accurate use of line accompanied by soft washing, he rendered the variety of nature with a Dürer-like acuteness. The rare balance between the objective manner of representation and the expression of the emotional effect of a landscape increases the appeal of these works. Van Vianen's almost modern sense of nature, besides being the most attractive feature of his drawings, is also evidence of the fact that Rudolphine art simultaneously marked the end of an epoch, and was a period of searching for new ways, leading to the horizons of the remote future.

In 1602, two years after the death of **Joris Hoefnagel**, his son **Jacob** was appointed Court painter. Developing his father's heritage in drawings of plants and animals, he stayed in Prague till 1621, when, as an adherent of Frederick of the Palatinate, he was forced to leave the country for political reasons. While *Jacob Hoefnagel* was to fill the gap left in Prague after his father's death, *Matthäus Gundelach* (about 1566—1654, born in Kassel) was appointed Court painter in 1609 after the death of Heintz. He had probably been working in Prague from as early as 1593 and was to occupy the place abandoned by his one-time collaborator, following his inspiring example. How close Gundelach was to Heintz can be seen in the charming picture of *Adam and Eve* (lent to Kroměříž Château). Proceeding from Mannerism, Gundelach displayed an ever greater inclination towards Correggio's Classicism and became more and more interested in dynamic movement and colour *sfumato* in the spirit of the new Baroque view.

SCULPTURE AT THE COURT OF RUDOLPH II

Although Rudolph II was a passionate collector of works of both Classical and contemporary sculpture, there were not so many diverse personalities working in the field of sculpture in Prague as there were in the various branches of painting. This does not mean, however, that the Emperor attached less value to three-dimensional expression. Painters were concerned with sculpture too (Spranger), and the masterpieces of the Rudolphine goldsmiths and medallists — generally ranked among the works of decorative art — are often supreme non-functional manifestations of high art, using the same language as painting and sculpture in the round. Even though the Emperor had a special liking for cabinet pieces of small size, he showed a similar interest in monumental works, mostly intended for the interior, of course, and therefore akin to intimate works in their precise execution and thematic conception.

Under Rudolph II, the royal mausoleum in St Vitus's Cathedral was completed; it had been planned from the 1540s and begun under the Archduke Ferdinand in 1566, when the model made by Alexander Colin, who was from Mecheln by origin and was working at Innsbruck, was approved. However, it was not until 1584, after an extension of the programme, that the sculptural works were brought to an end, and shortly afterwards (1590) the structural adaptations as well. The tomb with the recumbent figures of Bohemian kings and its well-balanced Renaissance composition with the dominant figure of the Resurrected Christ marks the beginning of monumental Rudolphine sculpture and surpasses all later works of this kind.

The first of the more remarkable sculptors at Rudolph's Court was *Hans Mont*[230] whose presence is confirmed only by a few records and by several works ascribed to him with little certainty.

Born in Ghent (1540—45) and trained in Italy by Giovanni da Bologna, Mont came to Vienna with Spranger in 1575, and there made stucco reliefs for the "New Building" (Neugebäude) in the Viennese pheasantry, and stucco and terra-cotta statues for the triumphal arch set up to welcome the Emperor Rudolph (1576). His activity in Prague (from 1580) was of short duration, being cut off tragically by the loss of one eye during a game in the Prague Ball Court (probably in 1582). Mont had to give up sculpture; he left Prague, carried out some fortification works at Ulm, went back to Italy and is said to have finally left for Turkey. According to the assumption recently forwarded by J. Krčálová, also the sculptural decoration of the Imperial Room in the château of Bučovice (from the 1580s) shows a close connection with Mont's art; this room is a good illustration of what the decoration in the Viennese Neugebäude, which has not survived, may have looked like.

Mont's friend Spranger also occasionally occupied himself with sculpture. But it was only with the arrival of *Adriaen de Vries* (about 1545—1628), who signed his works *"Fries"*, that a great sculptor or European reputation[231] appeared in Prague. This native of The Hague and disciple of Giambologna in Florence came to Prague for the first time in 1593 when he executed the two famous group sculptures of *Mercury and Psyche* (now in the Louvre) and *Psyche Carried to Olympus* (Nationalmuseum, Stockholm), both of which greatly affected Rudolphine art as a whole. After a stay at Augsburg where he made two fountains, one of Mercury in 1599, the other of Hercules in 1602, he settled in Prague for good, being appointed Court sculptor on May 1st, 1602.

Vries's conception was based on the effects of convoluted bodies (*figura serpentinata*), emphasizing the infinitely rich beauty of

movement of the human figure, attractive in all situations and from all points of view. The elegant elongated forms, at first noted for a grace and lightness reminiscent of Giambologna, grew gradually more robust like those of Spranger, acquiring both expressive accent and sensuality. The melody of softly gliding outlines and the smooth modelling of the conspicuously convex and perfectly chased bronze volumes, were accented by accurately reproduced and sometimes sharply stressed details, which were closely related to the conception of the subject matter. Related to the Hercules of Augsburg is another figure of Hercules (now at Drottningholm in Sweden, a cast in the Wallenstein Garden in Prague), dating probably from 1601—02; originally it stood in the New Hall of Prague Castle. Also among the first commissions executed by Vries in Prague was the excellent coloured stucco relief of *The Adoration of the Magi*, made about 1602 for the chapel of the Crown Castle at Brandýs-on-Elbe, often visited by Rudolph II (now in the Prague Castle Gallery). This work, deriving from Dürer's compositional scheme, translates into the refined language of Italian Mannerism the colour effects of Late Gothic polychrome reliefs in the spirit of Rudolphine historicism. Besides two mythological abductions *(Hercules and Deinaeira, Hercules and Iole)*, he executed several excellent busts of Rudoph II in Prague in the years 1603 and 1607 (Vienna). The less well-known portrait relief of Rudolph II of 1609 (Victoria and Albert Museum, London) belongs to the same period, its glorifying conception similarly emphasizing the Emperor rather than the man. Concerned with allegories of the Emperor like the Court painters, de Vries applied them in reliefs *(Rudolph II as Patron of Arts*, 1609, at Windsor), as well as in free-standing sculpture. *Virtue Conquering Vice* (1610, in Washington), a group conceived in the spirit of Ammannati, represents the triumphing Empire — *Imperium triumphans*. The Windsor relief was probably executed after Spranger's design, and the same was done in the case of a beautiful relief of a precise linear execution, *Bacchus Finds Ariadne on Naxos* (Rijksmuseum, Amsterdam) dating from about 1609—10. This work refers to a previous composition of Amor watching the sleeping Psyche. We know the latter from a copper-engraving by *Jan Muller*, which is, of course, only a reproduction of Spranger's terra-cotta relief.

Excellent sculptures of animals, in which the motifs of Giambologna were developed, form a notable part of de Vries's artistic production. The *Ambling Horse*, now at Drottningholm, is probably identical with that mentioned in the list of the artist's works of 1607, while the dynamically impressive variant in the Prague Castle Gallery dates from 1610.

A new expressive tone announcing the emergence of the Baroque is found in the seated figure of *The Man of Sorrows* (1607) and in the *Fettered St Sebastian* (1613—15, both in the Liechtenstein Palace in Vienna). In the latter, which is related to Spranger's painting in St Thomas's Church in Prague (about 1600)[232], the individual parts of the body are already subordinated to the homogeneous, uniform mass, in accordance with the new conception of the artist's late period. The ambitious stucco decoration of the New Hall at Prague Castle, unfortunately not preserved, is known through the records only; according to these ten mythological sculptures stood in their original places as late as 1650. After Rudolph's death, de Vries entered the service of the Emperor Matthias, but worked for other commissioners as well; he finished a fountain for the King of Denmark in 1617 (transferred by the Swedes from Frederiksborg to Drottningholm); he executed a richly decorated tombstone for the Prince of Schaumburg-Lippe

at Stadthagen in 1617—20, and after 1620 also the excellent bronze groups of *Venus and Adonis*, and of *The Abduction of the Sabines* (now in the Staatliche Museen, Berlin). The last phase of de Vries's artistic activity, however, is connected with Bohemia again, with the set of bronzes executed in the years 1623—26/27 for the garden of the Wallenstein Palace. (Only modern casts, placed in a way which does not correspond to the original situation, are to be found there nowadays; the original sculptures carried off to Drottningholm are disposed there in an equally arbitrary way.) According to W. Crowne's records of 1636[233], the Wallenstein Garden contained four more fountains with big bronze figures besides the centre fountain with Neptune surrounded by four nymphs below. They seem to be identical with the groups in the Drottningholm garden — *Venus and Adonis* (1624), *Bacchus* (1624), *The Wrestlers* (1625) and *Apollo* (about 1625). The design of the big fountain, which was originally to be surmounted by a group of *Laocoön and His Sons* (1623, also in Drottningholm), was changed in 1626 by the commissioner, Albrecht of Wallenstein, who ordered the figure of Neptune (1626—27) to be placed on top, most probably as a symbol of his ambitions to found a great naval power on the Baltic coast.[234] The simplicity of the general conception of the fountains was counterbalanced by the inventiveness of movement and by the painstaking composition of the individual groups of figures, modelled in a soft, often sketchy manner. The tension between the beautiful bodies and the rude faces was one of the characteristics of the artist's style in his old age, as was the vegetative energy of figures, dynamically connected with space and dazzling the eye in an interplay of light and shade. The figure of *Hercules*, executed in 1625—26 simultaneously with the sculptures for the Wallenstein Garden (formerly in the Prague Castle Gallery, now in the National Gallery, Prague), shows how, in the conception of movement, in dramatic contrasts and in proportional exaggerations, de Vries in his late work prepared the incoming of the Baroque style, although even here he did not surpass the limits of the Mannerist style.

This native of the Netherlands naturalized in Prague was one of the most outstanding sculptors of the Renaissance and Mannerism in Central Europe; there was nobody equal to him in bold invention, vigour of characterization, or in melodious composition of the whole. He was one of the great artists who influenced the development of sculpture in Bohemia. Only the masters of the "Beautiful Madonnas" before him, and the exponents of Bohemian Baroque sculpture after him, expressed themselves in a similarly eloquent and individually shaded language.

In the person of de Vries, Rudolphine art extended into the next epoch; it was one which sought its sources of artistic ideas no longer in Renaissance humanism, but in the Catholicism of the Counter-Reformation and simultaneously served a different, polemical and apologetic, function. After the death of Rudolph II a thorough change took place, for the art of the Court had lost its mainspring and its chief focus. Some of the Court artists, such as Heintz, G. Hoefnagel and Spranger, had died before their patron, others left shortly after his death. The moment Matthias ascended the throne showing but little interest in art, Prague lost the advantage and attractions of an Imperial residential city, and the once large group of artists gradually began to break up. Further disruption was caused by the Revolt of the Czech Estates and the cruel reprisal measures which followed its defeat, and the new cultural and artistic orientation of Ferdinand II's reign, politically one-sided and governed by the spirit of the Counter-Reformation. Only artists who had found a new home in Prague and had become permanently

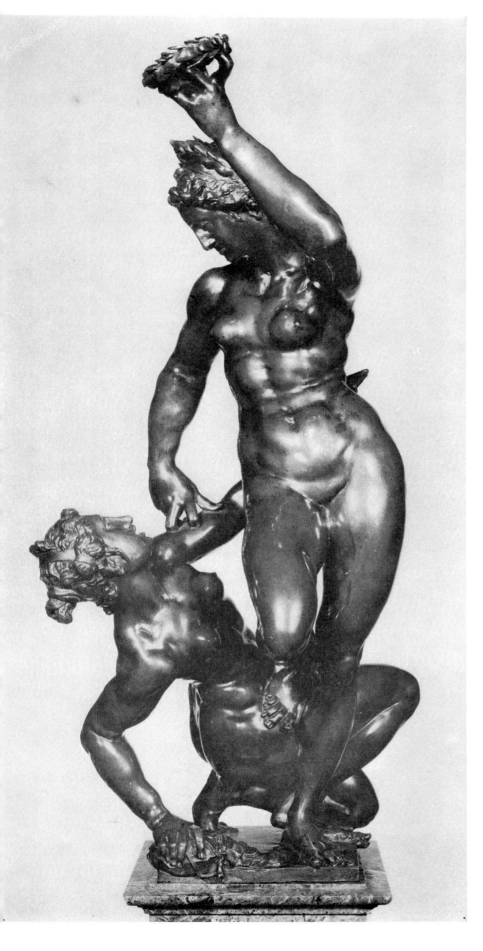

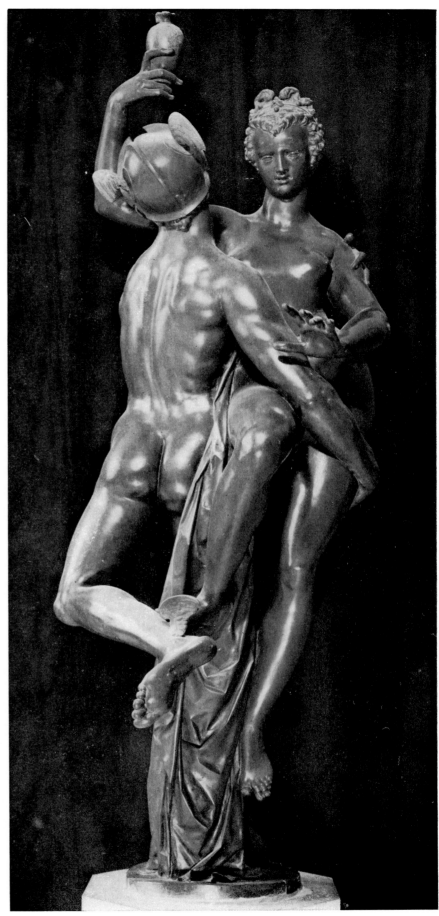

193 Adriaen de Vries, Virtue Conquering Vice (Imperium Trium-
phans), 1610, bronze, h. 77.3 cm, Washington, National Gallery
of Art

194 Adriaen de Vries, Mercury and Psyche, 1593, bronze, h. 250 cm,
Paris, Louvre

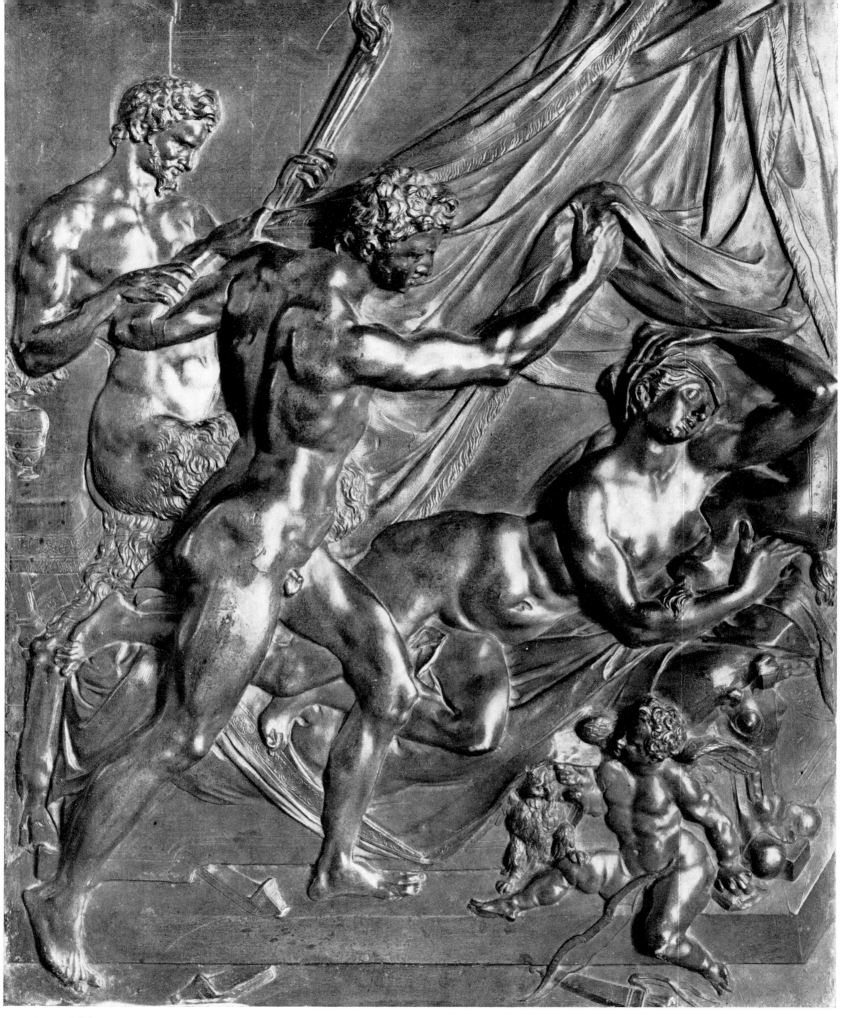

195 Adriaen de Vries, Bacchus Finds Ariadne on Naxos, about 1609 —10, bronze relief, 52.5 × 42 cm, Amsterdam, Rijksmuseum

196 Adriaen de Vries, The Adoration of the Magi, about 1602, polychrome stucco relief, 167 × 118 cm, Prague, Picture Gallery of Prague Castle

▶

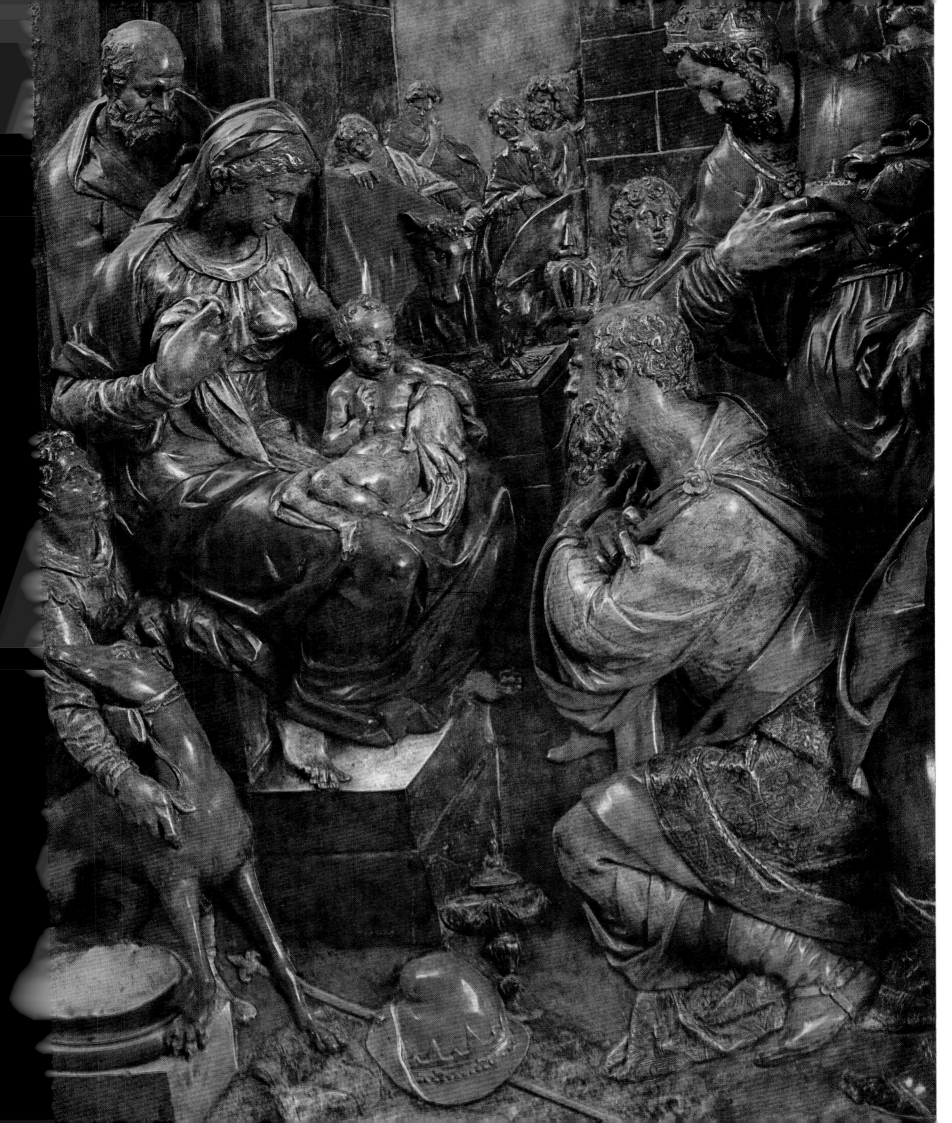

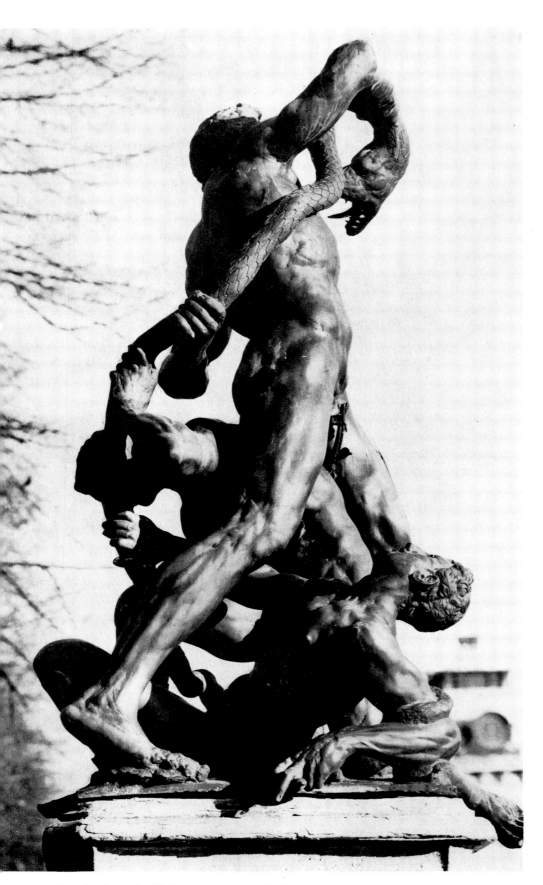

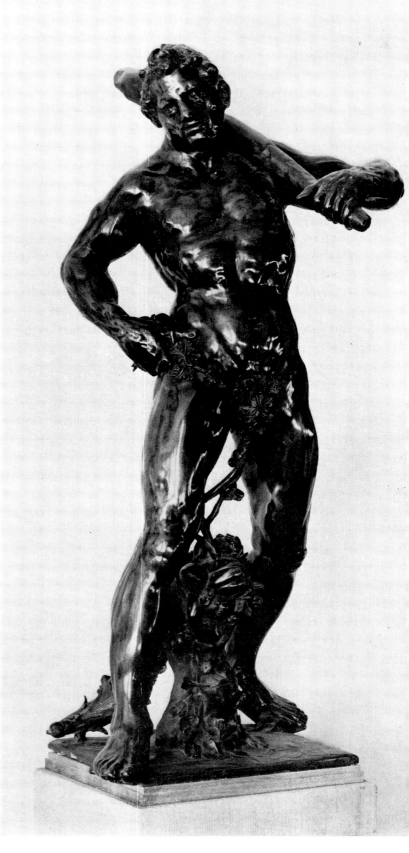

197 Adriaen de Vries, Laocoön and his Sons, 1623, bronze, h. 172 cm, Drottningholm, the Château Garden

198 Adriaen de Vries, Hercules, about 1625—26, bronze, h. 162,5 cm, Prague, National Gallery

199 Adriaen de Vries, Horse, detail, 1610, bronze, h. 52,5 cm, Prague, Picture Gallery of Prague Castle ▶

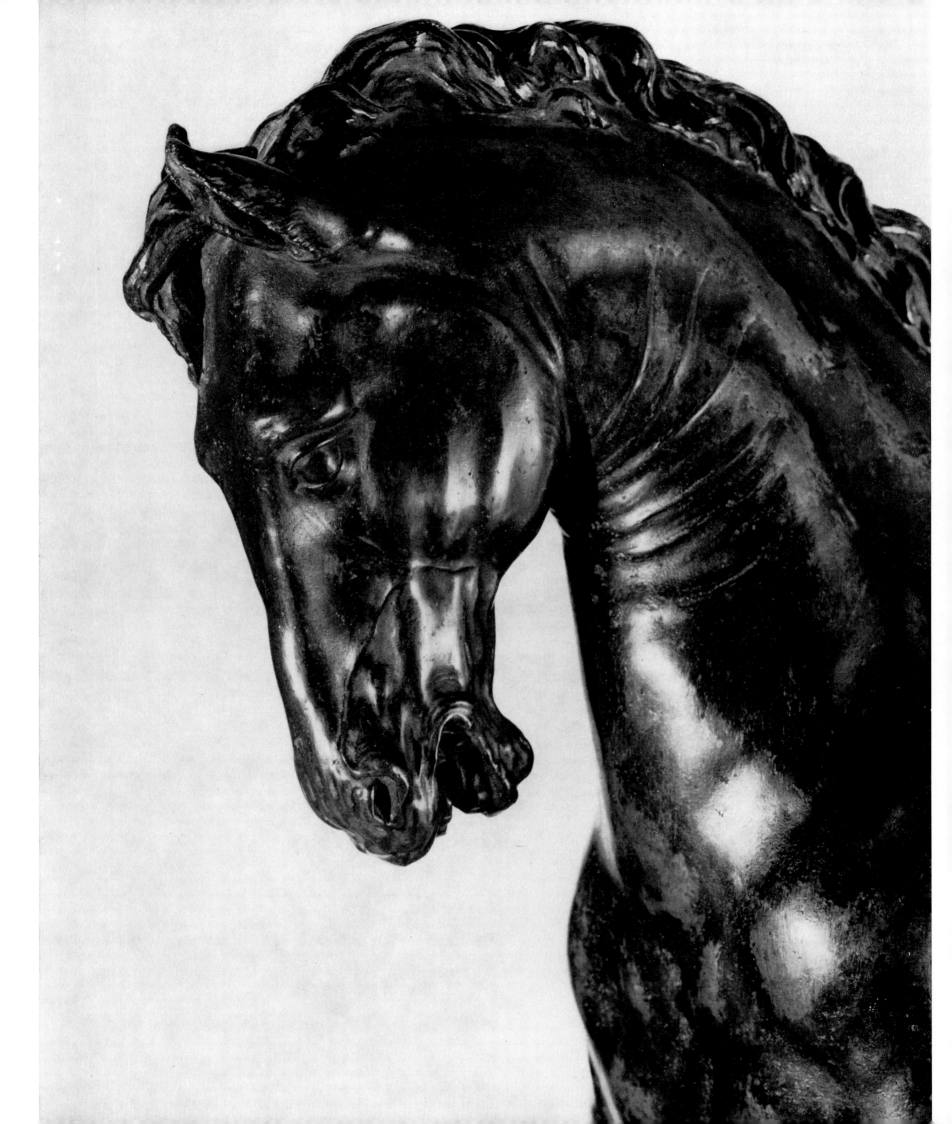

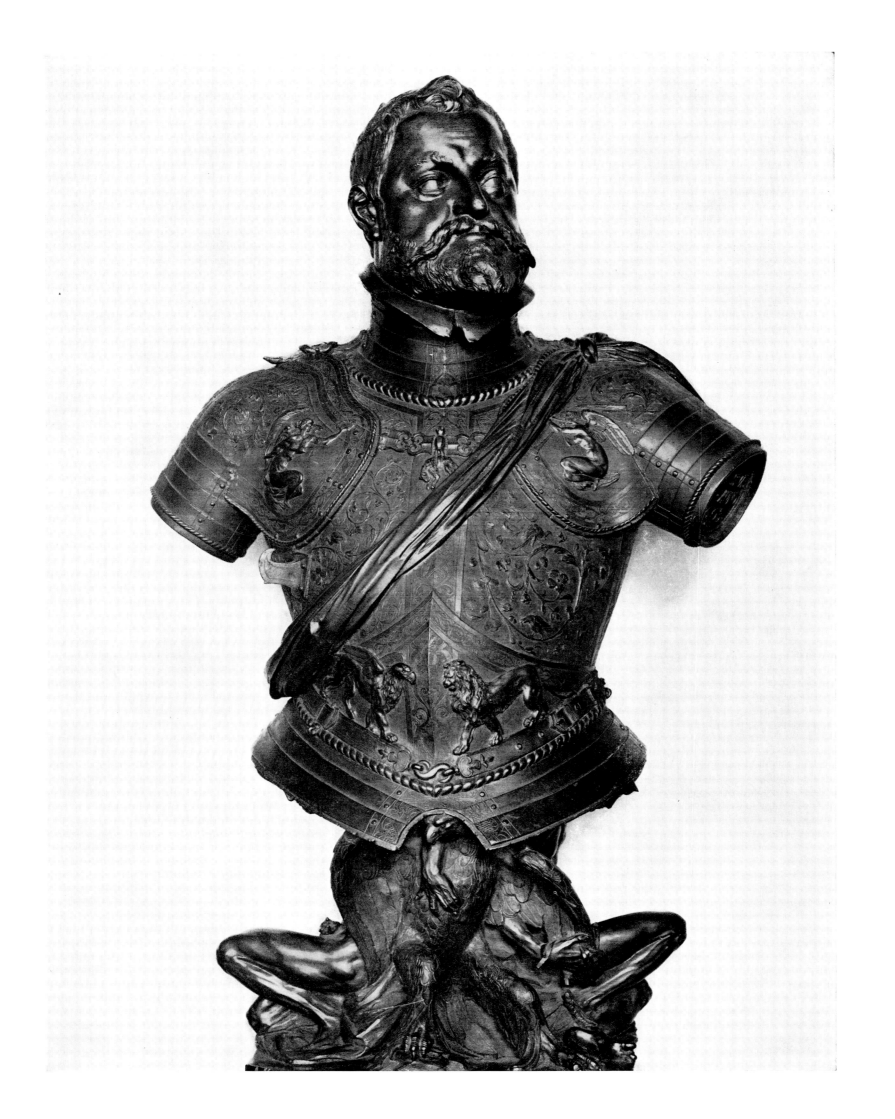

involved with the city, remained there. Those artists who carried on their creative work under the new conditions, bringing Rudolphine glyptic art into the Baroque era — be it Adrian de Vries, Egidius Sadeler or the Miseroni family, must take credit for not allowing the tradition of Rudolphine art to be broken up entirely by the adversity of the times.

The extensive collection of works of Court art in Prague Castle was substantially reduced under the rule of Matthias, who carried away to Vienna some exquisite examples uf Rudolphine painting and decorative art. The core of the famous collection of Rudolph II remained in Prague throughout the Thirty Years' War, but it was not to survive the youngest representatives of Court art. Dionysius Miseroni, the son and, from 1623 onwards, the successor of the foremost Rudolphine glyptographer Ottavio Miseroni, was forced in 1648 to hand over the keys of the famous Prague "Kunstkammer" to the Swedes who carried away the art treasures of the Saturnian Emperor and thus made the first fatal step towards their dispersion all over the world.

200 Adriaen de Vries, Bust of Rudolph II, 1603, bronze, h. 112 cm, Vienna, Kunsthistorisches Museum

NOTES

(References which occur repeatedly or are included in the final bibliography are abbreviated here)

1 From the Vladislav Jagiello's letter to Lord Henry of Hradec, 1504; cf. J. Kalousek, O Královském Hradě pražském (Prague Royal Castle), Prague, 1907, p. 19.

2 V. Mencl, Catalogue of the exhibition called "Prague Castle in the Middle Ages", Prague, 1946.

3 F. Palacký, Dějiny (History), 5, p. 241.

4 Bohuslaus Hassensteinus de Lobkovicz, Epistolae, ed. T. Kardos, 1946.

5 J. Lippert, Geschichte der Stadt Leitmeritz, 2, p. 457ff.

6 K. Chytil, Malířstvo (Painting), p. 63ff.

7 J. V. Šimák, "Zprávy o malířích" (Reports on Painters), in Památky archeologické (Archeological Monuments), 18, 1898/99, p. 458ff.

8 Archiv český (Czech Archives), 18, 1900, p. 54; F. Eckert, Posvátná místa (Sacred Places), 2, p. 16.

9 J. Pešina, "Paralipomena", in Umění (Art), 15, 1967, p. 252.

10 See Note 4.

11 B. Lazár, "Die Kunst der Brüder Koloszvári", in Studien zur Kunstgeschichte, Vienna, 1917; V. Kotrba, "Die Bronzensculptur", in Anzeiger des Germanischen Nationalmuseums, 1969, p. 9ff.; A. Kutal, "Bemerkungen zum Reiterstandbild des hl. Georg auf der Prager Burg", in Sborník prací filosofické fakulty brněnské university (Collection of papers of the Philosophical Faculty of Brno University), F 16, 1972, p. 35ff.

12 O. Kletzl, "Zur künstlerischen Ausstattung des Veitsdomes", in Germanoslavica, 1, 1931/32, p. 247 ff.

13 F. Palacký, Dějiny (History), 5, p. 526.

14 Archiv český (Czech Archives), 2, 1842, p. 137.

15 Ibid., 11, 1892, p. 37.

16 K. B. Mádl, "Ještě o Beneši z Loun" (More about Beneš of Louny), in Památky archeologické (Archeological Monuments), 14, 1889, p. 443.

17 F. Palacký, Dějiny (History), 5, p. 484.

18 Archiv český (Czech Archives), 7, 1887, p. 427ff.

19 Ibid., 15, 1896, p. 315; 16, 1897, p. 446.

20 Ibid., 10, 1890, p. 67.

21 Ibid., 4, 1846, p. 518; 5, 1862, p. 2ff.

22 M. Steiff, "Jörg Breu's Fresken", in Sborník E. W. Brauna (E. W. Braun Volume), 1931.

23 M. Levey, Painting at the Court, 1971.

24 A lot of festivities, triumphal processions, tournaments and theatrical performances were organized in Prague (in 1577, the Jesuits even erected a standing building for their school theatricals), above all by Archduke Ferdinand and by the Court artists, H. Gumperger or G. Arcimboldo, at the Castle, in the Royal Garden and in the streets of the city. Ferdinand was then followed by his younger relatives and by the leading aristocrats, in the capital and in their subject towns as well. The participants describe "inventions", allegorical and mythological scenes, tableaux and floats, triumphal arches and statues, mechanisms and fireworks. Some of these events were even immortalized by drawings and woodcuts, as for instance the tournaments of Archduke Ferdinand in Prague (and at Plzeň) of 1548, 1549, 1553, 1555, 1557, the triumphal procession of Emperor Ferdinand I in Prague in 1558, the festivities in honour of the wedding of John of Kolovraty in Innsbruck in 1580, the ceremony of bestowing the Order of the Golden Fleece at Prague Castle in 1585, the coronation of Queen Anne in 1616 and of Frederick of the Palatinate three years later. The renowned Hussar tournament of Prague (1557) is moreover documented by preserved parts of the equipment: Archduke Ferdinand's white hussar armour and the harness of his horse, by the masks of Turks and Moors, by spurs, gilt helmets, lances of Hungarian type.

25 K. Löcher, Jakob Seisenegger, pp. 54, 56; E. Bukolská, Renesanční portrét (Renaissance Portrait), 1, p. 18.

26 The Antique tradition, however, was not interrupted even in the Middle Ages, particularly in France; many gardens there were decorated with pavilions, colonnades, galleries and even automats, which were brought to perfection in the 16th century and vividly reflected the spirit of Mannerism (V. Hofmann, Review of W. Prinze's book Die Entstehung der Galerie in Frankreich und Italien, in Architectura, 1, 1971, pp. 102—112).

27 The other châteaux of the Crown, which Ferdinand I had rebuilt and expanded (at Lysá-on-Labe, Chlumec-on-Cidlina, Poděbrady, Přerov), have lost much of their original appearance.

28 It was ascribed to Wolmut by E. Bachmann in "Ein unbekanntes Alterswerk des Bonifaz Wolmut", in Ostdeutsche Wissenschaft 3/4, 1958, p. 9.

29 O. Frejková, Palladianismus v české renesanci (Palladianism in the Czech Renaissance), pp. 94, 98—99, 115—16, and other literature after her ascribe the design to two unidentified Italians from Vienna; however, these have only done the budget estimates for the building, the design and model having been supplied by Wolmut. The work as executed corresponds with the descriptions in Wolmut's analysis as well as in the Italians' estimates (Jahrbuch der kunsthistorischen Sammlungen, 5, 1887, reg. 4278, 4282; State Central Archives in Prague, fund ČDKM IV P 191/1, f. 111—16).

30 The design had certainly been made before this date; the main façade, intricately articulated and carrying many stone elements, was finished in the same year that the building works were started, which suggests that the carved components had been prepared beforehand. Wolmut had drawn the Ball Court in the partial plan of the Royal Garden of 1564, but nearer to the Summer Palace.

31 R. Dačeva, Pražské renesanční sgrafito (Prague Renaissance Sgraffito), pp. 18—20; S. Schéle, Cornelis Bos, pl. 124.

32 The first to use an oval space was apparently Michelangelo, in the design of the mausoleum of Julius II in 1505 (E. Panofsky, Grabplastik, p. 97).

33 R. Feuchtmüller, "Die Architektur", in Baldass — Feuchtmüller — Mrazek, Renaissance in Österreich, pp. 6—7.

34 W. Hilger, Ikonographie Kaiser Ferdinands I., pp. 114—15.

35 Prague had had a university for two centuries already, whereas Olomouc received one in 1573.

36 E. Forssman, Säule und Ornament, p. 12.

37 As was shown by E. Forssman on the Parr family (Säule und Ornament, p. 29).

38 H. A. Schmid, Die Wandgemälde im Festsaal des Klosters St. Georgen in Stein am Rhein, passim; Baldass—Feuchtmüller—Mrazek, Renaissance in Österreich, pls. 46—47, p. 63. The prototype of the composition of the Old and the New Testaments was executed in the years 1529—33 in the workshop of Lucas Cranach which gave it a stamp of Lutheran theology (E. Guldan — U. Riedinger, "Die protestantischen Deckenmalereien der Burgkapelle auf Strechau", in Wiener Jahrbuch für Kunstgeschichte 18, 1960, pp. 34—36).

39 Similar fictitious aediculae were painted in the château of Vaduz the restoration of which was financed at that time by the Emperor. (E. S., "La demeure féodale du prince de Liechtenstein", Connaissance des arts, No. 62, April 1957, pp. 38—41.)

40 Scamozzi's Palmanuova, Gonzaga's Sabbioneta, La Valetta on Malta, the towns of Freudenstadt in Schwarzwald and Zamość in Poland, the new part of the Carinthian town of Klagenfurt, and the surroundings of the Place de France of Henry IV in Paris were all designed at that time, and Nové Zámky in Slovakia in the years 1573—80.

41 The ornamentally decorated frame of the main portal (of the same type as that on house No. 8 in Tovačov) is put in an aedicula with carved motifs which Italians brought to Buda in the last quarter of the fifteenth century; in the first quarter of the *cinquecento* they travelled from there to Cracow, and were probably brought by a stone-mason from one or the other centre to Moravia.

42 In 1524 an attic-storey of large Venetian semicircles was built on the Dome in Halle; between the years 1521 and 1529 an attic of swallow tails and semicircular motifs was added to the house called Under the Golden Crown on the square in Wrocław; about 1530 a simple belt of small semicircles was used by B. Ried, the leading master of the Prague workshop, in Žabkowice in Silesia. (But some buildings in Austria were also finished in this way — in Melk, Zwettl, Stein an der Donau and Weitra.) The credit of having introduced the attic-storey cannot be attributed to any one of these areas, as only a fraction of the original number have come down to us. Horizontal attics could be found already in the Gothic period in Bohemia; in the Danube region and in southern Bohemia about 1500, attics with crenelations and sunken roofs used to be erected as protection against fire (J. Muk, Měšťanský dům (The burghers' house), pp. 60, 74—76, 114—116).

43 Semicircular motifs found a marked application also along the German Weser, in Slovakia and in other lands.

44 M. Vilímková — J. Muk, Pražský hrad, Lobkovický palác (Prague Castle, Lobkovice Palace), pp. 207—23.

45 M. Vilímková — J. Muk, Lobkovický palác (Lobkovice Palace), pp. 210—14, mention some buildings with terra-cottas in Prague and the application of terracotta elements on Šlik Palace in Loket in 1528—35. Similar terra-cottas have also been preserved in Chomutov.

46 These big châteaux with arcaded courtyards are sometimes described in literature as having been derived from Danubian, mainly Austrian, buildings. However, with the exception of the Porzia Château in the Carinthian Spittal an der Drau whose arcades match those in Moravia (and in the Summer Palace of Prague Castle)

even down to the carved decoration, the coherently conceived aristocratic residences in Austria, with arcades on all storeys, were either of a later date or did not have loggias in most wings, or they were of a lower artistic level (as was the case in Germany and Poland, with the exception of the Wawel in Cracow). In the adjoining areas of Bohemia, Moravia and Austria the châteaux naturally had many common features, particularly in their stylistic orientation, for these countries maintained busy trade and social contacts and the noble families were interrelated.

47 J. Wasserman, Ottaviano Mascarino, pp. 13 and 22.

48 This was pointed out in relation to the German buildings by E. Forssman, Säule und Ornament, p. 13.

49 The figures of the Piast couple above the entrance of the château in Brzeg in Silesia, to which they are related by a common idea, are quite different by virtue of their three-dimensional treatment, their placing and their inferior quality.

50 According to the architect J. Muk's findings, these staircase arms were added to the arcade somewhat later.

51 W. Wolters, Plastische Deckendekorationen des Cinquecento, pp. 11—12, 41, pls. 14, 15, 46, 47.

52 The attic and sgraffito of this wall are Neo-Renaissance as are the sgraffiti of the gables (J. Koula, "Majorátní dům Schwarzenberků na Hradčanech" (The Hereditary House of the Schwarzenberg Family at Hradčany) in Zprávy Spolku architektů a inženýrů (Reports of the Association of Architects and Engineers), 18, 1883, pp. 2, 3. — Agostino Galli's authorship of the Prague Palace is proved by a recorded statement about "Master Augustin" and indirectly by a record from 1576 saying that it was in this palace that a case concerning Galli's wife was tried.

53 In the library there were fifty-three large portraits, fourteen smaller ones hanging on the walls and fourteen small ones standing on the bookcases; on the walls between the windows there were four portraits, St Catherine, an Allegory of Love and three figures; above the entrances were four supraportas with still-lifes (birds, game, fish, fruit); on the door the face of Bacchus; the pictures in the smaller library room included twelve of Roman Emperors; Z. Wirth, "Inventář zámku litomyšlského z roku 1608" (Inventory of the Litomyšl Château of the Year 1608), in Časopis společnosti přátel starožitností českých (Journal of the Society of Friends of Bohemian Antiquities), 21, 1913, pp. 124—25.

54 The Czech and Moravian retinue sojourned in Genoa in 1551 for a longer time but at that time most of the remarkable palaces with their impressive interpenetration of spaces, courts, arcades and staircases had not even been conceived, let alone built. The Lercari Palace dates from as late as 1571—81.

55 This lucid characterization of the picture is taken from J. Pešina, "Skupinový portrét" (Group Portrait), in Umění, 2, 1954, p. 284; J. Vacková, "Epitafní obrazy" (Epitaph Pictures), p. 136.

56 E. Hubala, "Schloss Austerlitz", 1957, p. 174ff; V. Naňková, "Česká barokní architektura v zahraniční literatuře" (Czech Baroque Architecture in Foreign Literature), in Umění, 9, 1961, pp. 508—09.

57 Here we are concerned with several scenes of the Epic of the Hares, specifically the first and second acts of the trilogy (Revolt of the Hares against the Enemy, Development of the Hares' Empire, Restoration of the Old Order), which the Brunswick painter Heinrich Göding depicted in ninety-three pictures in Augustusburg in Saxony, a château built between 1568—72; he seems to have conceived it as a moralizing allegory and an interpretation of biblical texts about the rule of man over animals, parallelling the rule of the lords of the château.

58 The architect of the château is not known either. The literature unhesitatingly attributes it to Pietro Ferrabosco but he is not recorded in the sources preserved, which only record the participation of the architect Pietro Gabri, settled in Brno — reducing the northern wing to a mere arcaded corridor in 1579, he enlarged the courtyard, but impaired the symmetry of the whole.

59 Garovi's tombstone explicitly says: "arce Cromavi et in multis locis Moraviae edificie edificans". Francesco was very probably the grand-father of the famous architect Francesco Borromini on his mother's side.

60 The predominant idea was an ethical one but the conception of the hall as a whole does not correspond with that of the large German and Austrian halls with similar themes relating to the virtues which used to be reserved for the ceiling; such is the case with the stucco treatment in the Hvězda Summer Palace and in Kratochvíle. Here the allegoric figures directly confront the spectator.

61 A small sum of money was paid towards the end of 1610 to the painter Hans Neymann, about whom no dates are known, but no mention was made of the nature of the work executed. (State Archives Třeboň: II 249 3 — Rožmberk, Record from St Gall 1610 until St George 1611, f. 2). Transalpine Renaissance wall-painting has not so far been dealt with as a whole and to pinpoint a painter's stylistic starting point is not always easy.

62 V. Vokáčová, Renesanční interieurová výzdoba zámku Rožmberku (Renaissance decoration of the interior of Rožmberk Château), p. 68—69.

63 This has been traced in painting by J. Vacková, "Podoba a příčiny anachronismu" (Form and causes of anachronism), 1968, pp. 388—90.

64 J. Kšír, Olomoucké renesanční portály (Olomouc Renaissance Portals), pp. 19—24. The author tries to prove that it was disassembled and put together again as late as 1591 but it is improbable that it could have then been given the date 1564, "the date of its supposed execution", as the author suggests.

65 J. Maliva, "Olomoucké renesanční portály" (Olomouc Renaissance Portals), p. 96. In the treatment of the front, with the arcade hollowed in the mass of the building, the house differed fundamentally from the type with loggias protruding from the façade, a type known in Veneto as well as in the Czech Lands; insensitive modifications were made in the 19th century.

66 J. Krčálová, "O původu renesančních reliéfních cyklů v Olomouci" (On the origin of the Renaissance relief cycles at Olomouc), pp. 132—35.

67 The birds and circular reliefs with heads on the band between the storeys and the festoons on the attic were added in the 18th century when the façades were restored.

68 J. Vacková, Podoba a příčiny anachronismu (Form and causes of anachronism), p. 381, pl. 2.

69 Fest des Goldenen Vlies in Prag, Cod. 7906, Österreichische Nationalbibliothek in Vienna; a graphic transcription by Anton Boys was published by Joh. Mayer in Dillingen in 1587.

70 J. Pešina, Česká malba pozdní gotiky a renesance (Czech Painting of Late Gothic and Renaissance), pp. 80—88.

71 The illusive slanting of the window jambs was also known to Gothic architecture (the Cathedral in Siena, S. Lorenzo in Genoa, the Late-Gothic house of the architect G. Pellevoysin in Bourges), but architects at that time did not make use of the whole structure to produce an optical illusion.

72 Also Charles of Liechtenstein had an ambitious tomb made in 1600 for his father-in-law, John Šembera of Boskovice, the commissioner of Bučovice Château, in the church of the Minorites in Brno. It was apparently built against the wall in the form of an altar; a deep recess has been preserved with four marble columns, reliefs and coats of arms. (A. Kratochvíl, Dějiny Bučovic (History of Bučovice), 2, p. 15.)

73 Vincenzo Scamozzi published this idea as late as 1615, but he had spent some time at Rudolph's Court in 1599—1600. Cf. also P. Preiss, Panorama manýrismu (Panorama of Mannerism), pp. 232—33.

74 Inventory of 1737 in Jahrbuch der kunsthistorischen Sammlungen, 10, 1889, reg. 6234, No. 476—86. By the way, "allerley Modell" are recorded as having been in the attic above the Summer Rooms in 1620. (The Archives of the Prague Castle: HBA No. 398 — Description of the Prague Castle from 1620, item No. 24.)

75 A great number of other buildings were built, reconstructed and modified in the Castle's precincts and on other sites in as well as outside Prague. For more details see J. Krčálová, "Poznámky o rudolfínské architektuře" (Remarks on Rudolphine architecture), pp. 499—523.

76 The appearance of the tower was drawn in 1638 by G. Mattei (J. Morávek, "Giuseppe Mattei a 'Nová stavení' Pražského hradu" (Giuseppe Mattei and the 'New Buildings' of Prague Castle), pl. on page 346, but there it is erroneously identified as the White Tower. As early as the beginning of the 17th century it appeared in a woodcut 'Cvičení v jízdě' (Training in Horse-riding) in the book "Koňské lékařství sepsané od M. Albrechta mistra" (Horse Medicine, written by Master M. Albrecht), library of the National Museum in Prague, old prints, 28 G 51, p. 125.

77 The woodcut 'Training in Horse-riding' shows a part of the Gallery, both towers of the transverse block, the Castle's cylindrical tower and other buildings.

78 According to the engraving and a record of 1698; but in the plans from the first half of the 18th century, before the reconstruction of the Castle by Maria Theresa, the columns do not appear.

79 It is not easy to establish the authors of Rudolphine buildings; there are few written records — Prague was after all Rudolph II's place of residence — and little comparative material from the production of his architects and builders. In the second stage, when the New Building and the Episcopal (Northern) Tower were built, there is the possibility of the authorship, judging by the period and the style, of V. Scamozzi (who would not, however, have forgotten to mention his creative participance in his treatise in which he mentions the Castle's stables), and J. Heintz and G. M. Filippi. The latter came to Prague in the early spring of 1602 and supervised the construction of the New Building; its portals are both as advanced and as distinguished as those in the Church of St Rochus and Filippi's Matthias Gate. This artist, who knew the latest Roman works, seems to have had the greatest share in the conception of the building. (Cf. J. Krčálová, op. cit., p. 504).

80 This was pointed out by J. Zimmer, "Iosephus Heintzius", pp. 228—36. The assumption is supported by the analogy with the treatment of the Castle buildings and their details. (For further comment cf. J. Krčálová, "Das Oval", p. 331, Note 98.) But the Church of the Holy Trinity, its ground-plan and interior, as well as the pre-Baroque inner portico (used already by A. Palladio in S. Giorgio Maggiore in Venice) is akin above all to the church of Arco by Filippi.

81 In the arrangement of the ground-plan as well as in the mass, both Prague churches are near to that in Arco, in spite of the fact that the church in the Lesser Town had

one nave with the chapels drawn between the supporting pillars, and the church in the Old Town three naves with tribunes, whereas the structure in Arco had a hall with deeper chapels interconnected by passages. For the ground-plan of the Holy Trinity Church see J. Zimmer, "Iosephus Heintzius", pl. 7; for that of St Saviour, O. Zajícová, "Kostel sv. Salvátora", (Church of St Saviour), pl. p. 49; further J. Krčálová, "Das Oval", p. 331, Note 99. The original appearance of the exterior of St Saviour can only be assumed: towers seem to have been planned above the cubes of the west front; above the low roofs of the side aisles there were perhaps semicircular windows lighting the nave, which were changed into oval ones during the Baroque reconstruction. It is no longer possible to say whether the pilasters of this part were also connected with vertical volute walls.

82 The works for the chapter on Renaissance and Mannerist arts have been selected from a far longer number of monuments preserved in Bohemia and Moravia, therefore some of the discussion of them is based on archival sources and direct research, therefore some of the data of the given may differ in many cases from those in the literature quoted. Works of sculpture and painting having surpassed the average level only rarely, usually when in connection with the building, we have not treated these two branches of fine arts in special chapters.

83 A. Podlaha — E. Šittler, Chrámový poklad (The Cathedral Treasure), pp. LXXIX, LXXXIX, XCIV.

84 Ibid., p. 131. The date of 1690 given here is not correct.

85 Rhein und Maas (Catalogue of an exhibition in Cologne and Brussels), Cologne, 1972, p. 217.

86 This corresponds with the mention in the work of Tomáš Pešina of Čechorod, Phosphorus septicornis, p. 90; cf. also J. Cibulka, Dějepis výtvarného umění (History of plastic and graphic arts), 1, p. 409. In contrast, Cibulka regards the busts as the work of one and the same artist, namely Václav of Budějovice, whom A. Podlaha (Chrámový poklad (The Cathedral Treasure), pp. 98, 210) designated, without giving the source, as the author of the bust of St Vitus (dated 1486). However, from another source which Podlaha published in Památky archeologické (Archeological Monuments), 16, 1916, p. 127 we learn that Václav of Budějovice (Štraboch, active here in 1480—1535, cf. K. Pletzer, in Umění, 18, 1970, p. 414ff.) only gilded the bust.

87 Herbst des Mittelalters, No. 248, pl. 89.

88 J. M. Fritz, Goldschmiede Kunst, in Spätgotik am Oberrhein 1450/1530 (Catalogue of an exhibition in Karlsruhe), 1970, p. 219ff.; see also No. 89, pl. 84; No. 225, pl. 207; No. 226, pl. 208.

89 Ch. von Salm, Gotik in Böhmen, Munich, 1969, p. 396; in suggesting a relationship between the busts (as products of a common workshop) and the Master of the Kefermarkt Altar (Upper Austria), the author seems to proceed from the erroneous conjecture Václav of Budějovice is the author of the busts (cf. J. Cibulka, op. cit. p. 409). Yet this hypothesis accords with my thesis that Upper Austria is the place of the origin of these busts.

90 E. Poche, Poklad Svatovítský (St Vitus Treasure), Nos. 8, 9; cf. also Herbst des Mittelalters, pl. 85; Spätgotik am Oberrhein, pls. 191, 193.

91 J. Herain, Stará Praha (Old Prague), Prague, 1902, p. 194; A. Cechner, "Hrad Křivoklát" (Křivoklát Castle), in Soupis památek (List of Monuments), 36, 1911, p. 88ff.

92 A. von Euw — H. Rode, "Glasmalerei", in Herbst des Mittelalters, p. 57, see also Nos. 46—89; F. Rentsch, in Spätgotik am Oberrhein, p. 301ff.

93 A. Podlaha — E. Šittler, op. cit. p. XCIV.

94 A. Podlaha, "Z účtů kostela svatovítského" (Accounts of the Church of St Vitus), in Památky archeologické (Archeological Monuments) 26, 1916, p. 128.

95 J. Teige — J. Herain, Staroměstský rynk v Praze (The Old Town Square in Prague), Prague, 1905, p. 267.

96 For the chalices named here see Soupis památek (List of Monuments), 2, 1897, p. 59 (B. Matějka); 10, 1900, p. 17 (Fr. Mareš — J. Sedláček); 7, 1899, p. 179 (Fr. Vaněk — K. Hostaš).

97 K. Chytil, in Soupis památek (List of Monuments), 11, 1900, p. 107.

98 E. Poche, Uměleckoprůmyslové muzeum (Museum of Decorative Art), pl. 167.

99 A. Podlaha — E. Šittler, "Poklad svatovítský" (The St Vitus Treasure), in Soupis památek, Praha — Hradčany, 2/1, 1903, p. 148—49.

100 For the chasubles mentioned see A. Cechner in Soupis památek, 36, 1911, p. 143; J. Pečírka, in Umělecké poklady Čech (Artistic Treasures of Bohemia), 2, Prague, 1913, Nos. 214—15; Z. Drobná, La ricchezza, No. 59; M. Dvořák — B. Matějka, in Soupis památek, 27, 1907, p. 212.

101 Only fragments have been preserved after the robberies in the pre-war period: cf. Soupis památek, 27, 1907, Table 15.

102 Spätgotik am Oberrhein, Nos. 265—75.

103 R. Schmidt, in Soupis památek, 40, 1913, Table II.; K. Novotný, "Chrám Matky Boží před Týnem" (The Cathedral of the Virgin before Týn), in Umělecké památky (Artistic Monuments), Prague, 1916, p. 25.

104 Umělecké poklady Čech (Artistic Treasures of Bohemia), 1, Prague, 1913, p. 45.

105 J. Cibulka, "Pycklerův epitaf" (Pyckler's Epitaph), in Umění, 4, 1931, p. 164.

106 V. Richter, "Chorové lavice" (Choir pews), in Umění, 11, 1938, p. 515.

107 For the inlaid doors mentioned see F. Mareš — J. Sedláček, in Soupis památek, 10, 1900, p. 81; E. Poche, Pražské portály (Prague portals), 2nd ed., Prague, 1947, pl. 19; E. Poche, Uměleckoprůmyslové muzeum (Museum of Decorative Art), No. 2.

108 For the cabinets mentioned see J. Novák, in Soupis památek, 14, 1901, p. 79; K. Herain, "Z minulosti pražského nábytku" (From the past of Prague furniture), in Kniha o Praze (Book on Prague), 1, 1930, p. 130ff.; ibid. about guild chests.

109 For the church pews see A. Podlaha — K. Hilbert, Soupis památek v metropolitním chrámu sv. Víta v Praze (List of monuments in the metropolitan Cathedral of St Vitus in Prague), 1906, p. 212; A. Podlaha, in Soupis památek, 6, 1900, p. 114.

110 Z. Winter, Řemeslnictvo a živnosti (Craftsmen and trades), p. 543ff.

111 M. Dvořák — B. Matějka, in Soupis památek, 27, 1907, p. 177.

112 Jahrbuch der kunsthistorischen Sammlungen, 10, 1865, Nos. 6146, 6179; 12, 1867, Nos. 8213, 8208; A. Podlaha — K. Hilbert, op. cit., p. 170.

113 Z. Wirth, in Umělecké poklady Čech (Artistic treasures of Bohemia), 1, Prague, 1913, p. 15.

114 See Note 112.

115 J. Novák, in Soupis památek, 14, 1901, p. 131.

116 Ibid., p. 69.

117 V. Richter, Telč, státní zámek a městská památková rezervace (Telč, the State Castle and reserve of town monuments), Prague, 1953, pp. 11, 15.

118 E. Poche, Uměleckoprůmyslové muzeum (Museum of Decorative Art), p. 186.

119 For the Czech bell-founder's craft cf. articles by K. Guth and K. Chytil in Ročenka Kruhu (Annual of the Society) for 1917; cf. also J. Hráský, "O pražských konvářích" (Prague pewterers), in Kniha o Praze (Book on Prague), 1960, p. 115ff.

120 K. Chytil, in Ročenka Kruhu (Annual of the Society) for 1917, p. 28ff.

121 They are in Vrané and Louny; cf. B. Matějka, in Soupis památek, 2, 1897, p. 29; A. Podlaha — E. Šittler, in Soupis památek, 3, 1898, pp. 130—31; J. Soukup, in Soupis památek, 18, 1903, p. 241.

122 K. Chytil, in Ročenka Kruhu for the year 1917, p. 20ff.

123 J. Krčálová, "Kašny, fontány a vodní díla české a moravské renesance" (Fountains, cascades and other waterworks of the Bohemian and Moravian Renaissance), in Umění, 21, 1973, p. 527ff.

124 A. Podlaha — K. Hilbert, op. cit. p. 268.

125 L. Kybalová, Pražské zvony (Prague Bells), p. 121.

126 Ibid., p. 168.

127 K. Chytil, in Ročenka Kruhu for the year 1917, p. 39.

128 Z. Winter, Přepych uměleckého průmyslu (Luxury of artistic industry), p. 44.

129 Housed today in the château of Mělník, cf. M. Dvořák — B. Matějka, in Soupis památek, 27, 1907, p. 243ff.

130 A. Kudělková — M. Zemínová, Habánská fajáns ('Haban' faience), 1961.

131 F. X. Jiřík, České sklo (Bohemian glass), p. 40; K. Hetteš, in Tvar (Shape), 13, 1961, p. 1; E. Poche, "Histoire de la verrerie en Tchécoslovaquie", in Bulletin des journées internationales du verre, 4, 1965, p. 11; Z. Winter, op. cit., p. 35ff.

132 E. Poche, Uměleckoprůmyslové muzeum (Museum of Decorative Art), pl. 32.

133 K. Chytil, Umění v Praze za Rudolfa II. (Art in Prague in the reign of Rudolph II), p. 2; F. X. Harlas, Rudolf II., milovník umění a sběratel (Rudolph II, art lover and collector), s. a.; for the other literature on the personality of Rudolph II as collector and patron see the following chapter.

134 Reproduced by A. Kohlhausen, Geschichte des deutschen Kunsthandwerkes, p. 304.

135 The Connoisseur, London, 1964, p. 253.

136 K. Chytil, Umění v Praze za Rudolfa II (Art in Prague in the reign of Rudolph II), p. 63, Note 27ff.; C. Straka, in Památky archeologické (Archeological Monuments), 28, 1916, p. 18ff.

137 "Barokní princip v dějinách umění" (Baroque principle in the history of art), in Styl (Style), 5, 1924, p. 71.

138 H. Fillitz, Katalog, p. 20ff.; E. Steingräber, Die Schatzkammer, p. 19.

139 H. Thoma, Schatzkammer, Nos. 343—410, No. 598.

140 H. Opočenský, in Památky archeologické (Archeological Monuments), 31, 1919, p. 98; Z. Wirth, in Památky archeologické, 27, 1915, p. 187; K. Stloukal, "Portrét Rudolfa II" (Portrait of Rudolph II), in Od pravěku k dnešku (From the primeval age to modern times), 2, 1930, pp. 1—14.

141 K. Chytil, Koruna Rudolfa II. (Rudolph II's Crown), p. 51.

142 E. Poche, "Na okraj Cibulkových Korunovačních klenotů" (Some remarks on Cibulka's Coronation Jewels), in Umění, 19, 1971, p. 302ff.

143 E. W. Braun, "Ein unbekannter Entwurf", in Jahrbuch des Verbandes der deutschen Museen in ČSR, 1, 1931, p. 148.

144 H. Fillitz, Katalog, p. 21; E. Kris, Meister und Meisterwerke, 1929; V. Vokáčová, "Práce Paula van Vianen ve sbírkách Uměleckoprůmyslového muzea" (Paul van Vianen's works in the collections of the Museum of Decorative Art), in Sborník

stati na počest 70. výročí narození dr. E. Pocheho (Volume in honour of the 70th birthday of dr. E. Poche), Prague, 1973, p. 37.

145 E. Steingräber, "Email", in Reallexikon zur deutschen Kunstgeschichte, Munich, 1961.

146 K. Rossacher, Der Schatz des Erzstiftes Salzburg, Salzburg, 1966, p. 5ff., cat. 113—16.

147 E. Poche, Na okraj Cibulkových Korunovačních klenotů (Some remarks on Cibulka's Coronation Jewels), p. 302.

148 K. Rossacher, op. cit.

149 E. V. Strohmer, Prunkgefässe, p. 19ff.

150 E. Steingräber, Die Schatzkammer, Table 157.

151 K. Chytil, Výběr (Selection), No. 46.

152 P. Štěpánek, "Pohár Rudolfa II v Madridu" (Rudolph II's goblet in Madrid), in Lidová Demokracie of 9th April, 1971.

153 H. Thoma, Schatzkammer, Nos. 120—1, 343—5, 349—53, 384—6, 434, 535—6, 542.

154 H. Fillitz, Katalog, p. 67ff.

155 H. Kohlhausen, Geschichte, p. 314.

156 K. Chytil, Umění v Praze za Rudolfa II (Art in Prague in the reign of Rudolph II), p. 52; H. Kohlhausen, Europäisches Kunsthandwerk, Frankfurt-am-Main, 1972, 3, p. 14.

157. H. Thoma, op. cit., Nos. 384—85; cf. also B. Bukovinská, "Anmerkungen zur Persönlichkeit Ottavio Miseronis", in Umění, 18, 1970, p. 185.

158 H. Fillitz, Katalog, Nos. 55ff., 59.

159 Housed today in the château of Mělník, cf. M. Dvořák — B. Matějka, in Soupis památek, 27, 1907, p. 191; B. Bukovinská, "Další florentské mozaiky" (Further Florentine mosaics), in Umění, 20, 1972, p. 363ff.

160 K. Chytil, op. cit., p. 1.

161 Their recent identification has been contributed to by B. Bukovinská, Další florentské mozaiky (Further Florentine mosaics), p. 367; cf. also E. Neumann, in Jahrbuch der kunsthistorischen Sammlungen, 53, 1957, p. 157ff. and 55, 1959, p. 150.

162 The theme of the illusive picture on this small altar is unique in the workshop's output: for this reason I do not believe the hypothesis that this figural work was carried out in the workshop of Ottavio Miseroni.

163 E. Poche, Uměleckoprůmyslové muzeum (Museum of Decorative Art), pl. 3; cf. also H. Thoma, op. cit., No. 519.

164 A. Buchner, "Dvě privilegia císaře Rudolfa II." (Two privileges of Emperor Rudolph II), in Staletá Praha (Centuries-old Prague), 2, 1967, p. 76ff.

165 H. von Bertele — E. Neumann, "Jost Burgis' Beitrag", in Jahrbuch der kunsthistorischen Sammlungen, 51, 1955, p. 169ff.

166 K. Chytil, op. cit., p. 47; A. Rybička, "Umělci na dvoře Rudolfa II." (Artists at the Court of Rudolph II), in Památky archeologické (Archeological Monuments), 15, 1892, p. 684ff.; H. von Bertele — E. Neumann, op. cit., p. 169.

167 E. Herold — J. Herain, Malebné cesty po Praze (Picturesque strolls about Prague), 2, "Malá Strana" (Lesser Town), 1, Prague, 1896, p. 381; K. Chytil, op. cit., p. 64; Z. Winter, Řemeslnictvo a živnosti (Craftsmen and trades), p. 558.

168 E. Poche, Uměleckoprůmyslové muzeum (Museum of Decorative Art), pl. 188.

169 Z. Winter, op. cit., p. 424.

170 E. Steingräber, Alter Schmuck, p. 133; E. Fiala, Antonio Abondio, 1909; Z. Winter, op. cit., p. 426.

171 K. Hetteš, Böhmisches Glas, Prague, s. a., p. 9, Note 14.

172 F. X. Jiřík, České sklo (Bohemian Glass), pp. 58 and 103, where further literature on Lehman can be found; Z. Winter, op. cit., p. 519.

173 K. Hetteš, in Tvar (Shape), 13, 1961, pl. 9; K. Chytil, Výběr (Selection), No. 76.

174 E. Poche, op. cit., pl. 36.

175 E. Meyer-Heissig, Der Nürnberger Glasschnitt, 1963.

176 Cf. K. Chytil, Umění v Praze za Rudolfa II. (Art in Prague in the reign of Rudolph II), p. 55; besides this fundamental work cf. also K. Chytil, Umění a umělci na dvoře Rudolfa II. (Art and artists at the Court of Rudolph II), Prague 1912, 2nd ed., 1920; also in German: Kunst and Künstler am Hofe Rudolph II., Prague, 1912. An attempt at a new synthesis and evaluation cf. J. Neumann, Rudolfínské umění (Rudolphine Art) I, in Umění, 30, 1977, pp. 400—48; J. Neumann, Rudolfínské umění II, in Umění, 31, 1978.

177 H. Volavková, "Ohlasy manýrismu" (Response to Mannerism), in Výtvarné umění (Graphic and plastic arts), 19, 1969, pp. 134—35.

178 Cf. E. Petrová — L. Novák, "Manýrismus" (Mannerism), in Výtvarné umění (Graphic and plastic arts), p. 144ff.

179 S. J. Freedberg, "Observation on the Paintings of the Maniers", in the Art Bulletin, 48, 1956, p. 187ff; J. Shearman, Mannerism, 1957.

180 R. J. W. Evans, Rudolph II, 1973.

181 R. (J. W.) Evans, "Bílá hora" (White Mountain), in Československý časopis historický (Czechoslovak historic bulletin), 17, 1969, p. 851ff.

182 This was the view of J. von Schlosser, Die Kunst - und Wunderkammer der Spätrenaissance, 1908.

183 E. Neumann, "Das Inventar der rudolfinischen Kunstkammer", in Analecta Reginensis, 1, 1966, p. 262ff., especially p. 264. Cf. also Das Kunstinventar Kaiser Rudolfs II., 1607—1611, in Jahrbuch der kunsthistorischen Sammlungen in Wien, 72, 1976, p. XI ff.

184 H. von Bertele — E. Neumann, "Jost Burgis' Beitrag", in Jahrbuch der kunsthistorischen Sammlungen, 51, 1955, p. 169ff, cf. p. 186; H. v. Bertele — E. Neumann, Der kaiserliche Kammeruhrmacher Christoph Margraf, p. 39ff., cf. p. 62; numerous references in R. J. W. Evans, Rudolph II., passim.

185 For greater details cf. E. Fučíková, "Rudolph II", in Umění, 18, 1970, p. 128ff.

186 A. Lhotsky, "Die Geschichte der Sammlungen", in Festschrift des Kunsthistorischen Museums in Wien, 2. Vienna, 1941/45, pp. 237—98.

187 K. Oberhuber, Die stilistische Entwicklung im Werk Bartholomäus Sprangers, Vienna, 1958, p. 151ff., unpublished dissertation.

188 Cf. T. Gerszi, "Die humanistischen Allegorien", in Actes du XIIè Congrès international d'histoire de l'art, vol. 1, pp. 755—62, cf. pp. 758—59.

189 T. Gerszi, op. cit., p. 759.

190 K. Chytil, "Apotheosa umění od B. Sprangera" (Apotheosis of the art by B. Spranger), in Ročenka Kruhu (Annual of the Society) for 1918, Prague, 1919, p. 3ff.; this illuminating analysis can be supplemented in details only.

191 This allegory is dealt with in R. Chadraba, "Die Gemma Augustea", in Umění, 18, 1970, p. 289ff., especially 294—5; T. Gerszi, Die humanistischen Allegorien, p. 760—1; another analysis, more thorough but differing in detail, has been given by J. Neumann, Rudolfínské malířství a sochařství (Rudolphine painting and sculpture), Prague, 1972, in manuscript. First volume, abridged, was published in Umění, 30, 1977, p. 426.

192 Cf. L. O. Larsson, Adrian de Vries, p. 49ff.

193 For amorous mythological scenes and their allegoric conception cf. in particular K. Oberhuber, Die stilistische Entwicklung, pp. 105ff., 122ff.

194 B. Schnackenburg, "Beobachtungen", in Niederdeutsche Beiträge zur Kunstgeschichte, 9, 1970, pp. 143ff., especially 156—8.

195 This conception is analysed in connection with P. van Mander's views in E. K. J. Reznicek, Die Zeichnungen von Hendrick Goltzius, p. 195ff. — An example of a natural-historical interpretation of myth in Rudolphine art is the picture Venus and Adonis of Duchcov Château (lent to the National Gallery in Prague), cf. E. Fučíková, "Sprangerův obraz Venuše a Adonis", in Umění, 20, 1972, p. 347ff.

196 For Rudolphine emblems cf. K. Chytil, Umění v Praze za Rudolfa II. (Arts in Prague in the reign of Rudolph II), pp. 44ff., 63, Note 25, and especially R. J. W. Evans, Rudolph II, p. 269ff.

197 L. O. Larsson, Adrian de Vries, p. 36ff. — The latest research points out that Vries's bust is an adaptation of a type of Antique trophy for the bust itself has been replaced by mere armour, the symbolic meaning of which is elucidated by the allegoric figures carrying it, cf. I. Lavin, "Bernini's Death", in The Art Bulletin, 14, 1972, p. 159ff. and the chapter "The Portrait Bust as Apotheosis", p. 177ff., in particular the references to the Colonna Claudius (Prado) and to the portrait type created by Leone Leoni in his bust of Charles V.

198 E. Kris, Georg Hoefnagel, in Festschrift für Julis Schlosser, p. 243ff., p. 246.

199 Th. A. G. Wilberg Vignau-Schuurman, Die emblematischen Elemente, 1969.

200 J. Šíp spoke of this at a conference in Warsaw in 1972, held on the occasion of the exhibition European Landscape-painting 1550—1650. Cf. "Savery in and around Prague", in Bulletin du Musée National de Varsovie, 14, 1973, p. 69 ff.

201 This has been proved by J. A. Spicer, "Savery's Studies in Bohemia", in Umění, 18, 1970, pp. 270—5.

202 G. P. Lomazzo, Tratatto dell' arte della pittura, 1584—85; G. P. Lomazzo, Idea del Tempio della Pittura, Milan, 1590.

203 F. Zuccaro, L'Idea di pittori, 1/3, p. 38ff. (reissue 1961).

204 P. Preiss, Giuseppe Arcimboldo, p. 17ff.; the author is proceeding here from the views formulated by S. Alfons, Giuseppe Arcimboldo, 1957.

205 G. Comanini, Il Figino, 1591, p. 32ff.; cf. the quotations in B. Geiger, Die skurrilen Gemälde, and in the original Italian edition — cf. our Note 208.

206 V. Danti, Il primo libro del Trattato delle perfette proporzioni, chapt. XVI., p. 73: ritrarre means to render reality as we see it, imitare means to render it as we ought to see it; for more details cf. E. Battisti, "Il concetto d'imitazione", in Commentari, 7, 1956, pp. 86ff., 249ff.

207 L. Dolce, L'Aretino, reissue of 1785, p. 228.

208 The most important literature: B. Geiger, I pitturi ghiribizzosi di Giuseppe Arcimboldo, 1954; in German: B. Geiger, Die skurrilen Gemälde, 1960; further C. F. Legrand — F. Sluys, Arcimboldo, 1955; S. Alfons, Giuseppe Arcimboldo, 1957; a Czech study has been written by P. Preiss, Giuseppe Arcimboldo, 1967.

209 T. da Costa Kaufmann, "Arcimboldo's Imperial Allegories. G. B. Fonteo and the Interpretation of Arcimboldo's Painting", in Zeitschrift für Kunstgeschichte, 39, 1976, p. 275 ff. The titles of Fonteo's works, kept in Österreichische Nationalbibliothek, Handschriftsammlung (Codex 10 152, 10 206, 10 466) are quoted by Kaufmann in Note 9—11.

210 Commanini's poem about this painting has been quoted in German by B. Geiger, Die skurrilen Gemälde, pp. 83—9.

211 Basic literature: E. Diez "Der Hofmaler Barholomäus Spranger", in Jahrbuch der kunsthistorischen Sammlungen, 28, 1909/10, pp. 93—151; A. Niederstein, in Thieme — Becker, Künstlerlexikon, vol. 31, 1937, pp. 403—6; K. Oberhuber, Die stilistische Entwicklung, Vienna, 1958, unpublished dissertation; E. K. J. Reznicek, Die Zeichnungen, passim, especially pp. 149—71; K. Oberhuber, "Die Landschaft im Frühwerk Bartholomäus Sprangers", in Jahrbuch der Staatlichen Kunstsammlungen in Baden-Württemberg, 1, 1964, pp. 173—87. For Spranger's life story see the biography by C. van Mander, Het Leven, the German translation by H. Floerke, vol. 2, pp. 126—68.

212 J. Neumann, "Kleine Beiträge", in Umění, 18, 1970, p. 142ff.; for the technology of this fresco cf. A. and V. Bergers, "Technologische Erkenntnisse", in Umění, 18, 1970, pp. 170—1.

213 E. K. J. Reznicek, "Bartholomäus Spranger", in Festschrift Ulrich Middeldorf, Berlin, 1968, pp. 370—5.

214 E. K. J. Reznicek, Bartholomäus Spranger, p. 149ff.

215 A. Bredius — E. W. Moes, "Die Schilderfamilie Ravesteyn", in Oud-Holland, 9, 1891, pp. 208—13; R. Kuchynka, "Dětřich Ravesteyn", in Časopis Společnosti přátel starožitností českých (Bulletin of the Society of Friends of Bohemian Antiquities), 30, 1922, pp. 80—3; A. Pigler, "Notice sur Dirck de Quane van Ravesteyn", in Oud-Holland, 63, 1948, pp. 75—7.

216 Basic literature: R. A. Peltzer, "Der Hofmaler Hans von Aachen", in Jahrbuch der kunsthistorischen Sammlungen, 30, 1911/12, pp. 59—182; E. Fučíková, "Über die Tätigkeit Hans von Aachens in Bayern", in Münchner Jahrbuch der bildenden Kunst, 21, 1970, pp. 129—42; E. Fučíková, "Quae praestat iuvenis vix potuere viri", in Wallraf-Richartz-Jahrbuch, 33, 1971, pp. 115—24; Rüdiger an der Heiden, "Die Portraitmalerei des Hans von Aachen", in Jahrbuch der kunsthistorischen Sammlungen, 66, 1970, pp. 135—226. For the painter's life story cf. the biography by C. van Mander, Het Leven (in H. Floerke's edition of 1906, vol. 2, pp. 279—94).

216a Cf. Rüdiger an der Heiden, p. 181 ff. (A7, A7a) and p. 221 ff. (D1).

217 First published by J. Neumann, "Objevy vzácných obrazů" (Discoveries of precious paintings), in Výtvarné umění (Graphic and plastic arts), 12, 1962, p. 446, pl. 441 (2nd ed. 1966, pp. 64—6); Rüdiger an der Heiden, in Výtvarné umění, 20, 1970, pp. 202—3, No. A 30, has suggested that it might be a portrait of Aachen's daughter.

218 J. Neumann, "Aachenovo Zvěstování P. Marie" (Aachen's Annunciation), in Umění, 4, 1956, pp. 119—32.

219 Basic literature: B. Haendcke, "Joseph Heintz", in Jahrbuch der kunsthistorischen Sammlungen, 15, 1894, pp. 45—59; J. Zimmer, Joseph Heintz der Ältere als Maler, 1971 (contains a careful catalogue of works and detailed quotations from the literature). My account of Heintz's development is based on Zimmer's findings.

220 Important biographical facts have been published by E. Chmelarz, "Georg und Jakob Hoefnagel", in Jahrbuch der kunsthistorischen Sammlungen, 17, 1896, pp. 275—90. Modern interpretations: I. Bergström, Dutch Still-Life Painting, 1956; I. Bergström, "Georg Hoefnagel le dernier des grands miniaturistes flamands", in L'Oeil, 1963; No. 1, pp. 2—9, 66. For further literature see Notes 199 and 222.

221 E. Kris, "Der Stil 'rustique'", in Jahrbuch der kunsthistorischen Sammlungen, NF 1, 1927, p. 137ff.

222 This view has been put forward in the fundamental work on Hoefnagel by E. Kris, "Georg Hoefnagel", in Festschrift Julius Schlosser, pp. 243—53.

223 E. Panofski's term.

224 A basic work has been written by An Zwollo, "Pieter Stevens, ein vergessener Maler", in Jahrbuch der kunsthistorischen Sammlungen, 64, 1968, pp. 119—80; An Zwollo, "Pieter Stevens, neue Zuschreibungen", in Umění, 18, 1970, pp. 246—59.

225 U. M. Schneede, Das repräsentative Gesellschaftsbild, Kiel, 1965, unpublished dissertation.

226 R. van den Brande, Die Stilentwicklung im graphischen Werke des Aegidius Sadeler, Vienna, 1950, unpublished dissertation; De Sadelers, Jan, Raphael, Aegidius, 1963. Cf. also A. Lhotsky, "Die Geschichte der Sammlungen", in Festschrift des Kunsthistorischen Museums in Wien, 2, 1941—5, p. 266.

227 E. Fučíková, "Umělci na dvoře Rudolfa II." (Artists at the Court of Rudolph II), in Umění, 20, 1972, p. 149ff., especially 154—7.

228 Basic literature: K. Erasmus, Roelant Savery, 1908; J. Białostocki, "Les bêtes et les humains de Roelant Savery", in Bulletin des Musées Royaux de Beaux-Arts de Belgique, 7, 1958, pp. 69—90; broader versions: J. Białostocki, "Roelant Savery, jego ludzie i zwierzęta", in Biuletyn historii sztuki, 21, 1959, pp. 135—50; K. G. Boon, "Roelandt Savery te Praag", in Bulletin van het Rijksmuseum, 9, 1961, pp., 145—8; J. Fechner, "Die Bilder von Roelandt Savery in der Eremitage", in Jahrbuch des Kunsthistorischen Instituts der Universität Graz, 2, 1966/7, pp. 93—8; Czech works: R. Kuchynka, "R. Savery, Okolí Kamenného mostu" (Surroundings of the Stone Bridge), in Umělecké poklady Čech (Artistic treasures of Bohemia), 2, 1915, pp. 10—11; Z. Wirth, "Nový pohled na Prahu" (A new view of Prague), in Umění, 10, 1937, pp. 199—205; J. Burian, "Saveryho pohled na Malostranské náměstí" (Savery's View of the Lesser Town Square), in Umění, 5, 1957, p. 372; J. Šíp, Holandské krajinářství 17. století (Dutch landscape-painting of the 17th century), Prague, National Gallery, 1965, pp. 10, 42; J. Šíp, "Some remarks on a little-known masterpiece by Roelant Savery", in Sborník prací filosofické fakulty brněnské university (Collected papers of the Philosophical Faculty of the Brno University), 1964, F. 8, pp. 165—9; J. Šíp, "Roelandt Savery in Prague", in Umění, 18, 1970, pp. 276—83; J. Šíp, "Prag als Zentrum der Landschaftsmalerei zur Zeit Rudolf II.", in Europäische Landschaftsmalerei 1530—1650 (an exhibition in Dresden), Dresden, 1972, pp. 34—8; J. Šíp, "Savery in and around Prague", in Bulletin du Musée National de Varsovie, 14, 1973, p. 69 ff.; the following works are of a revealing character: J. A. Spicer, "Savery's Studies in Bohemia", in Umění, 18, 1970, pp. 270—5, and J. A. Spicer, "The 'naer het leven' Drawings", in Master Drawings, vol. 8, No. 1, 1970, pp. 3—30.

229 H. Modern, "Paulus van Vianen", in Jahrbuch der Kunsthistorischen Sammlungen, 15, 1894, pp. 60—120. The following authors deal with his landscape-drawings: W. Wegner in his "Skizzenbuchblätter von Paul van Vianen", in Mitteilungen der Gesellschaft für Salzburger Landeskunde, 96, 1956, and "Neue Ansichten von Salzburg von Paul van Vianen", in Mitteilungen der Gesellschaft für Salzburger Landeskunde, 98, 1968, pp. 219—24; and, in particular, the Hungarian researcher T. Gerszi in her book Netherlandish Drawings in the Budapest Museum, Amsterdam, 1971. Our comments here are based on the contributions which she had at the Rudolphine symposium in Prague in 1969: T. Gerszi, "Die Landschaftskunst von Paulus van Vianen", in Umění, 18, 1970, pp. 260—9.

230 A fundamental paper has been written by L. O. Larsson, "Hans Mont van Gent. Versuch einer Zuschreibung", in Konsthistorisk Tidskrift, 36, 1967; cf. also H. R. Weihrauch, Europäische Bronzestatuetten, p. 361, pl. 435a, b on p. 357. For biographical data see C. van Mander, Het Leven, ed. H. Floerke, 2, p. 149ff.

231 Basic works: J. Böttiger, Bronsearbeten af Adriaen de Vries i Sverige, 1884; C. Buchwald, Adriaen de Vries, 1899; E. V. Strohmer, "Bemerkungen zu den Werken des Adriaen de Vries", in Nationalmusei Årsbok, 1947—8, Stockholm, 1950, pp. 93—138. Also L. O. Larsson, Adrian de Vries, 1967; H. R. Weihrauch, Europäische Bronzestatuetten, pp. 351—9.

232 J. Neumann, "Nově objevený obraz Bartolomeje Sprangera" (A newly discovered painting by Bartholomeus Spranger), in Zprávy památkové péče (Reports of the Institute for the Protection of Monuments), 13, 1953, p. 27ff.

233 F. C. Springell, Connoisseur et Diplomat the Earl of Arundel's Embassy to Germany, 1963, p. 73.

234 J. Neumann, Das böhmische Barock, p. 100, No. 3.

BIBLIOGRAPHY

Art in Bohemia under the Jagiellos

Most often quoted bibliographical sources the titles of which are not translated in the list:

Památková péče — Protection of monuments
Památky archeologické — Archeological monuments
Umění — Art
Zprávy památkové péče — Reports of the society for the protection of monuments

Czech Archives, 1—22, Prague 1840—1905; 26, 1909; 28—30, 1912—13; 32—**33**, 1915—18; 38, 1941

Ausstellung Maxmilian I., Vienna, 1959 (Catalogue)

Ausstellung Maxmilian I., Innsbruck, 1969 (Catalogue)

Balogh, J., "Ioannes Dunkovich de Traugurio", in Acta historiae artium Academiae scientiarum Hungaricae, 8, Budapest, 1962

Balogh, J., "Wealthy patrons of the Hungarian Renaissance", in The Hungarian Quarterly, 7, Budapest, 1966

Birnbaum, V., "Vladislavský sál" (Vladislav Hall), in Listy z dějin umění (Leaves from the history of art), Prague, 1947

Buchner, E., Das deutsche Bildnis der Spätgotik und der frühen Dürerzeit, Berlin, 1953

Buchner, R., Maxmilian I. (Kaiser an der Zeitwende), Göttingen, 1959

Chadraba, R., Dürers Apokalypse, Prague, 1964

Chadraba, R., "Výstava Maxmiliána I. v Innsbrucku" (The Maximilian I exhibition in Innsbruck), in Umění, 18, Prague, 1970

Chytil, K., Vývoj miniaturního malířství českého z doby králů rodu Jagellonského (The development of Bohemian miniature-painting in the period of the kings of the Jagiello dynasty), Prague, 1896

Chytil, K., Malířstvo pražské XV. a XVI. věku a jeho cechovní kniha staroměstská z let 1490—1582 (The guild of Prague painters of the 15th and 16th centuries and its Old Town guild-book of 1490—1582), Prague, 1906

Chytil, K., Antikrist v naukách a umění středověku (Antichrist in the teachings and art of the Middle Ages), Prague, 1918

Chytil, K., České malířství prvních desítiletí 16. století (Bohemian painting of the first decades of the 16th century), Prague, 1931

Cibulka, J., Český řád korunovační a jeho původ (The Bohemian Coronation Order and its origin), Prague, 1934

Csikay, P., Die Beziehungen Matthias Corvinus' zu den Eidgenossen, Munich, 1952

Denkstein, V., Zvíkov, Prague, 1948

Eckert, F., Posvátná místa královského hlavního města Prahy (Sacred places of the royal town of Prague), 1—2, Prague, 1883—84

Fehr, G., Benedikt Ried, ein deutscher Baumeister zwischen Gotik und Renaissance in Böhmen, Munich, 1961 (Review in Umění, 11, 1963, 310ff.; 14, 1966, 181ff.; Acta historiae artium, 13, 1967, 289ff.)

Fehr, G., "Benedikt Ried — ein Baumeister der Donauschule", in Alte und moderne Kunst, 10, Vienna, 1965

Fógel, J., II. Ulászló Udvartartása (1490—1516), Budapest, 1913

Francastel, P., La figure et le lieu, Paris, 1967

Gerevich, L., "Réflexions sur le château de Buda à l'époque du Roi Matthias", in Acta historiae artium Academiae scientiarum Hungaricae, 8, Vienna, 1962

Gerevich, L., The Art of Buda and Pest in the Middle Ages, Budapest, 1971

Gotik in Böhmen, Munich, 1969 (Review in Umění, 19, 1971, 358ff.)

Hart, F., Kunst und Technik der Wölbung, Munich, 1966

Hejnic, J. — Martínek, J., Rukověť humanistického básnictví v Čechách a na Moravě (Endeiridion renatae poesis Latinae in Bohemia et Moravia cultae), 1—4 (A—Ř), Prague, 1966—73

Herbst des Mittelalters. Spätgotik in Köln und am Niederrhein, Cologne, 1970 (Catalogue)

Hersey, G. L., Alfonso II and the Artistic Renewal of Naples 1485—1495, New Haven and London, 1969

Hirschfeld, P., Mäzene, Hamburg, 1968

Hans Holbein der Ältere und die Kunst der Spätgotik, Augsburg, 1965 (Catalogue)

Hořejší, J., "Praha na konci 15. století?" (Prague at the end of the 15th century?), in Umění, 15, Prague, 1967

Hořejší, J., "Tvář pozdně středověkých historismů" (The face of late medieval historicism), in Umění, 17, Prague, 1969

Hořejší, J. — Vacková, J., "Král Vladislav II. ve světle 'neexistujících pramenů'" (King Vladislav II in the light of "non-existent" sources), in Dějiny a současnost (History and Presence), 4, Prague, 1967

Hořejší, J. — Vacková, J., An der Wende des Zeitalters — Hofkunst um 1500 in Böhmen, in Alte und moderne Kunst, 13, Vienna, 1968

Huizinga, J., The Waning of the Middle Ages, London, 1965

Jihočeská pozdní gotika (1450—1530) (South-Bohemian Late Gothic), Hluboká, 1965 (Catalogue)

Jůza, V. — Krsek, I. — Petrů, J. — Richter, V., Kroměříž, Prague, 1963

Jůzová-Škrobalová, A., "Zámecký portál v Tovačově a jeho místo v raně renesanční moravské architektuře" (The portal of Tovačov Castle and its place in Early Renaissance Moravian architecture), in Umění a svět, Uměleckohistorický sborník (Art and the world, a compendium of art history), Gottwaldov, 1956

Kampers, A., Vom Werdegange der abendländischen Kaiser-Mystik, Leipzig — Berlin, 1924

Kardos, T., A Magyarországi Humanismus Kora, Budapest, 1955

Kardos, T., "Čeští humanisté a budínská skupina učené společnosti dunajské" (Czech humanists and the Buda group in Danubian learned society), in Česká literatura (Czech literature), 9, Prague, 1961

Kletzl, O., "Zur künstlerischen Ausstattung des Veitsdomes in vorhussitischer Zeit", in Germanoslavica, 1, Prague, 1931—32

Kotrba, V., "Kaple svatováclavská v pražské katedrále (St Wenceslas' Chapel in Prague Cathedral), in Umění, 8, Prague, 1960

Kotrba, V., "Baukunst und Baumeister der Spätgotik am Prager Hof", in Zeitschrift für Kunstgeschichte, 31, Munich, 1968

Kotrba, V., "Wendel Roskopf, 'Mistr ve Zhořelci a ve Slezsku', v Čechách" (W. R., 'Master in Görlitz and Silesia', in Bohemia), in Umění, 16, Prague, 1968

Kotrba, V., "Die Bronzenskulptur des hl. Georg auf der Burg zu Prag", in Anzeiger des Germanischen Nationalmuseums, Nuremberg, 1969

Kotrba, V., "Zwei Meister der Jagellonischen Hofkunst", in Umění, 20, Prague, 1972

Krása, J., "Renesanční nástěnná výzdoba kaple svatováclavské v chrámu sv. Víta v Praze" (The Renaissance wall-decoration of St Wenceslas' Chapel in St Vitus' Cathedral in Prague), in Umění, 6, Prague, 1958

Krása, J., "Nástěnné malby žirovnické Zelené světnice" (Wall-paintings in the Green Room at Žirovnice), in Umění, 12, Prague, 1964

Krása, J. — Josefík, J., "Nové poznatky o průzkumu barevných vrstev některých obrazů v kapli sv. Václava" (New findings from the exploration of the colour layers of some paintings in St Wenceslas' Chapel), in Památková péče, 28, Prague, 1968

Kropáček, J. — Stádník, K., "K restauraci Týnského oltáře mistra IP" (On the restoration of the altar of the Master IP), in Umění, 15, Prague, 1967

Die Kunst der Donauschule, St. Florian — Linz, 1965 (Catalogue)

Kutal, A., "O Mistru zlíchovského epitafu" (On the Master of the Zlíchov Epitaph), in Časopis Národního muzea (Bulletin of the National Museum), 125, Prague, 1956

Kutal, A., Gotische Kunst in Böhmen, Prague, Artia, 1971 (in French: L'Art gothique de Bohême, 1971; in English: Gothic art in Bohemia, 1972; in Czech: České gotické umění, 1972)

Lavalleye, J., Les Primitifs Flamands, 7. Le Palais ducal d'Urbin, Brussels, 1964

Leminger, E., "Stavba pražského hradu za krále Vladislava II" (The building of Prague Castle under king Vladislav II), in Památky archeologické 14, Prague, 1889

Levey, M., Painting at the court, London, 1971

Lieb, N., Die Fugger und die Kunst, Munich, 1952

Lippert, J., Geschichte der Stadt Leitmeritz, 2, Prague, 1871

de Lobkowicz, Bohuslaus Hassensteinus, Epistolae, ed. Kardos T., Budapest, 1946

Lůžek, B., Stavitelé chrámu sv. Mikuláše v Lounech (The builders of the cathedral of St Nicholas at Louny), Louny, 1968

Mádl, K. B., "Řád zedníků a kameníků pražských v 16. století" (The statute of Prague bricklayers and stone-masons of the 16th century), in Památky archeologické, 16, Prague, 1896

Matějček, A., "Die freigelegten Wandmalereien der St. Wenzels-Kapelle im Prager Dome", in Mitteilungen der k. k. Zentralkommission, 13 (III. F.), Vienna, 1914

Matějková, A., Kutná Hora, Prague, 1962

Meister um Albrecht Dürer, Nuremberg, 1961 (Catalogue)

Meller, P., Physiognomical Theory in the Renaissance and Mannerism. Acts of the Twentieth International Congress of Art, 2, Princeton, 1963

Mencl, V., "Vznik a vývoj kroužené klenby" (The Origin and development of the tracery vault), in Ročenka Kruhu pro pěstování dějin umění (Annual of the Society for the pursuit of the history of art), 1934, Prague, 1935

Menclová, D., České hrady (Czech Castles), vol. 2, Prague, 1972

Palacký, F., Dějiny národu českého (History of the Czech nation), vol. 5, Prague, 1968

Panofsky, E., Early Netherlandish Painting, London, 1958

Papée, F., Studya i skice z czasów Kazimierza Jagiełłończyka, Warsaw, 1907

Pešina, J., "Malířská výzdoba Smíškovské kaple v kostele sv. Barbory v Kutné Hoře" (Painted decoration in the Smíšek Chapel in St Barbara's Cathedral at Kutná Hora), in Umění, 13, Prague, 1939—40

Pešina, J., Kaple sv. Václava v chrámu sv. Víta v Praze (St Wenceslas' Chapel in St Vitus' Cathedral in Prague), Prague, 1940

Pešina, J., "Slohový vývoj Mistra litoměřického oltáře" (The stylistic development of the Master of the Litoměřice Altar-piece), in Cestami umění (On the paths of art), Prague, 1949 (Collection of papers)

Pešina, J., Česká malba pozdní gotiky a renesance, deskové malířství 1450—1550 (Late Gothic and Renaissance Bohemian painting, panel-painting in 1450—1550), Prague, 1950

Pešina, J., Mistr litoměřický (The Master of Litoměřice), Prague, 1958

Pešina, J., Tafelmalerei der Spätgotik und der Renaissance in Böhmen 1450—1550, Prague, 1958

Pešina, J., "Der Anteil Böhmens an der Entwicklung des Stillebens in der Malerei des Spätmittelalters", in Festschrift K. M. Swoboda, Vienna — Wiesbaden, 1959

Pešina, J., "Podíl Čech na vývoji zátiší v evropské malbě středověku" (Bohemia's contribution to the development of still-life in European painting of the Middle Ages), in Umění, 8, Prague, 1960

Pešina, J., "Nový pokus o revizi dějin českého malířství 15. století" (A new attempt at a revision of the history of Bohemian painting of the 15th century), in Umění, 8, Prague, 1960

Pešina, J., Altdeutsche Meister. Von Hans von Tübingen bis Dürer und Cranach, Prague, Artia, 1962

Pešina, J., "Mistři kolem Albrechta Dürera" (Masters around Albrecht Dürer), in Umění, 10, 1962

Pešina, J., "Paralipomena k dějinám českého malířství pozdní gotiky a renesance"

(Paralipomena to the history of Bohemian painting of the Late Gothic and Renaissance), in Umění, 15, 1967

Pešina, J., "České malířství kolem roku 1500 a Itálie" (Bohemian painting about the year 1500 and Italy), in Umění, 18, Prague, 1970

Pešina, J., "Ještě k otázkám německého malířství 15.—16. století v Československu" (Some more remarks on German painting of the 15th and 16th centuries in Czechoslovakia), in Umění, 18, Prague, 1970

Poche, E., "Benedikt Rejt z Pístova", in Umění, 8, Prague, 1935

Pražský hrad ve středověku (Prague Castle in the Middle Ages), Prague, 1946 (Catalogue)

"La Renaissance et la Réformation en Pologne et en Hongrie", in Acta historiae Academiae scientiarum Hungaricae, 53, Budapest, 1963

A Reneszánsz-Kor Müvészete Magyarországon, Budapest, 1964

Restaurování nástěnných maleb a závěsných obrazů (Restoration of wall-paintings and hanging-pictures), Prague, 1967 (Catalogue)

Rotondi, P., Il Palazzo ducale di Urbino, 1—2, Urbino, 1950—51

Šamánková, E., Architektura české renesance (Architecture of Bohemian Renaissance), Prague, 1961

Šamánková, E., "Über die Anfänge der tschechoslowakischen Renaissance-Architektur", in Acta historiae artium Academiae scientiarum Hungaricae, 13, Budapest, 1967

Sandström, S., Levels of unreality, Uppsala, 1963

Schlegel, I., "Ein Beitrag zur Ikonographie König Ludwigs II. von Ungarn", in Miscellanea Jozef Duverger, Gent, 1968

Schulz, E., "Pintoricchio and the Revival of Antiquity", in Journal of the Wartburg and Courtauld Institutes, 25, London, 1962

Sedláček, A., Hrady, zámky a tvrze v království českém (Castles, châteaux and fortresses in the Kingdom of Bohemia), 4, Prague, 1885; 6—8, 1889—91; 9, 1893; 11, 1897

Seifertová, H., "Zátiší ve Smíškovské kapli v kostele sv. Barbory v Kutné Hoře" (Still-lifes in the Smíšek Chapel in St Barbara's Cathedral at Kutná Hora), in Krásné město (Beautiful town), 1, 1970

Šimák, J. V., "Zprávy o malířích a iluminátorech pražských doby jagelonské 1471—1526" (Reports on Prague painters and illuminators of the Jagiello period 1471—1526), in Památky archeologické (Archeological monuments), 18, Prague, 1898—99

Stange, A., Deutsche Malerei der Gotik, 9, Munich — Berlin, 1958

Stange, A., Malerei der Donauschule, Munich, 1964

Stefan, O., "K dějezpytným otázkám naší renesanční architektury" (On questions of historical research into our Renaissance architecture), in Umění, 12, Prague, 1964

Steiff, M., "Jörg Breu's Fresken im Olmützer Dom", in Sborník k šedesátým narozeninám E. W. Brauna (60th birthday volume for E. W. Braun), Augsburg, 1931

Sterling, Ch., La nature morte, Paris, 1959

Tomek, W. W., Dějepis města Prahy (History of the town of Prague), 8, Prague, 1891

Truhlář, J., Humanismus a humanisté v Čechách za krále Vladislava II. (Humanism and Humanists in Bohemia under King Vladislav II), Prague, 1894

Vacková, J., "K ideové koncepci renesančních nástěnných maleb ve svatováclavské kapli" (On the ideological conception of the Renaissance wall-paintings in St Wenceslas' Chapel), in Umění, 16, Prague, 1968

Vacková, J., Les Difficultés et la Fleur Tardive de la Renaissance en Bohême, in Ze Studiów nad Sztuka XVI. wieku na Śląsku i w krajach sasiednich, Wrocław, 1968

Vacková, J., "K malbám ve Smíškovské kapli" (On the paintings in the Smíšek Chapel), in Umění, 19, Prague, 1971

Voigt, P., "Una Bottega in Via dei Servi", in Acta historiae artium Academiae scientiarum Hungaricae, 7, Budapest, 1960

Votoček, O., "K opravě a původu obrazů Litoměřického mistra" (On the restoration and origin of the paintings of the Master of Litoměřice), in Zprávy památkové péče, 21, Prague, 1961

Winker, W., Kaiser Maximilian I. (Zwischen Wirklichkeit und Traum), Munich, 1950

The Arts in the Renaissance and Mannerist periods

Archival materials (documents, acta, registers and inventories) published in: Jahrbuch der kunsthistorischen Sammlungen des allerhöchsten Kaiserhauses in Wien, 5, 1887; 7, 1888; 10, 1889; 11, 1890; 12, 1891; 13, 1892; 14, 1893; 15, 1894; 19, 1898; 29, 1910—11; 30, 1911—13 (published by W. Boeheim, K. Köpl, F. Kreyczi, H. Peltz, D. Ritter von Schönherr, H. von Voltelini, H. Zimmerman)

Ackerman, J. S., Palladio, Harmondsworth — New York, 1966 (1967, 1972)

Alberti, L. B., De re aedificatoria libri decem, Florence, 1484 (Strasbourg, 1511, Paris, 1512)

Alvin, A., Catalogue de l'oeuvre des frères Wierix, Brussels, 1866

Architektúra na Slovensku do polovice XIX. storočia (Architecture in Slovakia till the middle of the 19th century), Bratislava, 1958

Argan, G. C., Brunelleschi, Milan, 1954

Arte e artisti dei laghi lombardi, 1, Como, 1959 (Collection of papers)

Arte italiana in Cecoslovacchia (Boemia e Moravia), mostra fotografica, Prague, 1950, (Exhibition Catalogue written by P. J. M. Preiss)

Augsburger Renaissance, Augsburg, 1955 (Exhibition catalogue written by N. Lieb, H. Müller, G. Threin)

Auszug einer Reisebeschreibung eines Schweden im Jahre 1688, Lieferungen für Boehmen von Boehmen, 13. Lieferung, Prague, 1793—94

Bachmann, E., "Ein unbekanntes Alterswerk des Bonifaz Wolmut", in Ostdeutsche Wissenschaft, 3—4, Munich, 1958

Bachmann, E., "Architektur", in Barock in Böhmen, ed. K. M. Swoboda, Munich, 1964

Bachman, W., "Nossenis Lusthaus auf der Jungfernbastei in Dresden", Neues Archiv für Sächsische Geschichte, 57, Dresden, 1936

Balbin, B., Miscellanea historica regni Bohemiae, 1—3, Prague, 1679—81

Baldass — Feuchtmüller — Mrazek, Renaissance in Österreich, Vienna — Hanover, 1966

Bange, E. F., Peter Flöttner, Leipzig, 1926

Barbieri, F., Vincenzo Scamozzi, Vicenza, 1952

Barbieri, F. — Cevese, R. — Magagnato, L., Guida di Vicenza, Vicenza, 1956

Baroni, C., L'Architettura lombarda da Bramante al Richini, Milan, 1941

Bartsch, A., Le Peintre-graveur, Leipzig, 1866—76

Bartušek, A., "Státní zámek ve Velkých Losinách" (The State Château at Velké Losiny), in Velké Losiny, Prague, 1954

Bartušek, A., Dačice, Prague, 1960

Bartušek, A. — Kába, A., Umělecké památky Jihlavy (Artistic monuments of the town of Jihlava), Havlíčkův Brod, 1960

Bartušek, A. — Kubátová, T., "Státní hrad Šternberk na Moravě" (The State Castle of Šternberk in Moravia), in Šternberk in Moravia, Prague, 1951

Bascapé, G. C., I palazzi della vecchia Milano, Milan, 1945

Bassermann-Jordan, E., Die dekorative Malerei der Renaissance am bayerischen Hofe, Munich, 1900

Baum, J., Baukunst und dekorative Plastik der Frührenaissance in Italien, Stuttgart, 1926

Baumgart, F., Renaissance und Kunst des Manierismus, Cologne, 1963

Baur-Heinhold, M., Süddeutsche Fassadenmalerei vom Mittelalter bis zur Gegenwart, Munich, 1952

Bažant, E., Hrad Rožmberk (Rožmberk Castle), Rožmberk, 1924

Beccherucci, L., La scultura italiana del Cinquecento, Florence, 1934

Beccherucci, L., L'architettura italiana del Cinquecento, Florence, 1936

Becker, C., Jobst Amman, Zeichner und Formschneider, Kupferätzer und Stecher, Leipzig, 1854

Bělohlávek, M., Plzeňská radnice (Plzeň Town Hall), Plzeň, 1955

Benesch, O., The Age of the Renaissance in Northern Europe, its relation to the contemporary spiritual and intellectual movement, Cambridge, Mass., 1947

Bergner, P., "Auszüge aus den Bürgerbüchern der königlichen Stadt Prag über Künstler und Kunsthandwerker vom J. 1550 bis 1783", in Mitteilungen des Vereines für die Geschichte der Deutschen in Böhmen, 54, Prague, 1915

Berliner, R., Ornamentale Vorlage-Blätter des 15. bis 18. Jahrhunderts, 1, Leipzig, 1925

Bernstein, F., Der deutsche Schlossbau der Renaissance, 1530—1618, Strasbourg, 1933

Beseghi, U., Palazzi di Bologna, Bologna, 1956

Beyer, K. G. — Reiman, G., Renaissance. Baukunst in Deutschland, Leipzig, 1966

Białostocki, J., Stil und Ikonographie, Dresden, 1966

Białostocki, J., "Two types of international Mannerism: Italian and Northern", in Umění, 18, Prague, 1970

Bibl, V., Maximilian II., der rätselhafte Kaiser, Vienna, 1929

Bimler, K., Schlesische Renaissanceplastik, Wrocław, 1934

Birk, E., "Jacob Seisenegger, Kaiser Ferdinand I. Hofmaler, 1531—1567", Mitteilungen der k. k. Zentral-Commission, 9, 1864

Birnbaum, V., "Původní průčelí kostela P. Marie Vítězné na Malé Straně" (The original façade of the Church of the Virgin Victorious in the Lesser Town), in Památky archeologické, 34, 1924—25

Blažíček, O. J., Sochařství baroku v Čechách (Baroque sculpture in Bohemia), Prague, 1958

Blažíček, O. J., Barockkunst in Böhmen, Prague, Artia, 1967 (in French: L'Art baroque en Bohême, 1967; in English: Baroque art in Bohemia, 1968)

Blunt, A., Art and Architecture in France 1500 to 1700, Melbourne — London — Baltimore, 1953

Blunt, A., Artistic theory in Italy 1450—1600, Oxford, 1956

Blunt, A., Philibert de l'Orme, London, 1958

Bode, W., Die Kunst der Frührenaissance in Italien, Berlin, 1923

Bollettino del Centro internazionale di studi di architettura "Andrea Palladio", 1—14, Vicenza, 1959—72

Bousquet, J., La peinture maniériste, Neuchâtel, 1964

Braun, G., Beschreibung und Contrafactur der vornambsten Statt der Welt, 1—3, Cologne, 1574—90

Braun, G., Civitates orbis terrarum, 1—6, Cologne, 1593—1617

Breitenbacher, A., "Oprava olomouckého dómu biskupem Stanislavem II. Pavlovským"

(Restoration of the Olomouc Cathedral by Bishop Stanislas II Pavlovský), in Časopis Moravského Musea zemského (Bulletin of the Moravian Land-Museum), 16, Brno, 1916

Brentani, L., Antichi maestri d'arte e di scuola delle terre ticinesi, Notizie e documenti, 1—7, Lugano, 1937—63

Bretholz, B., Brünn, Geschichte und Kultur, Brno, 1938

Březan, V., Život Viléma z Rosenberga (Life of William of Rosenberg), ed. F. Palacký, Prague, 1847

Březan, V., Život Petra Voka z Rosenberka (Life of Peter Vok of Rosenberg), ed. F. Mareš, Prague, 1880

Březan, V., Poslední Rožmberkové (The last of the Rožmberks), ed. J. Dostál, Prague, 1947

Brix, K., Baukunst der Renaissance in Deutschland, Dresden, 1965

Bruschi, A., Bramante architetto, Bari, 1969

Buchholtz, F. B., Geschichte der Regierung Ferdinand des Ersten, 1—9, Vienna, 1831—38

Büchner, J., Die spätgotische Wandpfeilerkirche Bayerns und Österreichs, Nuremberg, 1964

Bukolská, E., Renesanční portrét v Čechách a na Moravě (Renaissance Portrait in Bohemia and Moravia), 1—2, Prague, 1968 (unpublished dissertation)

Cataneo Senese, P., I quattro primi libri di architettura, Venice, 1554

Čelakovský — Kalousek — Rieger — Stupecký, O královském hradě pražském (On the Royal Castle of Prague), Prague, 1907

Černá, M. L., "Studenti ze zemí českých na universitě v Orléansu a na některých jiných francouzských universitách" (Students from the Czech Lands at the University of Orléans and some other French universities), in Český časopis historický (Czech Historical Journal), 40, Prague, 1934

Československá vlastivěda (Czechoslovak history and geography), 2, Dějiny (History), 1, ed. J. Kočí, Prague, 1963 (Collection of papers)

Chadraba, R., "K dějinám olomouckého dómu za renesance" (On the history of the Olomouc Cathedral in the Renaissance period), in Sborník památkové péče v Severomoravském kraji (Journal of the Institute for the Protection of Monuments in the Northern Moravian Region), 2, Ostrava, 1973

Chastel, A., L'art italien, 1—2, Paris, 1956

Chastel, A., Art et humanisme à Florence au temps de Laurent le Magnifique, Paris, 1959

Chastel, A., The Age of Humanism, Europe 1480—1530, New York, 1963

Chastel, A., La crise de la Renaissance 1520—1600, Geneva, 1968

Chierici, G., Il palazzo italiano dal secolo XI al secolo XIX, 2, Milan, 1954

Chiesa, C., L'Architettura del Rinascimento nel Cantone Ticino, Bellinzona, 1934

Chirol, E., Le Château de Gaillon, Rouen — Paris, 1952

Chudoba, P., Španělé na Bílé hoře (Spaniards on the White Mountain), Prague, 1945

Chytil, K., Umění v Praze za Rudolfa II. (in German: Die Kunst in Prag zur Zeit Rudolf II., 1904), Prague, 1904

Chytil, K., Malířstvo pražské XV. a XVI. věku a jeho cechovní kniha staroměstská z let 1490—1582 (The guild of Prague painters of the 15th and 16th centuries and its Old Town guild-book of 1490—1582), Prague, 1906

Chytil, K., Umění a umělci na dvoře Rudolfa II. (Art and artists at the court of Rudolph II), Prague, 1920

Chytil, K., "Vincenzo Scamozzi v Čechách a jeho brána na Hradě pražském" (Vincenzo Scamozzi in Bohemia and his gate in Prague Castle), in Ročenka Kruhu pro pěstování dějin umění (Annual of the Society for the pursuit of the history of art), 1922, Prague, 1923

Chytil, K., "Mistři lugánští v Čechách v XVI. století. Maestri luganesi in Boemia nel secolo XVI.", in op. cit. 1924, Prague, 1925

Co daly naše země Evropě a lidstvu (What our countries have given to Europe and mankind), 1, 2nd ed., Prague, 1940 (Collection of papers)

Collijn, I. G., Rožmberská knihovna (Rožmberk library), trans. H. Sperbe and E. Pacovský, Prague, 1913

Collijn, I. G., Nové příspěvky k dějinám rožmberské knihovny (New contributions to the history of the Rožmberk library), trans. F. Kleinschnitz, Prague, 1926

Crosato, L., Gli affreschi nelle ville venete del Cinquecento, Treviso, 1962

Crowne, W., A true relation of all the remarkable places ... observed in the Travels of the right honorable Thomas Lord Howard Earle of Arundel and Surrey ... to his sacred Majesty Ferdinando the second ... Anno Domini 1636, London, 1937

Dačeva, R., Pražské renesanční sgrafito (Prague Renaissance Sgraffito), Prague, 1969 (unpublished thesis at Charles University)

Daňková, M., Bratrské tisky ivančické a kralické (Moravian Brethren's prints of Ivančice and Kralice), 1554—1619, Prague, 1951, Časopis Národního muzea (Bulletin of the National Museum)

Davídek, V., Hrad a zámek Horšovský Týn (The Castle and Château of Horšovský Týn), Prague, 1949, in the series Poklady národního umění (Treasures of national art), 104—5

Deiseroth, W., Der Triumphbogen als grosse Form in der Renaissancebaukunst Italiens, Munich, 1970 (dissertation at Munich University)

Dějepis výtvarných umění v Československu (A History of the graphic and plastic arts in Czechoslovakia), ed. Z. Wirth, Prague, 1935 (Collection of papers)

Dějiny lidstva (The History of mankind), ed. J. Šusta, 5, Prague, 1938

Delorme (de l'Orme), P., Nouvelles inventions pour bien bastir, Paris, 1561

Delorme, P., L'architecture de Philibert de l'Orme, Paris, 1576

Diez, E., "Der Hofmaler Bartholomäus Spranger", in Jahrbuch der kunsthistorischen Sammlungen, 28, Vienna — Leipzig, 1909—10

Dimier, L., Dessins français du XVIe siècle, Paris, 1937

Dlabacž, G. J., Allgemeines historisches Künstler-Lexikon für Boehmen, 1—3, Prague, 1815

Dobrowolski, T., Sztuka Krakówa, Cracow, 1959

Dokoupil, Z. — Naumann, P. — Riedl, D. — Veselý, I., Historické zahrady v Čechách a na Moravě (Historic Gardens in Bohemia and Moravia), Prague, 1957

Donin, R. K., "Die Entwicklung des Schlossbaues in Südmähren und Südostböhmen", in Unsere Heimat, N. F., 12, Vienna, 1939

Donin, R. K., "Renaissanceschlösser in Mähren", in Der Bau 2 (39), Prague, 1943

Donin, R. K., Das Bürgerhaus der Renaissance in Niederdonau, Vienna, 1944

Donin, R. K., Vincenzo Scamozzi und der Einfluss Venedigs auf die Salzburger Architektur, Innsbruck, 1948

Donin, R. K., "Das Neugebäude in Wien und die venezianische Villa suburbana", in Mitteilungen der Gesellschaft für vergleichende Kunstforschung in Wien, 11, Vienna, 1958

Dornik-Egger, H., Albrecht Dürer und die Graphik der Reformationszeit, Vienna, 1969

Dostál, E., Umělecké památky Brna (Artistic monuments of Brno), Brno, 1928

Dražan, V., "Gotický a renesanční městský dům z jižních Čech a Moravy" (Gothic and Renaissance town houses in southern Bohemia and Moravia), in Zprávy památkové péče, 10, 1950

Dreger, M., Baugeschichte der k. k. Hofburg in Wien bis zum XIX. Jahrhunderte, Oesterreichische Kunsttopographie, 14, Vienna, 1914

Dressler, H., Alexander Colin, Karlsruhe, 1973

Dřímal, J., "Dům pánů z Lipé a sochař Jiří Gialdi" (The house of the Lords of Lipá and the sculptor Giorgio Gialdi), in Družstevní dům v Brně (Co-operative house in Brno), Brno, 1939

Dřímal, J., Zemský dům v Brně (The Land House in Brno), Brno, 1947

Du Cerceau, J. A., Livre d'architecture, Paris, 1582

Dürer, A., Opera Alberti Dureri, Arnhem, 1604

Dvořák, F. et al., Český Krumlov, Prague, 1948

Dvořák, M., Geschichte der italienischen Kunst im Zeitalter der Renaissance, Munich, 1928 (Akademische Vorlesungen, 2)

Dvořák, M., "Spanische Bilder einer österreichischen Ahnengalerie", in M. Dvořák, Gesammelte Aufsätze zur Kunstgeschichte, Munich, 1929

Dvořák, M., Italské umění od renesance k baroku (Italian art from the Renaissance to Baroque), Prague, 1946

Dvořáková, V., Horšovský Týn, Prague, 1963

Dvořáková, V. — Machálková, H., "Malovaná průčelí české pozdní gotiky a renesance" (Painted façades of the Bohemian Late Gothic and Renaissance), in Zprávy památkové péče, 14, Prague, 1954

Dvořáková, V. — Zbíralová, M., "Renesanční malovaný strop na Švihově a jeho restaurace" (A Renaissance ceiling at Švihov and its restoration), in Zprávy památkové péče, 14, 1954

Dyk, J., Rod rytířů Gryspeků z Gryspachu v Čechách (The Family of the knights Gryspek of Gryspach in Bohemia), Prague, 1924

Dytrt, K., "O třemešském zámku a jeho vlastnících" (Třemešek Château and its owners), in Vlastivědný sborník střední a severní Moravy (Journal of the history and geography of central and northern Moravia), 11, Kroměříž, 1932—33

Dytrt, K., "O lovčím zámku tatenickém a jeho zakladateli" (The hunting château of Tatenice and its founder), in op. cit., 13, Kroměříž, 1934—35

Ebhardt, B., Die zehn Bücher des Vitruv und ihre Herausgeber seit 1484, Berlin, 1918

L'École de Fontainebleau, ed. S. Béguin, Paris, 1972 (Exhibition catalogue)

Egg, E., "Der deutsche König und die neue Kunst", in Alte und moderne Kunst, 6, Vienna, 1961

Egger, H., Architektonische Handzeichnungen alter Meister, 1, Vienna — Leipzig, s. a.

Einem, H. von, Karl V. und Tizian, Cologne, 1960

Enciclopedia universale dell'arte, 1—14, Venice — Rome, 1958—66

Falke, J. von, Schloss Stern, Vienna, 1879

Fiocco, G. — Procacci, U. — Muraro, M. — Ivanoff, N. — Moretti, L., Pitture murali nel Veneto a tecnica dell'affresco, Venice, 1960 (Exhibition catalogue)

Firpo, L., Leonardo, architetto e urbanista, Torino, 1963

Fišer, F. — Lejsková-Matyášová, M., "Renesanční nástěnné malby ve státním zámku v Bučovicích a jejich restaurování" (Renaissance wall-paintings in the State Château of Bučovice and their restoration), in Zprávy památkové péče, 16, Prague, 1956

Fleischhauer, W., Die Renaissance im Herzogtum Württemberg, Stuttgart, s. a.

Forssman, E., Säule and Ornament, Stockholm, 1956

Forssman, E., Dorisch, jonisch, korinthisch, Gothenburg—Uppsala, 1961

Forssman, E., Palladios Lehrgebäude, Gothenburg—Uppsala, 1965

Fossi, M., Bartolomeo Ammannati architetto, Naples, 1968 (Pubblicazioni dell'Universita degli studi di Firenze)

Freedberg, D. J., Painting of the High Renaissance in Rome and Florence, 1—2, Cambridge, Mass., 1961

Frejková, O., Palladianismus v české renesanci (Palladianism in the Czech Renaissance), Prague, 1941

Freyer, C., "Die einstigen Malereien in der Augustusburg", in Neues Archiv für sächsische Geschichte und Altertumskunde, 7, Dresden, 1886

Fritsch, R. F. O., Der Kirchenbau des Protestantismus, Berlin, 1893

Fučíková, E., "Rudolf II. — einige Bemerkungen zu seinen Sammlungen", in Umění, 18, Prague, 1970

Garber, J., Schloss Ambras, Vienna—Augsburg, 1928

Gébelin, F., Le Style Renaissance en France, Paris, 1942

Gebessler, A., Der profane Saal des 16. Jahrhunderts in Süddeutschland und den Alpenländern, Munich, 1957 (dissertation at the University of Munich)

Giannoni, K., Bildende Kunst in Niederdonau, 3, Renaissance und Barock, St. Pölten, 1943

Gindely, A., Rudolf II. und seine Zeit (1600—1612), 1—2, 2nd ed., Prague, 1863

Ginhart, G. — Hammer, H. — Riehl, G., Die bildende Kunst in Österreich, 4, Renaissance und Barock, Baden bei Wien, 1939

Giovannoni, G., Antonio da Sangallo Il Giovane, Rome, 1959

Goering, M., "Die Malerfamilie Bocksberger", in Münchner Jahrbuch, N. F. 7, Munich, 1930

Gombrich, E. H., "Zum Werke Giulio Romanos", in Jahrbuch der kunsthistorischen Sammlungen, N. F. 8, Vienna, 1934; 9, 1935

Gombrich, E. H., Norm und Form, Studies in the Art of the Renaissance, London, 1966

Gothein, M. L., Geschichte der Gartenkunst, 1—2, Jena, 1926

Griesbach, H., Die Genealogie der Familie Griesbach von Griesbach, Giessen, 1929

Guerquin, B., Zamki śląskie, Warsaw, 1957

Guidi, M., Dizionario degli artisti Ticinesi, Rome, 1932

Guldan, E., "Ausstrahlungen der Comasken-Kunst in Europa", in Österreichische Zeitschrift für Kunst und Denkmalpflege, 12, Vienna, 1958

Halm, P., "Ein Entwurf A. Altdorfers zu den Wandmalereien im Kaiserbad zu Regensburg", in Jahrbuch der Preussischen Kunstsammlungen, 53, Berlin, 1932

Hálová-Jahodová, C., Brno, Prague, 1947

Hammer, H., Kunstgeschichte der Stadt Innsbruck, Innsbruck — Vienna — Munich, 1952

Hammerschmid, J. F., Prodromus gloriae Pragenae, Prague, 1723

Handcke, B., "Josef Heintz, Hofmaler Kaisers Rudolf II.," in Jahrbuch der kunsthistorischen Sammlungen, 14, Vienna, 1894

Hartig, O., "Die Kunsttätigkeit in München unter Wilhelm IV. und Albert V., 1520—1579", in Münchner Jahrbuch, N. F. 10, Munich, 1933

Haupt, A., Baukunst der Renaissance in Frankreich und Deutschland, Berlin, 1923

Hauser, A., Der Manierismus, Munich, 1964

Hauser, P. — Dvořák, M., "Sgraffiti im Schlosse zu Leitomischl", in Kunstgeschichtliches Jahrbuch der k. k. Zentralkommission, 1, Supplement, 1907

Hedicke, R., Cornelis Floris und die Florisdekoration. Studien zur niederländischen und deutschen Kunst im 16. Jahrhundert, 1—2, Berlin, 1913

Heinz, G., "Studien zur Porträtmalerei an den Höfen der österreichischen Erblande", in Jahrbuch der kunsthistorischen Sammlungen, N. F. 23, Vienna, 1963, No. 190

Hejna, A., "Opočno", in Opočno, Prague, 1957

Hejna, A., České tvrze (Fortified Seats of Bohemia), Prague, 1961

Hentschel, W., "Sächsische Renaissancebildhauer in Nordwestböhmen", in Nordwestböhmen in der Kunst von 1530—1680, Most, 1932

Hentschel, W., Dresdner Bildhauer des 16. und 17. Jahrhunderts, Weimar, 1969

Herbst, S., Zamość, Warsaw, 1954

Herget, E., "Wirkungen und Einflüsse des Palazzo del Tè nördlich der Alpen", in Festschrift für Harald Keller, Darmstadt, 1963

Herout, J., "Tábor", in Zprávy památkové péče, 10, Prague, 1950

Herout, J., "Nové poznatky o pernštejnské výstavbě Pardubic" (New findings about the Pernštejns' construction of Pardubice), in Památková péče, 22, Prague, 1962

Hikl, R., Moravská Třebová, náčrt dějin jejich (Moravská Třebová, an outline of its history), Moravská Třebová, 1949

Hilger, W., Ikonographie Kaiser Ferdinands I. (1503—64), Vienna, 1969

Hilmera, J., "Prachatice", in Zprávy památkové péče, 10, Prague, 1950

Hilmera, J., Jindřichův Hradec, Prague, 1956

Hilmera, J., Státní zámek v Litomyšli (The State Château at Litomyšl), Prague, 1959

Hirn, J., Erzherzog Ferdinand II. von Tirol, 1—2, Innsbruck, 1885—88

Historia sztuki polskiej, ed. T. Dobrowolski and W. Tatarkiewicz, 2, Cracow, 1962

Hocke, G. R., Die Welt als Labyrinth, Hamburg, 1957

Hoffmann, A. — Pfeffer, F., Baugeschichte der Linzer Burg, Linz, 1947

Hoffmann, H., Hochrenaissance, Manierismus, Frühbarock, Zurich, 1938

Hoffmann, V., Review of W. Prinze, Die Entstehung der Galerie in Frankreich und Italien, Berlin, 1970, in Architectura, 1, Munich — Berlin, 1971

Hollstein, F. W. H., German Engravings, Etchings and Woodcuts ca 1400—1700, 1—5, Amsterdam, 1954 and fol.

Holst, N. von, Die deutsche Bildnismalerei zur Zeit des Manierismus, Strasburg, 1930

Hosák, L., Historický místopis země Moravskoslezské (Historical geography of the Moravian-Silesian Land), Brno, 1938

Hrady a zámky (Castles and châteaux), ed. J. Hilmera, Prague, 1958

Hrejsa, F., Sborové Jednoty bratrské (The Unity of Moravian Brethren), Prague, 1939

Hrubý, F., "Z hospodářských převratů českých v století XV. a XVI." (The economic upsets in Bohemia in the 15th and 16th centuries), in Český časopis historický (Czech Historical Journal), 30, Prague, 1924

Hrubý, F., "Selské a panské inventáře v době předbělohorské" (Peasants' and Lords' inventories before the Battle of the White Mountain), in op. cit., 33, Prague, 1927

Hrubý, F., Ladislav Velen ze Žerotína, Prague, 1930

Hrubý, F., "Luterství a kalvinismus na Moravě před Bílou horou" (Lutheranism and Calvinism in Moravia before the period of the White Mountain), in op. cit. 40, Prague, 1934

Hrubý, F., Severní Morava v dějinách (Northern Moravia in history), Brno, 1947

Hrubý, F., Étudiants tchèques aux écoles protestantes de l'Europe occidentale à la fin du 16e siècle et au début du 17e siècle, Brno, 1970

Hrušková, M., Pražská sakrální architektura v době renesanční (Sacred architecture in Prague in the Renaissance period), Prague, 1954 (unpublished thesis at Charles University)

Hubala, E., "Schloss Austerlitz in Südmähren", in Stifter-Jahrbuch, 5, 1957

Ilg, A., "Giovanni da Bologna und seine Beziehung zum kaiserlichen Hofe", in Jahrbuch der kunsthistorischen Sammlungen, 4, Vienna, 1885

Ilg, A., "Francesco Terzio, der Hofmaler Erzherzogs Ferdinand von Tirol," in Jahrbuch der kunsthistorischen Sammlungen, 9, Vienna, 1889

Ilg, A., "Das Neugebäude bei Wien", in Jahrbuch der kunsthistorischen Sammlungen, 16, Vienna, 1895

Ilg, A., Kaiser Rudolf II. als Kunstfreund, s. a.

Indra, B., "Tři příspěvky k výtvarným dějinám ostravského kraje" (Three contributions to the history of art of Ostrava region), "1. Renesanční stavitel mistr Bernardo Leone z Lokarna v Moravské Ostravě" (The Renaissance master builder Bernardo Leone from Locarno in Moravská Ostrava), in Časopis Slezského muzea (Journal of the Silesian Museum), 9 (B), Opava, 1960

Indra, B., "K renesančnímu stavitelství na severovýchodní Moravě" (On Renaissance architecture in north-eastern Moravia), in op. cit., 15 (B), Opava, 1966

Janáček, J., Doba předbělohorská (The period before the battle of the White Mountain), 1/1, 1526—1547, Prague, 1971

Janáček, J., Velké osudy (Great Destinies), Prague, 1972

Janák, P., "Obnova sgrafit na Míčovně" (Restoration of the sgraffiti on the Ball Court), in Umění, 1, Prague, 1953

Janák, P., "Míčovna v Královské zahradě a její sgrafita" (The Ball Court in the Royal Garden and its sgraffiti), in Ochrana památek (Protection of Monuments), 29, Prague, 1954

Jednota bratrská (The Unity of Moravian Brethren), 1457—1957, Prague, 1956 (Collection of papers)

Jessen, P., Meister des Ornamentstichs, 1, Berlin, s. a.

Jindrová, J., "Sgrafita na pražské Minutě" (Sgraffiti on the Prague Minute House), in Pražskou minulostí (Through Prague's Past), 2, Prague, 1958

Jireček, J., "Výprava šlechtická do Janova léta 1551 k uvítání voleného krále Maxmiliána II." (The Retinue sent to Genoa in 1551 to welcome the elected king Maximilian II), in Sborník historický (Historical Journal), 2, Prague, 1884

Kalinowski, L., Treści artystyczne i ideowe kaplicy Zygmuntowskiej, Cracow, 1960

Kampis, A., The History of Art in Hungary, London, 1966

Kašička, F. — Vilímková, M., "Jízdárenský dvůr Pražského hradu" (The Courtyard of the Riding School in Prague Castle), in Památková péče, 29, Prague, 1969

Kašička, F. — Vilímková, M., "Lví dvůr Pražského hradu" (The Lion Court in Prague Castle), in Památková péče, 30, Prague, 1970

Kaufman, G., "Die Kunst des 16. Jahrhunderts", in Propyläen Kunstgeschichte, 8, Berlin, 1970

Kavka, F. — Polišenský, J. — Kutnar, F., Přehled dějin Československa v epoše feudalismu (Survey of the history of Czechoslovakia in the period of feudalism), 3 (1526—1781), Prague, 1956

Kębłowski, J., Renesansowa rzeźba na Śląsku 1500—1560, Poznań, 1967

Kent, W. W., The Life and Works of Baldassare Peruzzi, New York, 1925

Kibic, K., "Radnice Menšího Města pražského" (The town hall of the Lesser Town of Prague), in Stoletá Praha (Centuries-old Prague), 3, 1967

Kibic, K., Radnice — Town halls — Rathäuser, Prague, 1971

Kisa, A., "Mährisch Trübau", in Mitteilungen der k. k. Zentral-Commission, N. F. 10, 1884

Klauner, F., "Spanische Portraits des 16. Jahrhunderts", in Jahrbuch der kunsthistorischen Sammlungen, 57, N. F. 21, Vienna, 1961

Klopfer, P. — Hoffmann, J., Baukunst und dekorative Skulptur der Renaissance in Deutschland, Stuttgart, 1909

Knihopis českých a moravských tisků od doby nejstarší až do konce XVIII. století (Bibliography of Bohemian and Moravian prints from the earliest times until the end of the 18th century), ed. Z. Tobolka and F. Horák, vol. 2 (1501—1800), Prague, 1939—1965

Knox, B., The architecture of Prague and Bohemia, London, 1965

Koch, M., Quellen zur Geschichte Maxmilians II., Vienna, 1857

Königová-Kudělková, A., "Soupis stavebních památek v ostravském kraji" (Inventory of architectural monuments in the Ostrava region), in Slezský sborník (The Silesian bulletin), 51, 1953, Appendix to No. 3

Kotrba, V., "Státní hrad a zámek Frýdlant, Památky města Frýdlantu" (The State Castle and Château of Frýdlant, Monuments of the town of Frýdlant), in Frýdlant, Prague, 1959

Kotrba, V., "Die nachgotische Baukunst Böhmens zur Zeit Rudolfs II.", in Umění, 18, Prague, 1970

Kouba, J. J., Renesanční přestavba zámku v Telči (The Renaissance reconstruction of Telč Château), Prague, s. a. (unpublished thesis at Charles University)

Kovář, J., Plzeňské portály (Plzeň portals), Plzeň, 1958

Krakowskie odrodzenie, Cracow, 1954 (Collection of papers)

Kramarczyk, S., "Renesansowa budowa zamku piastowskiego w Brzegu i jej tlo historyczne", in Biuletyn historii sztuki, 23, Warsaw, 1961

Kratochvíl, A., Dějiny Bučovic (History of Bučovice), 1—2, Prague, s. a.

Krčálová, J., "Zámek v Brandýse nad Labem" (The Château at Brandýs-on-Labe), in Umění, 2, Prague, 1954

Krčálová, J., Sgrafitová výzdoba zámku v Telči (Sgraffito decoration on the château at Telč), Prague, 1954

Krčálová, J., "Kostelní stavby Mattea Borgorelliho" (Sacred buildings by Matteo Borgorelli), in Umění, 3, Prague, 1955

Krčálová, J., "Zámek Hluboká za pánů z Hradce" (Hluboká Castle under the Lords of Hradec), in Umění věků (Art of the Ages), Prague, 1956 (Josef Cibulka 70th birthday volume)

Krčálová, J., "Státní zámek v Jindřichově Hradci" (The State Château of Jindřichův Hradec), in Jindřichův Hradec, Prague, 1959

Krčálová, J., "Ke knize Evy Šamánkové Architektura české renesance" (On the book Architecture of the Bohemian Renaissance by Eva Šamánková), in Umění, 10, Prague, 1962

Krčálová, J., "Grafika a naše renesanční nástěnná malba" (Graphic art and our Renaissance wall-painting), in Umění, 10, Prague, 1962

Krčálová, J., "Renesanční nástěnné malby zámku Bechyně" (Renaissance wall-paintings at Bechyně Château), in Umění, 11, Prague, 1963

Krčálová, J., "Obnovené renesanční malby purkrabství Pražského Hradu" (Restored Renaissance paintings in the Burgrave's House at Prague Castle), in Památková péče, 24, Prague, 1964

Krčálová, J., "Doplňky k životopisu Bartoloměje Beránka" (Supplementary remarks to the biography of Bartoloměj Beránek), in Umění, 12, Prague, 1964

Krčálová, J., Renesanční nástěnná malba na panstvích pánů z Hradce a Rožmberka (Renaissance wall-paintings in the residences of the Lords of Hradec and Rožmberk), 1—3, Prague, 1964 (unpublished dissertation)

Krčálová, J., "Il palladianesimo in Cecoslovacchia e l'influenza del Veneto sull'architettura ceca", in Bollettino del Centro internazionale ... "A. Palladio", 6. Part 2, Vicenza, 1964

Krčálová, J., "Renesanční nástěnné malby zámku v Českém Krumlově" (Renaissance wall-paintings in the castle of Český Krumlov), Umění, 16, Prague, 1968

Krčálová, J., "Pietro Ferrabosco und sein Schaffen im Königreich Böhmen", Magistri Intelvesi Volume, in Ostbairische Grenzmarken, 11, Passau, 1969

Krčálová, J., "Byl v našich zemích vůbec manýrismus?" (Was there any Mannerism in our countries?), in Výtvarné umění (Graphic and plastic arts), Prague, 1969

Krčálová, J., "Palác pánů z Rožmberka" (The Palace of the Lords of Rožmberk), in Umění, 18, Prague, 1970

Krčálová, J., "Italští mistři Malé Strany na počátku 17. století" (Italian masters of the Lesser Town at the beginning of the 17th century), in Umění, 18, Prague, 1970

Krčálová, J., "Kruh v architektuře českého manýrismu" (The Circle in the Bohemian Mannerist architecture), in Umění, 20, Prague, 1972

Krčálová, J., "Kostel sv. Petra a Pavla v Kralovicích a Bonifác Wolmut" (The Church of St Peter and St Paul in Kralovice and Boniface Wolmut), in Umění, 20, Prague, 1972

Krčálová, J., "Das Oval in der Architektur des böhmischen Manierismus", in Umění, 21, Prague, 1973

Krčálová, J., "Ke genezi štukové výzdoby letohrádku Hvězda" (On the origins of the stucco decoration in the Hvězda Summer Palace), in Umění, 21, Prague, 1973

Krčálová, J., "Kašny, fontány a vodní díla české a moravské renesance" (Fountains,

cascades, and other waterworks of the Bohemian and Moravian Renaissance), in Umění, 21, Prague, 1973

Krčálová, J., Centrální stavby české renesance (Centrally planned buildings of the Bohemian Renaissance), Prague, 1974

Krčálová, J., "O původu renesančních reliéfních cyklů v Olomouci" (On the origin of the Renaissance relief cycles at Olomouc), in Umění, 23, Prague, 1975

Krčálová, J., "Poznámky k rudolfínské architektuře" (Remarks on Rudolphine architecture), in Umění, 23, Prague, 1975

Krčálová, J., Zámek v Bučovicích (Château of Bučovice), in print

Kreft, H. — Soenke, J., Die Weserrenaissance, Hameln, 1964

Kris, E., "Der Stil 'rustique', in Jahrbuch der kunsthistorischen Sammlungen", 33 (N. F. 1), 1926

Křivka, J., "O stavbě litomyšlského zámku" (On the construction of Litomyšl Château), in Sborník příspěvků k dějinám Litomyšle a okolí (Collection of papers on the history of Litomyšl and its surroundings), Pardubice, 1959

Křížek, F. — Černá, V., Dačice, Prague, 1943 (Poklady národního umění, 55)

Kšír, J., "Dům osvěty v Olomouci" (The house of culture in Olomouc), in Kdy, kde, co v kultuře v Olomouci (When, where and what in culture in Olomouc), February, 1959

Kšír, J., "Bývalý Haunschildův palác v Olomouci" (The former Haunschild palace in Olomouc), in Zprávy Vlastivědného ústavu v Olomouci (Reports of the Historical and Geographical Institute of Olomouc), No. 93, Olomouc, 1961

Kšír, J., "Stavební vývoj olomoucké radnice" (The building history of Olomouc town hall), in op. cit. No. 97, 1961

Kšír, J., Olomoucké renesanční portály (Olomouc Renaissance Portals), Olomouc, 1969

Kubíček, A., Pražské paláce (Prague palaces), Prague, 1946

Kubíček, A., "Rožmberský palác na Pražském hradě" (The Rožmberk Palace at Prague Castle), in Umění, 1, Prague, 1953

Kubíček, A., "Grisonští mistři v Praze" (Graubünden masters in Prague), in Umění, 2, Prague, 1954

Kubíček, A. — Líbal, D., Strahov, Prague, 1955

Kubler, G. — Soria, M., Art and Architecture in Spain and Portugal and their American Dominions 1500 to 1800, Harmondsworth, 1959

Kudělka, Z., "K dějinám hradu v Moravské Třebové" (On the history of the castle at Moravská Třebová), in Umění, 6, Prague, 1958

Kudělka, Z., "K otázce manýristické architektury na Moravě" (The subject of Mannerist architecture in Moravia), in Sborník prací filosofické fakulty brněnské university (Collection of papers of the Philosophical Faculty of Brno University), 7, Brno, 1958

Kudělka, Z., "Studie o italské manýristické architektuře" (Studies in Italian Mannerist architecture), in op. cit., 8, Brno, 1959

Kudělka, Z., "Prameny k stavebním dějinám Moravské Třebové" (Sources for the building history of Moravská Třebová), in Umění, 9, Prague, 1961

Kühndel, J. — Mathon, J., Pernštejnský zámek v Prostějově (The Pernštejn Château at Prostějov), Prostějov, 1932

Kühnel, H., Die Hofburg in Wien, Graz—Cologne, 1964

Kuchynka, R., Nástropní malby ve Švarcenberském paláci v Praze IV (Ceiling paintings in Schwarzenberg Palace in Prague IV), in Památky archeologické (Archeological monuments), 31, Prague, 1919

Kunst und Kultur in Boehmen, Maehren und Schlesien, Exhibition Catalogue, Nuremberg, 1955

Kux, H. — Kress, M., Das Rathaus zu Olmütz, Olomouc 1904

Labacco, A., Libro d'Architettura, alcune notabili antiquita di Roma, Rome, 1576

La Galerie François I, au Château de Fontainebleau, Paris 1972, Collection of papers

Lancinger, L. — Líbal, D. — Pavlík, M., Státní zámek Telč, pasportizace památkových objektů Jihomoravského kraje (The State Castle of Telč, a documentation of the monuments in the southern Moravian region), Prague, 1965 (unpublished manuscript)

Larsson, L. O., Adrian de Vries, Vienna—Munich, 1967

Larsson, L. O., "Hans Mont van Gent", Konsthistorisk Tidskrift, 36, 1967

Larsson, L. O., "Adrian de Vries v Praze" (Adrian de Vries in Prague), in Umění, 16, Prague, 1968

Larsson, L. O., "Bemerkungen zur Bildhauerkunst am rudolfinischen Hofe", in Umění, 18, Prague, 1970

Lašek, F., Litomyšl v dějinách a výtvarném umění (Litomyšl in history and fine arts), Litomyšl, 1945

Lauterbach, A., Die Renaissance in Krakau, Munich, 1911

Leisching, P., Kunstgeschichte Mährens, Brno — Prague — Leipzig — Vienna, s. a.

Lejsková-Matyášová, M., "Štuky a malby ve státním zámku v Bučovicích" (Stucco and paintings in the State Château of Bučovice), in Bučovice, Prague, 1953

Lejsková-Matyášová, M., "Státní zámek v Častolovicích" (The State Château of Častolovice), in Častolovice, Prague, 1954

Lejsková-Matyášová, M., "Zámek v Kostelci nad Černými Lesy ve světle urbáře z roku

1677" (The Château at Kostelec-on-Černé Lesy in the light of the nobility register of 1677), in Umění, 4, Prague, 1956

Lejsková-Matyášová, M., "K tématice nástropních maleb Zaječího sálu státního zámku v Bučovicích" (On the vault paintings of the Hare hall in Bučovice Château), in Umění, 7, Prague, 1959

Lejsková-Matyášová, M., "K otázce předloh pro sgrafita zámku v Telči" (On the patterns of the sgraffiti in Telč Château), in Umění, 7, Prague, 1959

Lejsková-Matyášová, M., "Výjevy z římské historie v prostředí české renesance" (Scenes from Roman history in the Bohemian Renaissance), in Umění, 8, Prague, 1960

Lejsková-Matyášová, M., "Florisův cyklus sedmera Svobodných umění a jeho odezva v české renesanci" (Floris's cycle of the seven Free Arts and the response to it in the Bohemian Renaissance), in Umění, 8, Prague, 1960

Lejsková-Matyášová, M., "Reliéfní výzdoba renesančního arkýře Haunschildovského domu v Olomouci" (The relief ornamentation of the Renaissance oriel window on the Haunschild house in Olomouc), in Umění, 9, Prague, 1961

Lejsková-Matyášová, M., "K malířské výzdobě rožmberské Kratochvíle" (Painted decoration in the Rožmberk Château of Kratochvíle), in Umění, 11, Prague, 1963

Lejsková-Matyášová, M., "K otázce autorství renesančního malovaného stropu z Thunovské ulice v Praze" (On the authorship of the Renaissance painted ceiling in Thun Street in Prague), in Časopis Národního muzea, odd. společenských věd (Bulletin of the National Museum, dept. of social sciences), 132, Prague, 1963

Lejsková-Matyášová, M., "Renesanční reliéfy z olomouckého lapidária a jejich restaurování" (Renaissance reliefs in the Olomouc lapidarium and their restoration), in Umění, 12, Prague, 1964

Lejsková-Matyášová, M., "Renesanční dům jihlavského náměstí a jeho obnovené malby" (A Renaissance house in Jihlava square and its restored paintings), in Umění, 16, Prague, 1968

Lejsková-Matyášová, M., "Figurální sgrafito v Benátkách nad Jizerou a jeho restaurace" (Figural sgraffito in Benátky-on-Jizera and its restoration, in Památková péče, 28, Prague, 1968

Lejsková-Matyášová, M., "K tématice sgrafitové výzdoby domu U minuty v Praze" (On the sgraffito decoration of At the Minute house in Prague), in Umění, 17, Prague, 1969

Lejsková-Matyášová, M., "Restaurování rožmberské Kratochvíle" (The restoration of the Rožmberk Summer Palace of Kratochvíle), in Památková péče, 30, Prague, 1970

Lejsková-Matyášová, M., "Figurální sgrafito ve Slavonicích a jeho restaurování" (Figural sgraffito in Slavonice and its restoration), in Památková péče, 30, Prague, 1970

Lejsková-Matyášová, M., "Schweizerische graphische Vorlagen in der Renaissancekunst der böhmischen Länder", in Zeitschrift für schweizerische Archeologie und Kunstgeschichte, 27, Zurich, 1970

Lejsková-Matyášová, M., "Hodovní síň renesančního zámku ve Velkých Losinách" (The Banqueting hall of the Renaissance Château of Velké Losiny), in Severní Morava — Vlastivědný sborník (Northern Moravia — Bulletin of history and geography), 22, Šumperk, 1972

Lejsková-Matyášová, M., "Program štukové výzdoby tzv. soudnice zámku v Bechyni" (Themes of the stucco decoration of the so-called court-room in Bechyně Château), in Umění, 21, Prague, 1973

Lhotsky, A., "Führer durch die Burg zu Wien", 1, Die Gebäude, Vienna, 1939

Lhotsky, A., "Die Geschichte der Sammlungen", in Festschrift des Kunsthistorischen Museums 1891—1941, 2, Vienna, 1941—45

Líbal, D., Alte Städte in der Tschechoslowakei, Prague, 1971

Lieb, N., "Augsburger Baukunst der Renaissance", in Augusta 955—1955, Augsburg, 1955

Lieb, N., Die Fugger und die Kunst im Zeitalter der hohen Renaissance, Munich, 1958

Lienhard Riva, A., Armoriale Ticinese, Bellinzona, 1945

Lifka, B., Knihovny státních hradů a zámků (Libraries of state castles and châteaux), Prague, 1954

Lill, G., Hans Fugger und die Kunst, Leipzig, 1908

Löcher, K., Jakob Seisenegger, Hofmaler Kaiser Ferdinands I., Munich — Berlin, 1962

Lomazzo, G. P., Trattato dell'arte della pittura, scultura et architettura, Milan, 1584—85

Lorenz, V. — Tříska, K., "Státní zámek v Krásném Dvoře" (The State Château at Krásný Dvůr), in Krásný Dvůr, Prague, 1954

Lotz, W., "Die ovalen Kirchenräume des Cinquecento", in Römisches Jahrbuch für Kunstgeschichte, 7, Rome — Vienna — Munich, 1955

Lotz, W., "Notizen zum kirchlichen Zentralbau der Renaissance", in Studien zur toskanischen Kunst. Festschrift für L. H. Heydenreich zum 23. März 1963, ed. W. Lotz and L. L. Möller, Munich, 1964

Loziński, J. Z. — Milobedzki, A., Monuments historiques d'architecture en Pologne, Warsaw, 1967

Luchner, L., Denkmal eines Renaissance Fürsten. Versuch einer Rekonstruktion des Ambraser Museums von 1583, Vienna, 1958

Lukomski, G. K., I Maestri della Architettura classica da Vitruvio allo Scamozzi, Milan, 1933

Mackerle, J. — Továrek, F. — Vacová, P., Moravskotřebovský okres (The District of Moravská Třebová), Jevíčko, 1940

Mádl, K. B., "Obrazárna a umělci Rudolfa II. v Praze" (The Picture Gallery of Rudolph II and Rudolphine artists in Prague), in Památky archeologické (Archeological monuments), 22, Prague, 1906—8

Maggi, G., Della fortificazione delle città, Venice, 1564

Maggiorotti, L. A., Architetti e architettura militari, 2, Gli architetti militari, 2, L'opera del genio italiano all'estero, Rome, 1936

Maliva, J., Sochař Jiří Gialdi (The sculptor Giorgio Gialdi), Brno, 1953 (unpublished thesis at Brno University)

Maliva, J., "Olomoucké renesanční portály (několik poznámek k publikaci J. Kšíra)" (Olomouc Renaissance portals — some remarks on the publication by J. Kšír), in Sborník památkové péče v Severomoravském kraji (Journal of the Institute for the Protection of Monuments in the northern Moravia region), 2, 1973

Mander, C. van, Het Leven der Doorluchtighe Nederlandtsche en Hooghduytsche Schilders, Amsterdam, 1617 (in German: Das Leben der niederländischen und deutschen Maler), ed. H. Flörke, 1—2, Munich — Leipzig, 1906

Mareš, F., "Někdejší epitafium Viléma z Rožmberka v chrámu Páně sv. Víta v Krumlově" (The former epitaph of William of Rožmberk in St Vitus' Church at Krumlov), in Památky archeologické, 15, Prague, 1892

Mareš, F., "Materialie k dějinám umění" (Materials on the history of art), in Památky archeologické, 16, Prague, 1896; 17, 1897; 18, 1900

Marchini, G., Giuliano da Sangallo, Florence, 1942

Marle, C. van, Iconographie de l'art profane au Moyen-âge et à la Renaissance et la décoration des demeures, 1—2, The Hague 1931, 1932

Martinola, G., "Contributo alla storia della emigrazione delle corporazioni murarie del Mendrisiotto dal sec. XVI al XVIII", in Archivio storico della Svizzera Italiana, 14, Bellinzona, 1939

Martinola, G., "Maestri ticinesi all'estero dal '500 al '700", in Bollettino Storico della Svizzera Italiana, 19, Bellinzona, 1944

Martinola, G., "Le Maestranze d'arte del Mendrisiotto in Italia nei secoli XVI, XVII, XVIII", in Bollettino Storico della Svizzera Italiana, 74, Bellinzona, 1962, 75; 1963

Martinola, G., Lettere dai paesi transalpini degli artisti di Meride e dei villaggi vicini XVII—XIX. In appendice: L'emigrazione delle maestranze d'arte del Mendrisiotto oltre le Alpi (XVI—XVII), Bellinzona, 1963

Masson, G. — Bamm, F., Italienische Villen und Paläste, Munich — Zurich, 1959

Matějček, A., O umění a umělcích (On art and artists), Prague, 1948

Matějček, A. — Tříska, K., Jindřichův Hradec, zámek a město (Jindřichův Hradec, château and town), Prague, 1944

Mathon, J., Prostějov, Prague, 1947 (Poklady národního umění, 79—80)

Matouš, F., "Třeboň, její minulost a památky" (Třeboň, its past and monuments), in Třeboň, Prague, 1964

Matouš, F., Třeboň, Prague 1972

Matoušek, J., "K problému osobnosti Rudolfa II." (On the problem of the personality of Rudolph II), in J. B. Novák 60th birthday volume, Prague, 1932

Matyášová-Lejsková, M. — Nováková, M., "K obnově zámeckého portálu v Třemešku a dalších plastik rodu Bukůvků na severní Moravě" (On the restoration of the portal at Třemešek and of other sculptural works of the Bukůvka family in northern Moravia), in Památková péče, 26, Prague, 1966

Mayer, J., "Dům U dvou zlatých medvědů" (The At Two Golden Bears house), in Umění, 6, Prague, 1958

Mayer, J., "Dva pražské renesanční domy" (Two Renaissance houses in Prague), in Pražský sborník vlastivědný (Prague Bulletin of history and geography), Prague, 1962

Mayer, J., "Architektonické dílo Jana Dominika de Barifis" (The Architectural work of Jan Dominik de Barifis), in Stoletá Praha (Centuries-old Prague), 5, Prague, 1971

Mayer-Löwenschwerdt, E., "Der Aufenthalt der Erzherzoge Rudolf und Ernst in Spanien 1564—1571", in Sitzungsberichte der Akademie der Wissenschaften in Wien, Phil.-hist. Klasse, Bd 206, 5. Abhandlung, Vienna, 1927

Mazzotti, G., Ville venete, 2nd ed., Rome, 1958

Mazzotti, G. — Bagatti Valsecchi, P. F., Ville d'Italia, Milan, 1972

Mencl, V., Tisíc a sto let české stavební tvorby (Eleven hundred years of Bohemian building), Prague, 1957

Menclová, D., "Přehled vývoje renesanční architektury na Slovensku" (Outline of the development of the Renaissance architecture in Slovakia), in Bratislava, Bratislava, 1934

Menclová, D., Švihov, státní hrad a městečko (Švihov, the State Castle and the town), Prague, 1953

Menclová, D., "Státní zámek v Bučovicích" (The State Château of Bučovice), in Bučovice, Prague, 1953

Menclová, D., České hrady (Bohemian castles), 1—2, Prague, 1972

Menclová, D. — Gardavský, Z., Helfštejn, státní hrad a památky v okolí (Helfštejn, the State Castle and surrounding monuments), Prague, 1961

Menclová, D. — Štech, V. V., "Bechyně, státní zámek a město" (Bechyně, the State Château and the town), in Bechyně, Prague, 1963

Merhout, C., Ostrov Kampa (The Island of Kampa), Prague, 1946

Merhout, C., Paláce a zahrady pod Pražským hradem (Palaces and gardens below Prague Castle), Prague, 1954

Merhout, C., O Malé Straně. Její stavební vývoj a dávný život (The Lesser Town. Its building development and distant past), Prague, 1956

Merten, K., Die Pfarrkirche St. Peter und Paul in Kralowitz (Kralovice bei Plass); St. Salvator im Clementinum — ehemals böhmische Jesuitenkirche und die Wälsche Kapelle in der Altstadt Prag. Bohemia, 8, Munich, 1967

Mielke, F., Die Geschichte der deutschen Treppen, Berlin — Munich, 1966

Michalski, E., "Das Problem des Manierismus in der italienischen Architektur", in Zeitschrift für Kunstgeschichte, 2, Munich, 1933

Michelagniolo architetto, ed. P. Portoghesi and B. Zevi, Turin, 1964

Mihulka, A., Královský letohrádek zvaný Belvedere na Hradě pražském (The Royal summer palace known as the Belvedere at Prague Castle), Prague, 1939

Míka, A., Osud slavného domu. Rozkvět a pád rožmberského dominia (The fate of a famous family. The heyday and decline of Rožmberk rule), České Budějovice, 1970

Missiag-Bocheńska, A., Glowy Wawelskie, Cracow, 1953

Mixová, V., Rožmberk, státní hrad a město (Rožmberk, the State Castle and the town), Prague, 1952

Molnár, A., Boleslavští bratří (The Brethren of Mladá Boleslav), Prague, 1952

Morávek, J., "Z počátků královské zahrady" (The Royal Garden from its beginnings), in Umění, 11, Prague, 1938

Morávek, J., "Ke vzniku Hvězdy" (The origin of the Hvězda), in Umění, 2, Prague, 1954

Morávek, J., "Giuseppe Mattei a 'Nová stavení' Pražského hradu 1638—1644" (Giuseppe Mattei and the 'New Buildings' of Prague Castle 1638—1644), in Umění, 5, Prague, 1957

Morávek, J., "Královské mausoleum v chrámu sv. Víta a jeho dokončení v letech 1565—1590" (The Royal Mausoleum in St Vitus' Cathedral and its completion in the years 1565—1590), in Umění, 7, Prague, 1959

Morávek, J. — Wirth, Z., Pražský hrad v renesanci a baroku 1490—1790 (Prague Castle in the Renaissance and Baroque 1490—1790), Prague, 1947

Morpurgo, E., Gli artisti italiani in Austria, 1. Dalle origini al secolo XVI, Rome, 1937 (L'opera del genio italiano all'estero)

Mousnier, R., Les XVIe et XVIIe siècles. Les progrès de la civilisation européenne et le déclin de l'Orient (1492—1715), Paris, 1956

Muchka, I., Stylové otázky v české architektuře kolem roku 1600 (Questions of style in Bohemian architecture about 1600), Prague, 1969 (unpublished thesis at Charles University)

Muchka, I., "Ornament v 16. století — význam a funkce" (Ornament in the 16th century — meaning and function), in Umění a Řemesla (Arts and Crafts), Prague, 1973

Muk, J., "Měšťanský dům gotiky a renesance z jižních Čech a Moravy" (The burghers' house of the Gothic and Renaissance in southern Bohemia and Moravia), Prague, 1968 (unpublished thesis at Charles University)

Müller, J. Th., Geschichte der Böhmischen Brüder, 1—3, Herrnhut 1922—31

Müller, R., "Die Salhausen im Elbetal", in Mitteilungen des Nordböhmischen Excursions-Clubs, 16, Česká Lípa, 1893

Murray, L., The Late Renaissance and Mannerism, London, 1967

Neder, E., Die geschichtlichen Kunstdenkmale der Stadt Bensen, Benešov-on-Ploučnice, 1931

Negri, E., Galeazzo Alessi, Genoa, 1957

Nejedlá, V., "Plastické dědictví města Mostu" (The sculptural heritage of the town of Most), in Památková péče, 34, Prague, 1974

Neumann, J., Obrazárna Pražského hradu (The Picture Gallery of Prague Castle), 2nd ed., Prague, 1966

Neumann, J., "Kleine Beiträge zur rudolfinischen Kunst", in Umění, 18, Prague, 1970

Niederstein, A., "Das graphische Werk des Bartholomäus Sprangers", in Repertorium für Kunstwissenschaft, 52, Berlin — Leipzig, 1931

Novák, J. B., Rudolf II. a jeho pád (Rudolph II and his fall), Prague, 1935

Novotný, V., "Poznámky o českém renesančním sgrafitu" (Remarks on Bohemian Renaissance sgraffito), in Památky archeologické 37, new series 1, Prague, 1931

Oberhuber, K., "Anmerkungen zu B. Spranger als Zeichner", in Umění, 18, Prague, 1970

Odložilík, O., Cesty z Čech do Velké Britanie v letech 1563—1620 (Journeys from Bohemia to Great Britain in the years 1563—1620), Brno, 1935

Odložilík, O., Karel Starší ze Žerotína (Charles the Elder of Žerotín), Prague, 1936

Oesterreichische Kunsttopographie, 1—38, Vienna, 1907—1972

Die Oesterreichisch-ungarische Monarchie in Wort und Bild, 2, Böhmen, 1, 2, Vienna, 1894, 1896

Oettinger, W. von, Antonio Averlino Filaretes Tractat über die Baukunst, Vienna, 1890

Osten, G. von der — Vey, H., Painting and Sculpture in Germany and the Netherlands 1500—1600, Harmondsworth, 1969

Ottův slovník naučný (Otto's Encyclopaedia), 1—23, Prague, 1883—1908

Palacký, F., Dějiny národu českého v Čechách a na Moravě (History of the Czech nation in Bohemia and Moravia), 5/2, 2nd Czech ed., Prague, 1878

Palladio, A., Le Antiquità di Roma, Rome, 1554

Palladio, A., I quattro libri dell'Architettura, Venice, 1570

Pane, R. Andrea Palladio, Turin, 1948 (1961)

Panofsky, E., Idea. Ein Beitrag zur Begriffsgeschichte der älteren Kunsttheorie, Leipzig — Berlin, 1924

Panofsky, E., Grabplastik. Vom alten Ägypten bis Bernini, Cologne, 1964

Paprocký z Hlohol, B., Zrcadlo slavného markrabství Moravského (Mirror of the famous Margraviate of Moravia), trans. Jan Vodička, Olomouc, 1593

Paprocký z Hlohol, B., Diadochos, id est Successio, jinak Posloupnost knížat a králů českých (Diadochos, id est Successio, in other words the Succession of Bohemian princes and kings), Prague, 1602

Pavel, J., "Nové Město nad Metují, státní zámek a městská památková rezervace" (Nové Město-on-Metuje, the State Castle and the reserve of town monuments), in Nové Město nad Metují, Prague, 1952

Pavel, J., "Pardubice", in Pardubice, Prague, 1953

Pavlík, M., "Dům U zlatého stromu v Praze 1" (The At the Golden Tree house in Prague 1), in Památková péče, 24, Prague, 1964

Pechová, O., Moravská Třebová, Prague, 1957

Pechová, O. — Zbíralová, M., "Renesanční kasetový strop bechyňského zámku a jeho restaurování" (The Renaissance coffer ceiling of Bechyně Castle and its restoration), in Zprávy památkové péče, 16, Prague, 1956

Peltzer, R. A., "Der Hofmaler Hans von Aachen, seine Schule und seine Zeit", in Jahrbuch der kunsthistorischen Sammlungen, 30, Vienna — Leipzig, 1911—12

Pešina, J., Česká malba pozdní gotiky a renesance, deskové malířství 1450—1550 (Bohemian painting of Late Gothic and Renaissance, panel-painting 1450—1550), Prague, 1950, (Tafelmalerei der Spätgotik und der Renaissance in Böhmen, 1958)

Pešina, J., "Renesanční malířská výzdoba kaple sv. Zikmunda v chrámu sv. Víta v Praze" (The Renaissance painted decoration of St Sigismund's Chapel in St Vitus' Cathedral), in Umění, 2, Prague, 1954

Pešina, J., Skupinový portrét v českém renesančním malířství (Group portrait in Bohemian Renaissance painting), in Umění, 2, Prague, 1954

Petr, F. — Kostka, J., Městské památkové rezervace v Čechách a na Moravě (Reserves of town monuments in Bohemia and Moravia), Prague, 1955

Petráň, J., Staroměstská exekuce (Execution in the Old Town Square), Prague, 1971

Pevsner, N., An Outline of European Architecture, Harmondsworth, 1943, 7th ed. 1963

Philippot, F., Die Wandmalerei, Vienna — Munich, 1972

Piel, F., Die Ornament-Groteske in der Italienischen Renaissance, Berlin, 1962

Pigler, A., Barockthemen, 1—2, Budapest, 1956

Pittaluga, M., L'incisione italiana nel cinquecento, Milan, s. a.

Plan und Bauwerk, Entwürfe 5 Jahrhunderte, Munich, 1952 (Exhibition catalogue)

Poche, E., Pražské portály (Prague portals), Prague, 1947

Poche, E. — Janáček, J., Prahou krok za krokem (Step by step around Prague), Prague, 1963

Poche, E. — Preiss, P., Pražské paláce (Prague palaces), Prague, 1974

Poche, E. — Wirth, Z. — Kozák, B., Hradčany a Malá Strana (Hradčany and the Lesser Town), Prague, 1964

Podlaha, A., "Materialie k slovníku umělců a uměleckých řemeslníků v Čechách" (Materials for a dictionary of artists and artistic craftsmen in Bohemia), in Památky archeologické, 23—34, Prague, 1908—25

Podlaha, A., "Plány a kresby chované v kanceláři správy hradu Pražského" (Plans and drawings kept in the administrative office of Prague Castle), in Památky archeologické, 32, Prague, 1921; 33, 1923

Poleggi, E., Strada Nuova. Una lottizzazione del Cinquecento a Genova, Genoa, 1968

Polišenský, J., Doba Rudolfa II. (Rudolph II's time), Prague, 1941

Polišenský, J., Anglie a my (England and us), Prague, 1947

Polišenský, J., Anglie a Bílá hora (England and the White Mountain), Prague, 1949

Polišenský, J., Nizozemská politika a Bílá hora (Netherlandish policy and the White Mountain), Prague, 1958

Pollak, O., "Studien zur Geschichte der Architektur Prags 1520—1600", in Jahrbuch der kunsthistorischen Sammlungen, 29, 1910—11

Pope Hennessy, J., Italian Renaissance Sculpture, 1—3, London, 1958

Portrétní umění španělských mistrů (Portraiture by the Spanish Masters), Roudnice-on-Labe, 1966 (Exhibition catalogue written by A. Vošťáková — J. Neumann — A. and V. Bergners)

Postavy českých dějin (Personalities of Czech History), Prague, 1938 (Exhibition catalogue written by V. Novotný)

Prášek, J. V., "Zámek Brandejs nad Labem, oblíbené sídlo Rudolfa II." (The Château

of Brandejs-on-Labe, the favourite seat of Rudolph II), in Časopis Českého musea (Journal of the Bohemian Museum), 80, 1906

Prášek, J. V., Dějiny Brandýsa nad Labem (History of Brandýs-on-Labe), 1—3, Prague, 1908—13

Prášek, J. V., Brandejs a. d. Elbe, Prague, 1915

Pražské baroko (Prague Baroque), Prague, 1938 (Catalogue of the exhibition Art in Bohemia 1600—1800)

Preiss, P., "Baroková ilusivní malba architektur a Čechy" (Baroque illusive painting of architecture and Bohemia), in Umění věků (Art of the Ages), Prague, 1956

Preiss, P., "Cykly českých panovníků na státních zámcích" (Cycles of Bohemian rulers at State Châteaux), in Zprávy památkové péče, 17, Prague, 1957

Preiss, P., Giuseppe Arcimboldo, Prague, 1967

Preiss, P., Panorama manýrismu (Panorama of Mannerism), Prague, 1974

Prinz, W., Die Entstehung der Galerien in Frankreich und Italien, Berlin, 1970

Prokop, A., Die Markgrafschaft Mähren in kunstgeschichtlicher Beziehung, 3, Vienna, 1904

Puppi, L., Michele Sanmicheli, architetto di Verona, Padua, 1971

Puppi, L., "La 'città ideale' nella cultura architettonica del rinascimento centro-europeo", in Actes Congrès Budapest, I, Budapest, 1972

Reinle, A. (— Gantner, J.), Kunstgeschichte der Schweiz, 3, Frauenfeld, 1956

The Renaissance and Mannerism, Studies in western art, 2, Acts of the twentieth international congress of the history of art, Princeton, 1963

Renaissance in Österreich, Niederösterreichische Landesausstellung Schloss Schallaburg, Vienna, 1974, (Exhibition catalogue; Introduction R. Feuchtmüller, papers B. Sutter, K. Gutkas, G. Mraz, G. Reingrabner, F. Schragl, G. Egger, R. Feuchtmüller, K. Schütz, G. Heinz, W. Mrazek, H. Heger, G. F. Heller)

Renesanční portrét (Renaissance Portrait), Roudnice-on-Labe, 1972, (Exhibition catalogue written by M. Saxl and L. Nosková)

Říčan, R., Die Böhmischen Brüder, Berlin, 1958

Říčan, R. — Molnár, A., Dějiny Jednoty bratrské (The History of the Moravian Brethren), Prague, 1957

Ricci, C., Baukunst und dekorative Plastik der Hoch- und Spätrenaissance in Italien, Stuttgart, 1923

Richter, V., Telč, Prague, 1958

Richter, V. — Samek, B. — Stehlík, M., Znojmo, Prague, 1966

Ripa, C., Iconologia, Siena, 1613

Robbiani, D., Maestranze di Genestrerio "Via per il mondo", Locarno, 1967

Roberts, J. F. A., "English wall-paintings after Italian engravings", in The Burlington Magazine, 78, London, 1941

Röttinger, H., Die Holzschnitte zur Architektur und zum Vitruvius Teutsch des Walter Rivius, Strasbourg, 1914

Röttinger, H., Peter Flettner, Holzschnitte, Strasbourg, 1916

Romanese, O., Riassunto storico sulla fondazione della Congregazione e sulla erezione della cappella italiana di Praga, Prague, 1898

Rosso, O., Portali e palazzi di Genova, Milan, s. a.

Rudolph II — The exhibition of the works of his Court artists and of the portraits of the personalities of his court, Introduction to the catalogue by K. Chytil, Prague, 1912

Rusconi, G. A., Della architettura ... con ... figure dissegnate ... secondo i precetti di Vitruvio ... Libri dieci, Venice, 1590

Rybička, A., "Pomůcky k životopisnému slovníku českých malířů" (Contributions to a biographical dictionary of Bohemian painters), in Památky archeologické, 8, Prague, 1870, col. 141—156, 13, 1886, col. 19—24

Rybička, A., "Umělci na dvoře Rudolfa II" (Artists at Rudolph II's court), in Památky archeologické, 15, Prague, 1890—92

Rybička, A., "K slovníku českých výtvarných umělců a jmenovitě malířů" (Remarks on a dictionary of Czech artists, particularly painters), in Památky archeologické, 16, Prague, 1896

Salaba, J., "Ke stykům Viléma z Rožmberka s Jakubem Stradou" (William of Rožmberk's contacts with Jacob Strada), in Památky archeologické, 20, 1902

Šamánková, E., Jihlava, Prague, 1955

Šamánková, E., Architektura české renesance (Architecture of the Czech Renaissance), Prague, 1961

Šamánková, E., Cheb, Prague, 1974

Šamánková, E. — Hájek, J., Benešov nad Ploučnicí, státní zámek a čínské sbírky Národní galerie (Benešov-on-Ploučnice, the State Castle and Chinese collections of the National Gallery), Prague, 1963

Šamánková, E. — Vondra, J., "Český Krumlov", in Český Krumlov, Prague, 1961

Samek, B., "Renesanční radnice v Moravské Třebové" (The town hall at Moravská Třebová), in Zprávy památkové péče, 17, Prague, 1957

Michele Sanmicheli, 1484—1559, studi raccolti, Verona, 1960

Sanpaolesi, P., Filippo Brunelleschi, Milan, 1962

Sbírky Rudolfa II., pokus o jejich identifikaci (The collections of Rudolph II, an attempt

at their identification), Prague, 1937 (Exhibition catalogue, introductory study by J. Morávek)

Scamozzi, V., Idea della architettura universale in X libri, Venice, 1615

Scamozzi, V., Klärliche Beschreibung der fünf Säulenordnungen und der ganzen Baukunst, Nuremberg, 1678

Schaller, J., Beschreibung der königlichen Haupt- und Residenzstadt Prag, 1, Prague, 1794

Schéle, S., Cornelis Bos, Stockholm, 1965

Schmidt, J., Linzer Kunstchronik, 1. Die Baumeister, Bildhauer und Maler, 2. Gesamtdarstellung, Linz, 1951—52

Schottky, M., Prag, wie es war und wie es ist, 1—2, Prague, 1831—32

Schubring, P., Die Architektur der italienischen Hochrenaissance, Munich, 1924

Schwarzenfeld, G. von, Rudolf II., der saturnische Kaiser, Munich, 1961

Scotti, A., Ascanio Vittozi, ingegnere ducale a Torino, Florence, 1969

Sebestyén, Gh. — Sebestyén, V., Arhitectura renasterii in Transylvania, Bucharest, 1963

Sedláček, A., Hrady, zámky a tvrze v království Českém (Castles, châteaux and fortresses in the Kingdom of Bohemia), 1—15, Prague, 1882—1927

Le Seizième Siècle Européen, Peintures et Dessins dans les Collections Publiques Françaises, Paris, 1965 (Exhibition catalogue, introduction by A. Chastel)

Šembera, A. V., Páni z Boškovic a pozdější držitelé hradu Boškovického na Moravě (The Lords of Boškovice and later owners of the castle of Boškovice in Moravia), 2nd ed., Vienna, 1870

Serlio, S., Regole generali di Architettura sopra le cinque maniere de gli edifici, Venice, 1537 (1540)

Serlio, S., Liure extraordinaire de architecture, Lyon, 1551

Serlio, S., Extra ordinem liber, Venice, 1568

Serlio, S., De Architectura libri quinque, Venice, 1569

Serlio, S., Il settimo libro d'architettura, Frankfurt-am-Main, 1575

Serlio, S., Tutte l'Opere d'Architettura, Venice, 1584

Shearman, J., Mannerism. Style and civilisation, Harmondsworth, 1967

Simona, L., Artisti della Svizzera italiana II° — in Boemia ed Austria nel XVI e XVII secolo, Lugano, 1933

Simona, L., "Lugano e dintorni un semenzaio d'artisti", in Bollettino Storico della Svizzera Italiana, 19, Bellinzona, 1944

Skála ze Zhoře, P., Historie česká od r. 1602 do r. 1623 (Czech history from 1602 to 1623), 1 (1602—1616), ed. K. Tieftrunk, Prague, 1865

Slabý, F., Příspěvky k dějinám Bučovic (Contributions to the history of Bučovice) 1, Bučovice, 1940

Slabý, F., "K stavebním dějinám bučovského zámku" (On the building history of Bučovice Château), in Vlastivědný sborník moravský (Historical and geographical bulletin of Moravia), 2, Brno, 1947

Sloschek, E., Geschichte der Stadt Mährisch-Kromau, Moravský Krumlov, 1937

Smetana, R., Průvodce památkami v Olomouci (A guide to the monuments in Olomouc), Olomouc, 1948

Šmrha, K., "Dvorní malíř Petra Voka z Rožmberka Bartoloměj Beránek -Jelínek" (Bartoloměj Beránek-Jelínek, court painter to Peter Vok of Rožmberk), in Časopis Rodopisné společnosti (Journal of the Genealogical Society), 14, Prague, 1942

Šmrha, K., "Renesanční freska v arcibiskupském paláci v Praze" (Renaissance frescoes in the Archbishop's Palace in Prague), in Časopis společnosti přátel starožitností (Journal of the Society of friends of antiquities), 49—50, Prague, 1946

Šmrha, K., "Budějovická brána v Českém Krumlově" (The Budějovice gateway at Český Krumlov), in Umění, 4, Prague, 1956

Šmrha, K., "K stavební historii zámku v Bučovicích" (The building history of Bučovice Château), in Vlastivědný věstník moravský (Historical and geographical bulletin of Moravia), 14, Brno, 1959

Šmrha, K., "Brněnští malíři z období kolem roku 1600" (Painters in Brno around 1600), in Brno v minulosti a dnes (Brno in the past and today), 2, Brno, 1960

Šmrha, K., "Brněnští malíři renesančního období" (Brno painters of the Renaissance period), in Umění, 11, Prague, 1963

Šmrha, K., "Brněnští stavitelé v době kolem roku 1600, 1. Petr Gabri a jeho stavební družina, 2. Stavební družina Antonia Gabriho, Antonio Paris a další mistři" (Builders in Brno around 1600. The Builder Pietro Gabri and his group. The group of Antonio Gabri, Antonio Paris and other master builders), in Umění, 15—16, Prague, 1967—8

Sokolová, J., Strahov, Prague, 1941 (Poklady národního umění, 26)

Soupis památek historických a uměleckých v Království českém (Inventory of historical and artistic monuments in the Kingdom of Bohemia), 1—51, Prague, 1897—1934

Šperling, I., "Malované dřevěné stropy v Praze" (Painted wooden ceilings in Prague), in Umění, 16, Prague, 1968

Stange, A., Die Deutsche Baukunst der Renaissance, Munich, 1926

Stefan, O., Pražské kostely (Prague churches), Prague, 1936

Stefan, O., Mluva pražské architektury (The language of Prague architecture), Prague, 1956

Stefan, O., "K počátkům klasicismu v renesanční architektuře Čech" (The beginnings

of Classicism in the Renaissance architecture of Bohemia), in Sborník prací filosofické fakulty brněnské university (Collection of papers of the Philosophical Faculty of Brno University), 10, Brno, 1961

Stefan, O., "K dějezpytným o´ázkám naší renesanční architektury" (Historical research into our Renaissance architecture), in Umění, 12, Prague, 1964

Stehlík, F., Zámek Litomyšl (Litomyšl Château), Prague, 1957

Steinherz, S., Briefe des Prager Erzbischofs Anton Brus von Müglitz 1562—1563, Prague, 1907

Stloukal, K., Papežská politika a císařský dvůr pražský na předělu XVI. a XVII. věku (Papal policy and the Prague Imperial Court at the turn of the 16th and 17th centuries), Prague, 1925

Stokstad, M., Renaissance art outside Italy, Dubuque—Iowa, 1968

Stránský, P., O státě českém (On the S ate of Bohemia), trans. B. Ryba, 3rd ed., Prague, 1946 (Respublica Bohemiae, 1634, Republica Bojema, 1643)

Strnad, J., "Vlachové v Plzni v XVI. století usedlí" (Italians settled in Plzeň in the 16th century), in Sborník dějepisných prací bývalých žáků dr. V. V. Tomka (Collection of papers of former pupils of dr. V. V. Tomek), 1888

Studia nad renesansem w Wielkopolsku, Poznan, 1970

Studia renesansowe, ed. M. Walicki, 1 ff, Wrocław — Warsaw — Cracow, 1956 on

Suchomel, M., "Restaurování figurálních štukových reliéfů v Nelahozevsi" (The restoration of the figural stucco reliefs at Nelahozeves), in Památková péče, 27, Prague, 1967

Suchomel, M., "Štuková výzdoba letohrádku Hvězda" (The stucco decoration of the Hvězda Summer House), in Umění, 21, Prague, 1973

Suida, W., Genua, Leipzig, 1906

Svoboda, J., "Materiálie k životu a dílu kameníka Vincence Strašryby" (Materials on the life and work of stone-mason Vincenc Strašryba), in Umění, 16, Prague, 1968

Szablowski, J., "Ze studiów nad zwiazkami artystycznymi polsko-czeskimi v epoce Renesansu i Renesansem Zachodnio-Slowiańskim", in Prace Komisji Historii Sztuki P.A.U., 9, Cracow, 1948

Tafuri, M., L'architettura del Manierismo nel Cinquecento Europeo, Rome, 1966

Tafuri, M., L'architettura dell'umanesimo, Bari, 1969

Tafuri, M., Jacopo Sansovino e l'architettura del '500 a Venezia, Padua, 1969

Thiem, G. and Ch., Toskanische Fassaden-Dekoration in Sgraffito und Fresko 14. bis 17. Jahrhundert, Munich, 1964

Thieme, U. — Becker, F., Allgemeines Lexikon der bildenden Künstler von der Antike bis zur Gegenwart, 1—36, Leipzig, 1907—47

Tobolka, Z., Žerotínská knihovna (Žerotín library), Prague, 1926

Tolnay, Charles de, Michelangelo, 1—5, Princeton, 1943—60

Toman, P., Nový slovník československých výtvarných umělců (New dictionary of Czechoslovak graphic and plastic artists), 1—2, Prague, 1947, 1950

Tomek, W. W., Dějepis města Prahy (A history of the town of Prague), 11—12, Prague, 1897—1901

Le Triomphe du Maniérisme européen de Michel-Ange au Gréco, ed. M. van Luttervelt, Amsterdam, 1955 (Exhibition catalogue)

Tschira, A., Orangerien und Gewächshäuser, Berlin, 1939

Umělecké památky Čech (Artistic monuments of Bohemia), ed. Z. Wirth, Prague, 1947

Umělecké památky Čech (Artistic monuments of Bohemia), ed. E. Poche, 1—4, Prague, 1977 on

Umělecké poklady Čech (Artistic treasures of Bohemia), ed. Z. Wirth, 1—2, Prague, 1913, 1915

Vacková, J., Malířství 2. poloviny 16. století v Čechách a na Moravě (Painting of the second half of the 16th century in Bohemia and Moravia), Prague, 1959 (unpublished dissertation)

Vacková, J., "Pozdně renesanční malované epitafy v Brně" (Late Renaissance painted epitaphs in Brno), in Umění, 8, Prague, 1960

Vacková, J., "Podoba a příčiny anachronismu" (The form and causes of anachronism), in Umění, 16, Prague, 1968

Vacková, J., "Epitafní obrazy v předbělohorských Čechách" (Epitaph paintings in Bohemia before the battle of the White Mountain), in Umění, 17, Prague, 1969

Vaňková-Frejková, O., Zámek Nelahozeves (Nelahozeves Château), Prague, 1941 (Poklady národního umění, 64)

Vaňková-Frejková, O., Česká renesance na Pražském hradě (The Bohemian Renaissance at Prague Castle), 2nd ed., Prague, 1949 (op. cit., vol. 37)

Venturi, A., Storia dell'arte italiana, 6—10, Milan, 1908—40

Venturi, A., Raffaelo, Rome, 1920

Venturi, A., Leon Battista Alberti, Rome, 1923

Vignola, G. Barozzi da, Regola delle cinque ordini d'architettura, Rome, 1562

Vignola, G. Barozzi da, Le due regole della prospettiva pratica, Rome, 1583

Vilímková, M., Mladotův dům (The Mladota house), Prague, 1968

Vilímková, M. — Muk, J., Pražský hrad, Lobkovický palác, čp. 3, průzkum Státního ústavu pro rekonstrukce památkových měst a objektů (Prague Castle, Lobkovice Palace, No. 3, Research by the State institute for the reconstruction of monument towns and buildings), Prague, 1965, in manuscript

Vitruvius Pollio, M., De architettura libri X, Lugduni, 1522, Venice, 1564

Vitruvius Pollio, M., Vitruvius Teutsch . . . Zehen Bücher von der Architektur, trans. W. H. Rivius, Nuremberg, 1548

Vitruvius Pollio, M., I Dieci Libri dell'Architettura. Tradotti e commentati da Mons. Daniel Barbaro, Venice, 1567

Vlastivěda moravská (Historical and geographical research in Moravia), 1 ff, Brno, 1897 ff.

Vojtíšek, V., Z minulosti naší Prahy (From the past of our city of Prague), Prague, 1919

Vokáčová, V., Renesanční interieurová výzdoba zámku Rožmberku (Renaissance interior decoration at Rožmberk Castle), Prague, 1957 (unpublished thesis at Charles university)

Volný, G., Die Markgrafschaft Mähren, 1—6, Brno, 1835—42

Volný, G., Die kirchliche Topographie von Mähren, 1—9, Brno, 1855—63

Votoček, O., Litoměřice, Prague, 1955

Vries, J. Vredeman de, Scenographiae sive Perspectivae . . ., Antwerp, 1560

Vries, J. Vredeman de, Pictores, Statuarii, Architecti, Latomi, et quicunque principum ... adeste hunc libellum varias Cenotaphiorum, tumulorum et mortuorum monumentorum formas ..., Antwerp, 1563

Vries, J. Vredeman de, Das erst Buch, gemacht auff die zwey Colonnen Dorica und Jonica, Antwerp, 1565; Das ander Buch gemacht auf die zway Colonnen Corinthia und Composita, Antwerp, 1565 (1578)

Vries, J. Vredeman de, Perspectiva theoretica ac practica, Amsterdam, 1647

Vries, J. Vredeman de, Architecture contenant Toscane, Dorique, Ionique, Corinthique et Compose (Architectura Das ist: Bauw-kunst Bestähnde in Fünf derley ahrt der Gebauwen: als nemblich Toscana, Dorica, Ionica, Corinthia und Composita), Amsterdam, 1662

Wachsmanová, V., "Státní zámek Nelahozeves" (The State Château of Nelahozeves), in Dvořákova Nelahozeves (Dvořák's Nelahozeves), Prague, 1951

Wachsmanová, V., "Státní zámek na Mělníce" (The State Castle of Mělník), in Mělník, Prague, 1960

Wagner, J., "Renesanční kostely v severovýchodních Čechách" (Renaissance churches in south-eastern Bohemia), in Zprávy památkové péče, 13, Prague, 1953

Wagner-Rieger, R., "Das Wiener Neugebäude," in Mitteilungen des Instituts für österreichische Geschichtsforschung, 59, Vienna, 1951

Wagner-Rieger, R., "Renaissancearchitektur in Oesterreich, Boehmen und Ungarn in ihrem Verhaeltnis zu Italien bis zur Mitte des 16. Jahrhunderts", in Arte e artisti dei laghi lombardi, 1, Como, 1959

Wagner-Rieger, R., Das Schloss zu Spittal an der Drau in Kärnten, Vienna, 1962

Wagner-Rieger, R., "Die Baukunst des 16. und 17. Jahrhunderts in Österreich. Ein Forschungsbericht" in Wiener Jahrbuch für Kunstgeschichte, 20, Vienna, 1965

Wagner-Rieger, R., "Il palladianesimo in Austria", in Bollettino del Centro ... "Andrea Palladio", 7, part 2, 1965

Wagner-Rieger, R., "Architektur und Plastik in Zentraleuropa", in Die Kunst des 17. Jahrhunderts, Propyläen Kunstgeschichte, 9, Berlin, 1970

Waldmann, E., Die Nürnberger Kleinmeister, Leipzig, s. a.

Walcher-Casotti, M., Il Vignola, 1—2, Trieste, 1960

Wasserman, J., Ottaviano Mascarino and his drawings in the Accademia nazionale di San Luca, Rome, 1966

Wastler, J. — Zahn, J., Das Landhaus in Graz, Vienna, 1890

Weihrauch, H. H., "Příspěvky k dílu Benedikta Wurzelbauera a Adriaena de Vriese" (Observation on the work of Benedikt Wurzelbauer and Adriaen de Vries), in Umění, 18, Prague, 1970

Willenberg, J., Pohledy na města, hrady a památné stavby království Českého z počátku XVII. století ... (Views of towns, castles and memorable buildings of the Kingdom of Bohemia from the beginning of the 17th century ...), ed. A. Podlaha and I. Zahradník, Prague, 1901

Willich, H., Giacomo Barozzi da Vignola, Strasbourg, 1906

Willich, H. — Zucker, P., Baukunst der Renaissance in Italien, Wildpark-Potsdam, s. a.

Winter, Z., Kulturní obraz českých měst (A cultural picture of Bohemian towns), 1—2, Prague, 1890

Winter, Z., Řemeslnictvo a živnosti XVI. věku v Čechách (Craftsmen and trades of the 16th century in Bohemia), 1526—1620, Prague, 1909

Wirth, Z., Praha v obraze pěti století (Prague in views of five centuries), Prague, 1941

Wirth, Z., "Die böhmische Renaissance", in Historica, 3, Prague, 1961

Wirth, Z., "Architektura renesanční" (Renaissance Architecture), in Architektura v českém národním dědictví (Architecture in the Bohemian national heritage), Prague, 1961

Wirth, Z. — Benda, J., Státní hrady a zámky (State castles and châteaux), Prague, 1953

Wittkover, R., Architectural principles in the age of humanism, London, 1967

Wölfflin, H., Renaissance und Barock, 4th ed., Munich, 1925

Wolters, W., Plastische Deckendekorationen des Cinquecento in Venedig und im Veneto, Berlin, 1968

Würtenberger, F., Der Manierismus, Vienna — Munich, 1962

Wüsten, E., Die Architektur des Manierismus in England, Leipzig, 1951

Zajícová, O., "Kostel sv. Salvatora v Praze" (St Saviour's Church in Prague), in Ročenka Kruhu pro pěstování dějin umění (Annual of the Society for the pursuit of the history of art), 1935, Prague, 1936

Zachwatowicz, J., Polnische Architektur bis zur Mitte des XIX. Jahrhunderts (Architektura polska do polowy XIX. wieku), 2nd ed., Warsaw, 1956

Zapletal, V., Paracelsus a Moravský Krumlov (Paracelsus and Moravský Krumlov), Moravský Krumlov — Znojmo, 1966

Zapletal, V., et al., Malé dějiny Olomouce (A short history of Olomouc), Olomouc, 1972

Zeiller, M., Topographia Bohemiae, Moraviae et Silesiae, 1, Frankfurt, 1650

Zendralli, A. M., I Magistri Grigioni architetti e costruttori, scultori, stuccatori e pittori dal 16° al 18° secolo, Poschiavo, 1958

Zíbrt, Č., Bibliografie české historie (Bibliography of Czech history), 1 and 3, Prague, 1900, 1906

Zimmer, J., Joseph Heintz der Ältere als Maler, Heidelberg, 1967

Zimmer, J., "Josephus Heinzius architectus cum antiquis comparandus", in Umění, 17, Prague, 1969

Zimmer, J., "Zum Stil in der rudolfinischen Kunst", in Umění, 18, Prague, 1970

Zimmermann, H., "Auszüge aus den Hofzahlamtsrechnungen in der k. k. Hofbibliothek", in Jahrbuch der kunsthistorischen Sammlungen, 29, 1910—11

Zlat, M., "Atyka renesansowa na Śląsku", in Biuletyn historii sztuki, 17, Warsaw, 1955

Zlat, M., Brzeg, Wroclaw, 1960

Zlat, M., "Brama zamkowa w Brzegu", in Biuletyn historii sztuki, 24, Warsaw, 1962

Zorzi, G., I disegni delle antichità di Andrea Palladio, Venice, 1958

Zschelletzschky, H., Das graphische Werk Heinrich Aldegrevers, Strasbourg, 1933

Zürcher, R., Stilprobleme der italienischen Baukunst des Cinquecento, Basle, 1947

Artistic Crafts in the Period of the Renaissance and Mannerism

Bertele, H. von — Neumann, E., "Jost Burgis' Beitrag zur Formenentwicklung der Uhren", in Jahrbuch der Kunsthistorischen Sammlungen, 51 (N.F. XV.), Vienna, 1955

Braun, E. W., "Ein unbekannter Entwurf für die Kaiser Krone Rudolfs II.", in Jahrbuch des Verbandes der deutschen Museen in ČSR, 1, Augsburg, 1931

Bukovinská, B., "Další florentské mozaiky z Prahy" (Further Florentine mosaics from Prague), in Umění 20, Prague, 1972

Chytil, K., Výběr uměleckoprůmyslových výrobků z Jubilejní výstavy 1891 (A selection of products of decorative art from the commemorative exhibition of 1891), Prague, 1891

Chytil, K., Umění v Praze za Rudolfa II. (The arts in Prague in the time of Rudolph II), Prague, 1904 (in German: Die Kunst in Prag zur Zeit Rudolf II., Prague, 1904)

Chytil, K., Koruna Rudolfa II. (The crown of Rudolph II), Prague, 1929

Cibulka, J., Dějepis výtvarného umění v Čechách (The history of the graphic and plastic arts in Bohemia), 1, Středověk (Middle Ages), Prague, 1931

Cibulka, J., "Pycklerův epitaf" (Pyckler's Epitaph), in Umění, 4, Prague, 1931

Drobná, Z., La ricchezza del bordato ecclesiastico en Checoslovaquia, Prague, 1949

Fiala, E., Antonio Abondio, keroplastik a medailér (Antonio Abondio, worker in wax and medallist), Prague, 1909

Fillitz, H., Katalog der weltlichen und der geistlichen Schatzkammer, Vienna, 1961

Guth, K. and Chytil, K., "Vývoj výzdoby zvonů v Čechách" (Development of the decoration of bells in Bohemia), in Ročenka Kruhu pro pěstování dějin umění za rok 1917 (Annual of the Society for the pursuit of the history of art for the year 1917), Prague, 1918

Herain, K., "Z minulosti pražského nábytku" (From the history of Prague furniture), in Kniha o Praze (A book on Prague), 1, 1930

Herbst des Mittelalters. Spätgotik in Köln und am Niederrhein, Cologne, 1970 (Catalogue)

Hráský, J., "O pražských konvářích" (Prague pewterers), in Kniha o Praze 1960 (A book on Prague 1960), Prague, 1960

Jiřík, F. X., České sklo (Bohemian glass), Prague, 1935

Kohlhausen, A., Geschichte des deutschen Kunsthandwerkes, Munich, 1955

Kris, E., Meister und Meisterwerke der Steinschmiederkunst, Vienna, 1929

Kudělková, A. — Zemínová, M., Habánská fajáns ("Haban" faience), Prague, 1961

Kybalová, L., Pražské zvony (Prague bells), Prague, 1958

Meyer-Heisig, E., Der Nürnberger Glasschnitt des 17. Jahrhunderts, Nuremberg, 1963

Pešina z Čechorodu, T., Phosphorus septicornis, h. e. Metropolitanae d. Viti ecclesiae majestas et gloria, Prague, 1673

Poche, E., Uměleckoprůmyslové muzeum v Praze (The Museum of Decorative art in Prague), Prague, 1955

Poche, E., "Na okraj Cibulkových Korunovačních klenotů" (Some remarks on Cibulka's Coronation Jewels), in Umění, 19, Prague, 1971

Poche, E., Poklad svatovítský (The St Vitus treasure), Prague, 1972

Poche, E., Pražské interiéry (Prague interiors), Prague, 1973

Podlaha, A., "Z účtů kostela svatovítského v Praze z konce 15. a začátku 16. století" (From the accounts of St Vitus' Church in Prague from the end of the 15th and the beginning of the 16th centuries), in Památky archeologické, 26, Prague, 1916

Podlaha, A. — Šittler, E., "Poklad svatovítský" (the St Vitus Treasure), in Soupis památek historických a uměleckých v království českém (Inventory of historical and artistic monuments in the Kingdom of Bohemia), Praha-Hradčany, 2/1, Prague, 1903

Podlaha, A. — Šittler, E., Chrámový poklad u sv. Víta v Praze (The treasure of St Vitus' Cathedral in Prague), Prague, 1903

Richter, V., "Chórové lavice jezuitského kostela v Brně" (Choir pews in the Jesuit Church in Brno), in Umění, 11, Prague, 1938

Soupis památek historických a uměleckých v Království českém (Inventory of historical and artistic monuments in the Kingdom of Bohemia): Praha-Hradčany, 2/1, Prague, 1903; 2, okres lounský (Louny District), Prague, 1897; 3, okres sedlčanský (Sedlčany District), Prague, 1898; 6, okres mělnický (Mělník District), Prague, 1900; 7, okres klatovský (Klatovy District), Prague, 1899; 10, okres třeboňský (Třeboň District), Prague, 1900; 11, okres chrudimský (Chrudim District), Prague, 1900; 14, okres jindřichohradecký (Jindřichův Hradec District), Prague, 1901; 18, okres pelhřimovský (Pelhřimov District), Prague, 1903; 27, zámek roudnický (Roudnice Châteaux), Prague, 1907; 36, okres rakovnický (Rakovník District), Prague, 1911; 40; okres jáchymovský (Jáchymov District), Prague, 1913

Steingräber, E., Alter Schmuck, Munich, 1956

Steingräber, E., Die Schatzkammer Europas, Munich, 1968

Stloukal, K., "Portrét Rudolfa II. z roku 1600" (Portrait of Rudolph II in the year 1600), in Od pravěku k dnešku (From the primaeval age until modern times), 2, Prague, 1930 (Collection of papers)

Strohmer, E. V., Prunkgefässe aus Bergkristall, Vienna, 1947

Thoma, H., Schatzkammer der Residenz München, Munich, 1958

Winter, Z., Přepych uměleckého průmyslu v měšťanských domácnostech 16. věku (Luxury art works in burghers' households in the 16th century), Prague, 1893

Winter, Z., Řemeslnictvo a živnosti XVI. věku v Čechách (Craftsmen and trades of the 16th century in Bohemia), 1526—1620, Prague, 1909

Art at the Court of Rudolph II

Alfons, S., Giuseppe Arcimboldo, Malmö, 1957

an der Heiden, Rüdiger, "Die Portraitmalerei des Hans von Aachen", in Jahrbuch der kunsthistorischen Sammlungen, Vienna, 1970

Battisti, E., "Il concetto d'imitazione nel Cirquecento da Raffaelo a Michelangelo. Il concetto d'imitazione nel Cinquecento dai Veneziani a Caravaggio", in Commentari, 7, 1956

Berger, A. and V., "Technologische Erkenntnisse über die Ausführung des Deckengemäldes 'Hermes und Athene' von B. Spranger", in Umění, 18, Prague, 1970

Bergström, I., Dutch Still-Life Painting in the Seventeenth Century, London, 1956

Bergström, I., "Georg Hoefnagel le dernier des grands miniaturists flamands", in L'Oeil, No. 1, 1963

Bertele, H. von — Neumann, E., "Der kaiserliche Kammeruhrmacher Christoph Margraf und die Erfindung der Kugellaufuhr", in Jahrbuch der kunsthistorischen Sammlungen, 59 (N. F. XIII), Vienna, 1963

Białostocki, J., "Les bêtes et les humains de Roelant Savery", in Bulletin des Musées Royaux des Beaux-Arts de Belgique, 7, Brussels, 1958 (in Polish: "Roelant Savery, jego ludzie i zwierzęta", in Biuletyn historii sztuki, 21, Warsaw, 1959)

Böttiger, J., Bronsearbeten of Adriaen de Vries i Sverige, särskilt å Drottningholm, Stockholm, 1884

Boon, K. G., "Roelandt Savery de Praag", in Bulletin van het Rijksmuseum, 9, 1961

van den Brande, R., Die Stilentwicklung im graphischen Werke des Aegidius Sadeler. Ein niederländischer Kupferstecher am Rudolfinischen Hofe, Vienna, 1950 (unpublished dissertation)

Bredius, A. — Moes, E. W., "Die Schilderfamilie Ravesteyn", in Oud-Holland, 9, Amsterdam, 1891

Buchwald, C., Adriaen de Vries, Leipzig, 1899

Burian, J., "Saveryho pohled na Malostranské náměstí" (Savery's view of the Lesser Town Square), in Umění, 5, Prague, 1957

Chadraba, R., "Die Gemma Augustea und die rudolfinische Alegorie", in Umění, 18, Prague, 1970

Chmelarz, E., "Georg und Jakob Hoefnagel", in Jahrbuch der kunsthistorischen Sammlungen, 17, Vienna, 1896

Chytil, K., Umění v Praze za Rudolfa II., Prague, 1904 (in German: Die Kunst in Prag zur Zeit Rudolfs II., Prague, 1904)

Chytil, K., Umění a umělci na dvoře Rudolfa II., Prague, 1912, 2nd ed. 1920 (in German: Kunst und Künstler am Hofe Rudolfs II., Prague, 1912)

Chytil, K., "Apotheosa umění od B. Sprangera" (Apotheosis of the art by B. Spranger), in Ročenka Kruhu pro pěstování dějin umění za rok 1918 (Annual of the Society for the pursuit of the history of art for the year 1918), Prague, 1919

Comanini, G., Il Figino, overo del fine delle Pitture, 1591

Da Costa Kaufmann, T., "Arcimboldo's Imperial Allegories. G. B. Fonteo and the Interpretation of Arcimboldo's Painting", in Zeitschrift für Kunstgeschichte 39, 1976

Danti, V., Il primo libro del Trattato delle perfecte proporzioni, 1567

Diez, E., "Der Hofmaler Bartholomäus Spranger", in Jahrbuch der kunsthistorischen Sammlungen, 28, Vienna — Leipzig, 1909—10

Dolce, L., L'Aretino, Dialogo della pittura, 1557 (reissued 1785)

Erasmus, K., Roelant Savery, sein Leben und seine Werke, Halle, 1908

Evans, R. (J. W.), "Bílá hora a kultura českých zemí" (The White Mountain and Culture in the Czech Lands), trans. F. Šmahel in Československý časopis historický (Czechoslovak Journal of History), 17, Prague, 1969

Evans, R. J. W., Rudolph II and his World. A Study in Intelectual History, 1576—1612, Oxford, 1973

Fechner, J., "Die Bilder von Roelandt Savery in der Eremitage", in Jahrbuch des Kunsthistorischen Instituts der Universität Graz, 2, 1966/7, Graz, 1967

Freedberg, S. J., "Observation on the Paintings of the Maniers", in The Art Bulletin, 48, 1956

Fučíková, E., "Rudolf II. — einige Bemerkungen zu seinen Sammlungen", in Umění, 18, Prague, 1970

Fučíková, E., "Über die Tätigkeit Hans von Aachens in Bayern", in Münchner Jahrbuch der bildenden Kunst, 21, Munich, 1970

Fučíková, E., "Quae praestat iuvenis vix potuere viri," Hans von Aachens Selbstbildnis in Köln, in Wallraf-Richartz-Jahrbuch, 33, Cologne, 1971

Fučíková, E., "Sprangerův obraz 'Venuše a Adónis', v zámecké galerii v Duchcově. K výkladu a ikonografii adónisovského mýtu v 16. století". (Spranger's painting 'Venus and Adonis' in the gallery at Duchcov Castle. On the interpretation and iconography of the Adonis myth in the 16th century), in Umění, 20, Prague, 1972

Fučíková, E., "Umělci na dvoře Rudolfa II. a jejich vztah k tvorbě Albrechta Dürera" (Artists at Rudolph II's Court and their relation to the work of Albrecht Dürer), in Umění, 20, Prague, 1972

Geiger, B., I pitturi ghirizzosi di Giuseppe Arcimboldo, Florence, 1954 (in German: Die skurrilen Gemälde des Giuseppe Arcimboldo, 1527—1593, Wiesbaden, 1960)

Gerszi, T., "Die Landschaftskunst von Paulus van Vianen", in Umění, 18, Prague, 1970

Gerszi, T., "Die humanistischen Allegorien der rudolfinischen Meister", in Actes du XIIe Congrès international d'histoire de l'art, Budapest, 1969. Évolution génerale et développements régionaux en histoire de l'art, vol. 1, Budapest, 1972

Gerszi, T., Netherlandish Drawings in the Budapest Museum, Sixteenth-Century Drawings, Amsterdam, 1971

Haendcke, B., "Josef Heintz, Hofmaler Kaiser Rudolfs II.", in Jahrbuch der kunsthistorischen Sammlungen, 15, Vienna, 1894

Kris, E., "Der Stil 'rustique'", in Jahrbuch der kunsthistorischen Sammlungen, 33, N. F. I, Vienna, 1926

Kris, E., "Georg Hoefnagel und der wissenschaftliche Naturalismus", in Festschrift für Julius Schlosser zum 60. Geburtstag, Zurich — Leipzig — Vienna, 1927

Kuchynka, R., "R. Savery, Okolí Kamenného mostu na Malé Straně kolem 1610" (R. Savery, The Surroundings of the Stone Bridge in the Lesser Town around 1610), in Umělecké poklady Čech (Artistic Treasures of Bohemia), 2, Prague, 1915

Kuchynka, R., "Dětřich Ravesteyn, dvorní malíř Rudolfa II." (Dětřich Ravesteyn, Court painter to Rudolph II), in Časopis Společnosti přátel starožitností českých (Journal of the Society of friends of Bohemian antiquities), 30, Prague, 1922

"Das Kunstkammerinventar Kaiser Rudolfs II., 1607—1611". Herausgegeben von Rotrand Bauer und Herbert Haupt, in Jahrbuch der Kunsthistorischen Sammlungen, Vienna, 72, 1976

Larsson, L. O., Adrian de Vries, Adrianus Fries Hagiensis Batavus, 1545—1626, Vienna — Munich, 1967

Larsson, L. O., "Hans Mont van Gent. Versuch einer Zuschreibung", in Konsthistorisk Tidskrift, 36, Stockholm, 1967

Legrand, C. F. — Sluys, F., Arcimboldo et les arcimboldesques, Brussels, 1955

Lhotsky, A., "Die Geschichte der Sammlungen", in Festschrift des Kunsthistorischen Museums in Wien 1891—1941, 2, Vienna, 1941—45

Lomazzo, G. P., Trattato dell'arte della pittura, scultura et architettura, Milan, 1584—85

Lomazzo, G. P., Idea del Tempio della Pittura, Milan, 1950, new edition: Gian Paolo Lomazzo, Scritti sulle arti, Vol. 1, A cura di Roberto Paolo Ciardi, Florence, 1973

Mádl, K. B., "Obrazárna a umělci Rudolfa II. v Praze" (Rudolph II's picture gallery and artists in Prague), in Památky archeologické, 22, Prague, 1906—8

Mander, C. van, Het Leven der Doorluchtighe Nederlandtsche en Hooghduytsche Schilders, Amsterdam, 1617 (in German: Das Leben der niederländischen und deutschen Maler, ed. H. Floerke, Munich — Leipzig, 1906)

Modern, H., "Paulus van Vianen", in Jahrbuch der kunsthistorischen Sammlungen, 15, Vienna, 1894

Neumann, E., "Das Inventar der rudolfinischen Kunstkammer von 1607/1611" in Analecta Reginensia, 1. Queen Christina of Sweden. Documents and Studies, Stockholm, 1966

Neumann, J., "Nově objevený obraz Bartoloměje Sprangera" (The recently discovered painting by Bartholomeus Spranger), in Zprávy památkové péče, 13, Prague, 1953

Neumann, J., "Aachenovo Zvěstování P. Marie" (Hans von Aachen's Annunciation) in Umění, 4, Prague

Neumann, J., "Objevy vzácných obrazů na Pražském hradě" (Discoveries of valuable paintings in Prague Castle), in Výtvarné umění (Graphic and plastic arts), 12, Prague, 1962

Neumann, J., Obrazárna Pražského hradu, 2nd ed., Prague, 1966 (in English: The Picture Gallery of Prague Castle, Prague, 1967)

Neumann, J., "Kleine Beiträge zur rudolfinischen Kunst und ihre Auswirkungen", in Umění, 18, Prague, 1970

Neumann, J., Das böhmische Barock, Vienna (Prague), 1970

Neumann, J., Rudolfínské malířství a sochařství (Rudolphine painting and sculpture), Prague, 1972, in manuscript

Neumann, J., "Rudolfínské umění I" (Rudolphine Art I) in Umění, 30, 1977; "Rudolfínské umění II", in Umění, 31, 1978

Niederstein, A., "B. Spranger", in Thieme — Becker, Künstlerlexikon, vol. 31, 1937

Oberhuber, K., Die stilistische Entwicklung im Werk Bartholomäus Sprangers, Vienna, 1958 (unpublished dissertation)

Oberhuber, K., "Die Landschaft im Frühwerk Bartholomäus Sprangers", in Jahrbuch der Staatlichen Kunstsammlungen in Baden — Württemberg, 1, Munich — Berlin, 1964

Peltzer, R. A., "Der Hofmaler Hans von Aachen, seine Schule und seine Zeit", in Jahrbuch der kunsthistorischen Sammlungen, 30, Vienna — Leipzig, 1911—12

Petrová, E. — Novák, L., "Manýrismus v moderních estetických aspektech" (Modern aesthetic aspects of Mannerism), in Výtvarné umění, 19, Prague, 1969

Pigler, A., "Notice sur Dirck de Quade van Ravesteyn", in Oud-Holland, 63, Amsterdam 1948

Preiss, P., Giuseppe Arcimboldo, Prague, 1967

Preiss, P., Panorama manýrismu — Kapitoly o umění a kultuře 16. století (Panorama of Mannerism, Chapters on 16th Century Art and Culture), Prague, 1974

Reznicek, E. K. J., Die Zeichnungen von Hendrick Goltzius, Utrecht, 1961

Reznicek, E. K. J., "Bartholomäus Spranger als Bildhauer", in Festschrift Ulrich Middeldorf, Berlin, 1968

de Sadelers, Jan, Raphael, Aegidius, Exhibition in Boymans-van Beuningen Museum, Rotterdam, February 28 — April 21, 1963

Schlosser, J. v., Die Kunst- und Wunderkammer der Spätrenaissance, Leipzig, 1908

Schnackenburg, B., "Beobachtungen zu einem neuen Bild von Barholomäus Spranger", in Niederdeutsche Beiträge zur Kunstgeschichte, vol. 9, 1970

Schneede, U. M., Das repräsentative Gesellschaftsbild in der niederländischen Malerei und seine Grundlagen bei Hans Vredeman de Vries, Kiel, 1965 (unpublished dissertation)

Shearman, J., Mannerism, Harmondsworth, 1967

Šíp, J., "Some Remarks on a little-known Masterpiece by Roelant Savery", in Sborník prací filosofické fakulty brněnské university (Collection of papers of the Philosophical Faculty of Brno University), F 8, Brno, 1964

Šíp, J., "Roelant Savery in Prague", in Umění, 18, Prague, 1970

Šíp, J., "Prag als Zentrum der Landschaftsmalerei zur Zeit Rudolfs II.", in Europäische Landschaftsmalerei 1550—1650, Dresden, 1972

Šíp, J., "Savery in around Prague", in Bulletin du Musée National de Varsovie, 14, 1973

Spicer, J. A., "Savery's Studies in Bohemia", in Umění, 18, Prague, 1970

Spicer, J. A., "The 'naer het leven' Drawings by Pieter Bruegel or Roelandt Savery?", in Master Drawings, vol. 8, No. 1, New York, 1970

Springel, F. C., Connoiseur et Diplomat. The Earl of Arundel's Embassy to Germany in 1636 as recounted in William Crowne's Diary, the Earl's letters and other contemporary sources with catalogue of the topographical drawings made on the journey by Wenceslaus Hollar, London, Hertford and Harlow, 1963

Strohmer, E. V., "Bemerkungen zu den Werken des Adriaen de Vries", in Nationalmusei Årsbok 1947—48, Stockholm, 1950

Volavková, H., "Ohlasy manýrismu v našem století" (Echoes of Mannerism in our century), in Výtvarné umění, 19, Prague, 1969

Wagner, W., "Skizzenbuchblätter von Paul von Vianen mit einer Ansicht von Salzburg", in Mitteilungen der Gesellschaft für Salzburger Landeskunde, 96, Salzburg, 1956

Wagner, W., "Neue Ansichten von Salzburg von Paul van Vianen", in op. cit. 98, Salzburg, 1968

Weihrauch, H. R., Europäische Bronzestatuetten 15.—18. Jahrhunderts, Brunswick, 1967

Wilberg Vignau-Schuurman, Th. A. G., Die emblematischen Elemente im Werke Joris Hoefnagels, 1—2, Leiden, 1969

Wirth, Z., "Nový pohled na Prahu od severu z doby Rudolfovy" (A new view of Prague from the north from Rudolph's time), in Umění, 10, Prague, 1937

Zimmer, J., Joseph Heintz der Ältere als Maler, Weissenhorn, 1971

Zuccaro, F., L'Idea de pittori, scultori ed architetti, 1, Turin, 1607 (Reissue: Scritti d'Arte di Federigo Zuccaro, ed. Heikamp, Florence, 1961)

Zwollo, An, "Pieter Stevens, ein vergessener Maler des rudolfinischen Kreises", in Jahrbuch der kunsthistorischen Sammlungen, 64, Vienna, 1968

Zwollo, An, "Pieter Stevens, neue Zuschreibungen und Zusammenhänge", in Umění, 18, Prague, 1970

LIST OF ILLUSTRATIONS

235

LIST OF ILLUSTRATIONS IN THE TEXT

INDEX OF NAMES

239

INDEX OF PLACES

PHOTOGRAPHIC ACKNOWLEDGEMENTS

Pictorial part of the book:

Frontispiece, No. 1, 3—8, 10—12, 16—19, 21—24, 26—30, 32—35, 37—38, 40—41, 44—46, 48, 53, 56, 61—67, 69, 73—74, 77—84, 86—89, 91, 93, 98, 100—105, 107, 111—113, 115, 117, 121—122, 124—125, 130, 132—133, 137, 140, 146, 166, 189, 196, 198—199, back endpaper: Prokop Paul, Prague. No. 2, 9, 13—15, 20, 131, 143, 145: Alexandr Paul, Prague. No. 25: Szépmüvészeti Múzeum, Budapest. No. 31: Tibor Honty, Prague. No. 36, 129: Karel Plicka, Prague. No. 39, 43, 47, 50, 68, 126, back of the jacket: Dr. Ivan Muchka, Prague. No. 42: Věra Pospíšilová, Prague. No. 49, 51—52, 54—55, 57—60, 70—72, 90, 95—96, 114, 123, 128, 139, 141, 144, 148, 150, 153—154, 156, 165, 174, 179, 181, 184: Ladislav Neubert, Prague. No. 75, 97, 118: Čestmír Šíla, Prague. No. 76: Anna Waltrová, Prague. No. 85, 92: Josef Erhart, Plav, district České Budějovice. No. 94, 116: Vladimír Hyhlík, Prague. No. 99, 106, 134: Vojtěch Obereigner, Prague. No. 108, 163, 169, 182, 192: Národní galerie, Prague. No. 109: Jaroslav Rajzík, Prague. No. 110: Jiří Hampl, Prague. No. 119, 120, 127: František Krejčí, Prague. No. 135: Staatliche Museen, Kunstgewerbemuseum, Berlin. No. 136: Muzeum hlavního města Prahy, Prague. No. 138: Museum für Kunsthandwerk, Frankfurt am Main. No. 142, 147, 151, 157—158, 160—162, 168, 170, 176, 183, 185, 187, 191, 200, jacket front: Kunsthistorisches Museum, Vienna. No. 149: Kungl. Husgerådskammaren, Stockholm. No. 152, 175: British Museum, London. No. 155: Stanislav Suk, Kralupy. No. 159: Kungl. Konsthögskolan, Stockholm. No. 164, 195: Rijksmuseum, Amsterdam. No. 167: Graphische Sammlung Albertina, Vienna. No. 171: Staatliche Kunsthalle, Karlsruhe. No. 172: Musée des Beaux-Arts, Besançon. No. 173: Kunstmuseum der Stadt Düsseldorf. No. 177: Stadtmuseum, Cologne. No. 178: Staatsgalerie, Stuttgart. No. 180: Bayerische Staatsgemäldesammlungen, Munich. No. 186: Kunstmuseum, Berne. No. 188: Musée des Beaux-Arts, Dijon. No. 190: National Galleries of Scotland, Edinburgh. No. 193: National Gallery of Art, Washington. No. 194: Louvre, Paris. No. 197: Stockholms Universitet, Stockholm. Front endpaper: Muzeum hlavního města Prahy, Prague.

Illustrations in the text:

pp. 17, 174: Prokop Paul, Prague. pp. 19, 53, 55, 70, 72, 82, 101, 102, 104, 106, 108, 136: Jarmila Hanušová, České Budějovice. p. 32: The Wallace Collection, London. p. 103: ing. arch. Dobroslava Menclová, Prague. p. 144: Muzeum hlavního města Prahy, Prague. p. 183: Kunsthistorisches Museum, Vienna. pp. 194—195: Ladislav Neubert, Prague. p. 207: Szépmüvészeti Múzeum, Budapest. p. 239: dr. Jaroslava Lencová, Prague.

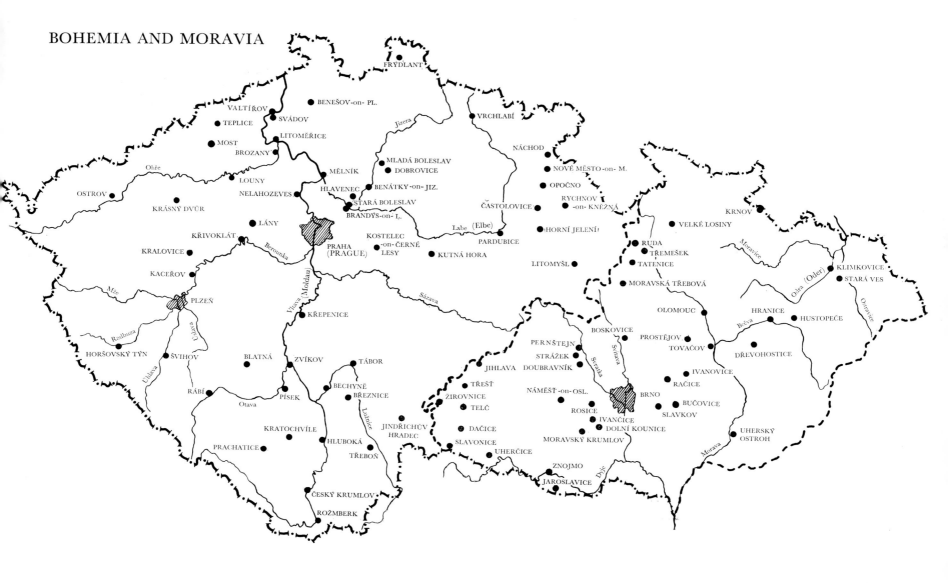

FRÝDLANT

BENEŠOV-on- PL.
VALTÍŘOV
TEPLICE SVÁDOV
VRCHLABÍ
LITOMĚŘICE
MOST NÁCHOD
BROZANY
Ohře MLADÁ BOLESLAV NOVÉ MĚSTO-on- M.
LOUNY DOBROVICE
OSTROV NELAHOZEVES MĚLNÍK OPOČNO
KRÁSNÝ DVŮR HLAVENEC BENÁTKY-on- JIZ. RYCHNOV
STARÁ BOLESLAV -on- KNĚŽNÁ KRNOV
LÁNY BRANDÝS-on- L. ČÁSTOLOVICE VELKÉ LOSINY
KŘIVOKLÁT PRAHA Labe (Elbe) HORNÍ JELENÍ
KRALOVICE (PRAGUE) KOSTELEC RUDA
-on- ČERNÉ PARDUBICE TŘEMEŠEK KLIMKOVICE
KACEŘOV LESY KUTNÁ HORA LITOMYŠL TATENICE STARÁ VES
Mže MORAVSKÁ TŘEBOVÁ
Radbuza PLZEŇ OLOMOUC HRANICE
HORŠOVSKÝ TÝN ŠVIHOV KŘEPENICE BOSKOVICE HUSTOPEČE
ŠVIHOV PERNŠTEJN PROSTĚJOV
BLATNÁ ZVÍKOV TÁBOR STRÁŽEK TOVAČOV DŘEVOHOSTICE
RÁBÍ JIHLAVA DOUBRAVNÍK IVANOVICE
BECHYNĚ TŘEŠŤ NÁMĚŠŤ -on-OSL. RAČICE
PÍSEK BŘEZNICE ŽIROVNICE BRNO
KRATOCHVÍLE TELČ ROSICE BUČOVICE
JINDŘICHŮV DAČICE IVANČICE SLAVKOV
PRACHATICE HLUBOKÁ HRADEC SLAVONICE DOLNÍ KOUNICE
TŘEBOŇ UHERČICE MORAVSKÝ KRUMLOV UHERSKÝ
ZNOJMO OSTROH
ČESKÝ KRUMLOV JAROSLAVICE
ROŽMBERK

PRAGUE

1 Prague Castle
2 Palace of John of Lobkovice (today the Palace of Schwarzenberg)
3 Palace of the Lords of Hradec
4 Italian Hospital
5 Strahov — Church of St Rochus
6 Town Hall of the Lesser Town
7 Church of the Holy Trinity (today the Church of Our Lady Victorious)
8 Church of St Saviour in Klementinum and the Italian Chapel
9 Pinkas Synagogue
10 The U minuty (At the Minute) house
11 Town Hall of the Old Town
12 Church of St Saviour (Lutheran)
13 Týn Courtyard
14 Church of the Virgin Mary before Týn
15 Powder Gate
16 The houses At Five Crowns, At the Melantrichs and At Two Golden Bears
17 Church of St Henry
18 Church of Virgin Mary and of St Charlemagne

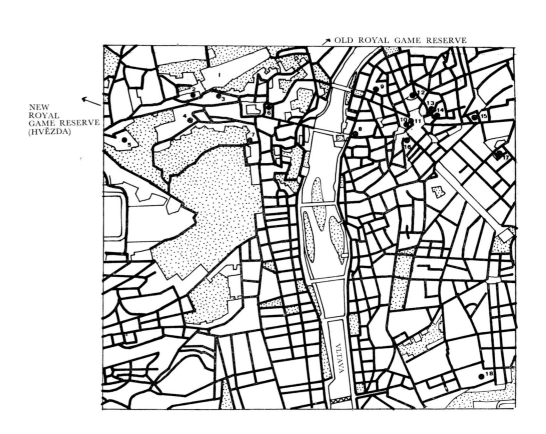

OLD ROYAL GAME RESERVE

NEW ROYAL GAME RESERVE (HVĚZDA)

CONTENTS

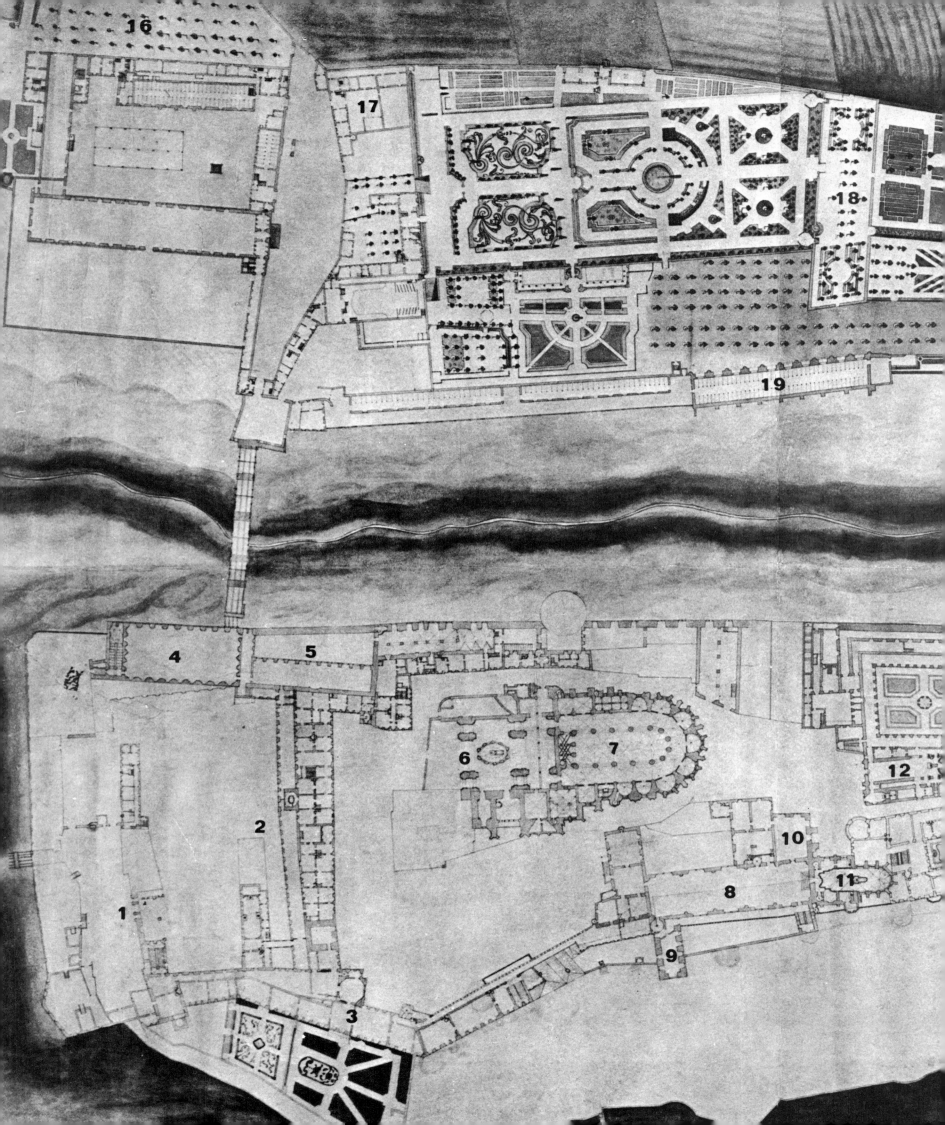